The Alps

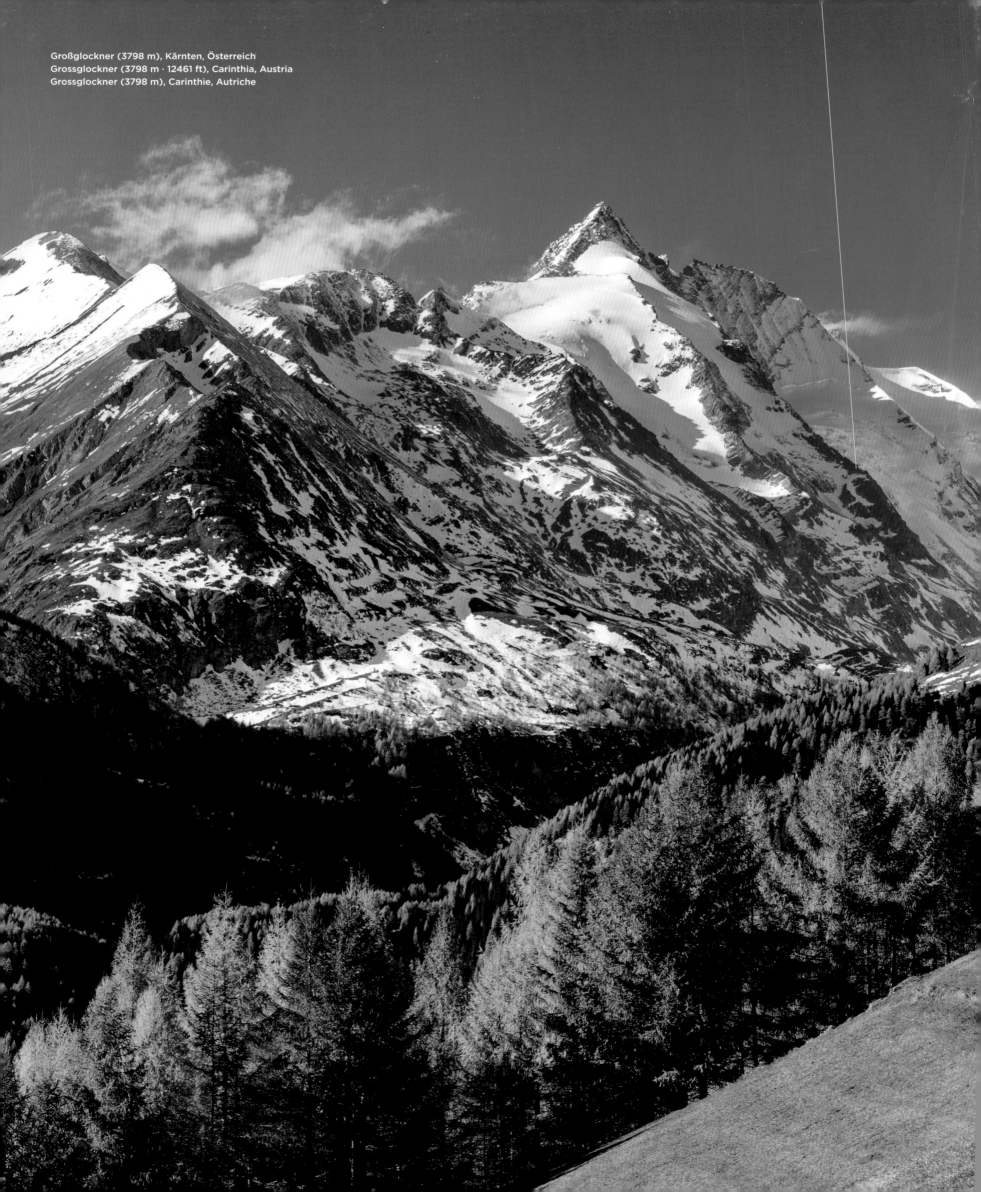

Großglockner (3798 m), Kärnten, Österreich
Grossglockner (3798 m · 12461 ft), Carinthia, Austria
Grossglockner (3798 m), Carinthie, Autriche

The Alps

Les Alpes
Die Alpen
Los Alpes
Os Alpes
De Alpen

Udo Bernhart
Bernhard Mogge

ÉDITIONS
PLACE DES
VICTOIRES

KÖNEMANN

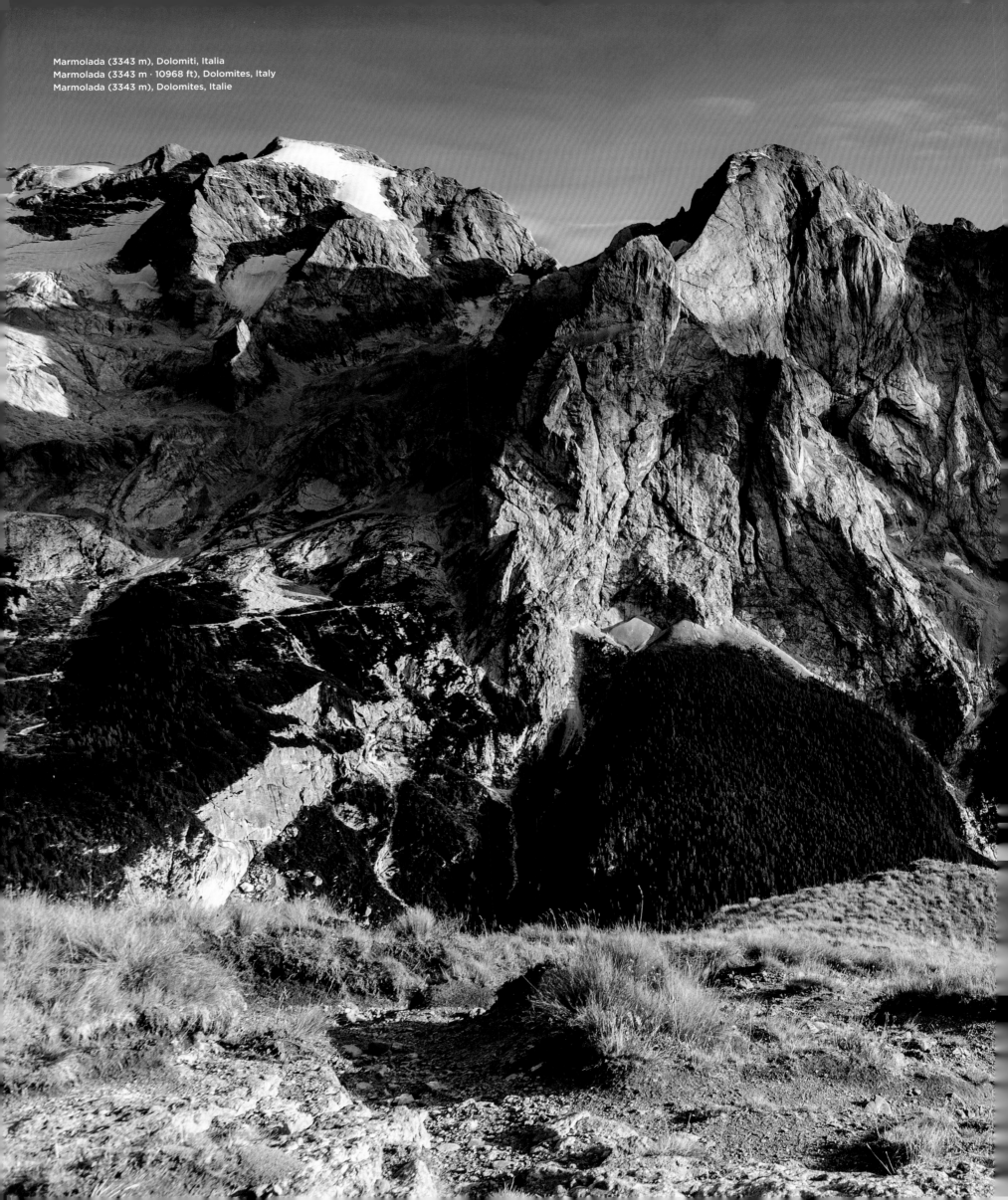

Marmolada (3343 m), Dolomiti, Italia
Marmolada (3343 m · 10968 ft), Dolomites, Italy
Marmolada (3343 m), Dolomites, Italie

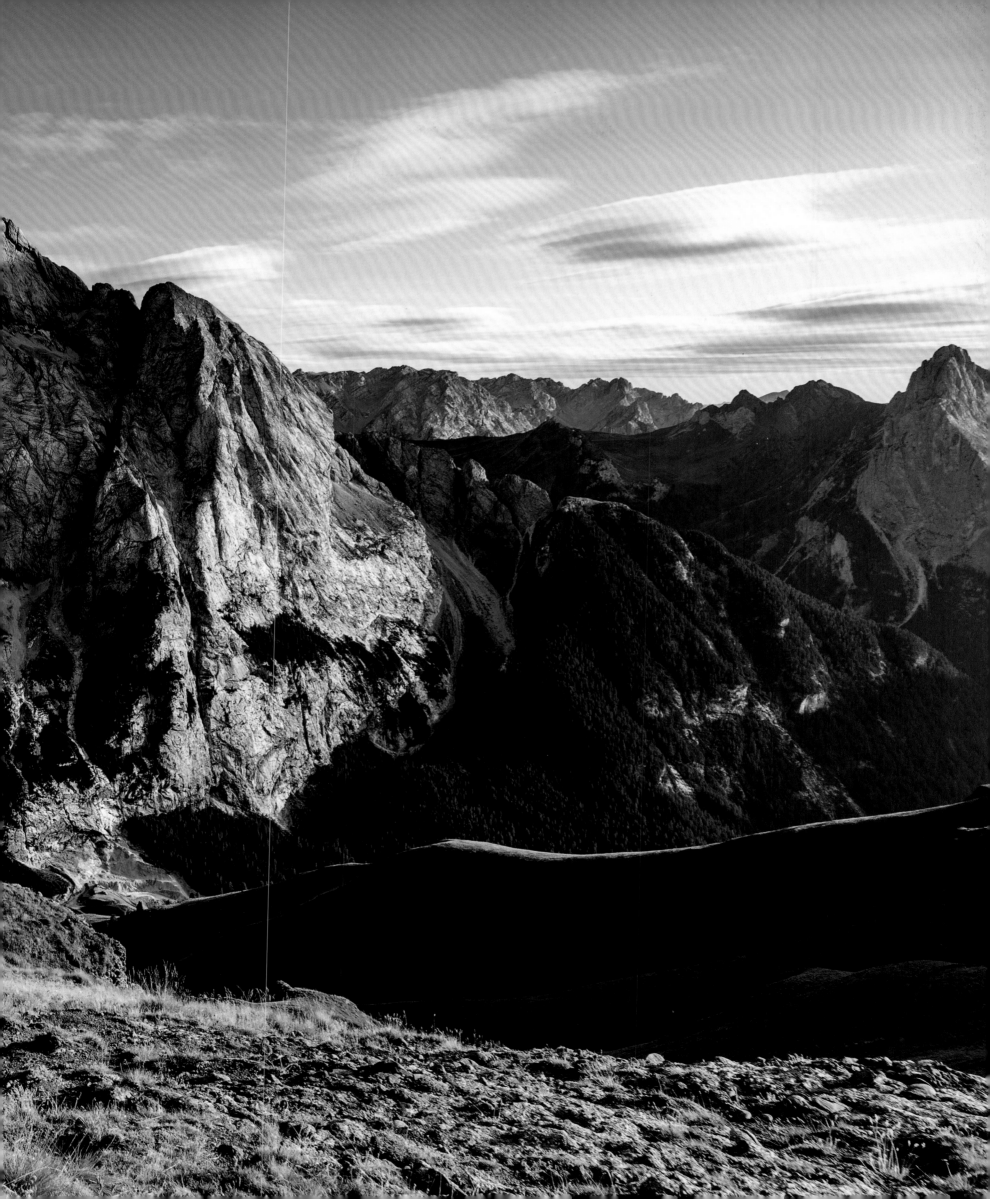

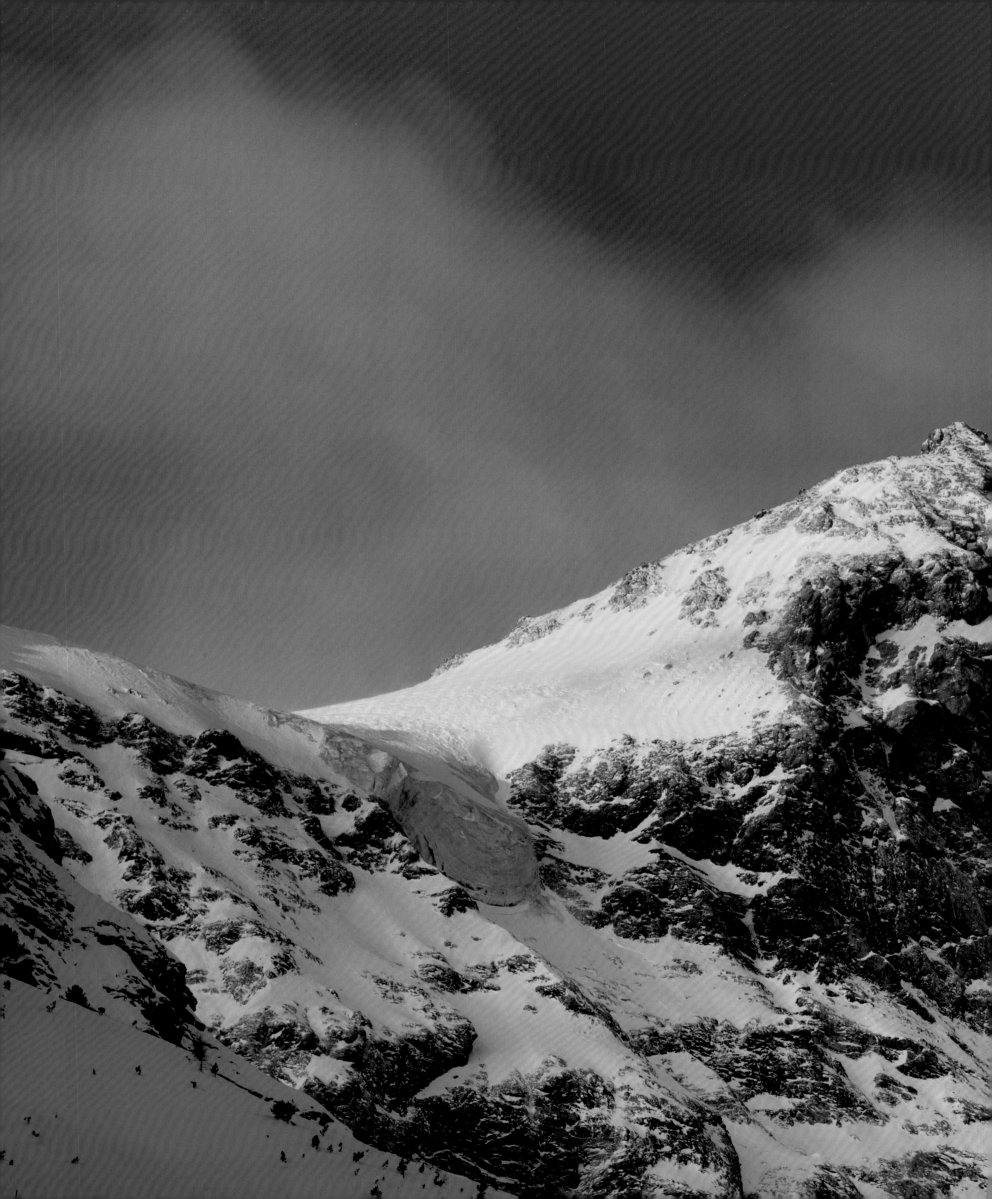

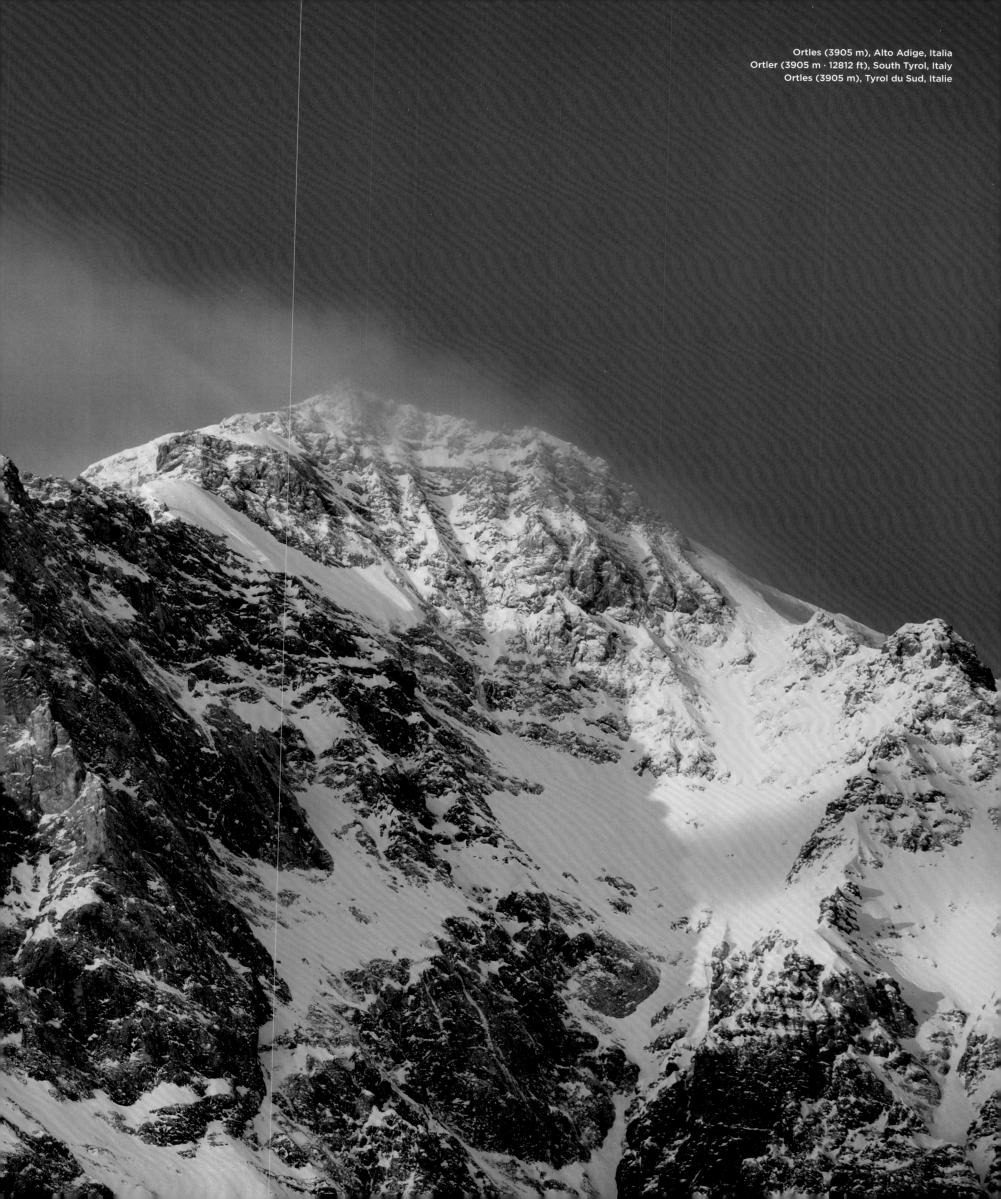

Ortles (3905 m), Alto Adige, Italia
Ortler (3905 m · 12812 ft), South Tyrol, Italy
Ortles (3905 m), Tyrol du Sud, Italie

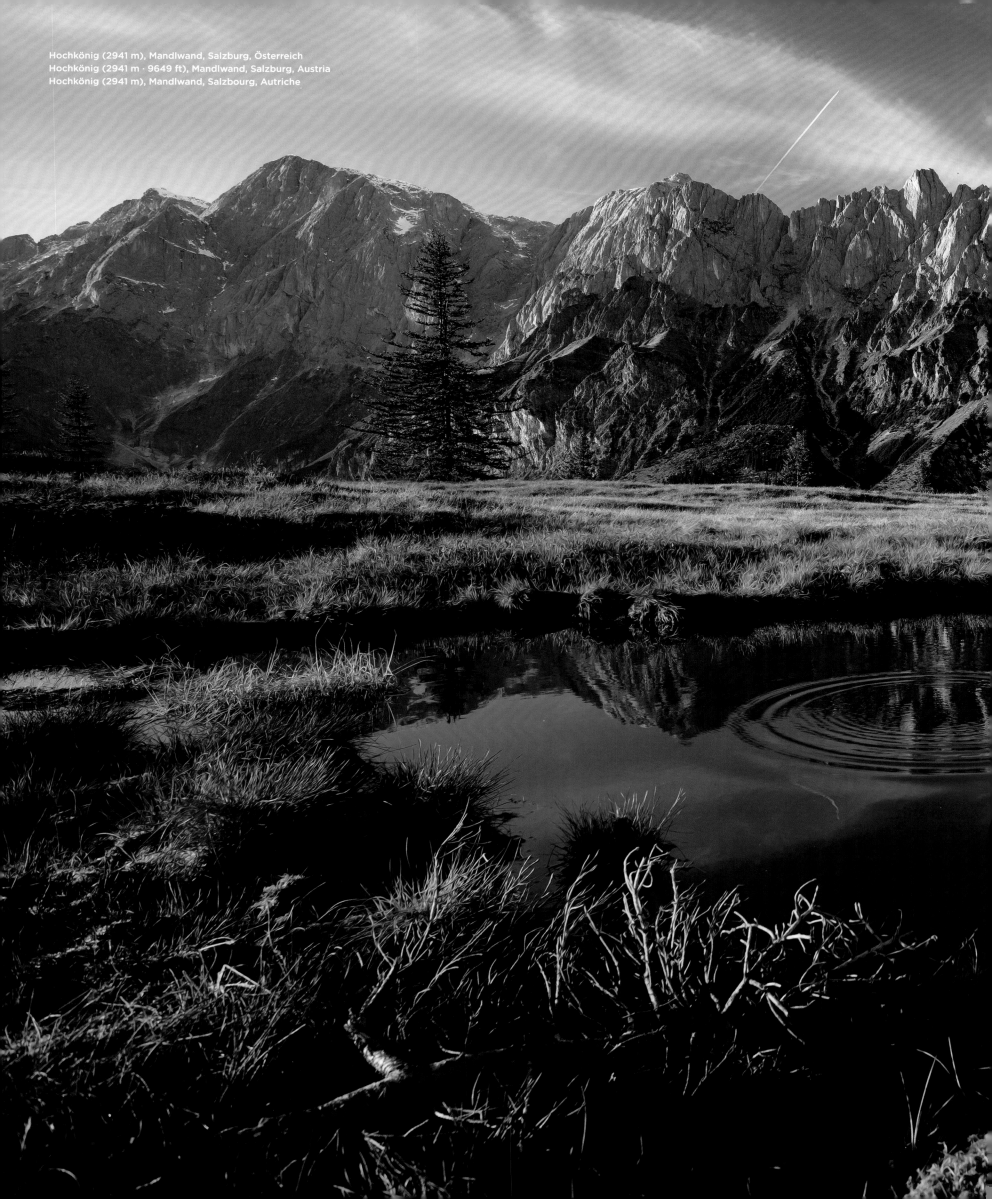

Hochkönig (2941 m), Mandlwand, Salzburg, Österreich
Hochkönig (2941 m · 9649 ft), Mandlwand, Salzburg, Austria
Hochkönig (2941 m), Mandlwand, Salzbourg, Autriche

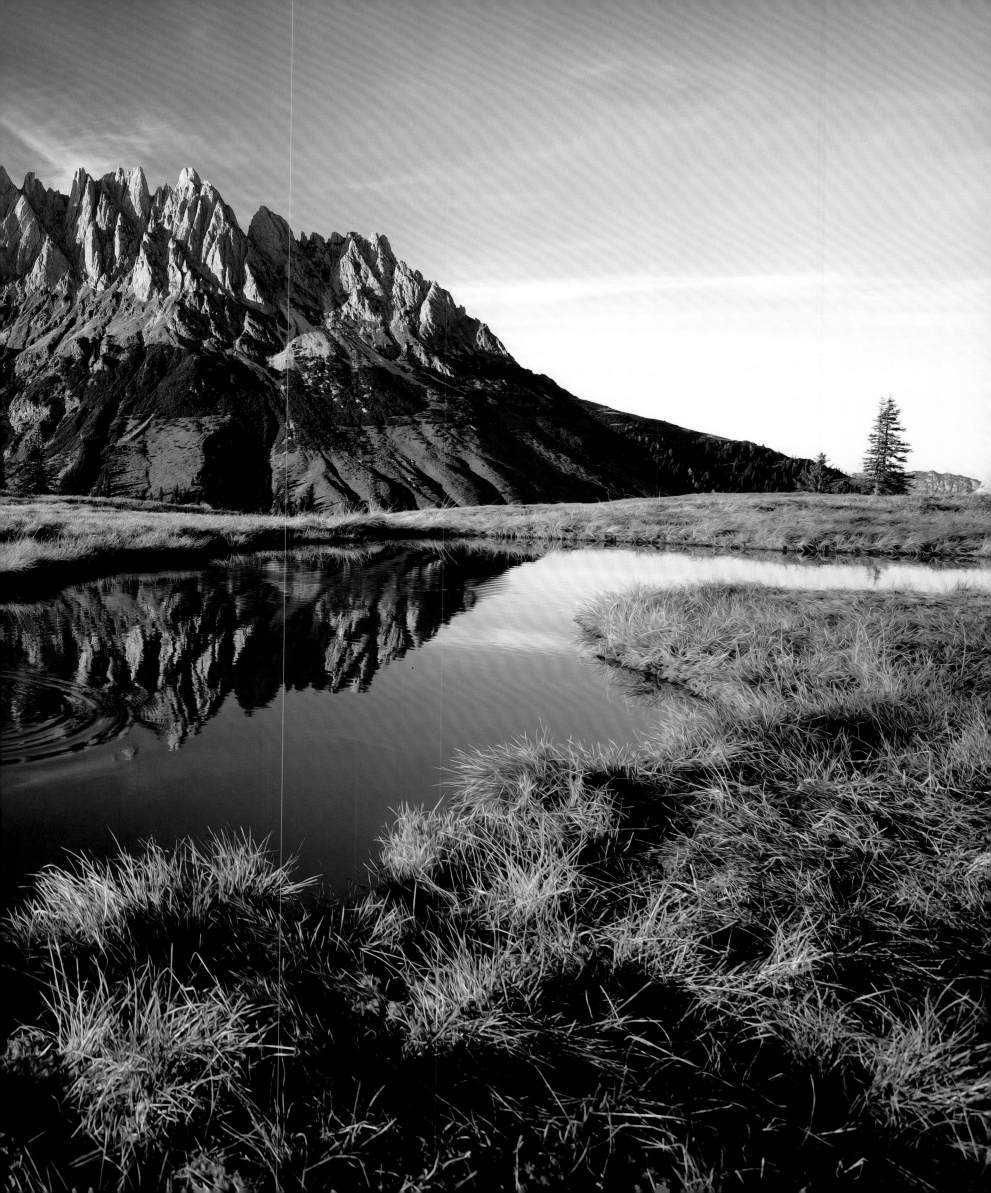

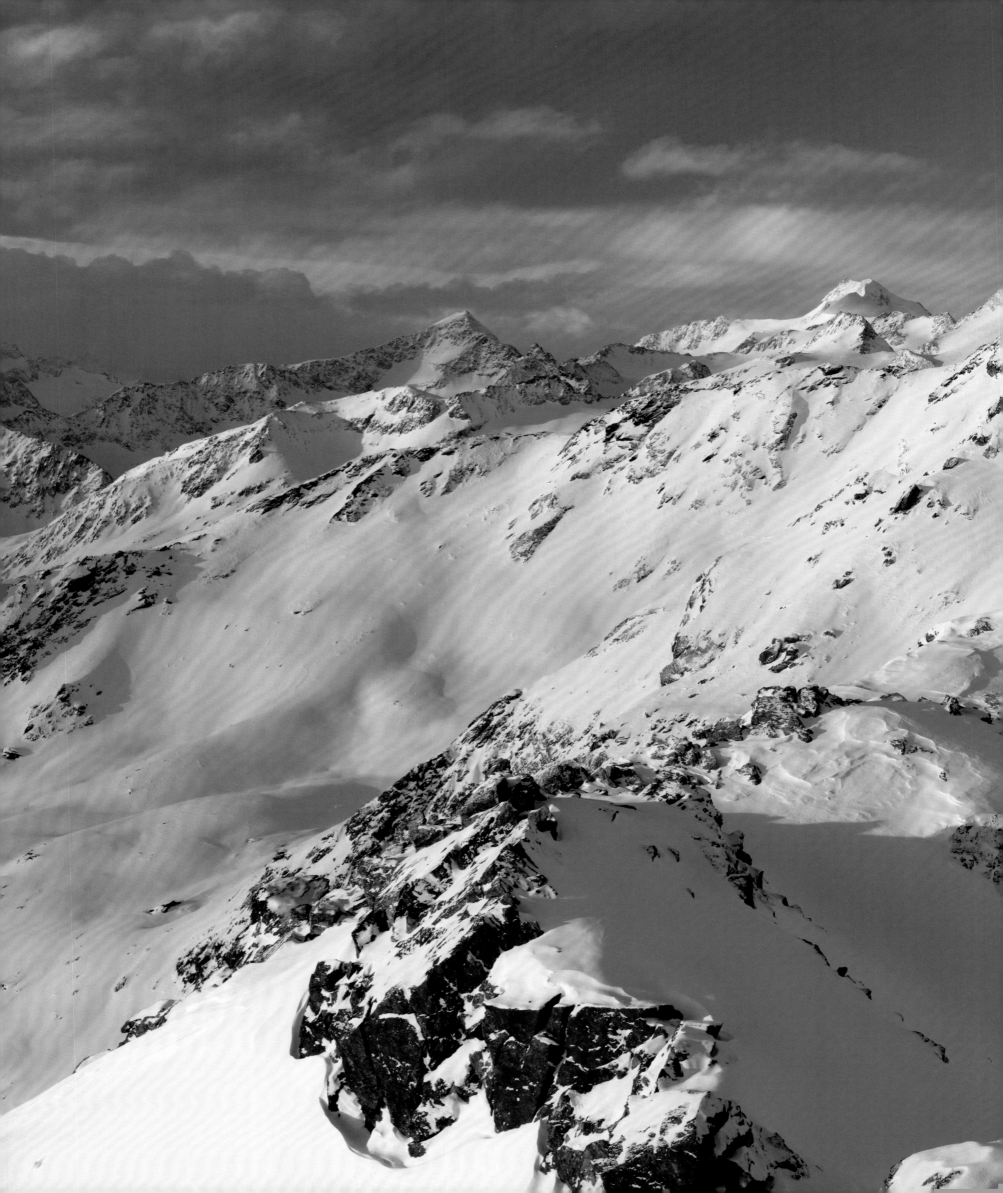

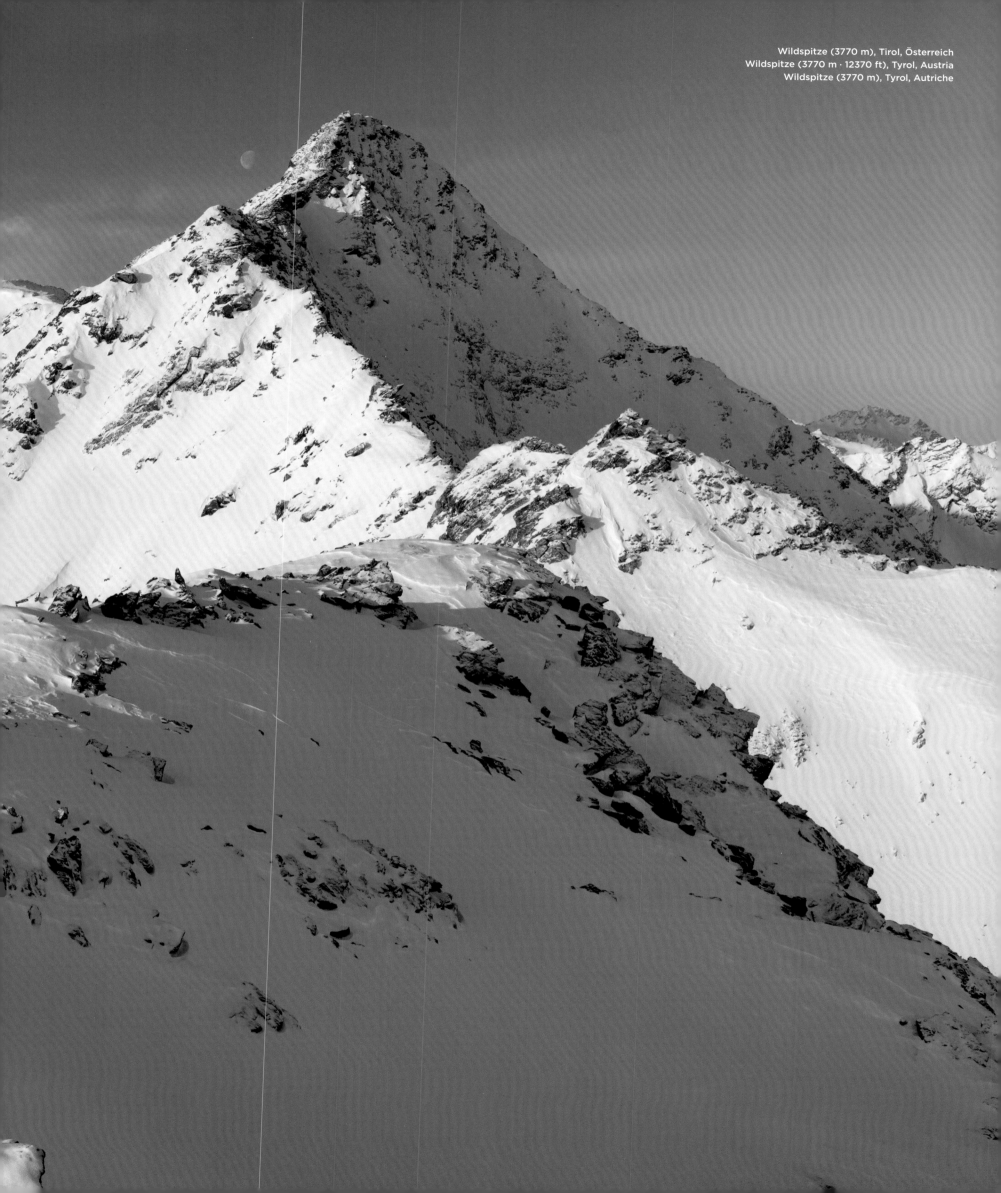

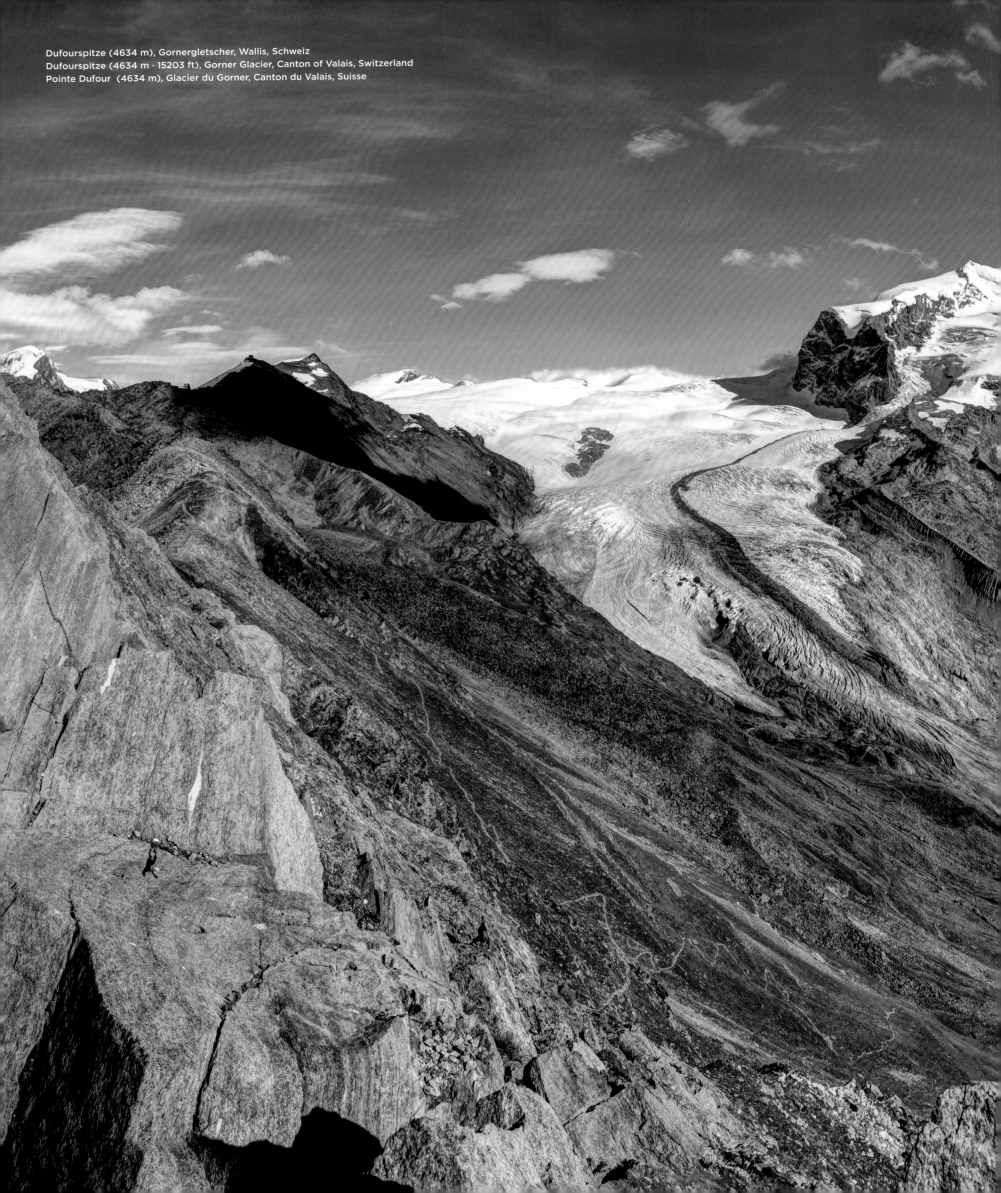

Dufourspitze (4634 m), Gornergletscher, Wallis, Schweiz
Dufourspitze (4634 m · 15203 ft), Gorner Glacier, Canton of Valais, Switzerland
Pointe Dufour (4634 m), Glacier du Gorner, Canton du Valais, Suisse

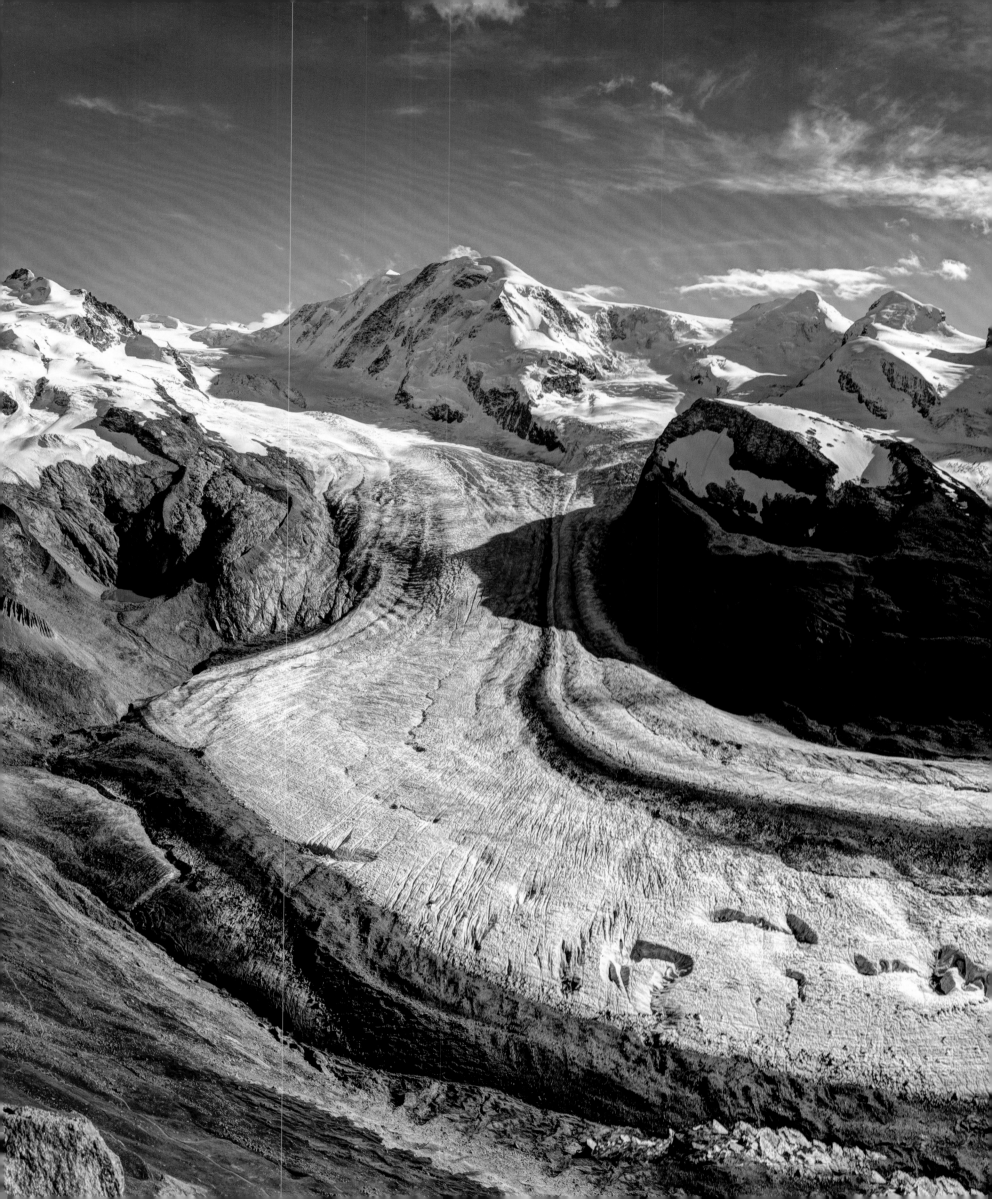

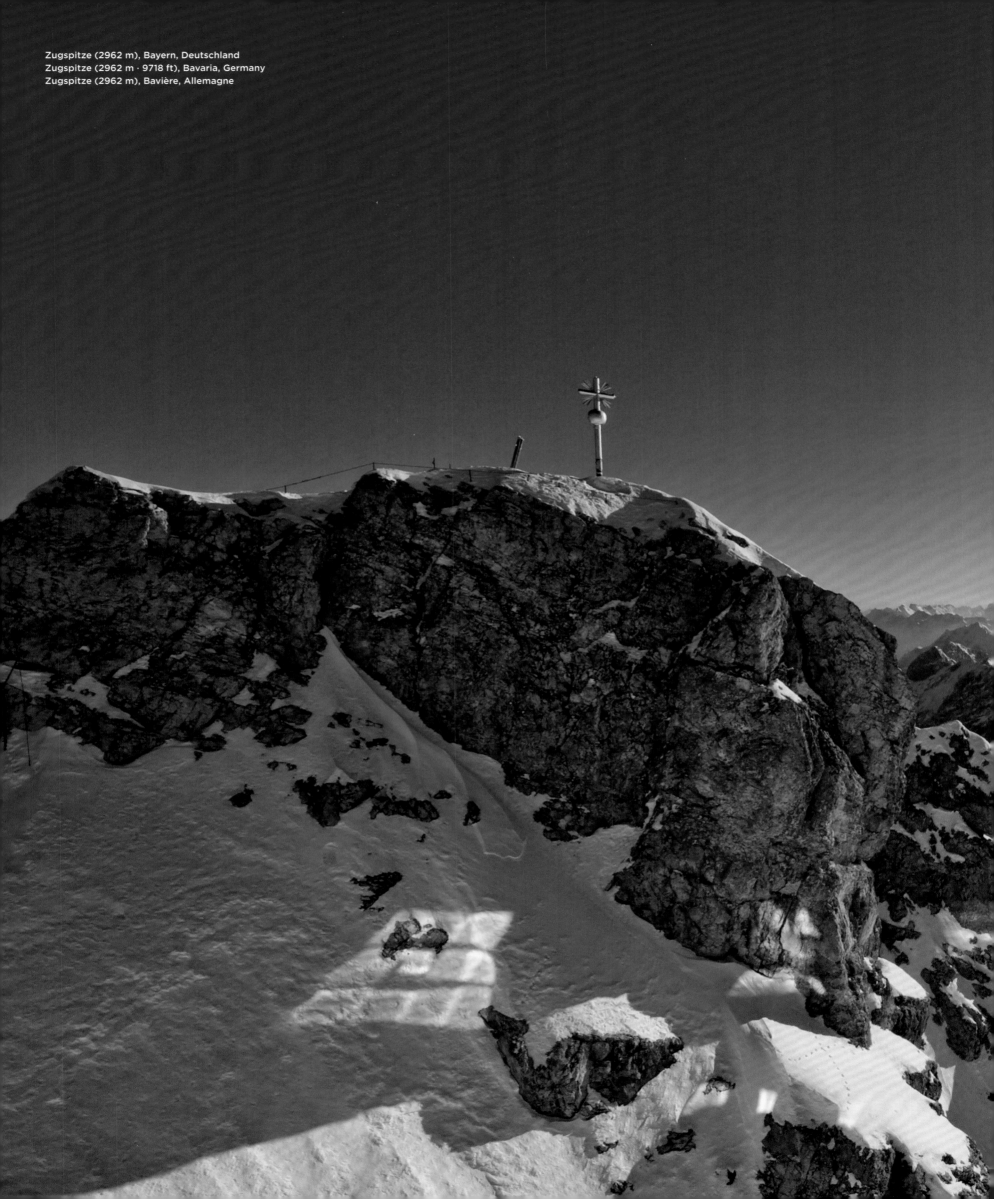

Zugspitze (2962 m), Bayern, Deutschland
Zugspitze (2962 m · 9718 ft), Bavaria, Germany
Zugspitze (2962 m), Bavière, Allemagne

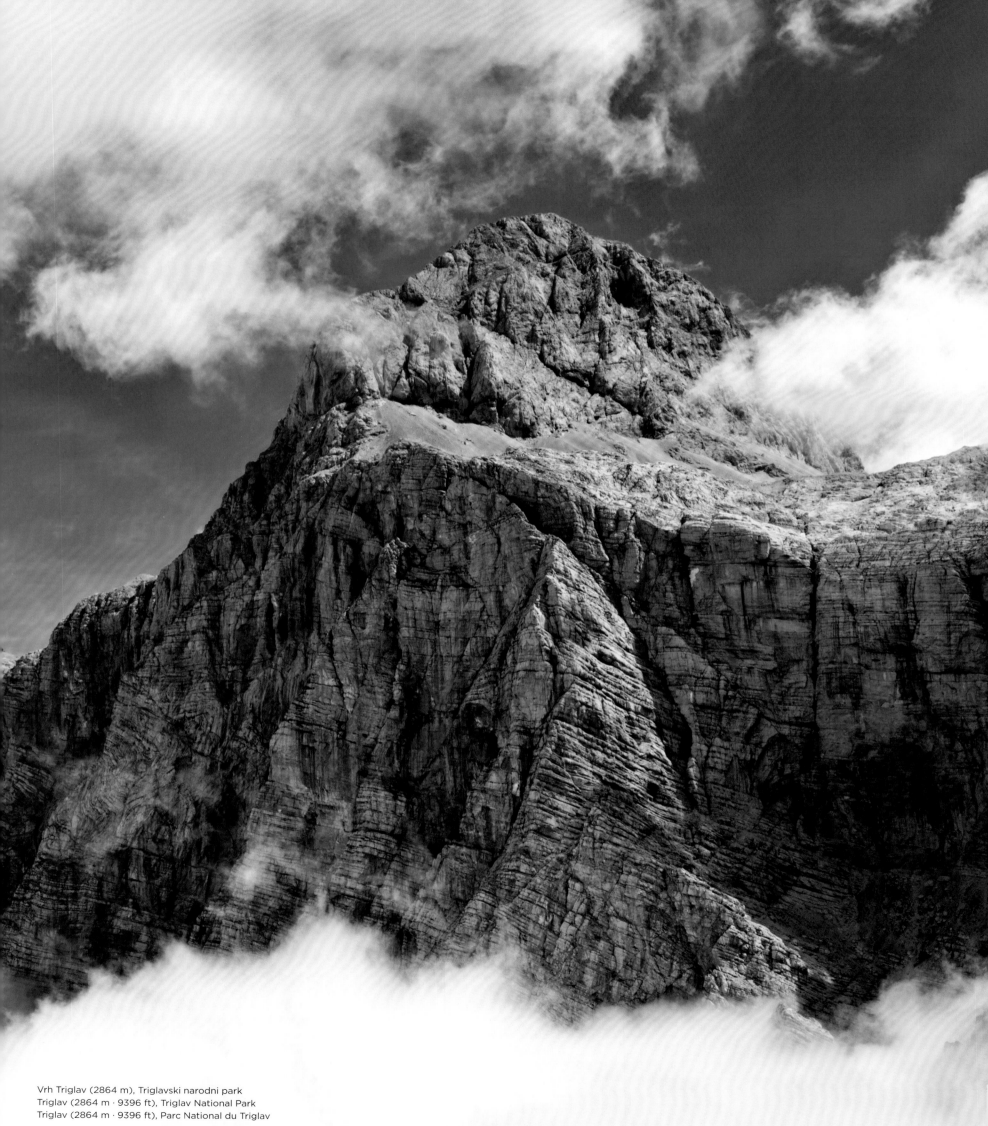

Vrh Triglav (2864 m), Triglavski narodni park
Triglav (2864 m · 9396 ft), Triglav National Park
Triglav (2864 m · 9396 ft), Parc National du Triglav

Contents · Sommaire · Inhalt · Índice · Indice · Inhoud

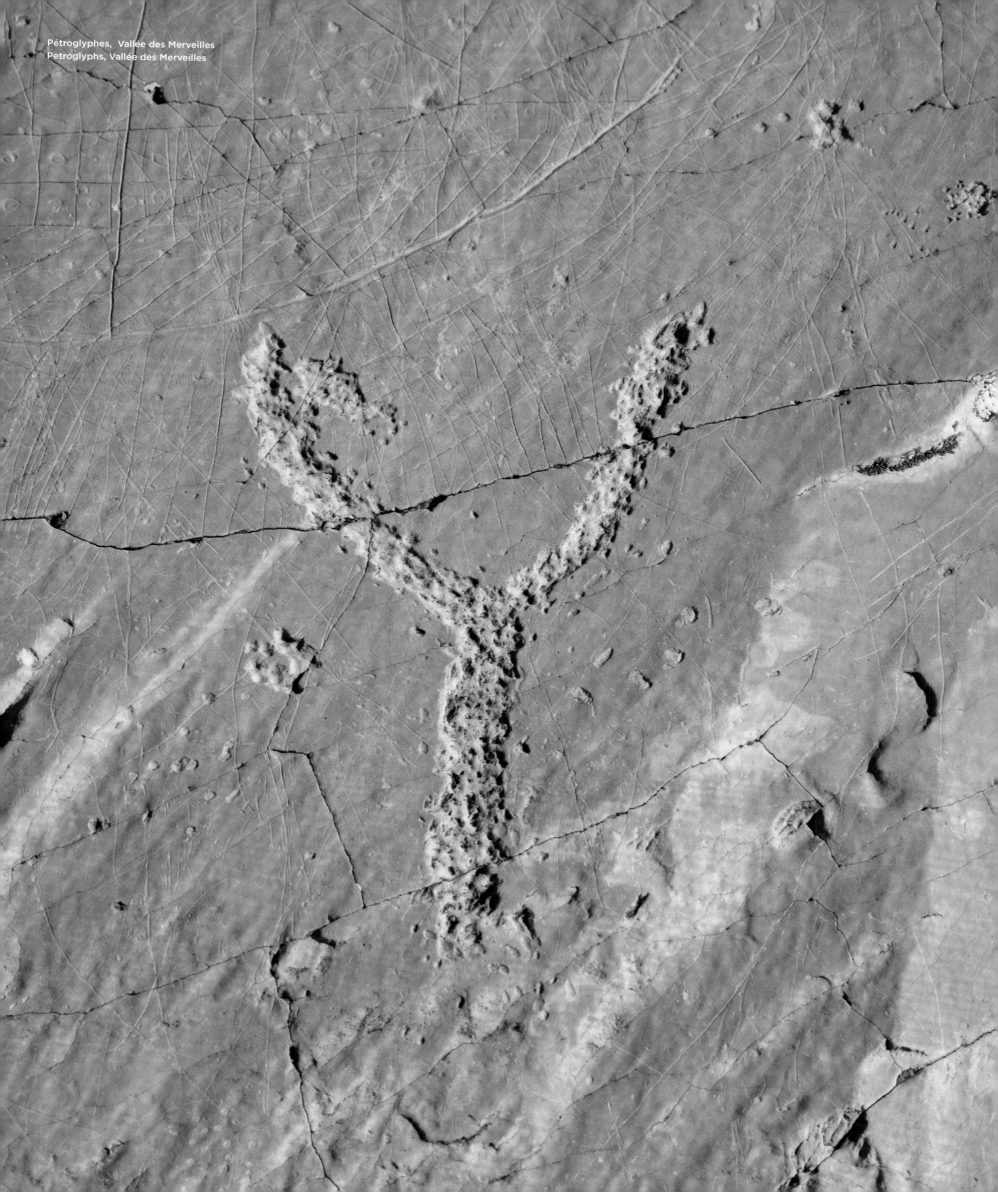

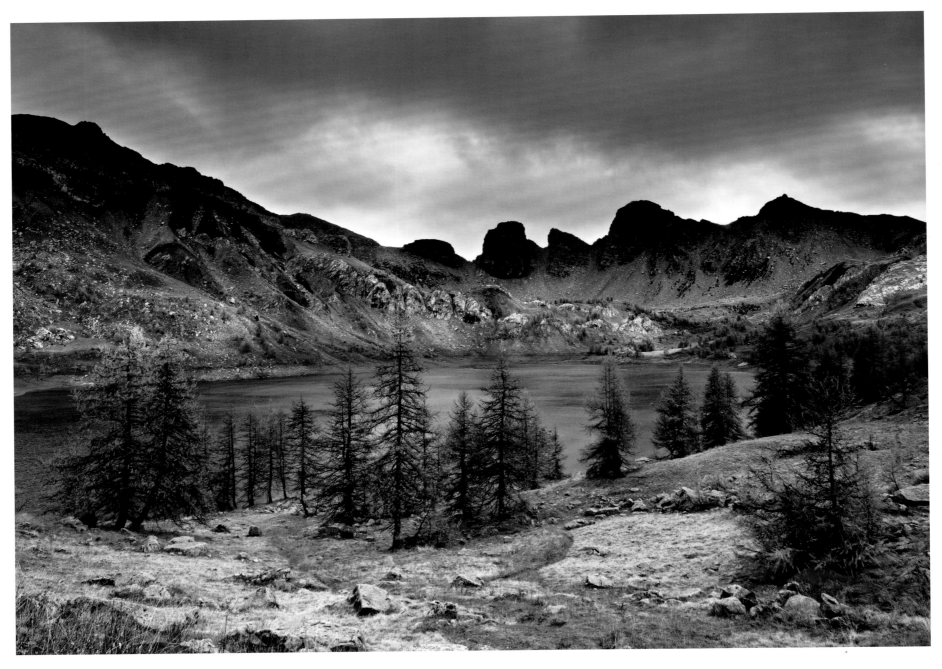

Lac d'Allos, Parc National du Mercantour

Parc National du Mercantour

The Mercantour National Park in the French Maritime Alps features a rich fauna and flora. In addition to alpine species such as chamois, ibex and Golden eagles, wolves from Italy have also found a new home here. There are also other connections with Italy: the park is going to form a large European park together with the neighbouring Italian Parco Naturale delle Alpi Marittime. A large area of the national park, which is crossed by numerous hiking trails, is strictly protected. There are spectacular views everywhere, as for instance on the high Lac d'Allos.

Le parc national du Mercantour

Le parc national du Mercantour, dans les Alpes du Sud françaises, surprend par la richesse de sa faune et de sa flore. Outre les animaux alpins typiques, comme le chamois, le bouquetin et l'aigle royal, des loups arrivés d'Italie se sont également installés ici. Il existe aussi des liens avec l'Italie dans d'autres domaines : ce parc est géré conjointement avec le Parco naturale delle Alpi Marittime, sous l'appellation de « Parc naturel européen ». Une grande partie du parc bénéficie d'une protection renforcée et on y trouve de nombreux chemins de randonnée, qui offrent des panoramas spectaculaires, notamment sur le lac d'Allos.

Nationalpark Mercantour

Eine reichhaltige Fauna und Flora zeichnet den Nationalpark Mercantour in den französischen Seealpen aus. Neben typisch alpinen Tierarten wie Gämsen, Steinböcken und Steinadlern haben auch aus Italien eingewanderte Wölfe hier ein neues Revier gefunden. Verbindungen mit Italien gibt es auch in anderer Hinsicht: Mit dem benachbarten Parco Naturale delle Alpi Marittime soll ein großer europäischer Park geschaffen werden. Streng geschützt ist ein großer Bereich des Nationalparks, den zahlreiche Wanderwege durchziehen; überall gibt es spektakuläre Ausblicke wie auf den hoch gelegenen Lac d'Allos.

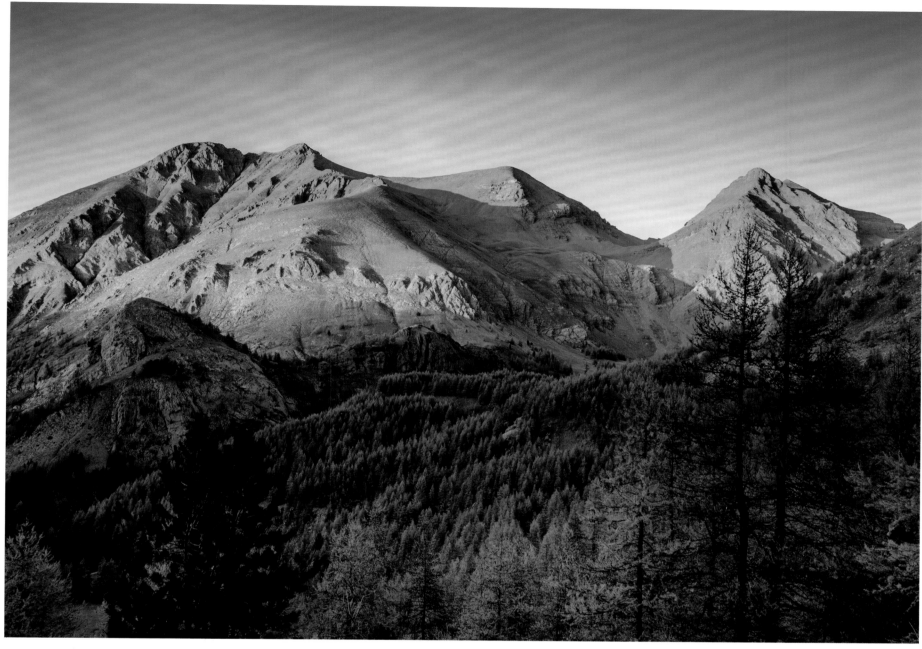

Mont Pelat (3052 m · 10013 ft), Trou de l'Aigle (2961 m · 9715 ft),
Parc National du Mercantour

Parque Nacional de Mercantour

Una rica fauna y flora distingue al Parque Nacional del Mercantour en los Alpes Marítimos Franceses. Además de las típicas especies alpinas como la gamuza, el íbice y el águila real, los lobos inmigrantes procedentes de Italia también han encontrado un nuevo hogar aquí. Pero esta no es la única conexión con Italia: con el vecino Parco Naturale delle Alpi Marittime se pretende crear un gran parque europeo. Una gran parte del parque nacional (que está atravesado por numerosas rutas de senderismo) se encuentra estrictamente protegida. En todas partes hay vistas espectaculares, como en el alto Lac d'Allos.

Parc National du Mercantour

Uma rica fauna e flora distingue o Parque Nacional Mercantour nos Alpes Marítimos Franceses. Além das espécies alpinas típicas, como a camurça, o ibex e as águias douradas, os lobos de Itália também encontraram aqui um novo lar. Existem também outras ligações com a Itália: o vizinho Parco Naturale delle Alpi Marittime pretende criar um grande parque europeu. Estritamente protegida é uma grande área do parque nacional, que é atravessada por numerosas trilhas para caminhadas; em todos os lugares, há vistas espetaculares como no alto Lac d'Allos.

Nationaal park Mercantour

Het nationaal park Mercantour in de Franse Maritieme Alpen heeft een rijke fauna en flora. Naast de typische alpendieren zoals gemzen, steenbokken en steenarenden leven hier ook wolven, die uit Italië stammen. Dit is echter niet de enige relatie met Italië: er bestaan plannen om dit park en het naburige Parco Naturale delle Alpi Marittime samen te voegen tot een groot Europees park. Een groot deel van het park, dat doortrokken is met wandelpaden, is streng beschermd en overal valt te genieten van spectaculaire vergezichten zoals bij het hooggelegen meer Lac d'Allos.

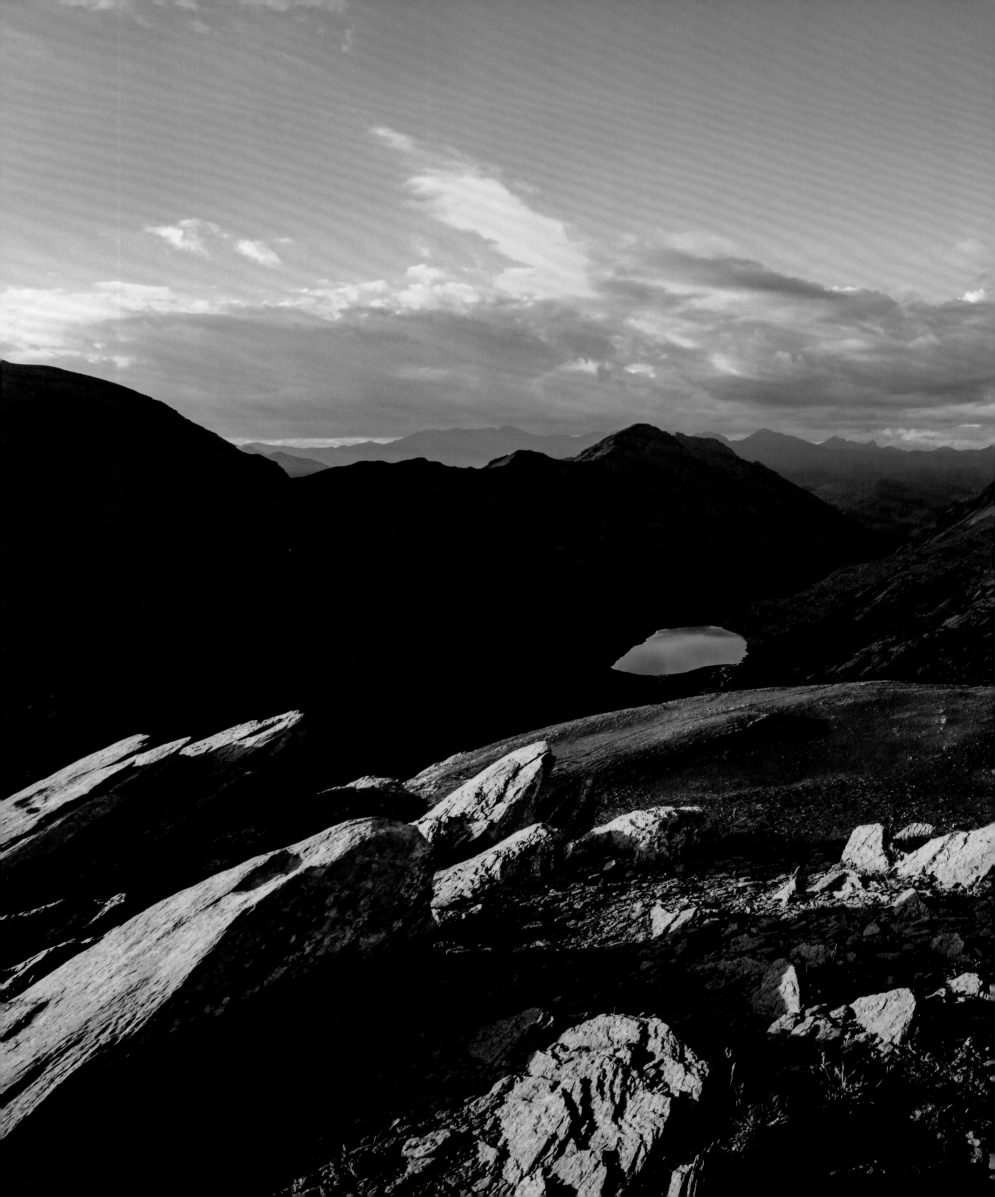

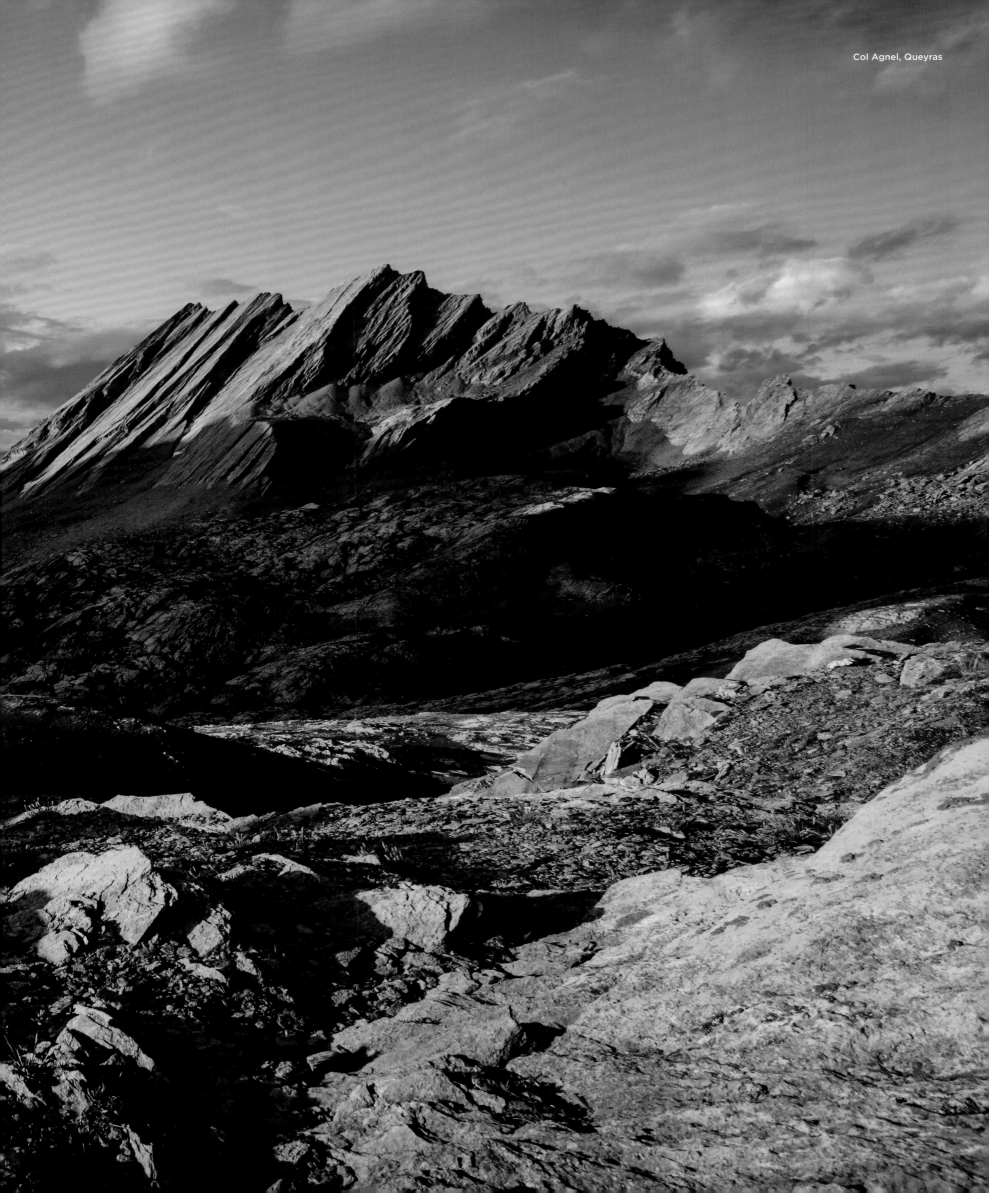

Col Agnel, Queyras

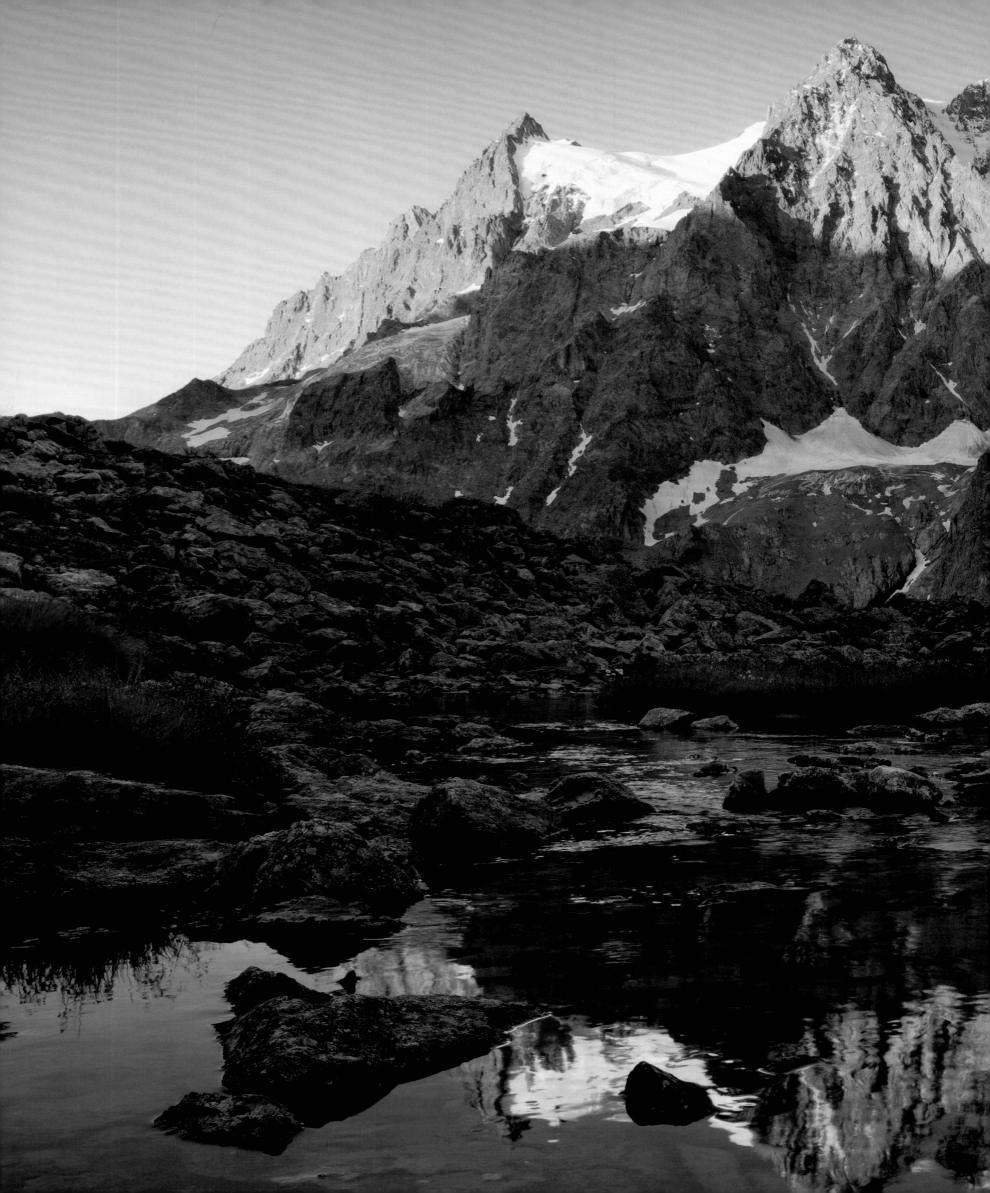

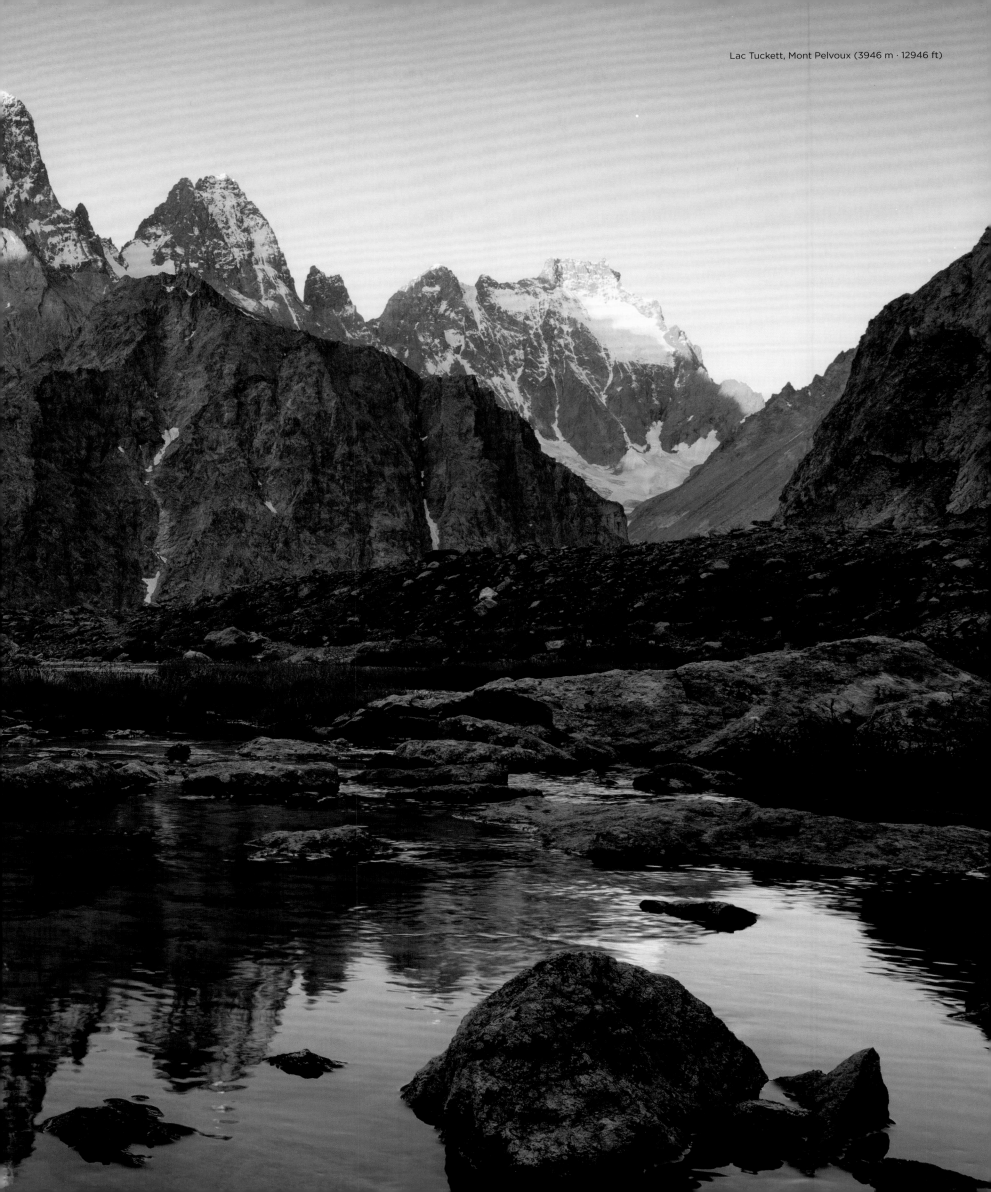

Lac Tuckett, Mont Pelvoux (3946 m · 12946 ft)

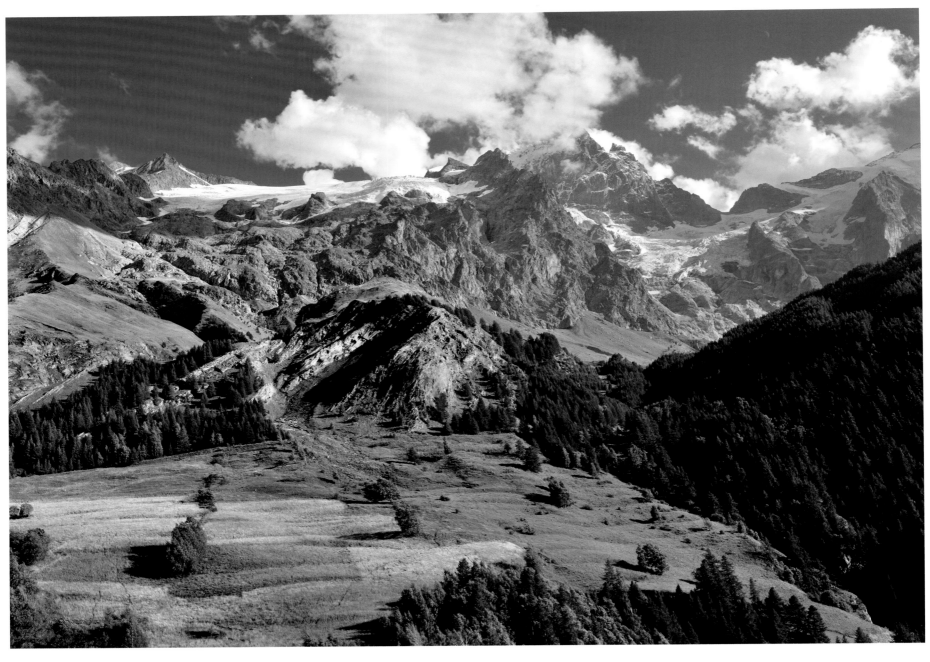

La Grave

Écrins National Park

The Col de Vallonpierre rises to a height of 2271 m (7451 ft). At its foot there is a mountain hut on the shore of a small lake. Hikers find solitude in the wild, magnificent mountains of the Écrins National Park in the French Dauphiné Alps, which they often share only with the local wildlife. A few kilometres northeast of the Refuge de Vallonpierre the mighty Barre des Écrins rises, at 4102 m (13,458 ft) the highest peak in the region, surrounded by glaciers. First climbed in 1864, the Barre des Écrins has since attracted countless climbers who venture on one of the routes to the summit.

Le parc national des Écrins

Situé à 2 271 m d'altitude sur le pic du même nom (2 741 m), le petit lac de Vallonpierre est flanqué d'un refuge. Dans les splendides montagnes sauvages du parc national des Écrins, dans le Dauphiné, les randonneurs peuvent savourer une paisible solitude, car ils n'y rencontrent souvent que les animaux qui habitent les lieux. À quelques kilomètres au nord-est du refuge de Vallonpierre se dresse la majestueuse barre des Écrins, le plus haut sommet de la région, qui culmine à 4 102 m et est entourée de glaciers. Cette barre des Écrins a été escaladée pour la première fois en 1864 et attire depuis lors de nombreux alpinistes, qui tentent d'en atteindre le sommet en suivant différentes voies d'ascension.

Nationalpark Écrins

2271 m ragt der Col de Vallonpierre auf, zu dessen Füßen am Ufer eines kleinen Bergsees eine Schutzhütte steht. Wanderer finden in der wilden, großartigen Bergwelt des Nationalparks Écrins in den französischen Dauphiné-Alpen Einsamkeit, die sie oft nur mit der einheimischen Tierwelt teilen. Einige Kilometer nordöstlich der Refuge de Vallonpierre erhebt sich die mächtige Barre des Écrins, mit 4102 m der höchste Gipfel der Region, der von Gletschern umgeben ist. Erstmals bestiegen wurde die Barre des Écrins 1864, seither zieht sie Bergsteiger an, die sich an einer der Routen zum Gipfel versuchen.

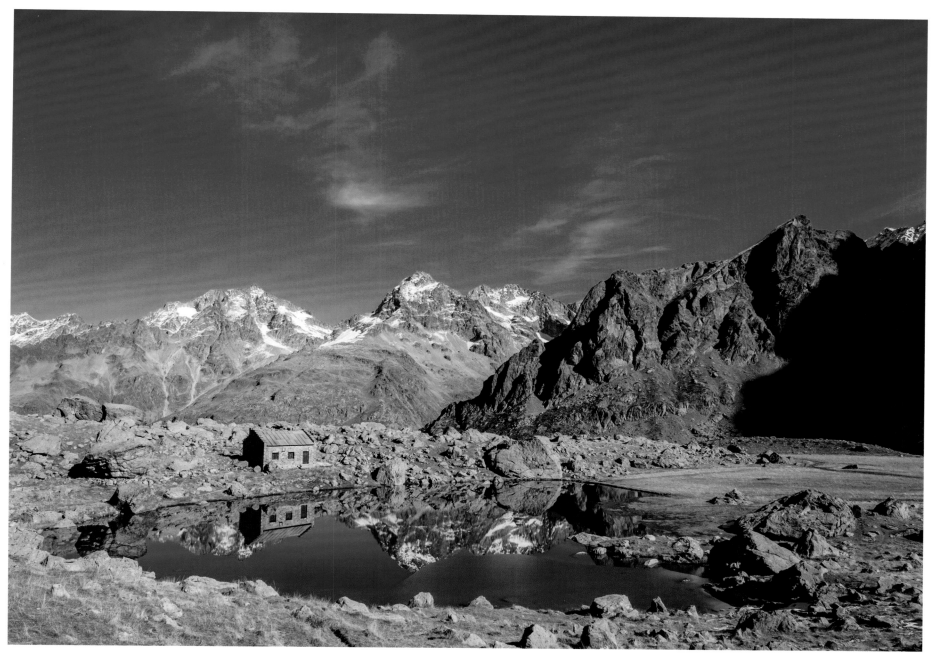

Refuge de Vallonpierre, Col de Vallonpierre (2271 m · 7451 ft)

Parque Nacional de los Écrins

El Col de Vallonpierre se eleva 2271 m, y a sus pies se encuentra un refugio a orillas de un pequeño lago de montaña. En las montañas salvajes y magníficas del Parque Nacional de los Écrins, en los Alpes franceses del Delfinado, los excursionistas encuentran la soledad, que a menudo solo comparten con la fauna local. A pocos kilómetros al noreste del Refuge de Vallonpierre se alza el imponente Barre des Écrins que, con sus 4102 m, es el pico más alto de la región, y está rodeado de glaciares. El Barre des Écrins fue escalado por primera vez en 1864 y desde entonces ha atraído a numerosos escaladores, que intentan una de las rutas hacia la cima.

Parque Nacional de Écrins

O Col de Vallonpierre sobe 2271 m, ao pé do qual há um refúgio na margem de um pequeno lago de montanha. Os caminhantes encontram solidão nas montanhas selvagens e magníficas do Parque Nacional de Écrins, nos Alpes franceses do Dauphiné, que muitas vezes só compartilham com a vida selvagem local. A poucos quilómetros a nordeste da Refuge de Vallonpierre sobe o poderoso Barre des Écrins, a 4102 m o pico mais alto da região, rodeado por glaciares. Primeiro escalado em 1864, o Barre des Écrins atraiu desde então escaladores que tentam uma das rotas para o cume.

Nationaal park Écrins

Aan de voet van de 2271 m hoge Col de Vallonpierre staat aan de oever van een bergmeertje een kleine schuilhut voor wandelaars. Hier in de ruige, prachtige bergen van het nationaal park Écrins in de Franse Dauphiné-Alpen, genieten zij van de eenzaamheid die ze alleen maar moeten delen met de dieren. Enkele kilometers ten noordoosten van de Refuge de Vallonpierre verrijst de majestueuze, door gletsjers omgeven Barre des Écrins, met 4102 m de hoogste top van de streek. Deze berg werd in 1864 voor het eerst beklommen en is een eldorado voor bergbeklimmers, die de top via verschillende routes kunnen bereiken.

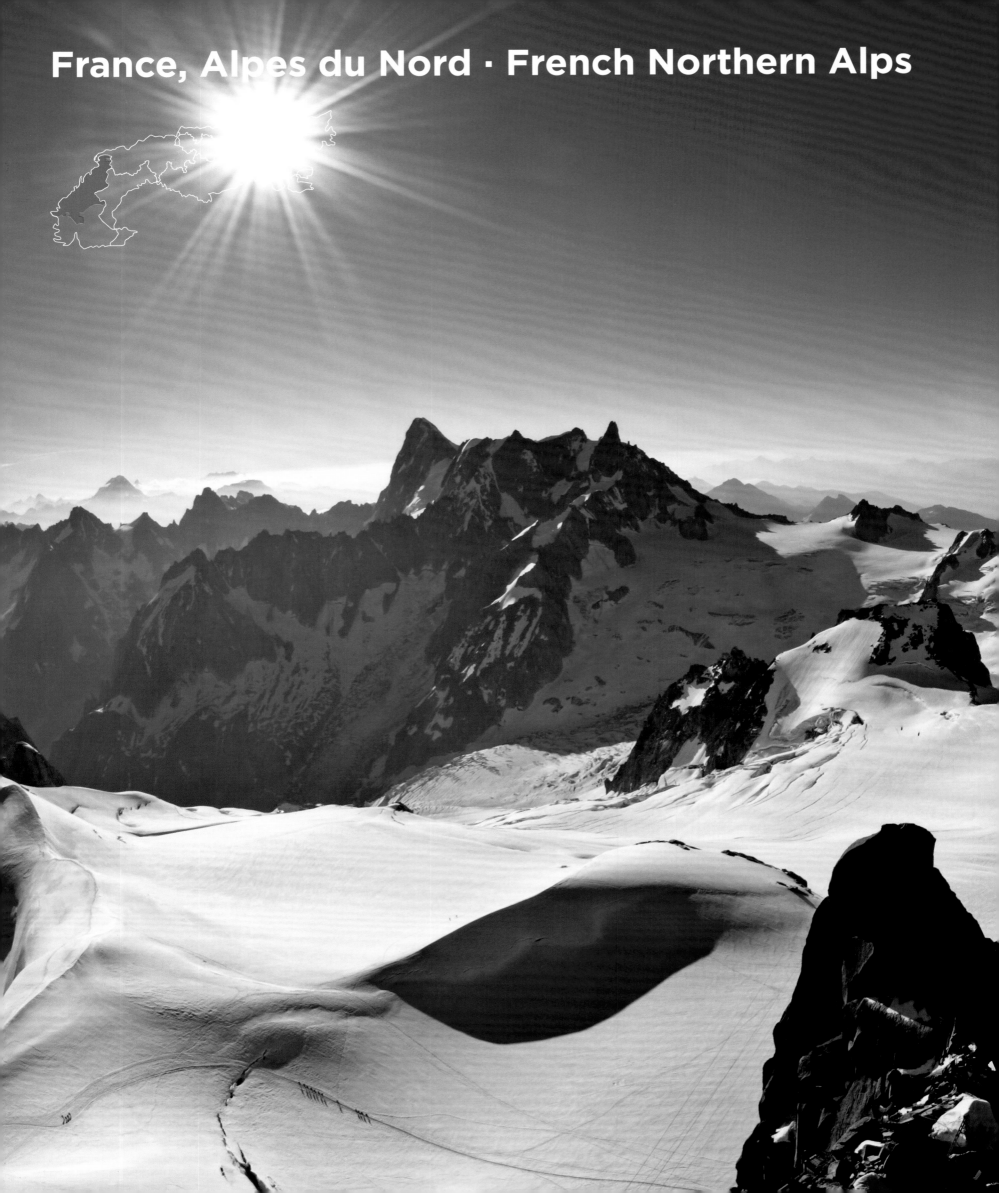

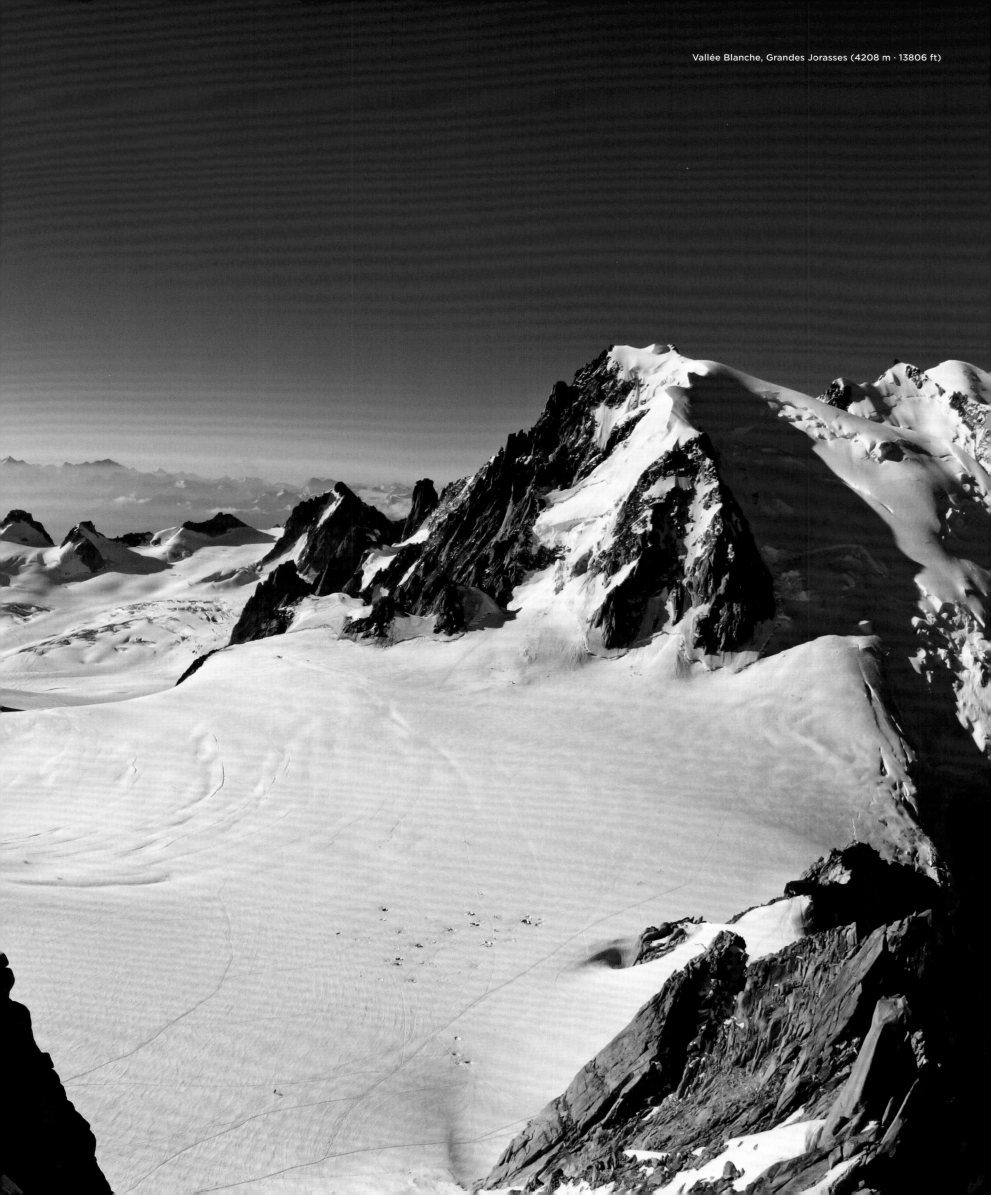

Vallée Blanche, Grandes Jorasses (4208 m · 13806 ft)

Col du Galibier (2645 m · 8678 ft)

French Northern Alps

In the southeast of France rise some of the highest peaks of the Alps, Mont Blanc with 4810 m (15781 ft) is the highest. The first ski resorts in France were built at the foot of this giant in the 1920s; the famous winter sports resort of Chamonix has been one of the top addresses in the Alps ever since, and Albertville and Grenoble also attract numerous holidaymakers. These three locations also hosted Winter Olympic Games. Grenoble is more than 2000 years old and presents itself as a young, modern metropolis in front of a magnificent mountain panorama. It boasts an important university and a dynamic cultural life.

Les Alpes du Nord

C'est dans le Sud-Est de la France que s'élèvent quelques-uns des plus hauts sommets des Alpes, le plus élevé étant le mont Blanc, avec ses 4 810 m. La première compétition de ski de France a eu lieu dans les années 1920 aux pieds de ce géant. Depuis, Chamonix est l'une des stations de sports d'hiver les plus populaires des Alpes, bien qu'Albertville et Grenoble attirent également de nombreux vacanciers. Ces trois endroits ont aussi accueilli les Jeux olympiques d'hiver. Bien qu'elle soit vieille de plus de 2 000 ans, Grenoble, avec sa vue splendide sur les montagnes, est une ville moderne, avec une université renommée et une vie culturelle dynamique.

Französische Nordalpen

Im Südosten Frankreichs erheben sich einige der höchsten Gipfel der Alpen, der Mont Blanc ist mit 4810 m der höchste. Am Fuß dieses Giganten entstanden in den 1920er-Jahren die ersten Skigebiete Frankreichs. Der berühmte Wintersportort Chamonix ist seither eine der ersten Adressen in den Alpen, und auch Albertville und Grenoble locken zahlreiche Urlauber. Diese drei Orte waren auch Schauplatz für Olympische Winterspiele. Das über 2000 Jahre alte Grenoble präsentiert sich vor grandiosem Bergpanorama als junge, moderne Metropole mit bedeutender Universität und einem lebendigen Kulturleben.

Alpe d'Huez, Lac Besson

Alpes franceses del norte

En el sureste de Francia se elevan algunos de los picos más altos de los Alpes y, con sus 4810 m de altura, el Mont Blanc es el más alto. Las primeras estaciones de esquí de Francia se construyeron a los pies de este gigante en la década de 1920; la famosa estación de deportes de invierno de Chamonix ha sido una de las mejores direcciones de los Alpes desde entonces, y Albertville y Grenoble también atraen a numerosos turistas. Estos tres lugares también sirvieron como escenario de los Juegos Olímpicos de Invierno. Con más de 2000 años de antigüedad, Grenoble se presenta ante un magnífico panorama montañoso como una metrópoli joven y moderna con una importante universidad y una animada vida cultural.

Alpes do Norte Franceses

No sudeste da França, alguns dos picos mais altos dos Alpes sobem, o Mont Blanc é com 4810 m o mais alto. As primeiras estações de esqui na França foram construídas aos pés deste gigante na década de 1920; o famoso resort de esportes de inverno de Chamonix tem sido um dos principais endereços nos Alpes desde então, e Albertville e Grenoble também atraem inúmeros turistas. Estes três locais foram também o cenário para os Jogos Olímpicos de Inverno. Com mais de 2000 anos, Grenoble se apresenta diante de um magnífico panorama montanhoso como uma metrópole jovem e moderna, com uma importante universidade e uma vida cultural animada.

Het Franse deel van de Noordelijke Alpen

In het zuidoosten van Frankrijk verrijzen enkele van de hoogste alpentoppen, waarvan de Mont Blanc met 4810 m de hoogste is. In de jaren 20 ontstonden aan de voet van deze reus de eerste Franse skigebieden. Naast het beroemde wintersportoord Chamonix trekken ook Albertville en Grenoble talloze vakantiegangers aan. Deze drie locaties vormden ook het decor voor Olympische Winterspelen. Het ruim 2000 jaar oude Grenoble is gelegen voor een prachtig bergpanorama en is tegenwoordig een jonge, moderne metropool met een vooraanstaande universiteit en een levendig cultureel leven.

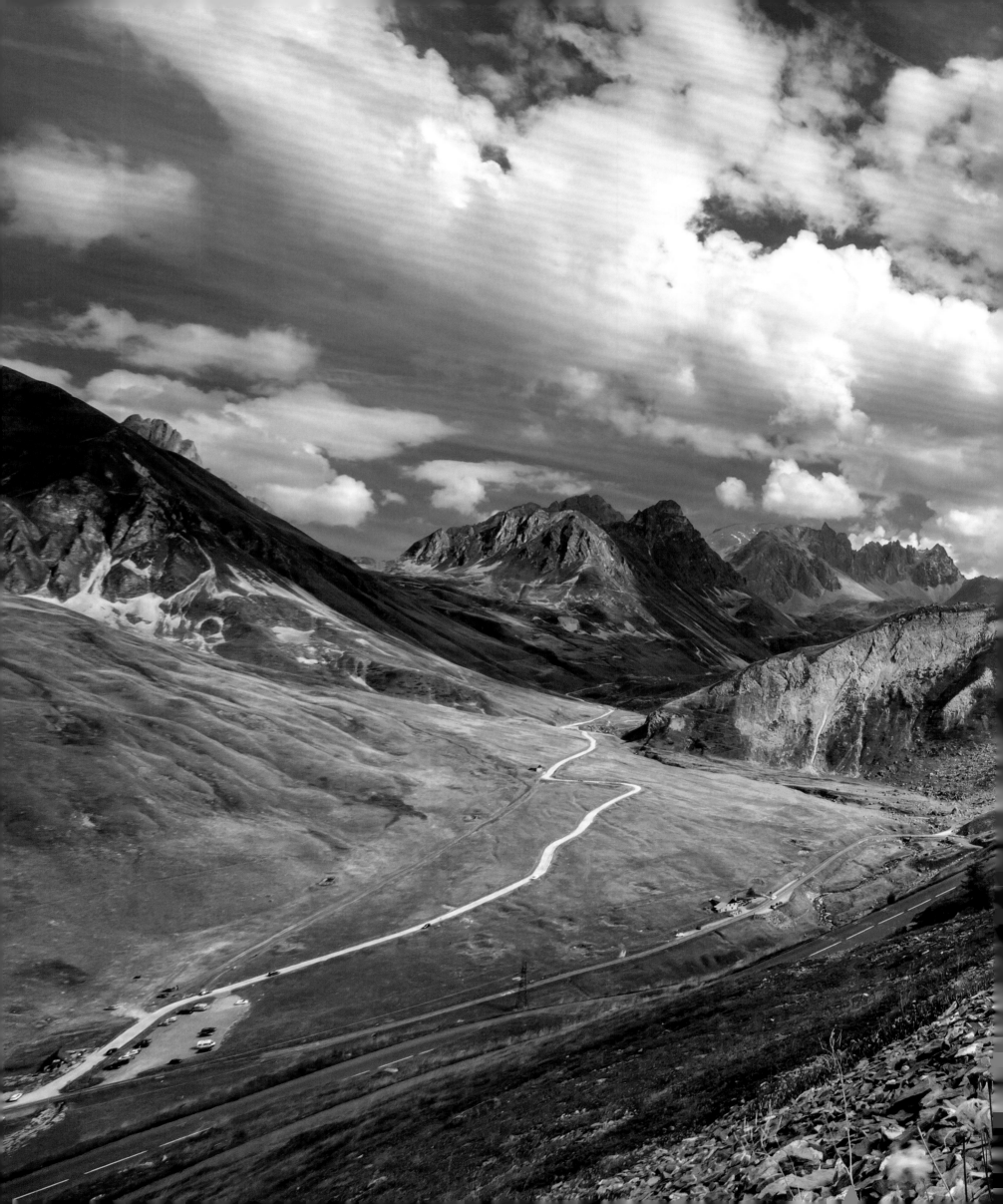

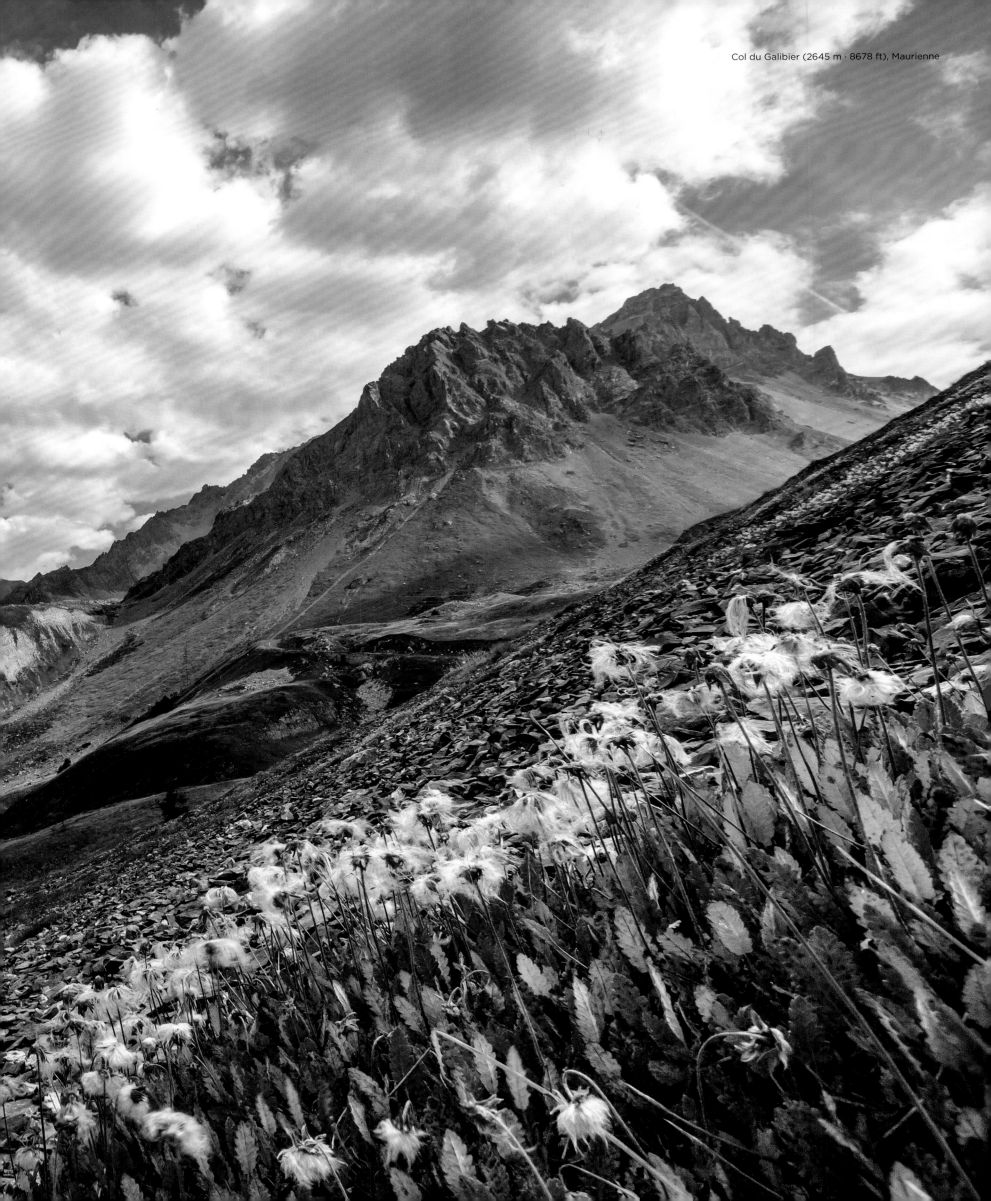

Col du Galibier (2645 m · 8678 ft), Maurienne

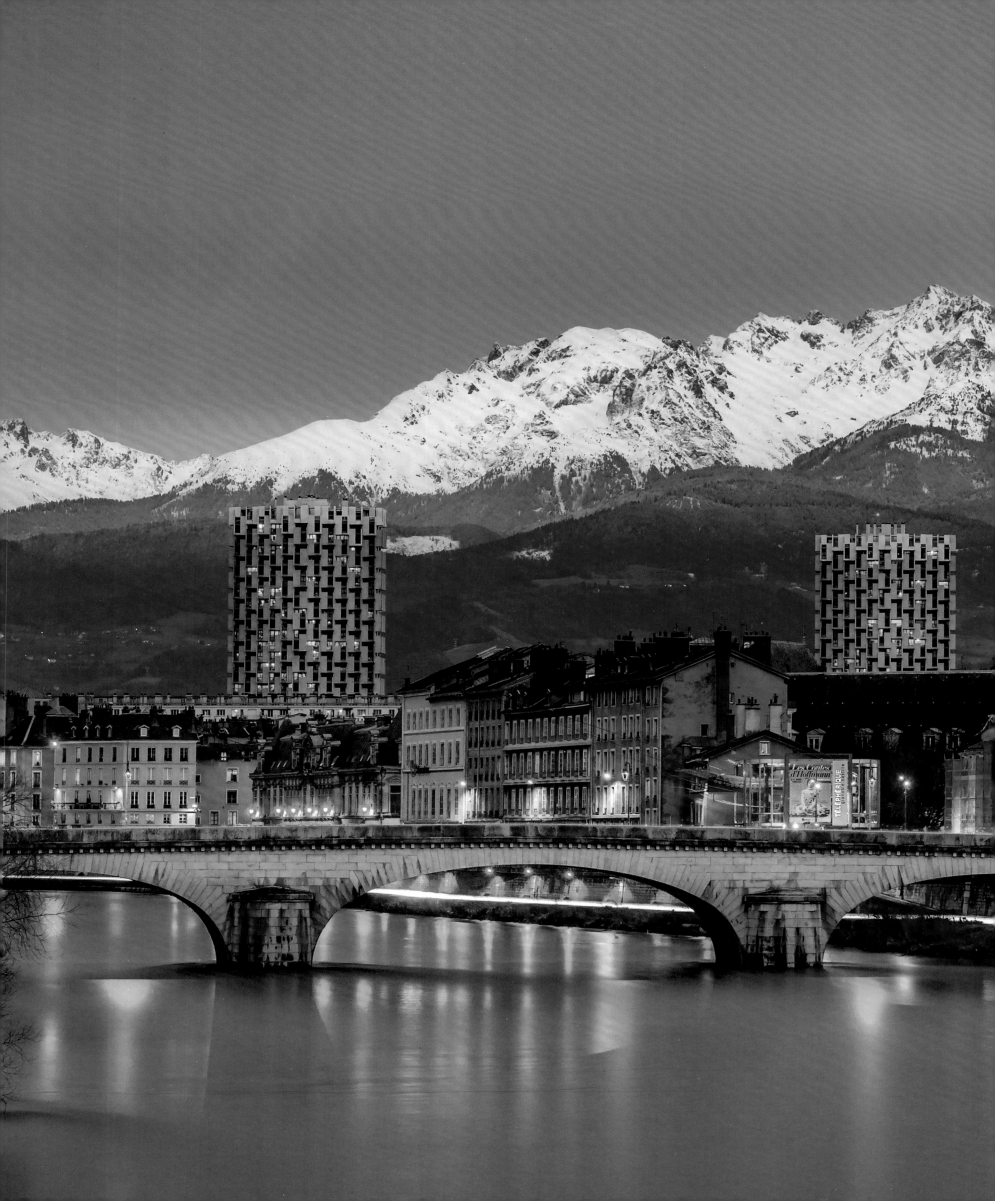

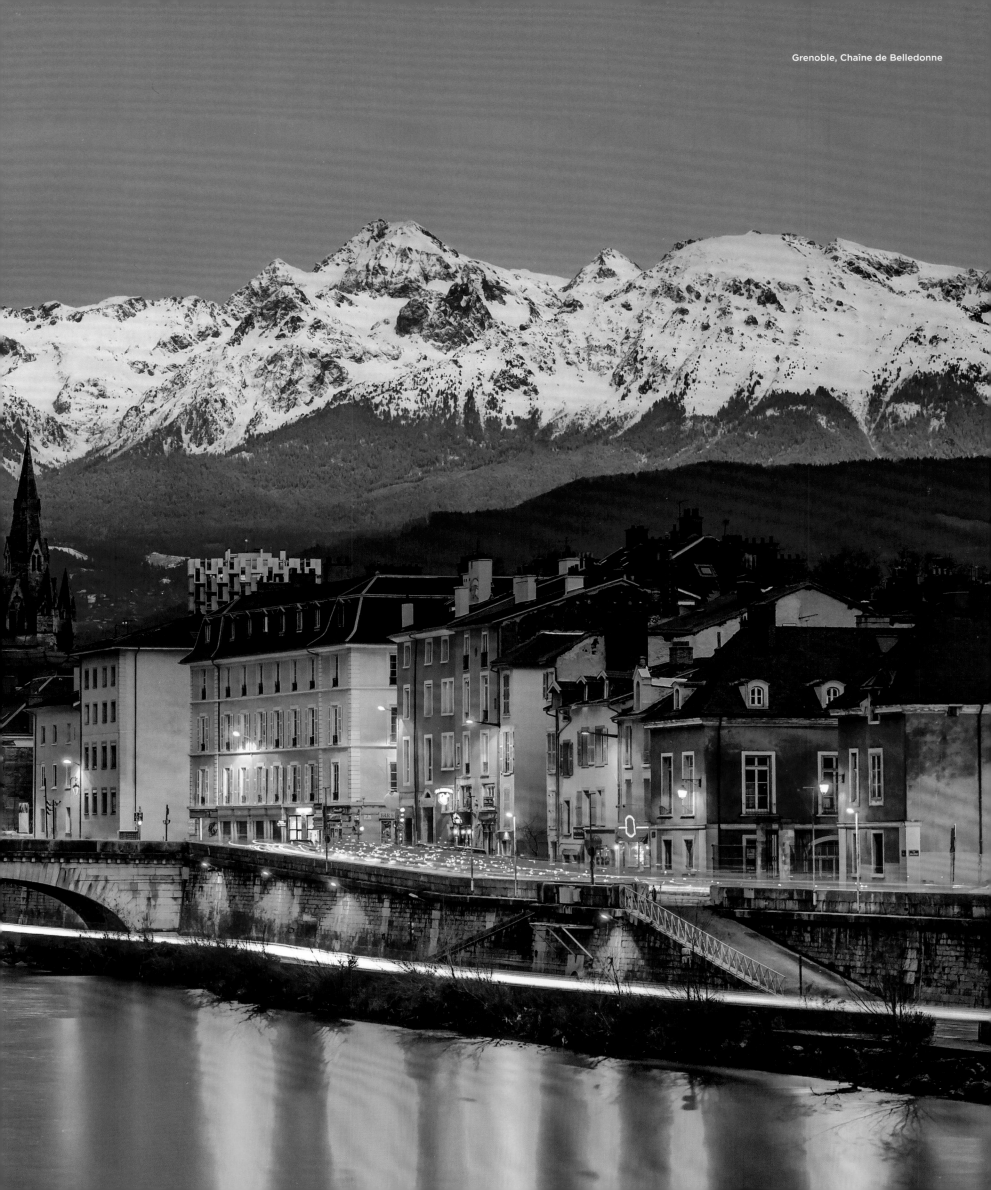

Grenoble, Chaîne de Belledonne

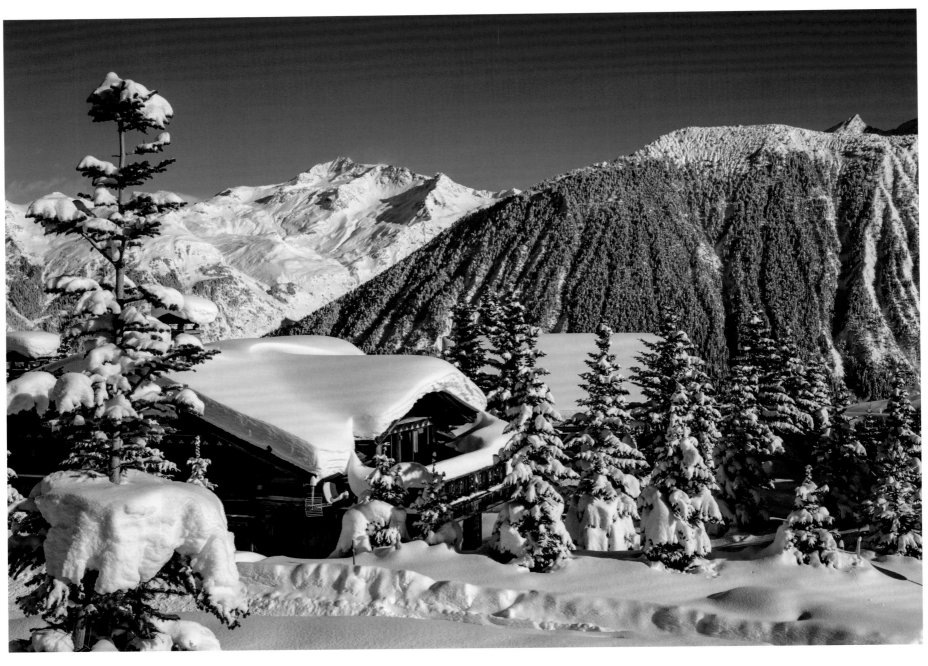

Courchevel

Trois Vallées

Skiing is good almost everywhere in the Alps, even if the certainty of snow is steadily diminshing due to climate change. But almost nowhere else is the alpine ski circus as extensively developed as in the Trois Vallées—the valleys of Belleville, Courchevel and Méribel—which, together with around 600 km (373 mi) of ski slopes and countless ski lifts, attract winter sports enthusiasts from all over the world. At peak times there are sometimes so many skiers on the slopes that dangerous encounters and serious accidents can occur. The Olympic site of Albertville lies about 50 km (31 mi) to the north.

Les Trois-Vallées

On peut pratiquer le ski presque partout dans les Alpes, bien qu'avec le changement climatique l'enneigement soit de moins en moins garanti. Mais presque aucun domaine skiable n'est aussi riche et varié que celui des Trois-Vallées, qui regroupe les vallées des Belleville, de Courchevel et de Méribel et attire des adeptes des sports d'hiver venus du monde entier grâce à ses quelque 600 km de pistes et à ses innombrables remontées mécaniques. Pendant la haute saison, il y a parfois tant de skieurs sur les pistes que cela peut occasionner des collisions dangereuses voire de graves accidents. La commune d'Albertville, qui a accueilli les Jeux olympiques, se trouve à une cinquantaine de kilomètres au nord.

Trois Vallées

Fast überall in den Alpen kann man gut skifahren, auch wenn die Schneesicherheit aufgrund des Klimawandels immer weniger gewährleistet ist. Aber fast nirgendwo sonst ist der alpine Skizirkus so umfassend wie in den Trois Vallées – die Täler von Belleville, Courchevel und Méribel –, die zusammen mit rund 600 km Skipisten und zahllosen Skiliften Wintersportbegeisterte aus aller Welt anziehen. Zu Hochzeiten tummeln sich manchmal so viele Skifahrer auf den Pisten, dass es durchaus zu gefährlichen Begegnungen und schweren Unfällen kommen kann. Rund 50 km nördlich liegt der Olympiaort Albertville.

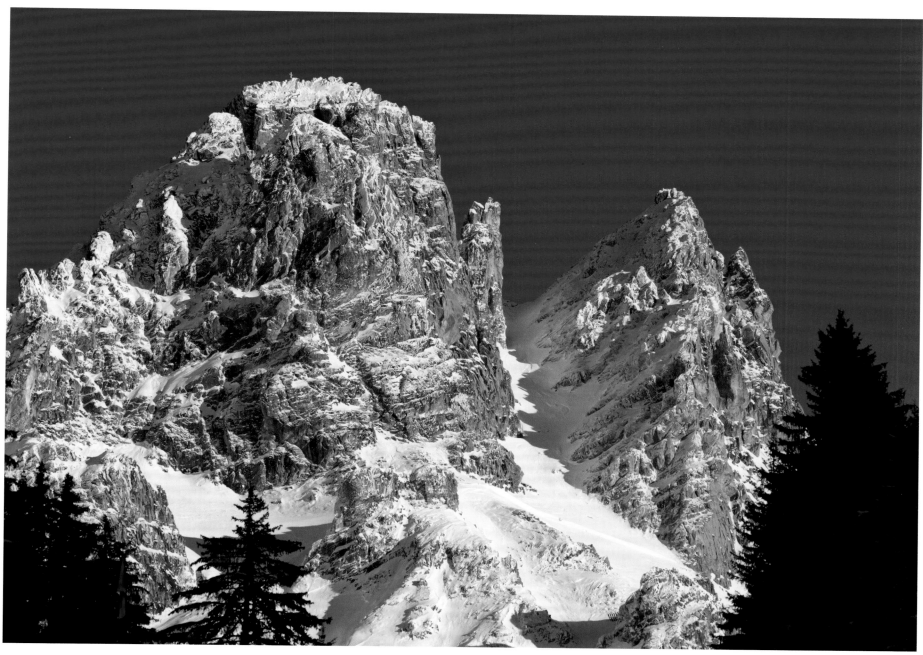

Dent de Burgin, Méribel

Trois Vallées

Casi en todas partes en los Alpes se puede esquiar bien a pesar de que la seguridad de la nieve está cada vez menos garantizada como consecuencia del cambio climático. Pero casi en ningún otro sistema de remontes alpino es tan extenso como en Trois Vallées (los valles de Belleville, Courchevel y Méribel) que, con sus aproximadamente 600 km de pistas de esquí y sus innumerables remontes de esquí, atraen a entusiastas de los deportes de invierno de todo el mundo. A veces en temporada alta hay tantos esquiadores en las pistas que pueden producirse encuentros peligrosos y accidentes graves. La Olmpiaort Albertville se encuentra a unos 50 km al norte.

Trois Vallées

Em quase todos os Alpes é possível esquiar bem, mesmo que a segurança da neve seja cada vez menos garantida devido à mudança climática. Mas em quase nenhum outro lugar o circo de esqui alpino é tão extenso como no Trois Vallées – os vales de Belleville, Courchevel e Méribel – que, juntamente com cerca de 600 km de pistas de esqui e inúmeros teleféricos de esqui, atraem entusiastas dos desportos de Inverno de todo o mundo. Nos casamentos, há por vezes tantos esquiadores nas encostas que podem ocorrer encontros perigosos e acidentes graves. O Olmpiaort Albertville fica a cerca de 50 km ao norte.

Les Trois Vallées

Bijna overal in de Alpen kun je goed skiën, hoewel de klimaatverandering ertoe bijdraagt dat steeds meer skigebieden steeds minder sneeuwzeker zijn. Bijna nergens in de Alpen zijn zoveel skipistes als in de 'Drie Valleien' – van Belleville, Courchevel en Méribel. Met een totale lengte van ongeveer 600 km en tal van skiliften trekt dit gebied wintersporters uit de hele wereld. In het hoogseizoen zijn er soms zoveel skiërs op de pistes dat het gevaarlijk dreigt te worden en ernstige ongelukken niet uitblijven. Ongeveer 50 kilometer ten noorden van dit skigebied ligt de Olympische stad Albertville.

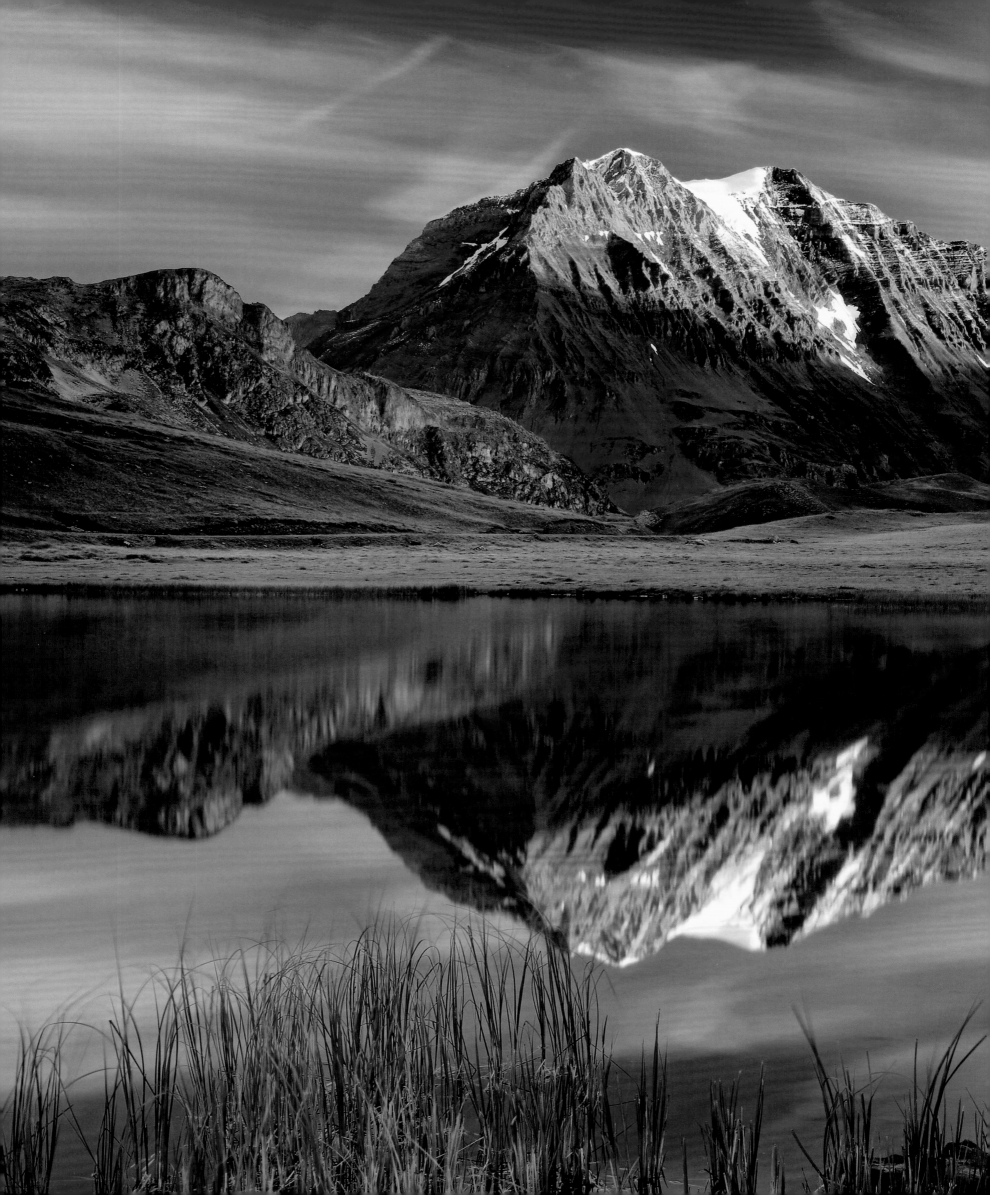

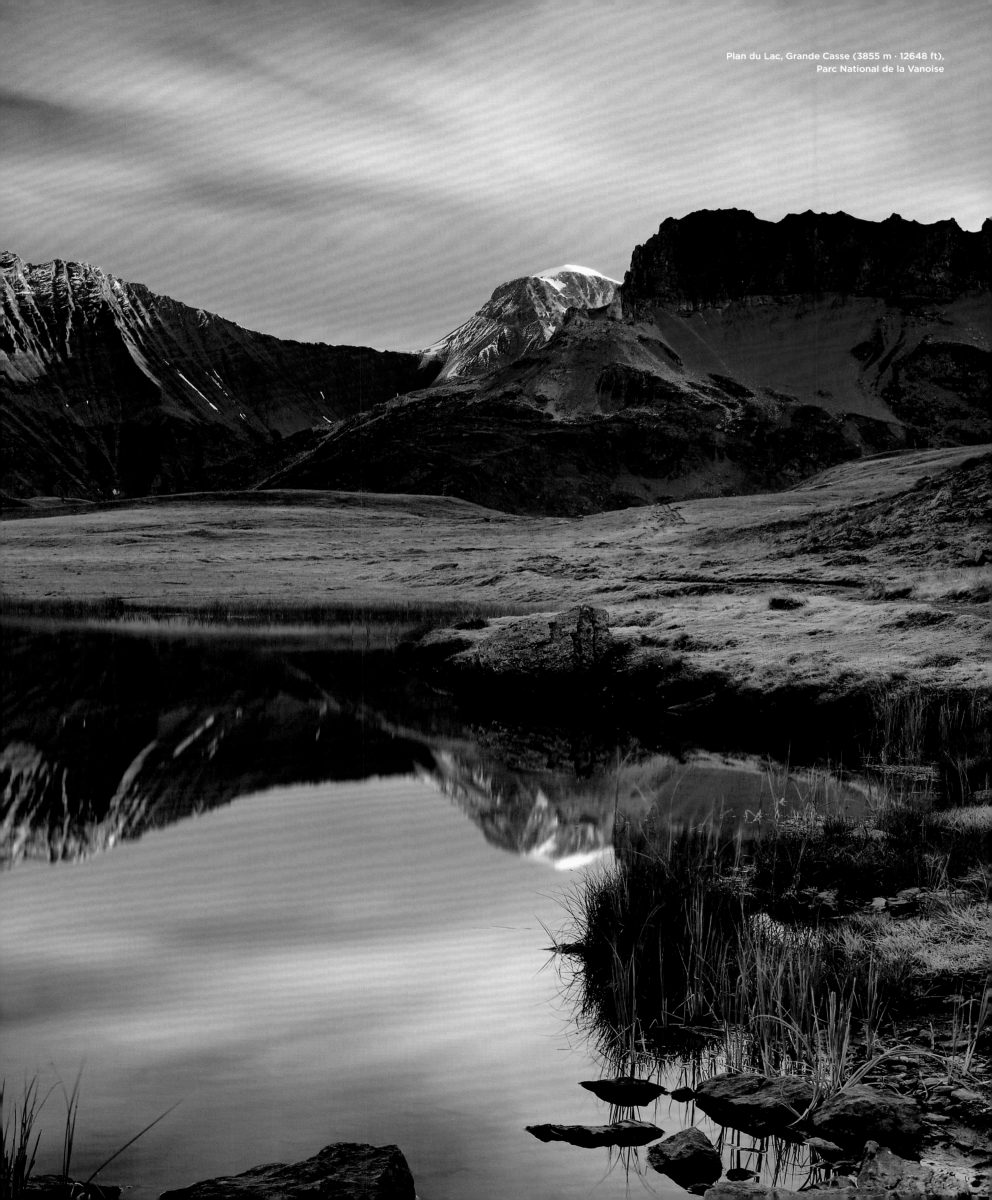

Plan du Lac, Grande Casse (3855 m · 12648 ft),
Parc National de la Vanoise

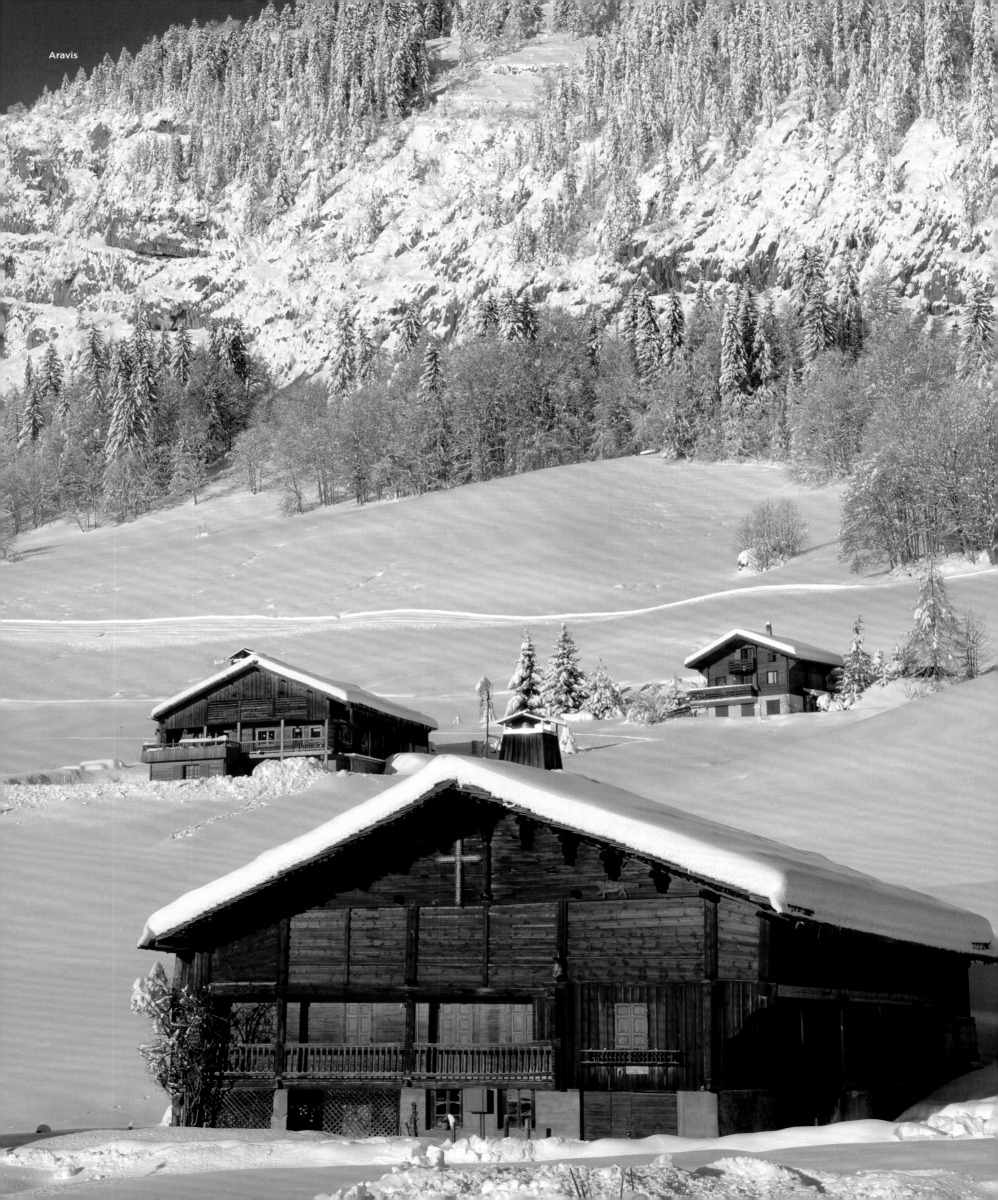

Aravis

Bonneval-sur-Arc, Parc National de la Vanoise

Bonneval-sur-Arc

A pretty Romanesque village church, old stone-roofed houses against a picturesque mountain backdrop— Bonneval-sur-Arc is rightly on the prestigious list of "France's most beautiful villages". It is also known for the nearby Col de l'Iseran, with 2764 m (9068 ft) (the highest mountain pass of the Alps, over which the Tour de France leads in some years.

Bonneval-sur-Arc

Avec sa jolie petite église romane, ses vieilles maisons aux toits de lauze et les montagnes magnifiques qui l'entourent, Bonneval-sur-Arc figure sur la liste prestigieuse des « Plus Beaux Villages de France ». Sa notoriété est également liée à sa proximité avec le col de l'Iseran, le plus haut col des Alpes avec ses 2764 m, par lequel passe régulièrement le Tour de France.

Bonneval-sur-Arc

Eine hübsche romanische Dorfkirche, alte, steingedeckte Häuser vor malerischer Bergkulisse – Bonneval-sur-Arc steht zu Recht auf der prestigeträchtigen Liste der „Schönsten Dörfer Frankreichs". Bekannt ist der Ort auch durch den nahen Col de l'Iseran, mit 2764 m der höchste Gebirgspass der Alpen, über den gelegentlich auch die Tour de France führt.

Bonneval-sur-Arc

Una bonita iglesia románica de pueblo, viejas casas de piedra sobre un pintoresco telón de fondo de montaña: Bonneval-sur-Arc se encuentra, con razón, en la prestigiosa lista de los "pueblos más bellos de Francia". El lugar también es conocido por el cercano Col de l'Iseran, que con sus 2764 m es el puerto de montaña más alto de los Alpes, por el que en ocasiones también pasa el Tour de Francia.

Bonneval-sur-Arc

Uma bela igreja românica de aldeia, casas antigas cobertas de pedra com um cenário pitoresco de montanha - Bonneval-sur-Arc está justamente na lista de prestígio das "mais belas aldeias da França". O lugar também é conhecido pelo vizinho Col de l'Iseran, com 2764 m a mais alta passagem de montanha dos Alpes, sobre a qual ocasionalmente o Tour de France também leva.

Bonneval-sur-Arc

Een pittoresk romaanse dorpskerkje, oude huizen met stenen daken en een schilderachtig bergdecor – Bonneval-sur-Arc staat geheel terecht op de prestigieuze lijst van 'mooiste dorpen van Frankrijk'. De plaats is bij veel Tour de France-liefhebbers bekend vanwege de nabijgelegen Col de l'Iseran, met 2764 m de hoogste bergpas van de Alpen.

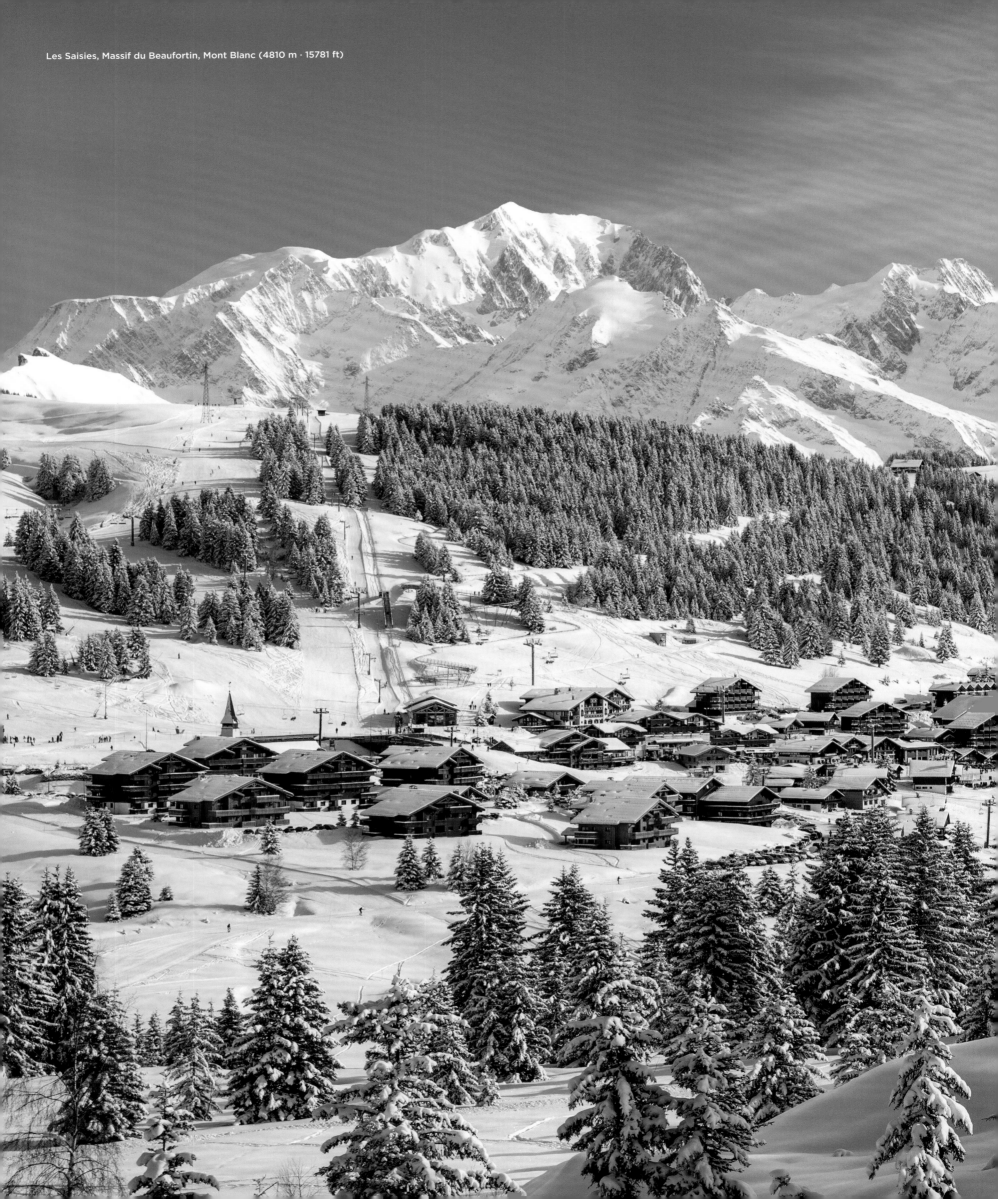

Les Saisies, Massif du Beaufortin, Mont Blanc (4810 m · 15781 ft)

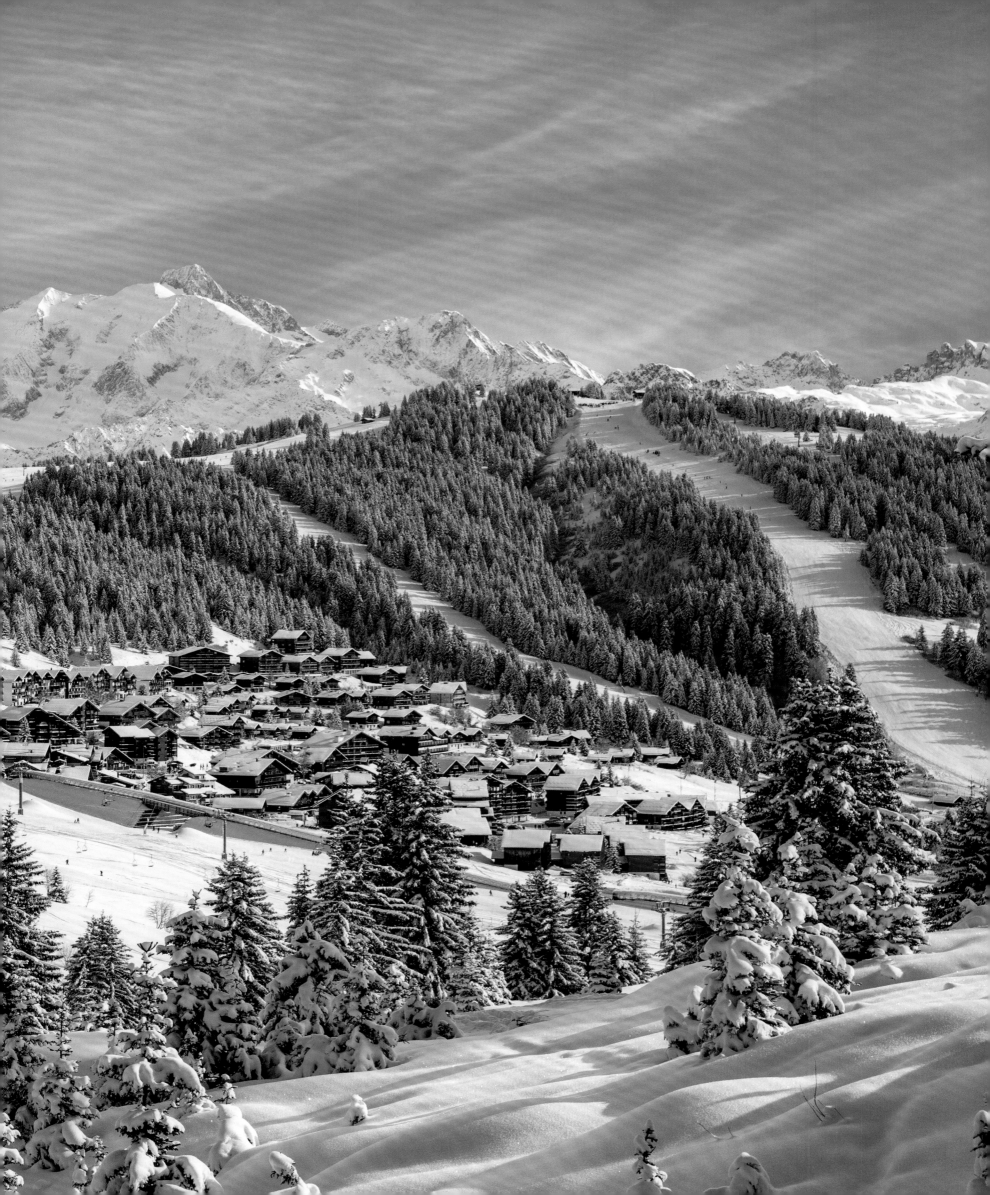

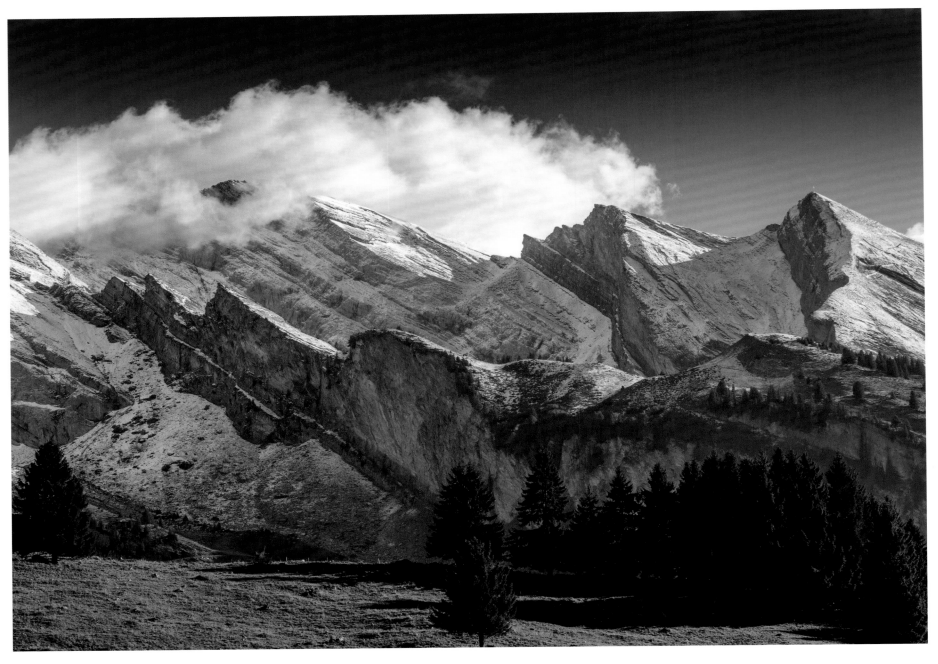

Massif du Aravis

Lac d'Annecy

The Lac d'Annecy, one of the cleanest lakes in the Alps, is surrounded by an ancient cultural landscape which was first settled 5000 years ago. The shores, especially in the northern part, are densely populated. Annecy, the capital of the département Haut-Savoie, was founded over 900 years ago, and is also located on its shores. It is the cultural and economic centre of the region and one of the most beautiful cities in the Alpine region. The reliability of the snow cover in the vicinity make it a popular winter sports destination. However, Annecy's application for the 2018 Winter Olympic Games remained unsuccessful.

Le lac d'Annecy

Tout autour du lac d'Annecy, l'un des plus propres des Alpes, s'étend un paysage culturel très ancien, où les hommes s'étaient déjà installés il y a 5000 ans. Les berges du lac, au nord surtout, sont densément construites. C'est là que se dresse Annecy, chef-lieu du département de Haute-Savoie, fondé il y a au moins 9 siècles. C'est le centre culturel et économique de la région et l'une des plus belles villes des Alpes. Les paysages enneigés qui l'entourent sont une destination prisée pour les sports d'hiver. La candidature d'Annecy pour accueillir les Jeux olympiques d'hiver de 2018 n'a néanmoins pas été retenue.

Lac d'Annecy

Rund um den Lac d'Annecy, der zu den saubersten Seen in den Alpen gehört, erstreckt sich eine uralte Kulturlandschaft, in der schon vor 5000 Jahren Menschen siedelten. Die Ufer vor allem im nördlichen Teil sind dicht bebaut. Hier liegt auch Annecy, die Hauptstadt des Départements Haut-Savoie, die vor gut 900 Jahren gegründet wurde. Sie ist kulturelles und wirtschaftliches Zentrum der Region und eine der schönsten Städte im Alpenraum. Die schneesichere Umgebung ist eine beliebte Wintersportdestination. Die Kandidatur Annecys für die Olympischen Winterspiele 2018 blieb allerdings erfolglos.

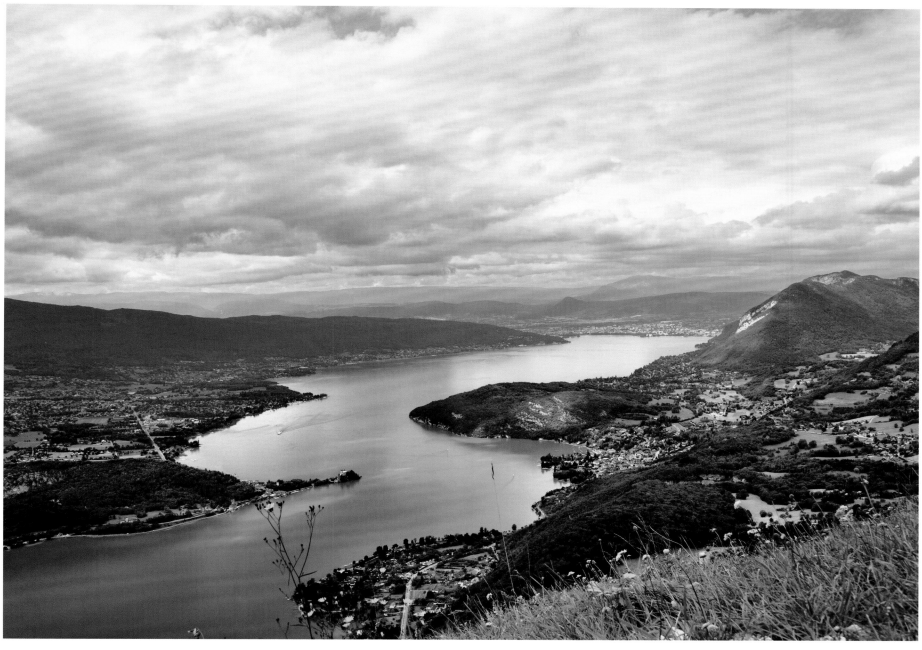

Lac d'Annecy

Lago de Annecy

El lago de Annecy, uno de los lagos más limpios de los Alpes, está rodeado de un paisaje cultural antiguo en el que hace 5000 años se asentaron personas. Su ribera, especialmente en la parte norte, está densamente construida. Aquí también se encuentra Annecy, la capital del departamento de Haut-Savoie, fundada hace más de 900 años. Es el centro cultural y económico de la región y una de las ciudades más bellas de la región alpina. El entorno, donde la nieve está asegurada, es un destino popular para los deportes de invierno. Sin embargo, la candidatura de Annecy para los Juegos Olímpicos de Invierno de 2018 no tuvo éxito.

Lac d'Annecy

O Lac d'Annecy, um dos lagos mais limpos dos Alpes, está rodeado por uma antiga paisagem cultural na qual as pessoas se estabeleceram há 5000 anos. Os bancos, especialmente na parte norte, são densamente povoados. Annecy, a capital do departamento de Haut-Savoie, que foi fundada há mais de 900 anos, também está localizada aqui. É o centro cultural e económico da região e uma das mais belas cidades da região alpina. Os arredores com neve são um destino popular para a prática de esportes de inverno. No entanto, a candidatura de Annecy para os Jogos Olímpicos de Inverno de 2018 não teve sucesso.

Meer van Annecy

Het Meer van Annecy (Lac d'Annecy) is een van de mooiste alpenmeren en is gelegen in een oud cultuurlandschap waarin de eerste bewoners zich 5000 jaar geleden vestigden. De oevers, vooral in het noorden, zijn dichtbebouwd. Hier ligt ook Annecy, de ruim 900 jaar oude hoofdstad van het departement Haut-Savoie. Annecy is zowel het culturele als economische centrum van de streek en een van de mooiste steden van het alpengebied. De omgeving van de plaats is zeer sneeuwzeker en daarom populair bij wintersporters. Annecy's kandidatuur voor de Olympische Winterspelen van 2018 was echter niet succesvol.

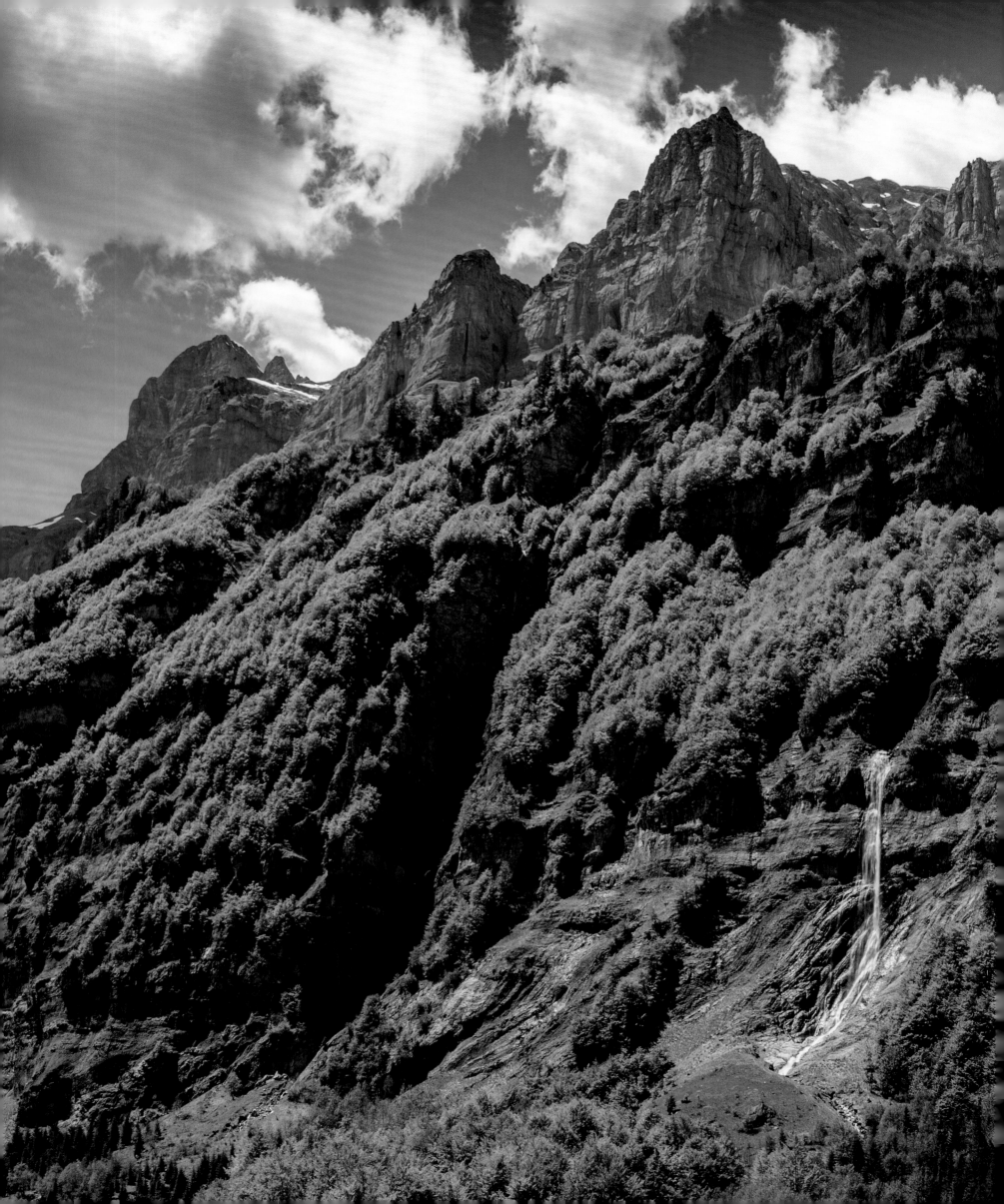

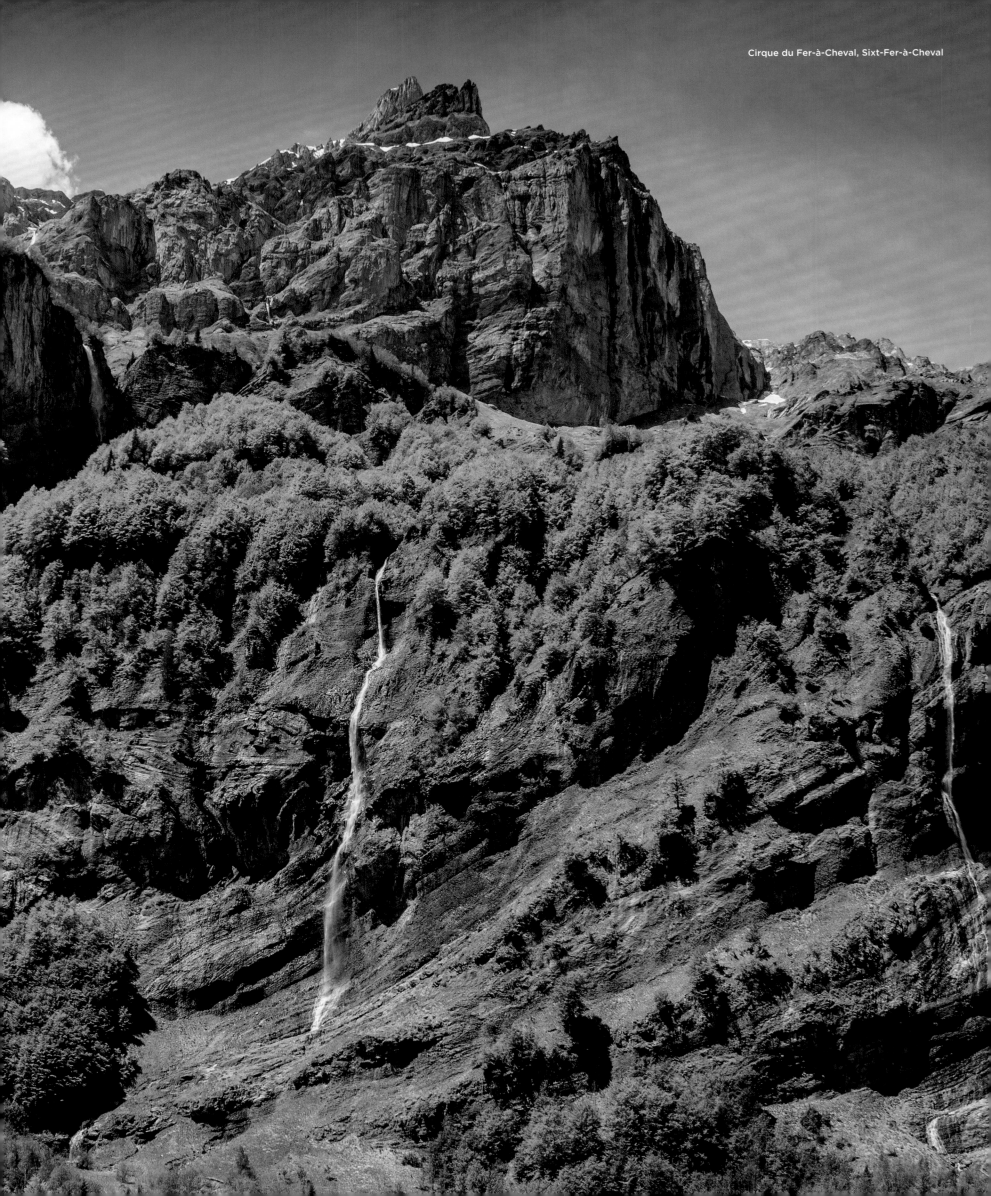

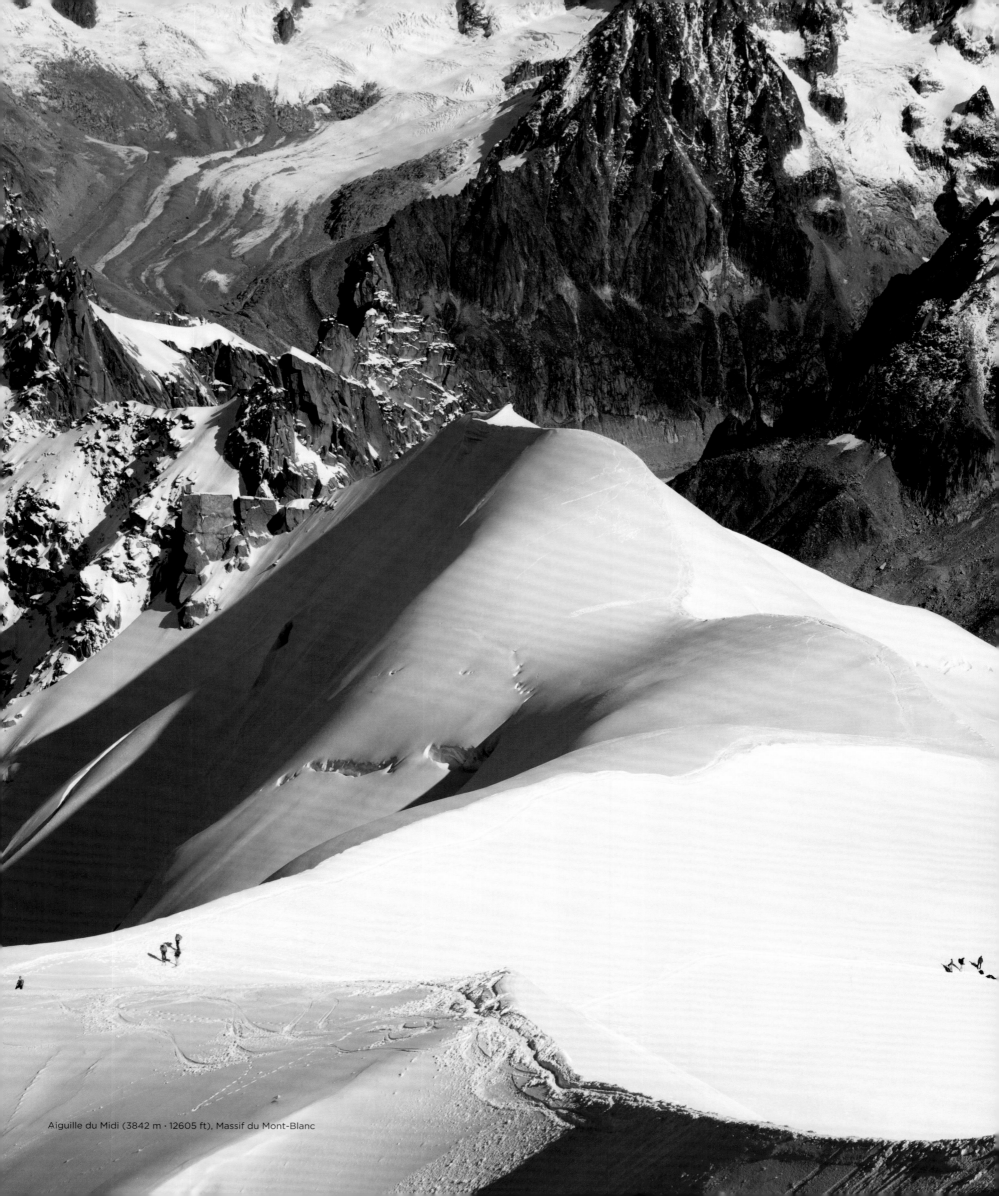

Aiguille du Midi (3842 m · 12605 ft), Massif du Mont-Blanc

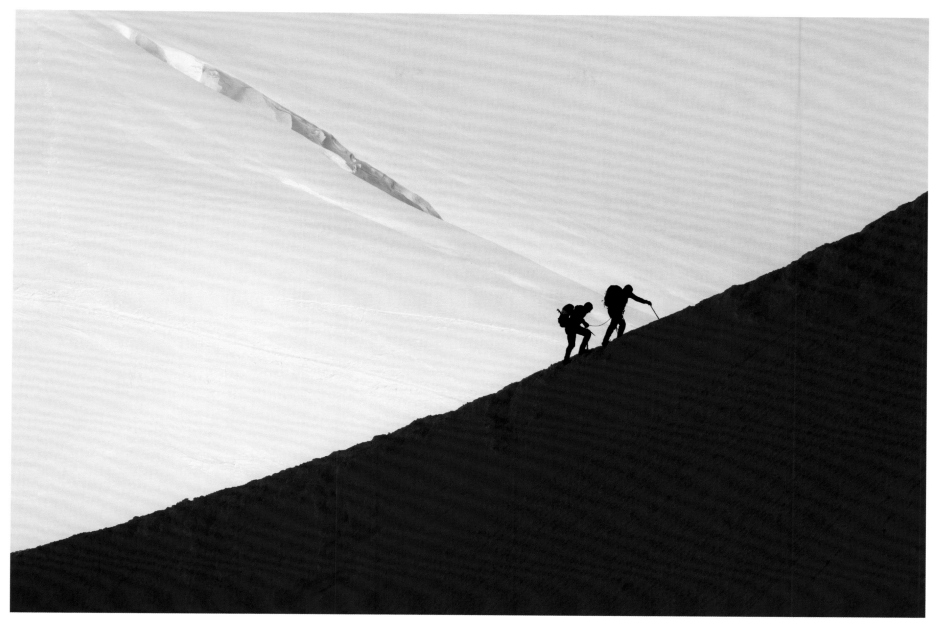

Aiguille du Midi (3842 m · 12605 ft), Massif du Mont-Blanc

Aiguille du Midi

High above Chamonix, the Aiguille du Midi rises 3842 m (12605 ft) into the sky as part of the Mont Blanc massif. The panoramic view from the summit could hardly be more beautiful, and attracts numerous tourists who ride up comfortably in the spectacular cable car. However there is hardly any alpine solitude to enjoy in the hustle and bustle at the top. Further cable cars provide access to the entire Mont Blanc massif.

L'aiguille du Midi

Au-dessus de Chamonix et face au mont Blanc, l'aiguille du Midi s'élance dans le ciel, avec ses 3842 m d'altitude. Depuis son sommet, le panorama est époustouflant, ce qui explique qu'une multitude de touristes montent confortablement là-haut grâce à un impressionnant téléphérique. Dans l'agitation, impossible pourtant pour eux de savourer la quiétude des montagnes. D'autres téléphériques permettent d'accéder à l'ensemble du massif du Mont-Blanc.

Aiguille du Midi

Hoch über Chamonix ragt die Aiguille du Midi 3842 m in den Himmel. Der Rundblick vom Gipfel könnte kaum schöner sein, deshalb fahren zahlreiche Touristen mit der spektakulär hohen Seilbahn bequem nach oben, wo sie im Trubel allerdings kaum Bergeinsamkeit genießen können. Weitere Seilbahnen erschließen das gesamte Mont-Blanc-Massiv.

Aiguille du Midi

En lo alto de Chamonix, la Aiguille du Midi se eleva 3842 m hacia el cielo en el Mont Blanc. La vista panorámica desde la cima no podría ser más bella, por lo que numerosos turistas suben cómodamente con el espectacular teleférico, donde difícilmente pueden disfrutar de la soledad de la montaña en el ajetreo y el bullicio. Otros teleféricos dan acceso a todo el macizo del Mont Blanc.

Aiguille du Midi

Acima de Chamonix, o Aiguille du Midi sobe 3842 m para o céu no Mont Blanc. A vista panorâmica do cume dificilmente poderia ser mais bonita, portanto, numerosos turistas dirigem-se confortavelmente com o teleférico espetacularmente alto, onde dificilmente podem desfrutar da solidão da montanha na azáfama. Mais teleféricos dão acesso a todo o maciço do Monte Branco.

Aiguille du Midi

De 3842 m hoge Aiguille du Midi in het Mont-Blancmassief torent hoog boven Chamonix uit. Het geweldige panorama vanaf de top trekt veel toeristen, die zich comfortabel naar boven laten brengen met de spectaculair hoge kabelbaan. Van eenzaamheid valt hier maar zelden te genieten. De meeste toppen in het Mont Blanc-massief zijn te bereiken met een kabelbaan.

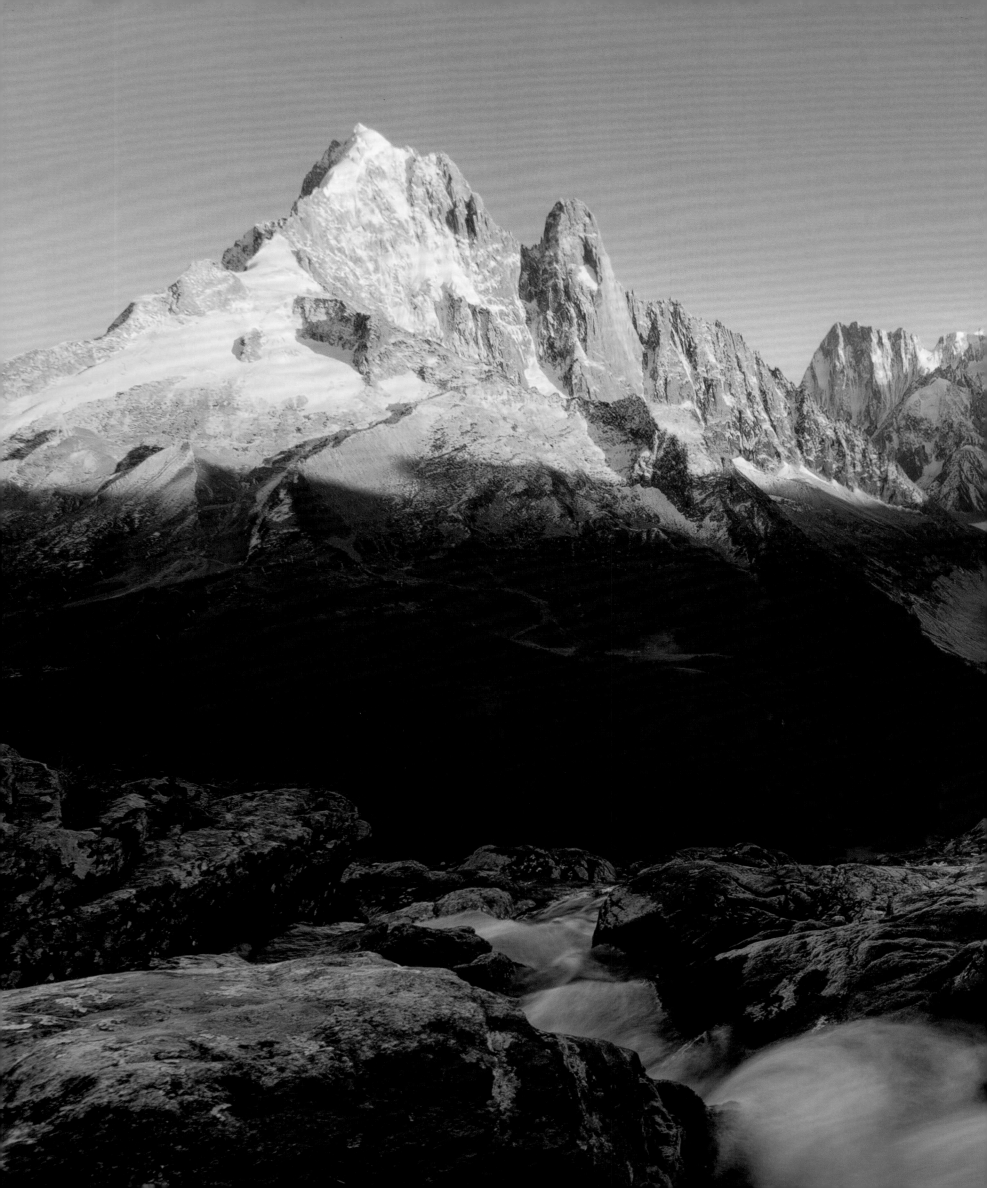

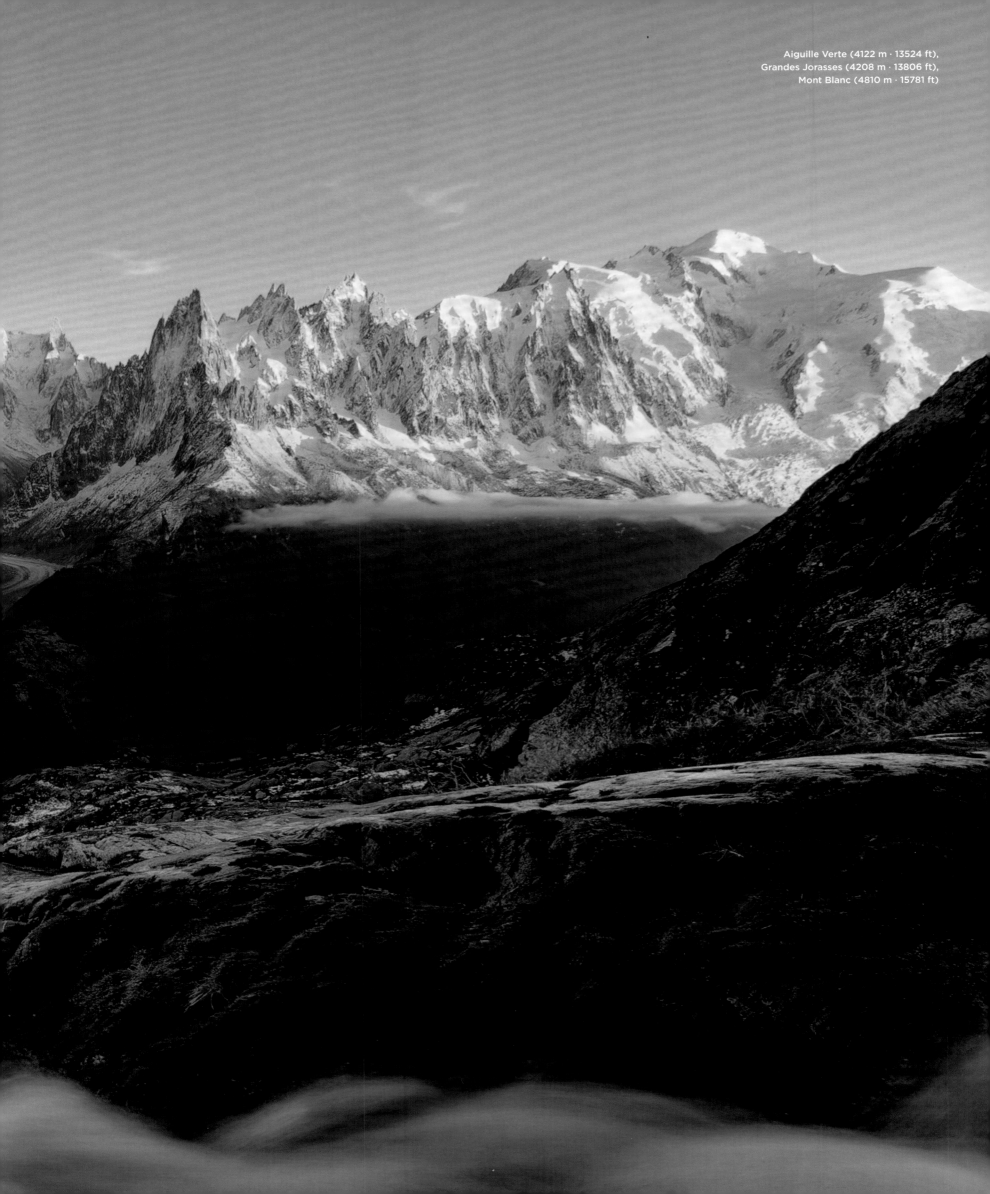

Aiguille Verte (4122 m · 13524 ft),
Grandes Jorasses (4208 m · 13806 ft),
Mont Blanc (4810 m · 15781 ft)

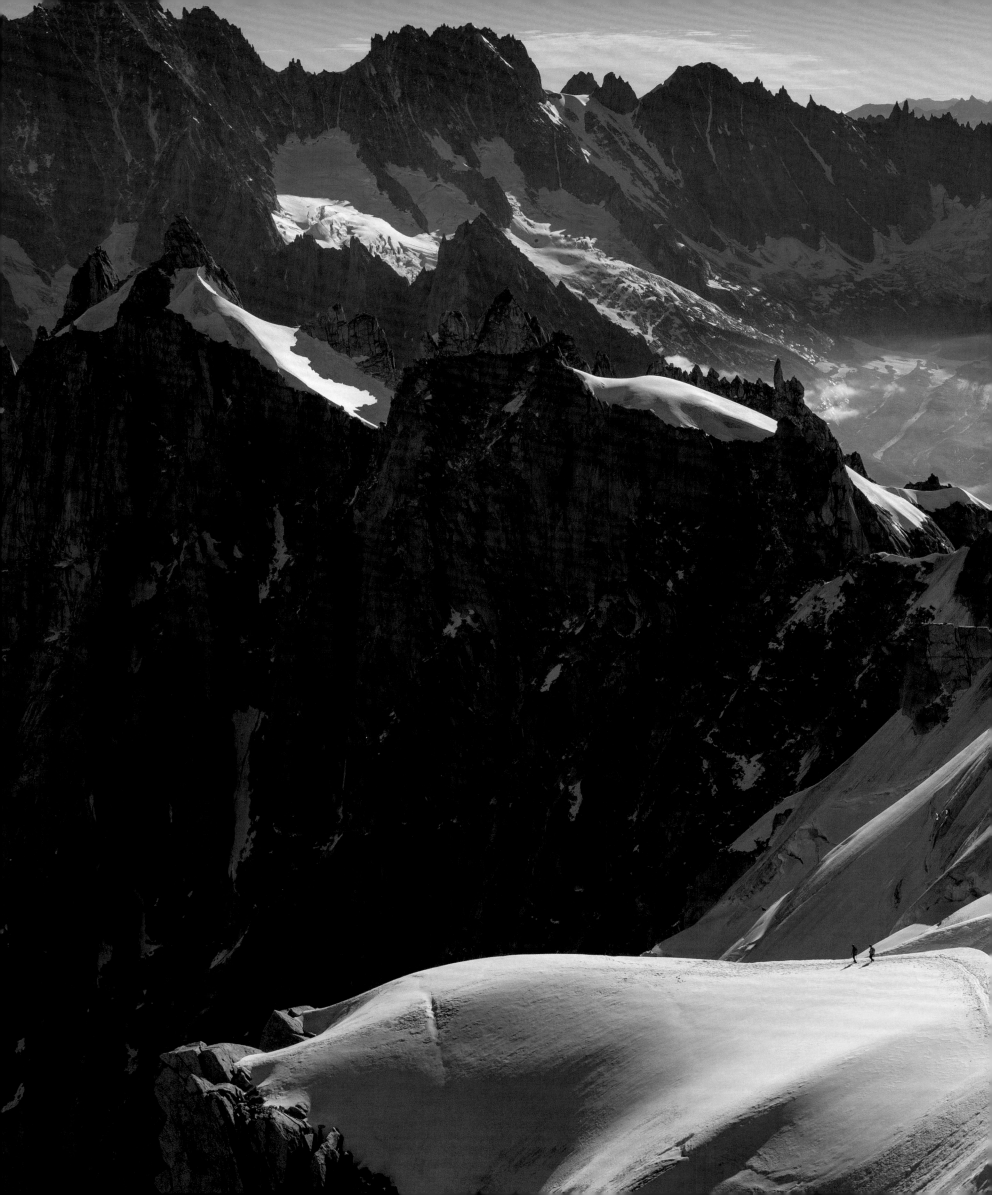

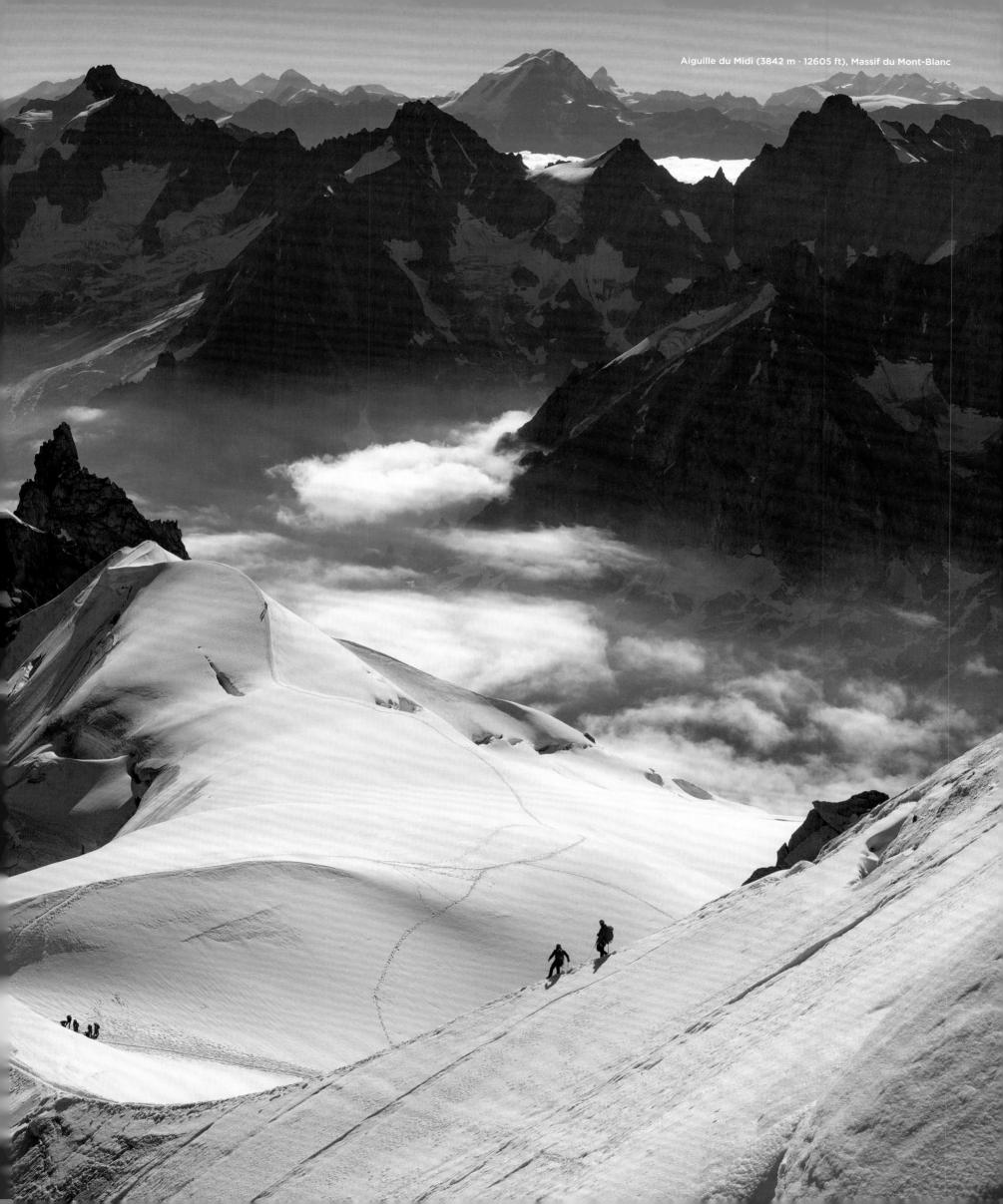

Aiguille du Midi (3842 m · 12605 ft), Massif du Mont-Blanc

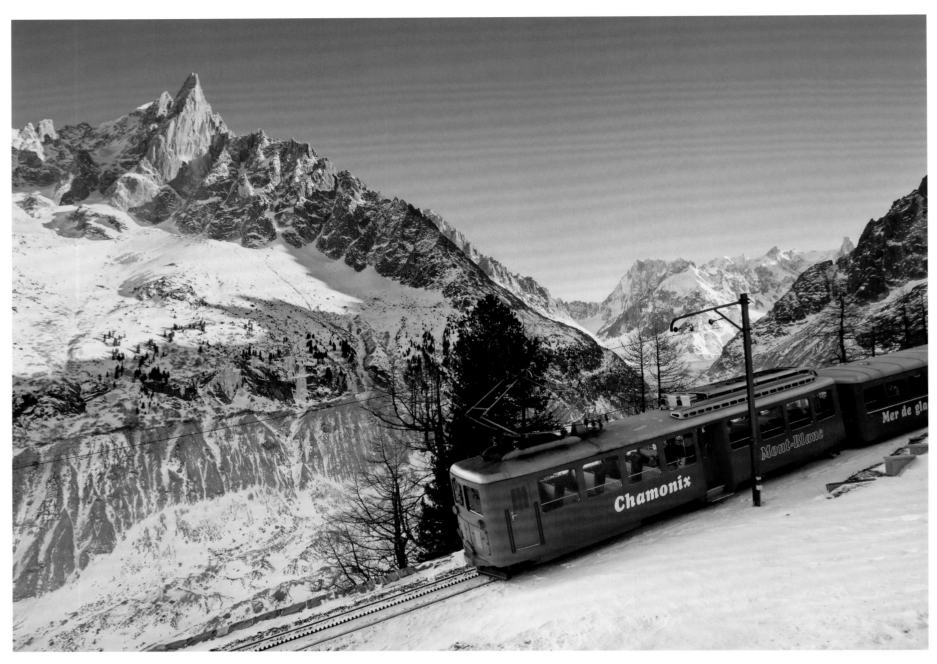

Train du Montenvers, Mer de Glace

Train du Montenvers

One of the most beautiful ways to enjoy the mountain panorama at Mont Blanc is a ride on the rack railway from Chamonix to Montenvers, over a distance of 5 km and almost 900 m (2953 ft) in altitude. There has been a train chugging up the mountain at a maximum speed of 20 km/h (12 mi/h) since 1909. At the top, one can visit a small museum about the alpine flora. From up here there is a beautiful view of the largest glacier in France, the Mer de Glace (Sea of Ice), which has always inspired poets and painters. However, like so many alpine glaciers, it is now in retreat.

Le train du Montenvers

L'une des plus belles manières de savourer les paysages du Mont-Blanc consiste à prendre le chemin de fer à crémaillère qui va de Chamonix à Montenvers, soit une distance de 5 km mais un dénivelé de près de 900 m. Ce train existe depuis 1909 et gravit tranquillement la montagne, n'excédant pas 20 km/h. En haut, les touristes peuvent visiter un petit musée consacré à la flore alpine et admirer la vue saisissante sur le plus gros glacier de France, la mer de Glace, qui inspire depuis toujours poètes et peintres. Aujourd'hui, comme tant d'autres glaciers alpins, celui-ci connaît un net recul.

Train du Montenvers

Eine der schönsten Arten, das Bergpanorama am Mont Blanc zu genießen, ist eine Fahrt mit der Zahnradbahn von Chamonix bis auf den Montenvers, wobei über eine Strecke von 5 km fast 900 Höhenmeter überwunden werden. Seit 1909 gibt es den Zug, der mit maximal 20 km/h auf den Berg tuckert, wo man ein kleines Museum über die alpine Pflanzenwelt besuchen kann. Von hier oben gibt es einen schönen Blick auf den größten Gletscher Frankreichs, das Mer de Glace (Eismeer), der immer schon Dichter und Maler inspiriert hat. Er ist, wie so viele Alpengletscher, im Rückzug begriffen.

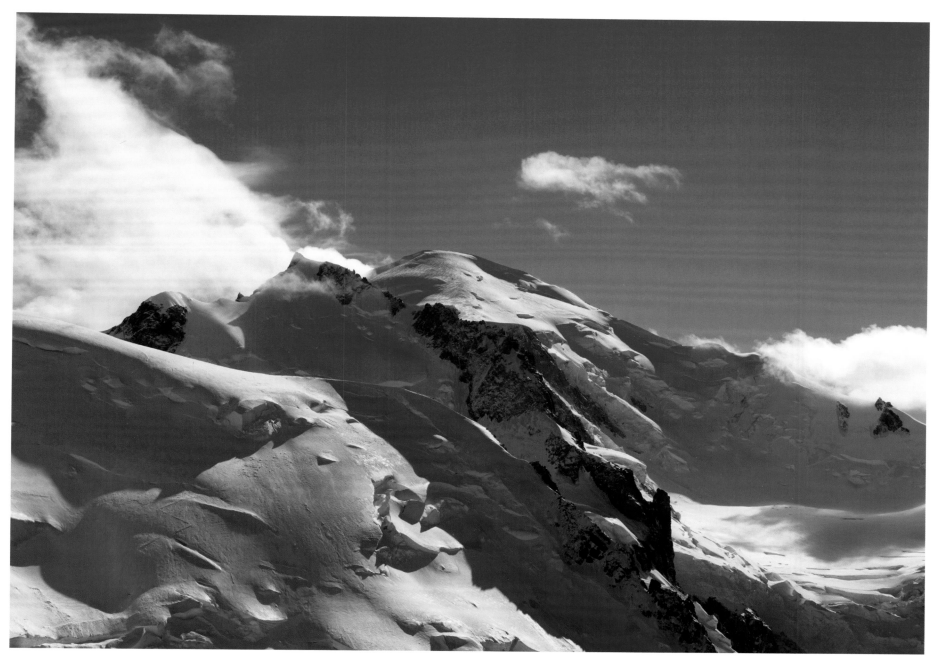

Mont Blanc (4810 m · 15781 ft)

Train du Montenvers

Una de las formas más bellas de disfrutar del panorama montañoso del Mont Blanc es un paseo en el ferrocarril de cremallera de Chamonix a Montenvers, a lo largo de 5 km y a casi 900 metros de altitud. Desde 1909 hay un tren que sube por la montaña a una velocidad máxima de 20 km/h, donde se puede visitar un pequeño museo sobre la flora alpina. Desde aquí arriba hay una hermosa vista del glaciar más grande de Francia, el Mer de Glace (que significa «mar de hielo»), que siempre ha inspirado a poetas y pintores. Sin embargo, como tantos glaciares alpinos, se encuentra en retroceso.

Train du Montenvers

Uma das mais belas formas de desfrutar do panorama montanhoso do Mont Blanc é um passeio de trem em rack de Chamonix a Montenvers, numa distância de 5 km a quase 900 metros de altitude. Desde 1909, existe um comboio que sobe a montanha a uma velocidade máxima de 20 km/h, onde se pode visitar um pequeno museu sobre a flora alpina. Daqui de cima há uma bela vista da maior geleira da França, o Mer de Glace (Oceano Ártico), que sempre inspirou poetas e pintores. No entanto, como tantos glaciares alpinos, está em retirada.

Trein naar Montenvers

Een van de mooiste manieren om van het vergezicht op de Mont Blanc te genieten is vanuit een wagon van de tandradbaan van Chamonix naar Montenvers – een 5 kilometer lang tochtje met een hoogteverschil van 900 meter. Sinds 1909 rijdt deze trein met een maximumsnelheid van 20 km/u de berg op, waar boven een klein alpenfloramuseum wacht. Vanaf hier hebt u een prachtig uitzicht op de grootste gletsjer van Frankrijk, de Mer de Glace ('Noordelijke IJszee'), die tal van dichters en schilders inspireerde. Zoals zo veel andere gletsjers in de Alpen smelt ook deze gletsjer zich steeds af.

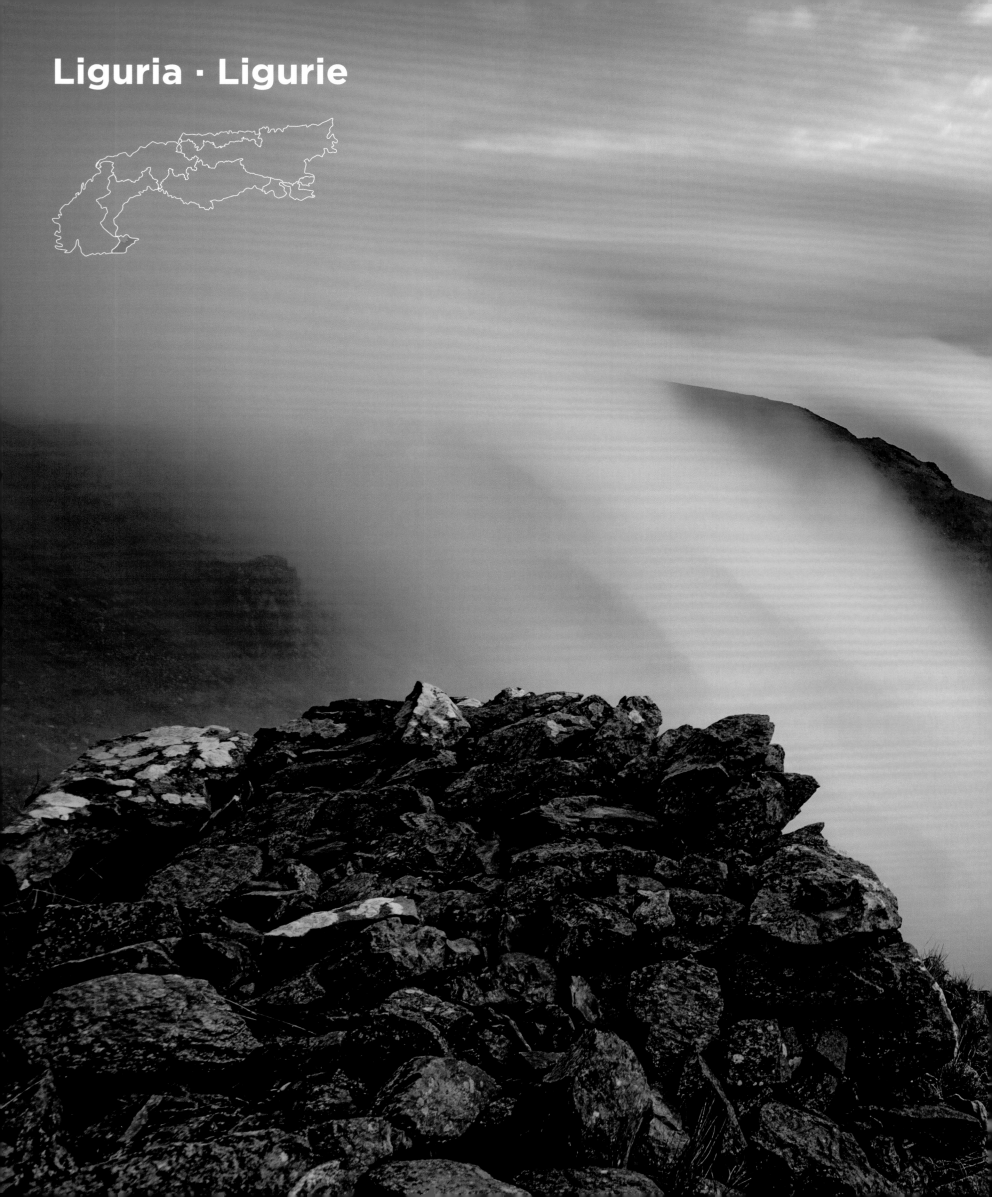

Liguria · Ligurie

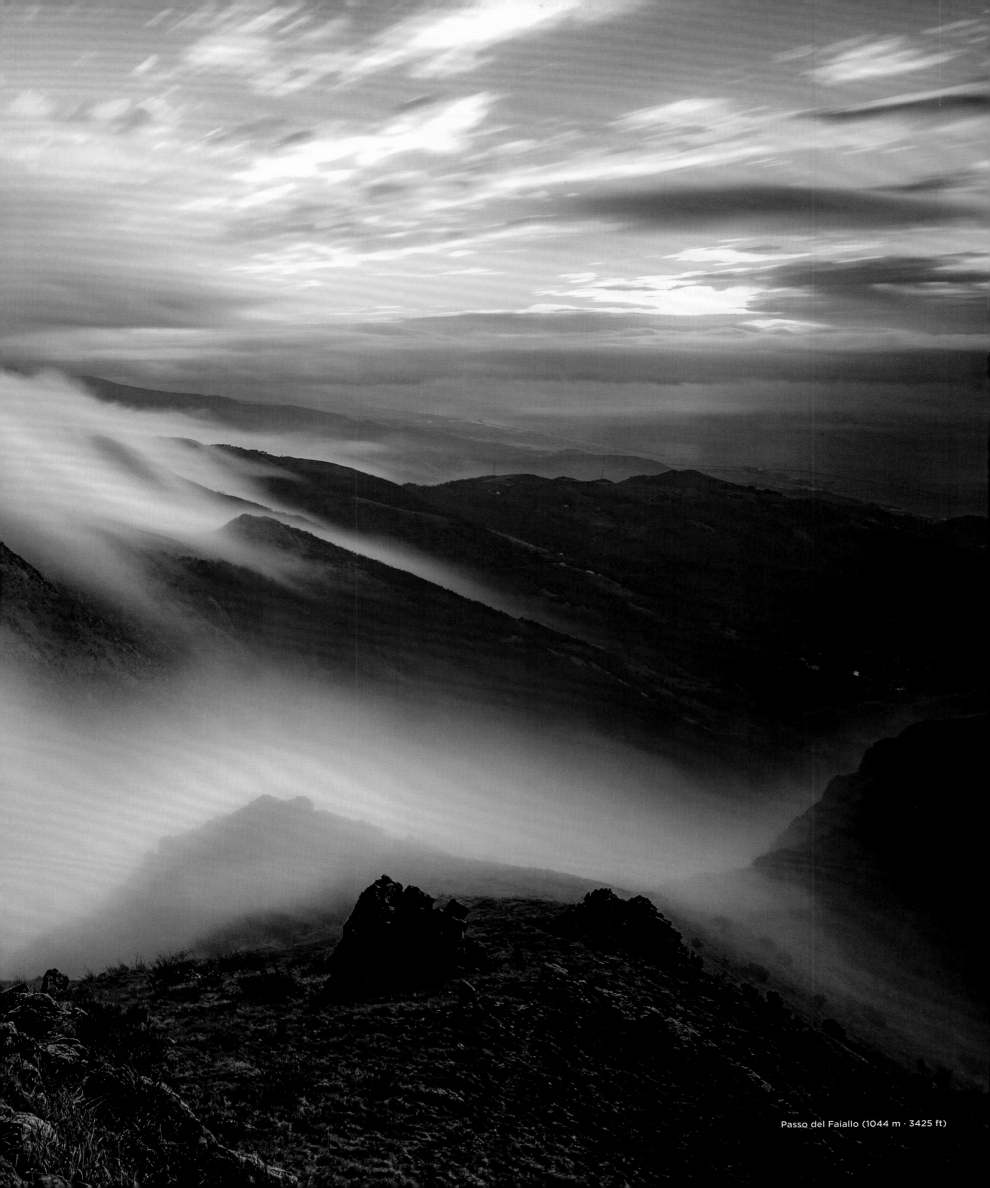

Passo del Faiallo (1044 m · 3425 ft)

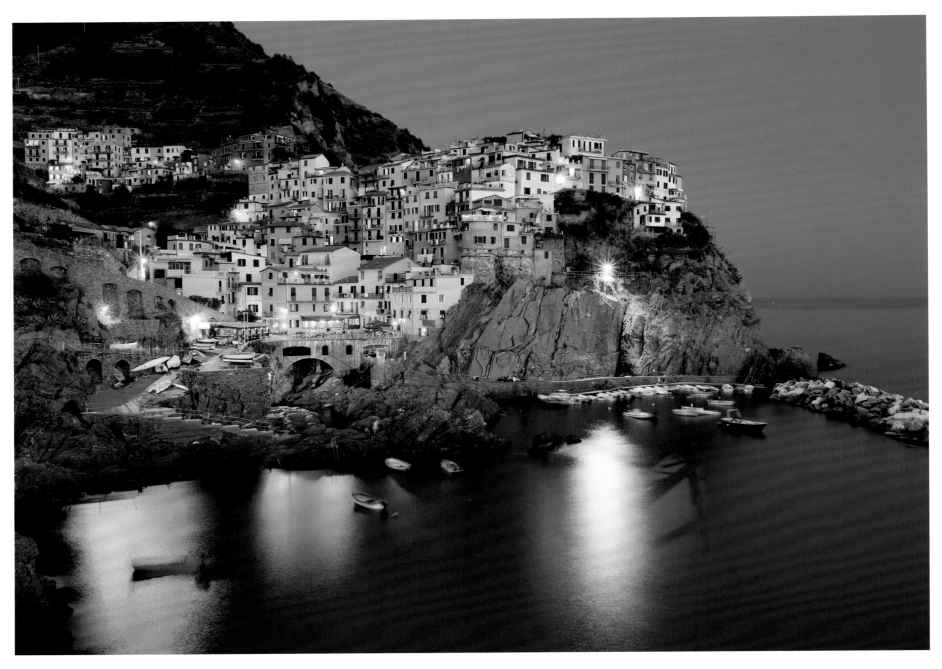

Manarola, Cinque Terre

Liguria

The mountains rise steeply behind the densely settled coastal strip of Liguria. Typical are picturesque mountain villages in narrow valleys, on hillsides and on rock spurs. Two thirds of the region are forested, there is not much room for agriculture. Olive groves dominate the landscape; Ligurian olive oil is one of the best in the world. The climate on the coast is mild even in winter; the Italians say that this is where "spring hibernates". In the east, the Alps make way to the Appenines. Here the Cinque Terre include some of the most charming holiday resorts in Italy.

La Ligurie

Les montagnes s'élèvent directement derrière la bande côtière très construite de la Ligurie. On y trouve des villages de montagne très pittoresques, bâtis dans les vallées étroites, sur les versants ou sur des promontoires rocheux. Les deux tiers de la région sont couverts de forêts, ne laissant que peu de place à l'agriculture. On trouve de nombreux champs d'oliviers et l'huile d'olive de Ligurie compte parmi les meilleures du monde. Le long de la côte, le climat est doux même en hiver ; les Italiens se plaisent à dire que « le printemps hiberne ». À l'est, les Alpes laissent la place aux Apennins. Dans la zone côtière dite des Cinque Terre (« Cinq Terres »), on trouve quelques-uns des lieux de villégiature les plus charmants d'Italie.

Ligurien

Hinter dem dicht bebauten Küstenstreifen Liguriens erheben sich steil die Berge. Typisch sind pittoreske Gebirgsdörfer, die in engen Tälern, an Hängen und auf Felsspornen erbaut sind. Zwei Drittel der Region sind bewaldet, viel Raum bleibt nicht für die Landwirtschaft. Olivenhaine bestimmen das Landschaftsbild, das ligurische Olivenöl gehört zu den besten der Welt. Das Klima an der Küste ist auch im Winter mild. Die Italiener sagen, dass hier „der Frühling überwintert". Im Osten werden die Alpen vom Apennin abgelöst. Hier liegen in den Cinque Terre einige der reizvollsten Ferienorte Italiens.

Monte Rossola (563 m · 1847ft)

Liguria

Detrás de la franja costera de Liguria densamente urbanizada, las montañas se elevan con fuerza. Son típicos los pintorescos pueblos de montaña construidos en valles estrechos, en laderas y en estribaciones rocosas. Dos tercios de la región están cubiertos de bosques; no hay mucho espacio para la agricultura. Los olivares dominan el paisaje; el aceite de oliva de Liguria es uno de los mejores del mundo. El clima de la costa es suave incluso en invierno. Los italianos dicen que aquí "la primavera hiberna". En el este, los Alpes son reemplazados por los Apeninos. Aquí, en las Cinque Terre, se encuentran algunos de los complejos vacacionales con más encanto de Italia.

Ligúria

Por detrás da faixa costeira densamente povoada da Ligúria, as montanhas sobem acentuadamente. Típicas são as pitorescas aldeias de montanha construídas em vales estreitos, em encostas e em esporões de rocha. Dois terços da região estão florestados, não há muito espaço para a agricultura. Os olivais dominam a paisagem, o azeite da Ligúria é um dos melhores do mundo. O clima na costa é ameno mesmo no inverno, dizem os italianos que aqui "hibernam na primavera". No leste, os Alpes são substituídos pelos Apeninos. Aqui no Cinque Terre encontram-se alguns dos resorts de férias mais charmosos da Itália.

Ligurië

Achter de dichtbebouwde kuststrook van Ligurië verrijzen steile bergen. Typisch voor deze streek zijn de pittoreske, in smalle dalen, op hellingen en op uitstekende rotsformaties gelegen bergdorpjes. Twee derde van Ligurië is bedekt met bossen, en in de landbouwgebieden bepalen olijfgaarden het beeld; de olijfolie vanhier is een van de beste ter wereld. Het klimaat langs de kust is mild, zelfs 's winters; volgens de Italianen 'overwintert de lente hier'. In het oosten gaan de Alpen over in de Apennijnen en Cinque Terre, waar enkele van de fraaiste vakantieoorden van Italië liggen.

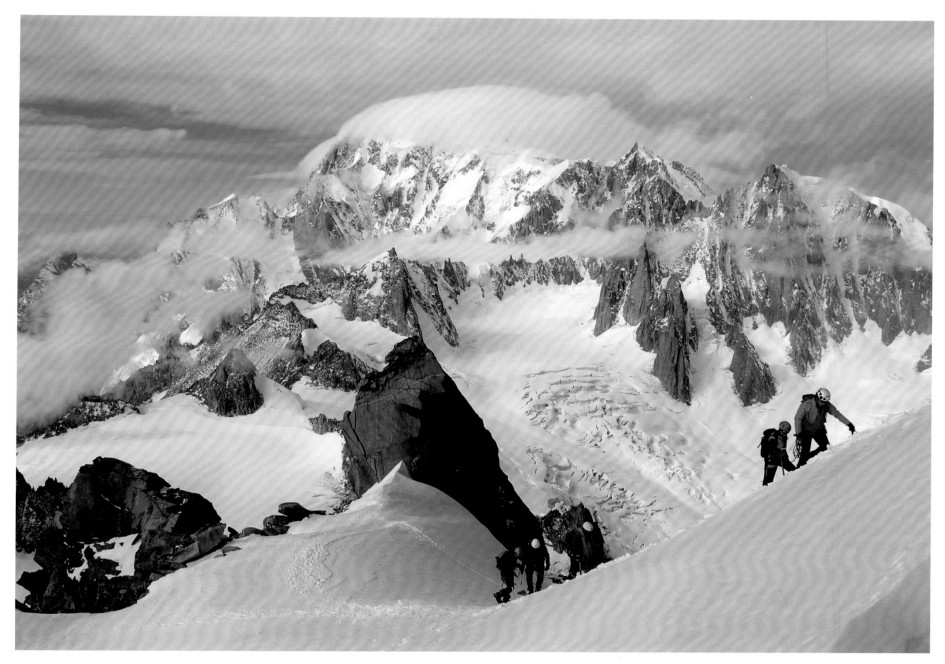

Dente del Gigante (4014 m · 13169 ft), Alpi del Monte Bianco
Dent du Géant (4014 m), Massif du Mont-Blanc

Valle de Aosta

Aunque la lengua materna de la gran mayoría de los habitantes es el italiano, oficialmente la región es bilingüe. La estrecha relación con Francia es el resultado de la historia. El valle también está bien comunicado con Francia por el túnel del Mont Blanc. Y con Francia comparte la mayor elevación de los Alpes, el Mont Blanc. Parte del parque nacional más antiguo de Italia, el Gran Paradiso, se encuentra en la zona del valle. La región autónoma es una de las más ricas de Italia. Los gourmets aprecian el Valle de Aosta sobre todo por sus excelentes vinos y sus famosos quesos.

Vale de Aosta

Embora a grande maioria dos habitantes fale italiano como língua materna, a região é oficialmente bilingue. Os laços estreitos com a França resultam da história. O vale também está bem ligado à França pelo túnel do Monte Branco. E com a França partilha a maior elevação dos Alpes, o Mont Blanc. Parte do parque nacional mais antigo da Itália, o Gran Paradiso, está localizado na área do vale. A região autónoma é uma das mais ricas da Itália. Os gourmets apreciam o Valle d'Aosta sobretudo por causa dos excelentes vinhos e do famoso queijo.

Valle d'Aosta

Hoewel het merendeel van de inwoners van de Aostavallei Italiaans spreekt, is Frans de tweede voertaal. De nauwe banden met Frankrijk gaan ver terug in de geschiedenis. Via de Mont Blanctunnel bestaat er ook een goede verkeersverbinding met Frankrijk. Bovendien ligt de hoogste bergtop van de Alpen, de Mont Blanc, deels in Frankrijk en deels hier. Voor een deel ligt de vallei in het oudste nationale park van Italië, het Gran Paradiso. De autonome regio is een van de welvarendste van Italië. Fijnproevers waarderen de Valle d'Aosta vooral vanwege de uitstekende wijnen en de beroemde kaas.

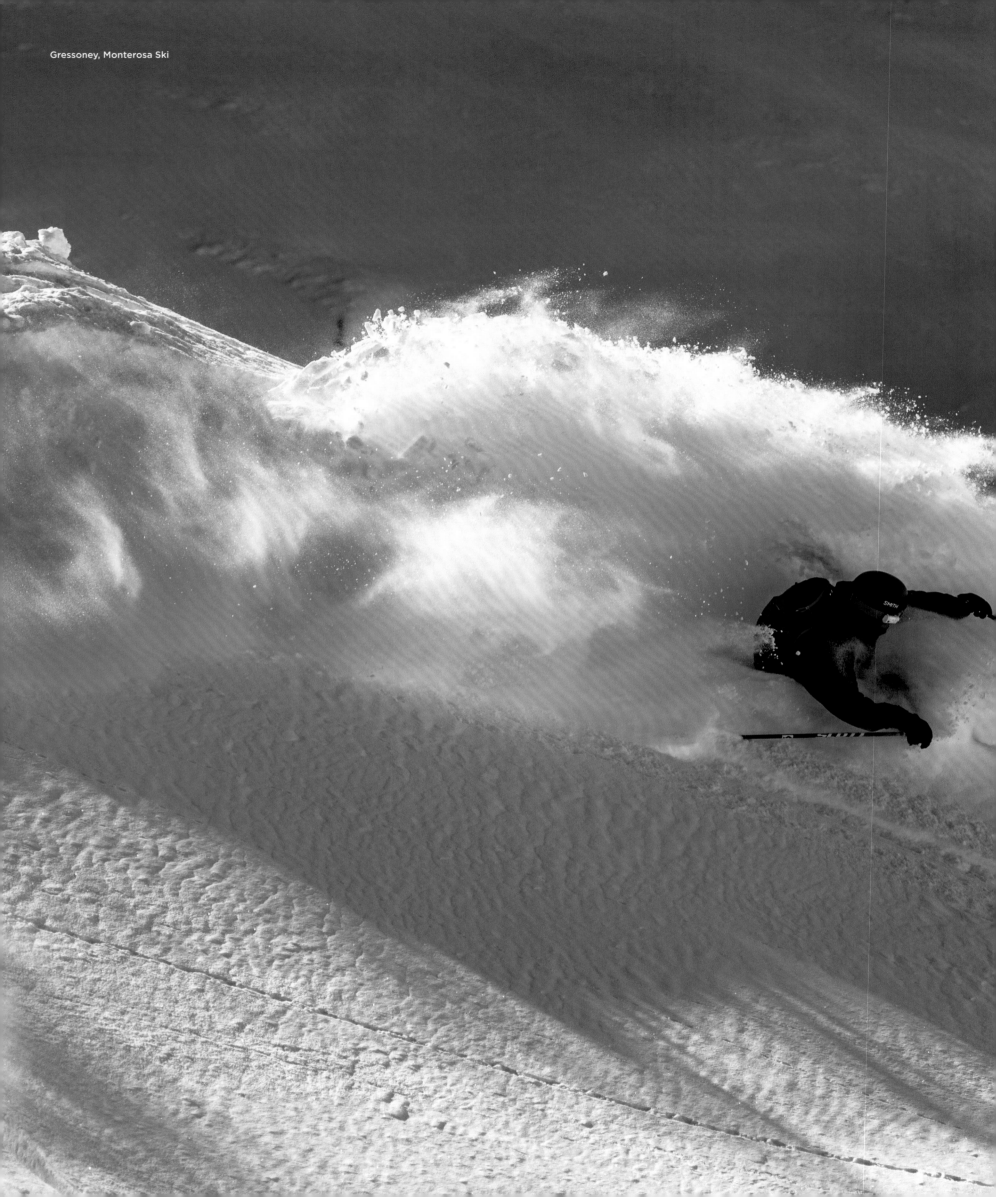

Gressoney, Monterosa Ski

Ghiacciaio del Lys, Massiccio del Monte Rosa
Glacier du Lys, Massif du Mont-Rose

Monte Rosa

The Monte Rosa massif in the Valais Alps, which is divided between Italy and Switzerland, contains the Dufourspitze, the second highest peak in the Alps after Mont Blanc (4634 m/15203 ft). On the Italian side, the valley of Gressoney (or Valle del Lys) is closest to the highest peaks, on the Swiss side Zermatt. The massif is covered by numerous glaciers. This also explains the name: "Rosa" is derived from the word "rouese", which comes from an ancient regional language in the Valle d'Aosta and means "glacier". The Monte Rosa massif is relatively easily accessible for mountain hikers and climbers.

Le Mont-Rose

Le Mont-Rose est un massif appartenant aux Alpes valaisannes et que se partagent l'Italie et la Suisse. Il comprend la pointe Dufour (4 634 m), qui est le plus haut sommet des Alpes après le mont Blanc. Du côté italien, elle est bordée par la vallée du Lys, et du côté suisse par celle de Zermatt. Ce massif est recouvert de nombreux glaciers. C'est à cela qu'il doit son nom : « Rose » provient du mot *rouésa* qui, en patois valdôtain, signifie « glacier ». Pour les randonneurs et les alpinistes, le mont Rose est relativement facile d'accès.

Monte Rosa

Das Monte-Rosa-Massiv in den Walliser Alpen, das sich Italien und die Schweiz teilen, hat mit der Dufourspitze den – nach dem Mont Blanc – zweithöchsten Gipfel der Alpen (4634 m). Auf italienischer Seite kommt man durch das Gressoneytal (Lystal) den höchsten Gipfeln am nächsten, auf schweizerischer Seite von Zermatt aus. Das Massiv ist von zahlreichen Gletschern bedeckt. Das erklärt auch den Namen: „Rosa" ist vom Wort „rouese" abgeleitet, das aus einer alten Regionalsprache des Aostatals stammt und „Gletscher" bedeutet. Für Bergwanderer und Kletterer ist das Monte-Rosa-Massiv relativ leicht zugänglich.

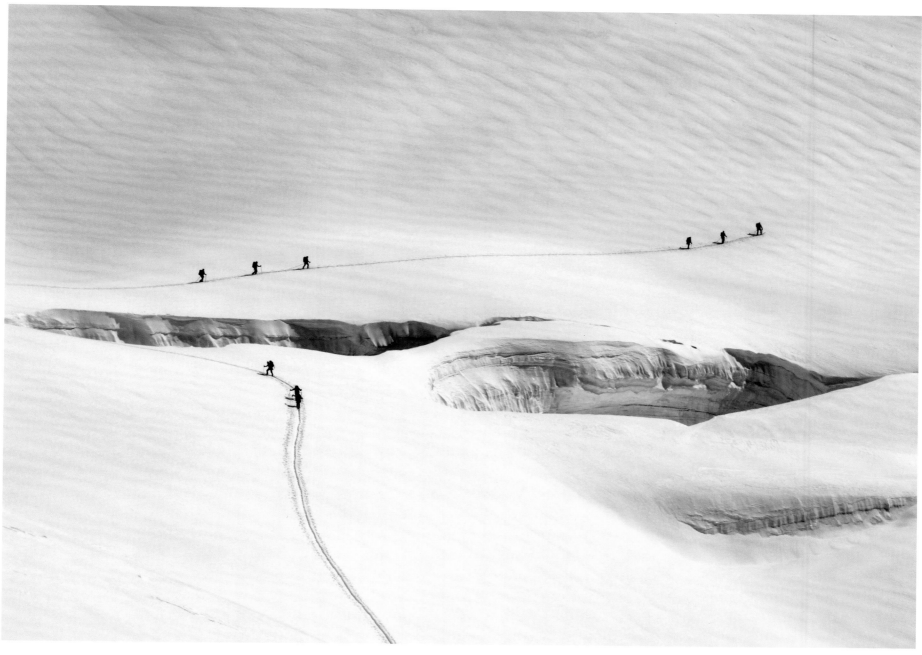

Massiccio del Monte Rosa
Massif du Mont-Rose

Monte Rosa

El macizo del Monte Rosa en los Alpes del Valais, que está dividido entre Italia y Suiza, tiene el pico Dufour, el segundo más alto de los Alpes después del Mont Blanc (4634 m). En el lado italiano, el Valle de Gressoney (Lystal) es el más cercano a los picos más altos, en el lado suizo de Zermatt. El macizo está cubierto por numerosos glaciares. Esto también explica su nombre: "rosa" proviene de la palabra «rouese», que procede de una antigua lengua regional del Valle de Aosta y significa "glaciar". El macizo del Monte Rosa es relativamente accesible para los excursionistas y escaladores.

Monte rosa

O maciço do Monte Rosa nos Alpes do Valais, dividido entre a Itália e a Suíça, tem o Dufourspitze, o segundo pico mais alto dos Alpes depois do Monte Branco (4634 m). Do lado italiano, o vale de Gressoneytal (Lystal) é o mais próximo dos picos mais altos, no lado suíço de Zermatt. O maciço está coberto por numerosos glaciares. Isso também explica o nome: "Rosa" é derivado da palavra "rouese", que vem de uma antiga língua regional do Vale de Aosta e significa "glaciar". O maciço do Monte Rosa é relativamente de fácil acesso para montanhistas e alpinistas.

Monte Rosa

Het Monte Rosamassief in de Walliser Alpen, dat deels in Italië, deels in Zwitserland ligt, beschikt met de 4634 m hoge Dufourspitze over de op één na hoogste alpentop, na de Mont Blanc. Aan de Italiaanse kant zijn de hoogste toppen bereikbaar via het Valle del Lys, aan de Zwitserse kant via Zermatt. Het massief is bedekt met talrijke gletsjers. Dit verklaart ook de naam van het massief: 'rosa' is afgeleid van 'rouese', een woord uit een oude lokale streektaal, wat 'gletsjer' betekent. Monte Rosa is een eldorado voor bergwandelaars en klimmers.

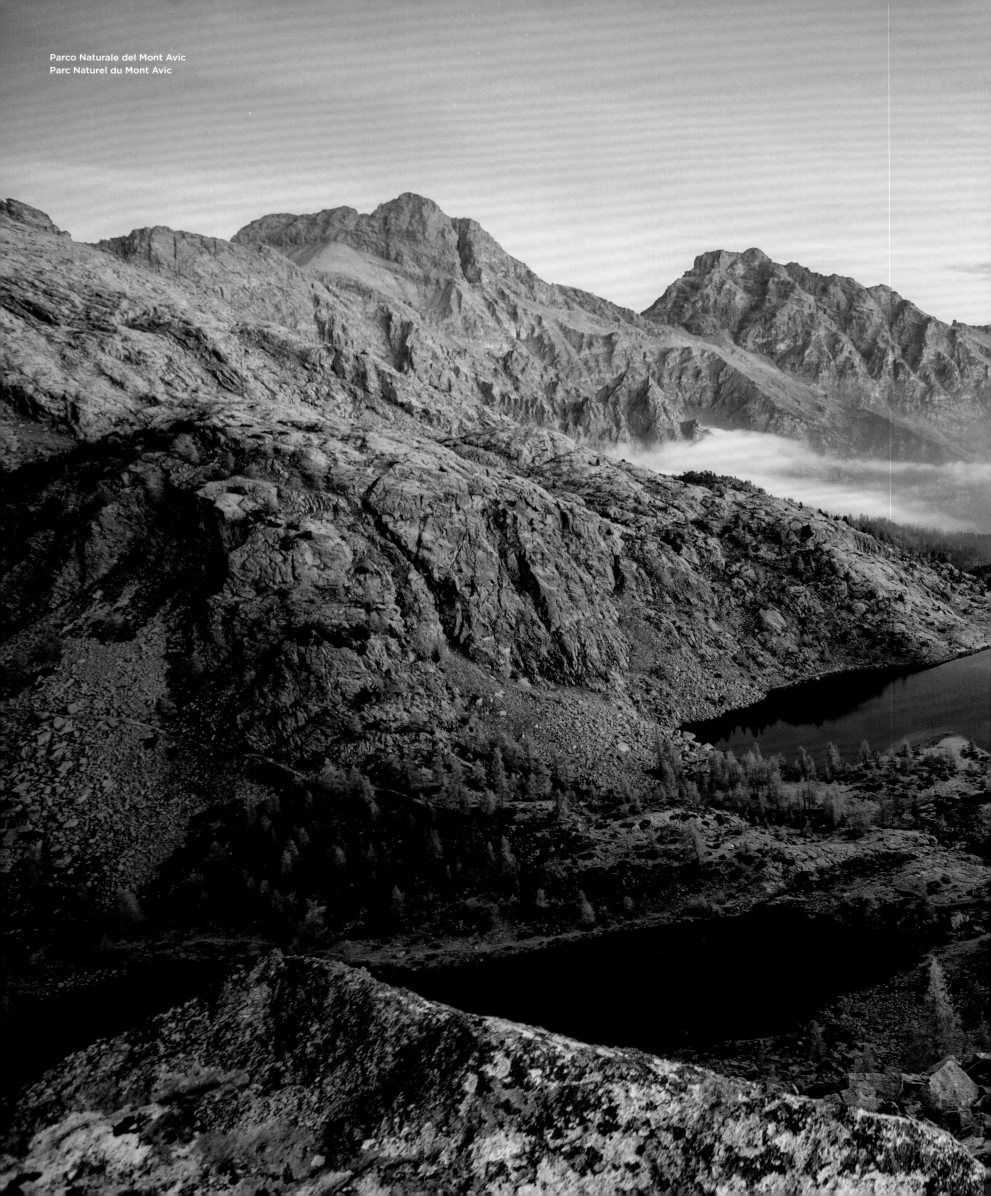

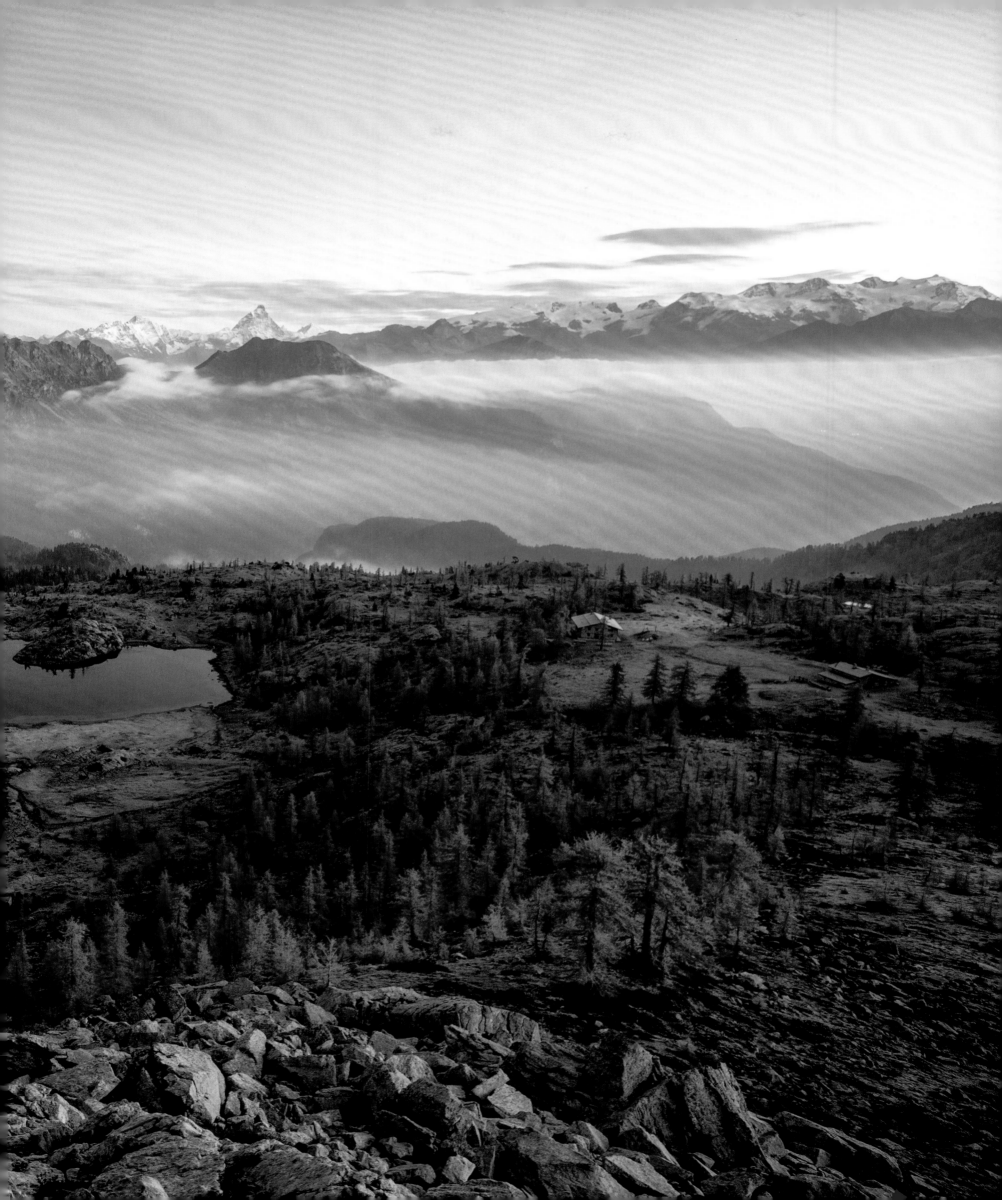

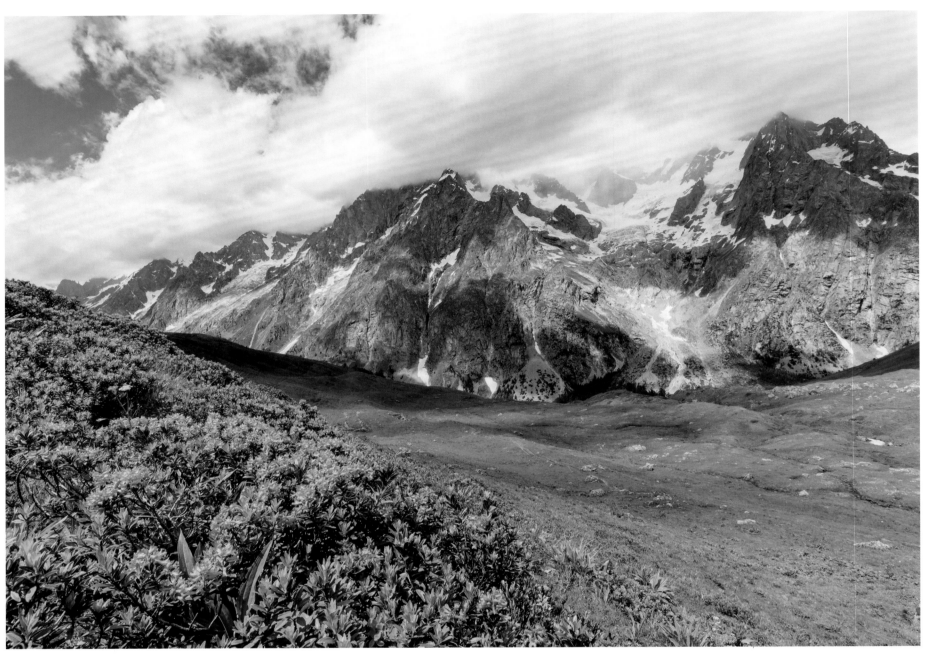

Val Ferret

Val Ferret

As an extension of the Valle d'Aosta, Val Ferret reaches to the southern foothills of the Mont Blanc massif. In the centre is the famous ski resort of Courmayeur, which can be reached from the north through the Mont Blanc tunnel. In winter there are numerous pistes for skiing fun, in spring and summer hikers can enjoy the view of the mountain massif and the alpenroses. The blooms of these rhododendron species sit on shrubs that can live up to 100 years and cover the slopes and meadows with a pale pink to bright red carpet of colour. Hence the common name "Rusty-leaved alpenrose".

Le Val Ferret

Dans le prolongement du Val d'Aoste, le Val Ferret s'étire jusqu'au versant sud du massif du Mont-Blanc. En son centre, on trouve le domaine skiable de Courmayeur, accessible par le nord via le tunnel du Mont-Blanc. En hiver, de nombreuses pistes permettent aux skieurs de s'en donner à cœur joie, tandis qu'en été les randonneurs savourent la vue sur le massif montagneux et les roses des Alpes. Ce type de rhododendron forme des buissons qui peuvent vivre jusqu'à une centaine d'années et ornent les versants des montagnes et les prairies de tapis allant du rose au rouge profond. C'est pourquoi on l'appelle aussi « rhododendron ferrugineux ».

Val Ferret

Als Verlängerung des Aostatals zieht sich das Val Ferret bis an die südlichen Ausläufer des Mont-Blanc-Massivs. Im Mittelpunkt liegt der bekannte Skiort Courmayeur, der vom Norden her durch den Mont-Blanc-Tunnel erreicht werden kann. Im Winter sorgen zahlreiche Pisten für Skispaß, im Frühjahr und Sommer erfreuen sich Wanderer am Ausblick auf das Bergmassiv und an den Alpenrosen. Die Blüten der Rhododendren-Art sitzen an Sträuchern, die bis zu 100 Jahre alt werden können und die Hänge und Wiesen mit einem zartrosa bis kräftig roten Farbteppich überziehen. Daher auch der Beiname „Rostroter Almrausch".

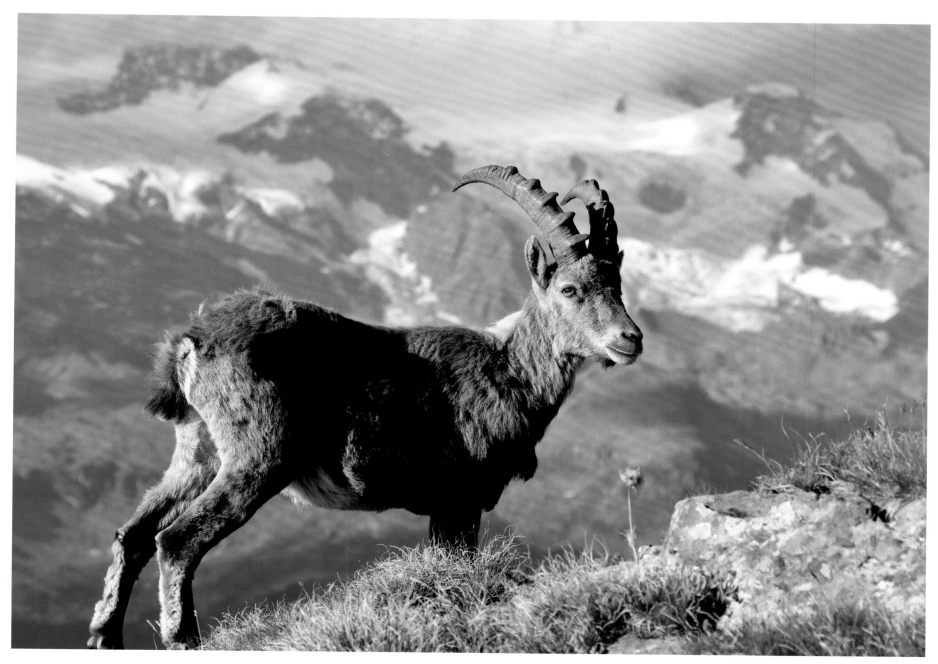

Stambecco delle Alpi, Val d'Ayas
Bouquetin des Alpes, Vallée d'Ayas
Alpine ibex, Ayas Valley

Val Ferret

Como prolongación del Valle de Aosta, Val Ferret se extiende hasta las estribaciones meridionales del macizo del Mont Blanc. En el centro se encuentra la famosa estación de esquí de Courmayeur, a la que se puede acceder desde el norte a través del túnel del Mont Blanc. En invierno hay numerosas pistas para divertirse esquiando, y en primavera y verano los excursionistas pueden disfrutar de la vista al macizo montañoso y las rosas alpinas. Las flores de la especie de rododendro se asientan sobre arbustos que pueden vivir hasta 100 años y cubren las laderas y praderas con una alfombra de color entre rosa pálido y rojo fuerte.

Val Furão

Como extensão do Vale de Aosta, Val Ferret estende-se até aos contrafortes meridionais do maciço do Monte Branco. No centro está a famosa estância de esqui de Courmayeur, que pode ser alcançada a partir do norte através do túnel do Monte Branco. No inverno há inúmeras pistas para esquiar, na primavera e no verão os caminhantes podem desfrutar da vista do maciço montanhoso e das rosas alpinas. As flores da espécie rododendro encontram-se em arbustos que podem viver até aos 100 anos e cobrem as encostas e prados com um tapete de cor rosa pálido a vermelho forte. Daí a alcunha "Rostroter Almrausch".

Val Ferret

Het in het verlengde van de Valle d'Aosta gelegen Val Ferret strekt zich uit tot aan de zuidelijke uitlopers van het Mont Blancmassief. Midden in de vallei ligt de beroemde wintersportplaats Courmayeur, die vanuit het noorden te bereiken is via de Mont Blanctunnel. In de winter bieden de talrijke pistes veel skiplezier, in de lente en de zomer genieten wandelaars er van het uitzicht op het bergmassief en van de alpenrozen. Als deze rododendronstruikjes, die wel 100 jaar oud kunnen worden, in bloei staan, zijn de hellingen en weiden bedekt met een tapijt van lichtroze tot felrode bloemen. Vandaar de bijnaam 'Rostroter Almrausch' (roestrode alm-orgie).

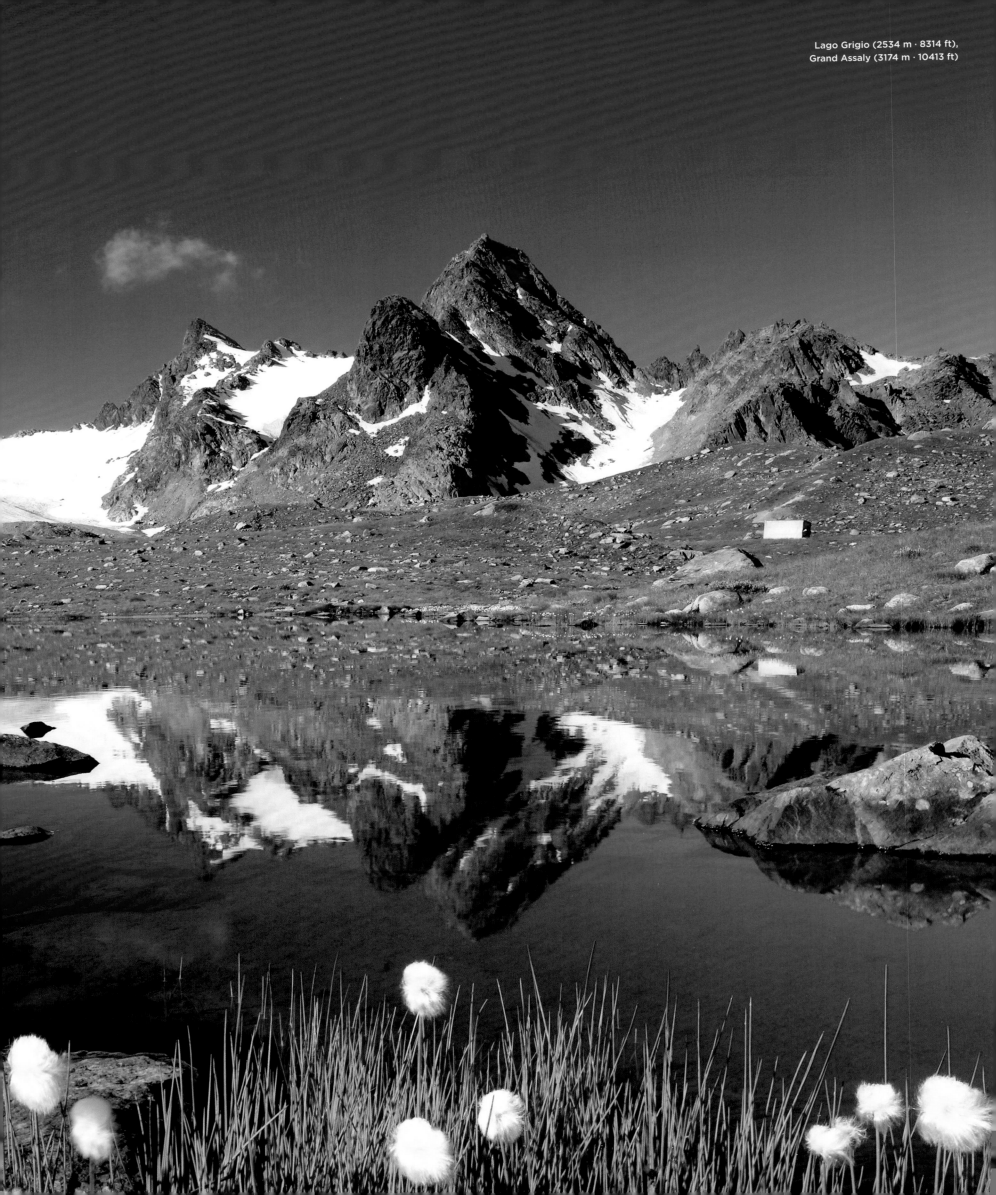

Lago Grigio (2534 m · 8314 ft),
Grand Assaly (3174 m · 10413 ft)

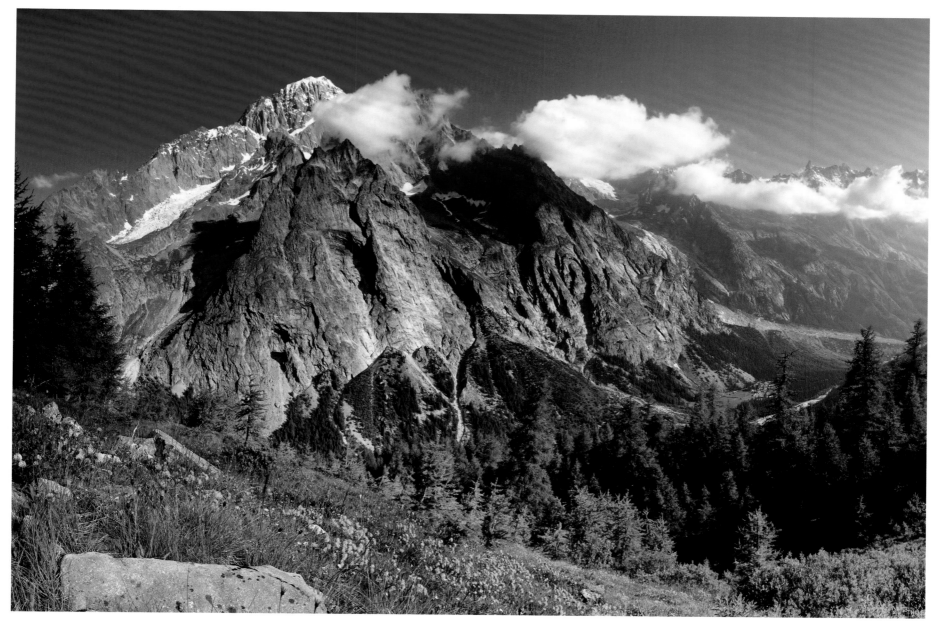

Plan Chécrouit (1709 m · 5607ft), Monte Bianco (4810 m · 15781 ft)
Plan Chécrouit (1709 m · 5607ft), Mont Blanc (4810 m · 15781 ft)

Mont Blanc Massif

The view from Val Ferret northwards to the Mont Blanc massif shows a panorama with several four-thousand-metre peaks, the highest of which, at 4810 m (15781 ft), is the Mont Blanc. The French-Italian border runs over the summit, but the exact course is controversial. First climbed in 1786, the Mont Blanc is a favoured destination for mountaineers.

Le massif du Mont-Blanc

Depuis le Val Ferret, quand on regarde vers le nord, on peut contempler plusieurs sommets de plus de 4000 m d'altitude, le plus haut d'entre eux étant le mont Blanc, avec ses 4810 m. La frontière franco-italienne passe par ce sommet, mais son tracé exact est toujours controversé. Escaladé pour la première fois en 1786, le mont Blanc est une destination très fréquentée par les alpinistes.

Mont-Blanc-Massiv

Der Blick vom Val Ferret nordwärts zum Mont-Blanc-Massiv zeigt ein Panorama mit mehreren Viertausendern, deren höchster mit 4810 m der Mont Blanc ist. Über den Gipfel verläuft die französisch-italienische Grenze, der genaue Verlauf ist allerdings umstritten. Bereits 1786 erstmals bestiegen, ist der Mont Blanc ein stark frequentiertes Ziel für Bergsteiger.

Macizo del Mont Blanc

La vista desde Val Ferret hacia el norte hasta el macizo del Mont Blanc muestra un panorama con varios picos de cuatro mil metros, el más alto de los cuales es el Mont Blanc (con 4810 metros). La frontera franco-italiana pasa por encima de la cumbre, pero existe polémica sobre su curso exacto. El Mont Blanc, al que se subió por primera vez en 1786, es un destino muy frecuentado por los alpinistas.

Maciço do Monte Branco

A vista de Val Ferret para o norte até o maciço do Monte Branco mostra um panorama com vários picos de quatro mil metros, o mais alto dos quais, com 4810 metros, é o Mont Blanc. A fronteira franco-italiana atravessa a cimeira, mas o rumo exacto é controverso. Primeiro escalado em 1786, o Mont Blanc é um destino muito frequentado por montanhistas.

Mont Blancmassief

Wie vanuit het Val Ferret naar het Mont Blancmassief in het noorden kijkt, ziet enkele toppen van meer dan 4000 m hoog. Boven op de hoogste, de Mont Blanc (4810 m), ligt de Frans-Italiaanse grens, hoewel het exacte grensverloop niet geheel duidelijk is. De Mont Blanc werd in 1786 voor het eerst beklommen en is nog steeds razend populair bij bergbeklimmers.

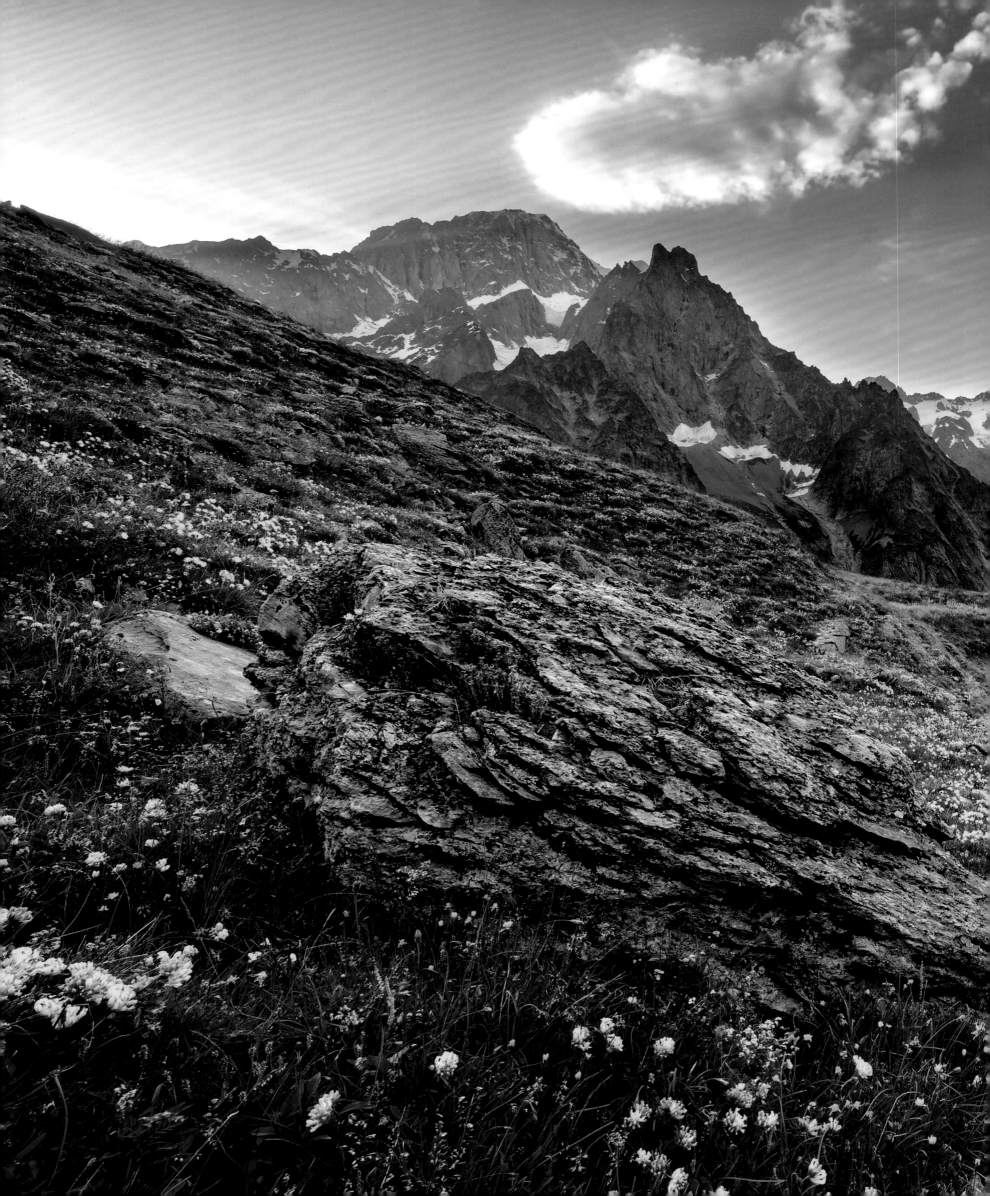

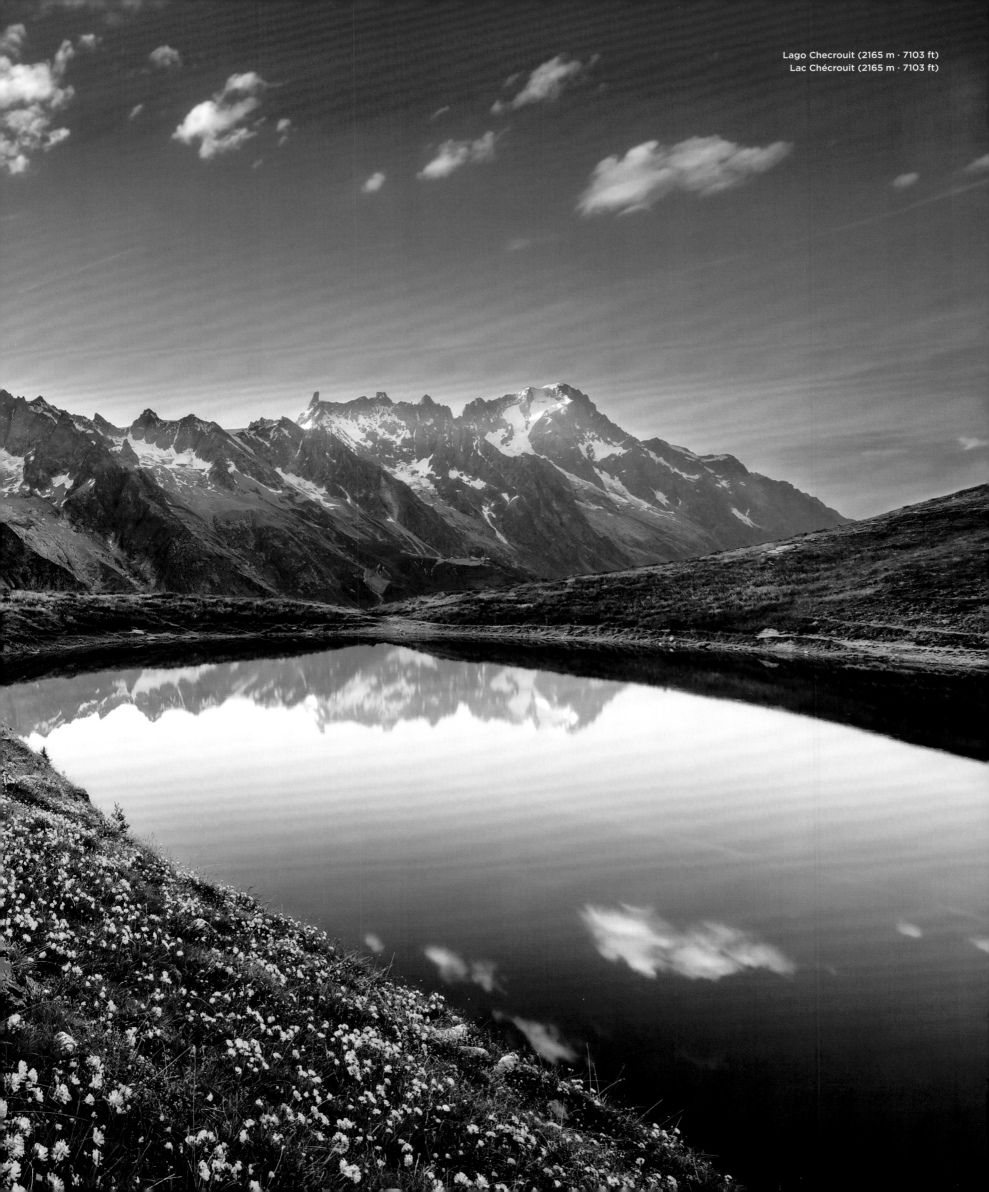

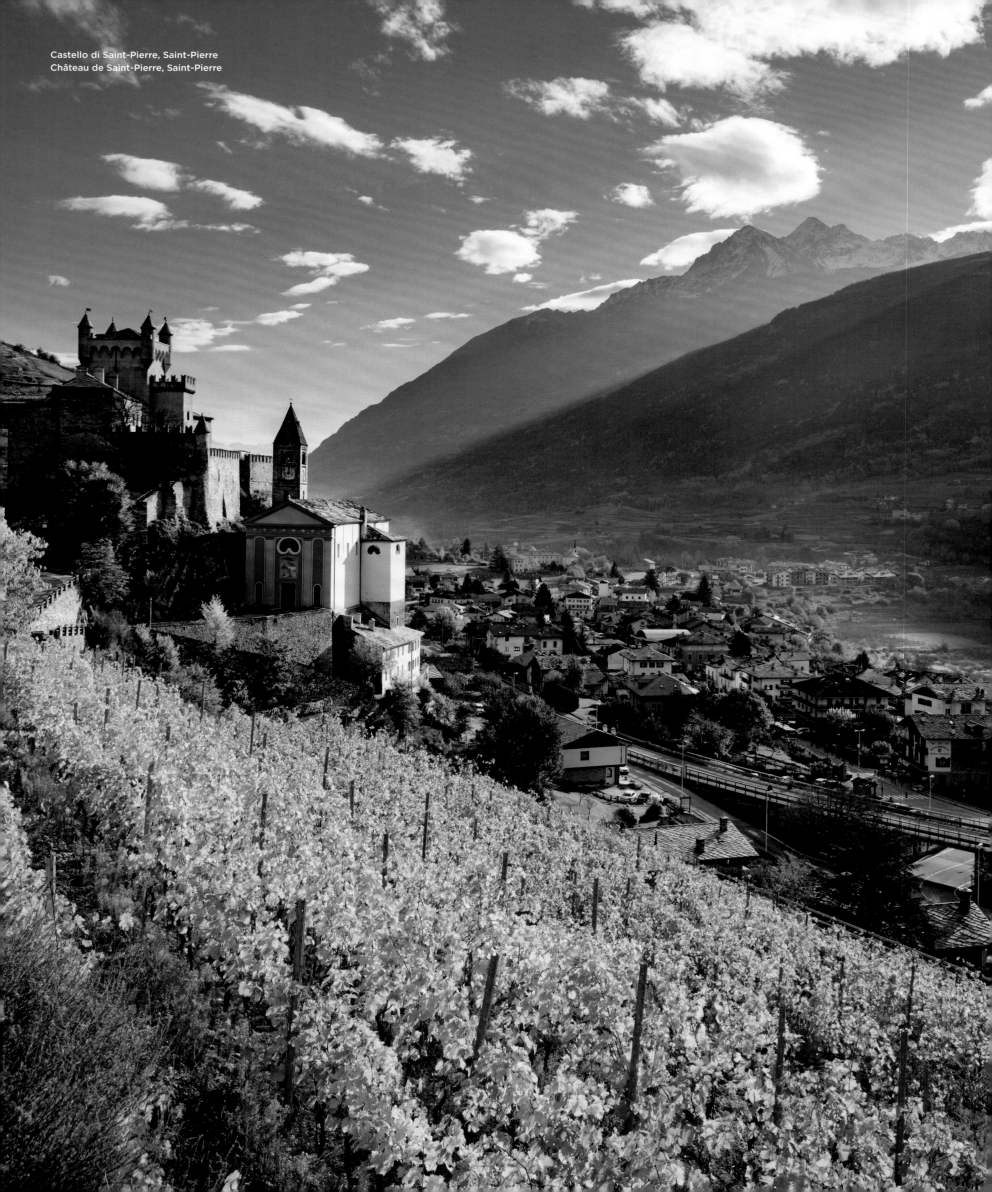

Castello di Saint-Pierre, Saint-Pierre
Château de Saint-Pierre, Saint-Pierre

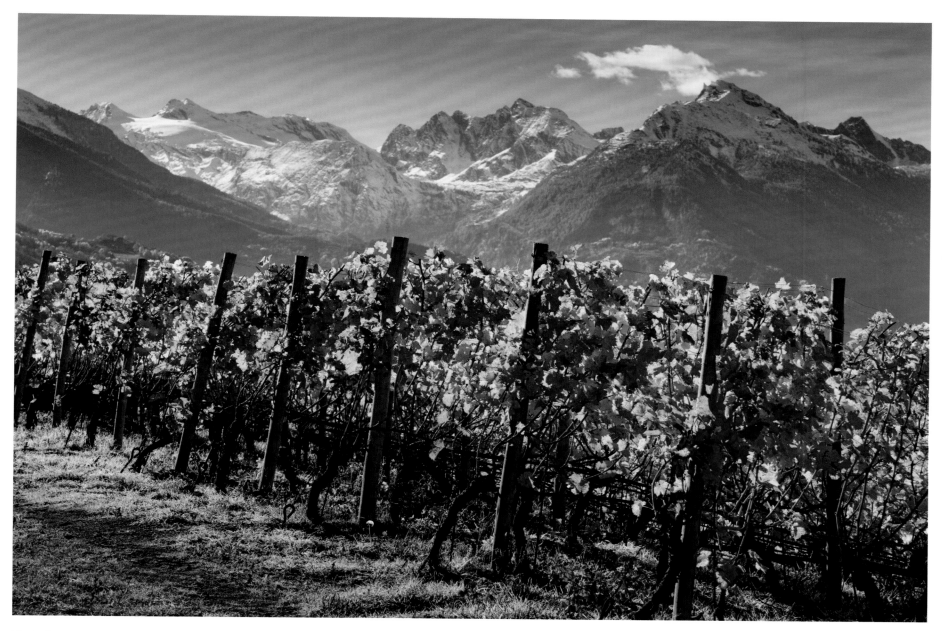

Monte Paramont (3301 m)
Mont Paramont (3301 m · 10830 ft)

Castello di Saint-Pierre

The castle of Saint-Pierre in the Valle d'Aosta, like almost all castles, has a varied architectural history and has been "work in progress" for centuries. Founded around 1190 as a fortress, it was extended and rebuilt several times and adapted to the respective needs and tastes of the time. What has remained is the fortified character; the magnificent furnishings are modern.

Le château de Saint-Pierre

Comme presque tous les châteaux forts, le château de Saint-Pierre, dans le Val d'Aoste, a eu une construction mouvementée et a été un *work in progress* pendant des siècles. Commencé en 1190 pour servir de forteresse, il a été plusieurs fois agrandi et adapté aux besoins et aux goûts de l'époque. Son caractère de fortification lui est resté, mais son cachet et son aspect majestueux sont plus modernes.

Castello di Saint-Pierre

Die Burg von Saint-Pierre im Aostatal hat, wie fast alle Burgen, eine wechselhafte Baugeschichte und war über Jahrhunderte „work in progress". Um 1190 als Festung gegründet, wurde sie mehrfach erweitert und umgebaut und an den jeweiligen Bedarf und Zeitgeschmack angepasst. Geblieben ist der wehrhafte Charakter, neuzeitlich die prächtige Ausstattung.

Castello di Saint-Pierre

El castillo de Saint-Pierre en el Valle de Aosta, como casi todos los castillos, tiene una historia arquitectónica variada y ha sido «work in progress» durante siglos. Fundado alrededor de 1190 como fortaleza, fue ampliado y reconstruido varias veces y adaptado a las necesidades y gustos de la época. Lo que ha quedado es su carácter fortificado y su magnífico equipamiento moderno.

Castello di Saint-Pierre

O castelo de Saint-Pierre no Vale de Aosta, como quase todos os castelos, tem uma história arquitetônica variada e tem sido "obra em andamento" durante séculos. Fundada por volta de 1190 como fortaleza, foi ampliada e reconstruída várias vezes e adaptada às respectivas necessidades e gostos da época. O que restou é o caráter fortificado; o mobiliário magnífico é moderno.

Castello di Saint-Pierre

Evenals veel andere burchten kijkt ook de burcht van Saint-Pierre in het Valle d'Aosta terug op een woelige bouwgeschiedenis. Eeuwenlang was hier in feite sprake van 'work in progress'. Het in 1190 als vesting verrezen bouwwerk werd herhaaldelijk uitgebreid, verbouwd en aangepast aan de behoeften van de betreffende tijd. Het versterkte karakter bleef altijd behouden, de prachtige inrichting is van latere datum.

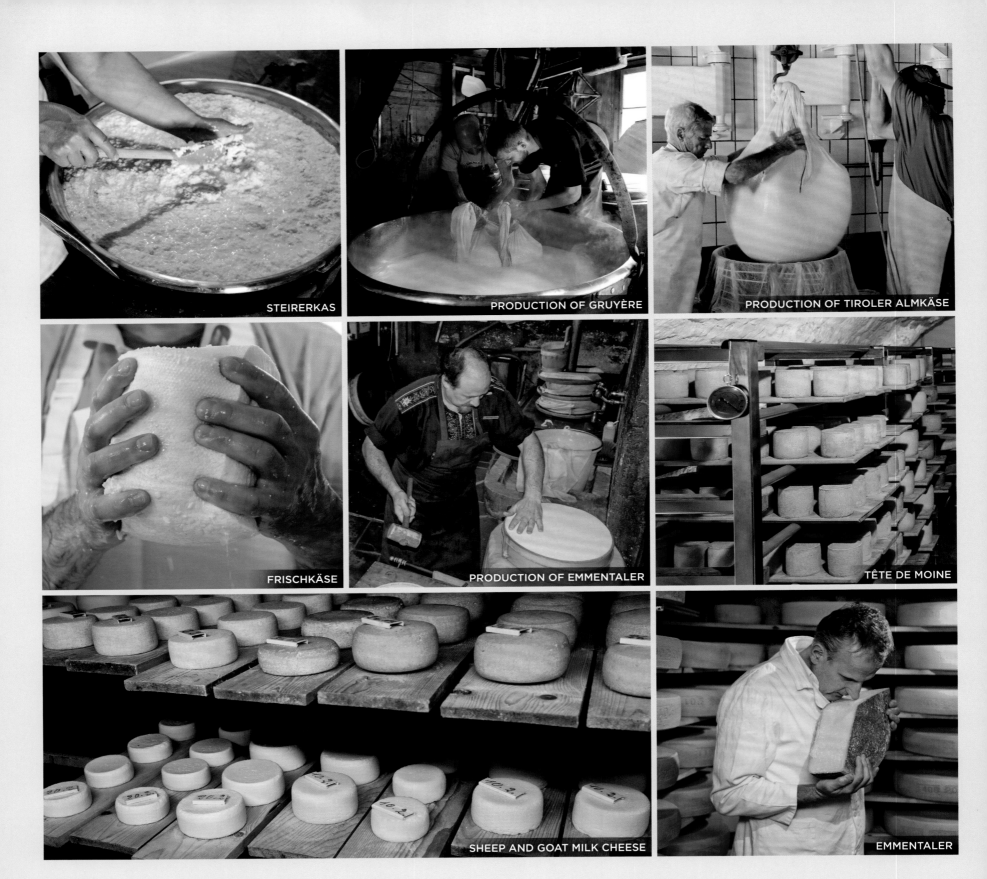

STEIRERKAS

PRODUCTION OF GRUYÈRE

PRODUCTION OF TIROLER ALMKÄSE

FRISCHKÄSE

PRODUCTION OF EMMENTALER

TÊTE DE MOINE

SHEEP AND GOAT MILK CHEESE

EMMENTALER

Cheese

Nearly all parts of the Alps have alpine pasture farming. From spring to autumn the cows are kept on meadows to feed. Juicy grass and herbs provide delectable milk from which an incredible variety of cheese is made. Each region has its own specialities; in Piedmont, for example, each valley has a variety produced exclusively there. Making cheese is usually strenous manual work, the ripening time ranges from a few weeks to several months or even years.

Le fromage

On exploite les pâturages dans presque toute la région des Alpes. Du printemps à l'automne, les vaches vivent au grand air. L'herbe grasse permet d'obtenir un lait parfumé, avec lequel on fabrique une multitude incroyable de fromages. Chaque région a sa spécialité : dans le Piémont par exemple, chaque vallée possède un type de fromage qui lui est propre. La fabrication du fromage est généralement artisanale et la durée d'affinage peut aller de quelques semaines à plusieurs mois, voire plusieurs années.

Käse

Fast überall im Alpenraum gibt es Almwirtschaft. Vom Frühjahr bis zum Herbst leben die Kühe im Freien. Saftiges Gras und Kräuter sorgen für würzige Milch, aus der eine unglaubliche Vielfalt von Käse hergestellt wird. Jede Region hat ihre Spezialitäten, im Piemont etwa gibt es in jedem Tal eine nur dort produzierte Sorte. Die Käserei ist meist aufwendige Handarbeit, die Reifezeit reicht von einigen Wochen bis zu mehreren Monaten oder gar Jahren.

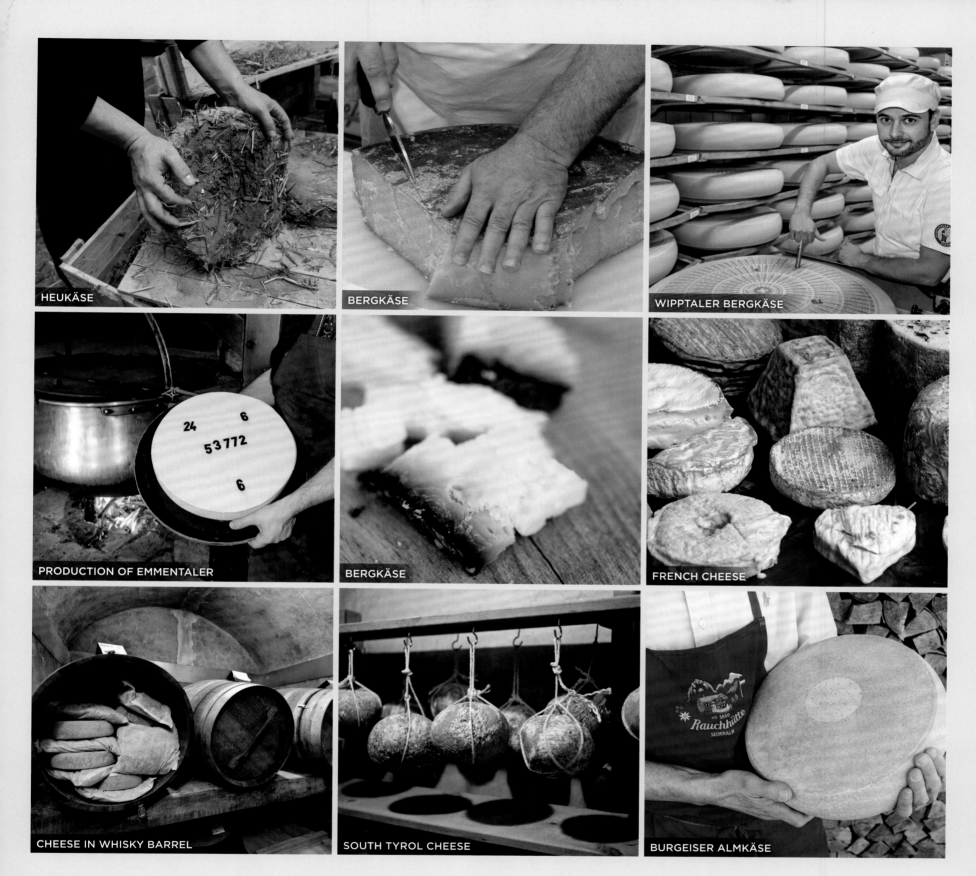

HEUKÄSE

BERGKÄSE

WIPPTALER BERGKÄSE

PRODUCTION OF EMMENTALER

BERGKÄSE

FRENCH CHEESE

CHEESE IN WHISKY BARREL

SOUTH TYROL CHEESE

BURGEISER ALMKÄSE

Queso

En casi todas partes de la región alpina hay agricultura alpina. Desde la primavera hasta el otoño las vacas viven en el exterior. La hierba jugosa y las hierbas proporcionan leche picante con la que se elabora una increíble variedad de quesos. Cada región tiene sus propias especialidades; en Piamonte, por ejemplo, cada valle tiene una variedad producida exclusivamente allí. La quesería suele ser un trabajo manual elaborado, el tiempo de maduración oscila entre unas pocas semanas y varios meses o incluso años.

Queijo

Quase em toda a região alpina existe uma agricultura de pastagem alpina. Da Primavera ao Outono, as vacas vivem no exterior. A erva suculenta e as ervas aromáticas fornecem leite picante do qual é feita uma variedade incrível de queijo. Cada região tem as suas próprias especialidades; no Piemonte, por exemplo, cada vale tem uma variedade produzida exclusivamente lá. A queijaria é geralmente elaborado trabalho manual, o tempo de maturação varia de algumas semanas a vários meses ou mesmo anos.

Kaas

Bijna overal in het Alpengebied wordt veeteelt bedreven. Van het voorjaar tot de herfst leven de koeien buiten en grazen sappig gras en kruiden. Van de kruidige melk die ze geven, worden ongelooflijk veel verschillende kaassoorten gemaakt. Elke regio heeft zijn eigen specialiteiten; in Piëmont bijvoorbeeld heeft elk dal een eigen soort die alleen daar wordt geproduceerd. In den Alpen is kaasmaken een arbeidsintensief gebeuren; de rijpingstijd van de kazen loopt varieert van enkele weken tot enkele maanden of zelfs jaren.

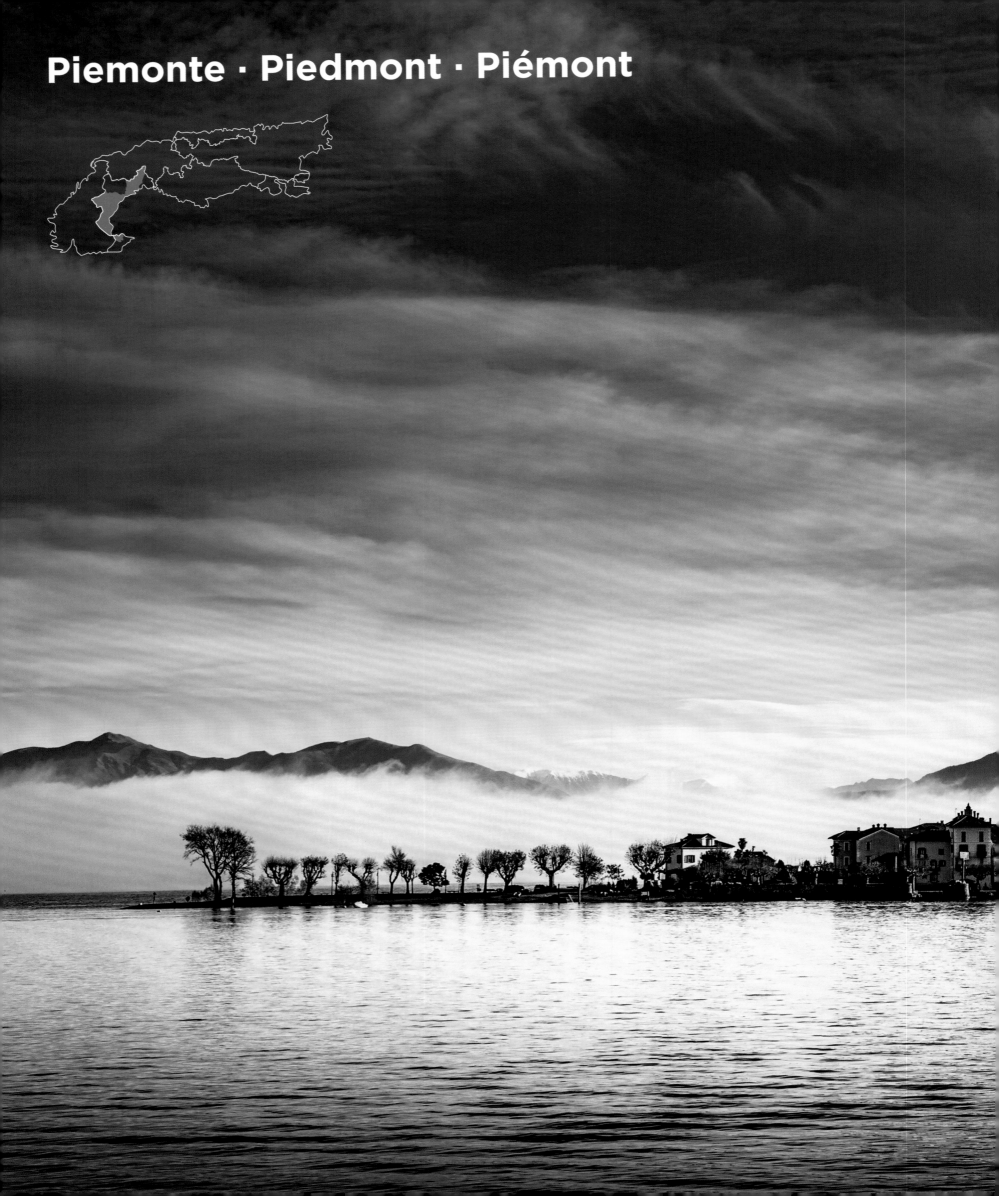

Piemonte · Piedmont · Piémont

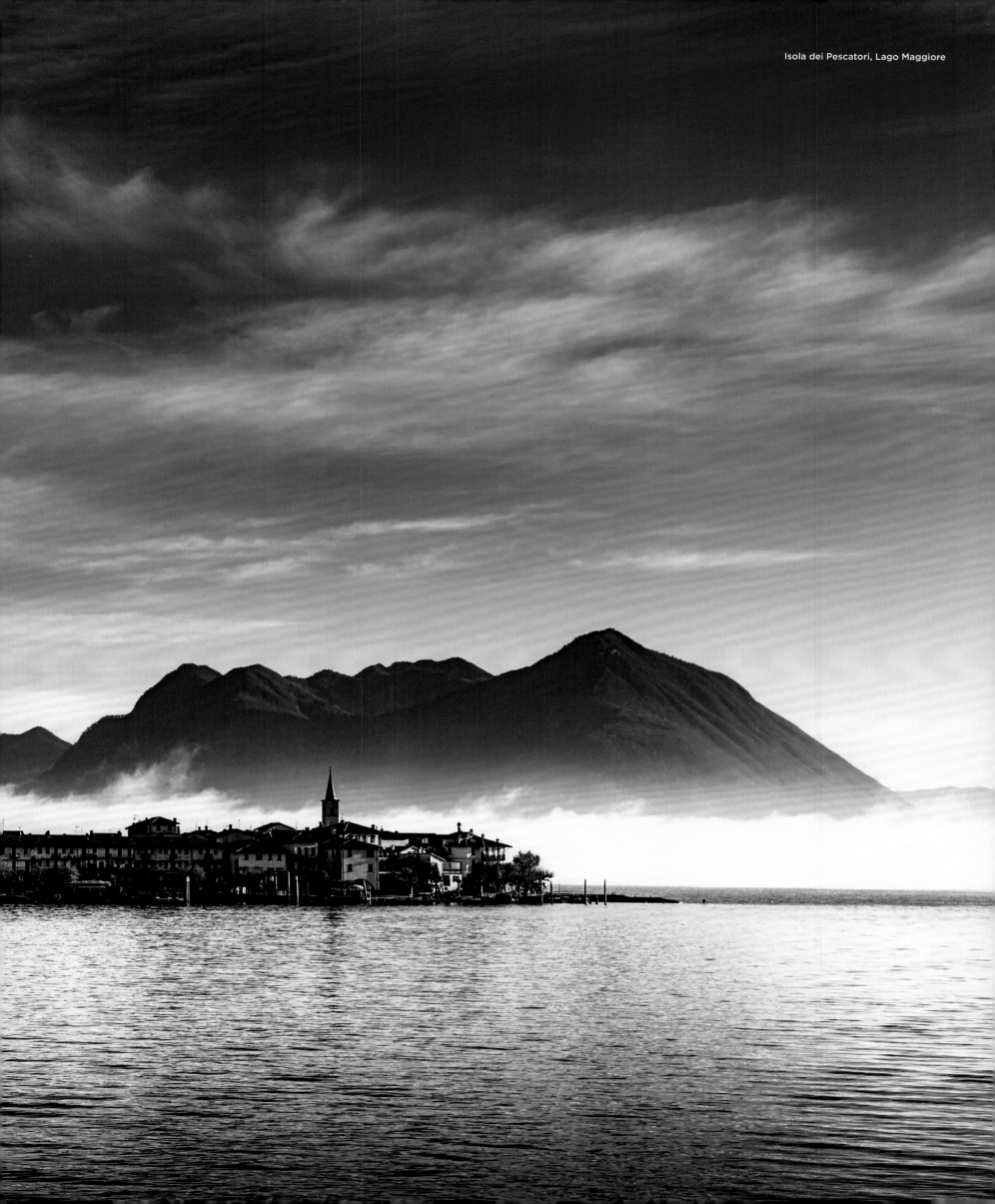

Isola dei Pescatori, Lago Maggiore

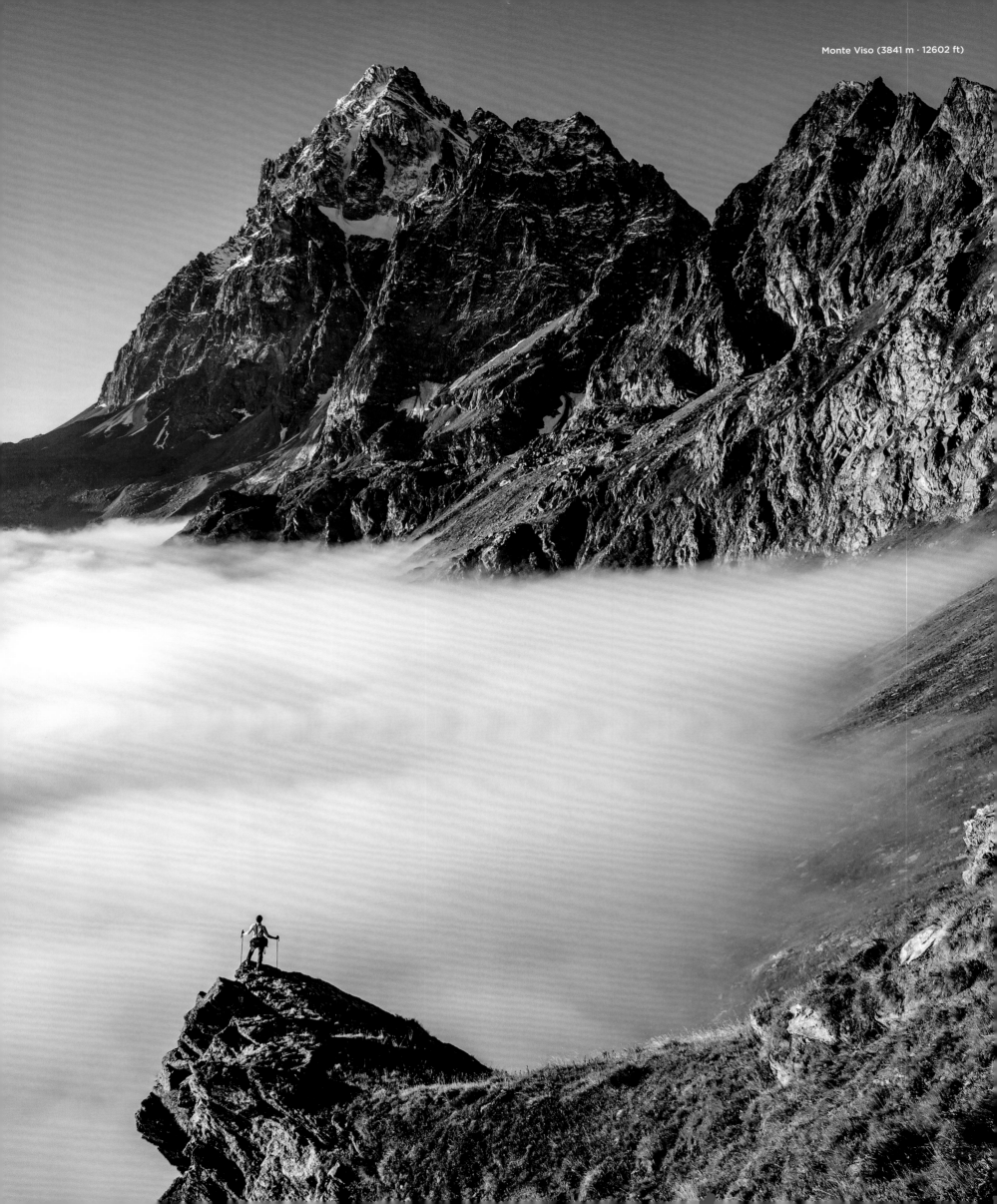

Monte Viso (3841 m · 12602 ft)

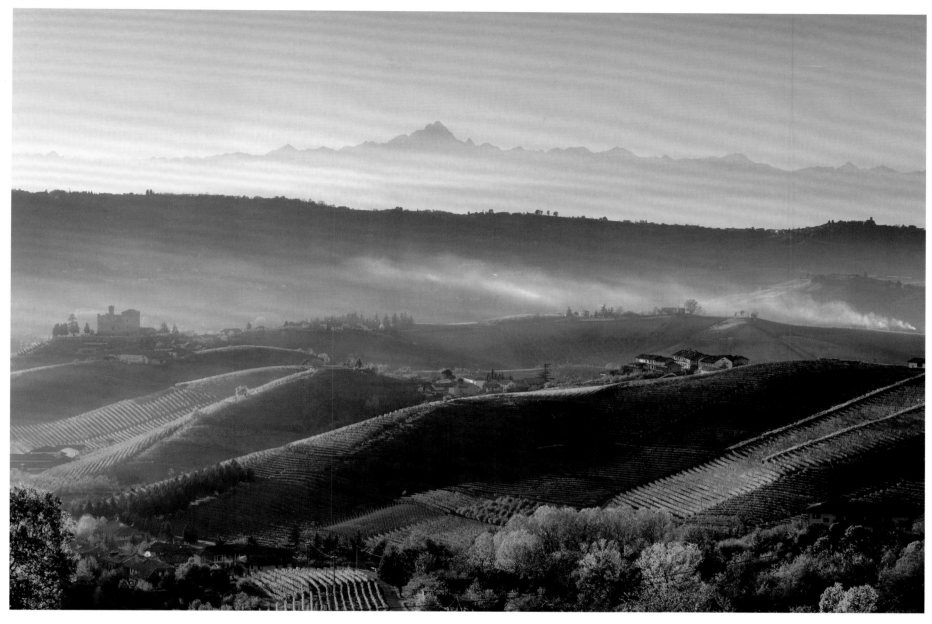

Castello di Grinzane Cavour, Monte Viso (3841 m · 12602 ft), Langhe

Piedmont

For travellers from the north, Piedmont is often only a transit station on the way to the sea. The region has more to offer than nearly any other in Italy—culturally and as a region to indulge oneself. The much praised Italian cuisine comes to its perfection here: cheese, white truffles, sweets. And Piedmont produces some of the best wines in the world.

Le Piémont

Pour les voyageurs venant du nord, le Piémont n'est souvent qu'une étape sur le chemin de la mer. Pourtant, c'est l'une des régions italiennes qui a le plus à offrir, tant sur le plan culturel que gastronomique. La célèbre cuisine italienne atteint ici la perfection, avec ses fromages, ses truffes blanches et ses confiseries. Et on trouve aussi dans le Piémont des vins qui sont parmi les meilleurs du monde.

Piemont

Für Reisende aus dem Norden ist das Piemont oft nur Durchgangsstation auf dem Weg zum Meer. Dabei hat die Region so viel zu bieten wie kaum eine andere in Italien – kulturell und als Genussregion. Die viel gerühmte italienische Küche erlebt hier ihre Vollendung: Käse, weiße Trüffel, Dolci. Und im Piemont wachsen einige der besten Weine der Welt.

Piamonte

Para los viajeros del norte, Piamonte es a menudo solo una estación de tránsito en el camino hacia el mar. La región tiene tanto que ofrecer como ninguna otra en Italia (tanto culturalmente, como como región de placer). La tan elogiada cocina italiana alcanza aquí su perfección: queso, trufas blancas, dulces. Además, en Piamonte se producen algunos de los mejores vinos del mundo.

Piemonte

Para os viajantes do norte, o Piemonte é muitas vezes apenas uma estação de trânsito a caminho do mar. A região tem tanto a oferecer como quase nenhuma outra na Itália – culturalmente e como uma região de prazer. A muito elogiada cozinha italiana experimenta aqui a sua perfeição: queijo, trufas brancas, dolci. E Piedmont produz alguns dos melhores vinhos do mundo.

Piëmont

Voor veel reizigers vanuit het noorden ligt Piëmont slechts op de weg naar de zee. En dat terwijl de streek meer te bieden heeft dan de meeste andere regio's in Italië – zowel cultureel als culinair. De veelgeprezen Italiaanse keuken bereikt hier een vorm van volmaaktheid: kaas, witte truffels, zoete gerechten. Bovendien komen uit Piëmont enkele van de beste wijnen van de wereld.

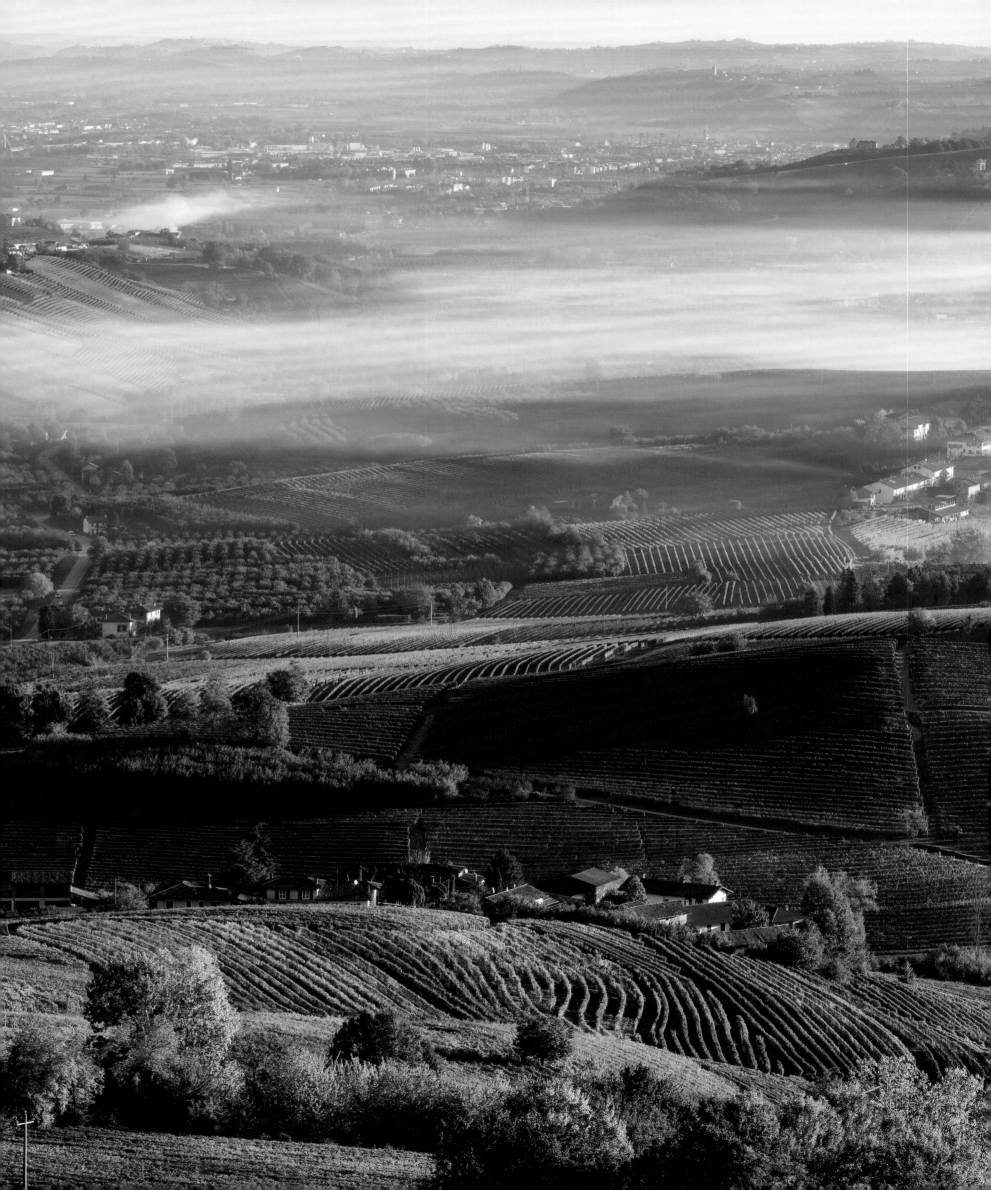

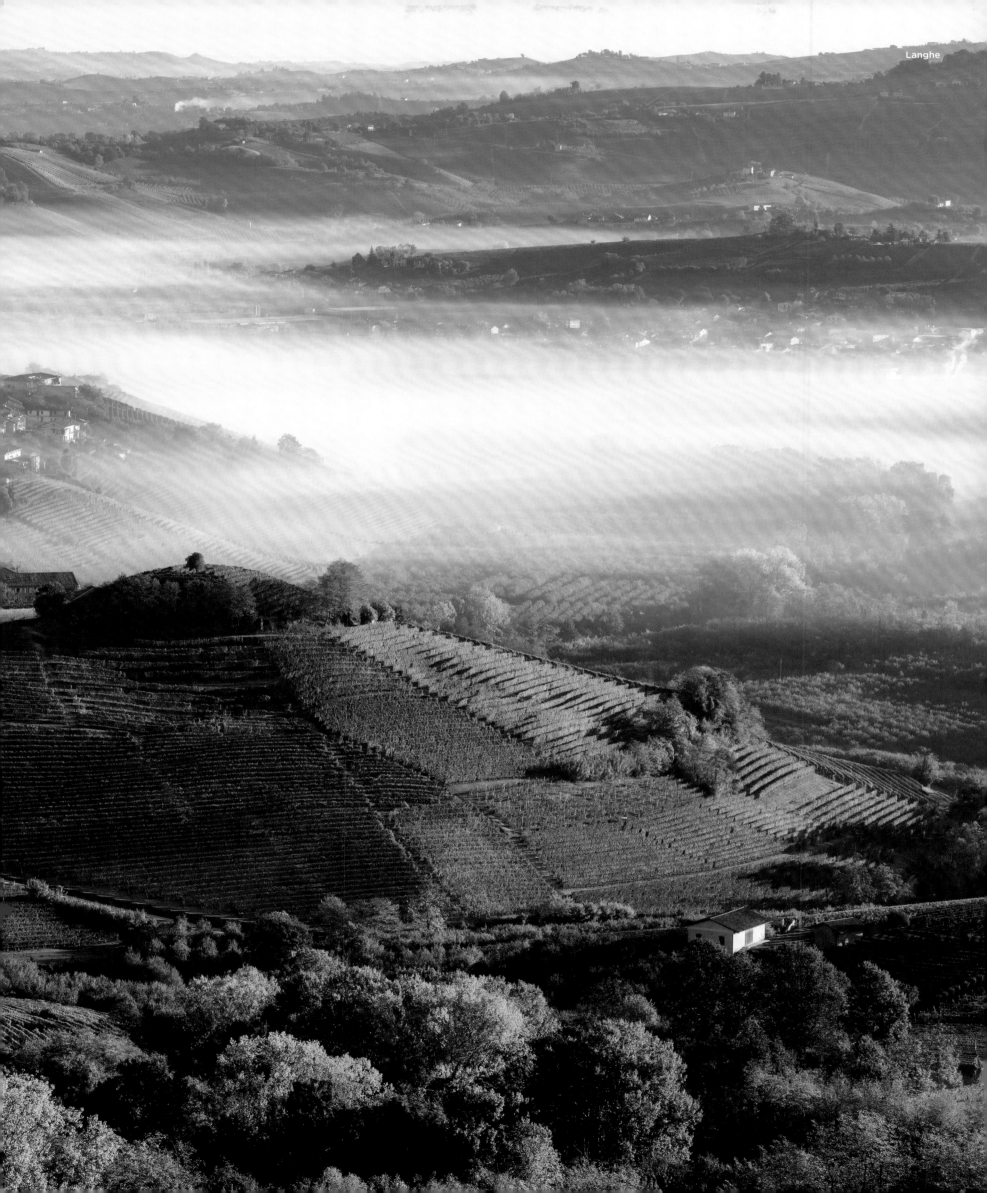

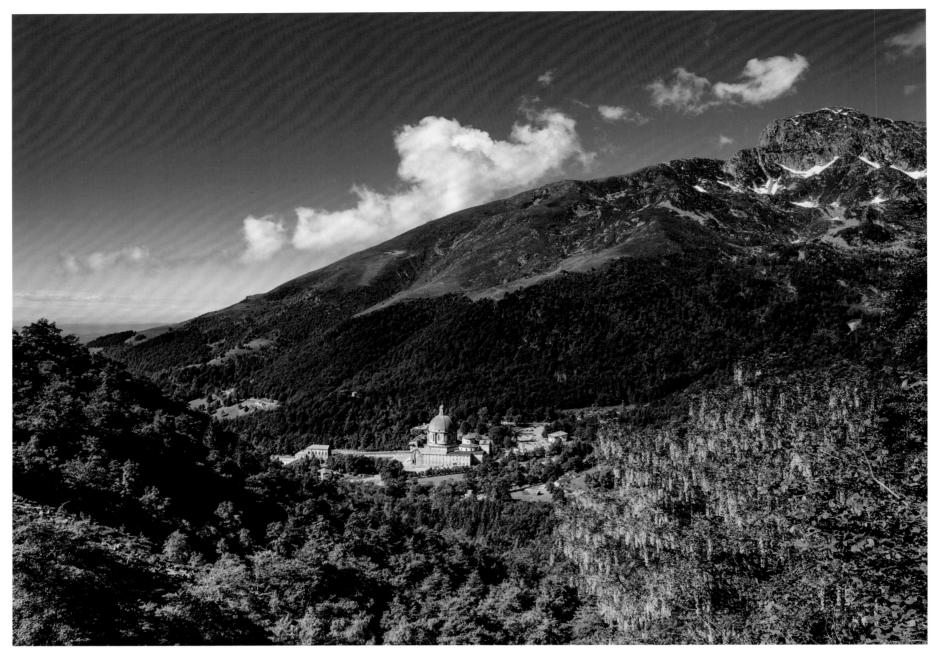

Santuario Sacro Monte di Oropa

Sanctuary Sacro Monte di Oropa

The Sacro Monte di Oropa near Biella is a famous pilgrimage site. 19 chapels, whose construction began in the 17th century and lasted more than 100 years, a pilgrimage church and several pilgrims' hostels and outbuildings form a large complex. Because Oropa quickly gained importance as a centre of Marian devotion in Catholic Italy, a mighty new church with a massive dome was added in the 19th century, dominating the overall picture. The statue of the Black Madonna, venerated here, dates from the 14th century. Every year there is a big procession from Biella to Oropa.

Le sanctuaire du Mont Sacré d'Oropa

Le Mont Sacré d'Oropa, à Biella, est un lieu de pèlerinage célèbre. C'est un grand complexe composé de 19 chapelles – dont la construction a débuté au XVIIᵉ siècle et a duré plus d'un siècle –, d'une église de pèlerinage, ou encore de logements pour les pèlerins et de divers bâtiments annexes. Comme Oropa est vite devenu un lieu incontournable du culte de la Vierge dans l'Italie catholique, une nouvelle église somptueuse dotée d'une coupole impressionnante a été bâtie au XIXᵉ siècle et domine l'ensemble. La statue qui honore la Vierge Noire date du XIVᵉ siècle. Chaque année, une grande procession relie Biella à Oropa.

Santuario Sacro Monte di Oropa

Der Sacro Monte di Oropa bei Biella ist ein bekannter Wallfahrtsort. 19 Kapellen, deren Bau im 17. Jahrhundert begonnen wurde und sich über mehr als 100 Jahre hinzog, eine Wallfahrtskirche sowie mehrere Pilgerherbergen und Nebengebäude bilden einen großen Komplex. Weil Oropa schnell Bedeutung als ein Zentrum der Marienverehrung im katholischen Italien erlangte, wurde im 19. Jahrhundert eine mächtige neue Kirche mit gewaltiger Kuppel hinzugefügt, die das Gesamtbild dominiert. Aus dem 14. Jahrhundert stammt die Statue der hier verehrten Schwarzen Madonna. Jährlich gibt es eine große Prozession von Biella nach Oropa.

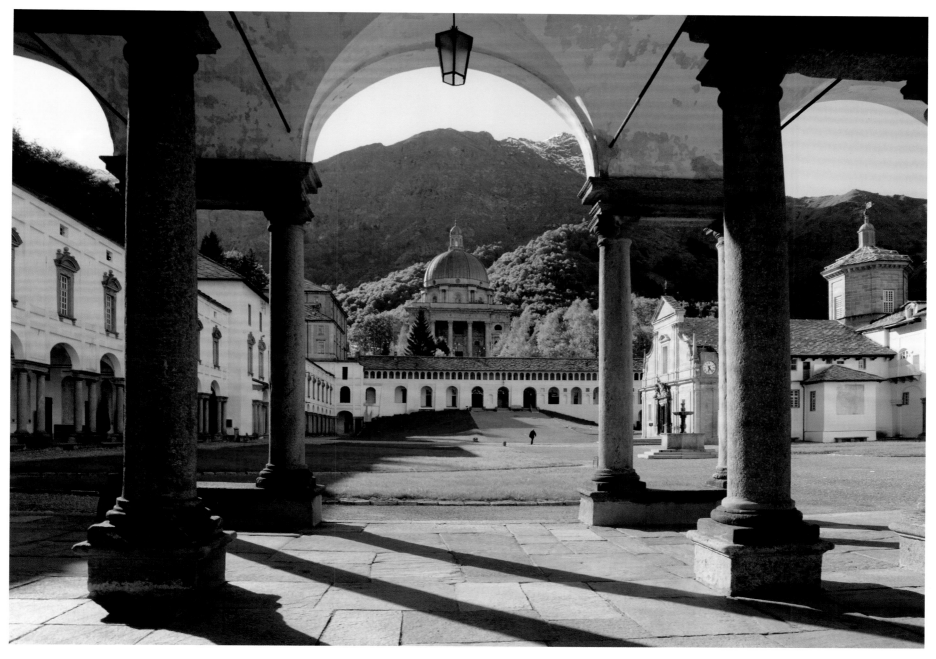

Santuario Sacro Monte di Oropa

Santuario Sacro Monte di Oropa

El Sacro Monte di Oropa, cerca de Biella, es un famoso lugar de peregrinación. 19 capillas, cuya construcción comenzó en el siglo XVII y duró más de 100 años, una iglesia de peregrinación y varios albergues de peregrinos y dependencias forman un gran complejo. Debido a que Oropa adquirió rápidamente importancia como centro de advocación mariana en la Italia católica, en el siglo XIX se añadió una nueva y poderosa iglesia con una cúpula masiva, dominando el panorama general. La estatua de la Virgen Negra aquí venerada data del siglo XIV. Cada año hay una gran procesión de Biella a Oropa.

Santuário Sacro Monte di Oropa

O Sacro Monte di Oropa perto de Biella é um famoso lugar de peregrinação. 19 capelas, cuja construção começou no século XVII e durou mais de 100 anos, uma igreja de peregrinação e vários albergues e anexos de peregrinos formam um grande complexo. Porque Oropa rapidamente ganhou importância como um centro de devoção mariana na Itália católica, uma nova e poderosa igreja com uma cúpula maciça foi adicionada no século 19, dominando o quadro geral. A estátua da Madona Negra, aqui venerada, data do século XIV. Todos os anos há uma grande procissão de Biella a Oropa.

Abdij Sacro Monte di Oropa

De abdij Sacro Monte di Oropa bij Biella is een beroemd bedevaartoord. Het grote complex bestaat uit 19 kapellen, waarvan de bouw in de 17e eeuw begon en meer dan 100 jaar duurde, een bedevaartkerk, enkele pelgrimsherbergen en bijgebouwen. Vanwege het groeiende belang van Oropa als centrum van Mariaverering in het katholieke Italië, werd de abdij in de 19e eeuw uitgebreid met een grote kerk met een enorme koepel, die sindsdien alles overheerst. Het beeld van de zwarte madonna, dat hier wordt vereerd, dateert uit de 14e eeuw. Elk jaar vindt er een grote processie plaats van Biella naar Oropa.

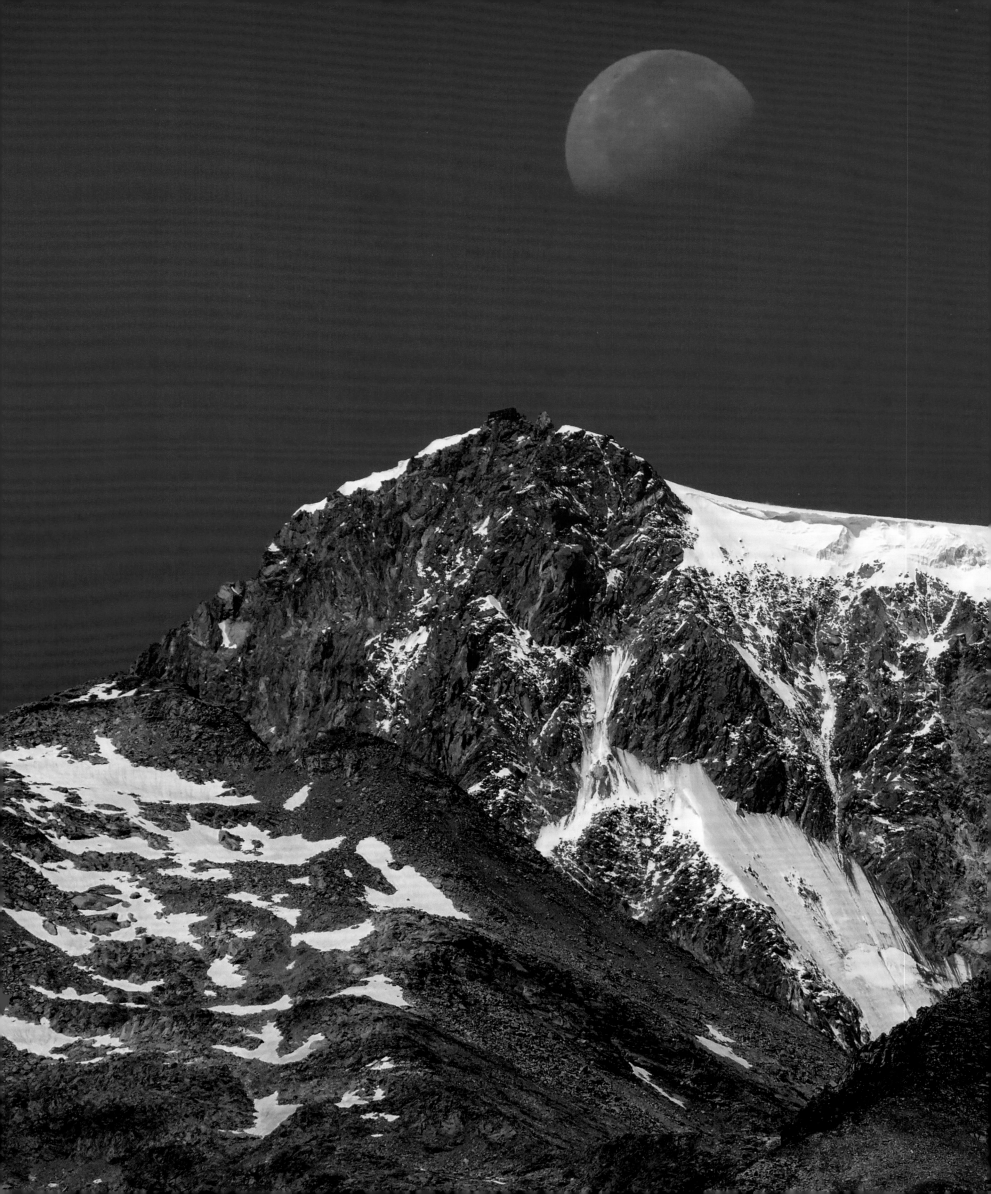

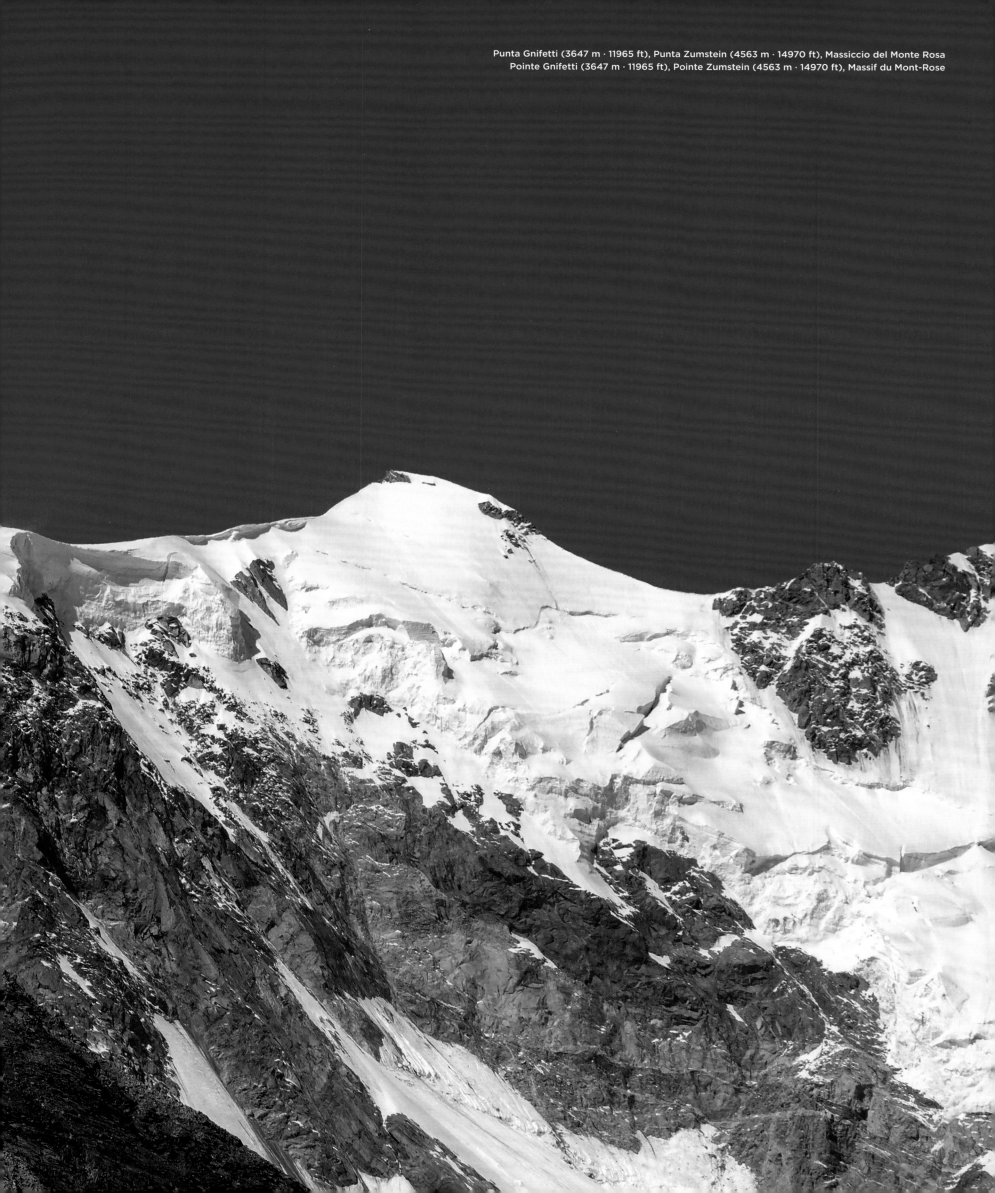

Punta Gnifetti (3647 m · 11965 ft), Punta Zumstein (4563 m · 14970 ft), Massiccio del Monte Rosa
Pointe Gnifetti (3647 m · 11965 ft), Pointe Zumstein (4563 m · 14970 ft), Massif du Mont-Rose

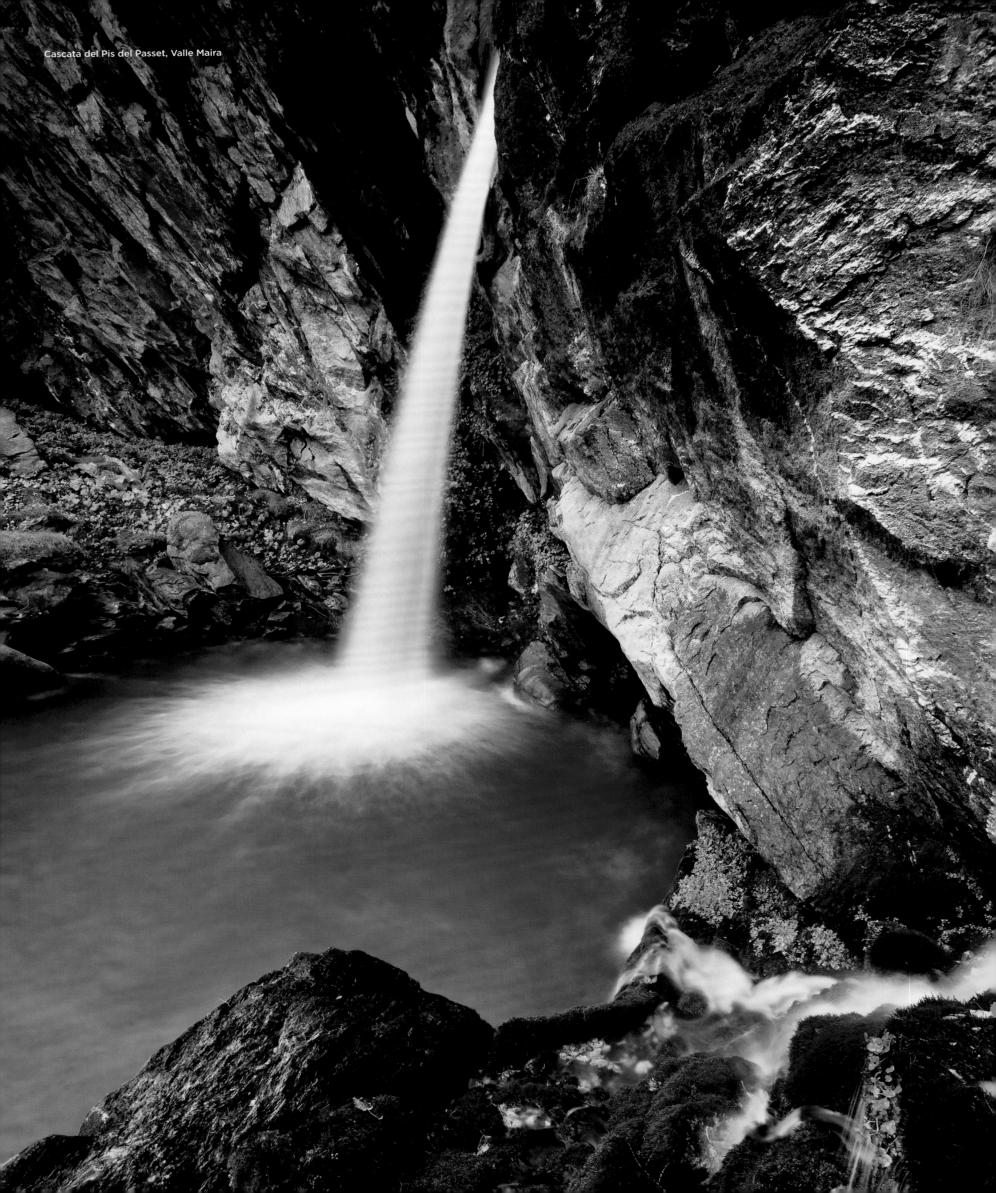

Cascata del Pis del Passet, Valle Maira

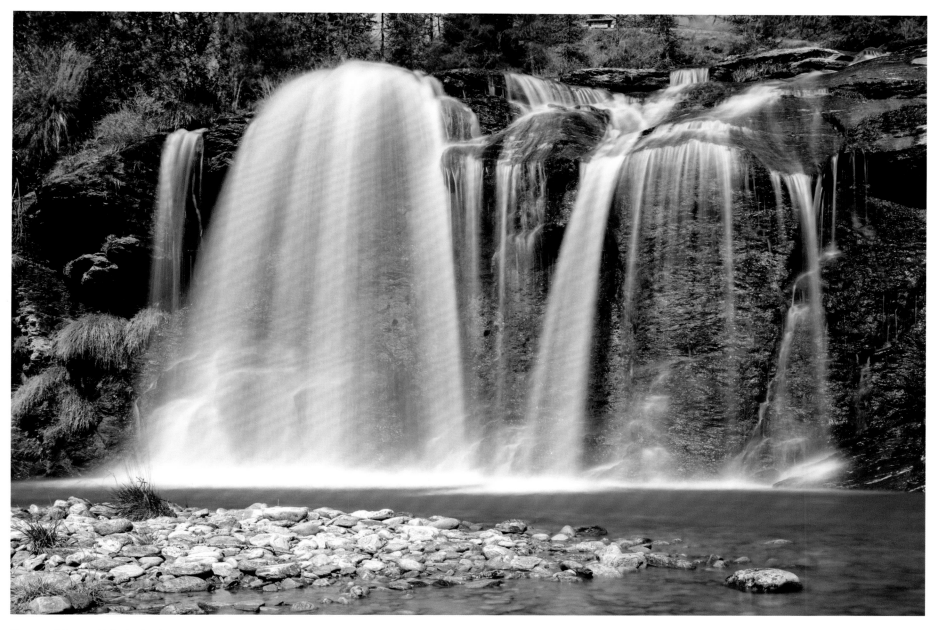

Cascate di Devero, Valle Antigorio

Valle Maira

Many valleys in the Piedmontese Alps, such as the Valle Maira, are popular hiking areas and delight visitors with natural beauties such as waterfalls and fantastic mountain panoramas. In former times these valleys were very poor and suffered from rural depopulation. Only in recent years have people migrated back again. The main source of income is tourism.

Le val Maira

Le val Maira, comme de nombreuses vallées des Alpes piémontaises, est un lieu idéal pour les randonnées et permet d'admirer des merveilles de la nature, notamment des chutes d'eau et une vue de rêve sur les montagnes. Autrefois, ces vallées étaient très pauvres et subissaient un fort exode rural. Cela ne fait que quelques années que les gens commencent à revenir s'y installer, le tourisme étant ici la principale ressource.

Valle Maira

Viele Täler in den piemontesischen Alpen wie das Valle Maira sind beliebte Wandergebiete und begeistern mit Naturschönheiten wie Wasserfällen und einem traumhaften Bergpanorama. Früher waren diese Täler sehr arm und litten unter der Landflucht der Bevölkerung. Erst seit wenigen Jahren wandern wieder Menschen zu, die Haupteinnahmequelle ist der Tourismus.

Valle Maira

Muchos de los valles de los Alpes piamonteses, como el Valle Maira, son zonas de senderismo populares y deleitan con bellezas naturales como cascadas y un fantástico panorama montañoso. Antiguamente estos valles eran muy pobres y sufrían el éxodo rural de la población. Solo desde hace unos años la gente está migrando aquí de nuevo. La principal fuente de ingresos del valle es el turismo.

Cascata del Pis del Passet, Valle Maira

Muitos vales nos Alpes Piemonteses, como o Valle Maira, são áreas populares para caminhadas e deleite-se com belezas naturais como cachoeiras e um fantástico panorama montanhoso. Antigamente estes vales eram muito pobres e sofriam com o êxodo rural da população. Apenas há alguns anos que as pessoas voltam a migrar, a principal fonte de rendimento é o turismo.

Cascata del Pis del Passet, Valle Maira

Veel valleien in de Piëmontese Alpen, zoals het Valle Maira, zijn populair bij wandelaars, die hier komen genieten van de fraaie natuur, watervallen en een fantastisch bergpanorama. Vroeger waren de mensen in deze valleien zeer arm en zochten velen hun toevlucht in de stad. Pas sinds een paar jaar groeit de bevolking in de valleien weer. De belangrijkste bron van inkomsten is het toerisme.

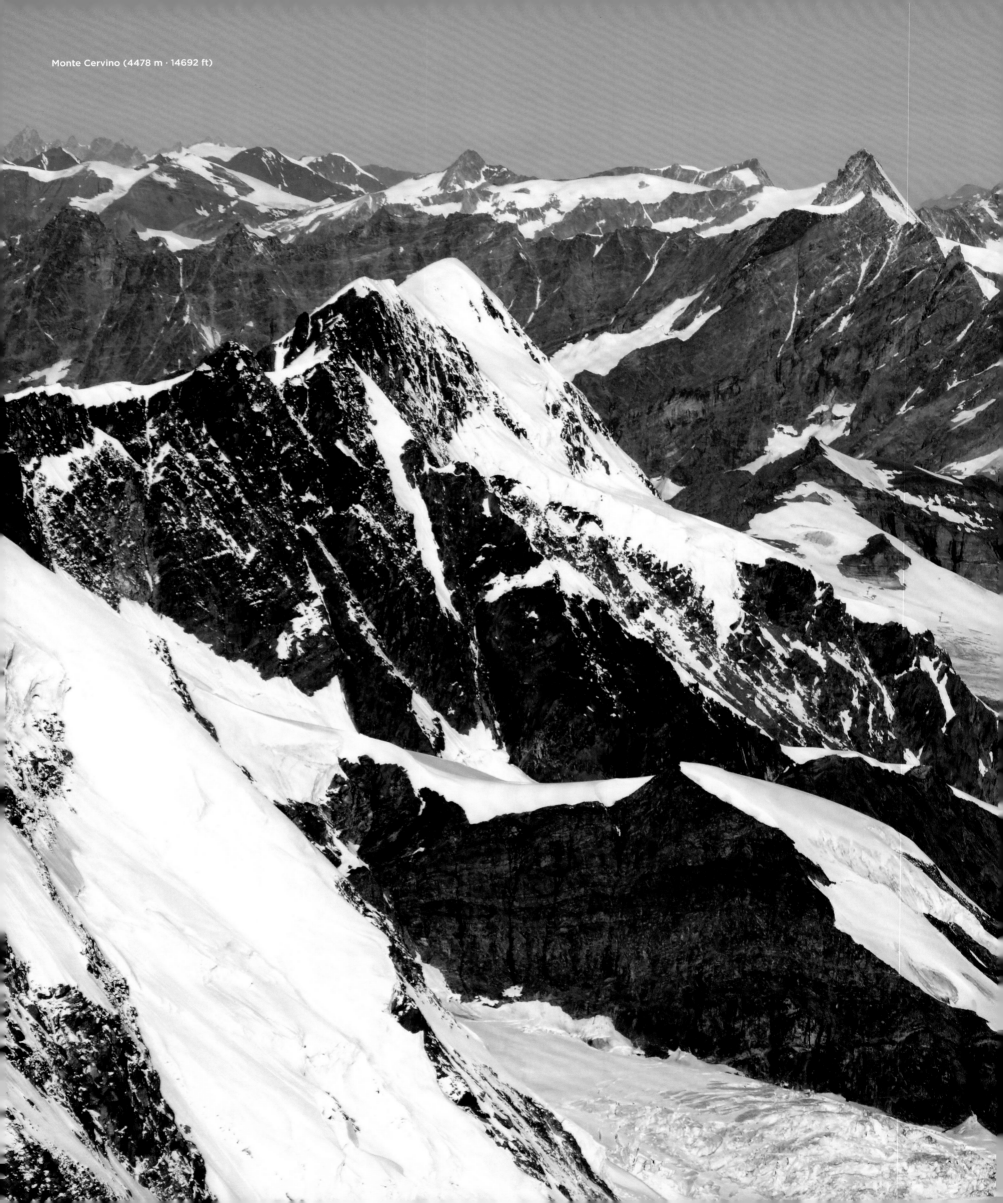

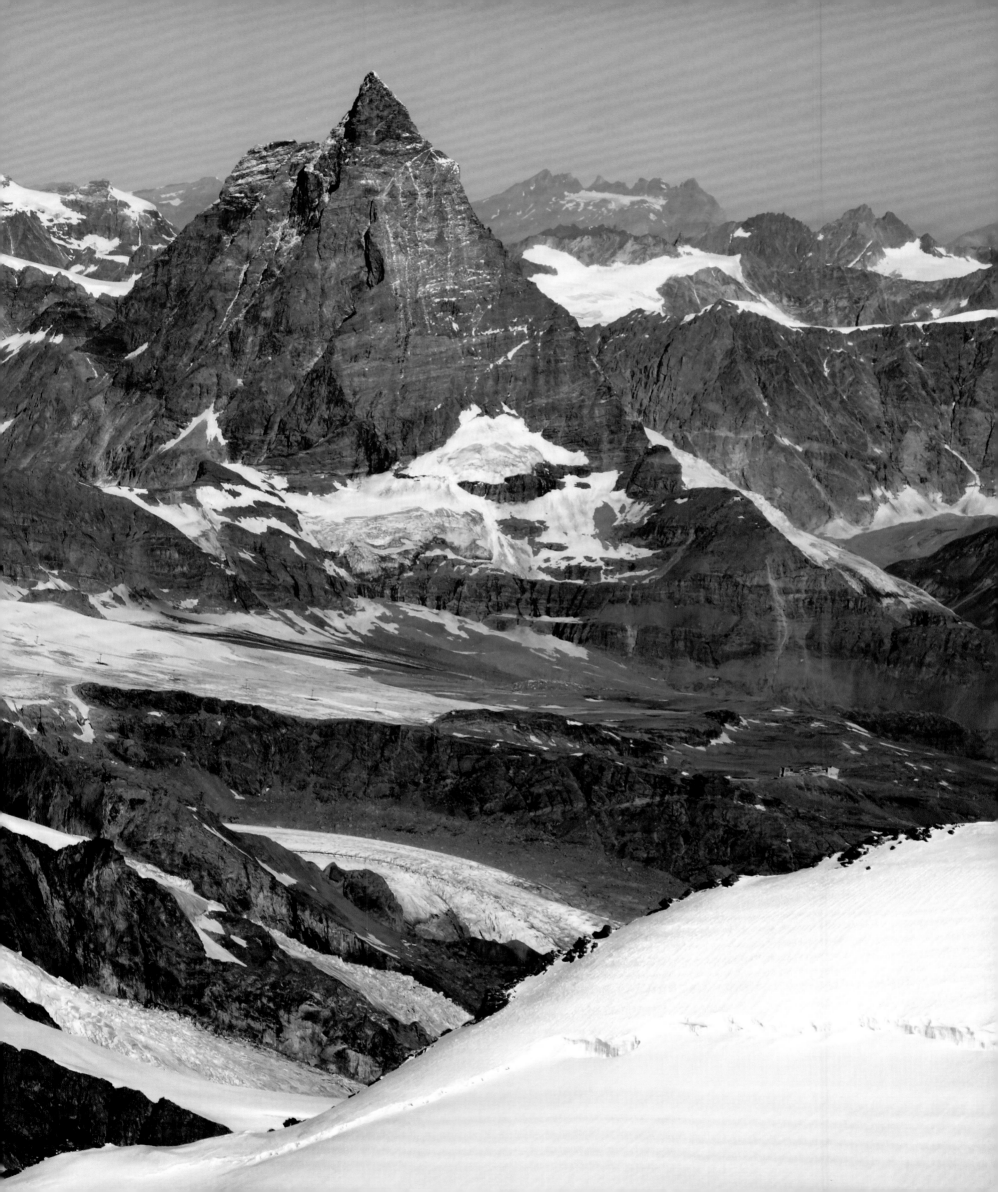

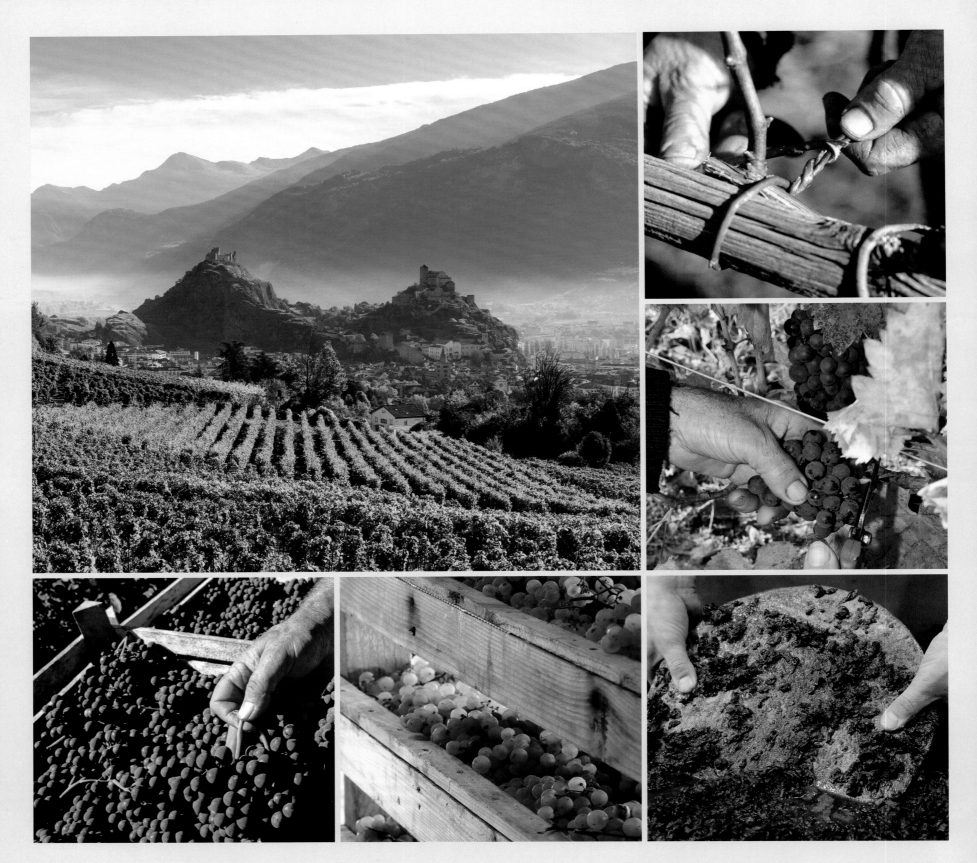

Wine

Many regions in the Alpine country offer excellent climatic conditions for viticulture, which has played an important role here since Roman times. Great wines are grown mainly in southern areas with lots of sunshine: from Provence through Piedmont and Liguria to South Tyrol and Slovenia. But the Swiss Jura and Styria are also known for the top wines which their winegrowers often laboriously raise on steep slopes.

Le vin

Beaucoup de contrées des Alpes jouissent de conditions climatiques parfaites pour les vignes, qui depuis l'Antiquité jouent un rôle essentiel. Les parties les plus méridionales bénéficient d'un ensoleillement idéal pour produire de grands vins : c'est le cas en Provence, dans le Piémont, en Ligurie, mais aussi dans le Tyrol du Sud et en Slovénie. Mais dans le Jura suisse et en Styrie, les vignerons produisent également des vins fins, souvent au prix d'un travail de longue haleine sur des coteaux escarpés.

Wein

Viele Regionen im Alpenland bieten beste klimatische Voraussetzungen für den Weinanbau, der schon seit Römerzeiten eine wichtige Rolle spielt. Vor allem in südlichen Lagen mit viel Sonnenschein wachsen große Weine: von der Provence über das Piemont und Ligurien bis nach Südtirol und Slowenien; aber auch im Schweizer Jura oder in der Steiermark produzieren Winzer in oft mühseliger Arbeit an steilen Hängen Spitzenweine.

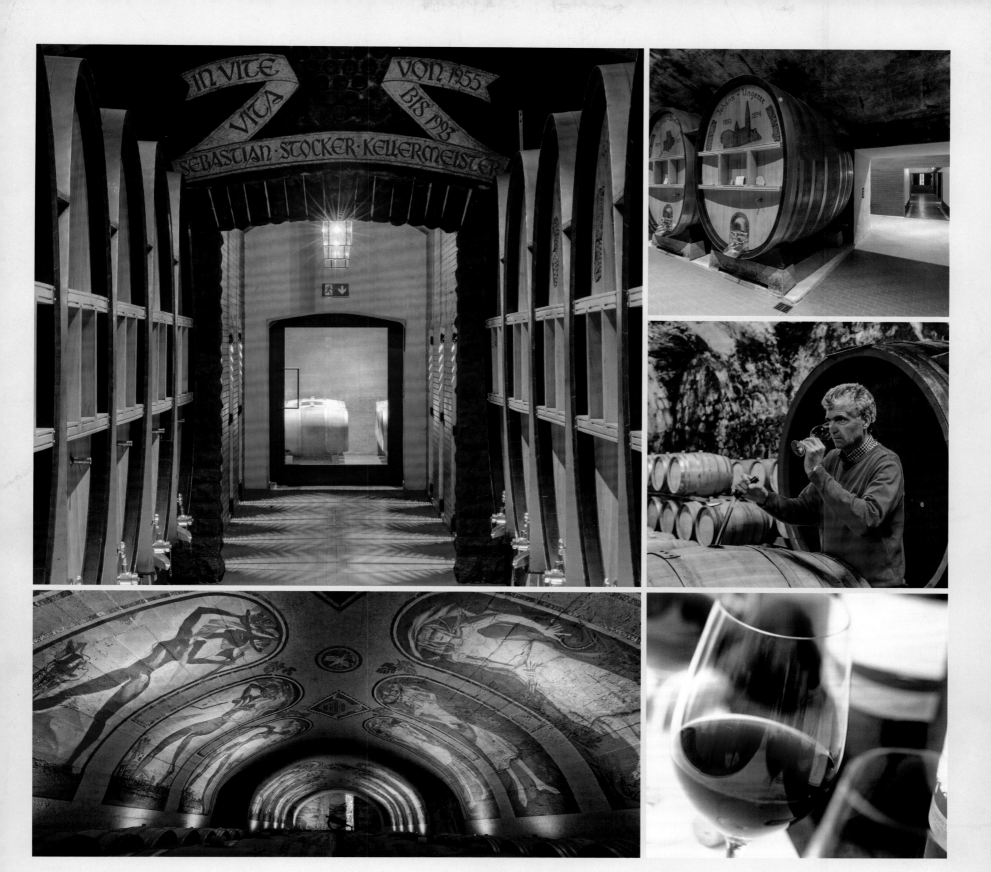

Vino

Muchas regiones del país alpino ofrecen las mejores condiciones climáticas para la viticultura, que ha desempeñado un papel importante desde la época de los romanos. Los grandes vinos crecen sobre todo en lugares del sur con mucho sol: desde Provenza, pasando por Piamonte y Liguria, hasta el Tirol del Sur y Eslovenia; pero también en el Jura suizo o Estiria, los viticultores a menudo producen laboriosamente los mejores vinos en laderas empinadas.

Vinho

Muitas regiões do país alpino oferecem as melhores condições climáticas para o cultivo do vinho, que tem desempenhado um papel importante desde a época romana. Os grandes vinhos crescem acima de tudo em locais do sul com muito sol: da Provença via Piemonte e Ligúria ao Tirol do Sul e Eslovénia; mas também no Jura suíço ou na Estíria, os viticultores muitas vezes produzem laboriosamente vinhos de topo em encostas íngremes.

Wijn

Veel streken in het Alpengebied hebben een uitstekend klimaat voor wijnbouw, die hier al sinds de Romeinen een belangrijke rol speelt. De beste druiven groeien in beschutte, zonovergoten, op het zuiden gelegen wijngaarden in streken zoals de Provence, Piëmont, Ligurië, Zuid-Tirol, Slovenië, maar ook in de Zwitserse Jura en in Stiermarken. Hier produceren wijnbouwers topwijnen van druiven die niet zelden op steile hellingen worden verbouwd.

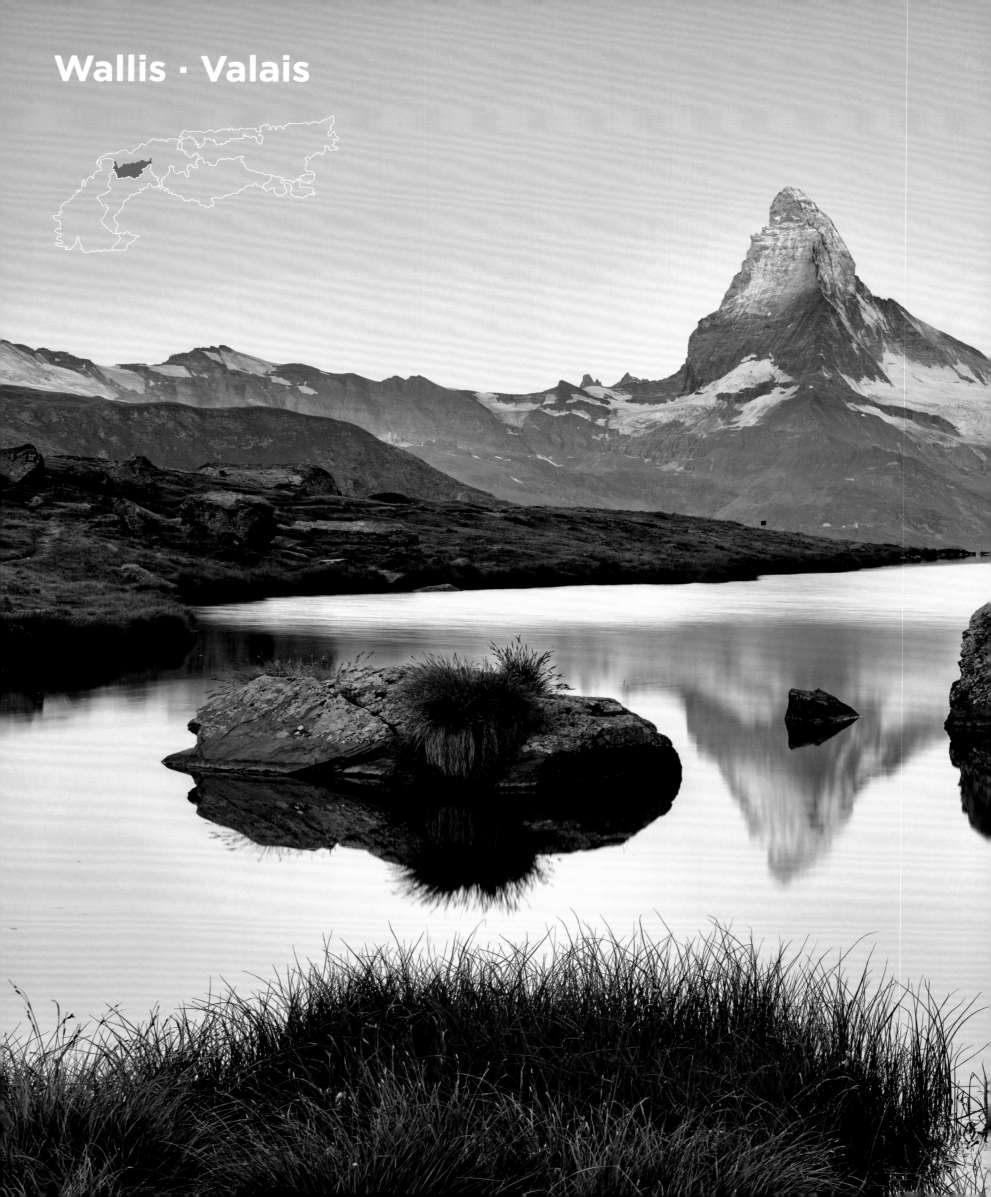

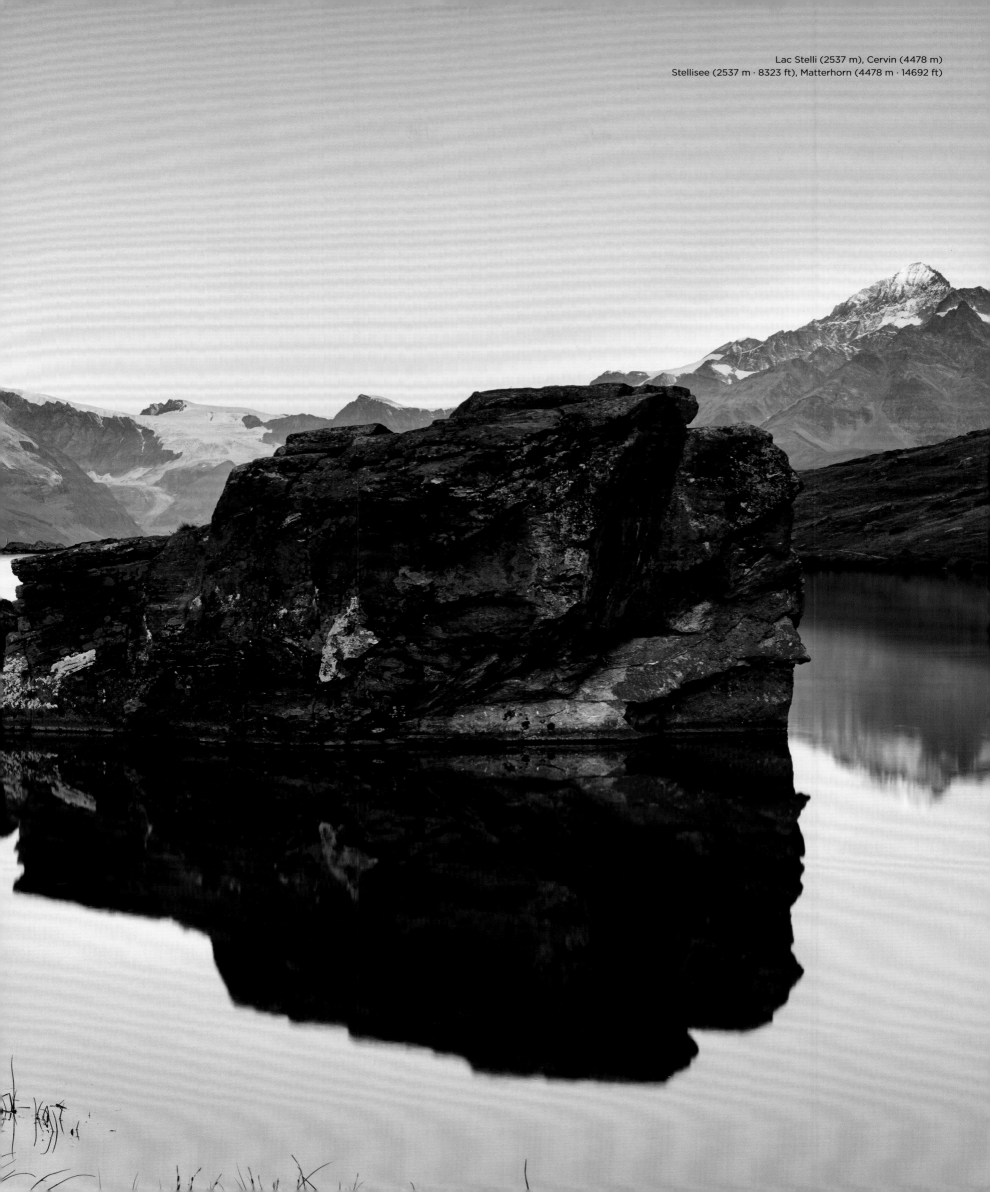

Lac Stelli (2537 m), Cervin (4478 m)
Stellisee (2537 m · 8323 ft), Matterhorn (4478 m · 14692 ft)

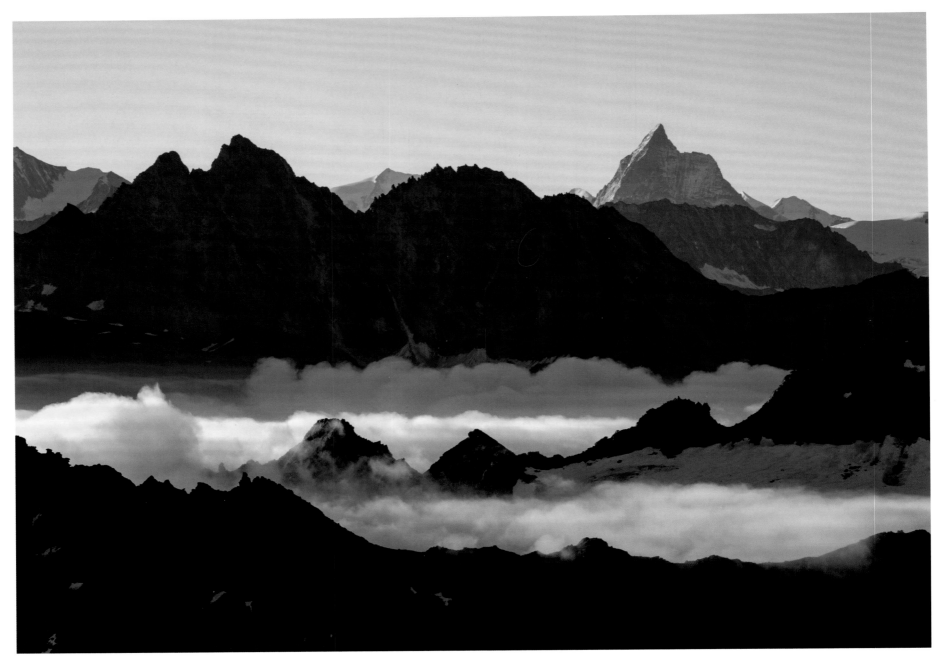

Vue de Mont Fort (3329 m), Verbier
View from Mont-Fort (3329 m · 10922 ft), Verbier

Valais

From the Rhône glacier in the northeast, the Rhône flows through the Valais to the southwest before it bends to the north and flows into Lake Geneva. High mountains rise on both sides of the Rhône valley, the southern range of the Alps has a number of four-thousand-metre peaks to offer, including the Monte Rosa massif and the Matterhorn, one of the most famous mountains in the world. Despite its natural beauty, Valais is losing many young people who see better prospects for themselves in the cities, for example those on the shores of Lake Geneva. In addition to tourism, agriculture is also important: Wine and fruit are the main crops of the Valais.

Le Valais

Le Rhône traverse le Valais, allant du glacier du Rhône, au nord-est, vers le sud-ouest, avant d'obliquer vers le nord et de se jeter dans le lac Léman. De part et d'autre de la vallée du Rhône se dressent de hautes montagnes : la crête sud des Alpes a beaucoup de sommets de plus de 4000 m à offrir, comme le massif du Mont-Rose ou encore le Cervin, sans doute l'une des montagnes les plus célèbres du monde. Malgré toutes ses beautés naturelles, le Valais perd aujourd'hui beaucoup de jeunes gens, qui partent en ville, notamment au bord du lac Léman, pour chercher de meilleures perspectives. Outre le tourisme, l'agriculture aussi est importante : on produit ici principalement des fruits et du vin.

Wallis

Vom Rhônegletscher im Nordosten nach Südwesten durchfließt die Rhône das Wallis, bevor sie nach Norden abknickt und in den Genfer See mündet. Auf beiden Seiten des Rhônetals erheben sich hohe Berge, der Südkamm der Alpen hat eine Reihe Viertausender zu bieten, darunter das Monte-Rosa-Massiv und das Matterhorn als einer der wohl bekanntesten Berge der Welt. Trotz aller Naturschönheiten verliert das Wallis viele junge Leute, die in den Städten, etwa am Genfer See, bessere Perspektiven für sich sehen. Neben dem Tourismus ist die Landwirtschaft von Bedeutung: Vor allem Wein und Obst werden hier angebaut.

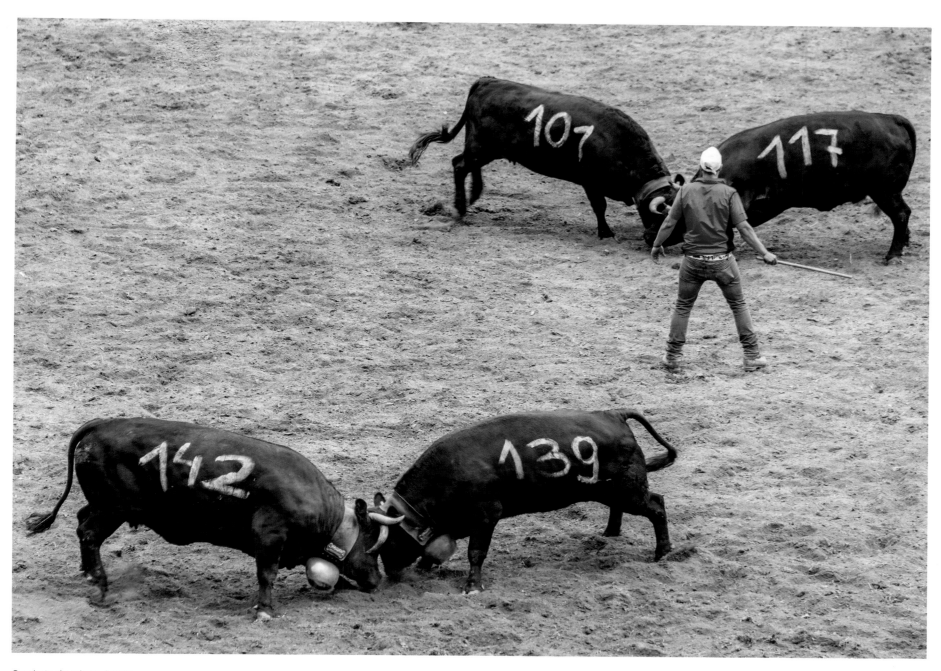

Combats de reines, Aproz
Eringer Ringkuhkämpfe, Aproz
Swiss cow fighting, Aproz

Vacas herens

El hecho de que la antigua raza de ganado vacuno de herens tenga una característica especial, a saber, la agresividad de las vacas entre sí, ha dado lugar a un espectáculo cada vez más popular que atrae a miles de visitantes a Aproz en el Valais cada año en el mes de mayo. En el «combate de reinas» se determinan las mejores vacas de pelea. Esto suena brutal, pero si lo comparamos con otras peleas de animales, es inofensivo. Las vacas solo luchan por su jerarquía natural. El evento hace que aumente el número de visitantes, por lo que las vacas son valiosas para sus dueños solo por este motivo.

Eringer wrestling cows

O facto de a antiga raça de animais domésticos de raça Hérens ter uma característica especial, nomeadamente a agressividade das vacas umas para com as outras, levou a um espectáculo cada vez mais popular que atrai milhares de visitantes a Aproz no Valais todos os anos em Maio. No "Kuhringkämpfen" as melhores vacas de combate são determinadas. Isso soa brutal, mas é dificilmente comparável a outras lutas de animais, mas relativamente inofensivo. As vacas só lutam contra a sua hierarquia natural. O evento está causando um boom no número de visitantes, então as vacas são valiosas para os seus proprietários só por causa disso.

Eringer

Een bijzonder kenmerk van het oude koeienras Eringer, de onderlinge agressiviteit, stond aan de wieg van een spektakel dat steeds populairder wordt en elk jaar in mei duizenden bezoekers naar Aproz in het Zwitserse kanton Wallis trekt. Bij deze 'koeiengevechten' worden de beste vechtkoeien bepaald. Deze koeiengevechten zijn nauwelijks te vergelijken met andere dierengevechten en verhoudingsgewijs onschuldig. In feite meten de koeien alleen hun krachten om de natuurlijke rangorde te bepalen. Door de enorme belangstelling voor het evenement zijn de koeien voor hun eigenaren nog waardevoller geworden.

Sion, Vallée du Rhône
Sitten, Rhonetal

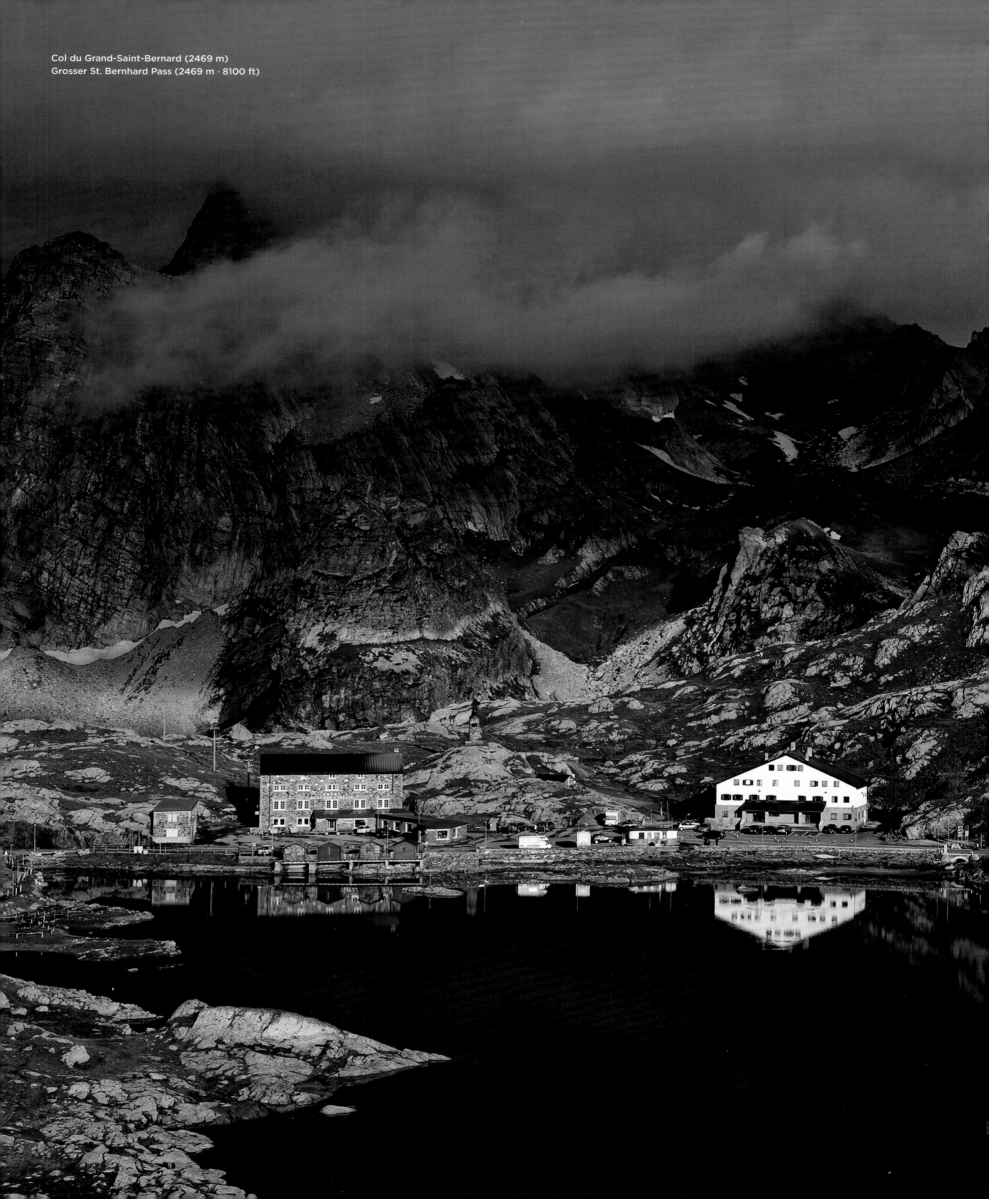

Col du Grand-Saint-Bernard (2469 m)
Grosser St. Bernhard Pass (2469 m · 8100 ft)

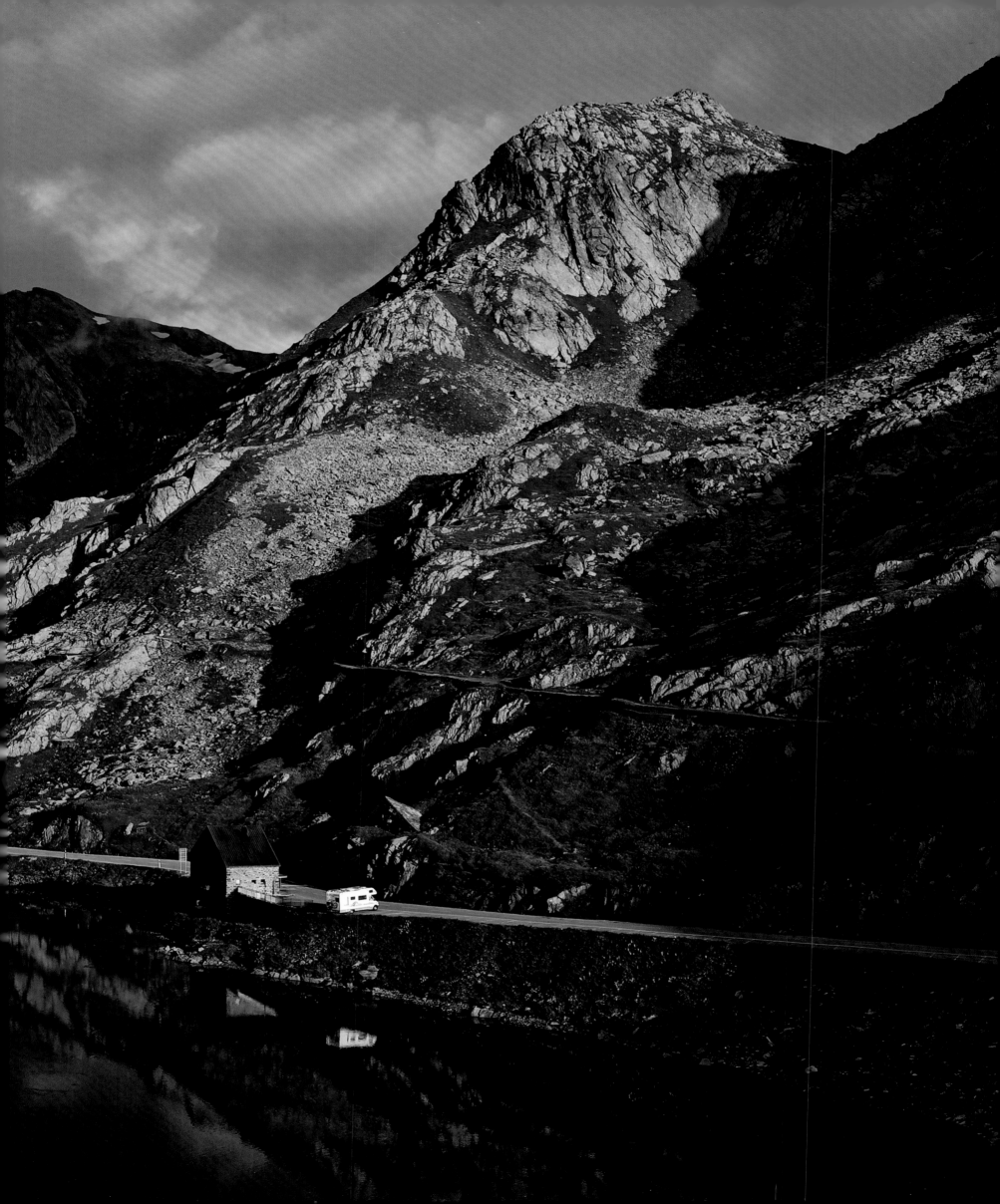

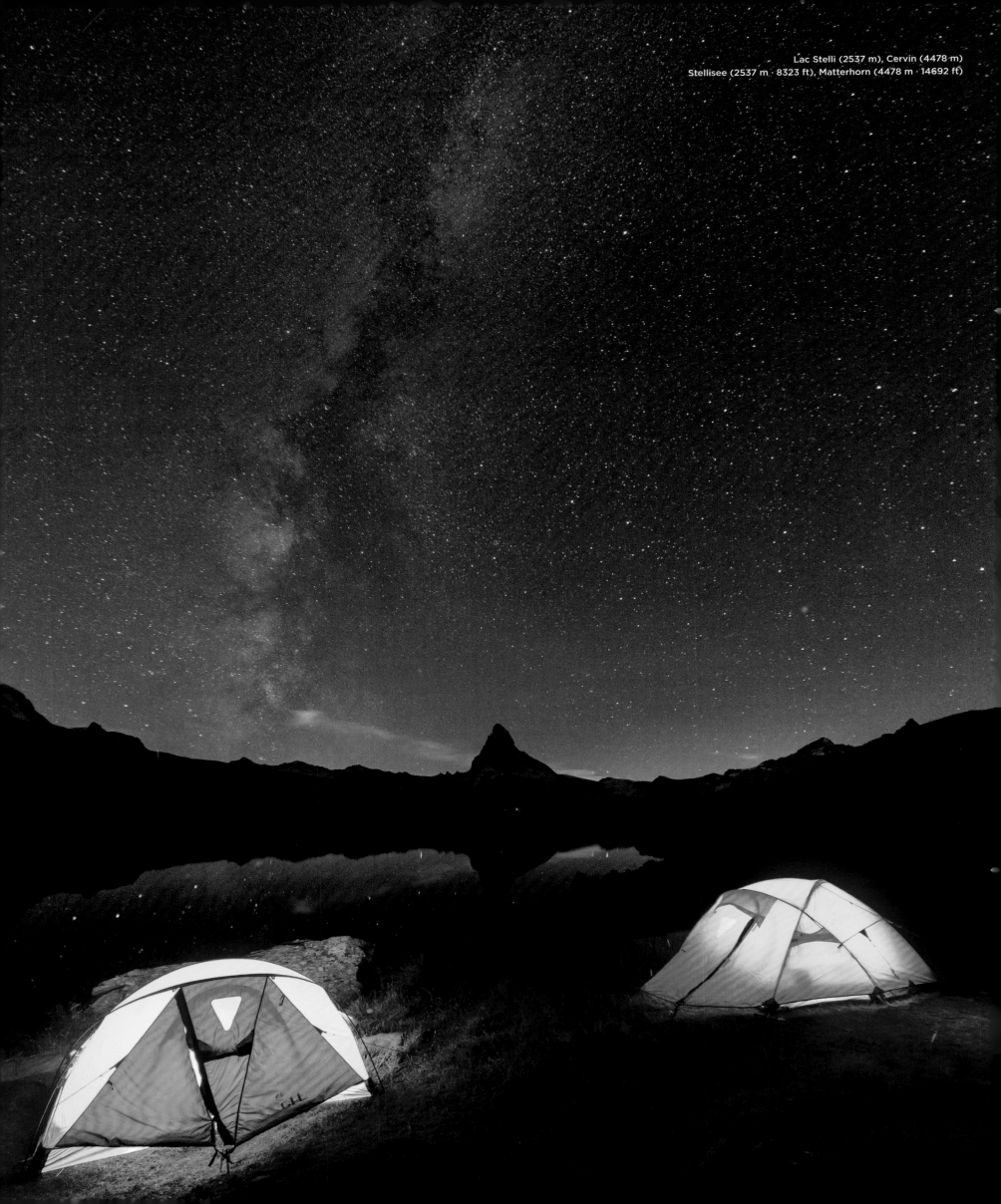

Lac Stelli (2537 m), Cervin (4478 m)
Stellisee (2537 m · 8323 ft), Matterhorn (4478 m · 14692 ft)

Vélo tout terrain, Valais
Mountain biking, Wallis

Matterhorn

Probably the most photographed mountain in the entire Alpine region is the Matterhorn with its characteristic triangular peak. The mountain was climbed for the first time in 1865, and since then climbers have been trying their hand at this ascent, which is regarded as very difficult. The Matterhorn is considered to be one of the most beautiful mountains in the world.

Le Cervin

Sans doute la montagne la plus photographiée des Alpes, si ce n'est du monde entier, le Cervin est aisément reconnaissable à son sommet pyramidal caractéristique. La première ascension victorieuse remonte à 1865 et, depuis lors, de plus en plus d'alpinistes tentent leur chance sur ce sommet réputé très difficile. Le Cervin est considéré comme l'une des plus belles montagnes au monde.

Matterhorn

Wohl der meistfotografierte Berg im gesamten Alpenraum und vielleicht der ganzen Welt ist das Matterhorn mit seinem charakteristischen spitzen Dreiecksgipfel. 1865 wurde der Berg erstmals bestiegen, seither versuchen sich immer wieder Kletterer an dem als sehr schwierig angesehenen Aufstieg. Das Matterhorn gilt als einer der schönsten Berge überhaupt.

Monte Cervino

Con su característica cumbre triangular y puntiaguda, el monte Cervino es, probablemente, la montaña más fotografiada de toda la región alpina y quizás del mundo entero. La montaña fue escalada por primera vez en 1865, y desde entonces los escaladores intentan subir a él una y otra vez, cosa que se considera muy difícil de conseguir. El monte Cervino está considerado como una de las montañas más bellas del mundo.

Matterhorn

Provavelmente a montanha mais fotografada de toda a região alpina e talvez de todo o mundo é o Matterhorn com o seu característico cume triangular pontiagudo. A montanha foi escalada pela primeira vez em 1865, e desde então os alpinistas têm tentado sua mão nesta subida, que é considerada muito difícil. O Matterhorn é considerado uma das mais belas montanhas do mundo.

Matterhorn

De Matterhorn met zijn karakteristieke spits toelopende driehoekige top is waarschijnlijk de meest gefotografeerde berg van het hele alpengebied, misschien wel van de hele wereld. De berg werd in 1865 voor het eerst beklommen en sindsdien hebben zich tal van klimmers aan de uiterst moeilijke beklimming gewaagd. De Matterhorn wordt beschouwd als een van de mooiste bergen ter wereld.

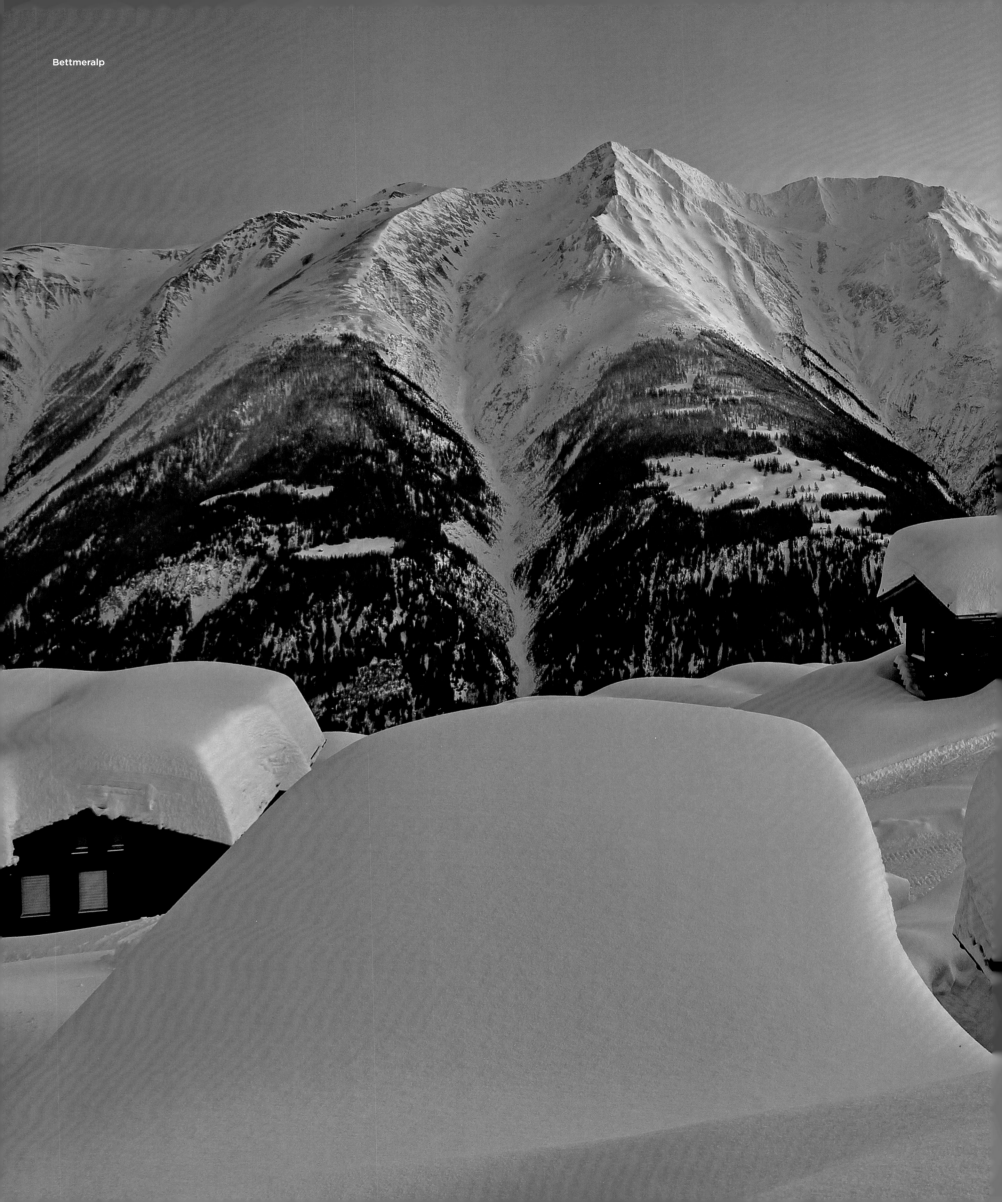

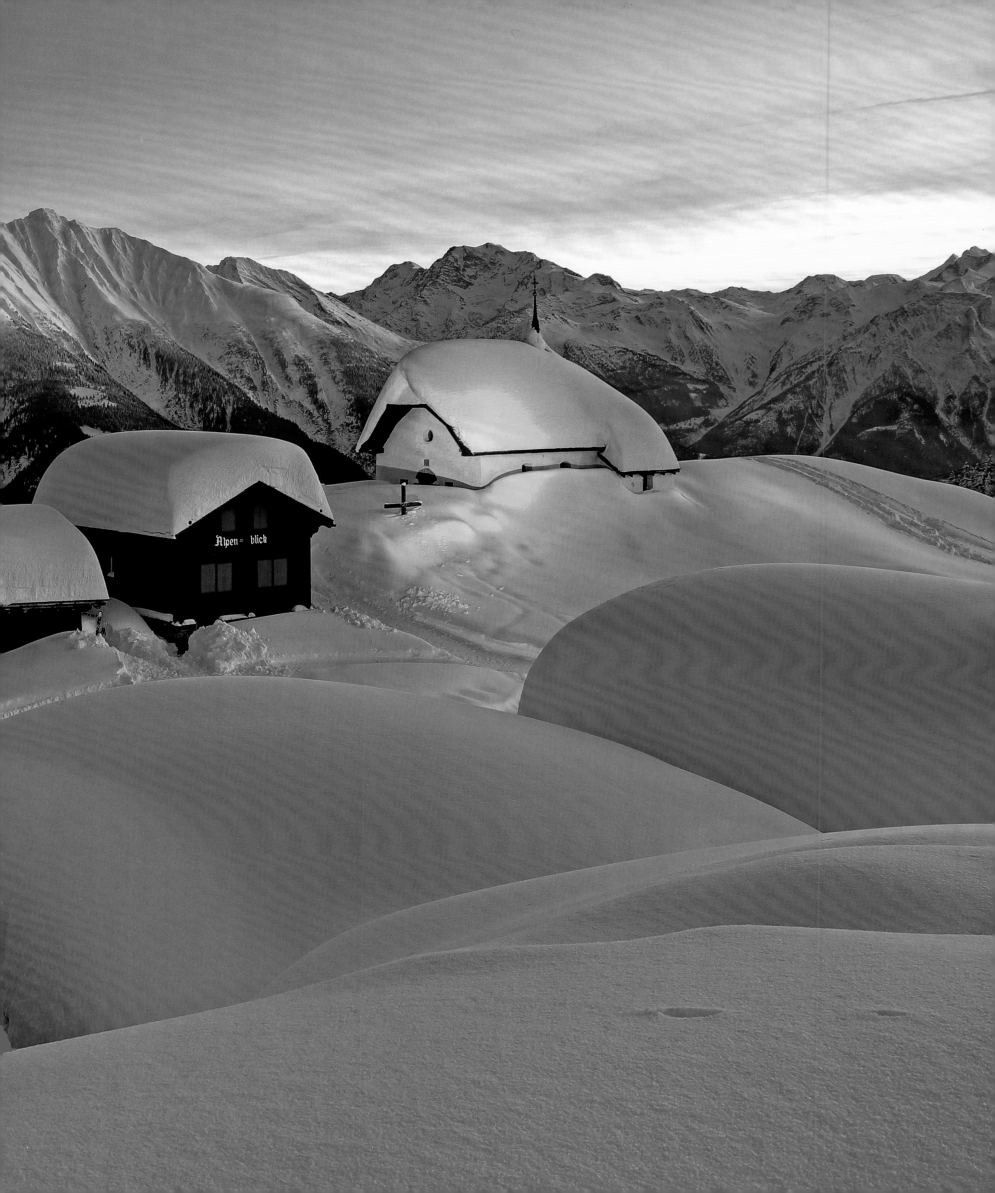

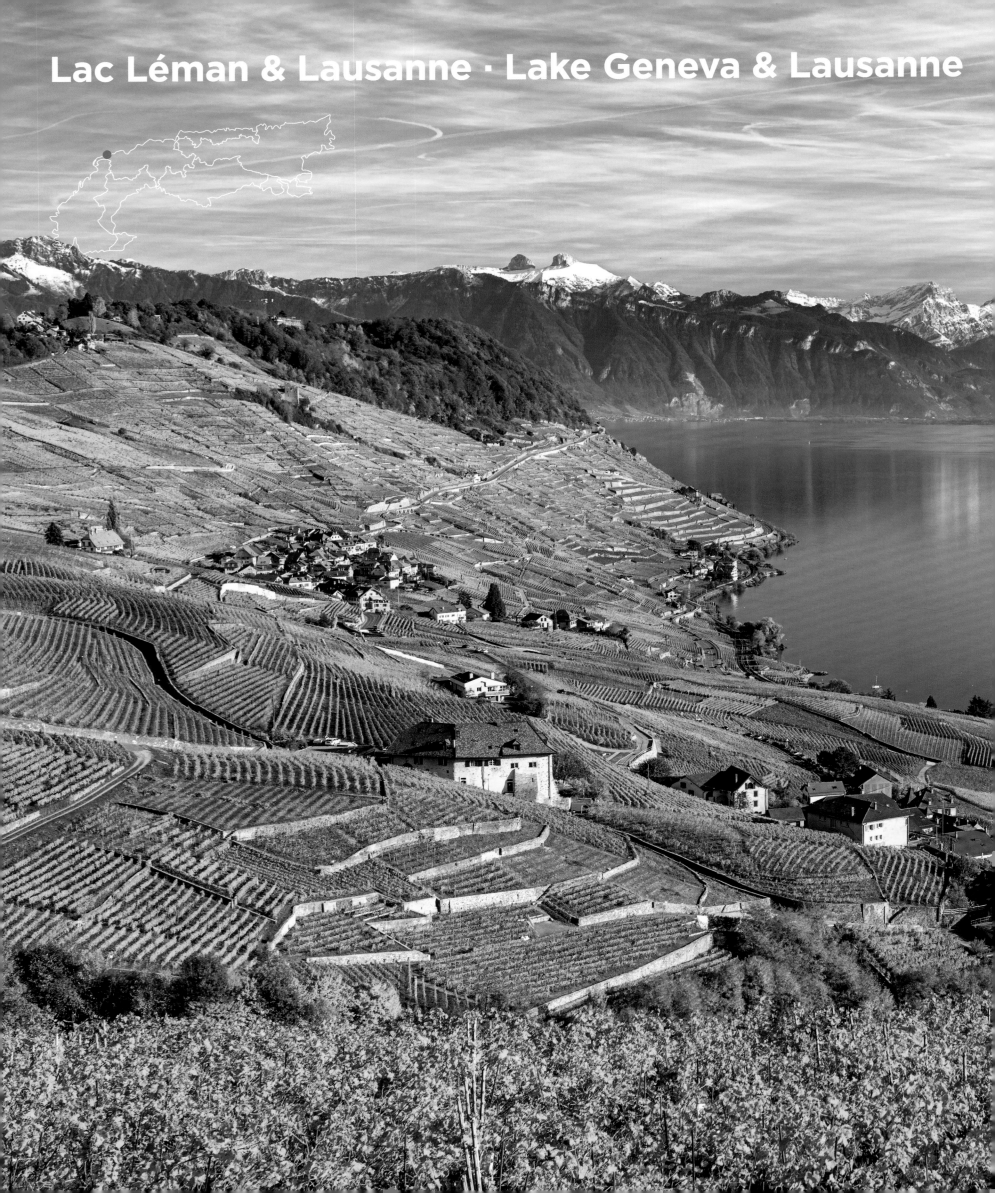

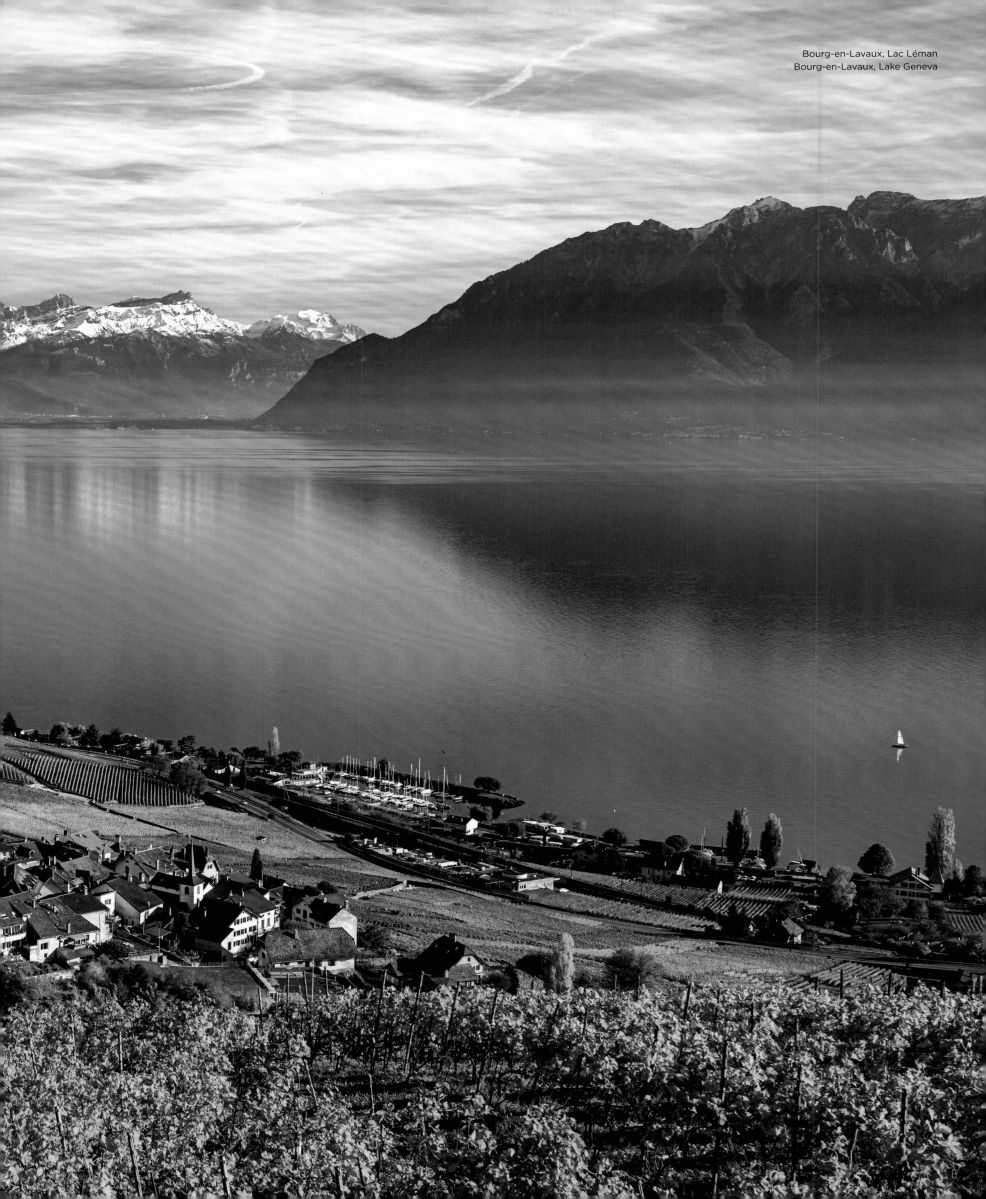

Bourg-en-Lavaux, Lac Léman
Bourg-en-Lavaux, Lake Geneva

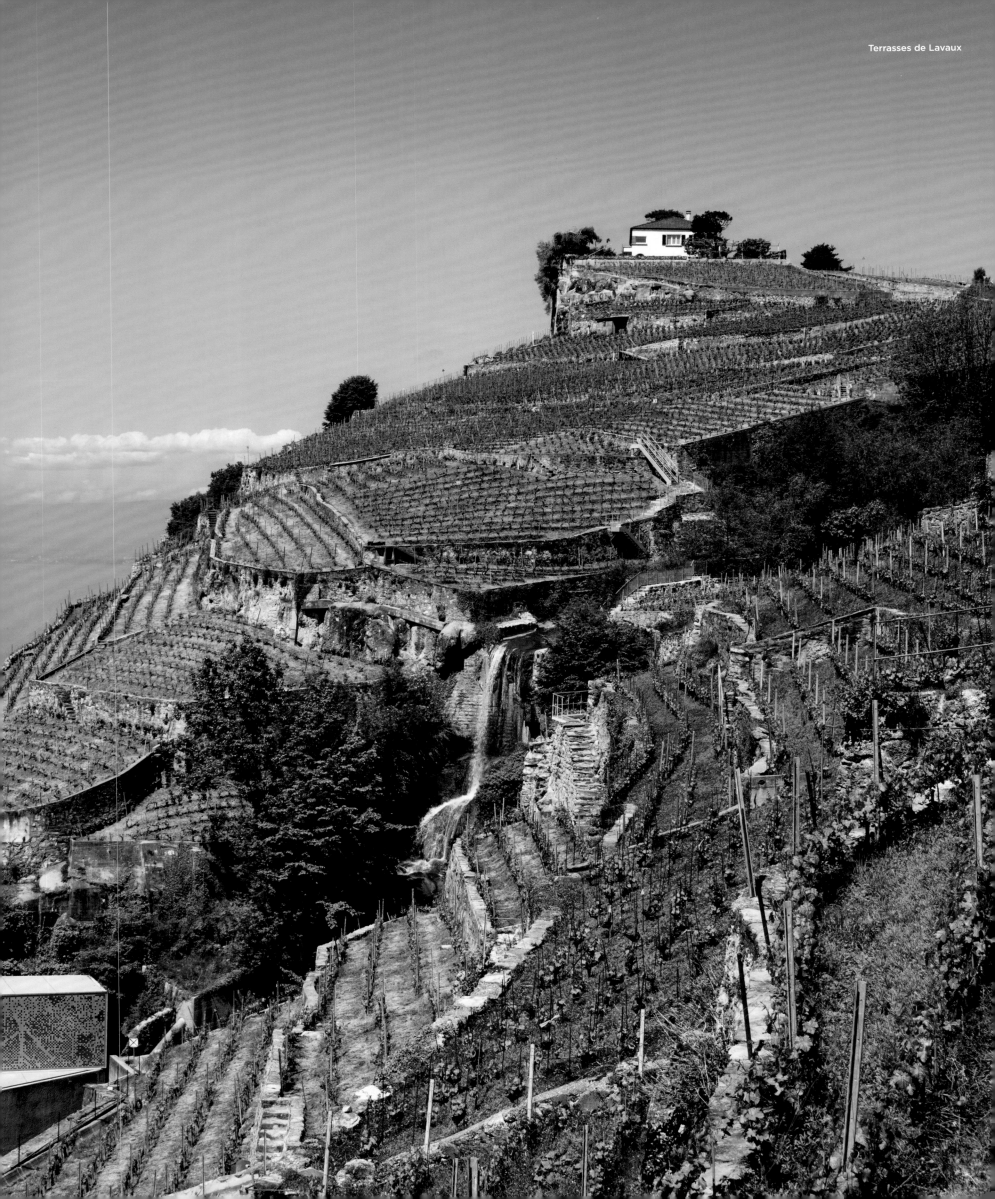

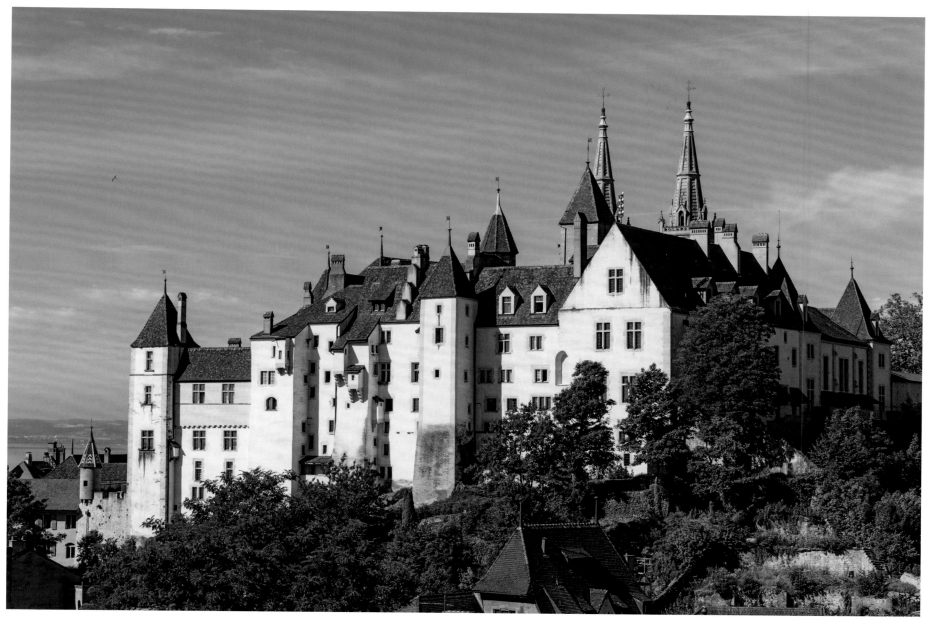

Château de Neuchâtel, Neuchâtel

Lake Geneva and Lausanne

A fantastic mountain scenery surrounds Lake Geneva, one of the largest lakes in Europe. The north shore is lined with numerous settlements, including Montreux and Lausanne, with fields and vineyards extending into the gentle Jura Mountains. At the south-western tip lies the Geneva, home to several UN organisations, in the south-east the white ice cap of Mont Blanc can be seen from afar.

Le lac Léman e Lausanne

Lové dans un décor de montagnes idyllique, le lac Léman est l'un des plus grands d'Europe. Son rivage nord est bordé de nombreuses villes, dont Montreux et Lausanne, derrière lesquelles s'étendent champs et vignes qui courent jusqu'au Jura. À l'extrémité sud-ouest du lac se dresse la ville de Genève, siège européen des Nations unies, tandis qu'au sud-est scintille la calotte glaciaire du mont Blanc.

Genfersee und Lausanne

Eine traumhafte Bergkulisse umgibt den Genfer See, einen der größten Seen Europas. Am Nordufer reihen sich zahlreiche Siedlungen, darunter Montreux und Lausanne, dahinter erstrecken sich Felder und Rebflächen bis in die sanfte Bergregion des Jura. An der Südwestspitze liegt die UNO-Stadt Genf, im Südosten leuchtet die weiße Eiskappe des Mont Blanc.

Lago Lemán y Lausana

Un fantástico paisaje montañoso rodea el lago Lemán, uno de los lagos más grandes de Europa. La orilla norte está bordeada por numerosos asentamientos, entre los que se encuentran, por ejemplo, Montreux y Lausana, con campos y viñedos que se extienden hasta las suaves montañas del Jura. En la punta suroeste se encuentra Ginebra, la ciudad de la ONU; en el sureste brilla la capa blanca de hielo del Mont Blanc.

Lago Genebra e Lausanne

Uma fantástica paisagem montanhosa rodeia o Lago Genebra, um dos maiores lagos da Europa. A margem norte está repleta de numerosos povoados, incluindo Montreux e Lausanne, com campos e vinhas que se estendem até às suaves montanhas do Jura. Na ponta sudoeste está a cidade de Genebra da ONU, no sudeste a calota de gelo branca do Mont Blanc brilha.

Meer van Genève en Lausanne

Het Meer van Genève, een van de grootste meren van Europa, is omgeven door een uniek berglandschap. Op de noordelijke oever liggen enkele bekende steden zoals Montreux en Lausanne en daarachter strekken zich de velden en wijngaarden uit tot aan de uitlopers van de Jura. Aan het zuidwestelijke uiteinde ligt de Genève en in het zuidoosten is de witte top van de Mont Blanc te zien.

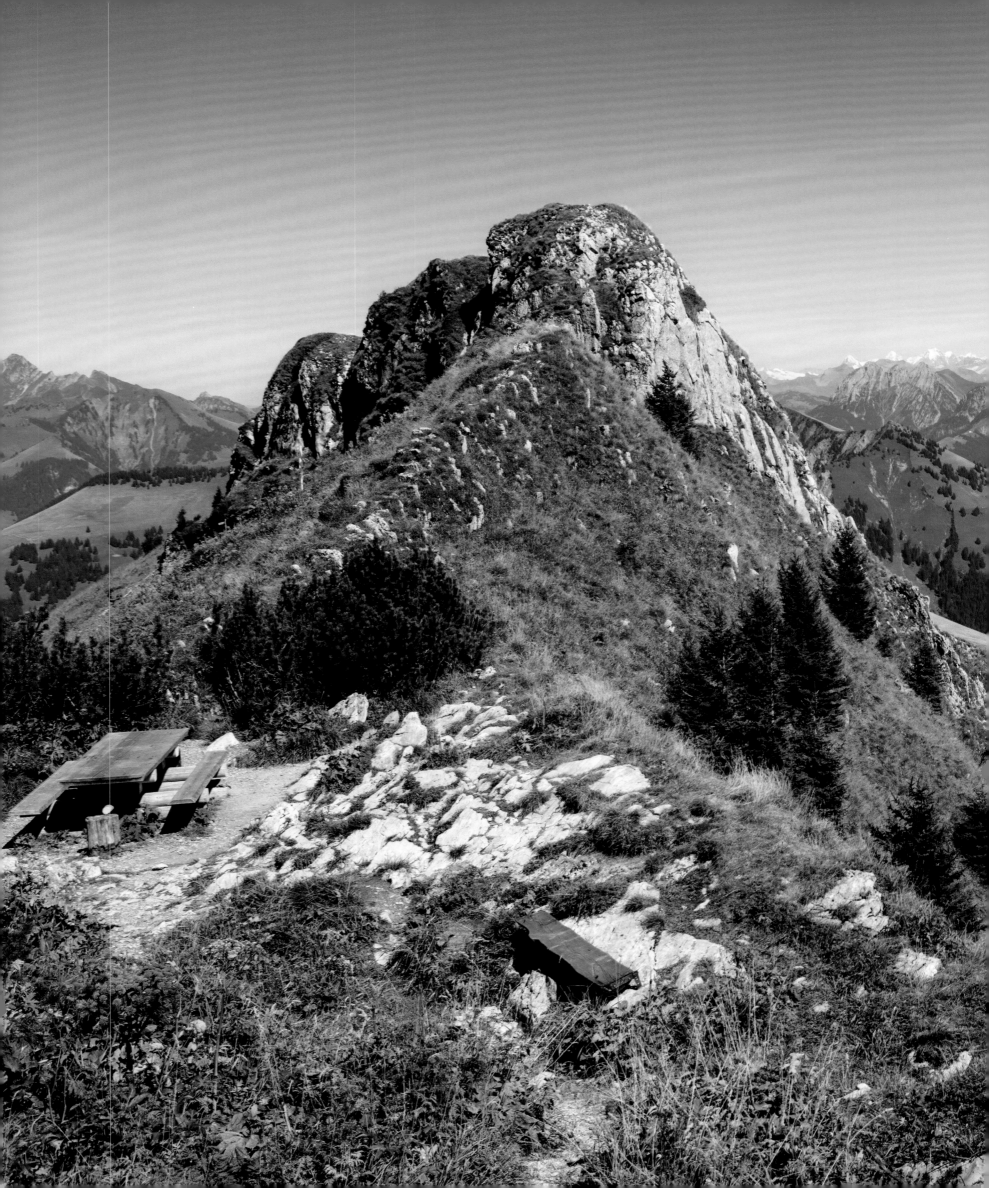

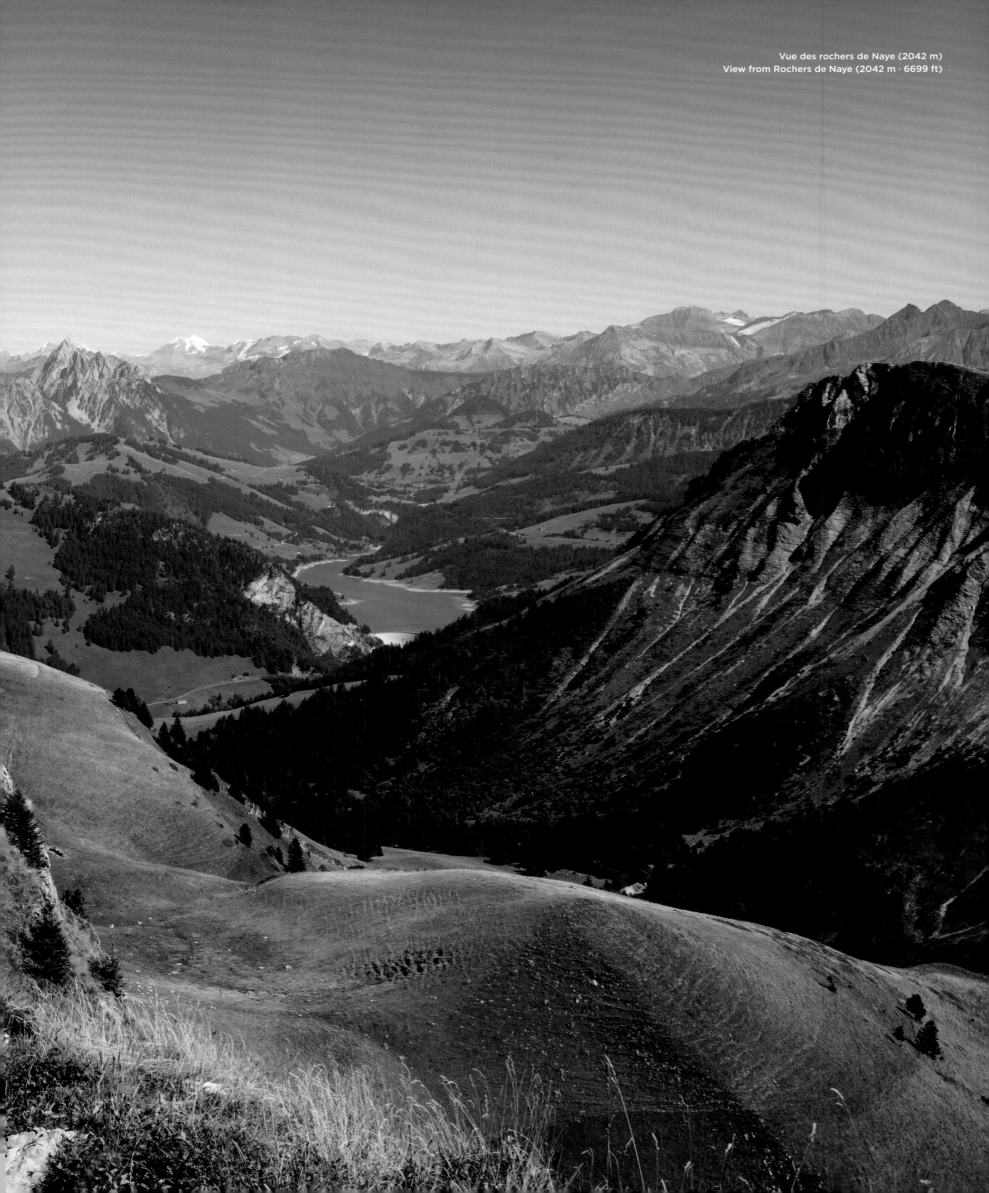

Vue des rochers de Naye (2042 m)
View from Rochers de Naye (2042 m · 6699 ft)

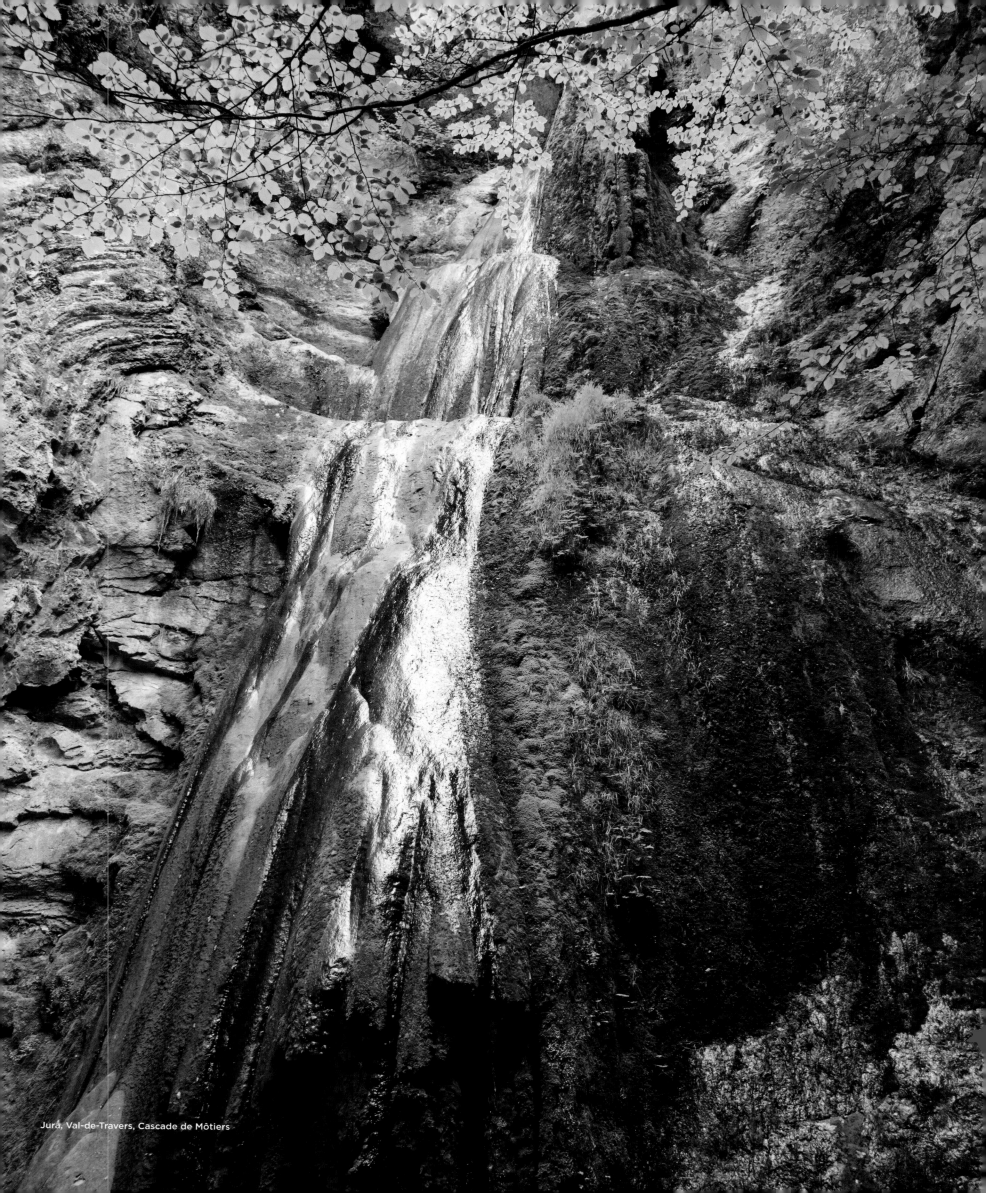

Jura, Val-de-Travers, Cascade de Môtiers

Col de Pierre-Pertuis (827 m · 2713 ft)

Pierre Pertuis

The road used to look different, of course, but the rock gate of Pierre-Pertuis in the Swiss Jura has existed for about 2000 years. The Romans spared no effort on their way through the Alps and used the tool available at the time to carve a tunnel. Ancient inscriptions can still be seen next to the tunnel. Today it is part of the "Swiss Cultural Routes".

Pierre-Pertuis

La route avait bien entendu autrefois une allure différente, mais le passage de pierre de Pierre-Pertuis, dans le Jura suisse, existe depuis environ 2000 ans. Les Romains ne rechignaient pas à la tâche quand il s'agissait de construire leurs voies alpines et ont donc creusé avec les moyens de l'époque un tunnel sur lequel on peut encore lire des inscriptions antiques. Il fait aujourd'hui partie des « itinéraires culturels en Suisse ».

Pierre-Pertuis

Die Straße sah früher natürlich anders aus, aber das Felsentor von Pierre-Pertuis im schweizerischen Jura gibt es seit rund 2000 Jahren. Die Römer scheuten für ihre Wege durch die Alpen keine Mühen und schufen mit den Mitteln der damaligen Zeit einen Tunnel, an dem noch antike Inschriften zu sehen sind. Heute ist er Teil der „Schweizer Kulturwege".

Pierre Pertuis

Naturalmente, el camino solía ser diferente, pero la puerta de Pierre-Pertuis en el Jura suizo existe desde hace unos 2000 años. Los romanos no escatimaron esfuerzos en su paso por los Alpes y utilizaron los medios de la época para crear un túnel en el que aún se pueden ver inscripciones antiguas. Hoy forma parte de las "rutas culturales suizas".

Pierre pertuis

A estrada costumava parecer diferente, é claro, mas o portão de pedra de Pierre-Pertuis no Jura suíço existe há cerca de 2000 anos. Os romanos não pouparam esforços no seu caminho através dos Alpes e usaram os meios do tempo para criar um túnel onde inscrições antigas ainda podem ser vistas. Hoje faz parte das "Rotas Culturais Suíças".

Pierre-Pertuis

De weg ziet er natuurlijk anders uit dan vroeger, maar de 'rotspoort' van Pierre-Pertuis in de Zwitserse Jura oogt nog net als 2000 jaar geleden. De Romeinen spaarden kosten noch moeite om wegen aan te leggen door de Alpen en zo ontstond ook deze tunnel, waarin nog steeds de oude inscripties te zien zijn. Tegenwoordig ligt de poort aan de Zwitserse culturele route.

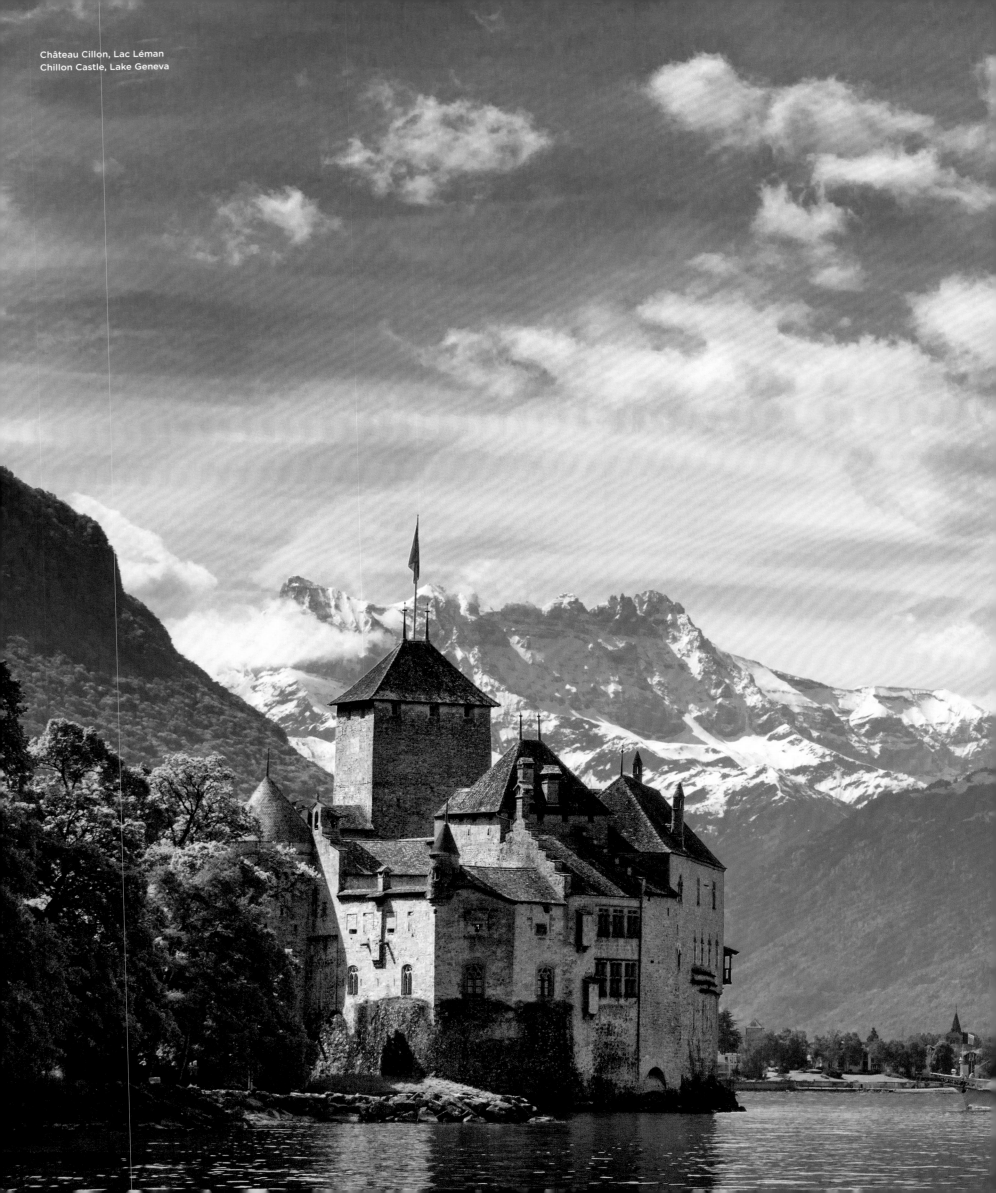

Château Cillon, Lac Léman
Chillon Castle, Lake Geneva

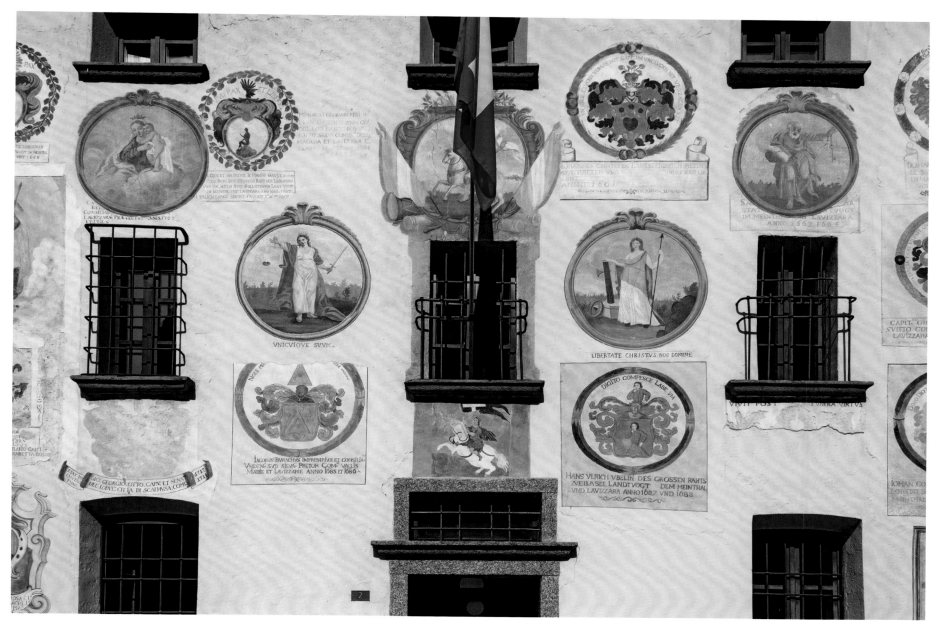

Valle Maggia Cevio

Ticino

In the south of Ticino, one does not know exactly whether one is still in Switzerland or already in Italy. Italian is the official language, the settlements have an Italian feeling, the flora is Mediterranean, and the Mediterranean itself is not far away. Two of the Upper Italian lakes partially belong to the canton, Lake Lugano and Lake Maggiore with the towns of Locarno and Ascona.

Le Tessin

Dans le Sud du Tessin, on ne sait plus trop si l'on se trouve encore en Suisse ou déjà en Italie. L'italien est la langue officielle, l'ambiance est plutôt italienne, la flore méditerranéenne, et la mer Méditerranée n'est pas loin. Ce canton partage deux lacs avec le Nord de l'Italie : le lac Majeur, avec les villes de Locarno et d'Ascona, et le lac de Lugano.

Tessin

Im Süden Tessins weiß man nicht so genau, ob man noch in der Schweiz ist oder schon in Italien. Italienisch ist Amtssprache, die Orte haben italienische Atmosphäre, die Flora ist mediterran, das Mittelmeer nicht weit. Der Kanton hat Anteil an zwei der oberitalienischen Seen, dem Lago Maggiore mit den Kulturstädten Locarno und Ascona und dem Luganer See.

Tesino

En el sur del Tesino no se sabe exactamente si se está todavía en Suiza o ya en Italia. El italiano es el idioma oficial, la atmósfera que se respira en los lugares es italiana, la flora es mediterránea, el Mediterráneo no está lejos. El cantón participa en dos de los lagos de la Alta Italia, el lago Mayor con las ciudades culturales de Locarno y Ascona y el lago de Lugano.

Ticino

No sul do Ticino, não se sabe exatamente se ainda se está na Suíça ou já na Itália. O italiano é a língua oficial, os lugares têm uma atmosfera italiana, a flora é mediterrânica, o Mediterrâneo não está longe. O cantão tem uma participação em dois dos lagos italianos superiores, o Lago Maggiore com as cidades culturais de Locarno e Ascona e o Lago Lugano.

Ticino

In het zuiden van het Ticino is niet geheel duidelijk of je nog in Zwitserland bent of al in Italië: de officiële taal is Italiaans, de plaatsen doen Italiaans aan, de flora is mediterraan en de Middellandse Zee is niet ver weg. Bovendien heeft het Zwitserse kanton een aandeel in twee grote Italiaanse meren: het Lago Maggiore met de steden Locarno en Ascona en het Meer van Lugano.

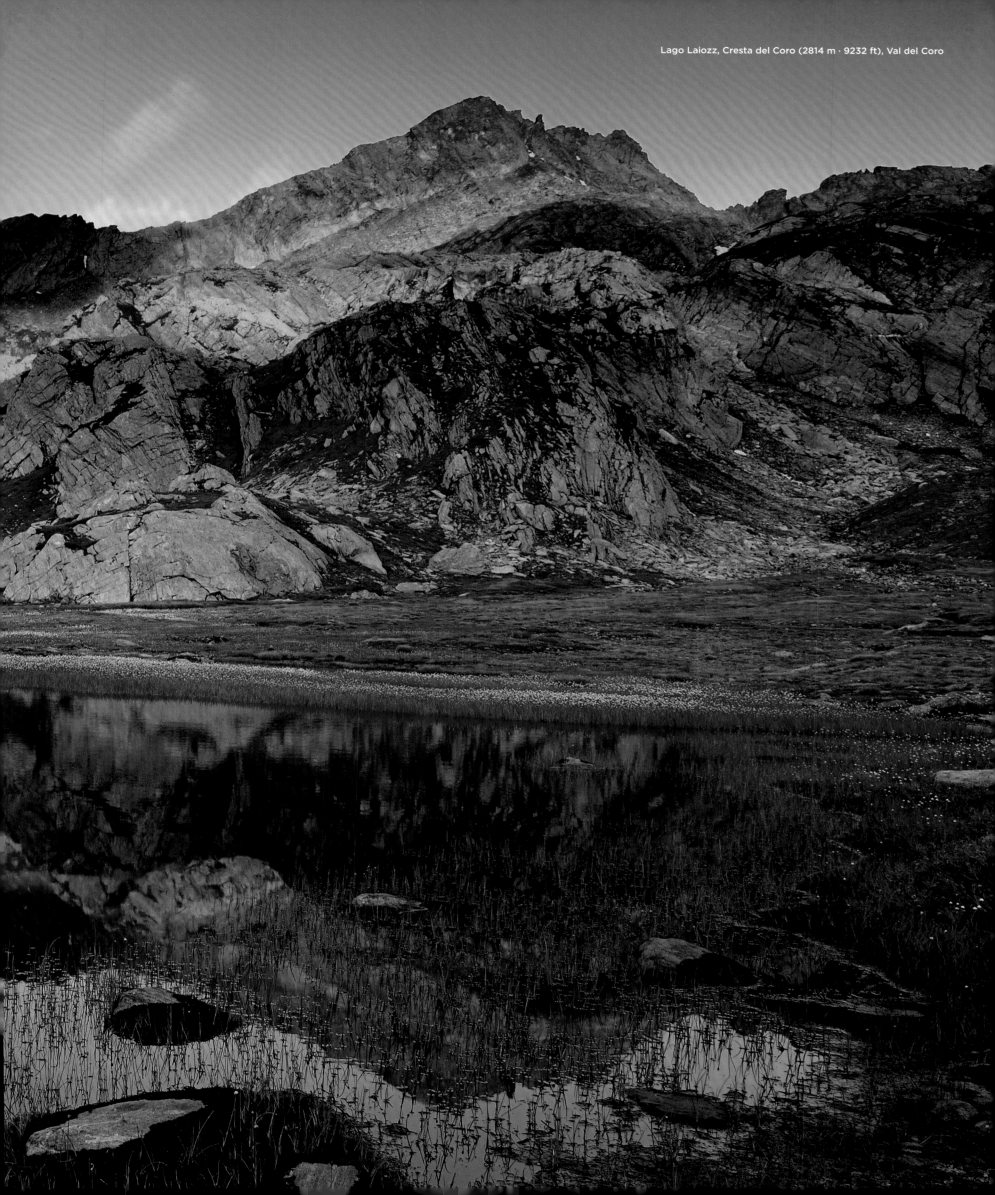

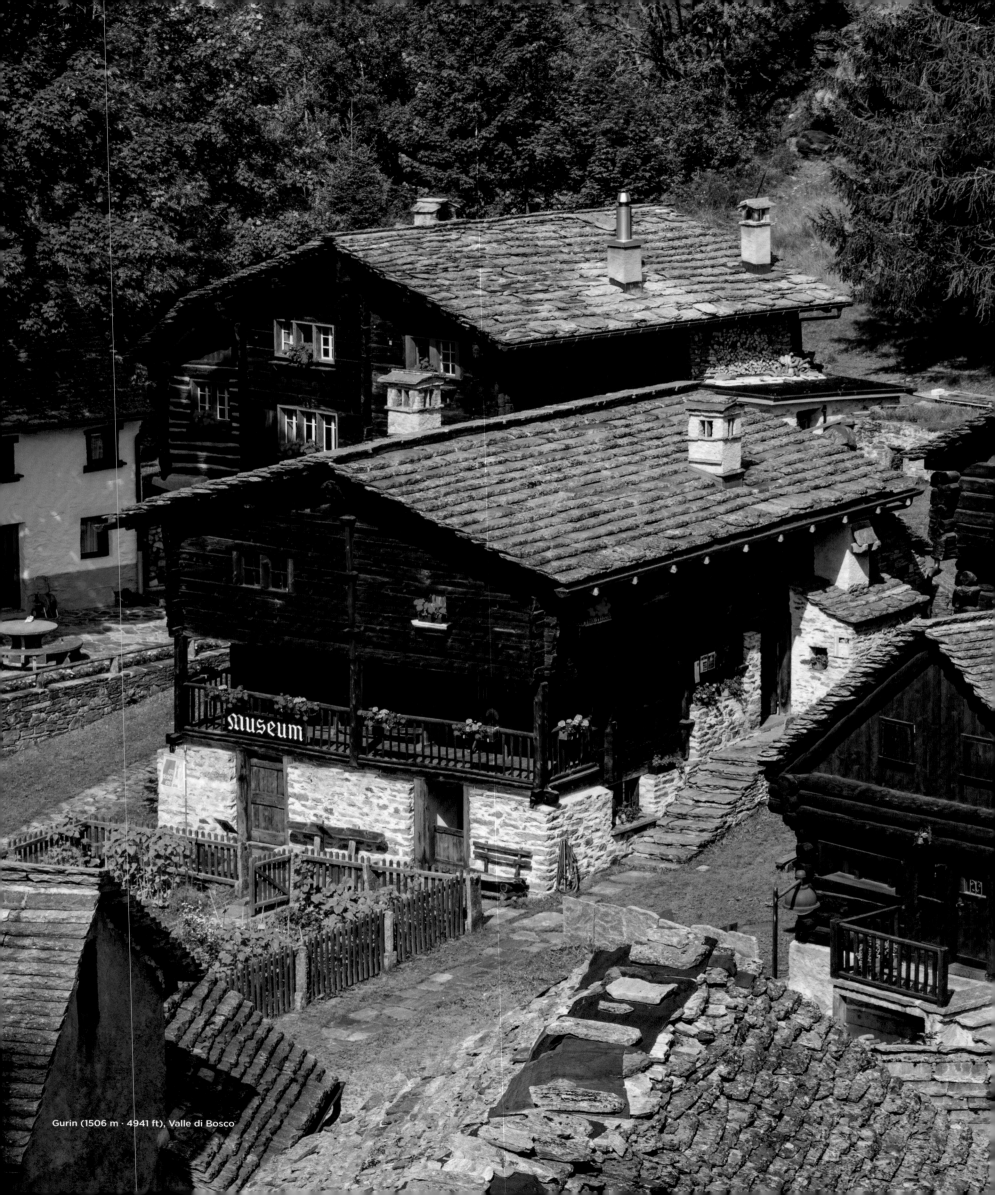

Gurin (1506 m · 4941 ft), Valle di Bosco

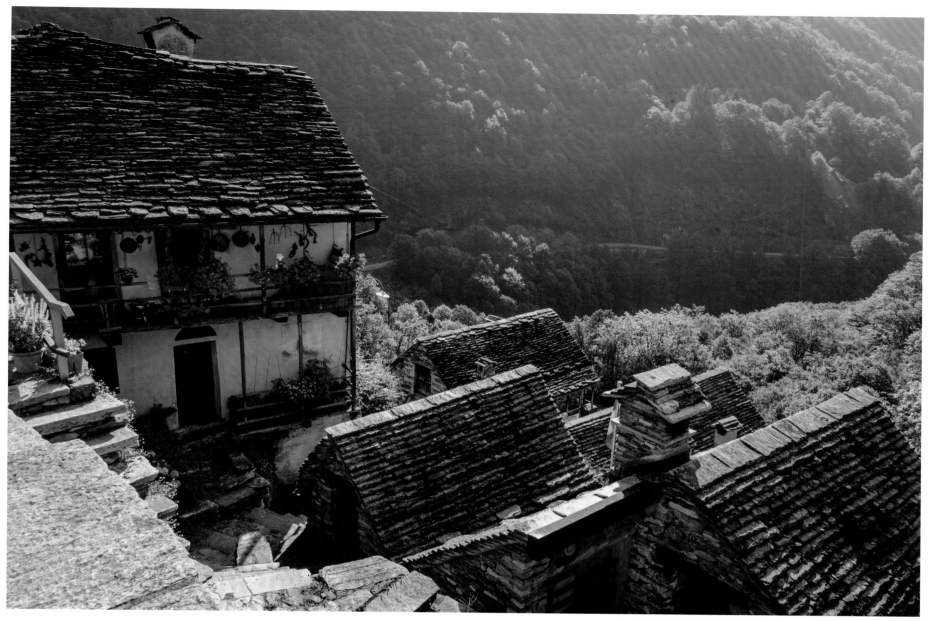

Corippo (563 m · 1847 ft), Valle Verzasca

Bosco Gurin

One of the many regional minorities in the Alpine region are the Walser, who migrated 600 to 800 years ago from the Alemannic regions to the Romansh-speaking Ticino. In the remote mountain valleys they were able to preserve their traditions and language for a long time. Today only a few Walser villages such as Bosco Gurin still show their original appearance.

Bosco Gurin

Les Walser sont l'une des nombreuses minorités de la région des Alpes et ont migré il y a 6 à 8 siècles des zones alémaniques vers le Tessin, où l'on parlait des langues romanes. Installés dans des vallées isolées, ils ont longtemps pu conserver leur langue et leurs traditions. Aujourd'hui, peu de localités walser ont gardé, comme Bosco Gurin, leur charme traditionnel.

Bosco Gurin

Eine der vielen regionalen Minderheiten im Alpenraum sind die Walser, die vor 600 bis 800 Jahren aus dem Alemannischen ins romanischsprachige Tessin eingewandert waren. In den abgeschiedenen Bergtälern konnten sie lange Zeit ihre Traditionen und ihre Sprache bewahren. Heute haben nur noch wenige Walser-Orte wie Bosco Gurin das ursprüngliche Aussehen.

Bosco-Gurin

Una de las muchas minorías regionales de la región alpina son los walser, que emigraron hace 600 u 800 años del Tesino alemán al de habla romana. En los remotos valles montañosos pudieron conservar sus tradiciones y su lengua durante mucho tiempo. Hoy en día, solo unos pocos pueblos walser como Bosco-Gurin conservan su aspecto original.

Bosco Gurin

Uma das muitas minorias regionais na região alpina é a de Walser, que há 600 a 800 anos migrou do Alemão para o Ticino de língua romanche. Nos remotos vales das montanhas, conseguiram preservar as suas tradições e a sua língua durante muito tempo. Hoje apenas algumas aldeias Walser como Bosco Gurin ainda têm a sua aparência original.

Bosco Gurin

Het alpengebied telt tal van regionale minderheden zoals de Walser. Dit Alemannische volk vestigde zich 600 tot 800 jaar geleden in het Romaanse Ticino. Door de afgelegen ligging van de bergdalen die ze bewonen, konden ze hun tradities en taal lange tijd in ere houden. Van de Walser dorpen wist slechts een handvol, waaronder Bosco Gurin, zijn oorspronkelijke karakter te bewaren.

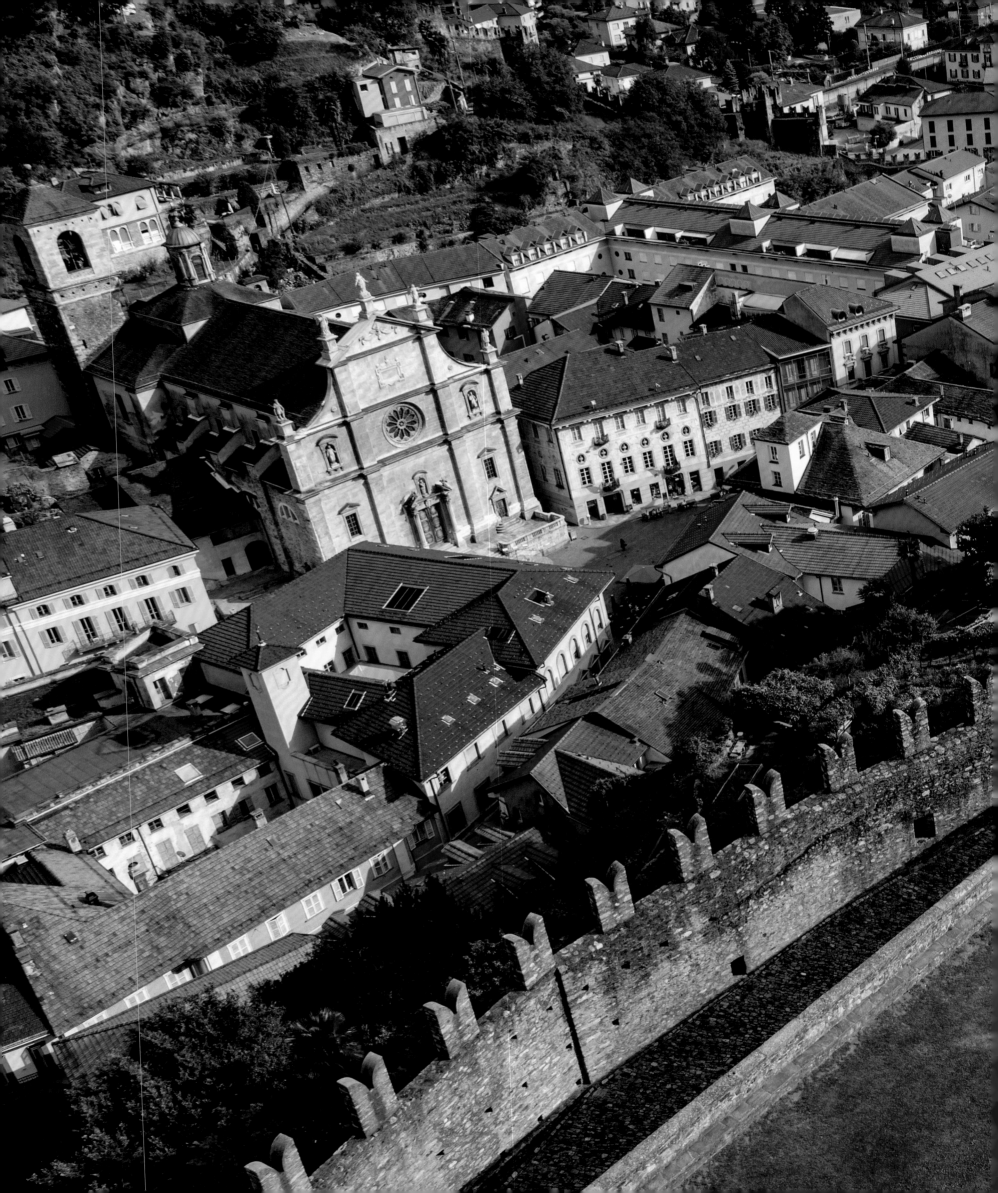

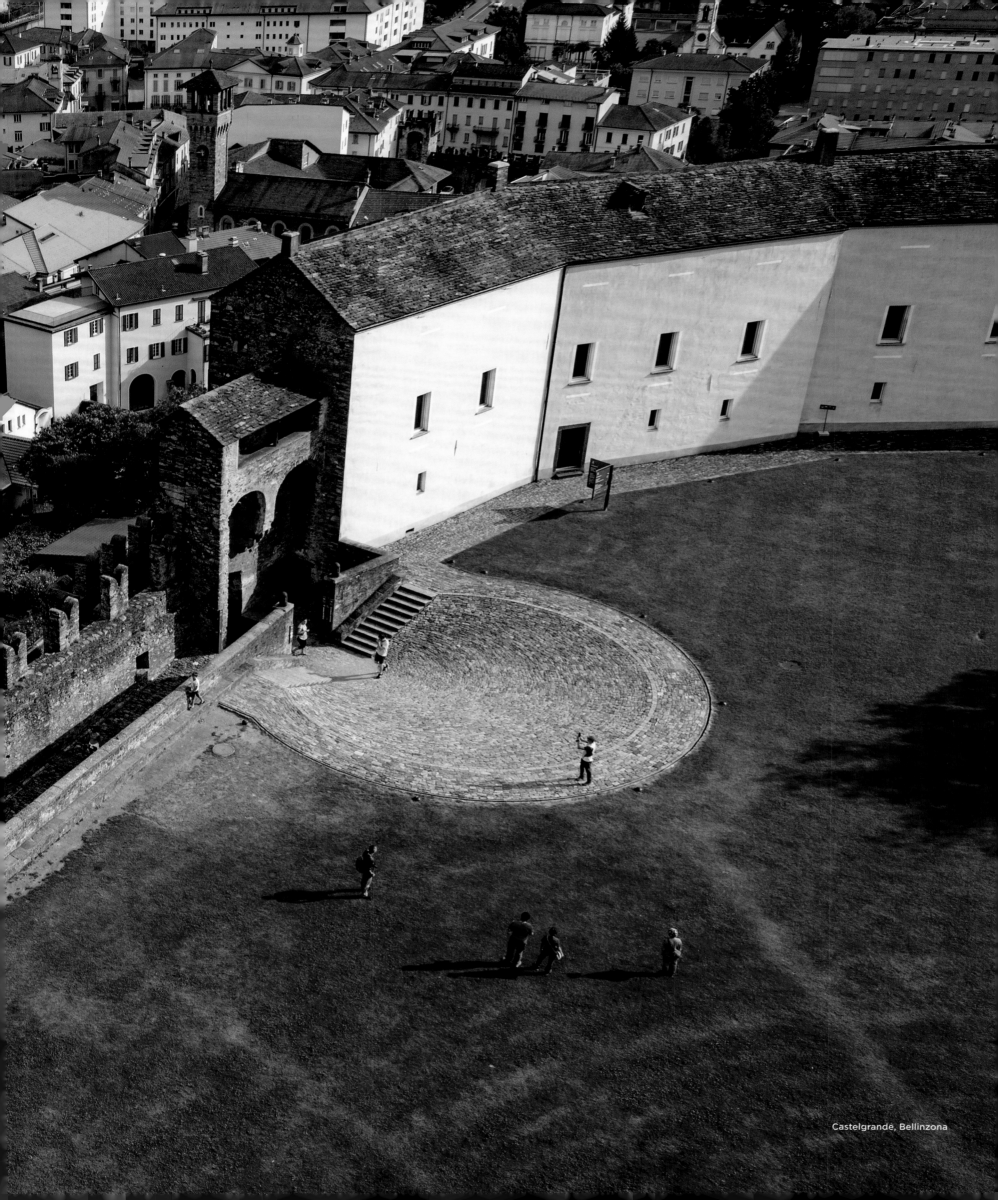

Castelgrande, Bellinzona

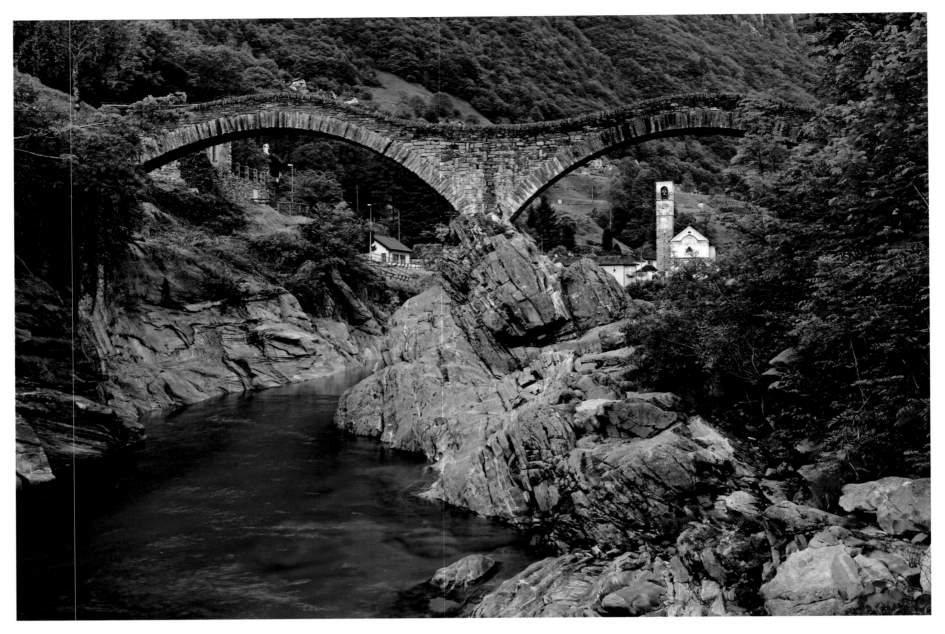

Lavertezzo, Valle Verzasca

Ponte dei Salti

North of Lake Maggiore, the spectacular Ponte dei Salti spans the Versasca Valley near Lavertezzo. Built in the 17th century and repaired several times since then, the bridge was formerly part of an important transport route. Today it is a tourist attraction for visitors with a head for heights, because it is very narrow and has low stone railings.

Le pont des Sauts

Au nord du lac Majeur, le pont des Sauts enjambe avec panache la Verzasca, près de Lavertezzo. Construit au XVIIᵉ siècle et plusieurs fois réparé depuis, ce pont était jadis une voie importante pour le transport. Aujourd'hui, c'est surtout une attraction touristique, réservée toutefois à ceux qui ne sont pas sujets au vertige, car le pont est étroit et ses parapets bien bas.

Ponte dei Salti

Nördlich des Lago Maggiore überspannt die spektakuläre Ponte dei Salti bei Lavertezzo das Versascatal. Im 17. Jahrhundert erbaut und seither mehrmals repariert, wurde die Brücke früher als wichtiger Transportweg genutzt. Heute ist sie eine Touristenattraktion, die allerdings Schwindelfreiheit erfordert, denn sie ist sehr schmal und hat niedrige Steingeländer.

Ponte dei Salti

Al norte del Lago Maggiore, el espectacular Ponte dei Salti, cerca de Lavertezzo, se extiende por el valle de Versasca. Construido en el siglo XVII y reparado varias veces desde entonces, el puente se utilizaba antiguamente como una importante vía de transporte. Hoy en día es una atracción turística que, sin embargo, no es muy recomendable para las personas que se marean fácilmente, ya que es muy estrecha y tiene barandillas de piedra bastante bajas.

Ponte dei Salti

Ao norte do Lago Maggiore, a espetacular Ponte dei Salti, perto de Lavertezzo, atravessa o Vale Versasca. Construída no século XVII e reparada várias vezes desde então, a ponte foi anteriormente utilizada como uma importante via de transporte. Hoje é uma atração turística, que no entanto exige uma cabeça para alturas, porque é muito estreita e tem grades de pedra baixas.

Ponte dei Salti

De Ponte dei Salti bij Lavertezzo ten noorden van het Lago Maggiore overspant op spectaculaire wijze het Valle Verzasca. De 17e-eeuwse brug werd al herhaaldelijk gerestaureerd en lag vroeger op een belangrijke handelsroute. Tegenwoordig is de brug een toeristenattractie, althans voor mensen zonder hoogtevrees, aangezien de brug zeer smal is en de stenen borstweringen zeer laag.

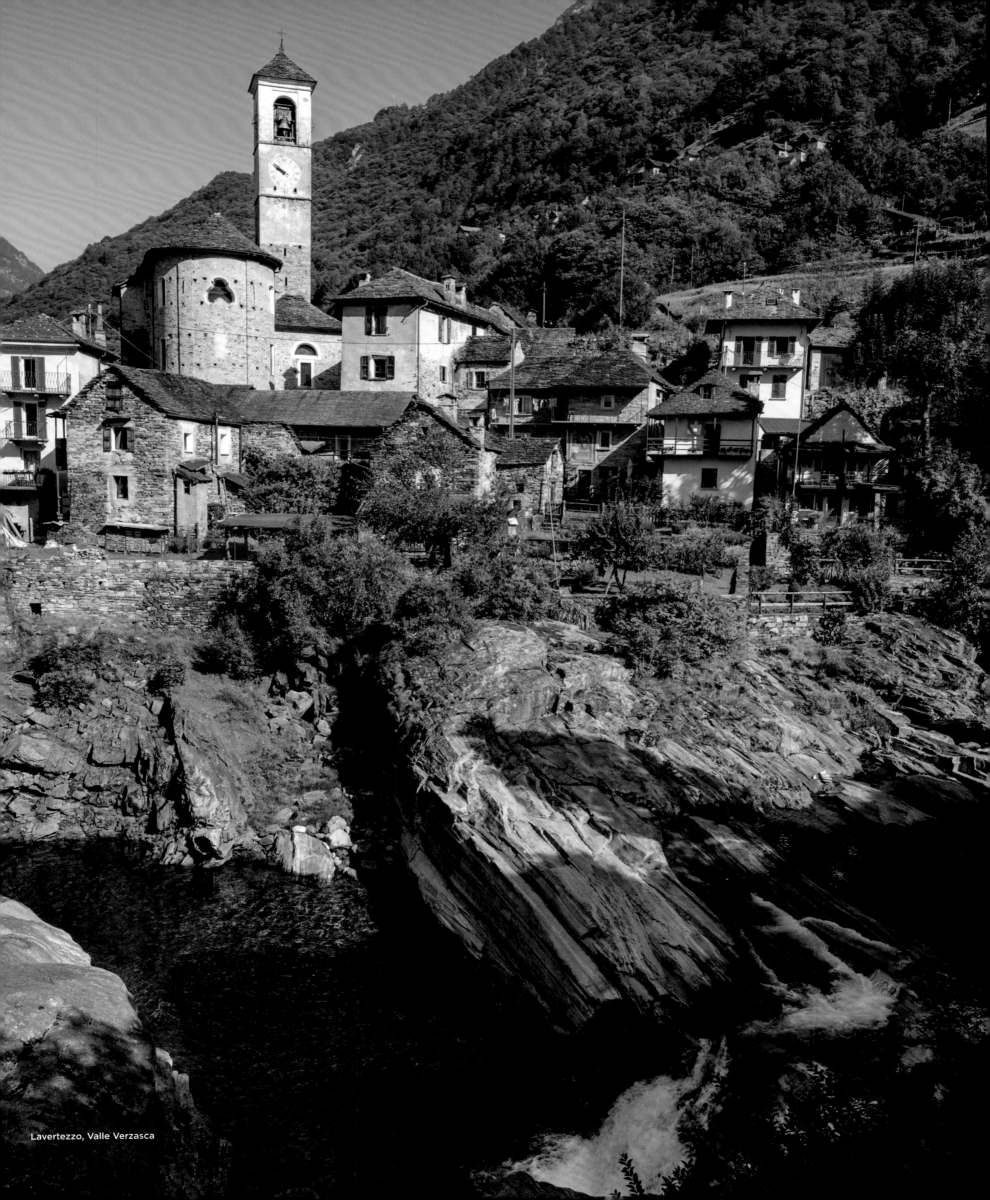

Lavertezzo, Valle Verzasca

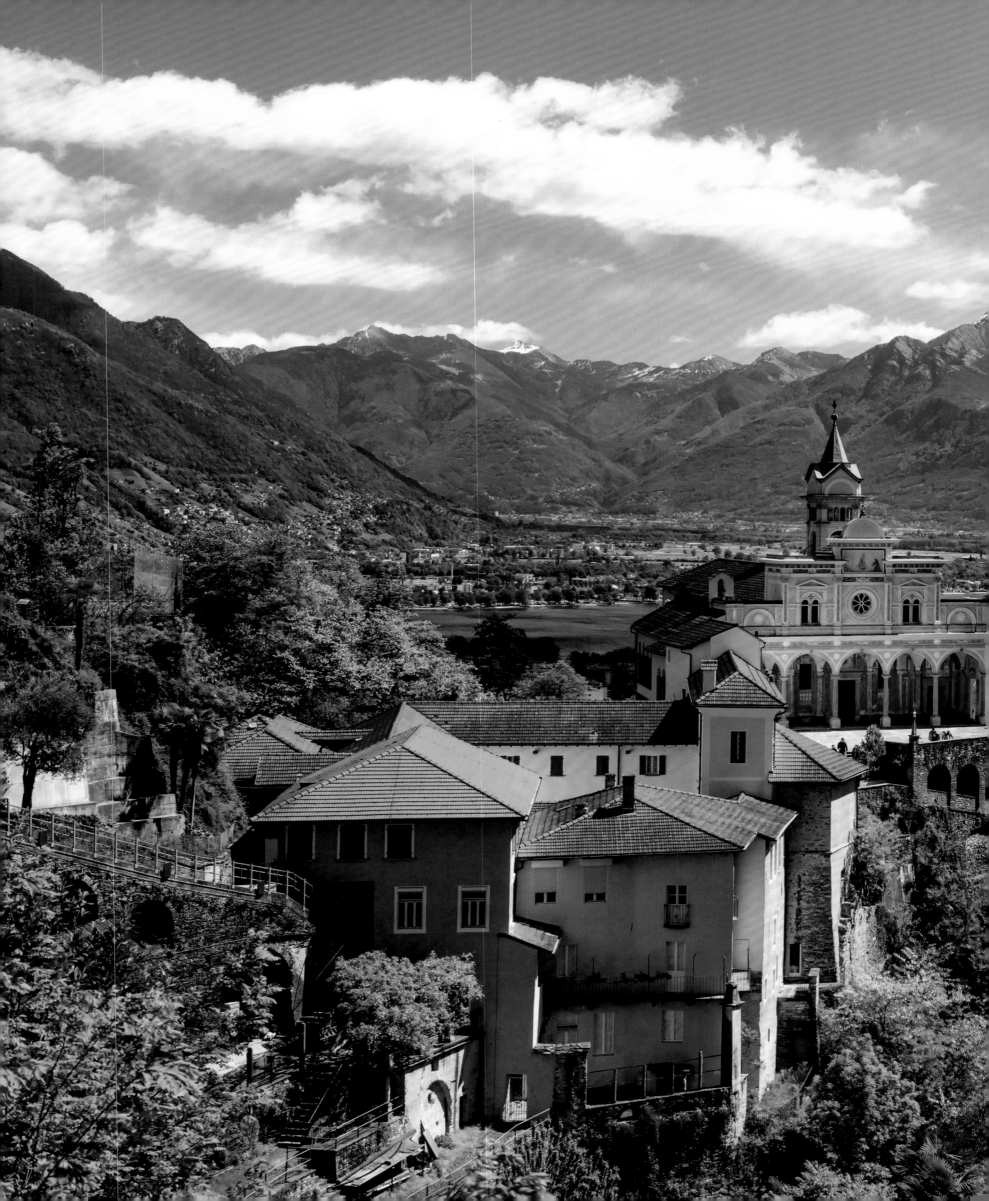

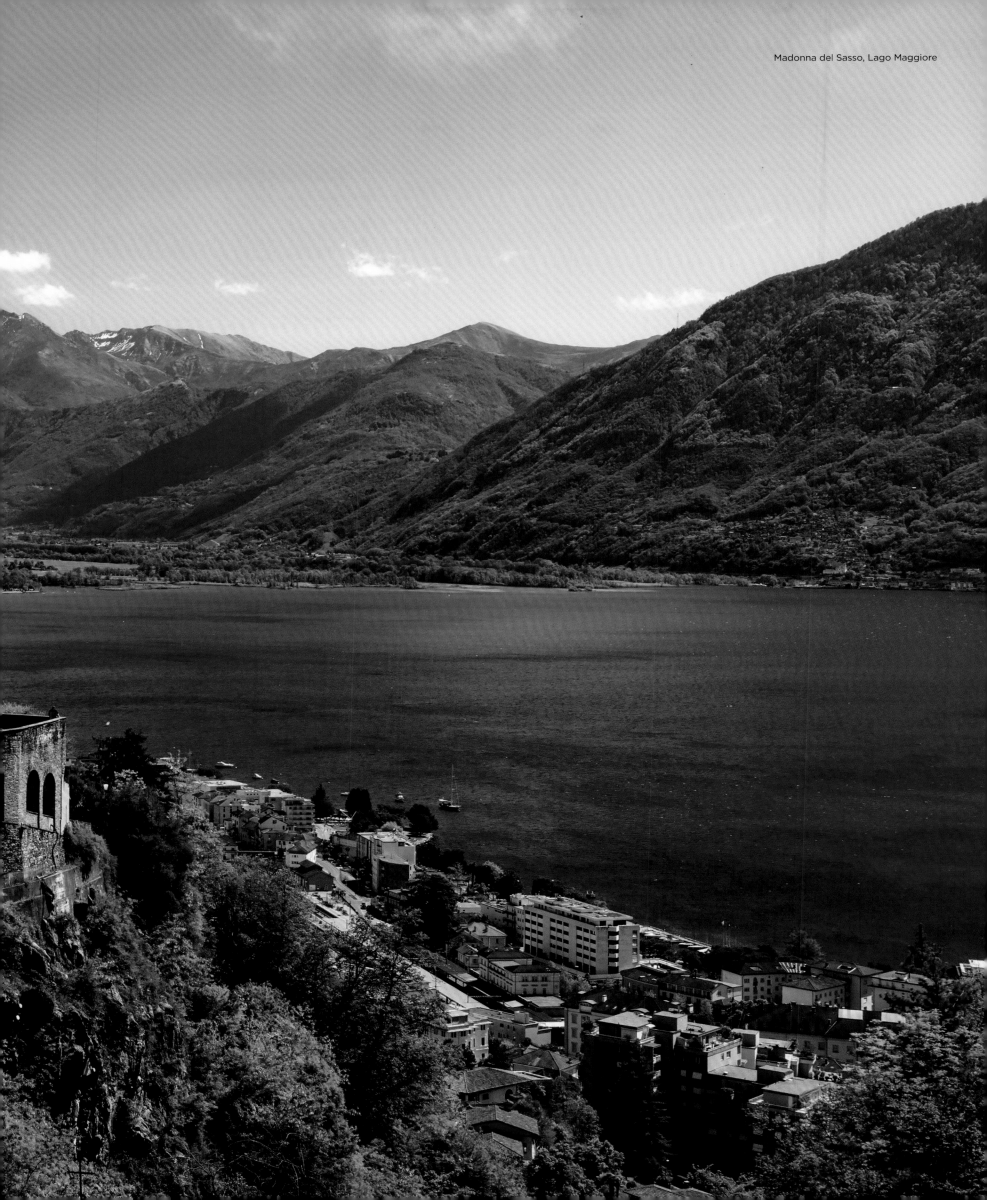

Madonna del Sasso, Lago Maggiore

Lago Lugano, Lugano

Lugano

Lugano is 1200 years old, but except for some churches and palazzi from different epochs (Baroque, Renaissance and Classicism) the city centre is modern. The best view of the picturesquely situated town on the shore a semicircular bay of Lake Lugano can be had from Monte Brè or Monte San Salvatore to the north or south of the bay. Lugano is one of the most important financial centres in Switzerland.

Lugano

La ville de Lugano a beau avoir environ 1200 ans, son centre-ville est plutôt moderne, si l'on excepte quelques églises et palais d'architecture baroque, Renaissance ou classique. C'est depuis le Monte Brè ou le Monte San Salvatore, situés respectivement au nord et au sud, que l'on peut le mieux admirer la vue magnifique sur cette ville qui s'étend le long d'une baie en arc de cercle du lac de Lugano. Lugano est l'une des places financières les plus importantes de Suisse.

Lugano

Zwar ist Lugano gut 1200 Jahre alt, aber bis auf einige Kirchen und Palazzi, die aus verschiedenen Epochen wie Barock, Renaissance oder Klassizismus stammen, ist das Stadtzentrum neuzeitlich. Den besten Überblick über die malerisch an einer halbkreisförmigen Bucht des Luganersees gelegene Stadt hat man vom Monte Brè oder vom Monte San Salvatore nördlich bzw. südlich der Bucht. Lugano ist einer der wichtigsten Finanzplätze der Schweiz.

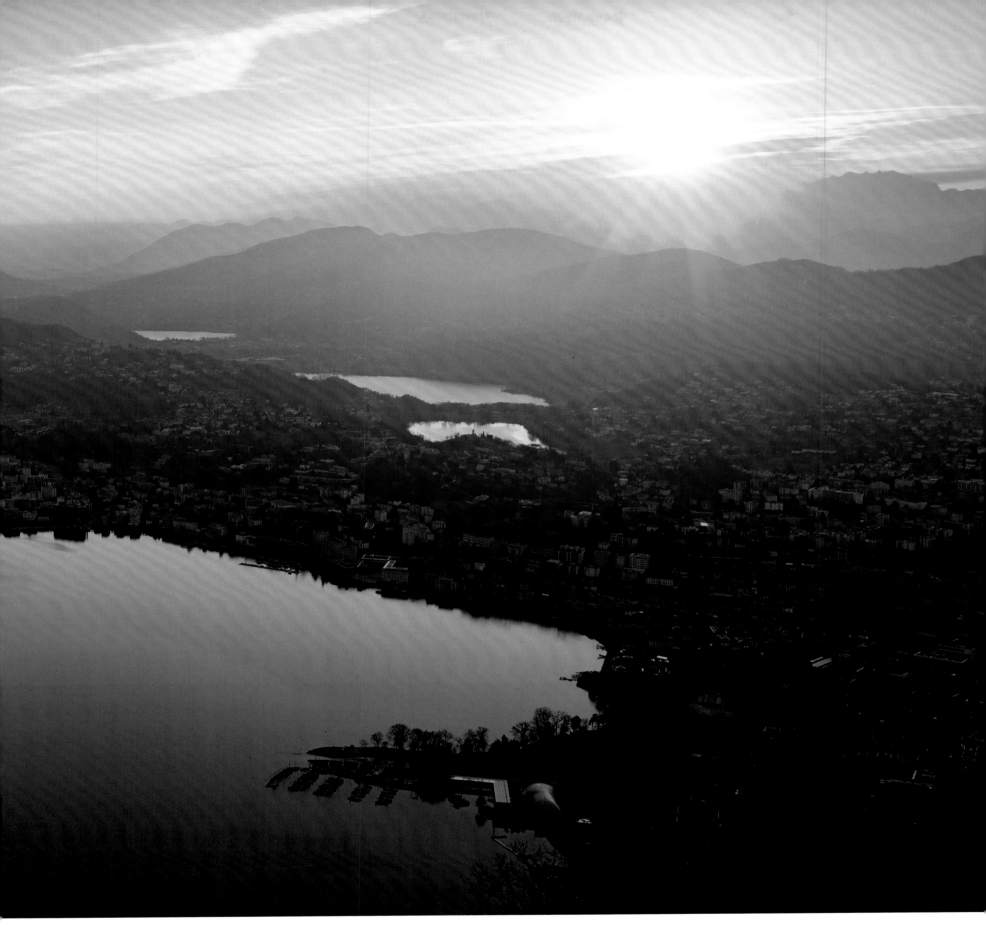

Lugano

Lugano tiene unos 1200 años largos pero, a excepción de algunas iglesias y palacios, que provienen de diferentes épocas como el barroco, el renacimiento o el clasicismo, el centro de la ciudad es moderno. La mejor vista de la pintoresca ciudad situada en una bahía semicircular del lago de Lugano se puede obtener desde Monte Brè o Monte San Salvatore, al norte o al sur de la bahía. Lugano es uno de los centros financieros más importantes de Suiza.

Lugano

Lugano tem 1200 anos, mas com exceção de algumas igrejas e palácios, que têm origem em diferentes épocas como o barroco, o renascimento ou o classicismo, o centro da cidade é moderno. A melhor vista da cidade pitorescamente situada em uma baía semicircular do Lago Lugano pode ser obtida do Monte Brè ou Monte San Salvatore ao norte ou sul da baía. Lugano é um dos centros financeiros mais importantes da Suíça.

Lugano

Lugano is al 1200 jaar oud, maar op enkele kerken en palazzo's uit verschillende stijlperioden zoals barok, renaissance of classicisme na is het stadscentrum modern. Het mooiste uitzicht over de fraai aan een halfronde baai gelegen stad van het gelijknamige meer bieden de Monte Brè ten noorden en de Monte San Salvatore ten zuiden van de baai. Lugano is een van de belangrijkste financiële centra van Zwitserland.

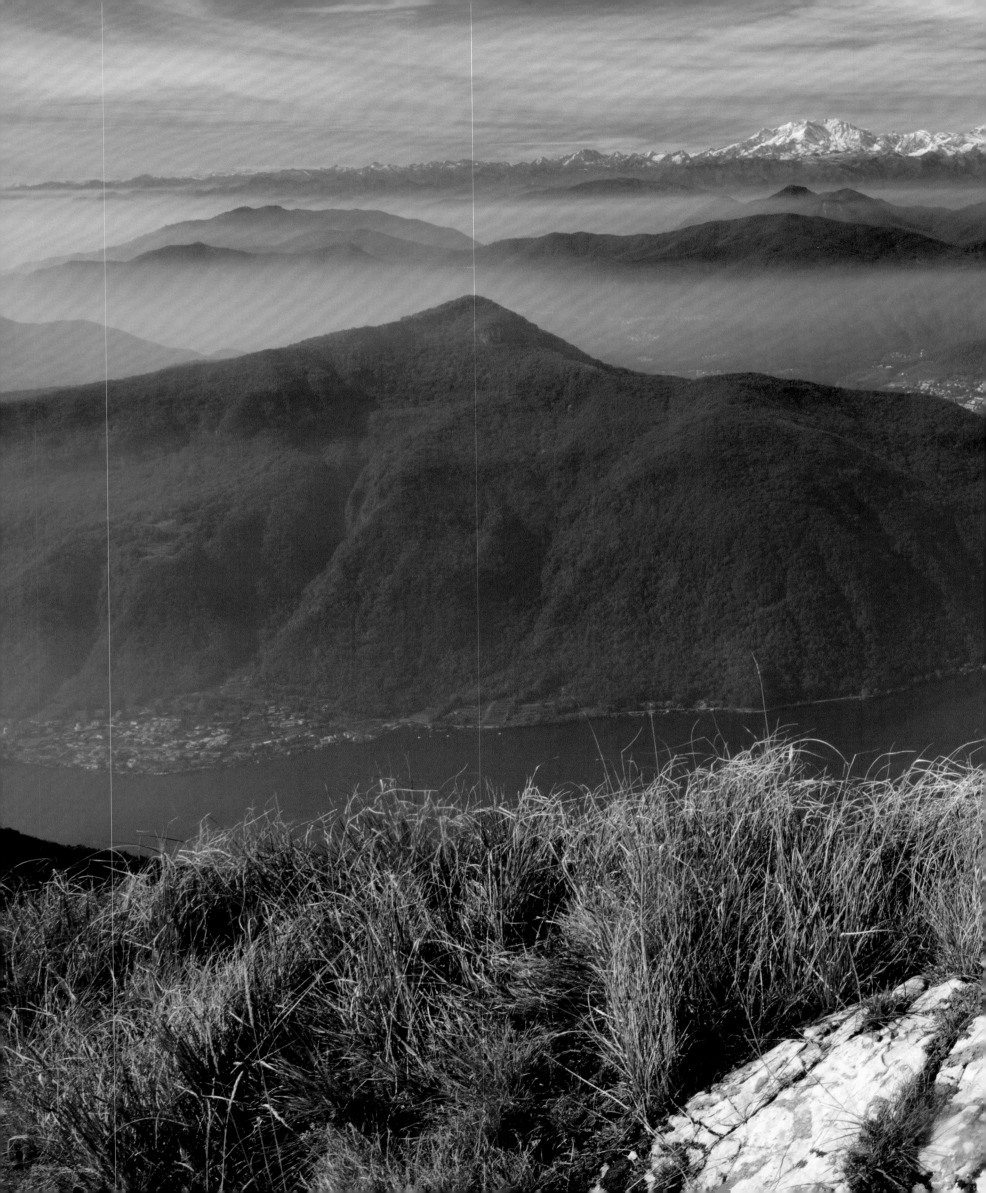

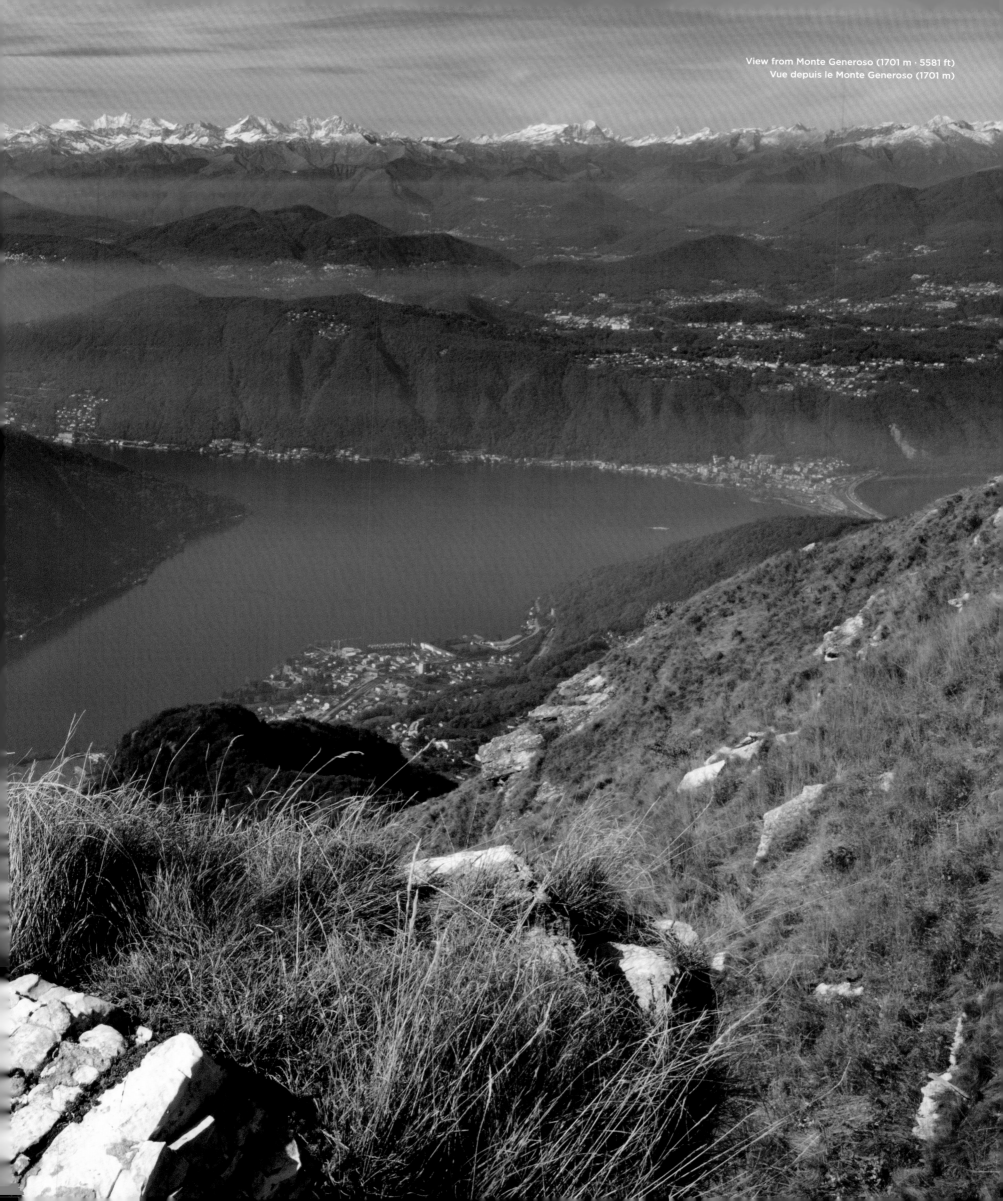

View from Monte Generoso (1701 m · 5581 ft)
Vue depuis le Monte Generoso (1701 m)

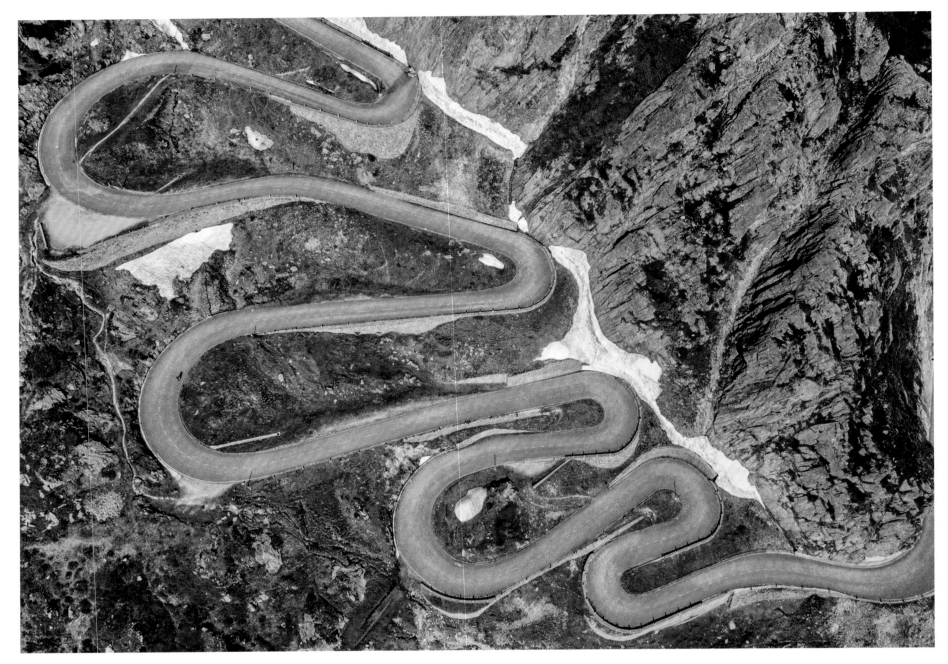

Passo del San Gottardo (2107 m · 6913 ft), Tremola

Gotthard

The main Alpine crossings such as the Gotthard have always been economically important. The Romans used the Gotthard, but it was not until the Middle Ages that it became more important. With the growing transport of people and goods, the infrastructure also grew: from a narrow mule track over wider paths to a road that could be travelled by carriages. Then the "Tremola" was used for car traffic. Tunnel construction began at the end of the 19th century. Today, three tunnels pass under the Gotthard massif, including the longest railway tunnel in the world at 57 km (35 mi). The road tunnel is 17 km (11 mi) long.

Le col du Saint-Gothard

Un point de traversée des Alpes comme le col du Saint-Gothard joue toujours un rôle économique important. Les Romains utilisaient déjà ce col, mais c'est au Moyen Âge qu'il a commencé à compter véritablement. Les infrastructures se sont développées en même temps que le transport d'hommes et de marchandises, passant d'un sentier étroit à un chemin plus large, puis à une route praticable en voiture à cheval. La « Tremola » a ensuite été construite pour la circulation automobile. À la fin du XIXe siècle, on a commencé à creuser un tunnel. Aujourd'hui, trois tunnels traversent le massif du Saint-Gothard, dont un tunnel ferroviaire qui, avec ses 57 km, est le plus long du monde. Le tunnel routier mesure, quant à lui, 17 km.

Gotthard

Eine wichtige Alpenquerung wie der Gotthard ist immer auch ein bedeutender Wirtschaftsfaktor. Schon die Römer nutzten den Gotthard, aber erst im Mittelalter erlangte er größere Bedeutung. Mit dem wachsenden Transport von Menschen und Waren wuchs auch die Infrastruktur: vom schmalen Saumpfad über breitere Wege bis zur Straße, die von Kutschen befahren werden konnte. Die „Tremola" diente dann dem Autoverkehr. Ende des 19. Jahrhundert wurde mit dem Tunnelbau begonnen. Heute unterqueren drei Tunnel das Gotthard-Massiv, darunter der mit 57 km längste Eisenbahntunnel der Welt. Der Straßentunnel ist 17 km lang.

Bodio

San Gotardo

Una importante ruta alpina como la de San Gotardo es siempre un factor económico importante. Los romanos ya utilizaban el San Gotardo, pero no fue hasta la Edad Media que se hizo más importante. Con el crecimiento del transporte de personas y mercancías, la infraestructura también creció: desde la estrecha pista de mulas, pasando por senderos más anchos, hasta la carretera por la que podían conducir coches de caballos. El «Tremola» se utilizaba entonces para el tráfico de coches. La construcción del túnel comenzó a finales del siglo XIX. Hoy en día, tres túneles pasan por debajo del macizo de San Gotardo, incluido el túnel ferroviario más largo del mundo, con 57 km. El túnel de carretera tiene una longitud de 17 km.

Gotardo

Uma importante travessia alpina como a do Gotardo é sempre um factor económico importante. Os romanos já usavam o Gotardo, mas não foi até a Idade Média que ele se tornou mais importante. Com o crescimento do transporte de pessoas e mercadorias, a infra-estrutura também cresceu: desde o estreito caminho de mula sobre caminhos mais largos até à estrada que podia ser conduzida por carruagens. O "Tremola" foi então usado para o trânsito automóvel. A construção do túnel começou no final do século XIX. Hoje, três túneis passam sob o maciço do Gotardo, incluindo o mais longo túnel ferroviário do mundo, com 57 km. O túnel rodoviário tem 17 km de comprimento.

Gotthardpas

Belangrijke Alpenpassen zoals de Gotthardpas waren altijd al van groot economisch belang. Al de Romeinen gebruikten de Gotthardpas, maar pas in de Middeleeuwen nam zijn betekenis flink toe. Het toenemende vervoer van mensen en goederen vereiste een betere infrastructuur en zo groeide het smalle bergpad gaandeweg uit tot een weg voor koetsen. Pas veel later werd deze Via Tremola gebruikt voor het autoverkeer. Met de bouw van tunnels begon men al eind 19e eeuw. Tegenwoordig passeert het verkeer het Gotthardmassief via drie tunnels, waaronder de met 57 km langste spoortunnel ter wereld en een 17 km lange autotunnel.

Lombardia · Lombardy · Lombardie

Castello di Vezio, Lago di Como

Rocca di Manerba, Lago di Garda

Lombardy

One of the largest Italian regions is Lombardy. The northern, alpine part reaches an altitude of almost 4000 m (13123 ft) in the Bernina Group. From the high valleys one descends to the great lakes, such as Lake Como or Lake Garda, and on to the plain of the river Po. The region is economically strong, and tends to distance itself from the poor south of Italy.

La Lombardie

La Lombardie est l'une des plus grandes régions d'Italie. Sa partie septentrionale, alpine, culmine à presque 4000 m d'altitude, dans la chaîne de la Bernina. En descendant des hautes vallées, on arrive à de grands lacs, comme le lac de Côme et le lac de Garde, puis dans la plaine du Pô. Cette région est puissante économiquement et se démarque volontiers du Sud de l'Italie, nettement plus pauvre.

Lombardei

Eine der größten italienischen Regionen ist die Lombardei. Der nördliche, alpine Teil erreicht in der Berninagruppe fast 4000 m Höhe. Von den Hochtälern geht es hinunter zu den großen Seen, etwa dem Comersee oder dem Gardasee, und weiter in die Poebene. Die Region ist wirtschaftlich stark, deshalb grenzt sie sich gern vom armen Süden Italiens ab.

Lombardía

Una de las regiones italianas más grandes es Lombardía. La parte alpina septentrional del macizo de la Bernina alcanza una altitud de casi 4000 metros. Desde los valles altos se desciende hasta los grandes lagos, como el de Como o el de Garda, y se llega a la llanura del Po. La región es económicamente fuerte, por lo que les gusta separarse de los pobres del sur de Italia.

Lombardia

Uma das maiores regiões italianas é a Lombardia. A parte norte e alpina do Grupo Bernina atinge uma altitude de quase 4000 metros. Desde os altos vales você desce até os grandes lagos, como o Lago Como ou o Lago Garda, e segue para a planície do Pó. A região é economicamente forte, e é por isso que também se separa do sul pobre de Itália.

Lombardije

Lombardije is een van de grootste Italiaanse regio's. In het noordelijke deel ligt het Berninamassief met toppen van bijna 4000 meter hoog. Via de hooggelegen valleien daalt men af naar de grote meren, zoals het Comomeer en het Gardameer, en de nog lager gelegen Povlakte. Vanwege de florerende economie zet zich de regio graag af tegen het arme zuiden van Italië.

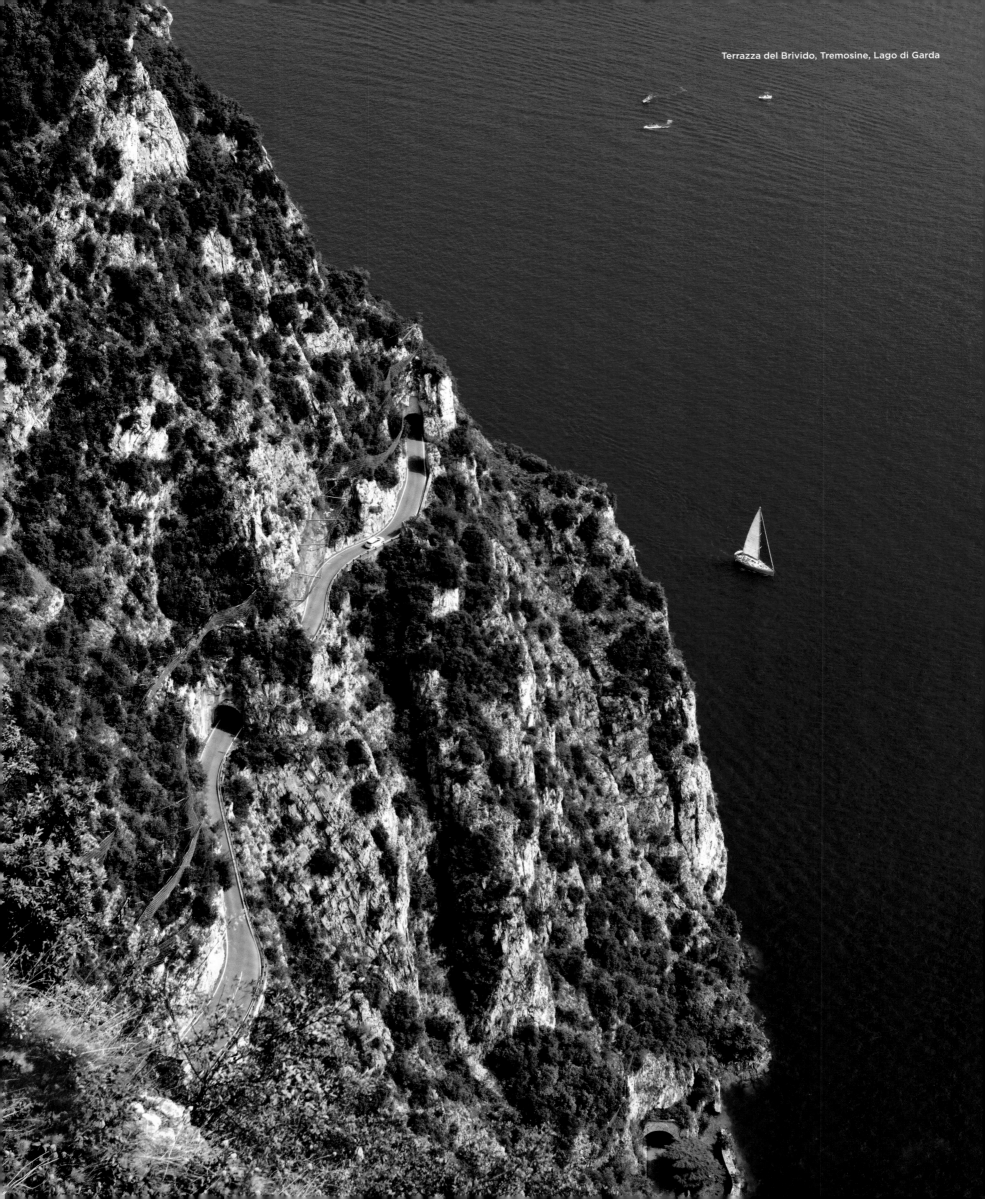

Terrazza del Brivido, Tremosine, Lago di Garda

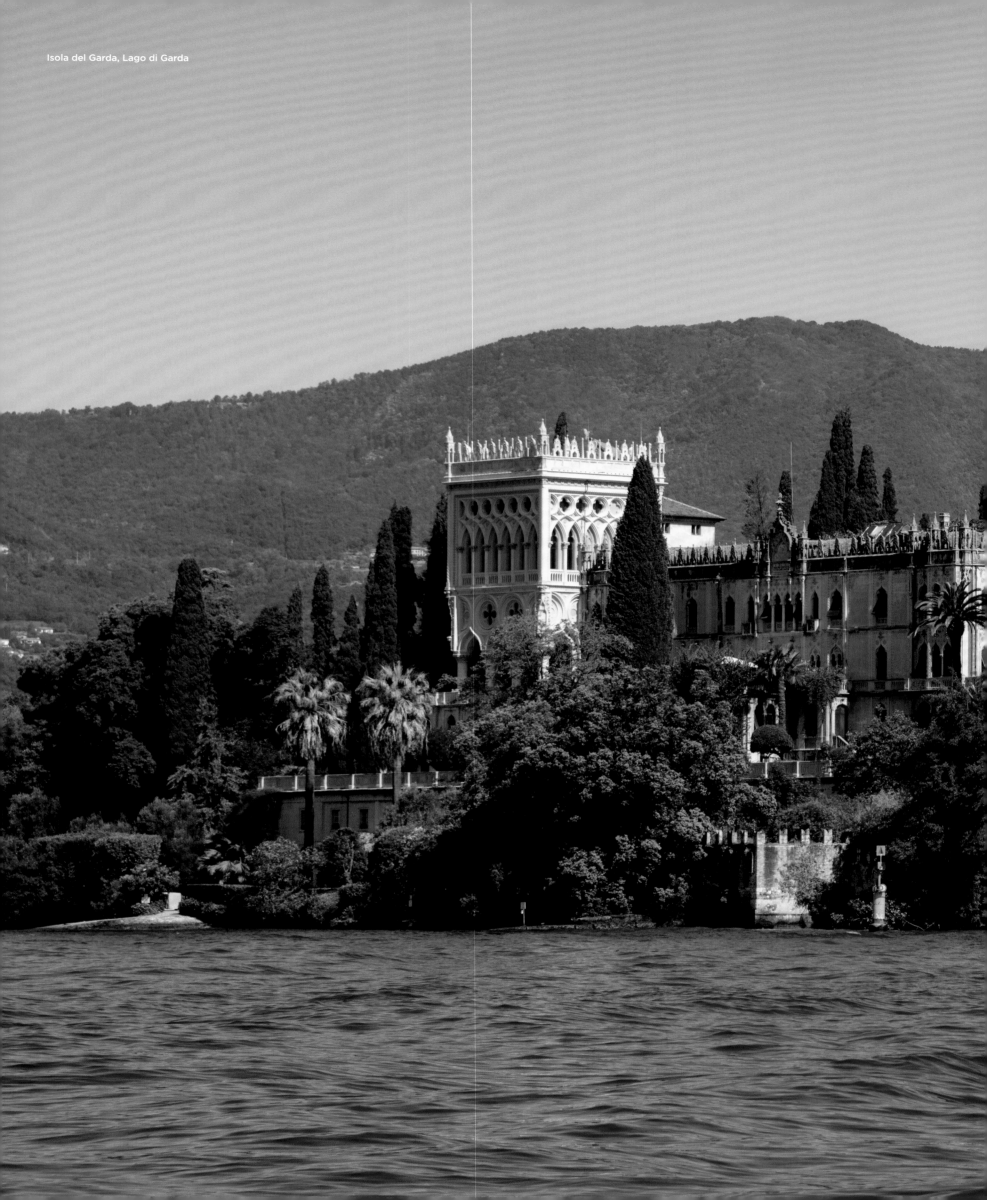

Isola del Garda, Lago di Garda

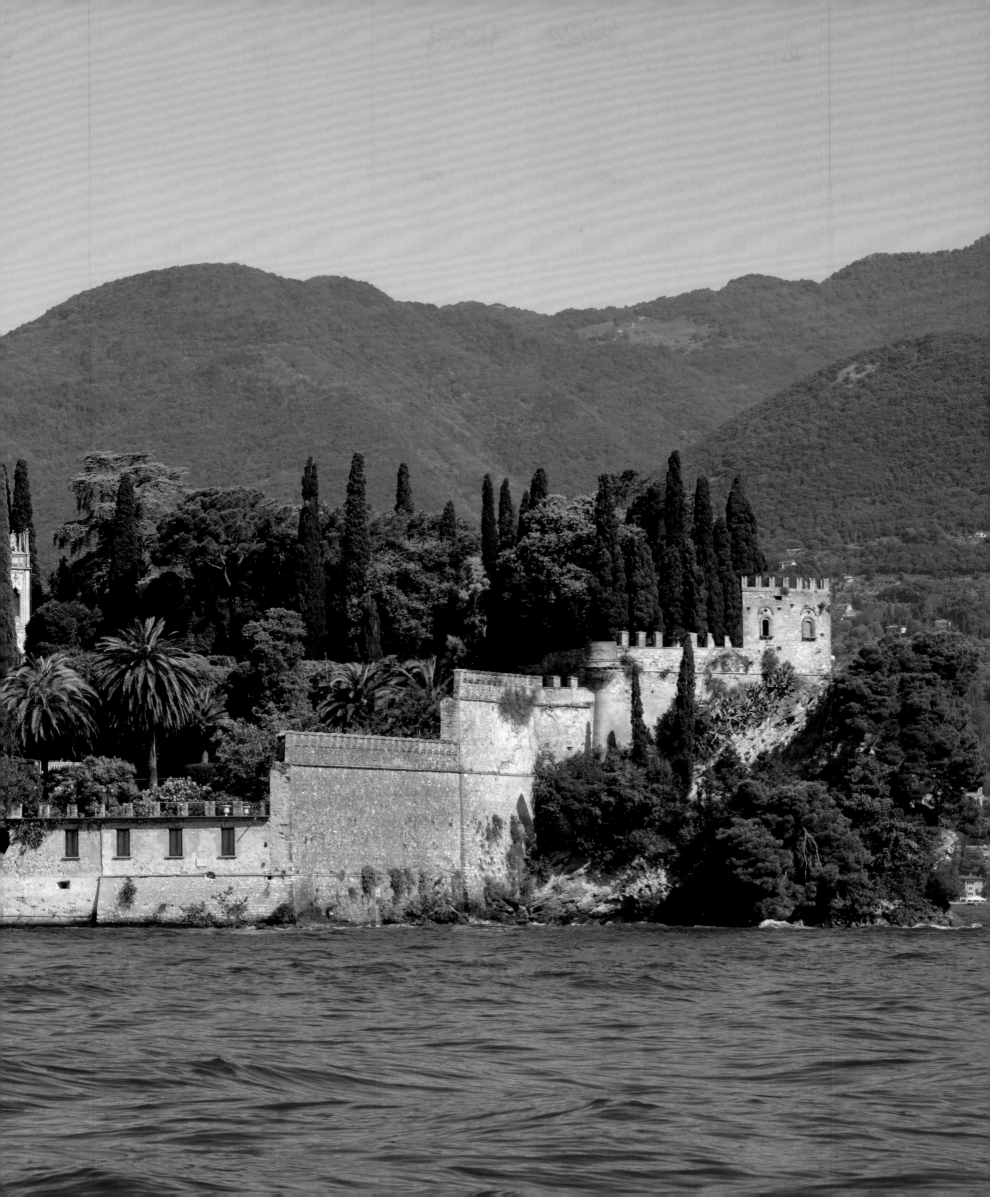

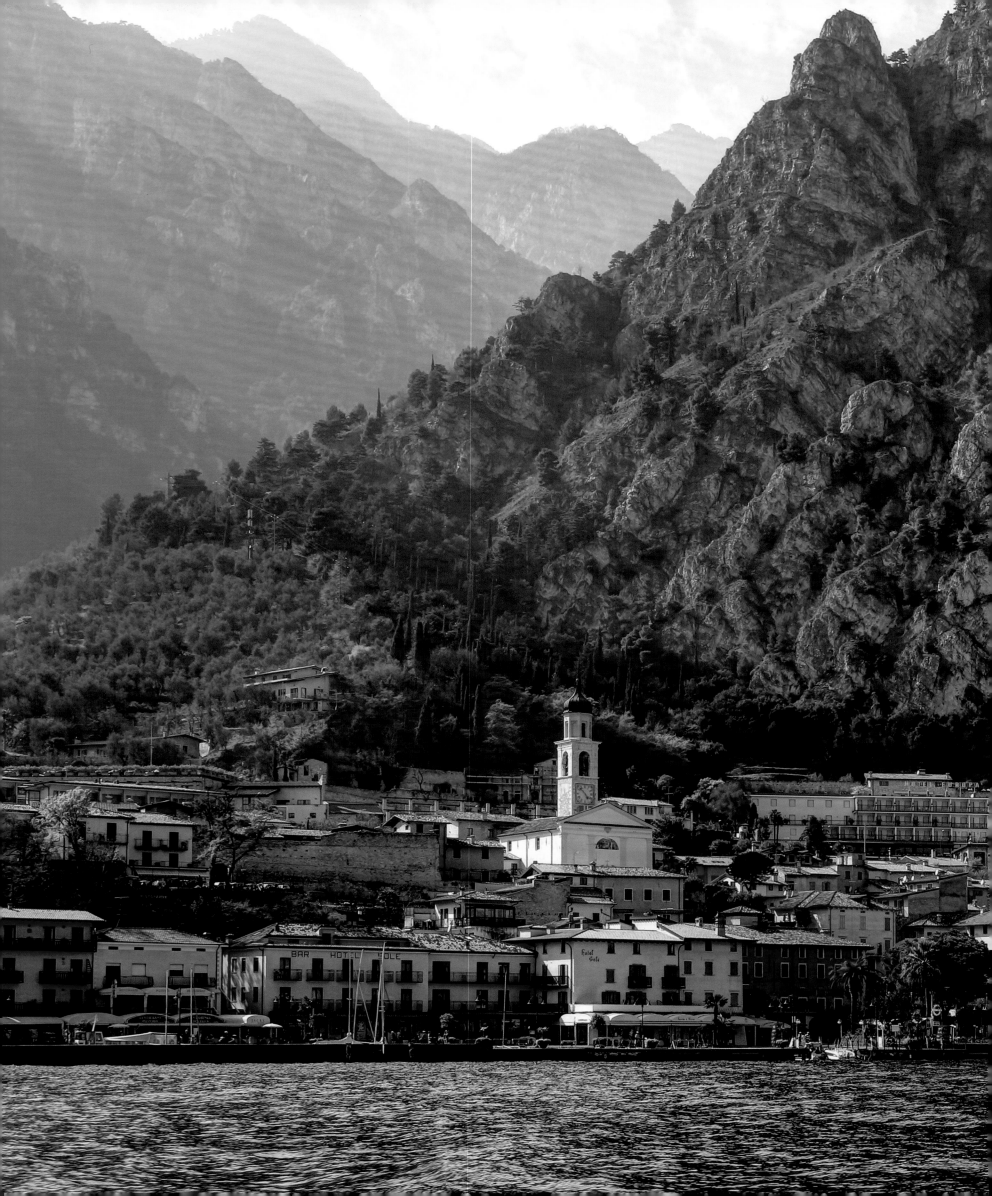

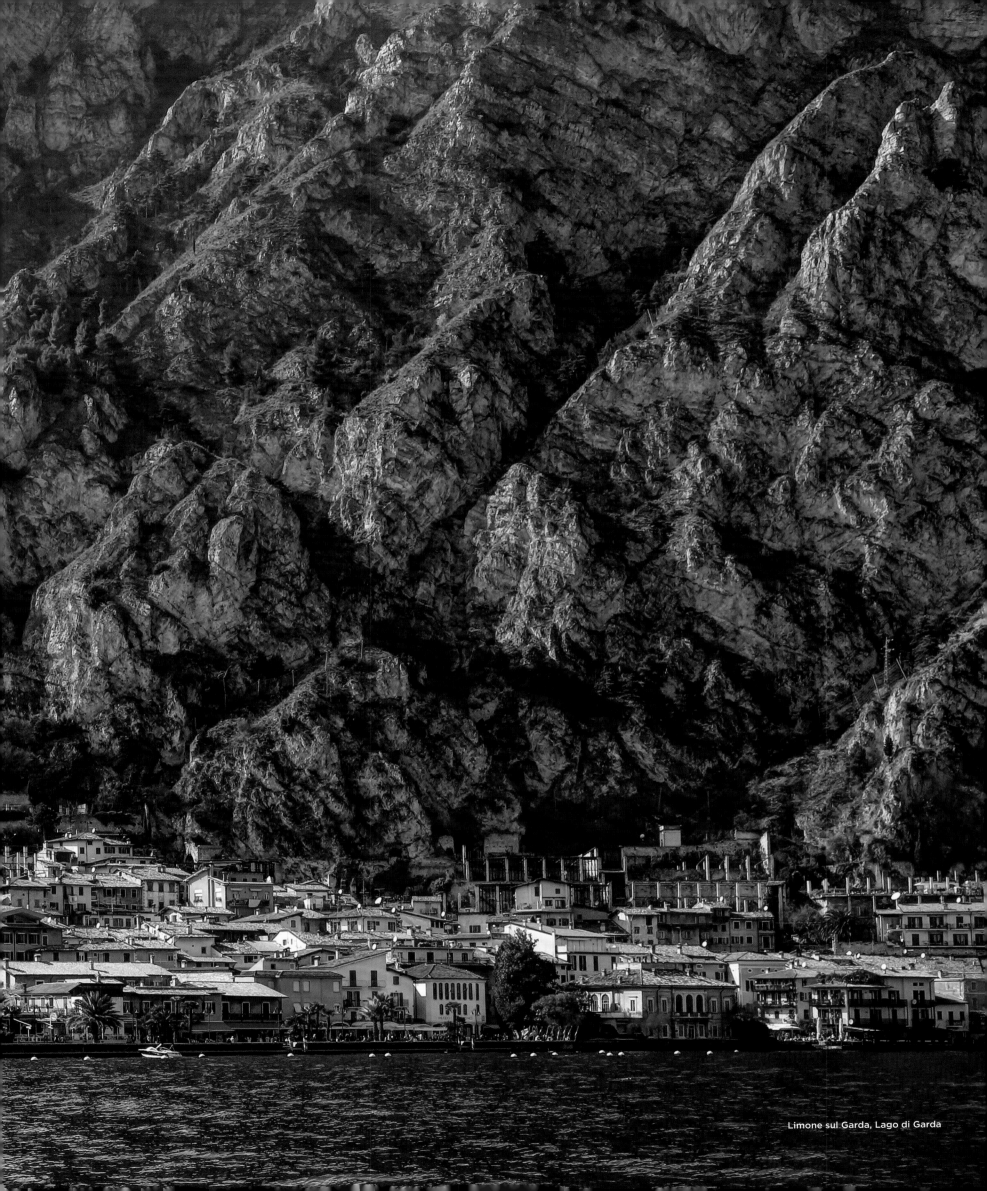

Limone sul Garda, Lago di Garda

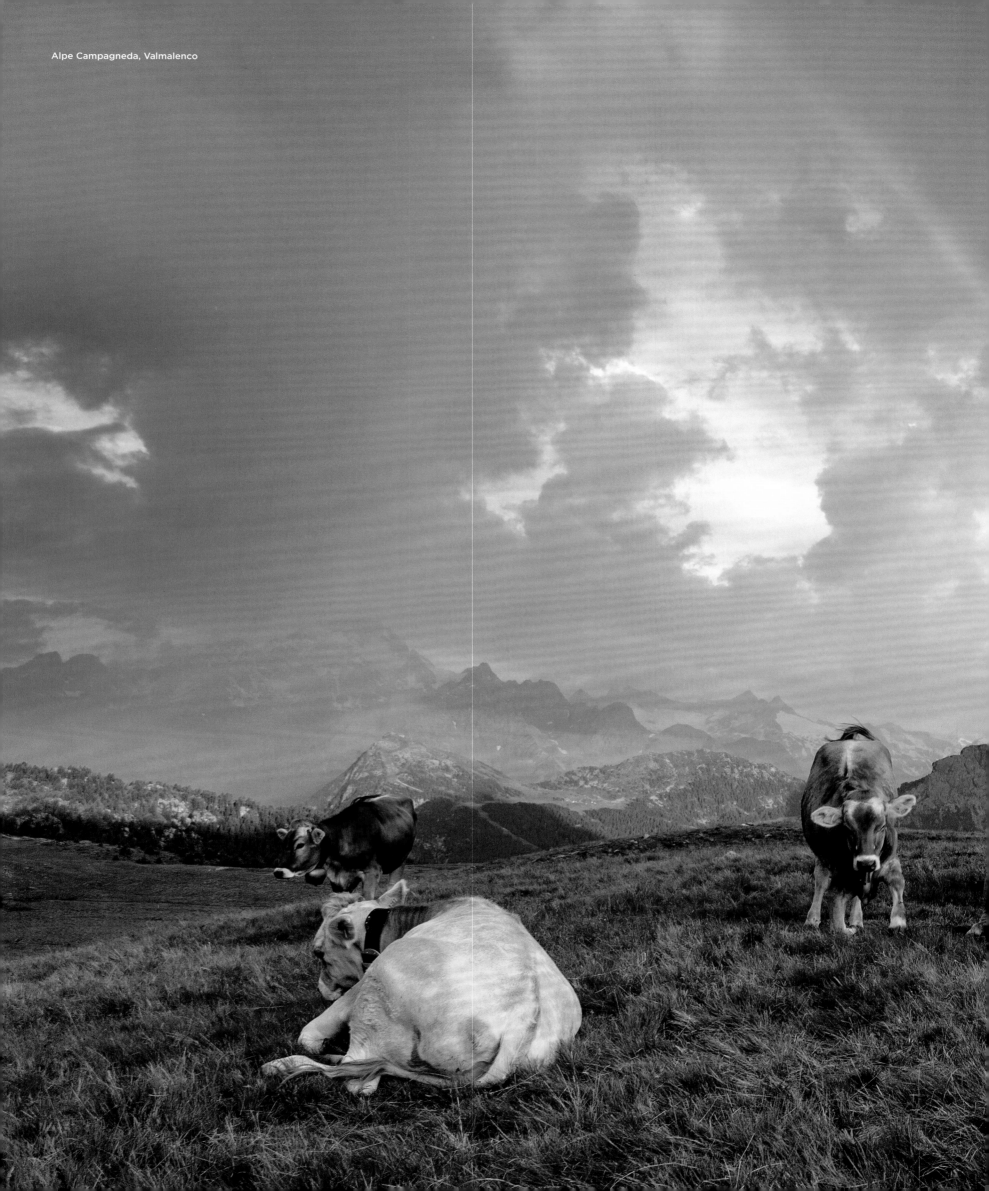

Alpe Campagneda, Valmalenco

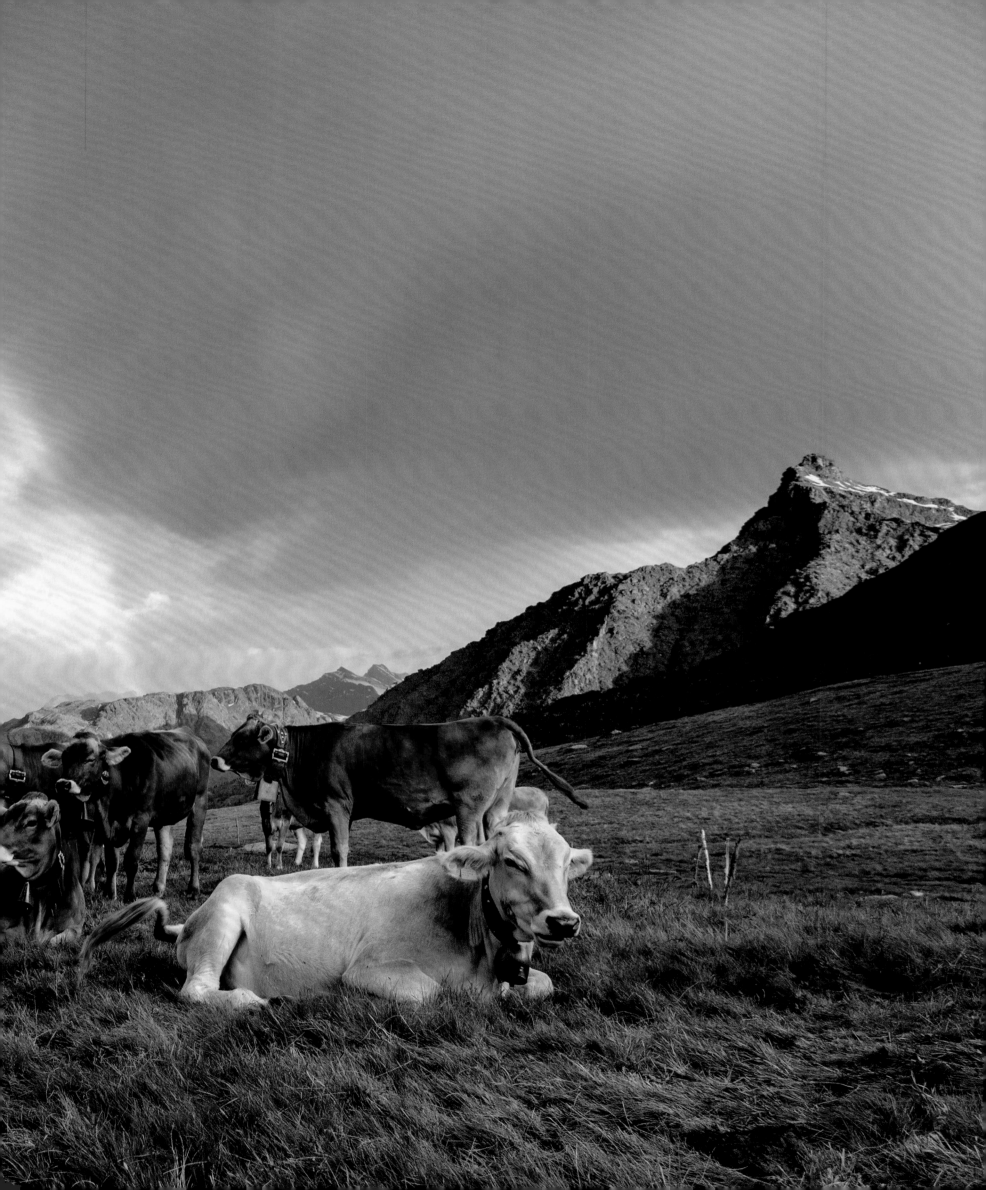

Lago d'Iseo, Sulzano, Monte Isola

Lago d'Iseo

The Lago d'Iseo is the smallest and most unknown of the large lakes in northern Italy. Steep rock faces and lush Mediterranean flora make it a holiday paradise. In 2016, the lake temporarily achieved world fame with a spectacular installation by the artists Christo and Jeanne-Claude: The 16 m (52 ft) wide, yellow illuminated, walk-in "Floating Piers" spanned the lake from Sulzano on the eastern shore to the island of Monte Isola and on to the small island of San Paolo. In the two weeks of its existence, more than a million people took the opportunity to walk across the water.

Le lac d'Iseo

Parmi les grands lacs du Nord de l'Italie, le lac d'Iseo est le plus petit et le moins connu. Ses parois rocheuses abruptes et sa flore méditerranéenne luxuriante en font un petit paradis pour les vacanciers. En 2016, ce lac a pourtant acquis une renommée mondiale, grâce à une installation spectaculaire due aux artistes Christo et Jeanne-Claude : leurs « Floating Piers » (jetées flottantes), d'un jaune vif, mesuraient 16 m de large et étaient praticables à pied, reliant Sulzano, sur le rivage est du lac, à l'île de Monte Isola, puis à la petite île de San Paolo. En l'espace de deux semaines, plus d'un million de personnes ont ainsi saisi l'opportunité de marcher sur l'eau.

Lago d'Iseo

Unter den großen norditalienischen Seen ist der Lago d'Iseo der kleinste und unbekannteste. Steil abfallende Felswände und üppig mediterran blühende Flora machen ihn zu einem Urlaubsparadies. 2016 erlangte der See vorübergehend Weltruhm durch eine spektakuläre Installation der Künstler Christo und Jeanne-Claude: Die 16 m breiten, gelb leuchtenden, begehbaren „Floating Piers" überspannten den See von Sulzano am Ostufer bis zur Insel Monte Isola und weiter bis zum Inselchen San Paolo. In den zwei Wochen des Bestehens nutzten mehr als eine Million Menschen die Gelegenheit, über das Wasser zu wandeln.

Lago d'Iseo, Iseo Lungolago

Lago d'Iseo

El Lago d'Iseo es el más pequeño y desconocido de los grandes lagos del norte de Italia. Las escarpadas paredes rocosas y la exuberante flora mediterránea lo convierten en un paraíso vacacional. En 2016, el lago alcanzó temporalmente fama mundial con una espectacular instalación de los artistas Christo y Jeanne-Claude: los «Floating Piers» de 16 m de ancho sobre los que se podían caminar y que estaban iluminados en amarillo atravesaban el lago desde Sulzano, en la orilla oriental, hasta la isla de Monte Isola y la pequeña isla de San Pablo. En las dos semanas de su existencia, más de un millón de personas aprovecharon la oportunidad de caminar sobre el agua.

Lago d'Iseo

O Lago d'Iseo é o menor e mais desconhecido dos grandes lagos do norte da Itália. Os rostos íngremes das rochas e a exuberante flora mediterrânica fazem dele um paraíso de férias. Em 2016, o lago alcançou temporariamente a fama mundial com uma espetacular instalação dos artistas Christo e Jeanne-Claude: os 16 metros de largura, iluminados de amarelo, caminhando em "Piers Flutuantes" atravessaram o lago desde Sulzano, na margem leste, até a ilha de Monte Isola e até a pequena ilha de San Paolo. Nas duas semanas da sua existência, mais de um milhão de pessoas aproveitaram a oportunidade para caminhar sobre a água.

Meer van Iseo

Het Meer van Iseo (Lago d'Iseo) is het kleinste en tevens onbekendste van de grote meren in Noord-Italië. Toch is het een vakantieparadijs met steile rotswanden en weelderige mediterrane flora. In 2016 verwierf het meer tijdelijk wereldfaam met een spectaculaire installatie van de kunstenaars Christo en Jeanne-Claude: twee weken lang overspanden de 16 m brede, geel verlichte, begaanbare 'Floating Piers' het meer van Sulzano aan de oostkust tot aan de eilanden Monte Isola en San Paolo. Ruim een miljoen mensen maakten van de gelegenheid gebruik gemaakt om eens over het water te lopen.

Cervo, Parco Nazionale dello Stelvio
Deer, Stelvio National Park

National Park Stelvio Pass

The pass Stilfser Joch spectacularly screws its way up to a height of 2757 m (9045 ft). In summer it exerts a magical fascination: Cyclists torture themselves to the top of the pass, and motorcyclists enjoy the winding route. The pass gave its name to the national park of almost 1350 km² (839 sq mi), which was founded in 1935 and today is one of the largest high mountain protected areas in the Alps. It reaches from an altitude of about 600 m (1968 ft) to 3000 m (9843 ft) in higher regions. The park is characterized by a rich flora and fauna, including deer which can be observed again regularily after having become almost extinct in the region.

Le parc national du Stelvio

Le col du Stelvio s'élève majestueusement en lacets jusqu'à une altitude de 2 757 m. En été, il offre un spectacle fascinant : les cyclistes grimpent péniblement la côte, tandis que les motards se font plaisir dans les virages. Ce col a donné son nom à un parc national d'une superficie de près de 1350 m², fondé en 1935, qui constitue l'une des plus grandes zones protégées de haute montagne des Alpes. Il commence à 600 m d'altitude et s'élève jusqu'à 3 000 m. Ce parc se distingue par sa flore et sa faune extrêmement riches. On peut notamment y observer de nombreux cerfs qui, pourtant à une époque, avaient presque disparu.

Nationalpark Stilfser Joch

Das Stilfser Joch schraubt sich spektakulär auf eine Höhe von 2757 m. Im Sommer übt es eine magische Faszination aus: Radfahrer quälen sich auf die Passhöhe, und Motorradfahrer genießen die kurvige Strecke. Der Pass ist Namensgeber für den knapp 1350 km² umfassenden Nationalpark, der 1935 gegründet wurde und heute eines der größten Hochgebirgs-Schutzgebiete in den Alpen darstellt. Er reicht von etwa 600 m Höhe bis in hochalpine Regionen von 3000 m. Der Park zeichnet sich durch eine reiche Flora und Fauna aus, auch Rotwild ist wieder reichlich zu beobachten, nachdem es hier fast ausgestorben war.

Ermellino, Parco Nazionale dello Stelvio
Stoat, Stelvio National Park

Parque Nacional del Stelvio

El Paso Stelvio se enrosca de manera espectacular hasta alcanzar una altura de 2757 m. En verano genera una fascinación mágica: los ciclistas luchan por llegar hasta la cima del paso y los motociclistas disfrutan de la sinuosa ruta. El paso ha dado el nombre al parque nacional de casi 1350 km², que fue fundado en 1935 y que hoy en día es una de las mayores áreas protegidas de alta montaña de los Alpes. Alcanza, desde unos 600 m, una altitud de 3000 m en regiones de alta montaña. El parque se caracteriza por una rica flora y fauna, y también pueden volver a verse venados en abundancia, despúes haberse casi extinguido en el lugar.

Yoke do Parque Nacional Stelvio

O Stilfser Joch aparafusa espetacularmente o seu caminho até uma altura de 2757 m. No verão exerce um fascínio mágico: Os ciclistas se torturam até o topo do passe, e os motociclistas desfrutam da rota sinuosa. O passe é o epónimo do parque nacional de quase 1350 km², que foi fundado em 1935 e é hoje uma das maiores áreas protegidas de alta montanha dos Alpes. Atinge desde uma altitude de cerca de 600 m até 3000 m em regiões alpinas altas. O parque é caracterizado por uma rica flora e fauna, também veado vermelho pode ser observado novamente abundantemente, depois de quase extinto aqui.

Nationaal park Stelvio-Stilfser Joch

Het hoogste punt van de bergpas Stilfser Joch ligt op 2757 m en heeft 's zomers een magische aantrekkingskracht op toeristen: fietsers stampen zwetend naar de top en motorrijders genieten er van de vele haardspeldbochten. Het gelijknamige, in 1935 gestichte nationaal park meet bijna 1350 km² en is tegenwoordig een van de grootste natuurreservaten in het hooggebergte van de Alpen. De laagste delen van het park liggen op 600 m, de hoogste op 3000 m hoogte. Het park wordt gekenmerkt door een rijke flora en fauna. Zelfs edelherten, die hier al bijna uitgestorven waren, zijn er weer volop te zien.

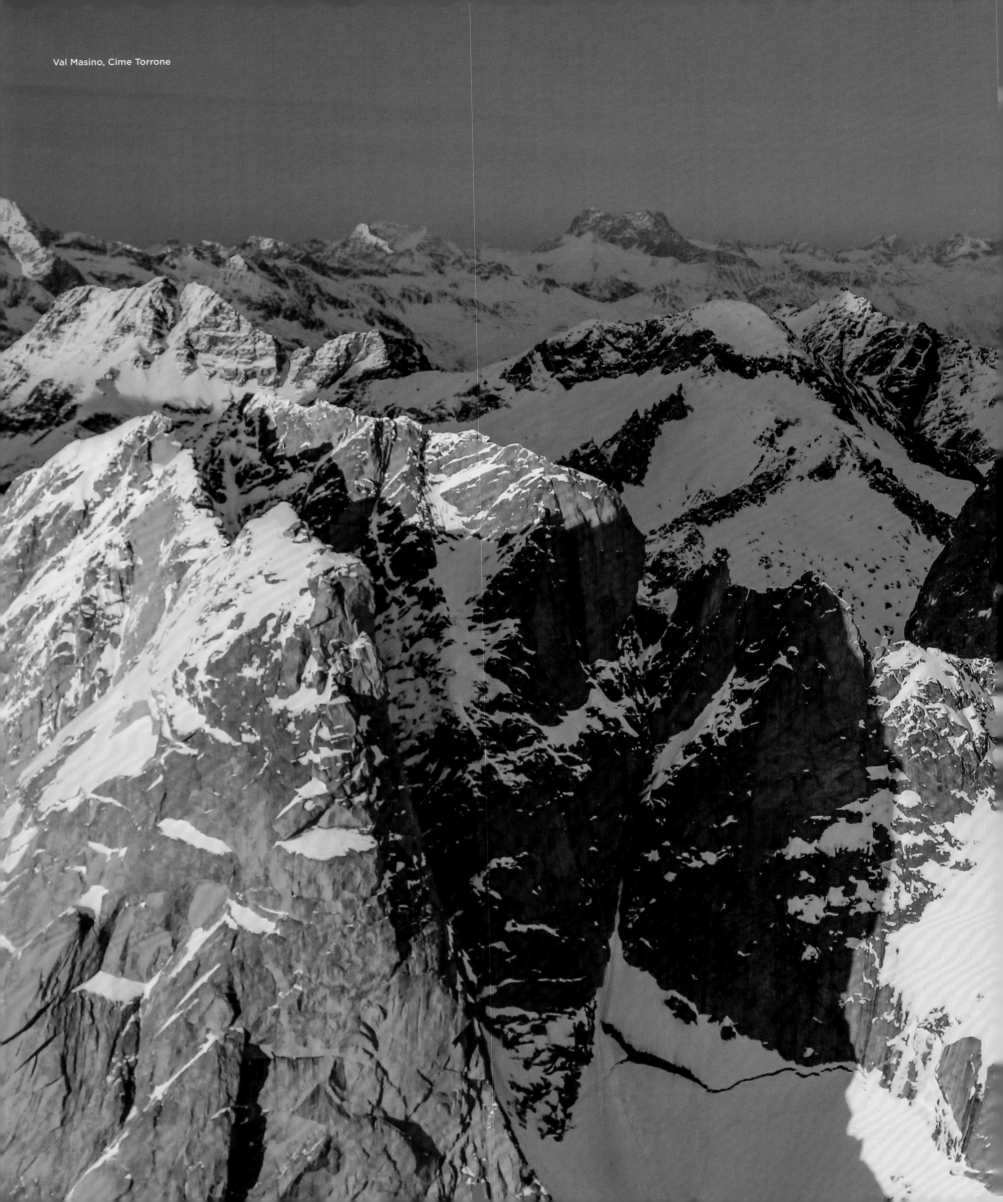

Val Masino, Cime Torrone

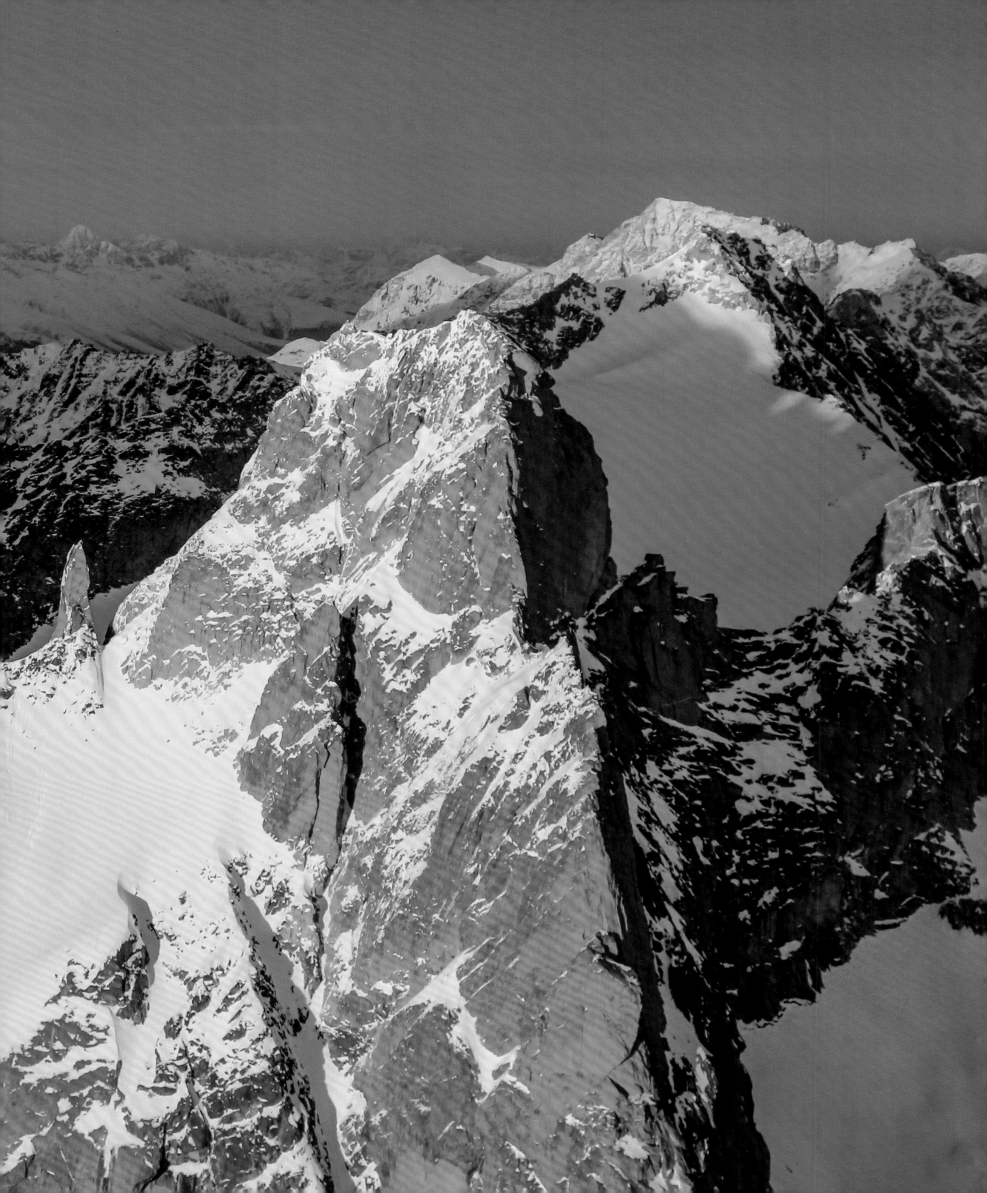

Graubünden · Grigioni · Grisons

Piz Bernina (4049 m · 13284 ft), Piz Roseg (3937 m · 12917 ft)

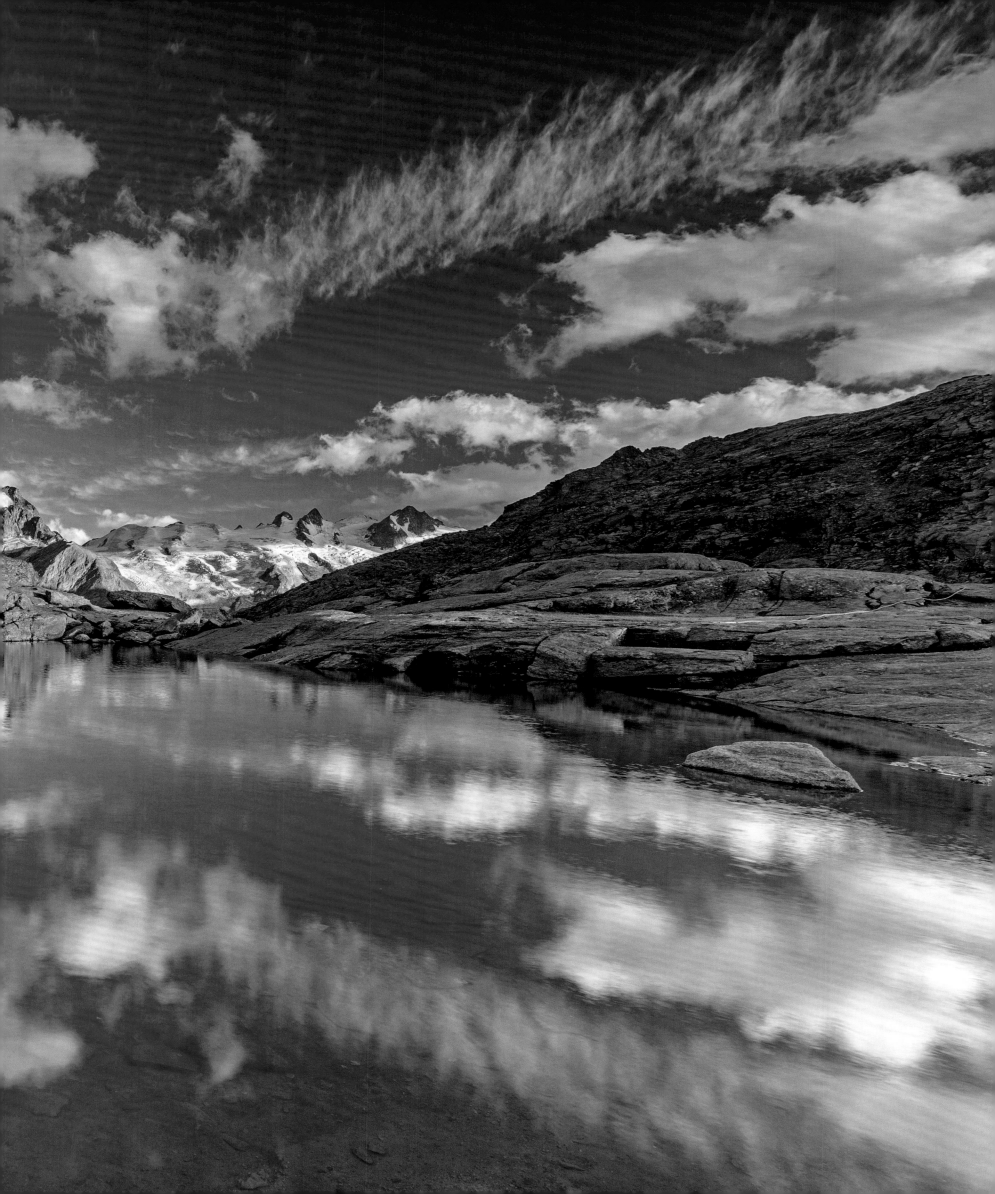

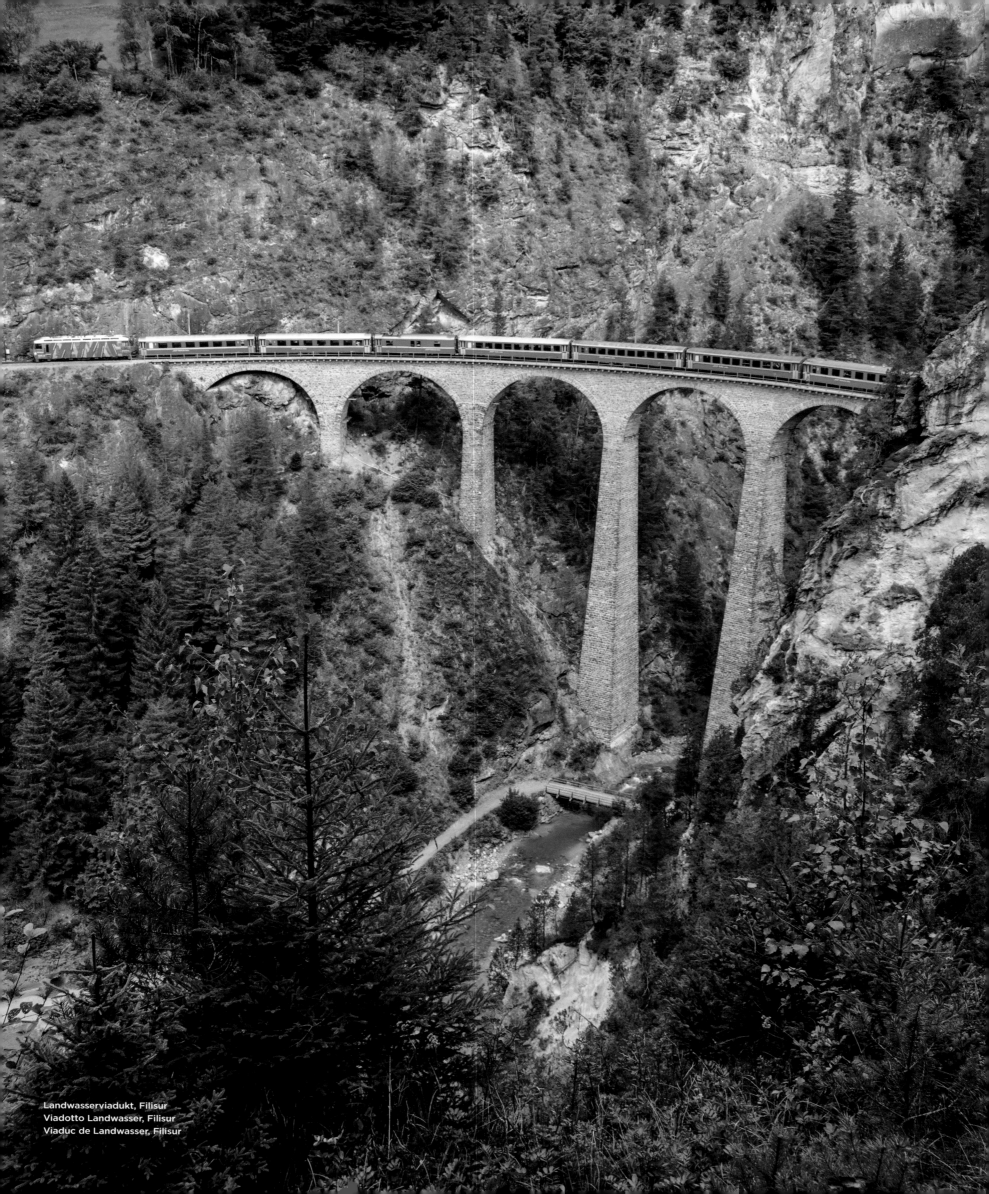

Landwasserviadukt, Filisur
Viadotto Landwasser, Filisur
Viaduc de Landwasser, Filisur

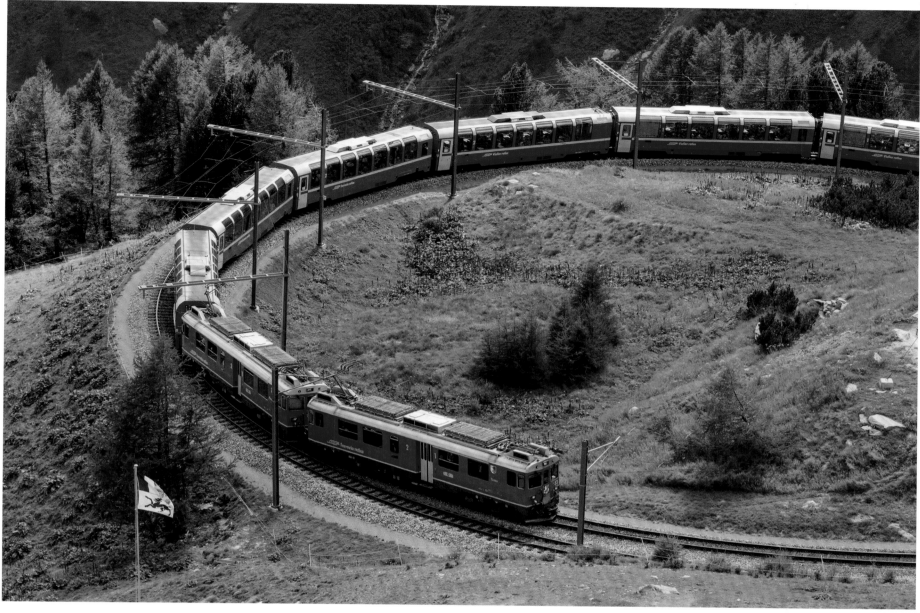

Bernina Express, Alp Grüm (2103 m · 6900 ft)

Grisons

The Rhine flows through the largest Swiss canton. Mountain peaks, lakes and high valleys characterise the landscape. The winters are snowy, so one finds important winter sports resorts such as Arosa, Davos and St. Moritz in the canton. One of the most beautiful and spectacular train routes in the Alps is the Bernina Express from Chur via Pontresina to Tirano in Italy.

Les Grisons

Le plus étendu des cantons de Suisse est arrosé par le Rhin. Le paysage est composé de sommets, de lacs et de hauts plateaux. Les hivers sont très neigeux, ce qui explique qu'on y trouve d'importantes stations de sports d'hiver, comme Arosa, Davos et Saint-Moritz. L'une des lignes de chemin de fer les plus belles et les plus impressionnantes des Alpes, le Bernina Express, relie Coire à Pontresina, puis à Tirano, en Italie.

Graubünden

Der größte Schweizer Kanton wird vom Rhein durchflossen. Berggipfel, Seen und Hochtäler prägen die Landschaft. Die Winter sind schneereich, deshalb findet man hier bedeutende Wintersportorte wie Arosa, Davos und St. Moritz. Eine der schönsten und spektakulärsten Zugstrecken der Alpen führt mit dem Bernina-Express von Chur über Pontresina ins italienische Tirano.

Grisones

El Rin atraviesa el mayor cantón suizo. El paisaje se caracteriza por picos de montaña, lagos y valles altos. Los inviernos son nevados, por lo que aquí encontramos importantes centros de deportes de invierno como Arosa, Davos y St. Moritz. Una de las más bellas y espectaculares rutas de tren en los Alpes lleva el Bernina Express desde Coira, pasando por Pontresina, hasta Tirano en Italia.

Grisões

O Reno atravessa o maior cantão suíço. Picos de montanha, lagos e vales altos caracterizam a paisagem. Os invernos são nevados, então você vai encontrar importantes resorts de esportes de inverno como Arosa, Davos e St. Uma das mais belas e espetaculares rotas de trem nos Alpes leva o Bernina Express de Chur via Pontresina até Tirano na Itália.

Graubünden

In het grootste Zwitserse kanton ontspringt de Rijn en bepalen bergtoppen, meren en hooggelegen valleien het landschapsbeeld. De winters zijn sneeuwrijk en daarom verbaast het niet dat de streek bekende wintersportplaatsen herbergt zoals Arosa, Davos en St. Moritz. Een van de mooiste en spectaculairste treinroutes in de Alpen, de Berninabahn, loopt van Chur via Pontresina naar Tirano in Italië.

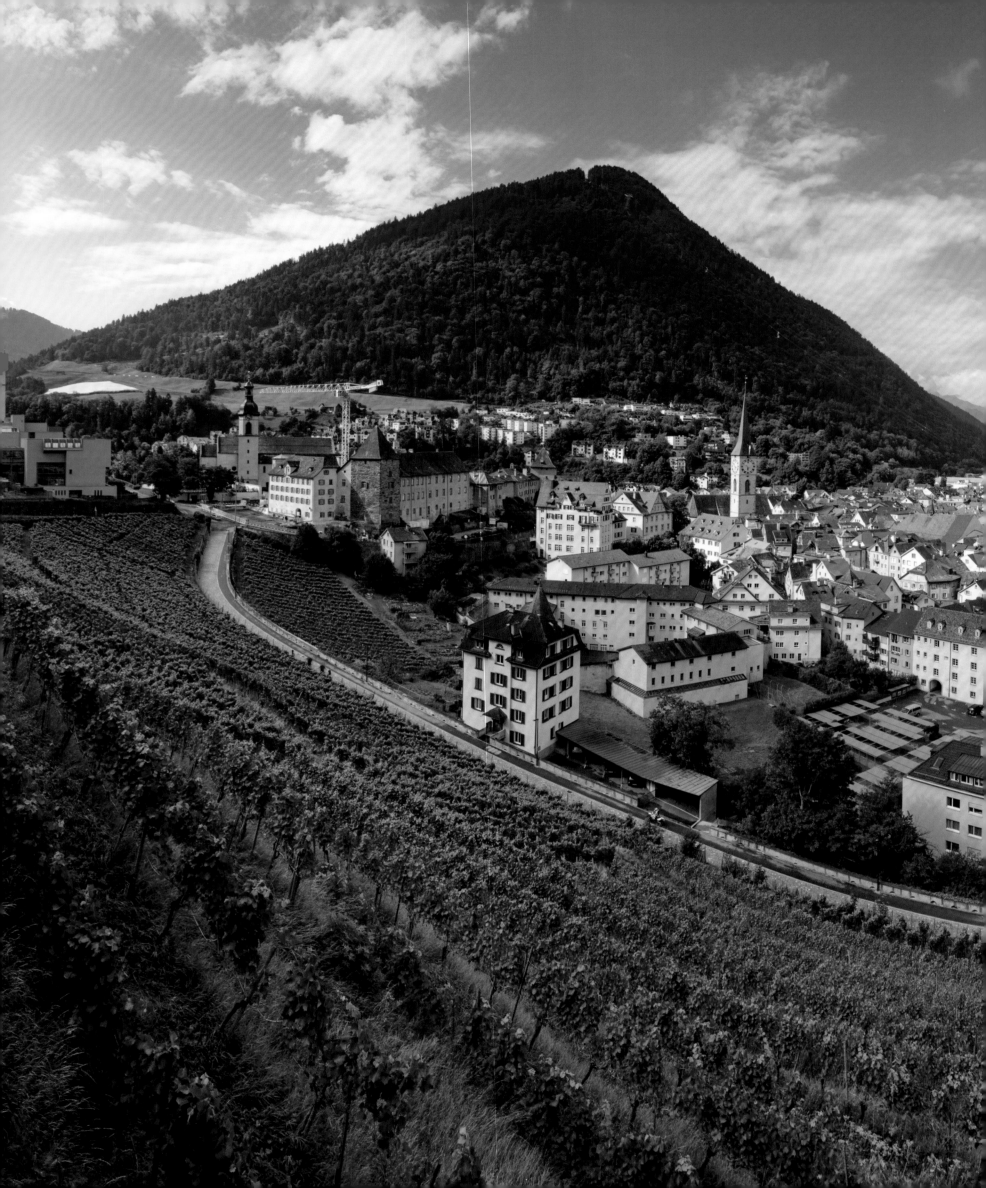

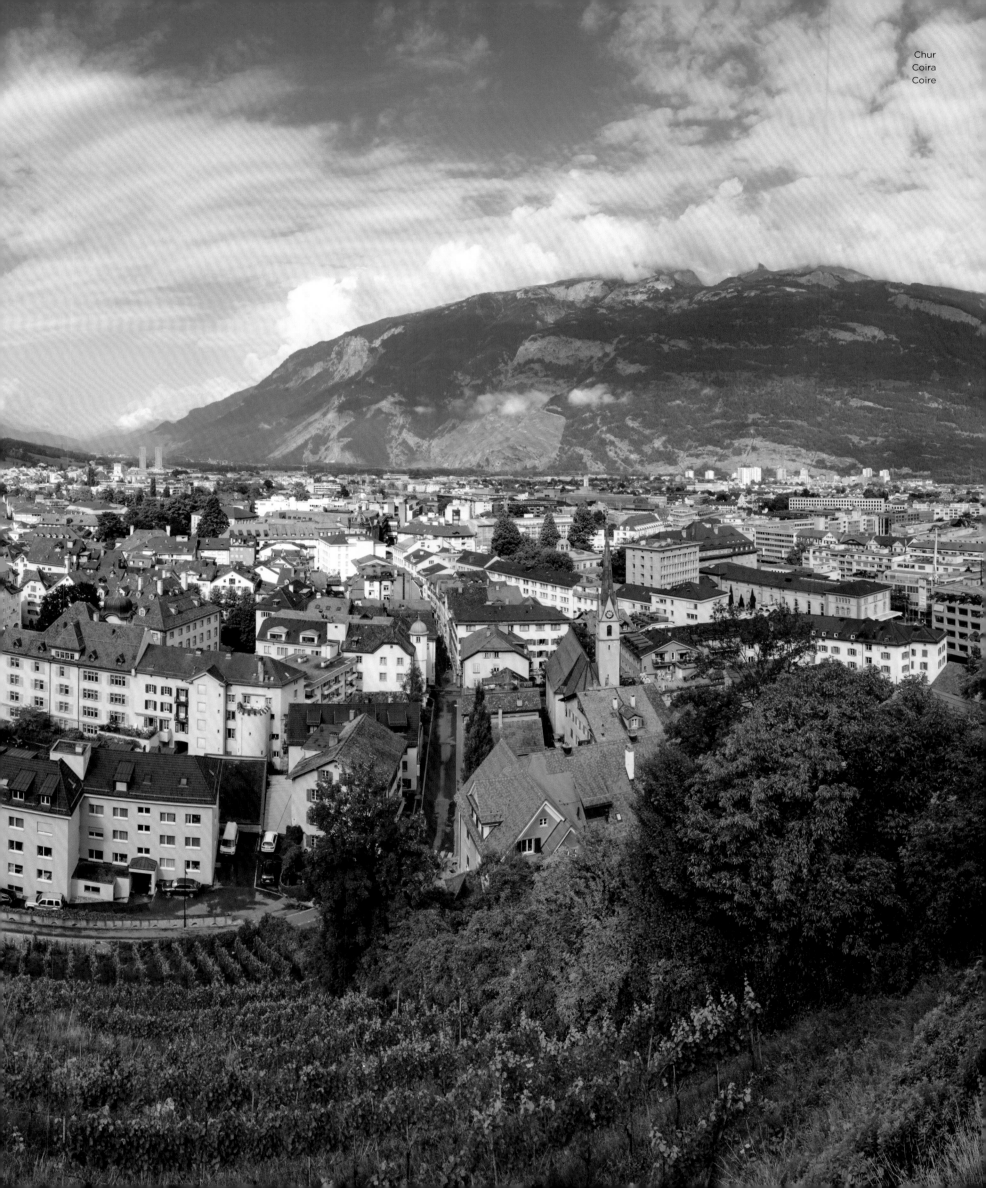

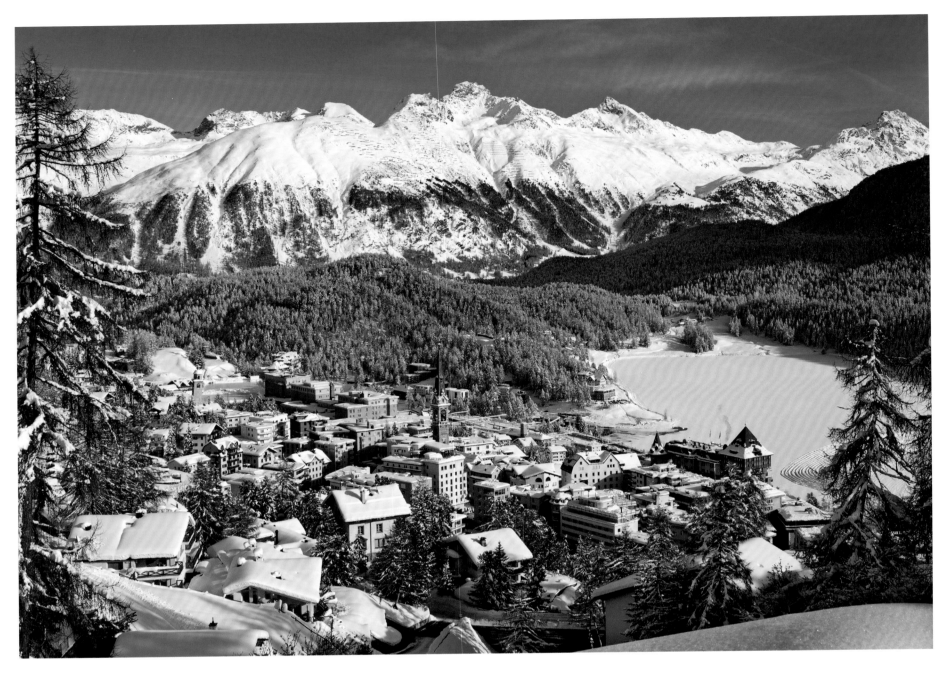

St. Moritz, St. Moritzersee
San Maurizio, Lago di San Maurizio
Saint-Moritz, lac de Saint-Moritz

St. Moritz

St. Moritz in the Engadine has only 5000 inhabitants. In winter, however, the number rises sharply because the town is one of the most famous winter sports resorts in the world and is also one of the centres of the international jet set. On the sporting side, St. Moritz has twice hosted the Winter Olympics, the Alpine World Championships several times, and there are exclusive sporting events such as polo on ice. But celebrities meet here in the noble ambience of luxury hotels any time of winter, and the list of rich property owners residing in St. Moritz is long.

Saint-Moritz

Saint-Moritz, dans l'Engadine, ne compte qu'environ 5 000 habitants. On s'y bouscule pourtant en hiver, car ce lieu de cure fait partie des stations de sports d'hiver les plus célèbres au monde et que c'est l'un des rendez-vous de la jet-set. Sur le plan sportif, Saint-Moritz a accueilli par deux fois les Jeux olympiques d'hiver, à de nombreuses reprises les championnats du monde de ski alpin, et on y trouve même des compétitions très sélectes de polo sur neige. Des personnalités de premier plan se retrouvent ici dans l'ambiance feutrée des hôtels de luxe et la liste des propriétaires immobiliers fortunés résidant à Saint-Moritz est longue.

St. Moritz

Nur rund 5000 Einwohner hat St. Moritz im Engadin. Im Winter tummeln sich hier aber sehr viel mehr Menschen, denn der Kurort gehört zu den bekanntesten Wintersportorten der Welt, und außerdem ist er eines der Zentren des internationalen Jetset. Was die sportliche Seite angeht: Zweimal war St. Moritz Austragungsort der Olympischen Winterspiele, etliche Male Alpiner Weltmeisterschaften, und es gibt exklusive Sportevents wie Polo auf dem Eis. Ansonsten trifft sich hier im edlen Ambiente von Luxushotels die Prominenz, und die Liste der reichen in St. Moritz residierenden Immobilienbesitzer ist lang.

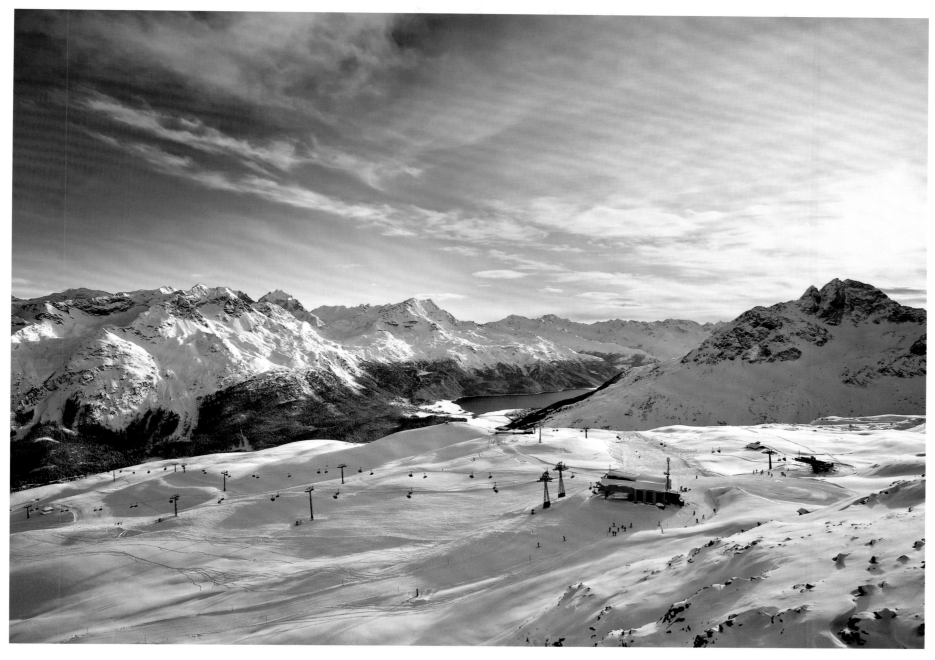

Piz Nair (3056 m · 10026 ft)

St. Moritz

St. Moritz en Engadina tiene solo 5000 habitantes.
En invierno, sin embargo, hay mucha más gente aquí
porque el complejo es uno de los centros de deportes
de invierno más famosos del mundo y es también
uno de los centros de la jet set internacional. En lo
que respecta al deporte, St. Moritz ha sido en dos
ocasiones sede de los Juegos Olímpicos de Invierno
y en varias ocasiones de los Campeonatos Mundiales
de los Alpes; además, aquí hay eventos deportivos
exclusivos como el polo sobre hielo. Aparte de esto,
las celebridades se reúnen aquí en el noble ambiente
de los hoteles de lujo, y la lista de ricos propietarios
que residen en St. Moritz es larga.

St. Moritz

St. Moritz no Engadine tem apenas 5000 habitantes.
No inverno, no entanto, há muitas mais pessoas aqui
porque o resort é um dos mais famosos resorts de
esportes de inverno do mundo e também é um dos
centros do jet set internacional. Do lado esportivo, St.
Moritz já sediou duas vezes os Jogos Olímpicos de
Inverno, várias vezes o Campeonato Mundial Alpino,
e há eventos esportivos exclusivos como o polo em
gelo. Caso contrário, as celebridades se encontram
aqui no ambiente nobre dos hotéis de luxo, e a lista
de proprietários ricos que residem em St. Moritz
é longo.

St. Moritz

St. Moritz in het Engadin heeft slechts 5000 inwoners,
maar in de winter vertoeven hier veel meer mensen.
Als een van de bekendste wintersportplaatsen
ter wereld trekt het tal van toeristen, vooral uit
de internationale jetset. Naast de Olympische
Winterspelen, die hier al twee keer georganiseerd
werden, vindt in St. Moritz ook regelmatig het
wereldkampioenschap skiën plaats. Exclusieve
sportevenementen zoals polo op sneeuw zijn hier
eveneens populair. De plaats is een trefpunt van
beroemdheden, die elkaar hier in de luxe hotels
ontmoeten of hier een huis bezitten.

Gletschergarten Cavaglia
Giardino dei Ghiacciai, Cavaglia
Jardin des glaciers, Cavaglia

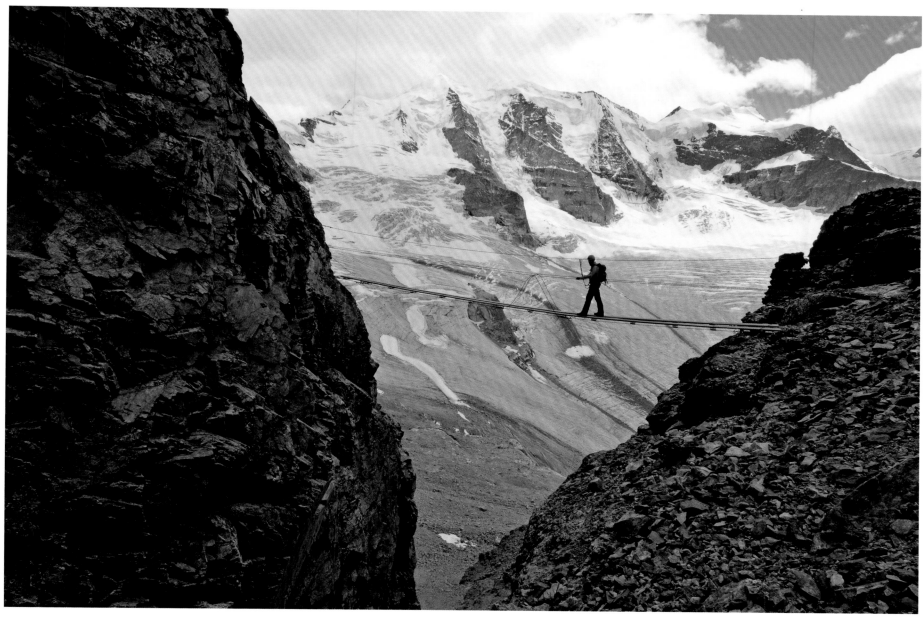

Piz Trovat (3145 m · 10318 ft)

Cavaglia Glacial Mills

The scientific explanation for glacial mills is relatively simple: Meltwater and rock rotate to create circular depressions in the ice that can be hundreds of metres deep. But the old stories are much more appealing: The deep holes in the ice are used as cooking pots by giants.

Les moulins de Cavaglia

Les moulins sont des puits taillés dans les glaciers par un phénomène scientifiquement assez facile à expliquer : les eaux de fonte s'écoulent en tourbillonnant et en charriant des cailloux, formant des excavations pouvant atteindre des centaines de mètres de profondeur. Mais il est beaucoup plus poétique de s'en tenir aux légendes, selon lesquelles ces trous profonds dans la glace sont en fait des marmites de géants.

Gletschermühlen, Cavaglia

Die wissenschaftliche Erklärung für das Entstehen von Gletschermühlen ist relativ einfach: Schmelzwasser und Gestein schaffen in rotierender Bewegung die kreisförmigen Vertiefungen, die Hunderte Meter tief sein können. Viel schöner aber ist es, die dazugehörenden Geschichten zu hören, nämlich dass die tiefen Löcher im Eis Kochtöpfe von Riesen sind.

Molinos glaciares, Cavaglia

La explicación científica del surgimiento de los molinos glaciares es relativamente sencilla: el agua de deshielo y la roca giran y crean depresiones circulares que pueden tener cientos de metros de profundidad. Pero es mucho más bello escuchar las historias correspondientes: que los agujeros profundos en el hielo son cazuelas de gigantes.

Moinhos glaciares de Cavaglia

A explicação científica para o surgimento de moinhos glaciais é relativamente simples: água de fusão e rocha giram para criar depressões circulares que podem ter centenas de metros de profundidade. Mas é muito mais agradável ouvir as histórias correspondentes, nomeadamente que os buracos profundos no gelo são panelas de cozinha de gigantes.

Gletsjermolen van Cavaglia

De wetenschappelijke verklaring voor het ontstaan van gletsjermolens is vrij eenvoudig. Het zijn door ronddraaiend smeltwater en rotskeien uitgeslepen gaten in rotsen, die soms wel enkele honderden meters diep zijn. Minder wetenschappelijk en leuker om te horen is de legende die het verhaal vertelt dat deze diepe gaten in feite kookpotten van reuzen zijn.

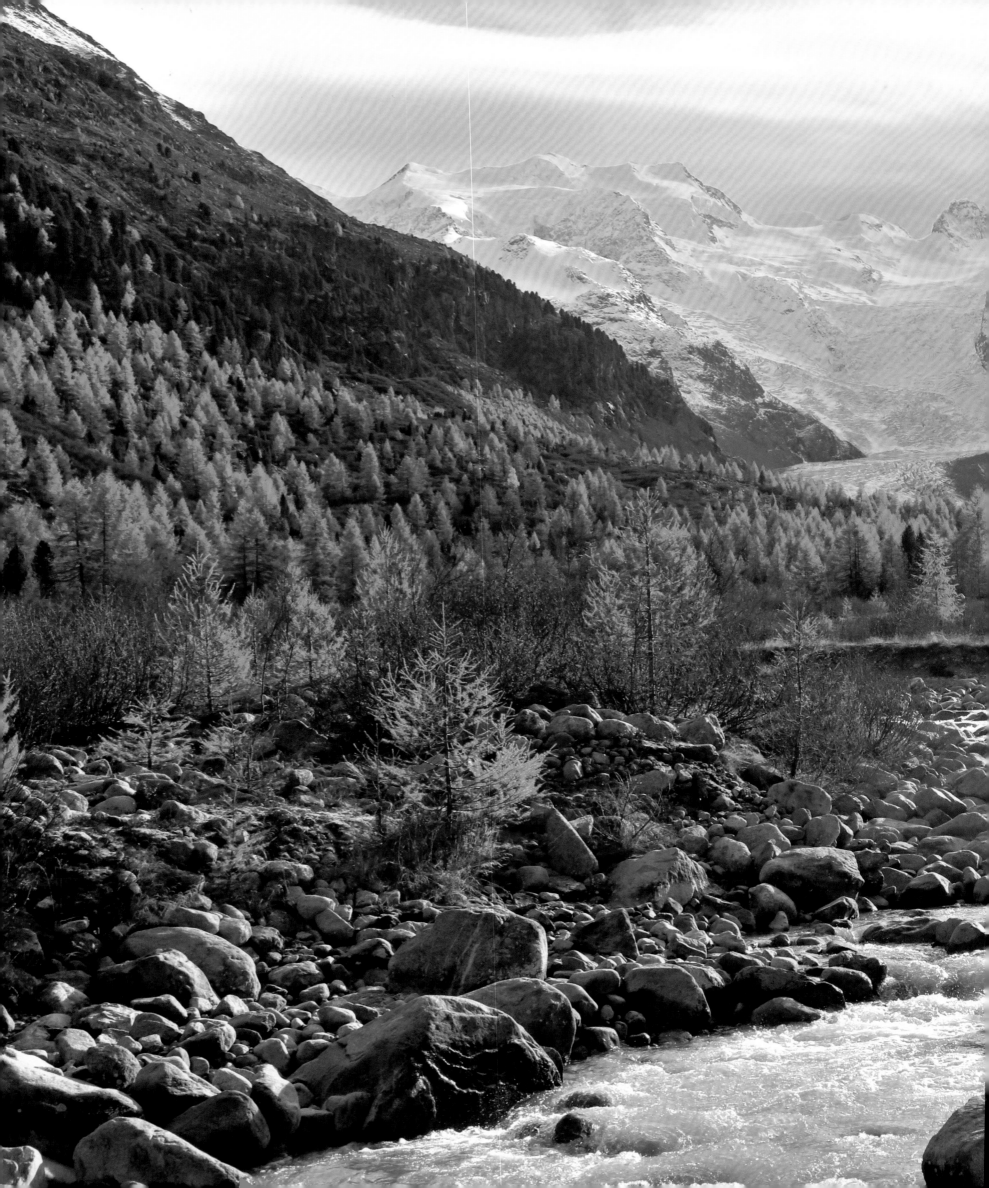

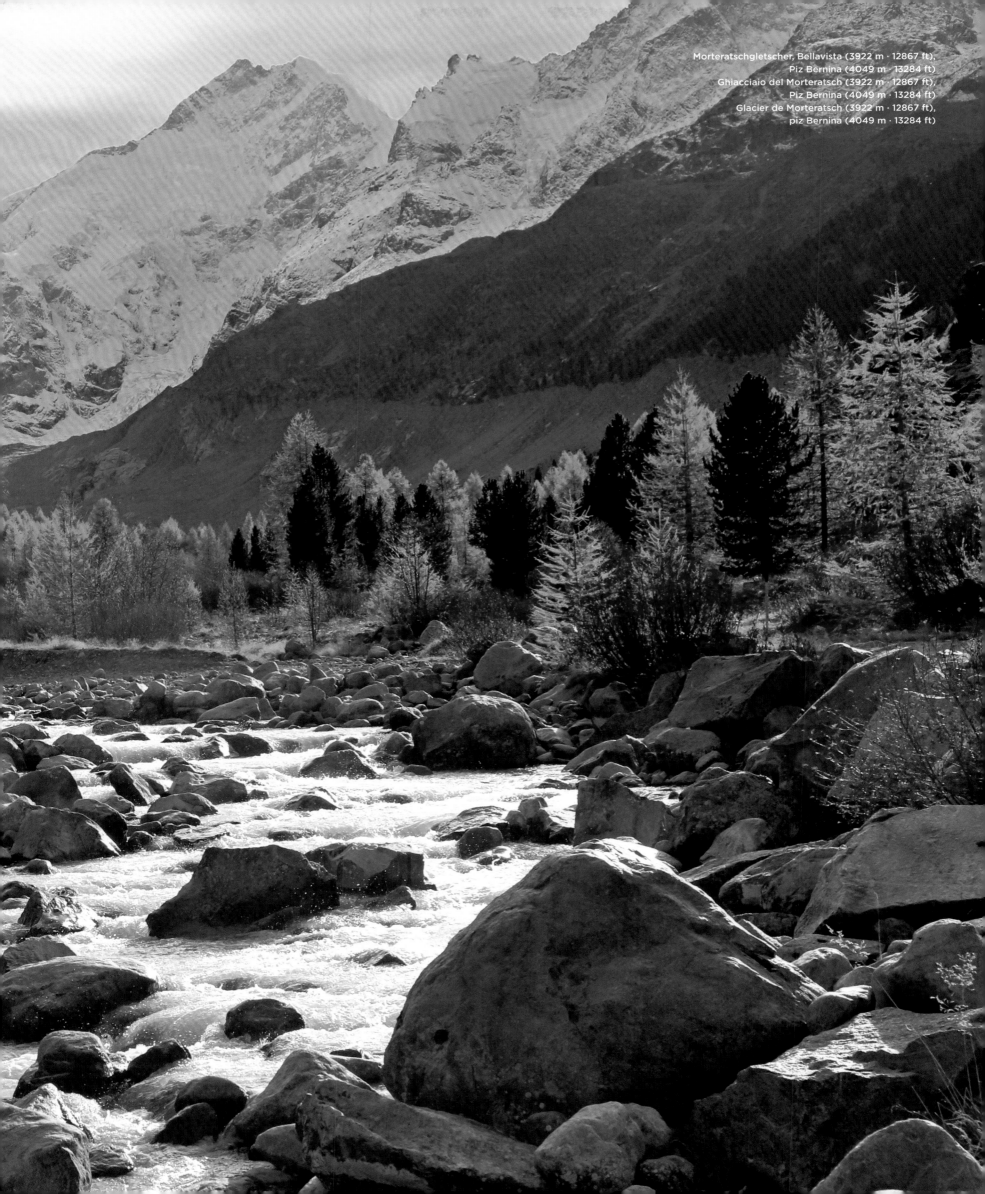

Morteratschgletscher, Bellavista (3922 m · 12867 ft),
Piz Bernina (4049 m · 13284 ft)
Ghiacciaio del Morteratsch (3922 m · 12867 ft),
Piz Bernina (4049 m · 13284 ft)
Glacier de Morteratsch (3922 m · 12867 ft),
piz Bernina (4049 m · 13284 ft)

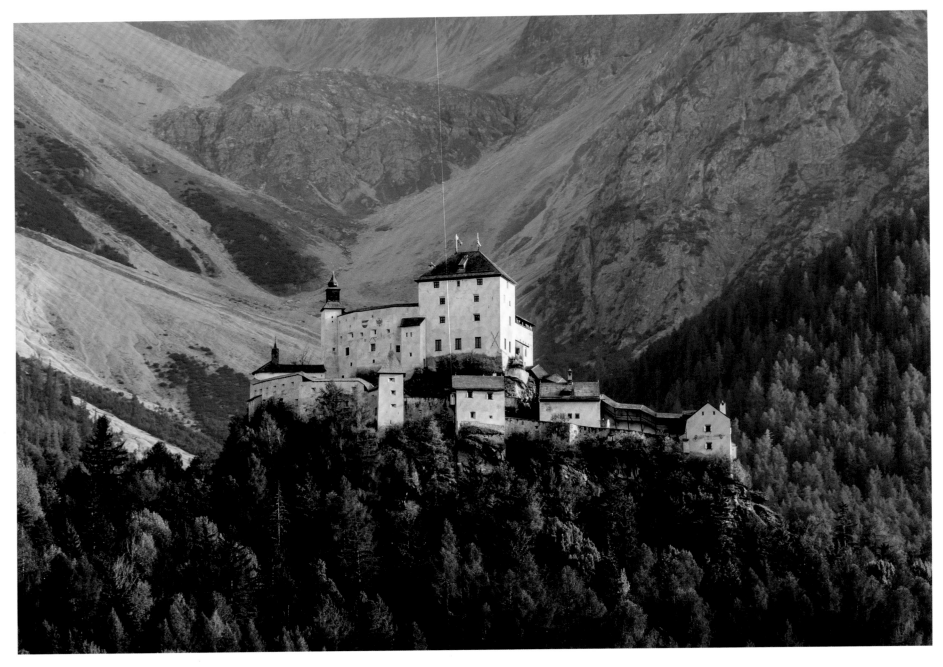

Schloss Tarasp
Castello di Tarasp
Château de Tarasp

Tarasp Castle

Tarasp Castle, one of the landmarks of the Lower Engadine, has an eventful history. Around 1040 the castle was founded as a fortress and then changed hands several times: bishops, princes and bailiffs were owners before it finally came to the Habsburgs. After a long period of fierce controversy—castles are always an economic and strategic factor in their region or even beyond its borders—Tarasp finally lost its significance as a fortress and became increasingly dilapidated. Plans to transform it into a congress centre failed, today the complex belongs to an artist.

Le château de Tarasp

Le château de Tarasp, l'un des symboles de la Basse-Engadine, a une histoire haute en couleur, tant en ce qui concerne sa construction que ses propriétaires. Cette forteresse a été bâtie autour de 1040 puis a changé plusieurs fois de main : celles d'évêques, de comtes, de ducs, avant d'être récupérée par les Habsbourg. Longtemps source de tensions – les châteaux forts jouaient toujours un rôle économique et stratégique déterminant dans leur région, voire au-delà des frontières –, il a finalement perdu en importance en tant que place forte, se délabrant de plus en plus. Un projet visant à en faire un centre de congrès a fait long feu et il appartient aujourd'hui à un artiste.

Schloss Tarasp

Schloss Tarasp, eines der Wahrzeichen des Unterengadin, hat eine wechselvolle Bau- und Besitzergeschichte. Um 1040 wurde die Burg als Festung gegründet, wechselte in der Folge mehrmals die Eigentümer: Bischöfe, Fürsten und Vögte, und kam schließlich zu den Habsburgern. Nachdem Tarasp lange Zeit heftig umstritten war – Burgen sind immer ein Wirtschafts- und strategischer Faktor in ihrer Region oder sogar über die Landesgrenzen hinaus –, verlor es schließlich seine Bedeutung als Festungsbau und verfiel immer mehr. Pläne zur Umgestaltung in ein Kongresszentrum scheiterten, heute gehört die Anlage einem Künstler.

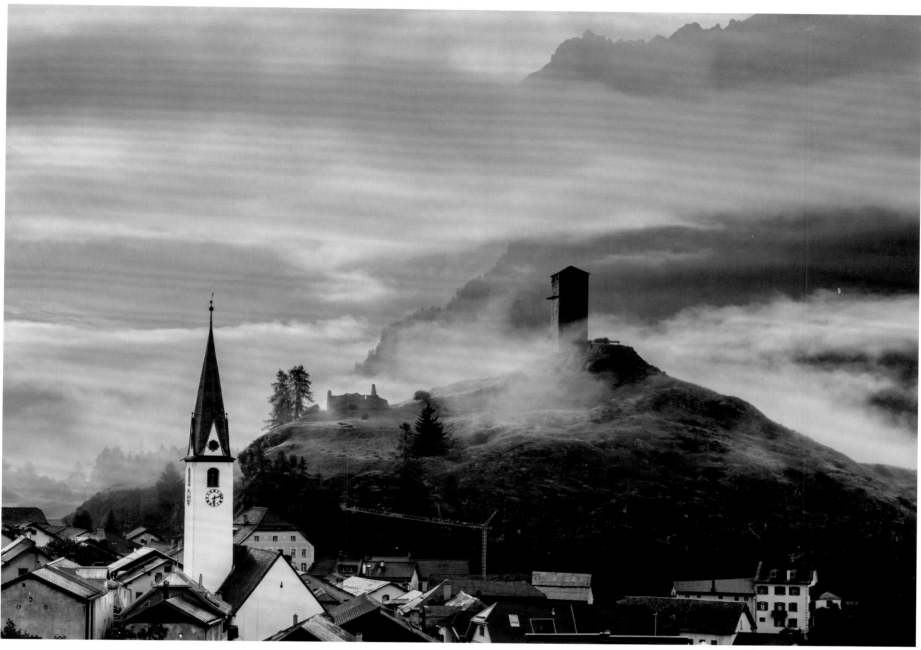

Ardez

Castillo de Tarasp

El castillo de Tarasp, uno de los hitos de la Baja Engadina, cuenta con una tumultuosa historia respecto a su construcción y a sus propietarios. El castillo se fundó alrededor de 1040 como fortaleza, cambió de manos varias veces (obispos, príncipes y alguaciles) y finalmente llegó a los Habsburgo. Después de un largo período de feroz controversia (ya que los castillos son siempre un factor económico y estratégico en su región o incluso más allá de sus fronteras), Tarasp finalmente perdió su importancia como fortaleza y se fue deteriorando cada vez más. Los planes de convertirlo en un centro de congresos fracasaron, y actualmente el complejo es propiedad de un artista.

Castelo de Tarasp

O Castelo de Tarasp, um dos marcos do Baixo Engadine, tem uma história memorável de edifícios e proprietários. Por volta de 1040 o castelo foi fundado como uma fortaleza, mudou de mãos várias vezes: bispos, príncipes e oficiais de justiça, e finalmente chegou aos Habsburgos. Após um longo período de feroz controvérsia - os castelos são sempre um fator econômico e estratégico em sua região ou mesmo além de suas fronteiras – Tarasp finalmente perdeu seu significado como fortaleza e ficou cada vez mais dilapidada. Os planos para transformá-lo num centro de congressos falharam, hoje o complexo pertence a um artista.

Kasteel Tarasp

Het kasteel van Tarasp, een van de grote bezienswaardigheden van het Beneden-Engadin, kijkt terug op een woelige geschiedenis. Het in 1040 als vesting gestichte kasteel veranderde meerdere malen van eigenaar: na bisschoppen, prinsen en landvoogden namen uiteindelijk de Habsburgers het over. Na een lange periode fel betwist te zijn geweest – kastelen zijn altijd van economisch en strategisch belang voor een streek en soms zelfs erbuiten – boette Tarasp gaandeweg aan betekenis in en raakte steeds meer in verval. Plannen om er een congrescentrum van te maken mislukten, tegenwoordig behoort het complex toe aan een kunstenaar.

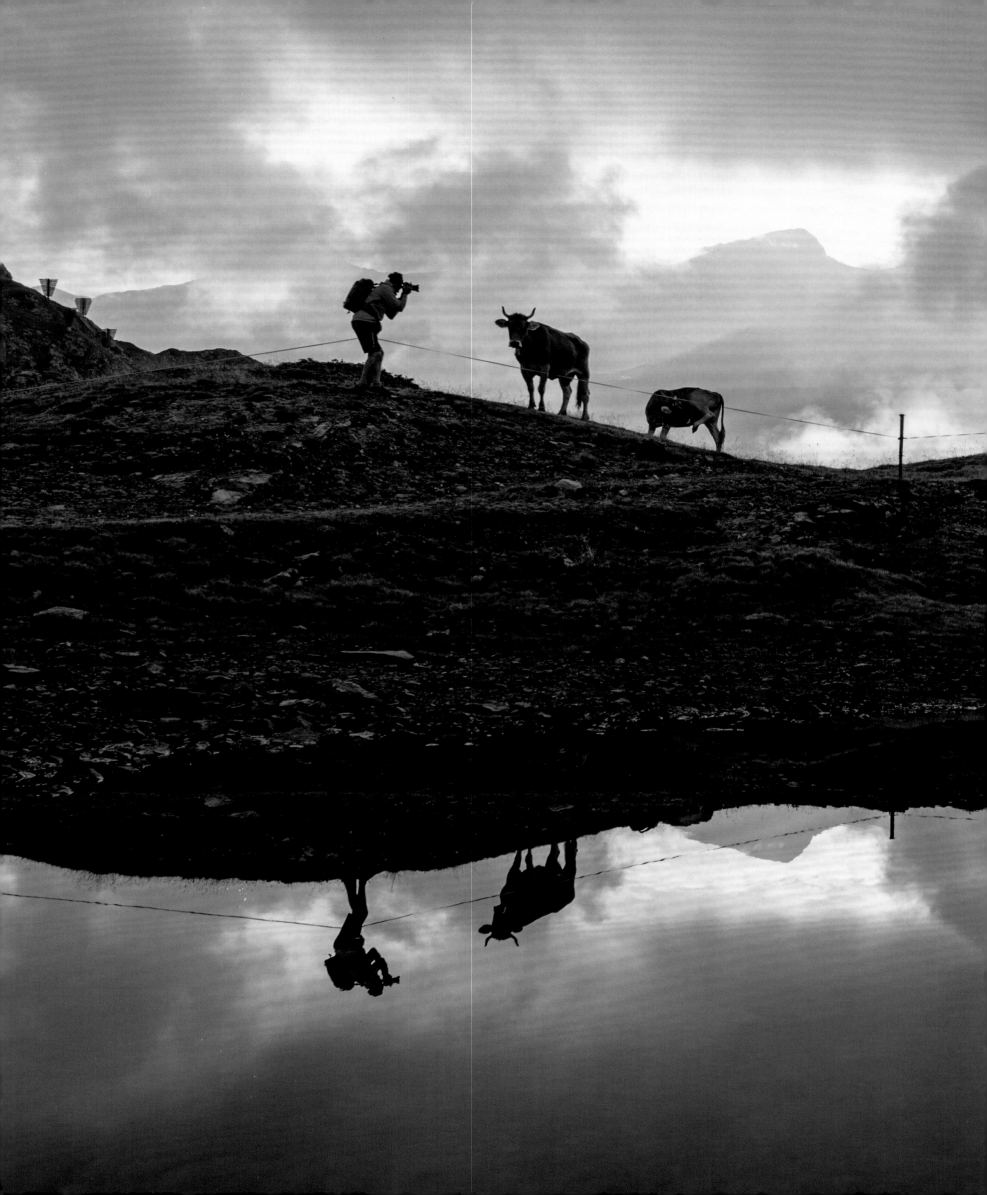

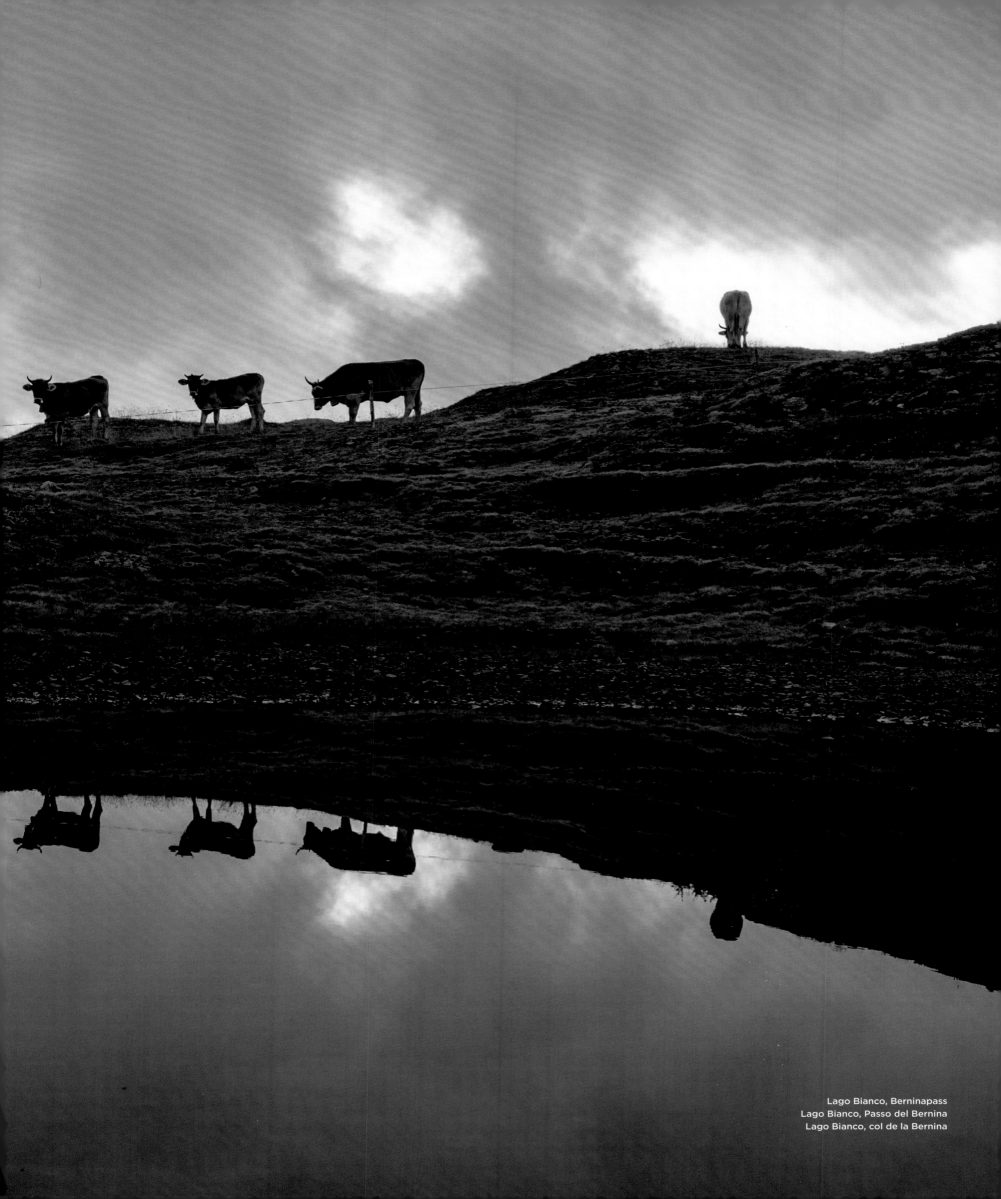

Lago Bianco, Berninapass
Lago Bianco, Passo del Bernina
Lago Bianco, col de la Bernina

Guarda

Guarda

Since its foundation, the Graubündeb village of Guarda – which means as much as "guard" or "wait"—has been destroyed twice and rebuilt each time. Today, with its intact townscape, it is regarded as one of the best preserved Engadine settlements. This pays off for the villagers because laborious agriculture has been replaced by tourism as a source of income.

Guarda

Le village de Guarda, dans le canton des Grisons, a été détruit à deux reprises depuis sa création, mais a été, à chaque fois, reconstruit. On le considère aujourd'hui comme l'un des mieux conservés et des plus authentiques de l'Engadine. Et c'est tout à son avantage : les revenus du tourisme ont aujourd'hui remplacé les maigres recettes de l'agriculture.

Guarda

Zweimal wurde der Graubündner Ort Guarda – was soviel wie „Wache" oder „Warte" bedeutet – nach seiner Gründung zerstört, aber jedesmal wieder aufgebaut. Heute gilt er als eines der besterhaltenen Engadiner Dörfer mit intaktem Ortsbild. Das macht sich bezahlt, denn die mühselige Landwirtschaft wurde inzwischen durch den Tourismus als Einnahmequelle ersetzt.

Guarda

Tras su creación, la plaza Guarda de los grisones fue destruida dos veces, pero siempre se volvió a reconstruir. Hoy en día es considerado como uno de los pueblos mejor conservados de Engadina, con un paisaje urbano intacto. Esto es algo muy importante, ya que la laboriosa agricultura ha sido reemplazada por el turismo como fuente de ingresos.

Guarda-Redes

Duas vezes o lugar Graubündner Guarda – que significa tanto quanto "guarda" ou "espera" – foi destruído após a sua fundação, mas foi reconstruído a cada vez. Hoje é considerada como uma das aldeias mais bem preservadas de Engadine, com uma paisagem urbana intacta. Isto compensa porque a agricultura laboriosa foi substituída pelo turismo como fonte de renda.

Guarda

Het in Graubünden gelegen Guarda – wat evenveel betekent als 'wacht' of 'waakpost' – werd in zijn bestaan twee keer volledig verwoest, maar telkens opnieuw opgebouwd. Tegenwoordig is het in deze streek een van de best bewaard gebleven dorpen met een historisch centrum. Dat is lonend voor de huidige inwoners, want het toerisme heeft de landbouw intussen als belangrijkste inkomstenbron afgelost.

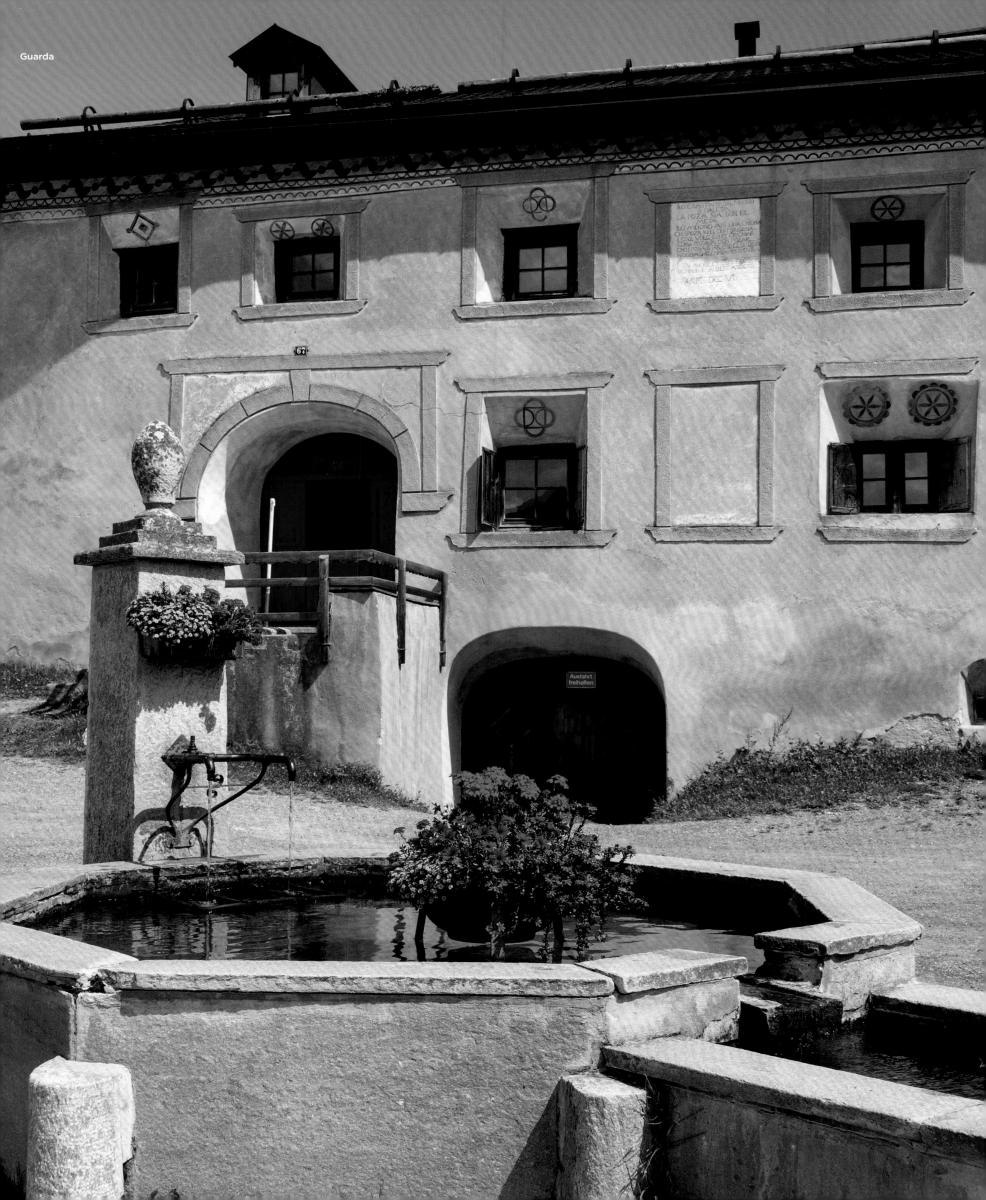

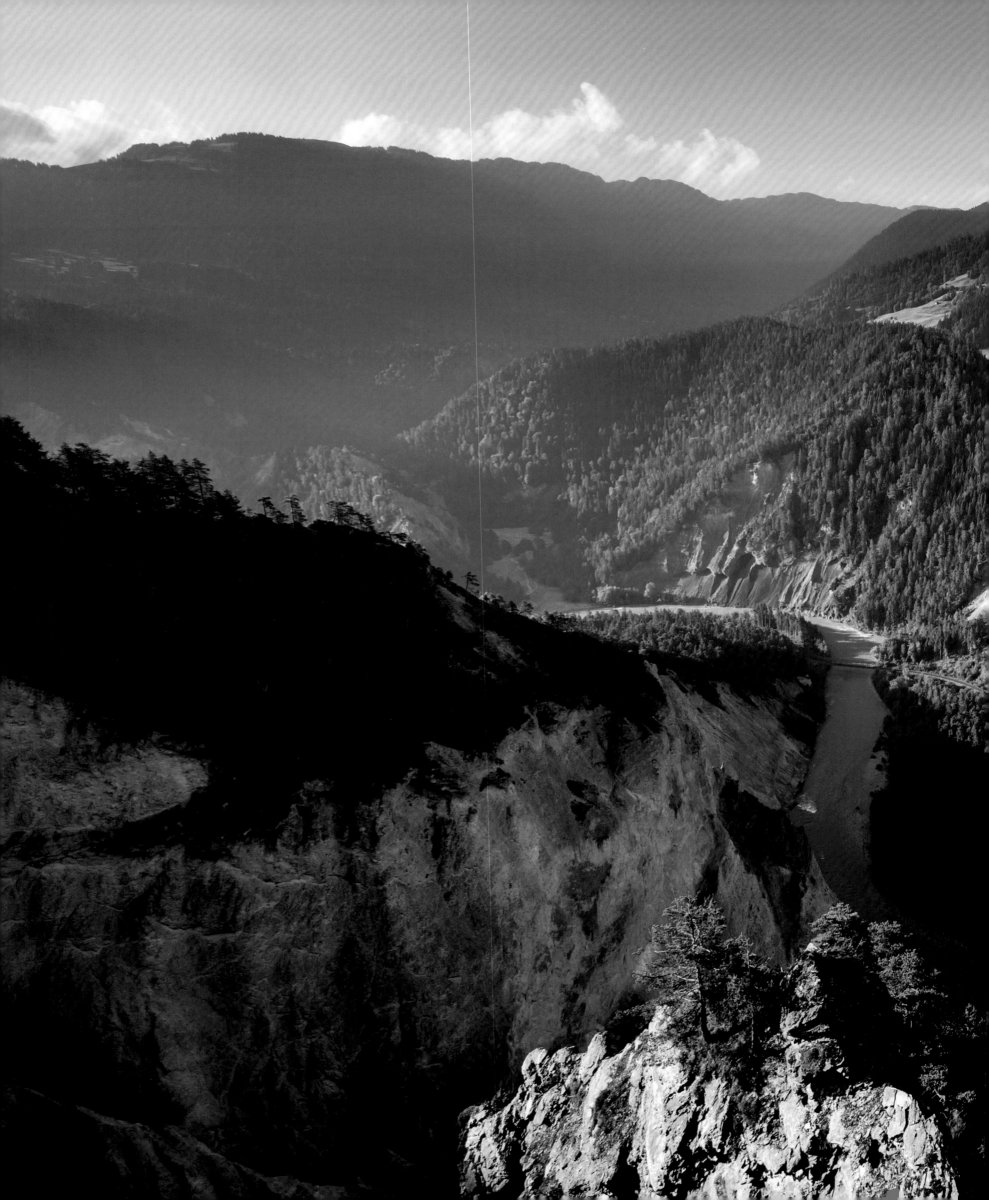

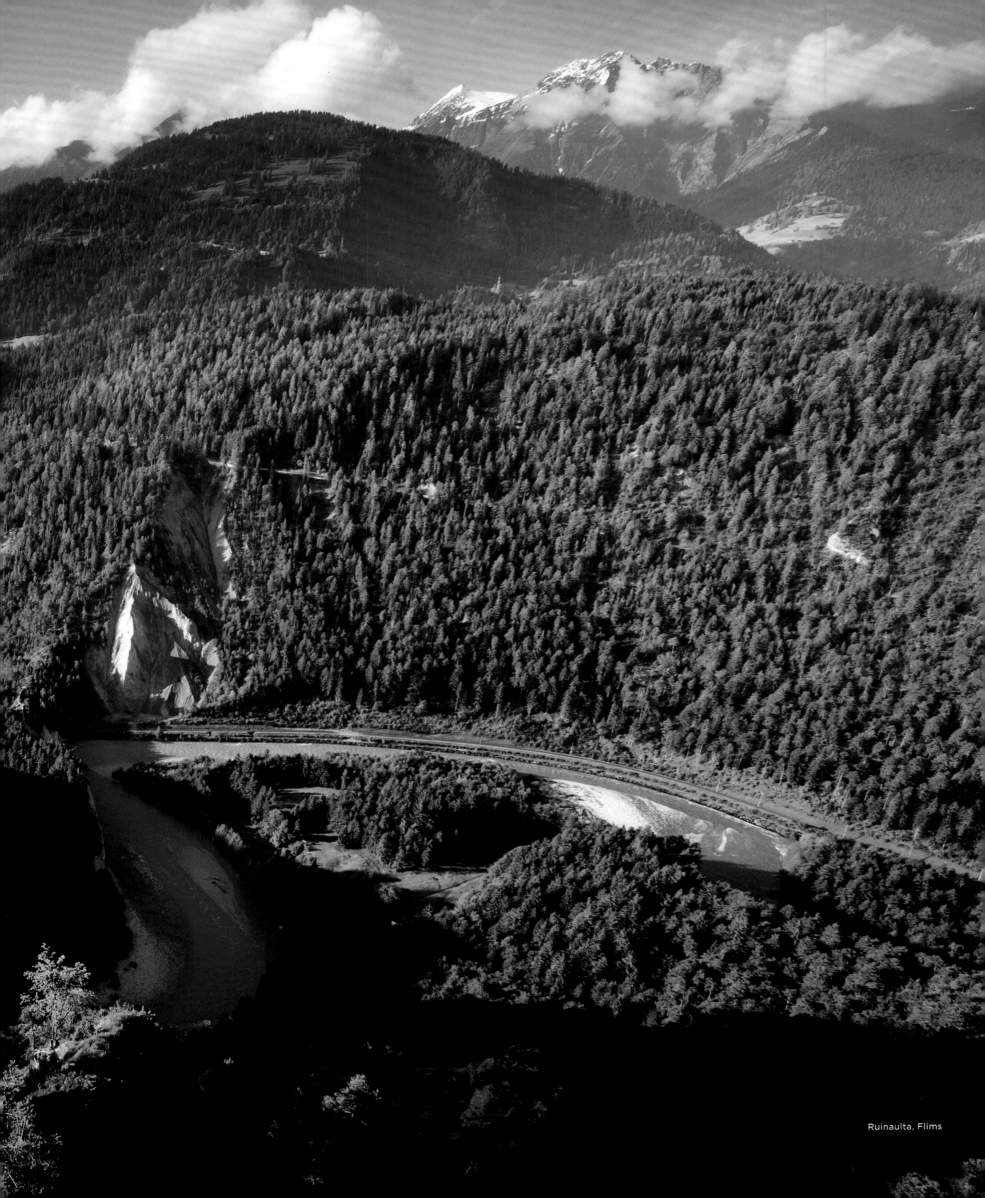

Ruinaulta, Flims

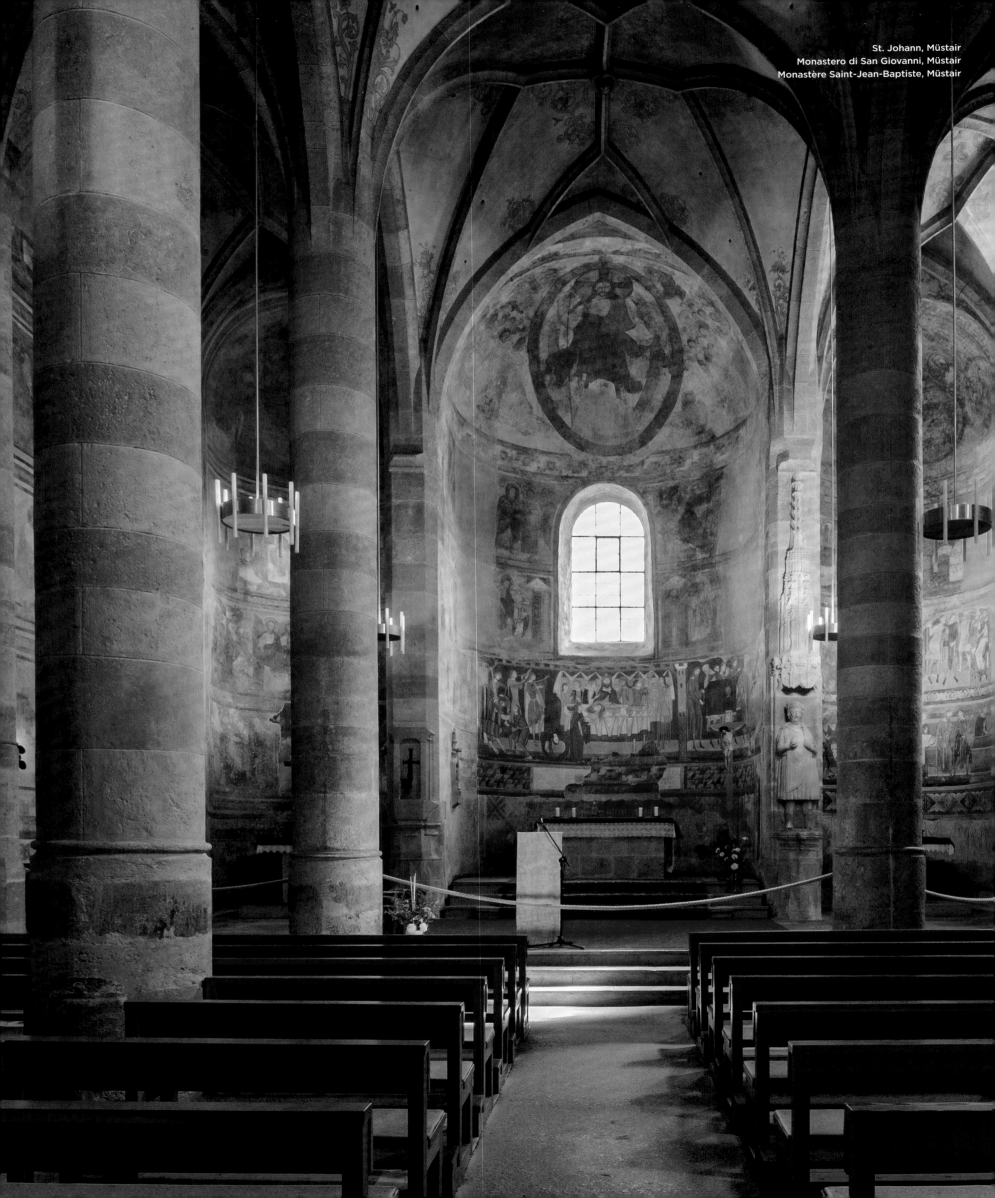

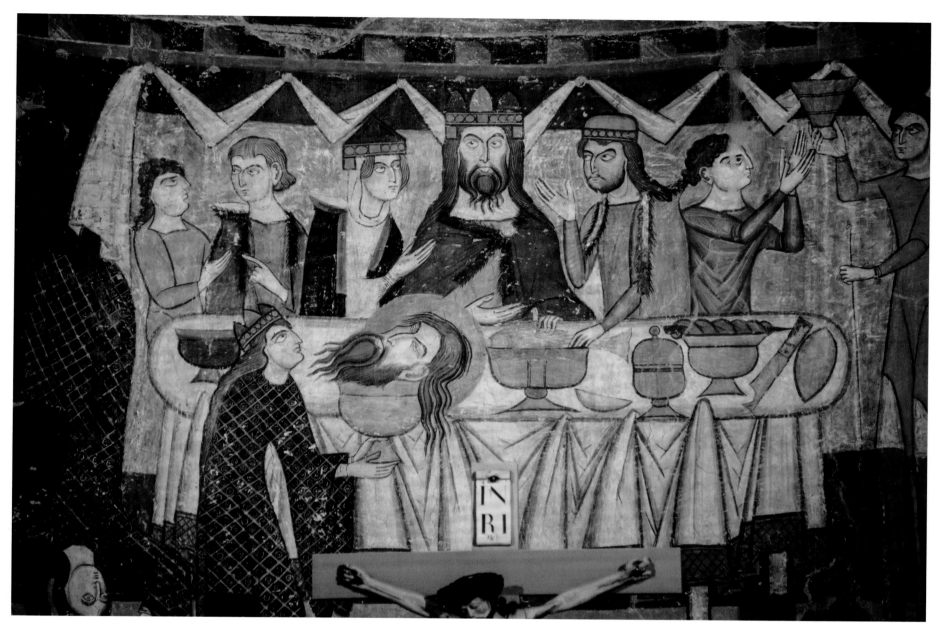

Fresko, St. Johann, Müstair
Fresco, Monastero di San Giovanni, Müstair
Fresque, monastère Saint-Jean-Baptiste, Müstair

St. Johann, Müstair

The Abbey of Saint John in Müstair offers several superlatives making it unique: The murals in the monastery church are the oldest preserved medieval fresco cycle in the Alpine region. The building ensemble also has the oldest residential and defensive tower in the region. The Benedictine monastery has been on the UNESCO World Heritage List since 1983.

Le monastère Saint-Jean-Baptiste

Le monastère Saint-Jean-Baptiste, à Müstair, est unique et attire à lui tous les superlatifs : les peintures qui ornent les murs de son église sont les fresques les plus anciennes de la région des Alpes à nous être parvenues. Cet ensemble possède aussi les plus vieilles tours de la région. Depuis 1983, cette abbaye bénédictine est classée au patrimoine mondial de l'UNESCO.

St. Johann, Müstair

Einzigartig ist das Kloster St. Johann in Müstair, das mit Superlativen aufwarten kann: Die Wandmalereien in der Klosterkirche sind der älteste erhaltene mittelalterliche Freskenzyklus im Alpenraum. Das Gebäudeensemble hat auch den ältesten Wohn- und Wehrturm der Region. Seit 1983 steht das Benediktinerinnenkloster auf der Weltkulturerbeliste der Unesco.

San Juan, Müstair

El monasterio de San Juan en Müstair es único y puede calificarse con superlativos: los murales de la iglesia del monasterio son el ciclo de frescos medievales más antiguo conservado en la región alpina. El conjunto edilicio cuenta además con la torre residencial y defensiva más antigua de la región. Desde 1983, el monasterio benedictino está inscrito en la Lista del Patrimonio Mundial de la UNESCO.

Mosteiro St. Johann

Único é o mosteiro St. Johann em Müstair, que oferece superlativos: Os murais da igreja do mosteiro são o mais antigo ciclo de afrescos medievais preservados na região alpina. O conjunto de edifícios tem também a mais antiga torre residencial e defensiva da região. Desde 1983, o mosteiro beneditino está na Lista do Patrimônio Mundial da Unesco.

Klooster St. Johann in Müstair

St. Johann in Müstair is een enkele opzichten een uniek klooster: in de kloosterkerk bevinden zich de oudste bewaard gebleven middeleeuwse muurschilderingen van het alpengebied en het complex beschikt over de oudste woon- en verdedigingstoren van de streek. Sinds 1983 staat het benedictijnenklooster op de Werelderfgoedlijst van Unesco.

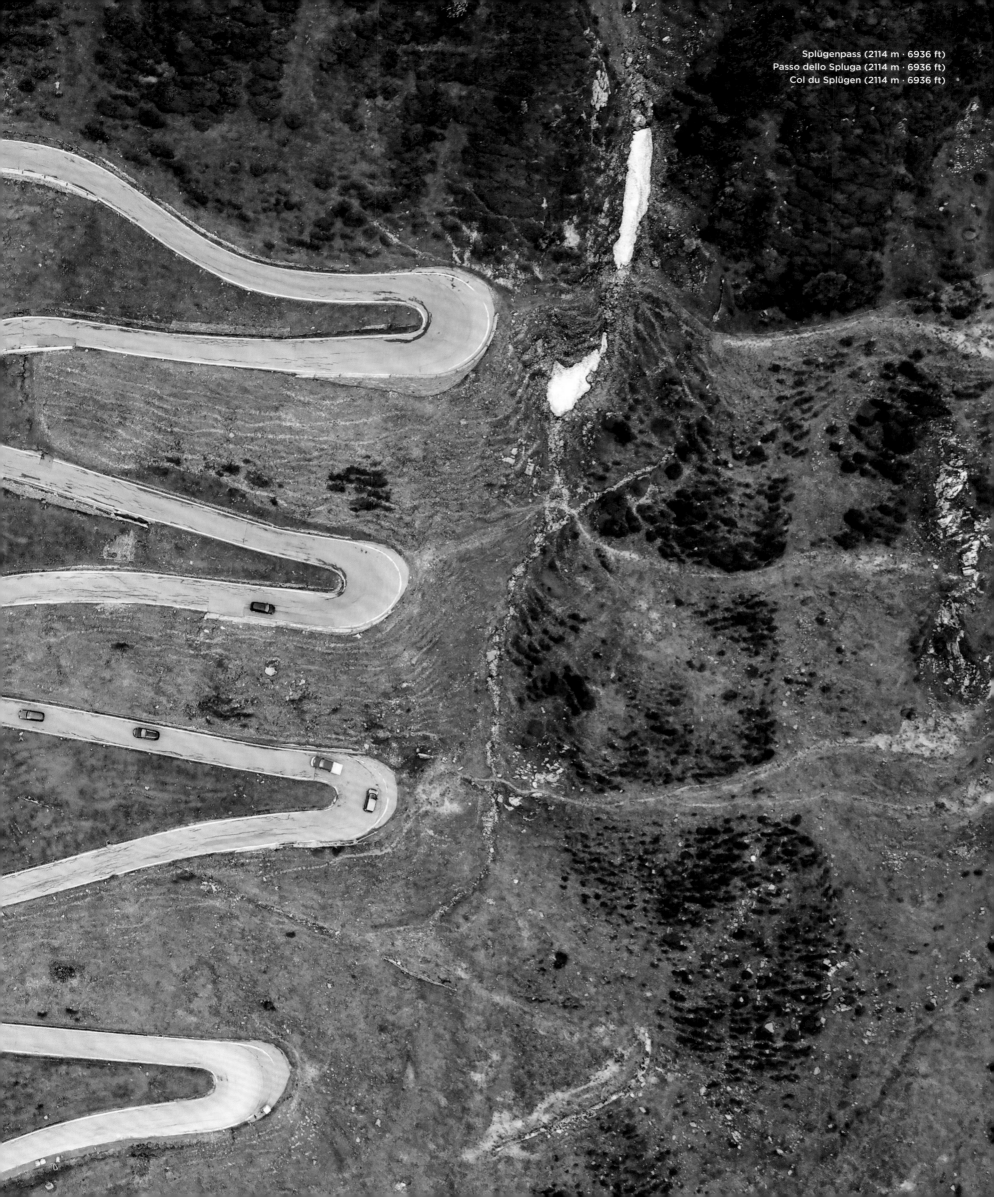

Splügenpass (2114 m · 6936 ft)
Passo dello Spluga (2114 m · 6936 ft)
Col du Splügen (2114 m · 6936 ft)

Tschingelhörner

Martinsloch, Tectonic Arena Sardona
The fact that the Alps are an active mountain range can be clearly seen in Flims in Graubünden. During the Glarus overthrust, "young" rock strata were pushed under much older ones. The geological lesson, also illustrated by the famous Martinsloch, is part of the Unesco World Heritage as the Sardona Tectonic Arena.

Le « trou de Martin » et le haut lieu tectonique de Sardona
À Flims, dans les Grisons, on peut avoir confirmation que les Alpes sont toujours actives. Au niveau du chevauchement principal de Glaris, des couches de roche « jeunes » sont passées sous des couches nettement plus anciennes. Ce véritable cours de géologie à ciel ouvert, agrémenté du célèbre « trou de Martin », fait partie du patrimoine mondial de l'UNESCO sous le nom de « haut lieu tectonique suisse Sardona ».

Martinsloch, Tektonikarena Sardona
Dass die Alpen ein aktives Gebirge sind, kann man in Flims in Graubünden deutlich sehen. Bei der Glarner Hauptüberschiebung haben sich „junge" Gesteinsschichten unter wesentlich ältere geschoben. Der geologische Anschauungsunterricht, der auch vom berühmten Martinsloch illustriert wird, gehört als Tektonikarena Sardona zum Weltnaturerbe der Unesco.

Martinsloch
El hecho de que los Alpes son una cadena montañosa activa se puede ver claramente en Flims de los Grisones. en la falla tectónica suiza de Sardona, las capas de roca «jóvenes» fueron empujadas bajo otras mucho más viejas. La instrucción visual geológica, también ilustrada por el famoso Martinsloch («la ventana del sol»), pertenece al Patrimonio Natural de la Humanidad de la Unesco como el Área Tectónica de Sardona.

Martinsloch, Arena Tectônica Sardona
O facto de os Alpes serem uma cordilheira activa pode ser visto claramente em Flims, em Graubünden. Durante o derrube de Glarus, os estratos rochosos "jovens" foram empurrados sob estratos muito mais velhos. A aula de geologia, também ilustrada pelo famoso Martinsloch, faz parte do Patrimônio Mundial da Unesco como a Sardona Tectonic Arena.

Tektonische arena Sardona, Martinsloch
Dat de Alpen een jong gebergte zijn en in beweging zijn valt in Flims in Graubünden te zien. Een mooi voorbeeld is de Glarus-overschuiving, waarbij 'jonge' gesteentelagen onder veel oudere gesteentelagen zijn geduwd. Dit geologische verschijnsel, waartoe ook het beroemde Martinsloch behoort, staat als 'Zwitserse tektonische arena Sardona' op de Werelderfgoedlijst van de Unesco.

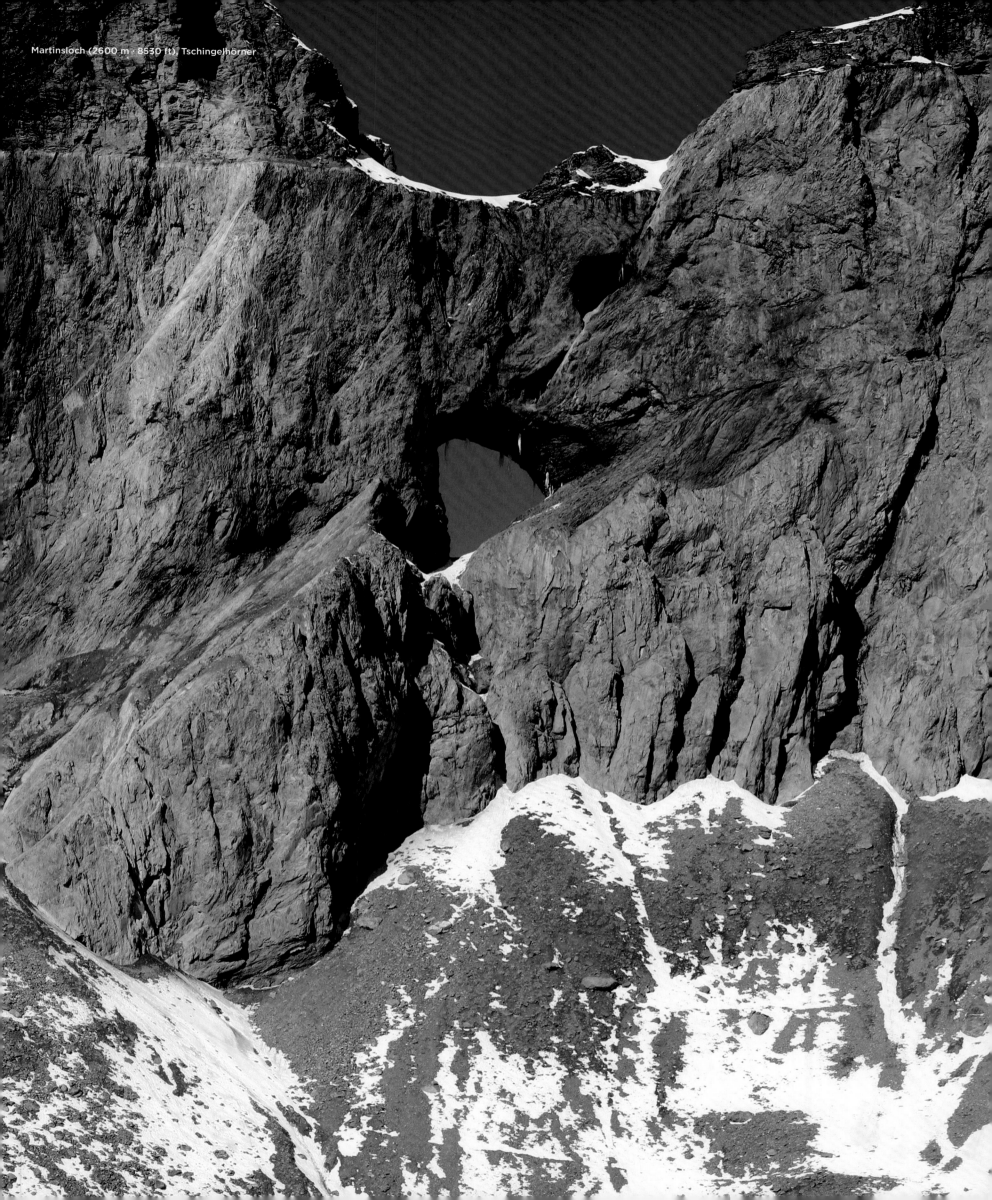
Martinsloch (2600 m · 8530 ft), Tschingelhörner

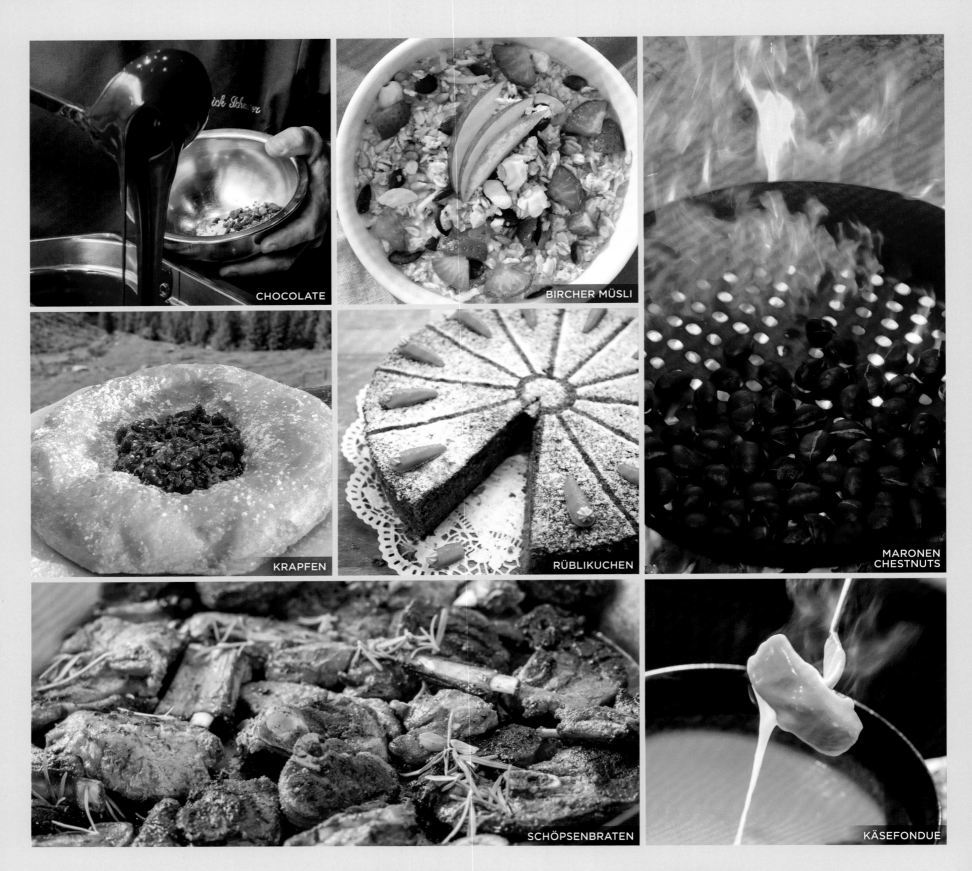

CHOCOLATE

BIRCHER MÜSLI

KRAPFEN

RÜBLIKUCHEN

MARONEN CHESTNUTS

SCHÖPSENBRATEN

KÄSEFONDUE

Alpine cuisine

The Alps are a transit area in which cultural influences from all directions meet. The cuisines of many countries also meld with local traditions. Regionally produced raw materials are the basis for a unique fusion with clearly discernible rural origins. Typical bakery products, pasta, cheese, meat, vegetables and sweets make the Alpine region a paradise for gourmets.

La cuisine des Alpes

Les Alpes étant un point de passage, des influences culturelles venant de toutes les directions s'y mêlent. Les gastronomies de nombreux pays viennent ici s'ajouter aux traditions locales. Les matières premières produites dans la région permettent une fusion unique en son genre au bon goût paysan. Pâtisseries traditionnelles, pâtes, fromage, viande, légumes et desserts font des Alpes un paradis pour les gourmets.

Alpenküche

Die Alpen sind ein Durchgangsgebiet, hier treffen kulturelle Einflüsse aus allen Himmelsrichtungen aufeinander. Auch die Küchen vieler Länder vermischen sich mit einheimischen Traditionen. Regional erzeugte Rohstoffe sind die Grundlage für eine einzigartige Fusion mit eindeutig bäuerlicher Herkunft. Typische Backwaren, Pasta, Käse, Fleisch, Gemüse und Süßspeisen machen den Alpenraum zu einem Paradies für Feinschmecker.

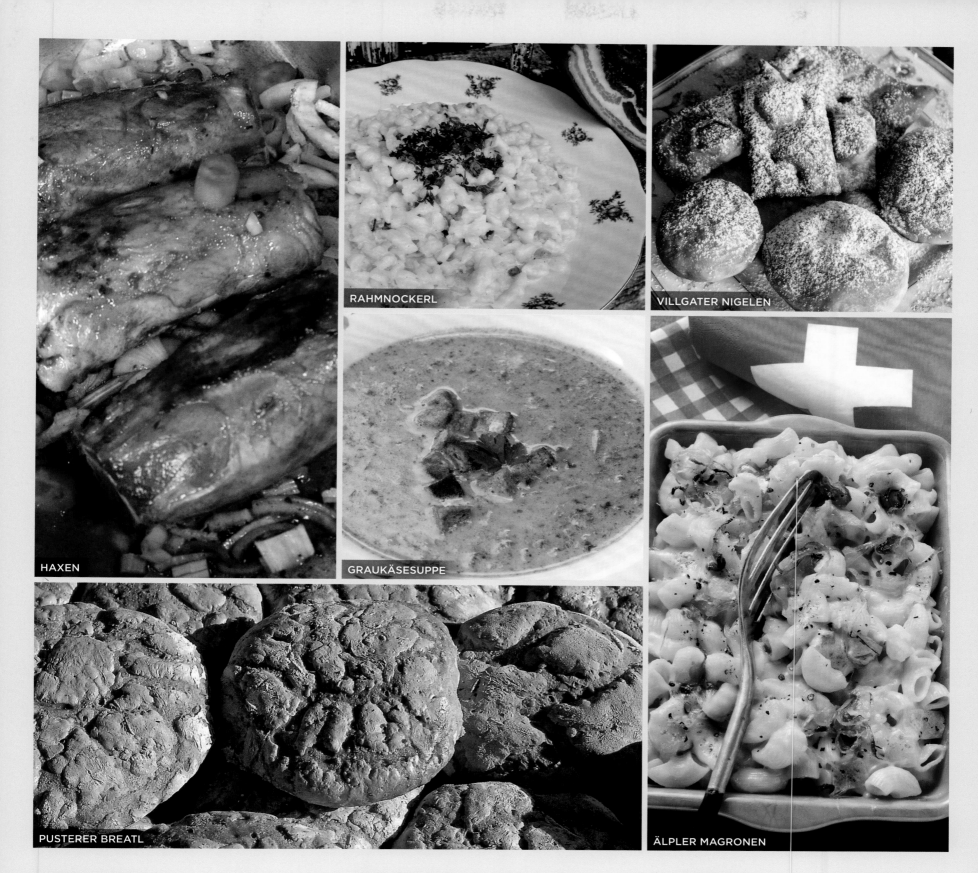

RAHMNOCKERL

VILLGATER NIGELEN

HAXEN

GRAUKÄSESUPPE

PUSTERER BREATL

ÄLPLER MAGRONEN

Cocina alpina

Los Alpes son una zona de tránsito donde se encuentran influencias culturales de todas las direcciones. La cocina de muchos países también se mezcla con las tradiciones locales. Las materias primas producidas en la región son la base de una fusión única con orígenes claramente rurales. Los productos típicos de panadería, pasta, queso, carne, verduras y dulces hacen de la región alpina un paraíso para los gourmets.

Cozinha Alpina

Os Alpes são uma área de trânsito onde as influências culturais de todas as direções se encontram. As cozinhas de muitos países também se misturam com as tradições locais. As matérias-primas produzidas regionalmente são a base para uma fusão única com origens claramente rurais. Produtos típicos de panificação, massas, queijos, carnes, vegetais e doces fazem da região alpina um paraíso para os gourmets.

Alpenkeuken

Door hun ligging midden in Europa vormen de Alpen een trefpunt van allerlei culturen. Geen wonder dat de keuken van al deze culturen ook hun intrede hebben gedaan in lokale culinaire tradities. Aan de basis van deze fusie met de plattelandskeuken staan streekproducten. Typische bakkerijproducten, pasta, kaas, vlees, groenten en zoete gerechten maken het alpengebied tot een paradijs voor fijnproevers.

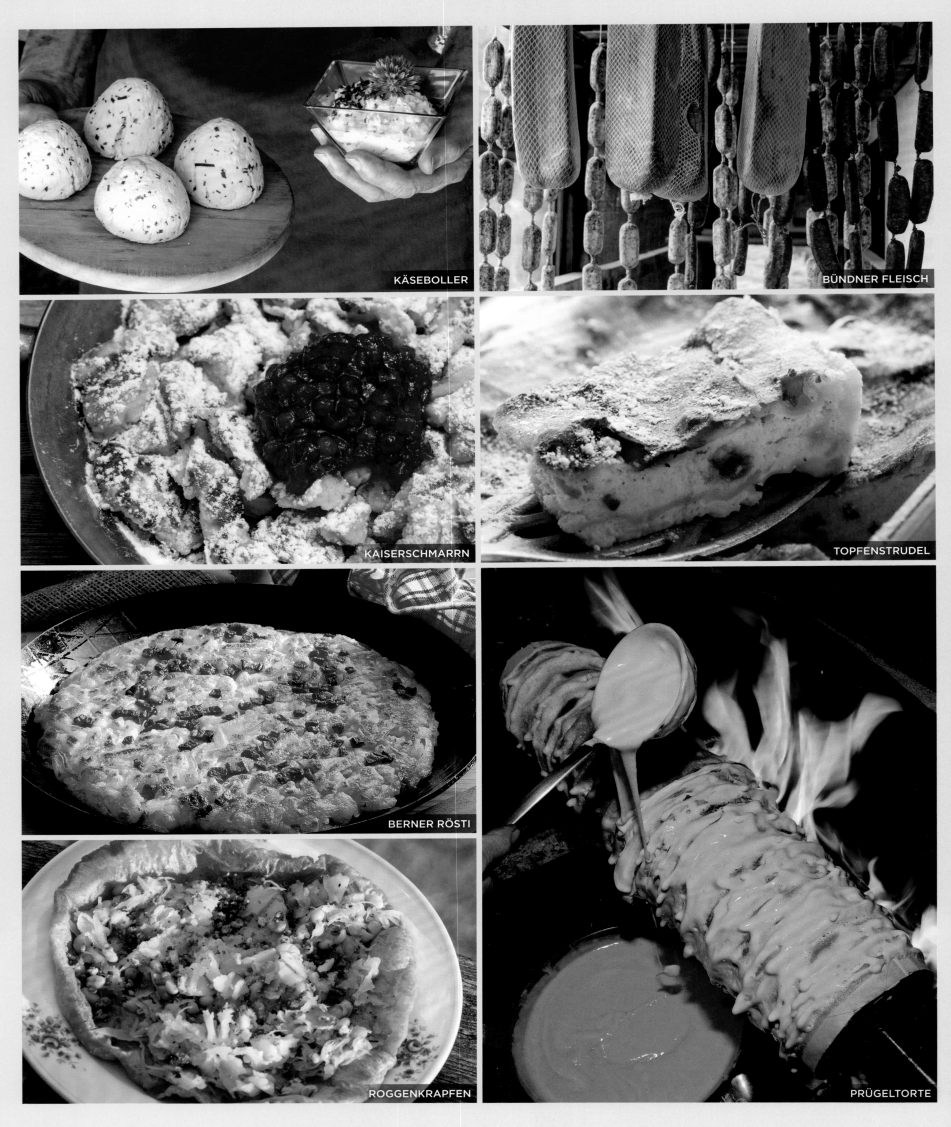

KÄSEBOLLER

BÜNDNER FLEISCH

KAISERSCHMARRN

TOPFENSTRUDEL

BERNER RÖSTI

ROGGENKRAPFEN

PRÜGELTORTE

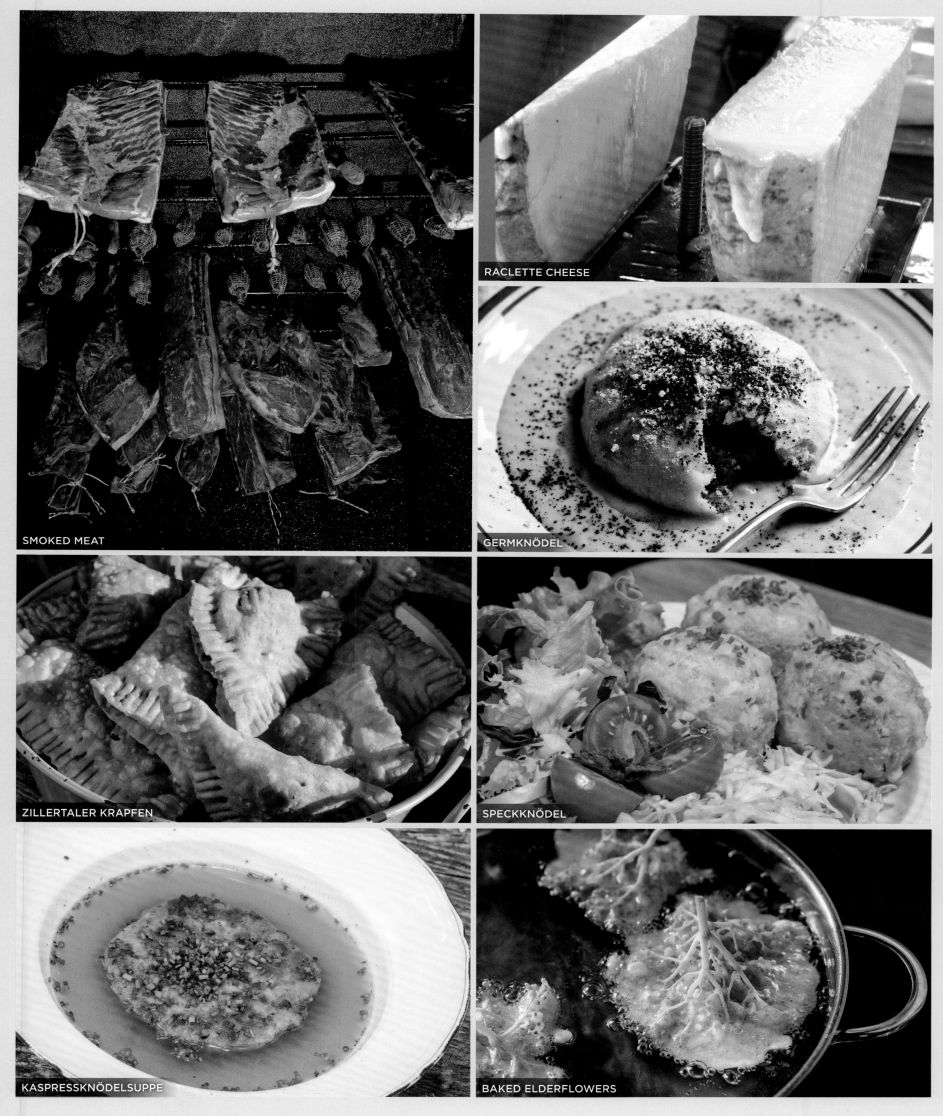

SMOKED MEAT

RACLETTE CHEESE

GERMKNÖDEL

ZILLERTALER KRAPFEN

SPECKKNÖDEL

KASPRESSKNÖDELSUPPE

BAKED ELDERFLOWERS

Zentralschweiz & Berner Oberland ·
Central Switzerland & Bernese Oberland ·
Suisse centrale & l'Oberland bernois

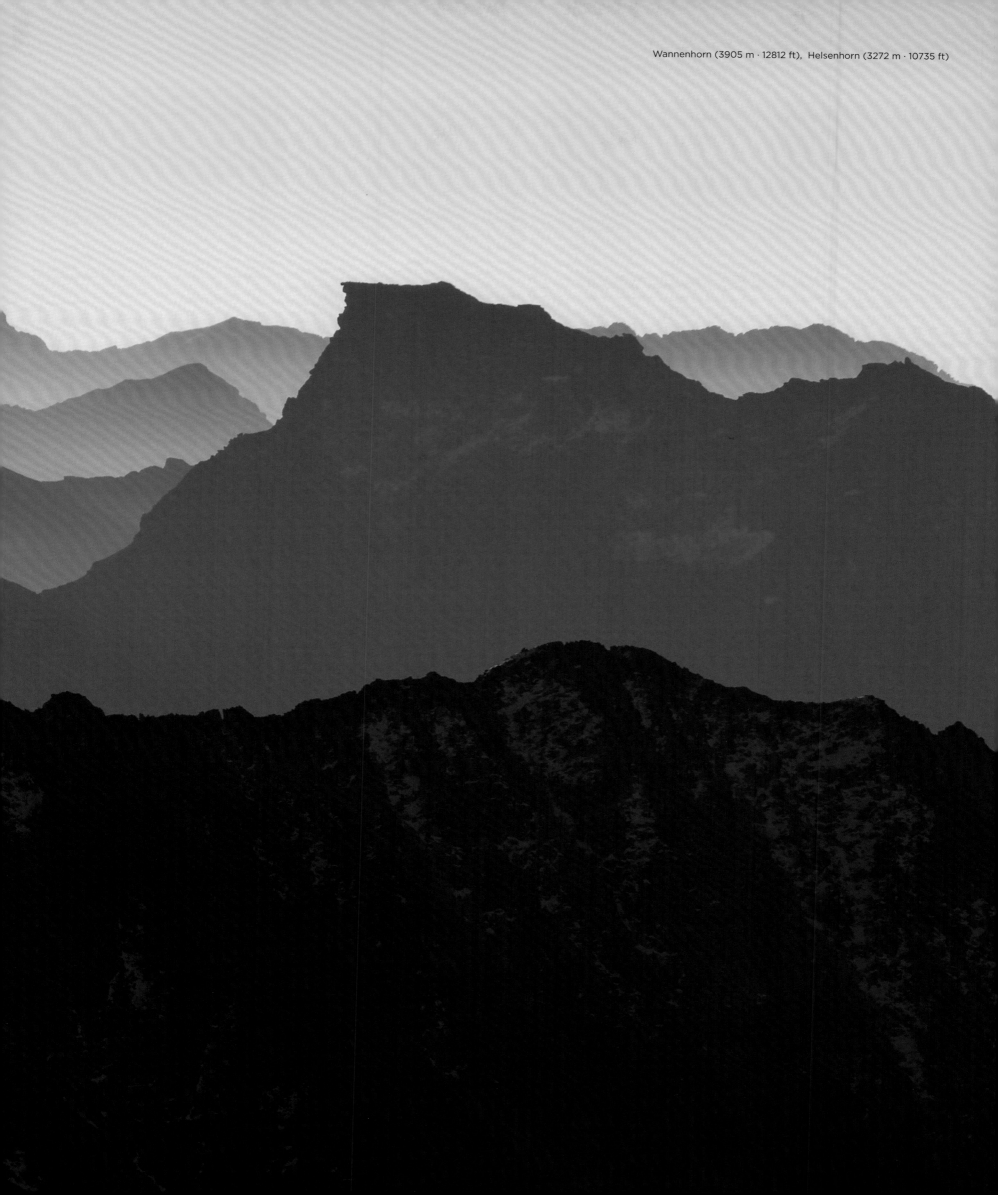

Wannenhorn (3905 m · 12812 ft), Helsenhorn (3272 m · 10735 ft)

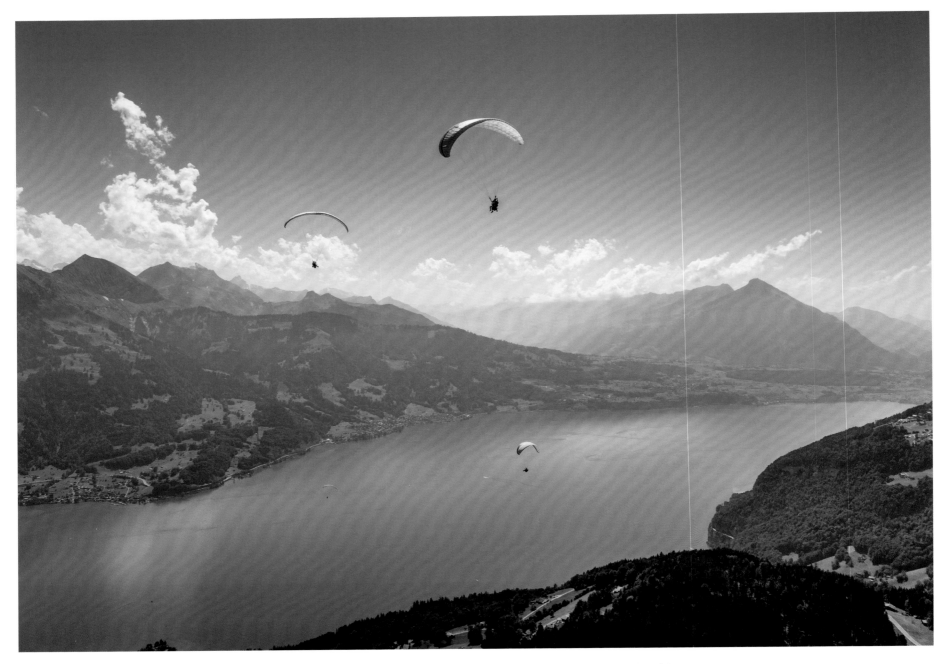

Thunersee
Lac de Thoune

Lake Thun

The 17 km (11 mi) long Lake Thun, a popular holiday region, stretches to the southeast about 25 km (16 mi) south of the Swiss capital Bern. Its banks were already populated about 3000 years ago. In 2016 remains of pile dwellings from the Bronze Age were discovered. At the northern end of the lake lies Thun, the cultural and economic centre of the Bernese Oberland. The city silhouette is dominated by the mighty castle tower on the northern bank of the Aare with its steep roof and the four round corner towers. A trip on Lake Thun with the historic paddle wheel steamer "Blümlisalp" is a charming outing for visitors.

Le lac de Thoune

Le lac de Thoune, lieu de villégiature très apprécié, commence à environ 25 km au sud de la capitale suisse, Berne, et s'étend vers le sud-est. Son rivage était déjà habité il y a près de 3000 ans. En 2016, on y a trouvé des restes de constructions sur pilotis datant de l'âge du bronze. À l'extrémité nord du lac se dresse la ville de Thoune, centre économique et culturel de l'Oberland bernois. Situé sur la rive nord de l'Aar, l'imposant château, avec son toit si pentu et ses quatre tours d'angle rondes, domine la ville. Le *Blümlisalp,* un bateau à aubes ancien, propose de charmantes excursions sur le lac de Thoune.

Thunersee

Rund 25 km südlich der Schweizer Hauptstadt Bern erstreckt sich der 17 km lange Thunersee, ein beliebtes Feriengebiet, nach Südosten. Seine Ufer waren schon vor rund 3000 Jahren besiedelt. 2016 wurden Reste von Pfahlbauten aus der Bronzezeit entdeckt. Am Nordende des Sees liegt Thun, kulturelles und wirtschaftliches Zentrum des Berner Oberlands. Dominiert wird die Stadtsilhouette von dem mächtigen Schlossturm mit seinem steilen Dach und den vier runden Ecktürmchen am nördlichen Ufer der Aare. Besonders reizvoll ist ein Ausflug auf dem Thunersee mit dem historischen Schaufelraddampfer „Blümlisalp".

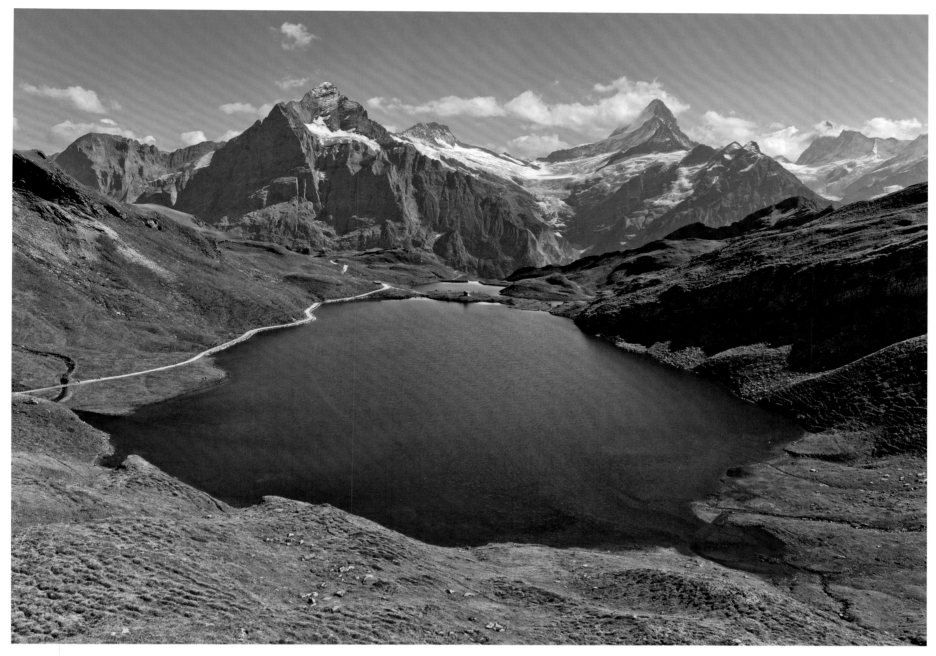

Bachalpsee, Wetterhorn (3692 m · 12113 ft), Schreckhorn (4078 m · 13379 ft), Finsteraarhorn (4274 m · 14022 ft)

Lago de Thun

El lago de Thun, de 17 km de longitud y muy frecuentado por los turistas, se extiende unos 25 km al sur de la capital suiza, Berna, hacia el sureste. Su ribera ya estaba poblada hace unos 3000 años. En 2016 se descubrieron restos de viviendas en pilotes de la Edad de Bronce. En el extremo norte del lago se encuentra Thun, el centro cultural y económico del Oberland bernés. La silueta de la ciudad está dominada por la poderosa torre del castillo con su techo empinado y las cuatro torres redondas en la orilla norte del Aar. Una excursión por el lago de Thun con el histórico vapor de ruedas de paletas «Blümlisalp» es especialmente atractiva.

Lago Thun

O Lago Thun, uma popular região de férias, com 17 km de extensão, se estende cerca de 25 km ao sul da capital suíça, Berna, até o sudeste. Os seus bancos já estavam povoados há cerca de 3000 anos. Em 2016, restos de moradias de pilha da Idade do Bronze foram descobertos. No extremo norte do lago encontra-se Thun, o centro cultural e económico do Oberland Bernês. A silhueta da cidade é dominada pela poderosa torre do castelo com o seu telhado íngreme e as quatro torres de canto redondas na margem norte do Aare. Uma viagem no Lago Thun com o histórico vaporizador de rodas de pás "Blümlisalp" é particularmente atraente.

Meer van Thun

Het Meer van Thun, 25 km ten zuiden van de Zwitserse hoofdstad Bern, is toeristische trekpleister en strekt zich over circa 17 km uit naar het zuidoosten. Uit in in 2016 ontdekte resten van paalwoningen uit de bronstijd blijkt dat de eerste nederzettingen hier zo'n 3000 jaar geleden werden gesticht. Thun aan de noordkant van het meer is het culturele en economische centrum van het Berner Oberland. Het stadsbeeld wordt bepaald door de enorme kasteeltoren met zijn steile dak en de vier ronde hoektorens op de noordelijke oever van de Aare. Een rondvaart over het meer met de historische raderstoomboot 'Blümlisalp' is een echte aanrader.

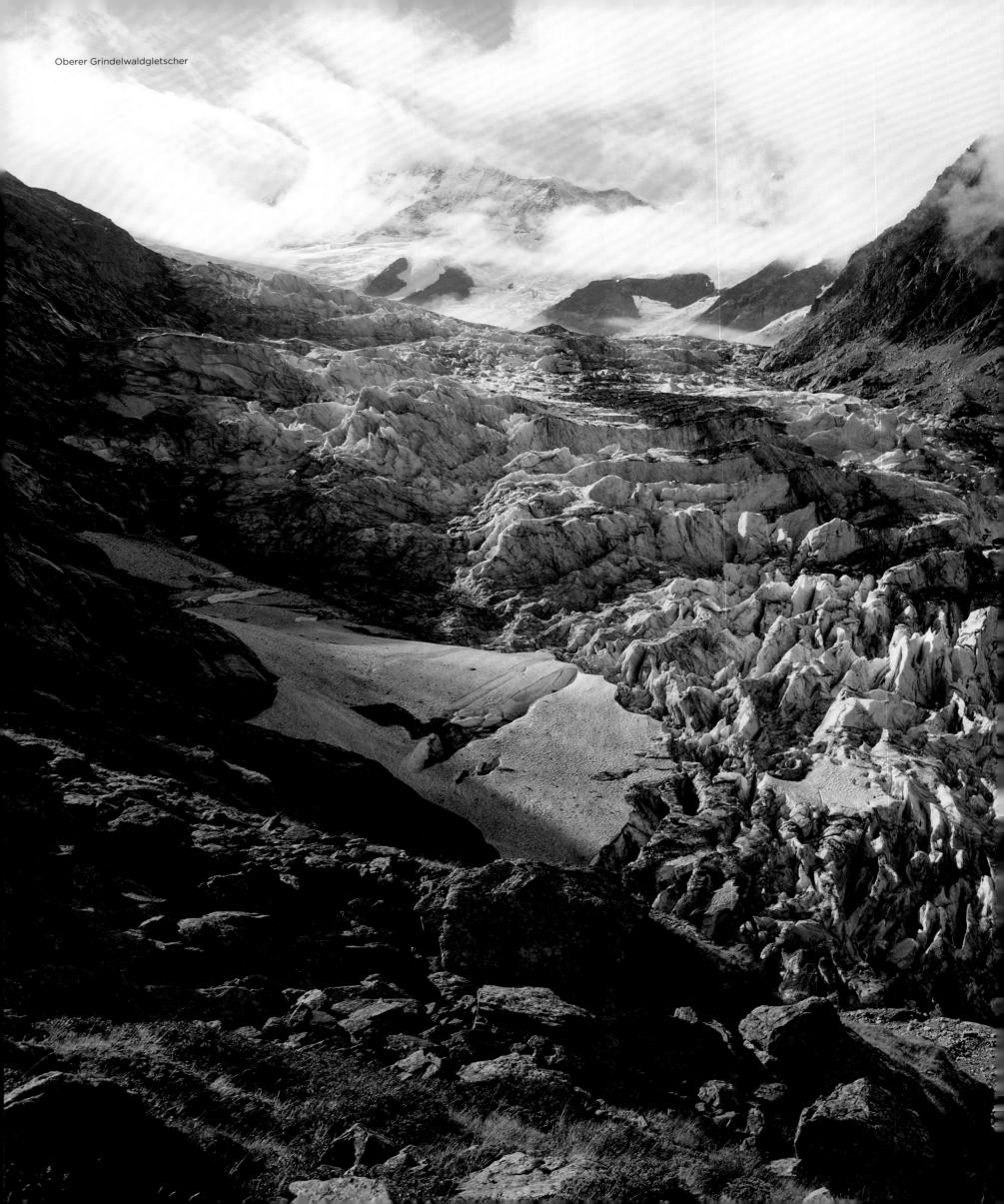

Oberer Grindelwaldgletscher

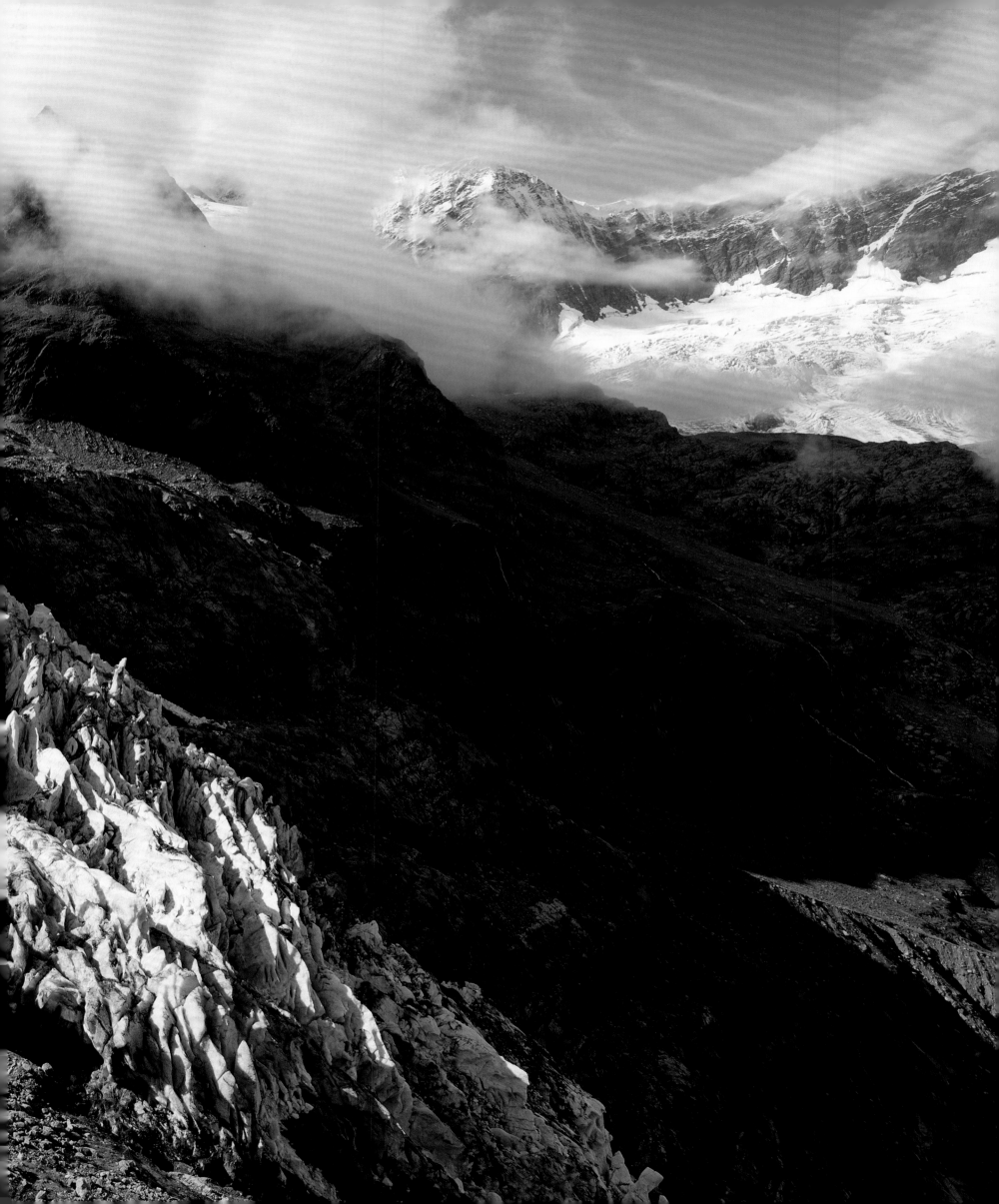

Vierwaldstätter See, Raddampfer „Schiller"
Lac des Quatre-Cantons, Bateau à roues à aubes « Schiller »
Lake Lucerne, Paddle steamer "Schiller"

Lucerne

Lucerne lies on the north-western tip of Lake Lucerne. It is best known for the chapel bridge built in the 14th century, a 200 m (656 m) long covered wooden bridge over the Reuss river connecting the old and the new town, which used to serve as a defensive walkway. In 1993 it burned down almost completely, but was reconstructed faithfully.

Lucerne

La ville de Lucerne se trouve à la pointe nord-ouest du lac des Quatre-Cantons. Elle est surtout connue pour son pont de la Chapelle, un pont de bois couvert construit au XIVe siècle, long de 200 m, qui enjambe la Reuss, reliant la vieille ville à la ville nouvelle. Il servait autrefois de chemin de ronde. Ce pont a brûlé presque intégralement en 1993, mais a été reconstruit à l'identique.

Luzern

An der Nordwestspitze des Vierwaldstättersees liegt Luzern. Bekannt ist die Stadt vor allem durch die im 14. Jahrhundert errichtete Kapellbrücke, eine gut 200 m lange überdachte Holzbrücke über die Reuss, die Altstadt und Neustadt verbindet und früher als Wehrgang diente. 1993 brannte sie fast vollständig ab, wurde aber originalgetreu rekonstruiert.

Lucerna

Lucerna se encuentra en el extremo noroeste del lago de Lucerna. Es más conocido por el puente de la capilla construido en el siglo XIV, un puente de madera cubierto de 200 m de largo sobre el río Reuss, que conecta el casco antiguo con la parte nueva de la ciudad y que servía de pasarela defensiva. En 1993 se quemó casi por completo, pero fue reconstruido fielmente al original.

Luzerna

Lucerna fica na ponta noroeste do Lago Lucerna. É mais conhecida pela ponte da capela construída no século XIV, uma ponte de madeira coberta de 200 m de comprimento sobre o rio Reuss, que liga a cidade velha e a nova cidade e serviu de passadiço defensivo. Em 1993, queimou quase completamente, mas foi reconstruído fiel ao original.

Luzern

Luzern ligt in de noordwestelijke hoek van het Vierwoudstedenmeer en staat vooral bekend om de 14e-eeuwse Kapelbrug. Deze 200 m lange overdekte houten brug over de rivier de Reuss vormt de verbinding tussen de oude en de nieuwe stad en diende ooit als verdedigingsbrug. In 1993 brandde de brug bijna volledig af, maar werd weer getrouw het origineel gereconstrueerd.

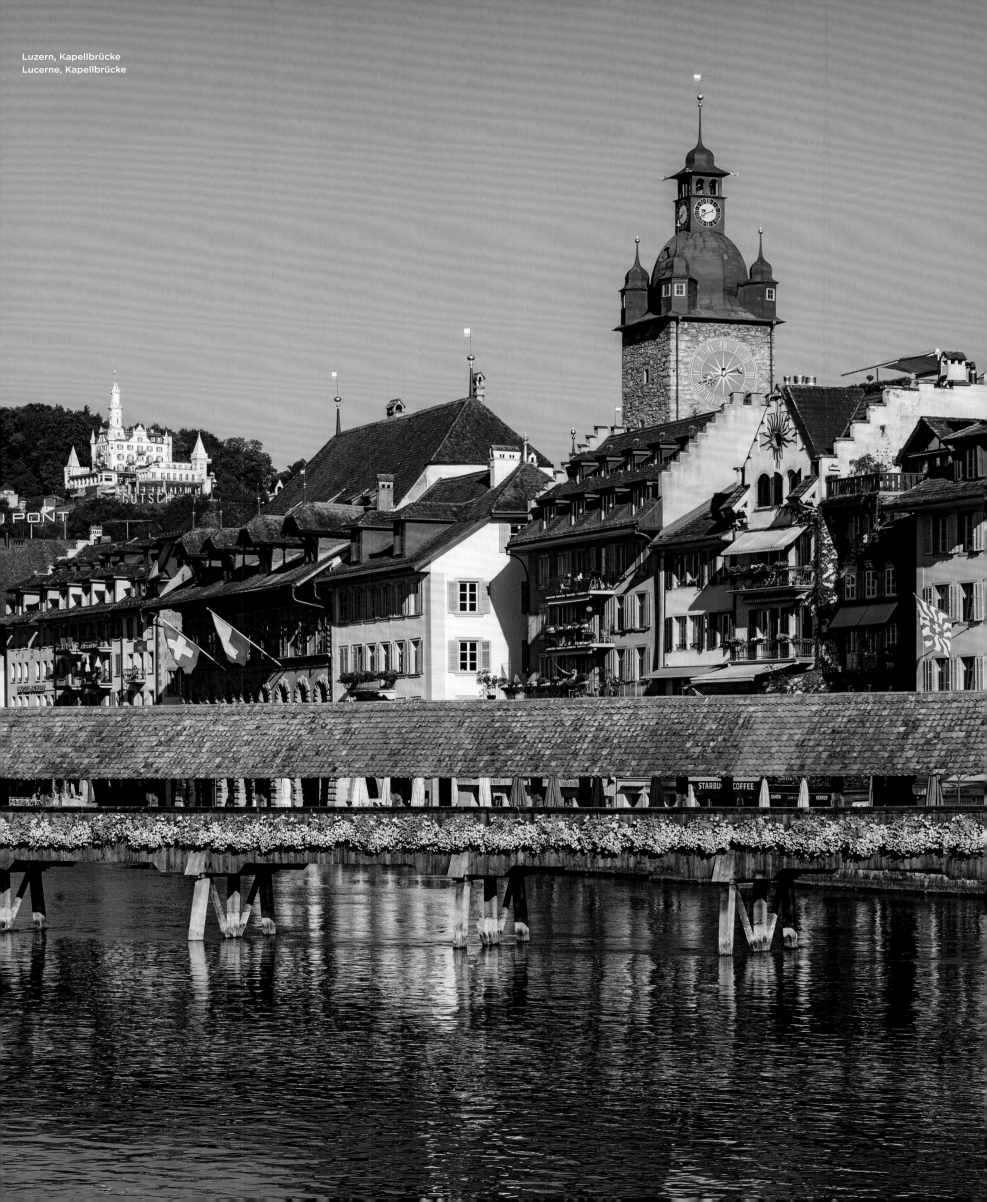

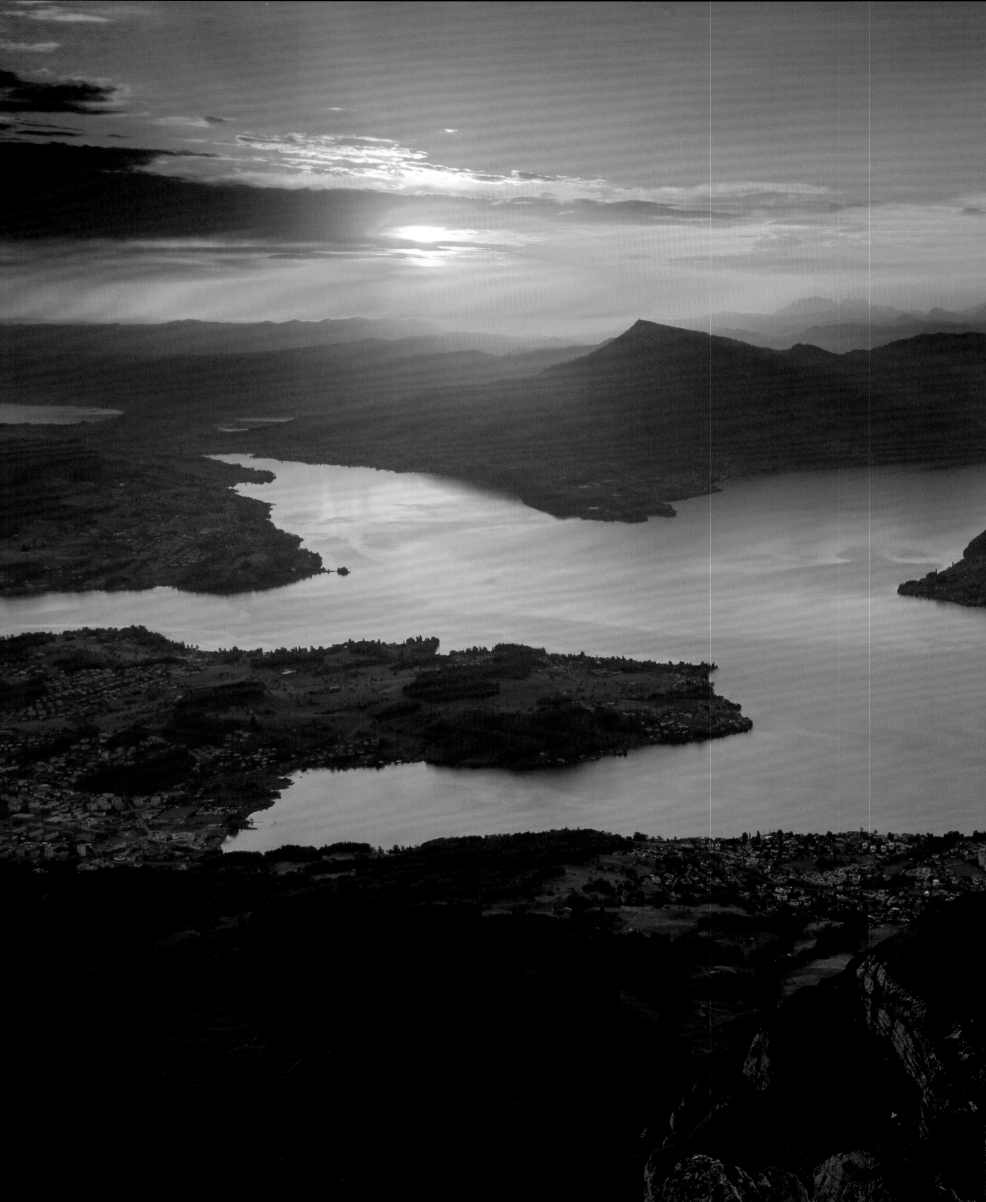

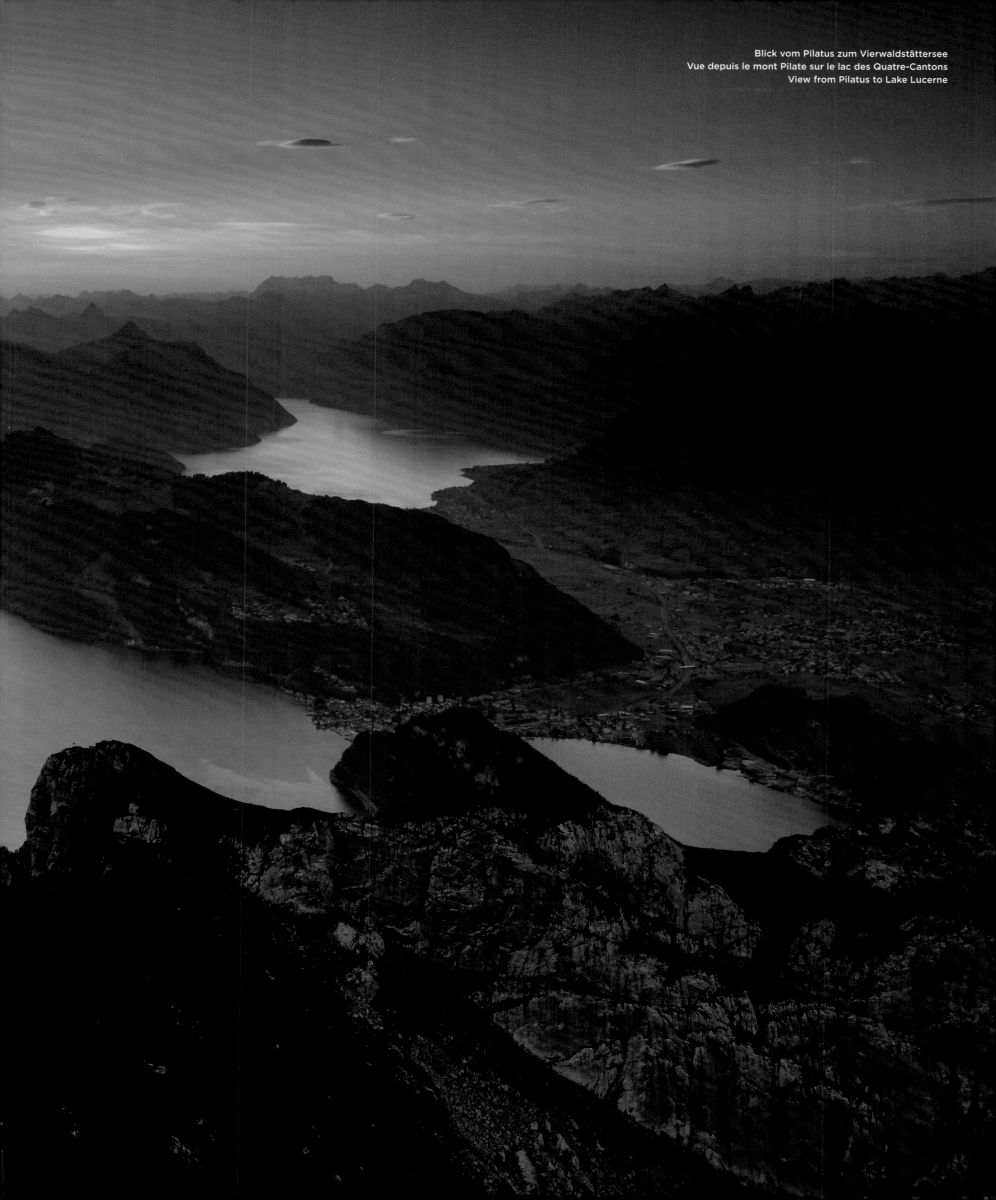

Blick vom Pilatus zum Vierwaldstättersee
Vue depuis le mont Pilate sur le lac des Quatre-Cantons
View from Pilatus to Lake Lucerne

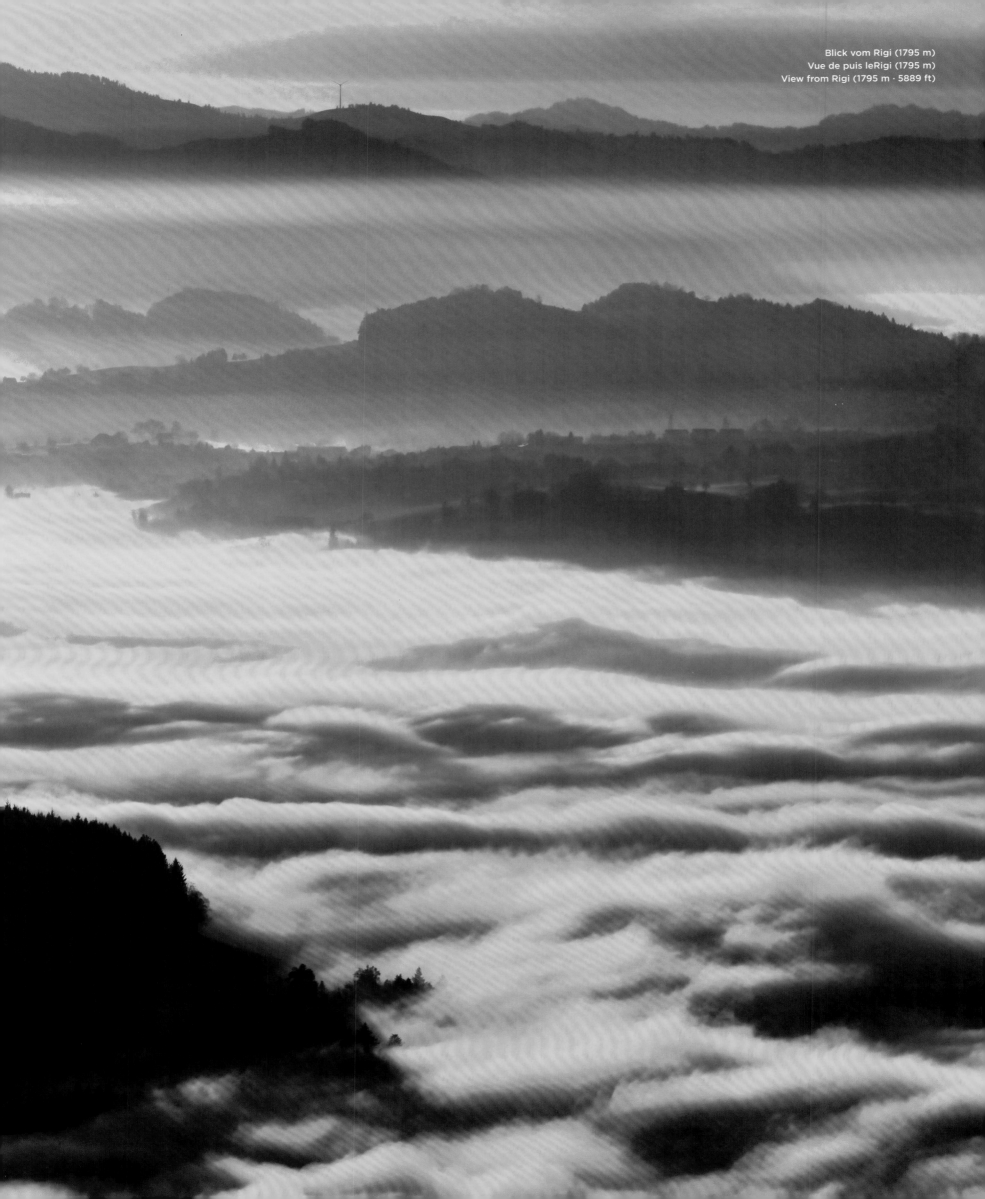

Blick vom Rigi (1795 m)
Vue de puis leRigi (1795 m)
View from Rigi (1795 m · 5889 ft)

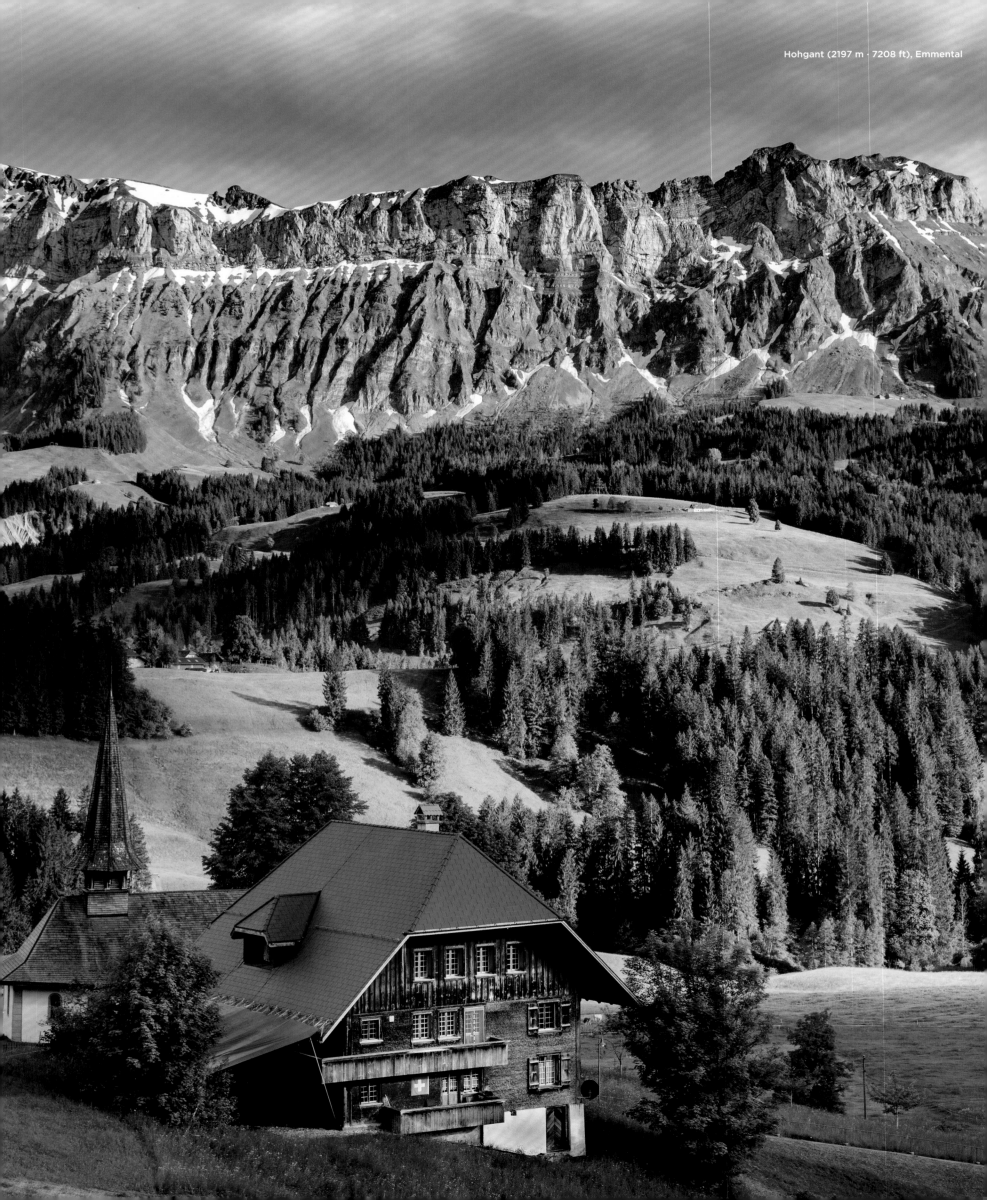

Kuh, Emmental
Vache, Emmental
Cow, Emmental

Emmental

Livestock breeding traditionally plays an important role in the Emmental not far from Bern. Cow's milk is processed into a spicy cheese, which is called "Emmentaler" and is one of the Swiss cheeses par excellence. However, Emmentaler cheese is by no means only produced here, the name is not protected. But all Emmentaler cheeses have the typical holes in common.

L'Emmental

Dans l'Emmental, une vallée située non loin de Berne, l'élevage joue traditionnellement un rôle incontournable. Le lait de vache est transformé en un fromage au goût prononcé, l'emmental, le fromage suisse par excellence. Mais cette région est loin d'être la seule où l'on fabrique de l'emmental, car cette appellation n'est pas protégée. Tous les emmentals ont néanmoins en commun leurs trous typiques.

Emmental

Viehzucht spielt im unweit von Bern gelegenen Emmental traditionell eine wichtige Rolle. Kuhmilch wird zu einem würzigen Käse verarbeitet, der als „Emmentaler" für Schweizer Käse schlechthin steht. Allerdings wird Emmentaler keineswegs nur hier hergestellt, die Bezeichnung ist nicht geschützt. Allen Emmentalern gemeinsam sind aber die typischen Löcher.

Emmental

La cría de ganado desempeña tradicionalmente un papel importante en el Emmental, no lejos de Berna. La leche de vaca se transforma en un queso picante: el emmental, que es del queso suizo por excelencia. Sin embargo, el queso emmental no solo se produce aquí; el nombre no está protegido. Pero todos los quesos emmental tienen en común los típicos agujeritos.

Emmental

A criação de gado desempenha tradicionalmente um papel importante no Emmental não muito longe de Berna. O leite de vaca é transformado em queijo picante, que se destaca como "Emmental" para queijo suíço por excelência. No entanto, o Emmental não é produzido apenas aqui, a denominação não é protegida. Mas todos os Emmentalern têm os buracos típicos em comum.

Emmentaler

Al van oudsher speelt veeteelt een belangrijke rol in het nabij Bern gelegen Emmental. Hier verwerkt men koemelk tot een kruidige kaas, de 'emmentaler', de Zwitserse kaas bij uitstek. Aangezien de naam niet beschermd is, hoeft een Emmentaler niet per sé uit dit dal te komen. Maar één ding hebben alle emmentalers gemeen: de typische gaten.

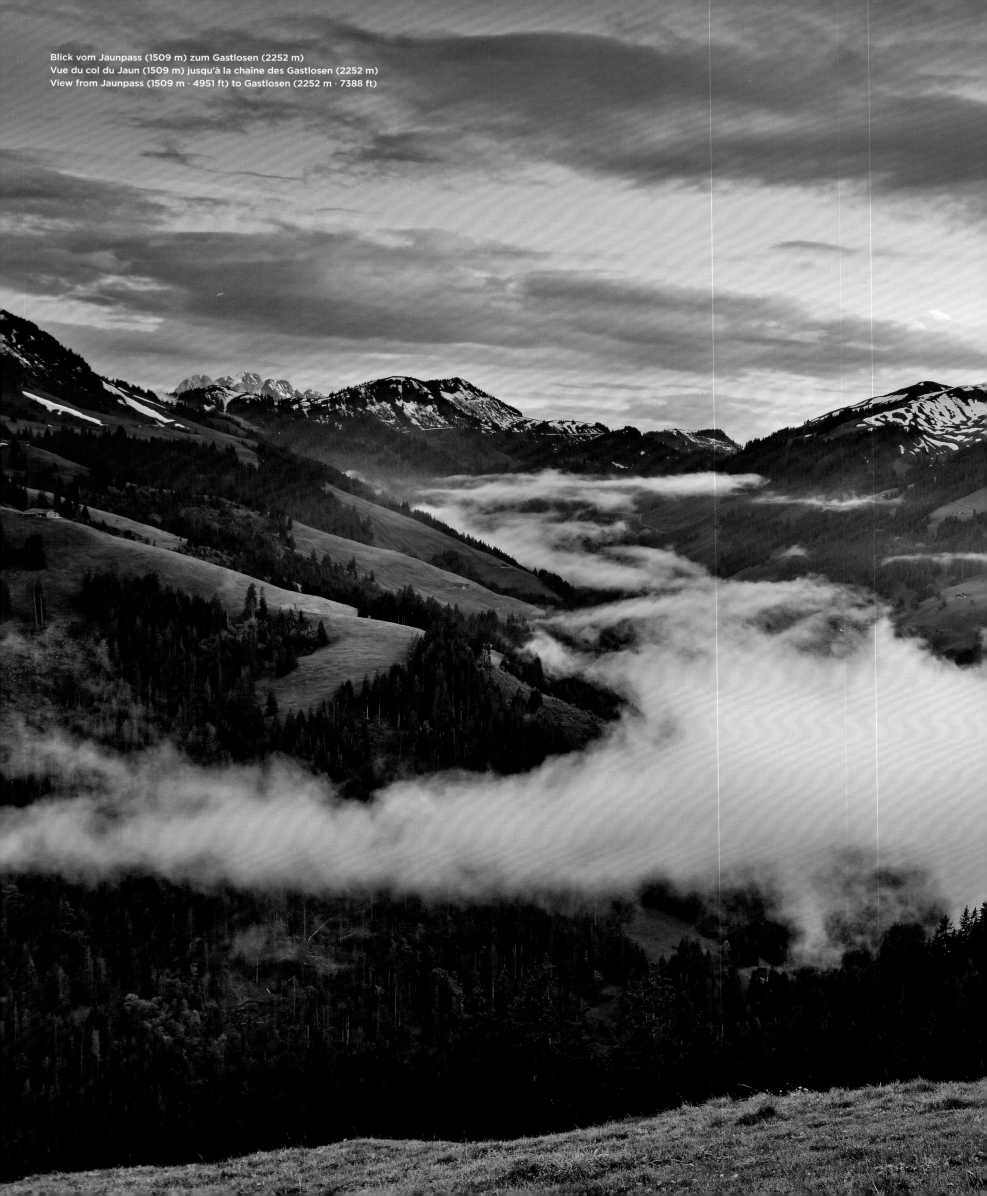

Blick vom Jaunpass (1509 m) zum Gastlosen (2252 m)
Vue du col du Jaun (1509 m) jusqu'à la chaîne des Gastlosen (2252 m)
View from Jaunpass (1509 m · 4951 ft) to Gastlosen (2252 m · 7388 ft)

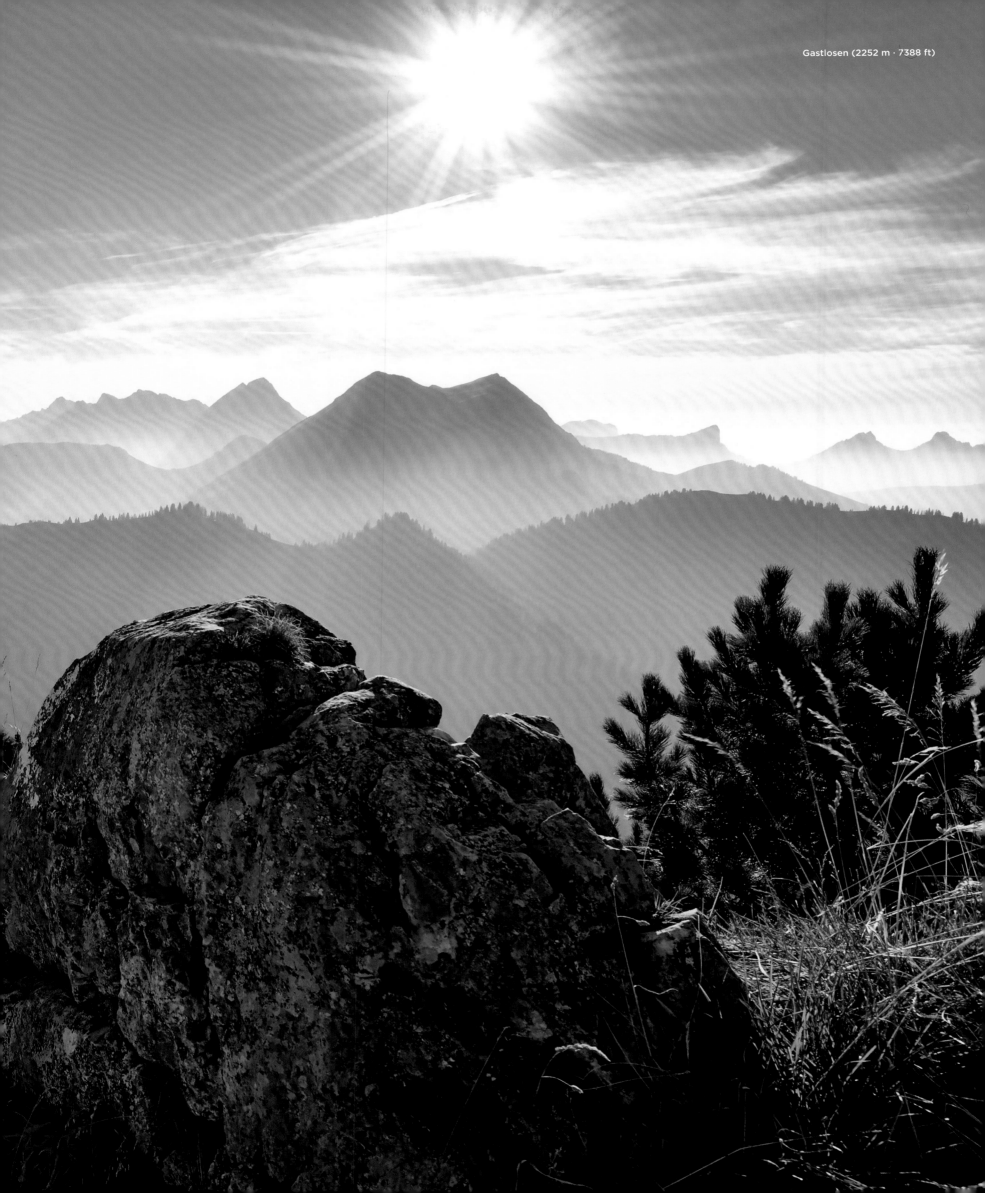

Gastlosen (2252 m · 7388 ft)

HOTEL SCHIFF

Morat
Murten

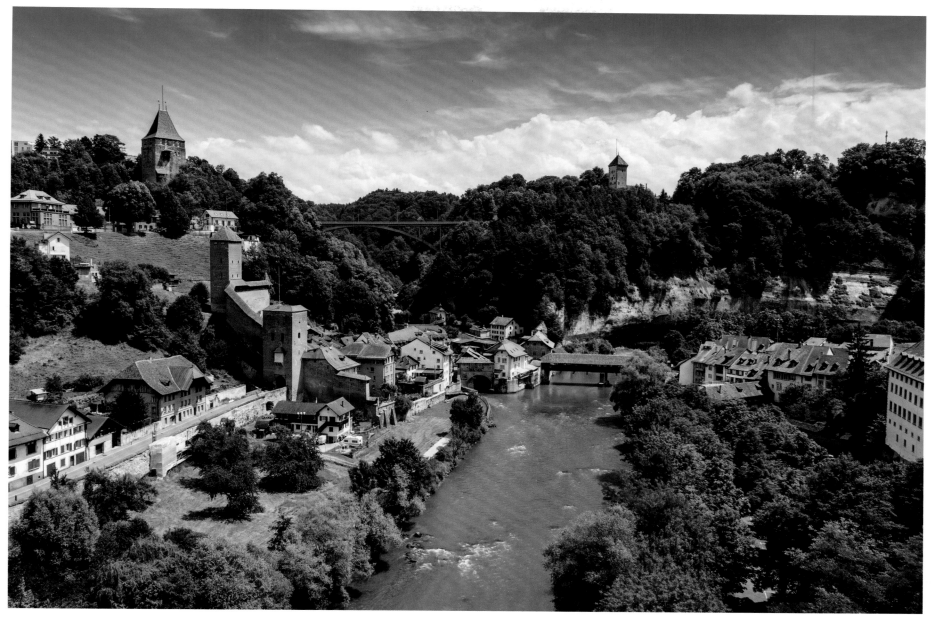

Fribourg
Freiburg

Fribourg

The Canton of Fribourg in western Switzerland stretches from the foothills of the Alps up into the Alps themselves. France is close, about two thirds of the population speak French. The other towns in the canton are smaller than the capital Fribourg, Murten on Lake Murten is particularly picturesque. In the west, the canton extends to the largest lake in the region, Lake Neuchâtel.

Le canton de Fribourg

Le canton de Fribourg s'étend à l'ouest de la Suisse, des Préalpes aux Alpes. La France n'est pas loin et les deux tiers de la population parlent français. Outre sa capitale, Fribourg, le canton est surtout composé de petites localités, comme Morat, joliment lovée au bord du lac éponyme. À l'ouest, le canton va jusqu'au plus grand lac de la région, le lac de Neuchâtel.

Freiburg

Von den Voralpen bis in die Alpen erstreckt sich der Westschweizer Kanton Freiburg. Frankreich ist nahe, etwa zwei Drittel der Bevölkerung sprechen Französisch. Neben der Hauptstadt Freiburg gibt es überwiegend kleine Orte, besonders hübsch liegt Murten am Murtensee. Im Westen reicht der Kanton bis zum größten See der Region, dem Neuenburger See.

Friburgo

El cantón de Friburgo, en el oeste de Suiza, se extiende desde las estribaciones de los Prealpes suizos hasta los Alpes. Francia está cerca y aproximadamente dos tercios de la población hablan francés. Junto a la capital de Friburgo hay principalmente ciudades pequeñas, Murten en el lago Murten es particularmente bonita. En el oeste, el cantón se extiende hasta el lago más grande de la región, el lago Neuchâtel.

Friburgo

O Cantão de Friburgo, na Suíça ocidental, estende-se desde os contrafortes dos Alpes até aos Alpes. A França está perto, cerca de dois terços da população fala francês. Além da capital Freiburg, existem principalmente pequenas cidades, Murten no lago Murten é particularmente bonita. A oeste, o cantão estende-se até ao maior lago da região, o Lago Neuchâtel.

Freiburg

Het West-Zwitserse kanton Freiburg strekt zich uit van de uitlopers van de Alpen tot aan hun hoofdkam. Frankrijk is dichtbij, ongeveer twee derde van de bevolking spreekt Frans. Naast de hoofdstad Freiburg bestaat de streek vooral uit kleine stadjes. Een ervan, Murten aan het gelijknamige meer, is zeer bezienswaardig. In het westen grenst het kanton aan het grootste meer van de regio, het Meer van Neuchâtel.

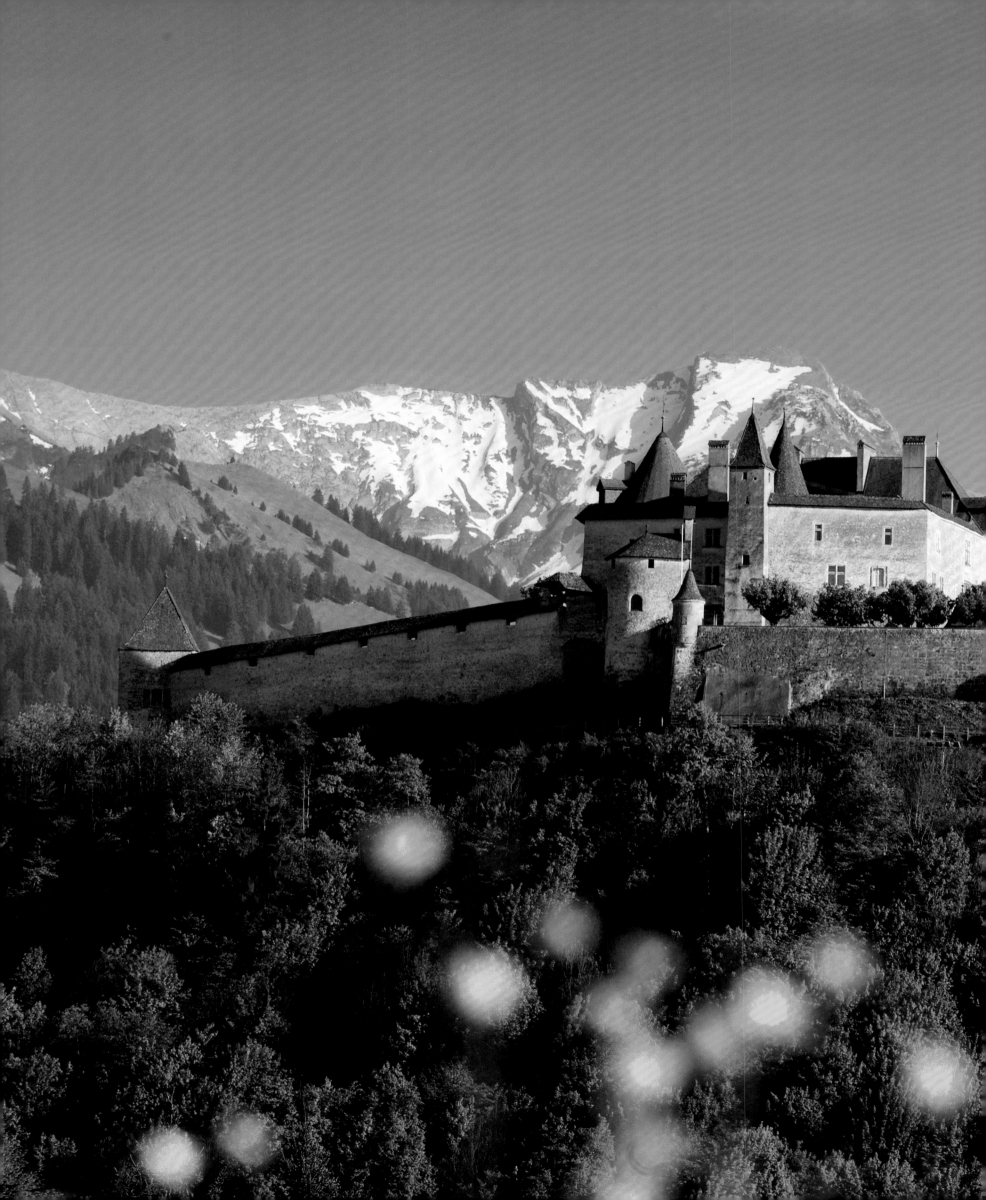

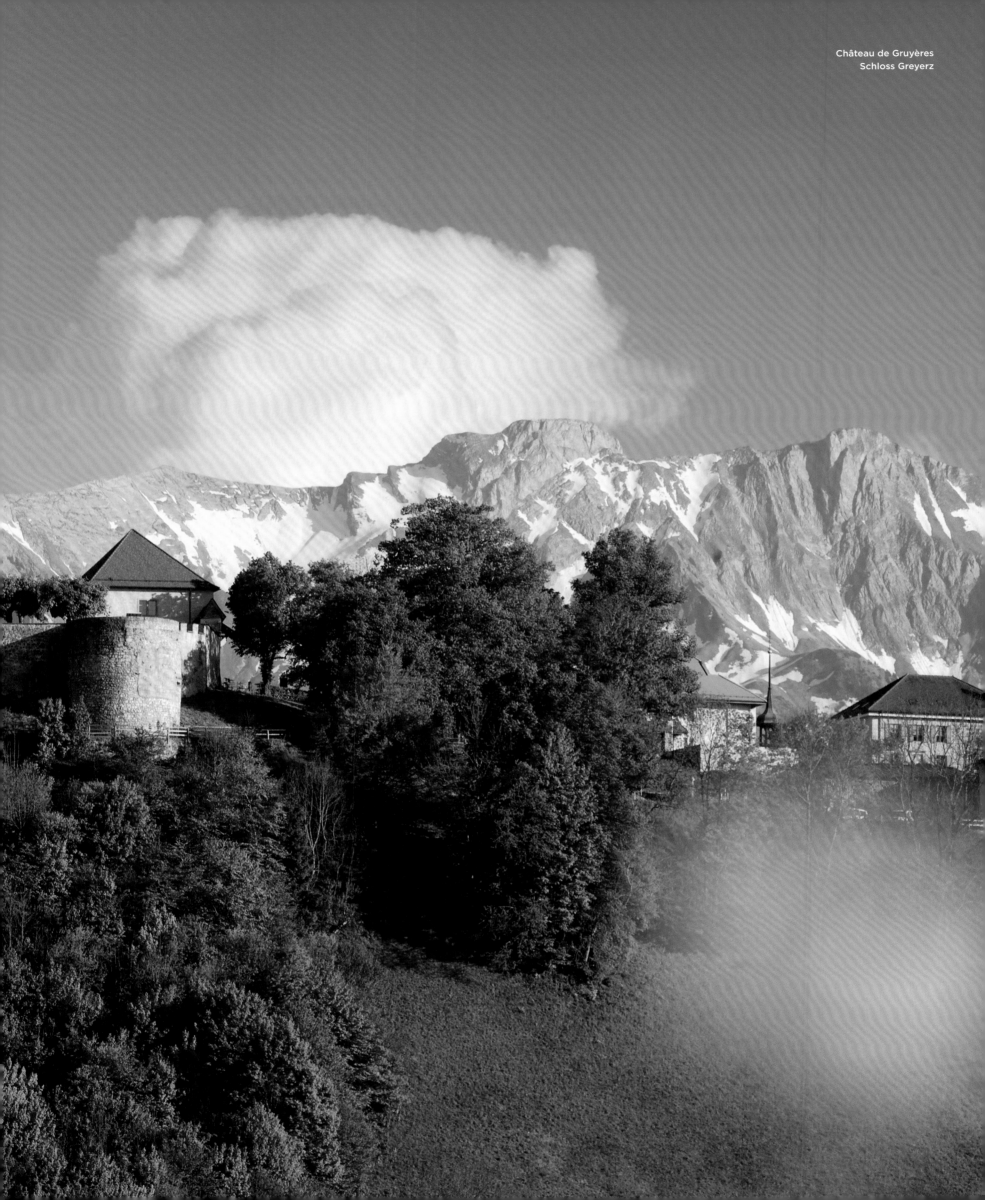

Château de Gruyères
Schloss Greyerz

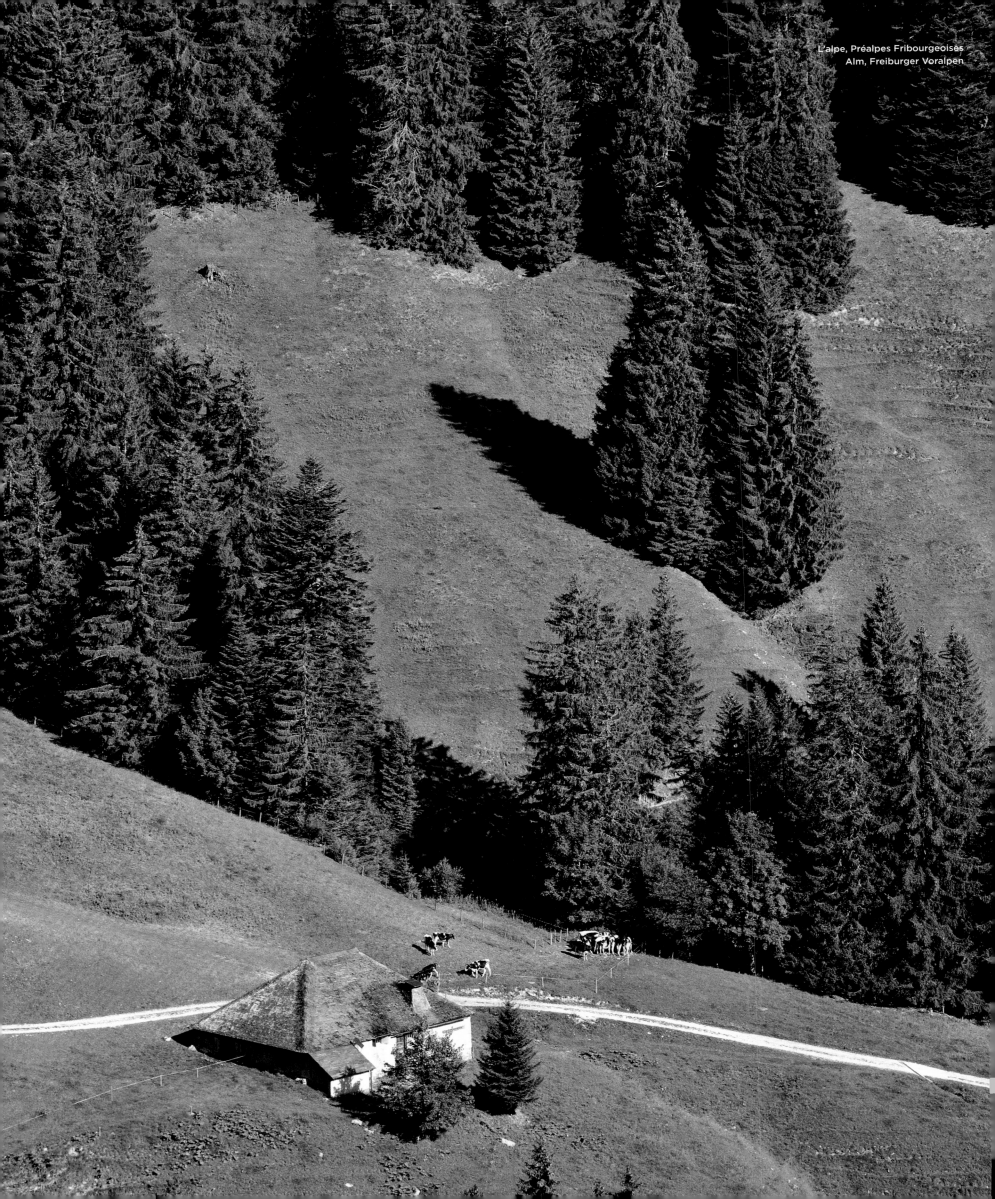

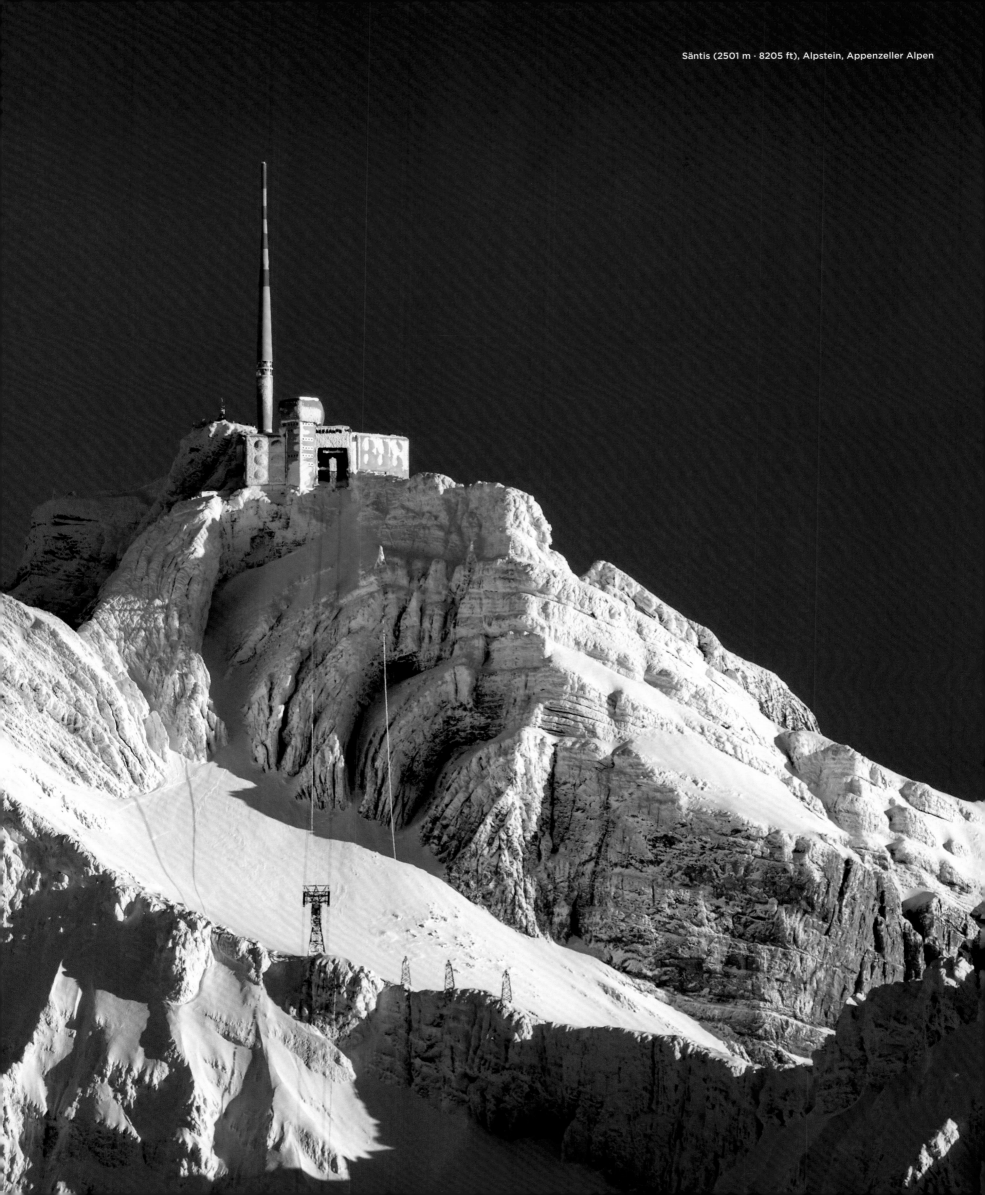

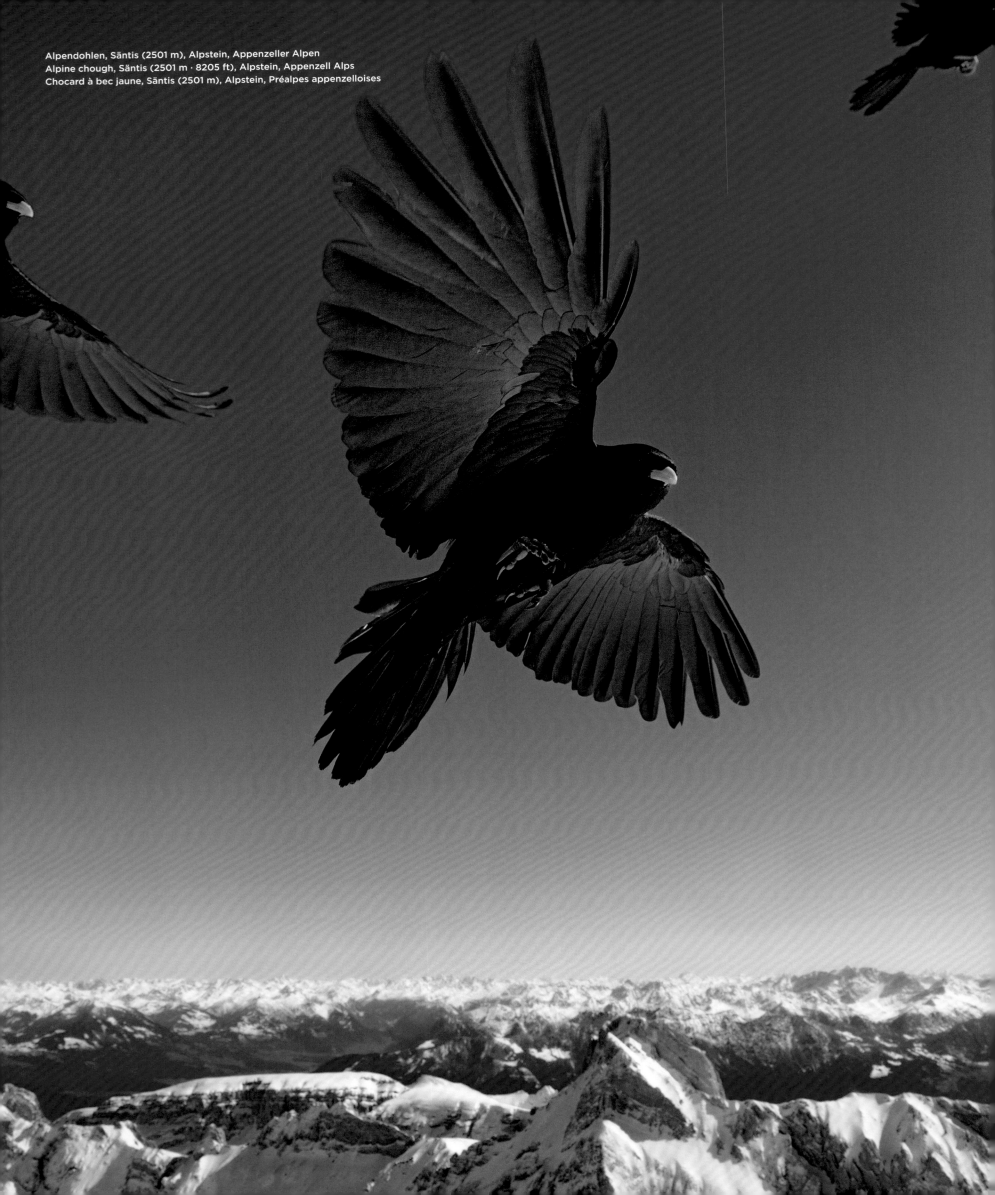

Alpendohlen, Säntis (2501 m), Alpstein, Appenzeller Alpen
Alpine chough, Säntis (2501 m · 8205 ft), Alpstein, Appenzell Alps
Chocard à bec jaune, Säntis (2501 m), Alpstein, Préalpes appenzelloises

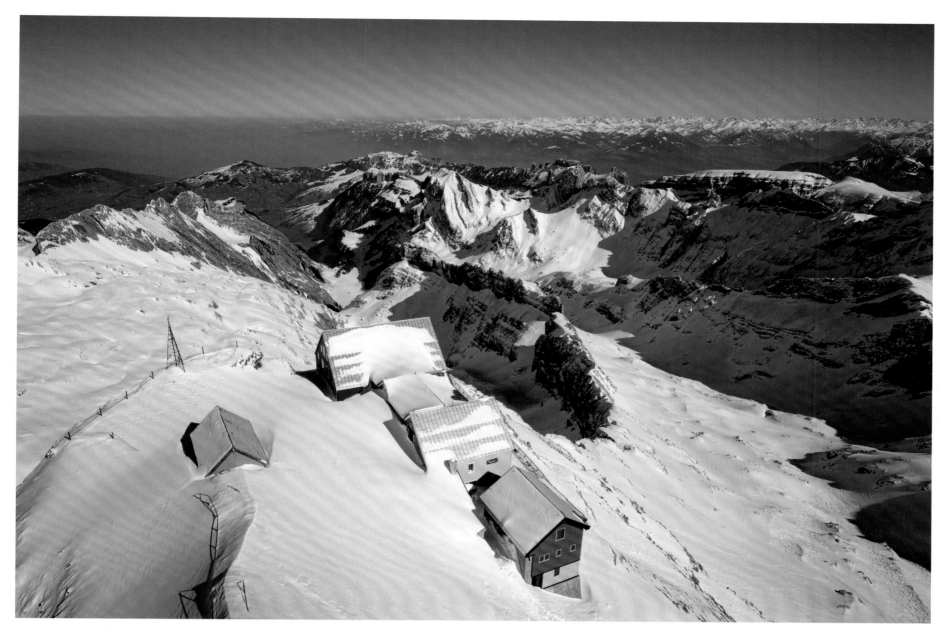

Säntis (2501 m · 8205 ft), Alpstein, Appenzeller Alpen

Eastern Switzerland

Cosmopolitan and backward-looking: Eastern Switzerland is both. Liberal Zürich, Switzerland's largest city and economic centre, is regularly ranked among the most liveable and expensive cities in the world. The cantons to the east cultivate patriarchal traditions; in Appenzell Innerrhoden women's suffrage has only been in force since 1990.

La Suisse orientale

La Suisse orientale est en même temps ouverte sur le monde et tournée vers le passé. Zurich est à la fois la plus grande ville de Suisse et son centre économique. C'est aussi une ville universitaire vivante et dynamique, qui jouit d'une réputation internationale dans le domaine des arts et de la culture. Les cantons orientaux sont très attachés aux traditions patriarcales : l'Appenzell Rhodes-Intérieures n'a accordé le droit de vote aux femmes qu'en 1990.

Ostschweiz

Weltoffen und rückwärtsgewandt: Beides ist die Ostschweiz. Zürich, größte Stadt und Wirtschaftszentrum der Schweiz, hat auch dank der vielen Studenten eine liberale Atmosphäre und einen internationalen Ruf als Kunst- und Kulturstadt. Die östlich gelegenen Kantone pflegen patriarchalische Traditionen; in Appenzell Innerrhoden gilt erst seit 1990 das Frauenwahlrecht.

Suiza oriental

Cosmopolita y retrógrada: la Suiza del este es ambas cosas. La ciudad liberal de Zúrich, la ciudad y centro económico más grande de Suiza, tiene una atmósfera liberal gracias a la gran cantidad de estudiantes y goza de reputación internacional como ciudad de arte y cultura. Los cantones del este cultivan tradiciones patriarcales; en Appenzell Rodas Interiores, el sufragio femenino solo está en vigor desde 1990.

Suíça Oriental

Cosmopolita e retrógrada: A Suíça Oriental é ambos. A cidade liberal de Zurique, a maior cidade e centro econômico da Suíça, é regularmente classificada entre as cidades mais habitáveis – e caras – do mundo. Os cantões a leste cultivam tradições patriarcais; em Appenzell Innerrhoden, o sufrágio feminino só vigora desde 1990.

Oost-Zwitserland

Kosmopolitisch en reactionair, zo is Oost-Zwitserland. Daarentegen is Zürich een zeer liberale stad, mede dankzij de vele studenten, en heeft het een internationale reputatie als kunst- en cultuurstad. In de kantons in het oosten houdt men patriarchale tradities in ere; in Appenzell Innerrhoden werd pas in 1990 het vrouwenkiesrecht ingevoerd.

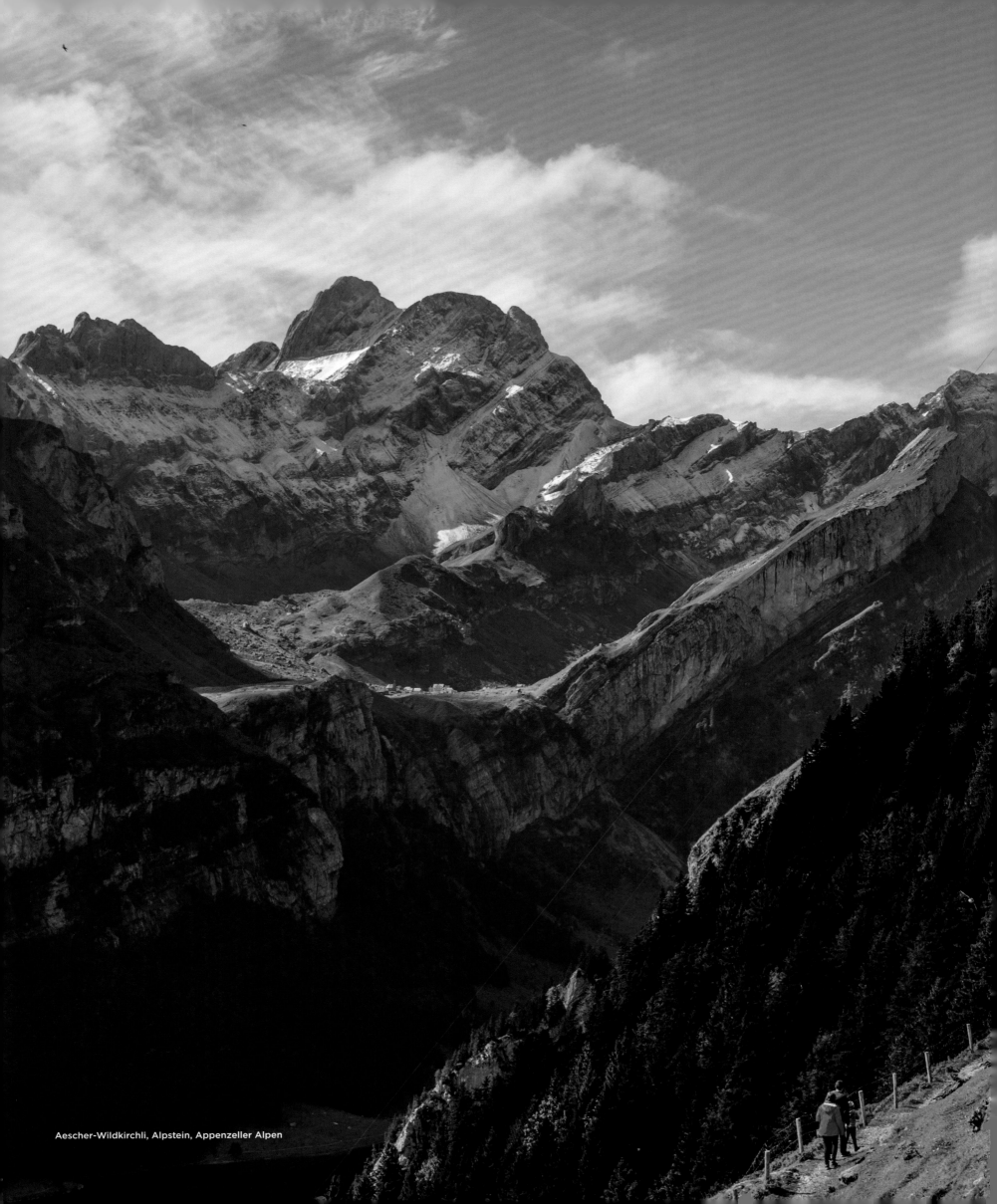

Aescher-Wildkirchli, Alpstein, Appenzeller Alpen

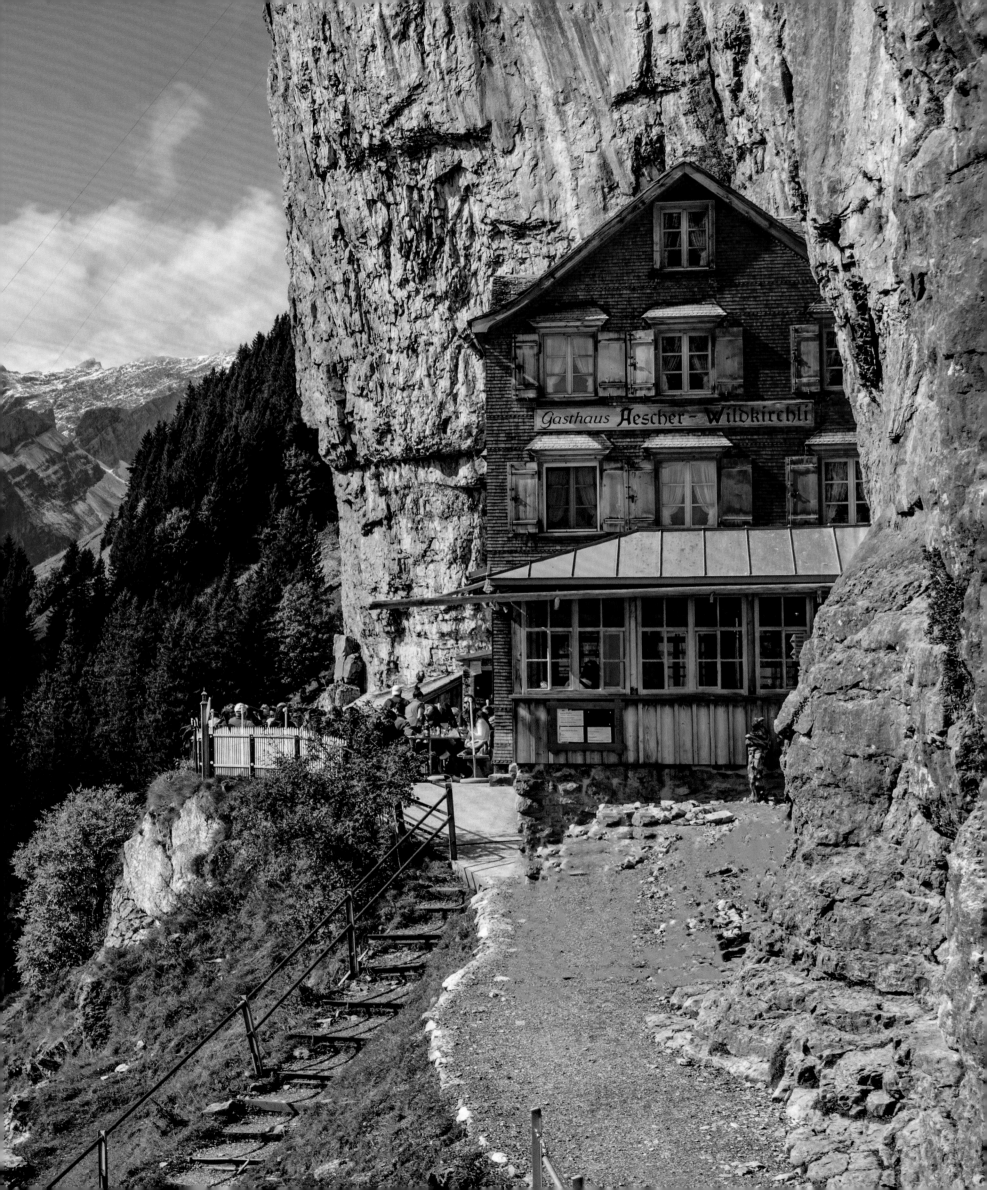

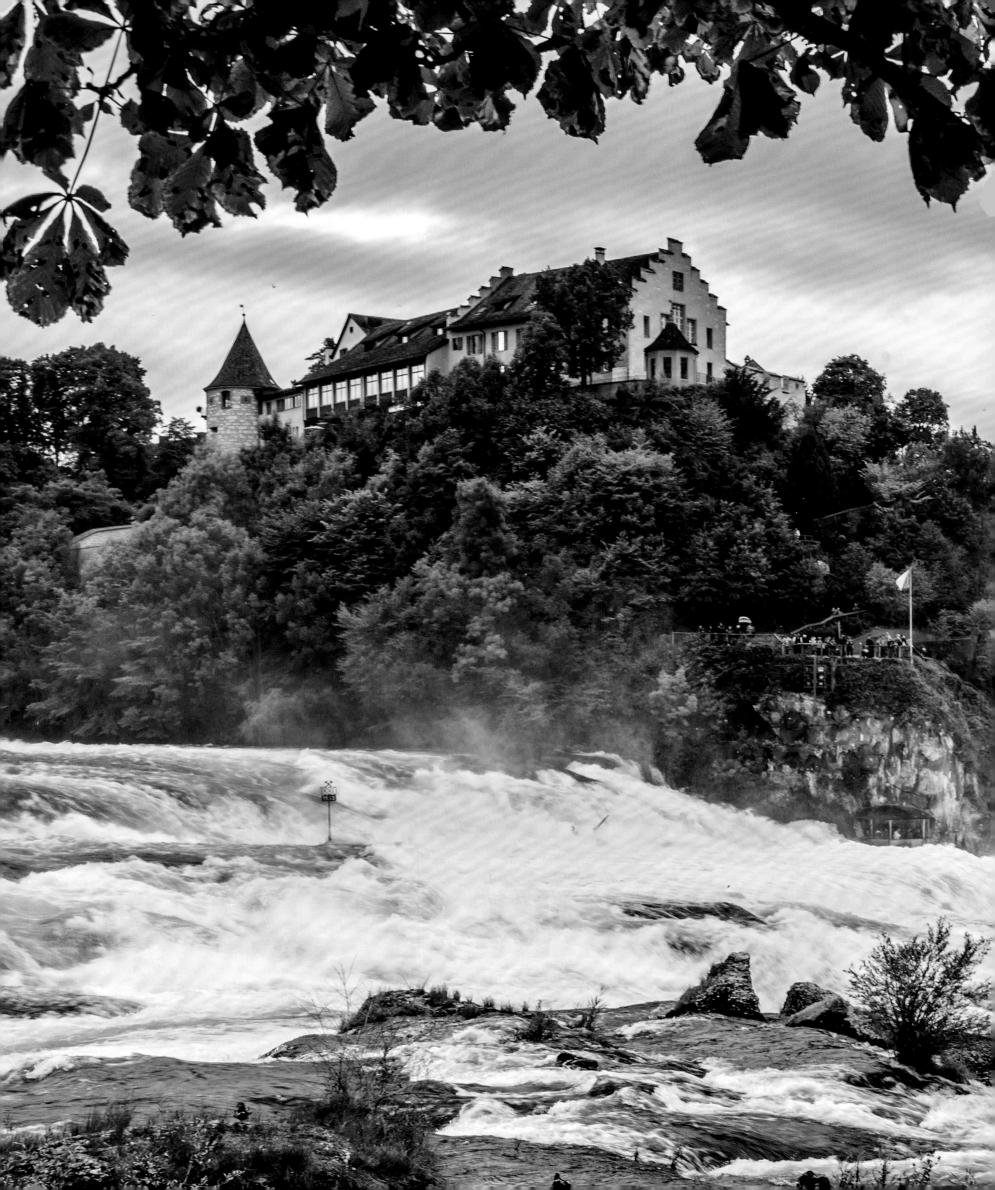

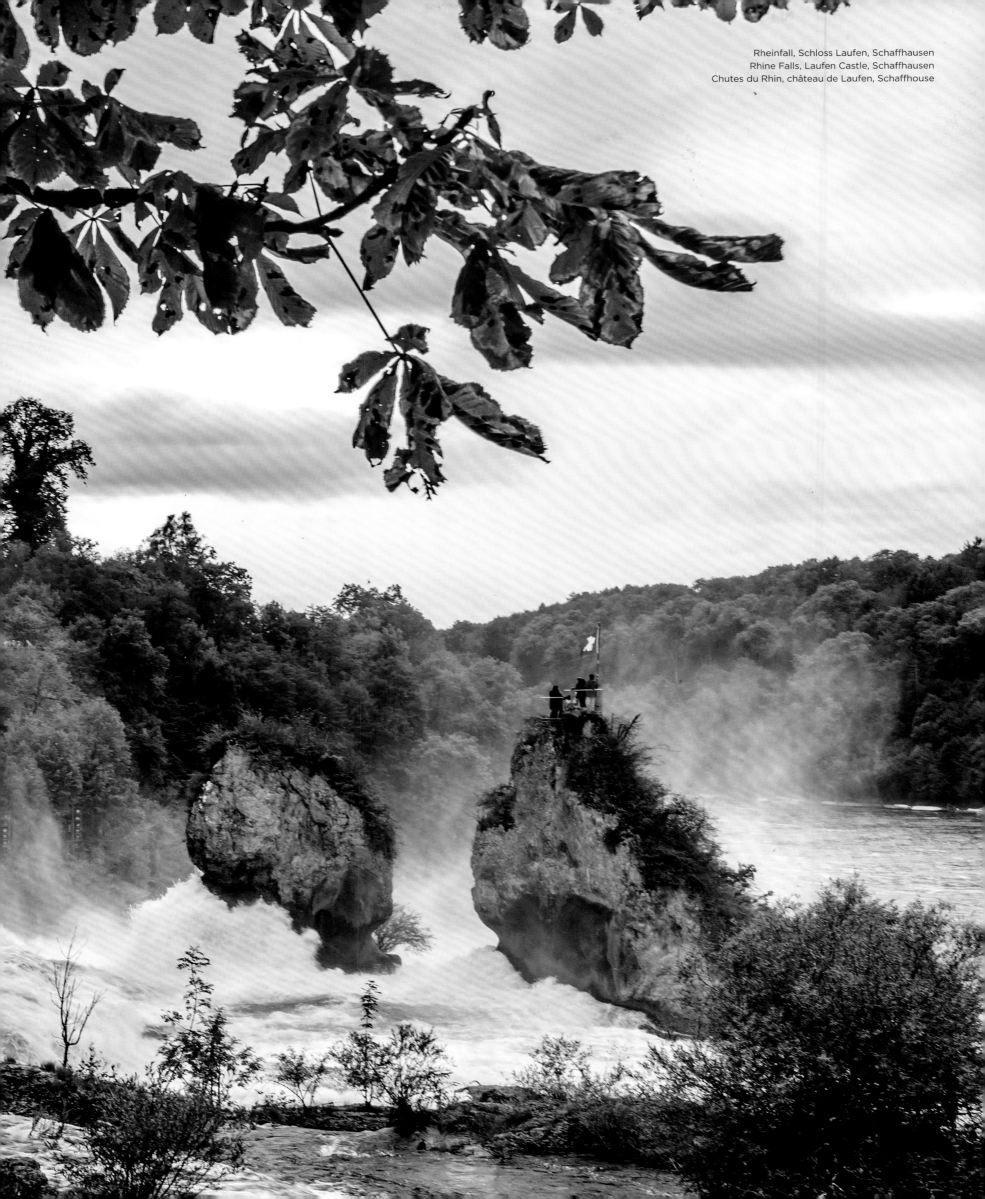

Rheinfall, Schloss Laufen, Schaffhausen
Rhine Falls, Laufen Castle, Schaffhausen
Chutes du Rhin, château de Laufen, Schaffhouse

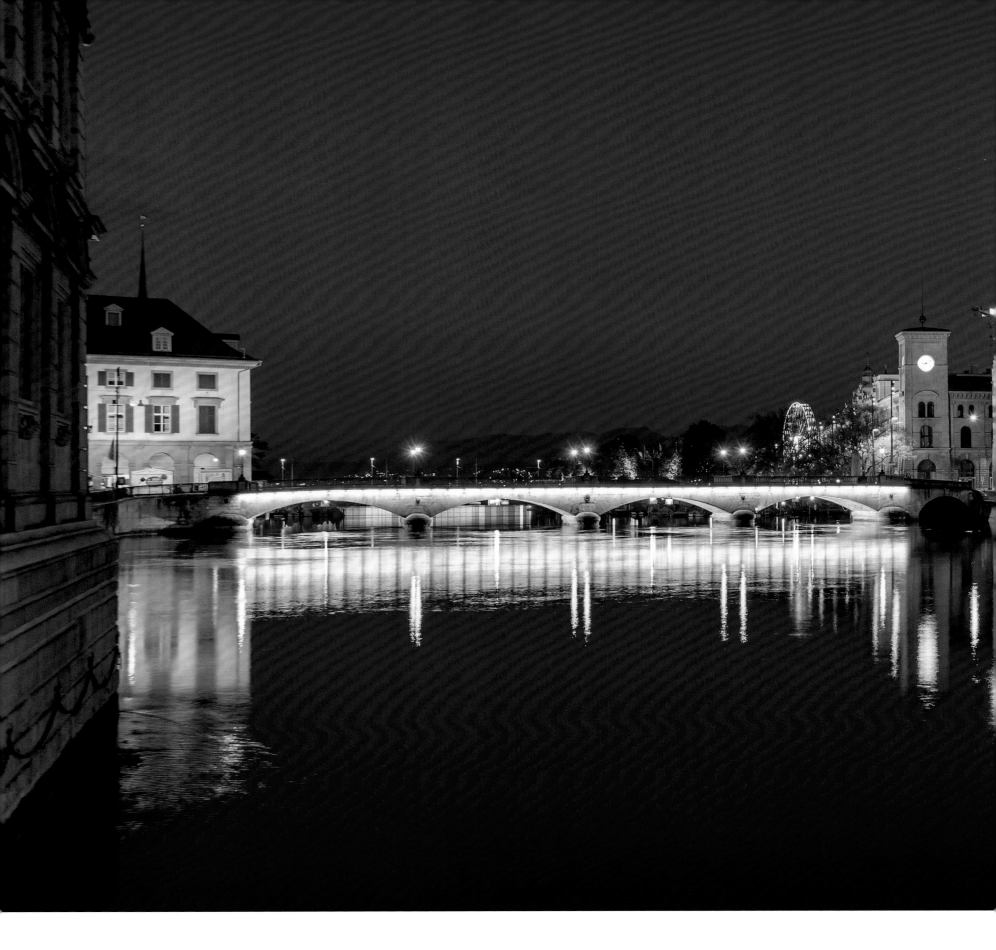

Zürich

The most important city in the Alpine region is
Zürich, which has around 400,000 inhabitants and
is beautifully situated at the northern end of Lake
Zürich. Zürich regularly occupies one of the top
places in international rankings on the quality of life in
cities. The medieval town centre is well worth seeing;
the cultural offerings are world class. However, this
has its price: In rankings on the cost of living, Zurich is
also right at the top.

Zurich

Zurich compte environ 400 000 habitants et c'est la
ville la plus importante des Alpes, joliment lovée sur
la rive nord du lac de Zurich. Dans les classements
des villes les plus agréables à vivre, Zurich obtient
régulièrement l'une des premières places. Le centre-
ville médiéval est remarquable et l'offre culturelle de
tout premier choix. Tout cela a néanmoins un prix :
Zurich figure également tout en haut des classements
des villes les plus chères.

Zürich

Die bedeutendste Stadt im Alpenraum ist Zürich, das
rund 400 000 Einwohner zählt und wunderschön
am Nordende des Zürichsees gelegen ist. In
internationalen Rankings zur Lebensqualität von
Städten belegt Zürich regelmäßig einen der
vordersten Plätze. Der mittelalterliche Stadtkern
ist sehr sehenswert, das Kulturangebot weltklasse.
Das hat allerdings seinen Preis: In Rankings zu
den Lebenshaltungskosten liegt Zürich ebenfalls
ganz vorn.

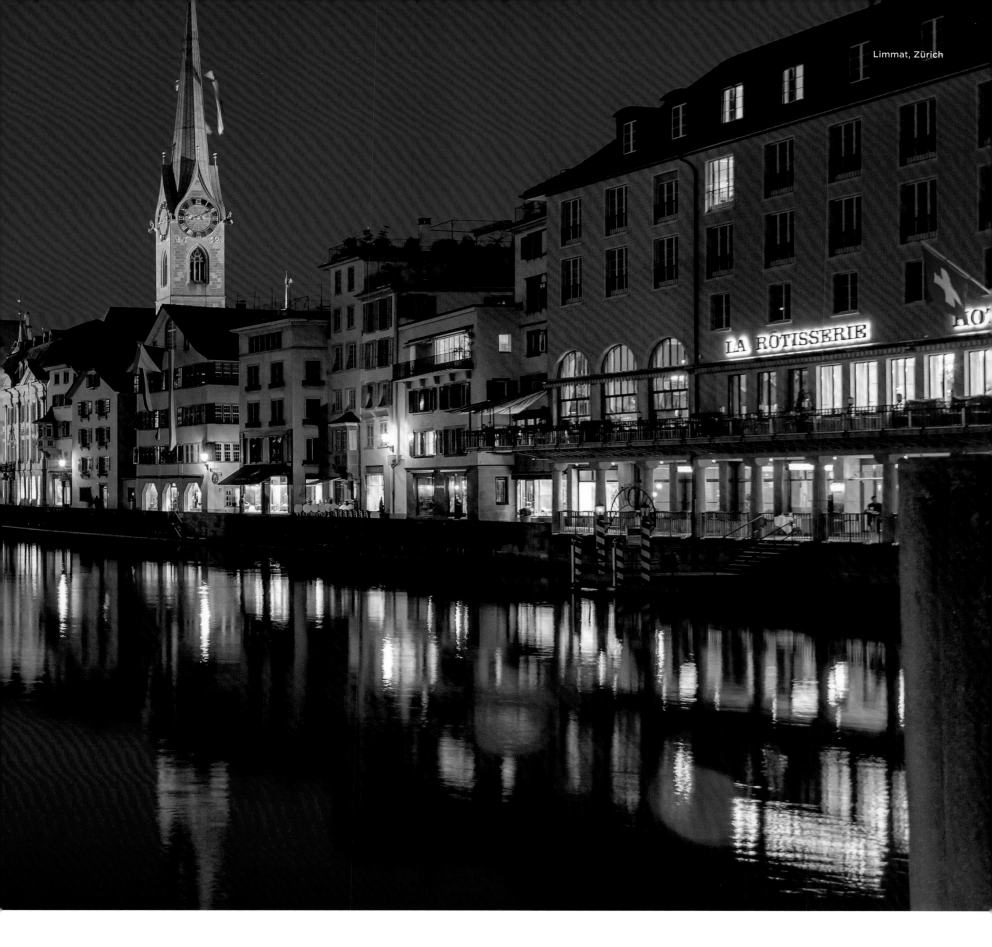

Limmat, Zürich

Zúrich

La ciudad más importante de la región alpina es Zúrich, que tiene alrededor de 400 000 habitantes y está situada en el extremo norte del lago de Zúrich. Zúrich suele ocupar uno de los primeros puestos en los rankings internacionales sobre la calidad de vida en las ciudades. El centro de la ciudad medieval es muy digno de ver, la oferta cultural es de primera categoría a nivel mundial. Sin embargo, esto tiene su precio: en las clasificaciones sobre el coste de la vida, Zúrich también se encuentra en lo más alto.

Zurique

A cidade mais importante da região alpina é Zurique, que tem cerca de 400 000 habitantes e está lindamente situada no extremo norte do Lago Zurique. Zurique ocupa regularmente um dos primeiros lugares nos rankings internacionais sobre a qualidade de vida nas cidades. O centro da cidade medieval é muito interessante, a oferta cultural é de classe mundial. No entanto, isto tem o seu preço: em rankings sobre o custo de vida, Zurique também está no topo.

Zürich

Het prachtig aan de noordkant van het gelijknamige meer gelegen Zürich telt ongeveer 400 000 inwoners en is de belangrijkste stad van het alpengebied. Het is wereldwijd een van de steden met de hoogste levenskwaliteit. Het middeleeuwse stadscentrum is zeer bezienswaardig en het culturele aanbod is subliem. Daaraan hangt echter een prijskaartje: op de ranglijst 'Kosten van levensonderhoud' staat Zürich namelijk ook altijd bovenaan.

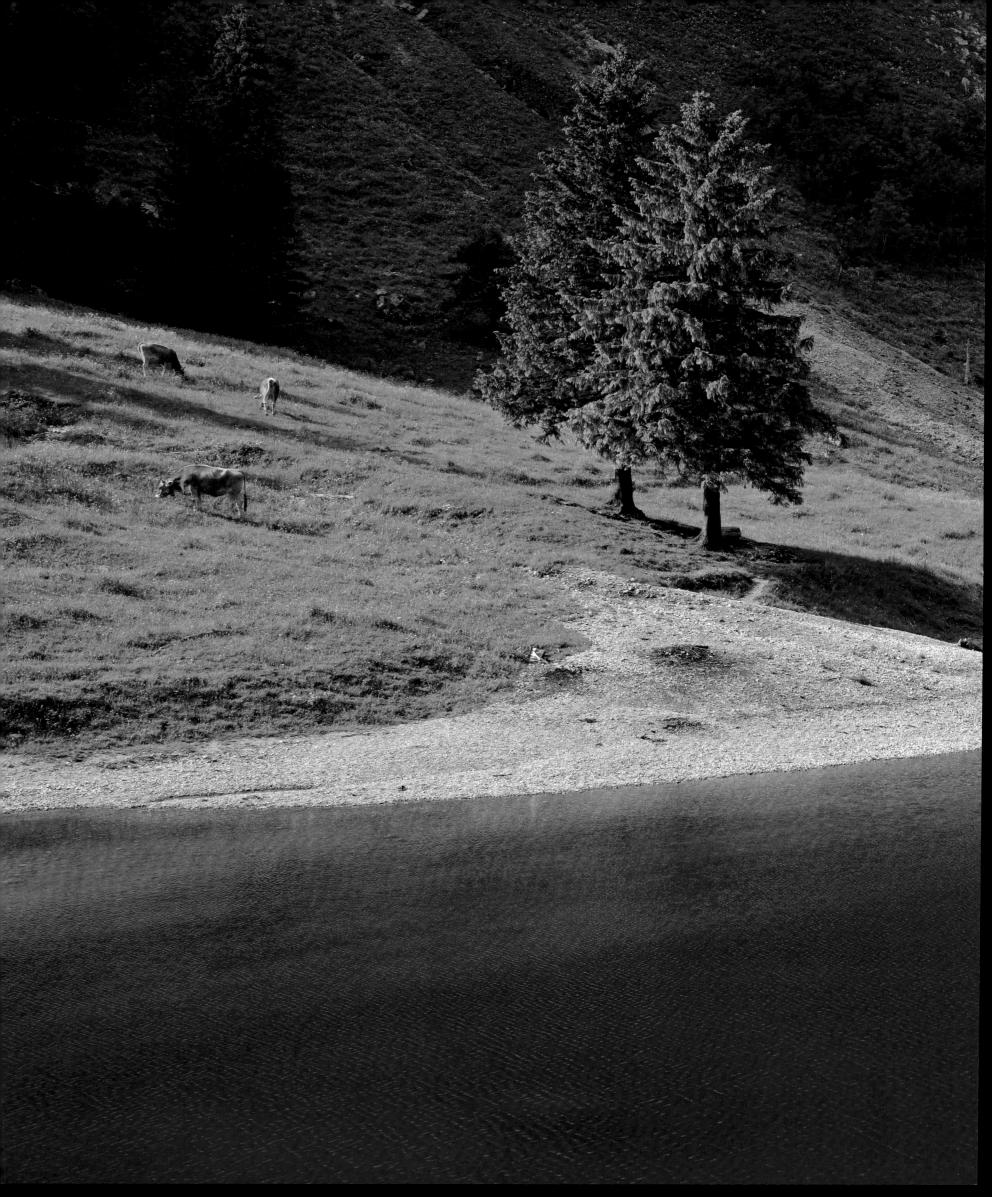

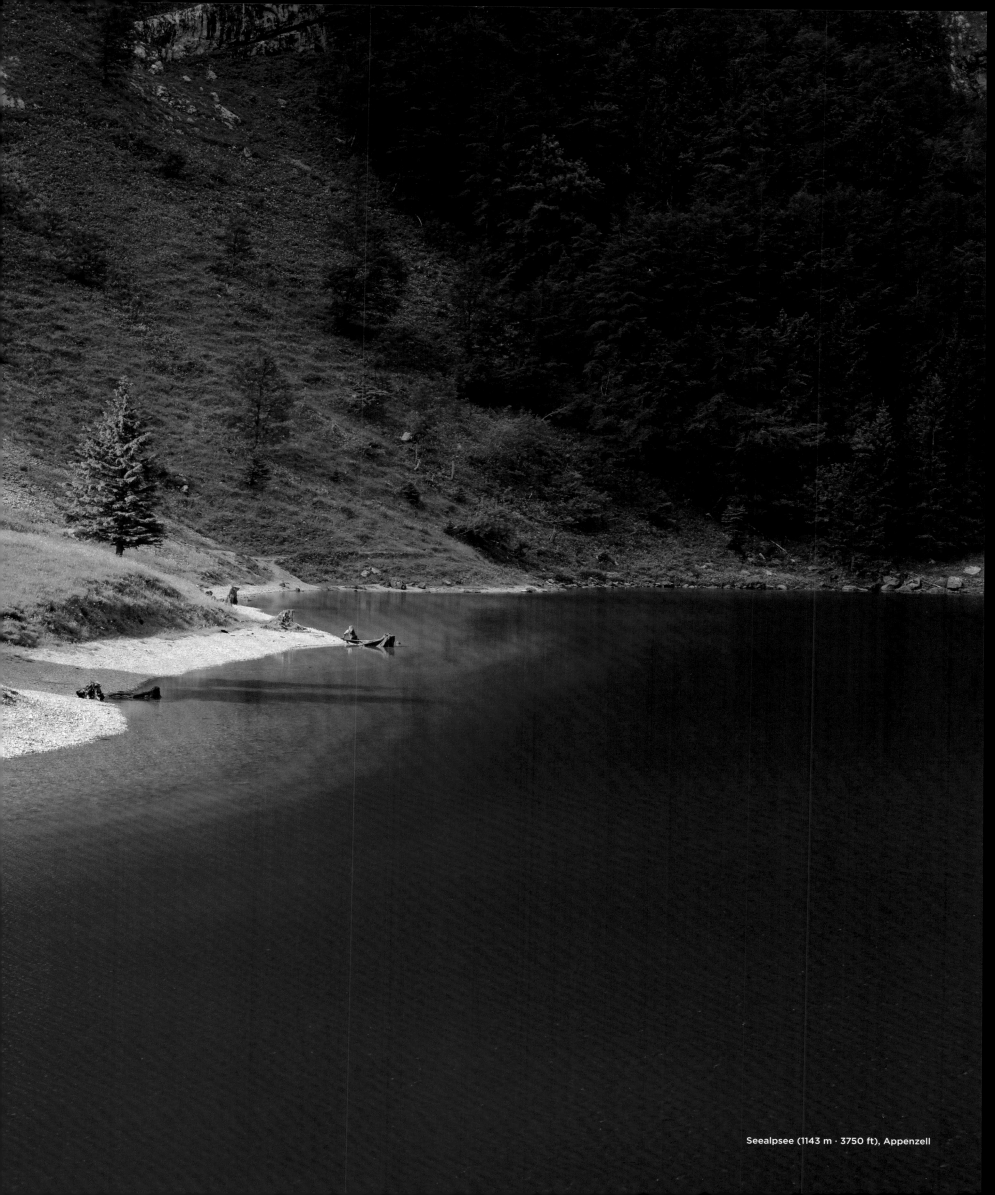

Seealpsee (1143 m · 3750 ft), Appenzell

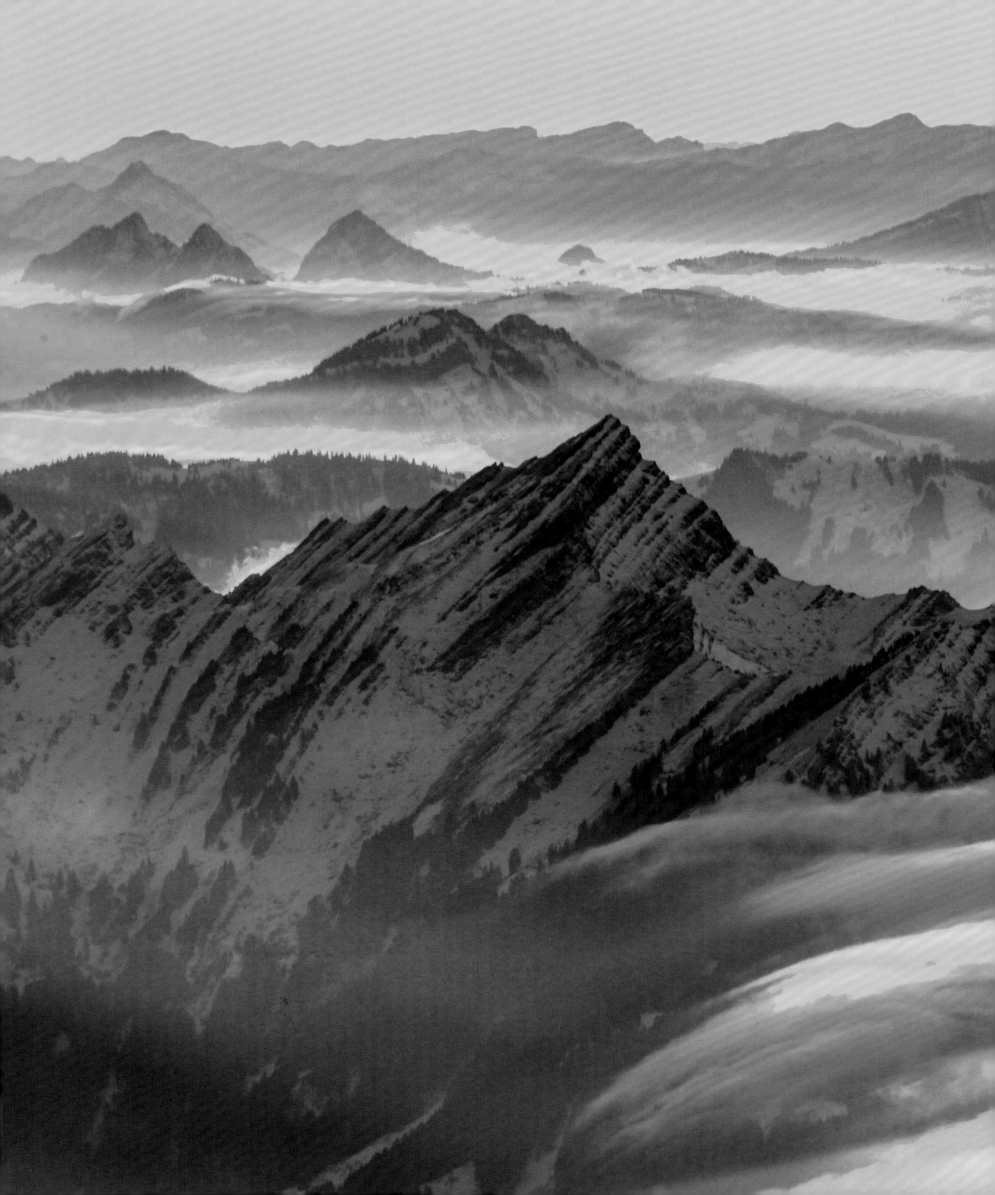

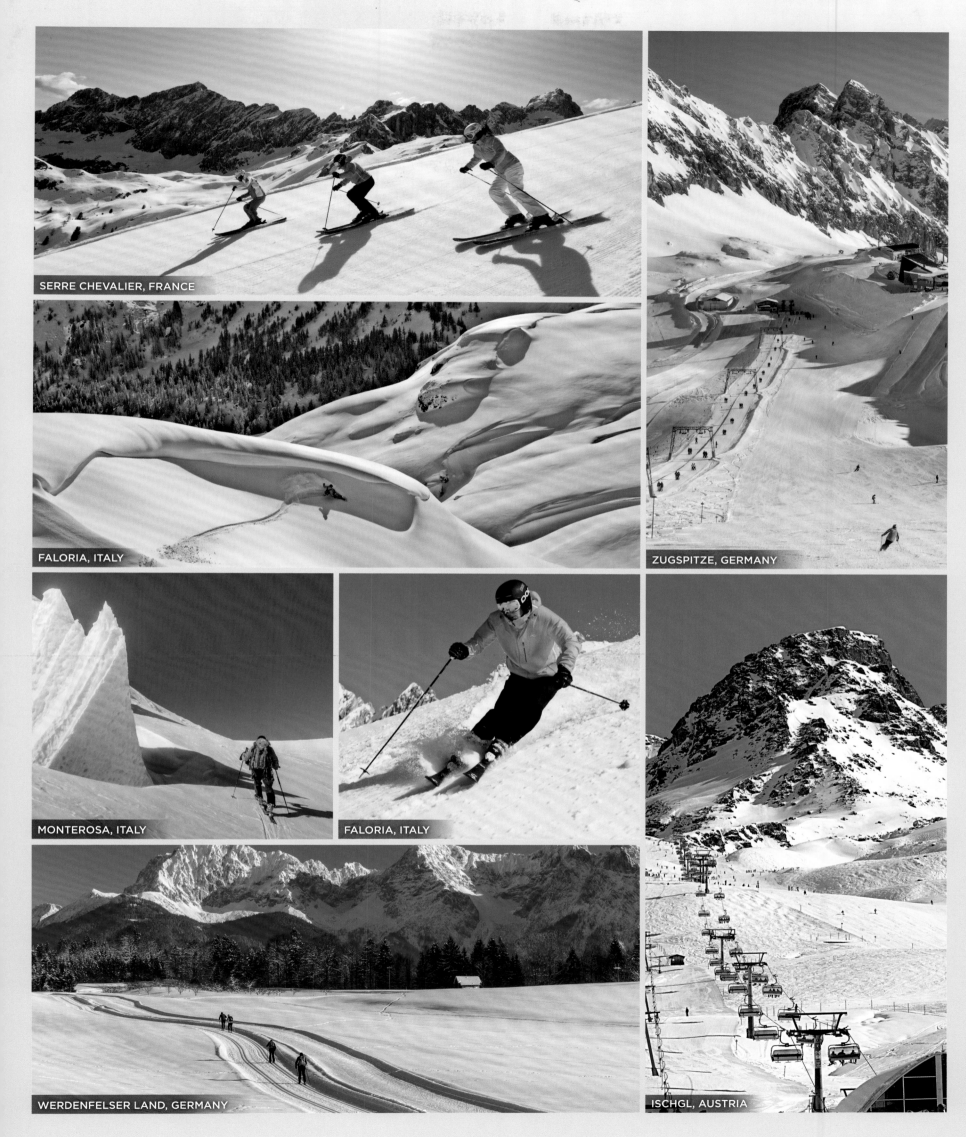

SERRE CHEVALIER, FRANCE

FALORIA, ITALY

ZUGSPITZE, GERMANY

MONTEROSA, ITALY

FALORIA, ITALY

WERDENFELSER LAND, GERMANY

ISCHGL, AUSTRIA

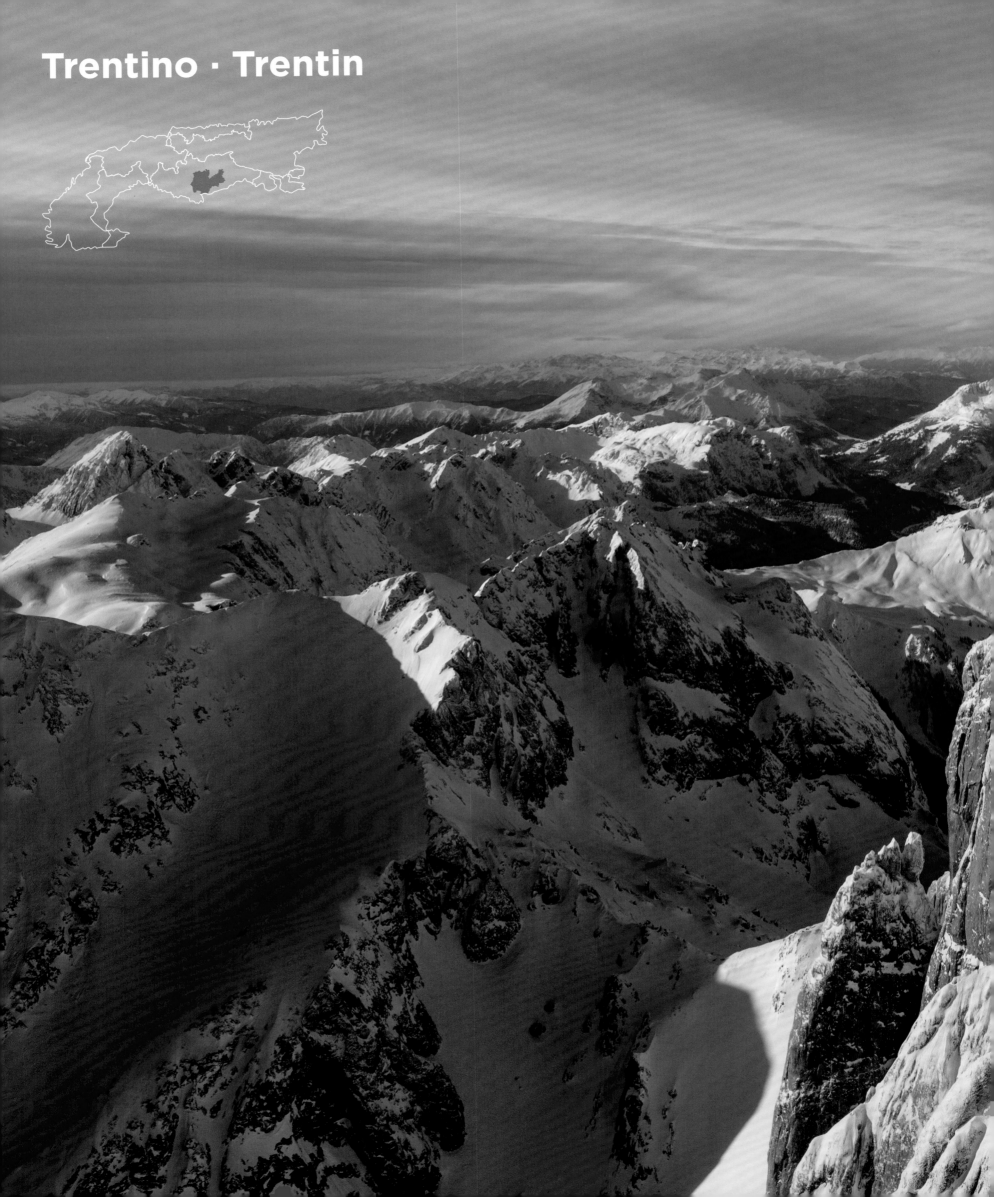

Trentino · Trentin

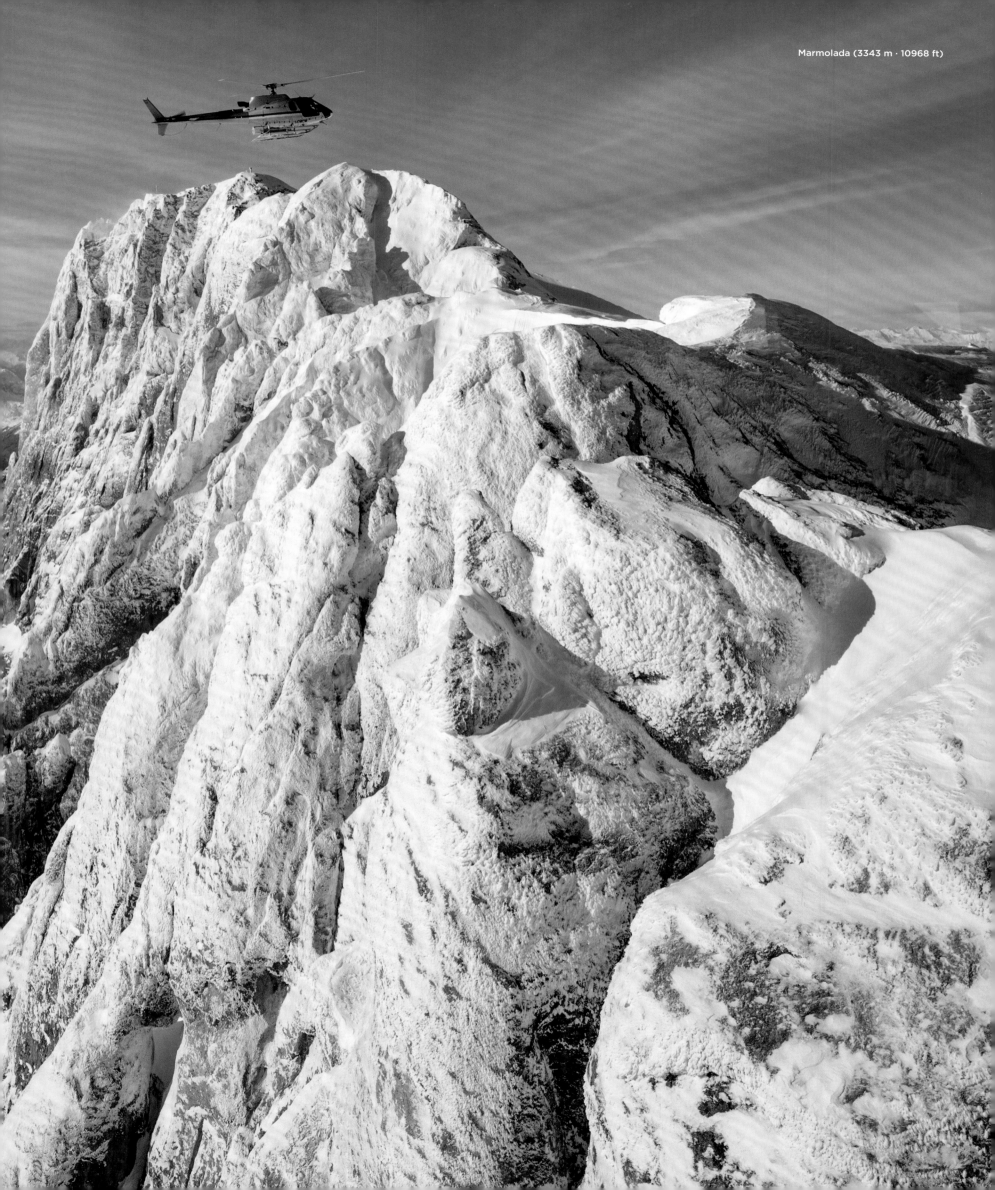

Marmolada (3343 m · 10968 ft)

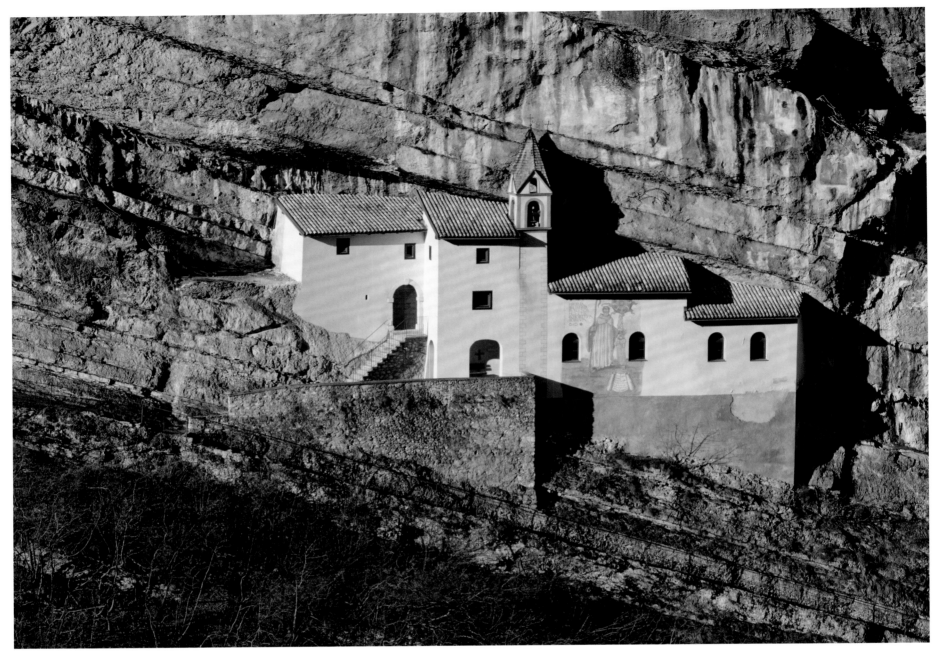

Eremo di San Colombano, Rovereto

Trentino

The province of Trentino stretches from the high mountains with peaks of over 3000 m (9843 ft) in the Marmolata group to the northern tip of Lake Garda. Extensive forests and high alpine pastures characterise the landscape in the Dolomites, intensive agriculture with fruit and wine growing in the valleys. The Adige flows through Trentino and its valley with the Brenner Pass at the northern end is one of the most important north-south connections in the Alps. The Autonomous Province has many special rights and is economically prosperous. Tourism generates a large part of the income with important winter sports resorts such as Madonna di Campiglio.

Le Trentin

La province du Trentin s'étend des hautes montagnes de la Marmolada, avec leurs sommets de plus de 3000 m, à la pointe nord du lac de Garde. Vastes forêts et hauts pâturages forment les paysages des Dolomites, tandis que les vallées sont plutôt consacrées à la culture intensive de fruits et aux vignes. Le Trentin est arrosé par l'Adige, dont la vallée constitue dans les Alpes l'une des liaisons nord-sud majeures, passant au nord par le col du Brenner. Cette province autonome jouissant de nombreux droits spécifiques est plutôt prospère. Elle tire principalement ses revenus du tourisme, avec des stations de sports d'hiver renommées comme Madonna di Campiglio.

Trentino

Vom Hochgebirge mit Gipfeln von über 3000 m Höhe in der Marmolatagruppe bis zur Nordspitze des Gardasees reicht die Provinz Trentino. Ausgedehnte Wälder und hochgelegene Almen prägen das Landschaftsbild in den Dolomiten, intensive Landwirtschaft mit Obst- und Weinanbau die Täler. Durch das Trentino fließt der Etsch, sein Tal gehört zu den wichtigsten Nord-Süd-Verbindungen in den Alpen mit dem Brenner am nördlichen Ende. Die Autonome Provinz mit vielen Sonderrechten ist wohlhabend. Einen großen Teil des Einkommens generiert der Tourismus mit wichtigen Wintersportorten wie Madonna di Campiglio.

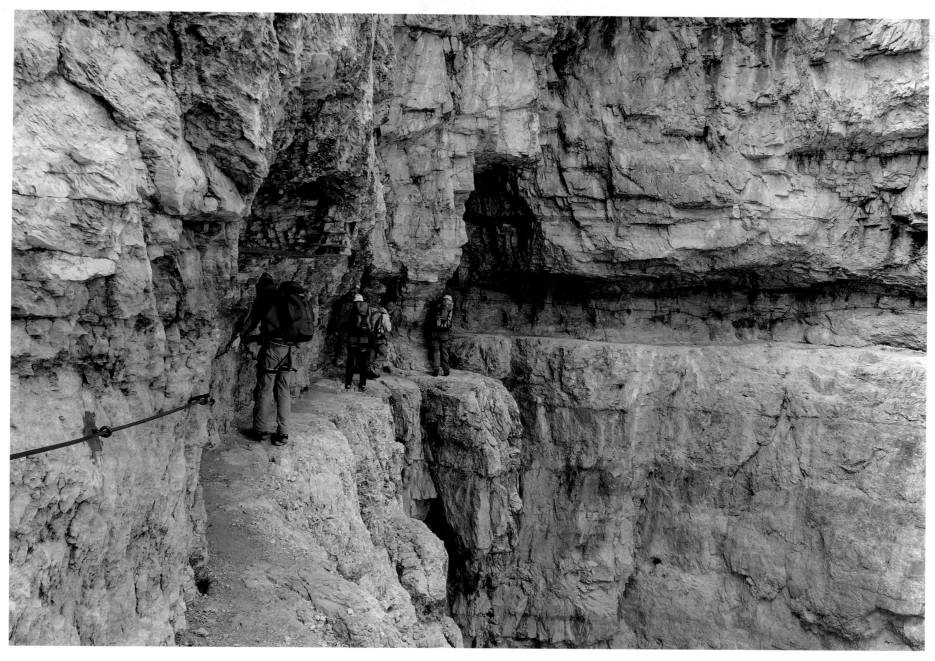

Via delle Boccette, Brenta Dolomiten

Trentino

La provincia de Trentino se extiende desde las altas montañas con picos de más de 3000 m en el grupo de Marmolada hasta el extremo norte del lago de Garda. Extensos bosques y pastos de alta montaña caracterizan el paisaje de las dolomitas, una agricultura intensiva con cultivos frutales y vitivinícolas en los valles. El Adigio atraviesa Trentino y su valle es una de las conexiones norte-sur más importantes de los Alpes, con el paso del Brennero en el extremo norte. La provincia autónoma con muchos derechos especiales es próspera. El turismo genera gran parte de los ingresos con importantes centros de deportes de invierno como Madonna di Campiglio.

Trentino

A província do Trentino estende-se desde as altas montanhas com picos de mais de 3000 m no grupo Marmolata até ao extremo norte do Lago Garda. Florestas extensas e pastagens altas alpinas caracterizam a paisagem nas Dolomitas, agricultura intensiva com cultivo de fruta e vinho nos vales. O Adige atravessa o Trentino e o seu vale é uma das mais importantes ligações norte-sul nos Alpes, com a passagem do Brenner no extremo norte. A Província Autónoma com muitos direitos especiais é próspera. O turismo gera grande parte da renda com importantes resorts de esportes de inverno, como Madonna di Campiglio.

Trentino

De provincie Trentino strekt zich van het tot 3000 m hoge Marmolada-gebergte uit tot aan het noordelijke puntje van het Gardameer. Kenmerkend voor het landschap in de Dolomieten zijn de uitgestrekte bossen en hooggelegen alpenweiden, terwijl in de dalen intensieve landbouw met fruit- en wijnbouw het beeld bepaalt. De riviervallei van de Adige is een van de belangrijkste noord-zuidroutes in de Alpen en loopt in het noorden tot aan de Brennerpas. De autonome provincie heeft veel privileges en is zeer welvarend. Te danken heeft het dit in de eerste plaats aan het toerisme en aan belangrijke wintersportplaatsen zoals Madonna di Campiglio.

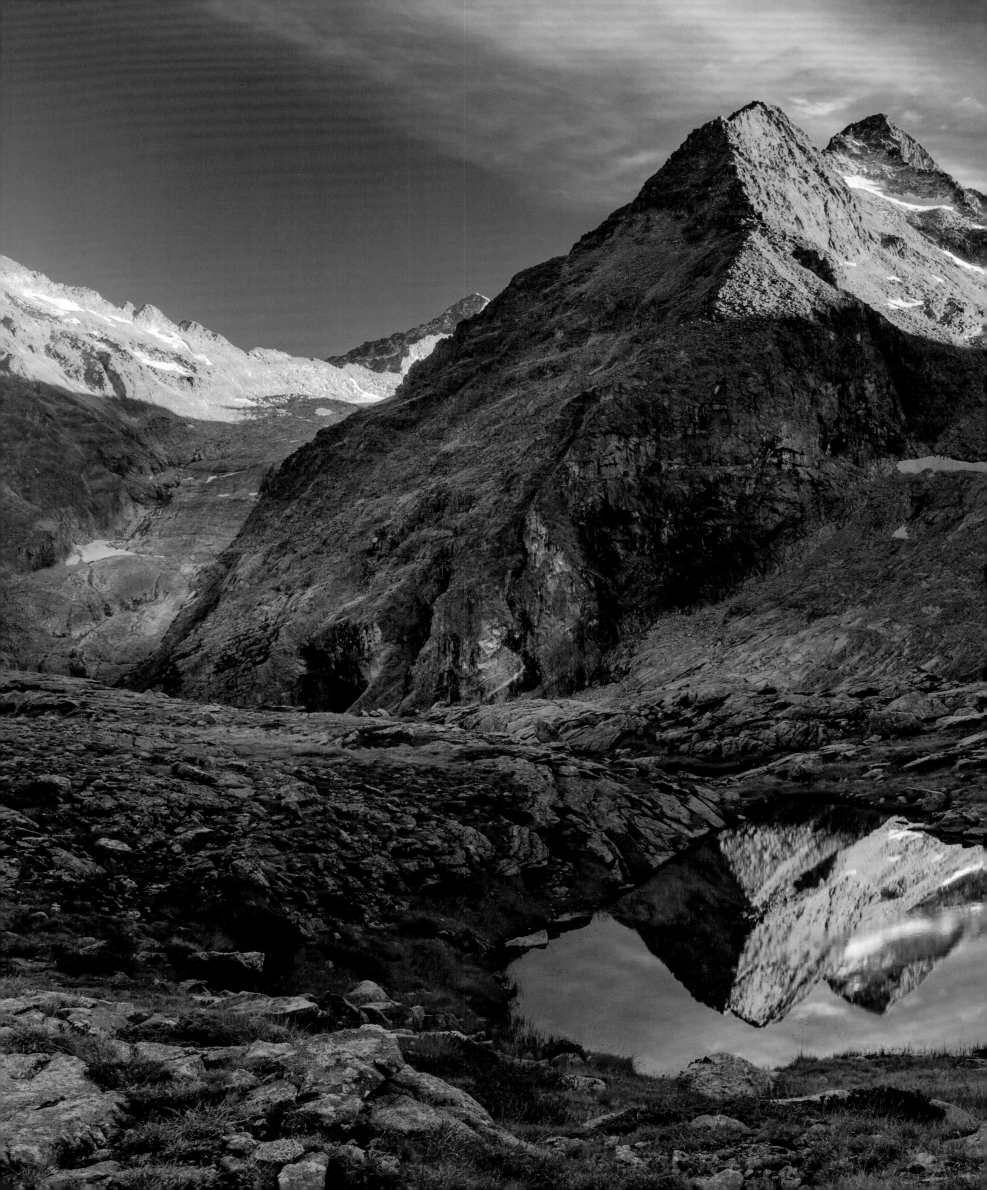

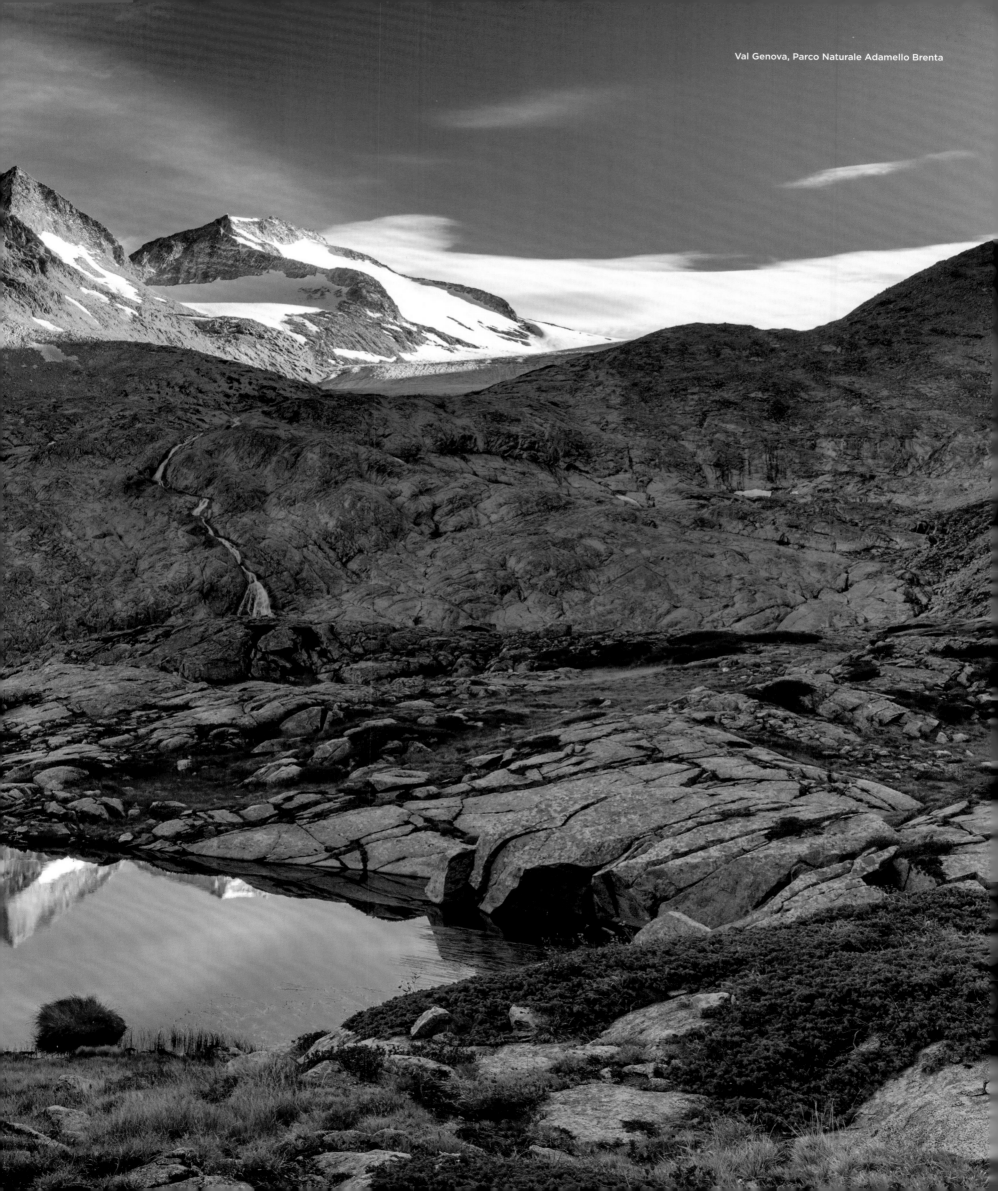

Val Genova, Parco Naturale Adamello Brenta

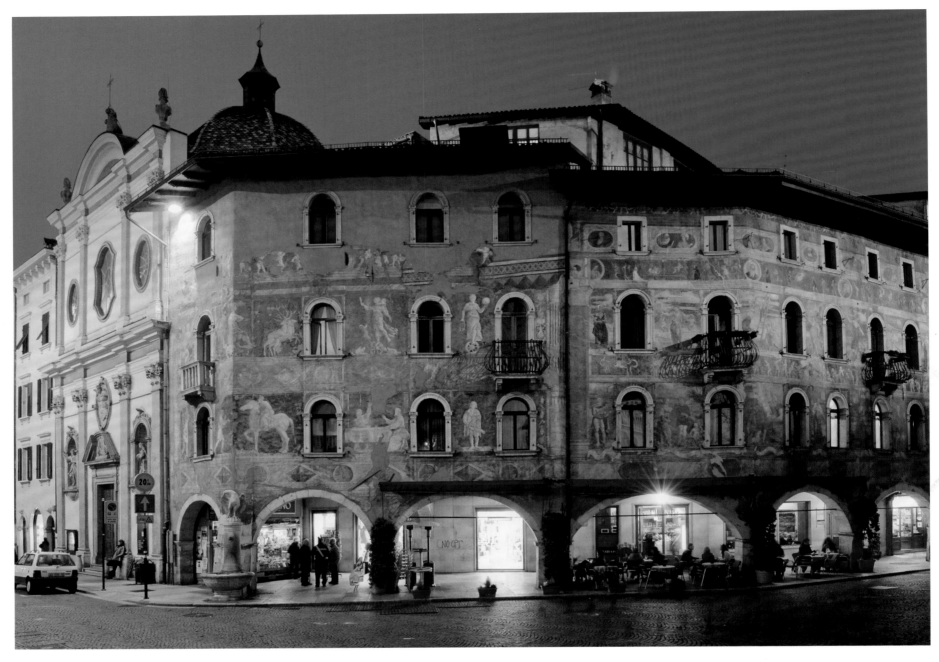

Case Cazuffi-Rella, Trento

Trento

The capital of Trentino lies in the Adige Valley. Magnificent buildings, churches, castles and palaces bear witness to a long and significant history, in the course of which possession of the city was often disputed. But Trento, owing to its many students, is also a young city. The most significant historical event from 1545 to 1563 was the Council of Trent, which the Catholic Church considered necessary during the Reformation. Some moderate reforms were adopted. The opening session took place in the Cathedral of San Vigilio, one of the city's most important monuments.

Trente

Le chef-lieu du Trentin se trouve dans la vallée de l'Adige. Bâtiments somptueux, églises, châteaux et palais témoignent d'une histoire longue et importante, au cours de laquelle cette ville a souvent été disputée. Trente est aussi une ville jeune, grâce à ses nombreux étudiants. L'un de ses événements marquants est sans aucun doute le concile de Trente, entre 1545 et 1563, considéré comme nécessaire par l'Église catholique suite à la Réforme et qui adopta quelques réformes modérées. La session inaugurale eut lieu dans la cathédrale de San Vigilio, l'un des monuments les plus impressionnants de la ville.

Trento (Trient)

Die Hauptstadt des Trentino liegt im Etschtal. Prächtige Gebäude, Kirchen, Burgen und Palazzi verweisen auf eine lange und bedeutungsvolle Geschichte, in deren Verlauf die Stadt häufig umstritten war. Sehr viele Studenten machen Trento aber auch zu einer jungen Stadt. Markantestes historisches Ereignis war von 1545 bis 1563 das Konzil von Trient, das aus Sicht der katholischen Kirche durch die Reformation notwendig geworden war. Dabei wurden einige moderate Reformen beschlossen. Die eröffnende Sitzung fand in der Kathedrale San Vigilio statt, die zu den bedeutendsten Sehenswürdigkeiten der Stadt zählt.

Piazza Duomo, Trento

Trento

La capital de Trentino se encuentra en el valle del Adigio. Magníficos edificios, iglesias, castillos y palacios son la prueba de una larga y significativa historia, en el curso de la cual la ciudad fue a menudo controvertida. Pero muchos estudiantes también hacen de Trento una ciudad joven. El acontecimiento histórico más significativo de 1545 a 1563 fue el Concilio de Trento, que la Iglesia Católica consideró necesario durante la Reforma. Se adoptaron algunas reformas moderadas. La sesión inaugural tuvo lugar en la Catedral de San Vigilio, uno de los monumentos más importantes de la ciudad.

Trento

A capital do Trentino fica no Vale do Adige. Magníficos edifícios, igrejas, castelos e palácios são provas de uma longa e significativa história no decurso da qual a cidade foi muitas vezes controversa. Mas muitos estudantes também fazem de Trento uma cidade jovem. O acontecimento histórico mais significativo de 1545 a 1563 foi o Concílio de Trento, que a Igreja Católica considerou necessário durante a Reforma. Foram adoptadas algumas reformas moderadas. A sessão de abertura teve lugar na Catedral de San Vigilio, um dos mais importantes monumentos da cidade.

Trento

De hoofdstad van Trentino ligt in het dal van de rivier de Adige. Prachtige gebouwen, kerken, kastelen en palazzi getuigen van een lange en indrukwekkende geschiedenis, waarin de stad soms fel betwist werd. Dankzij de vele studenten maakt het huidige Trento desondanks een jonge indruk. Het belangrijkste historische feit was het Concilie van Trente van 1545 tot 1563, waarmee de katholieke kerk met gematigde hervormingen reageerde op de reformatie. De eerste zitting vond plaats in de kathedraal San Vigilio, een van de belangrijkste bezienswaardigheden van Trento.

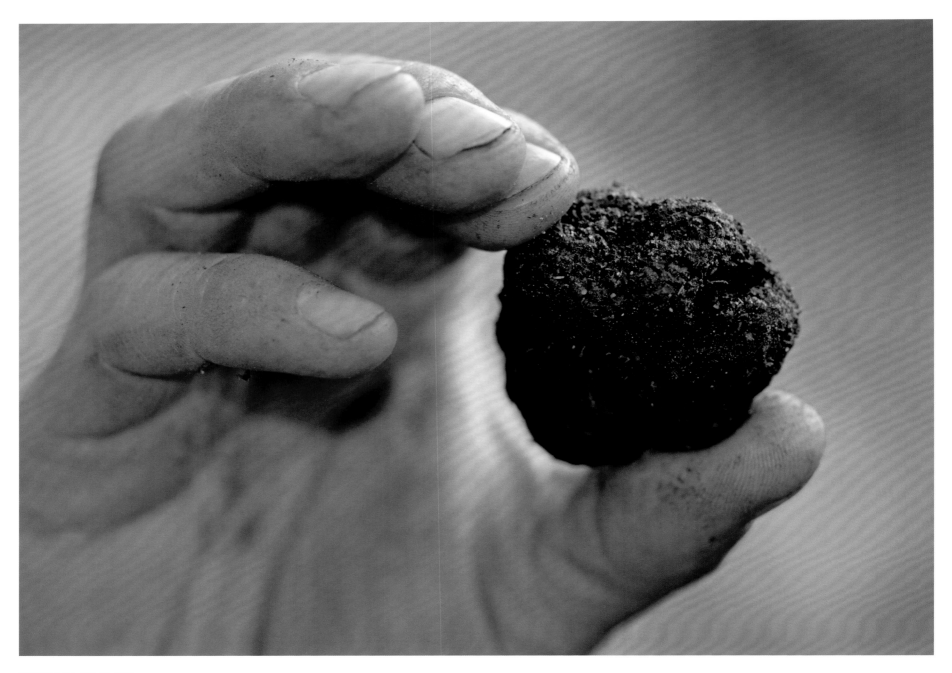

Tartufo nero, Val d'Adige
Black truffle, Etschtal
Truffe noire, vallée de l'Adige

Truffles and Olives

The southern Adige Valley is known for its exquisite agricultural products. For example, excellent olive oils are produced here. But that is nothing unusual in Italy. Black truffles, however, are particularly popular with gourmets and are very expensive but by no means as expensive as white truffles from Piedmont. They are found by specially trained dogs, whose extremely sensitive noses sniff out the tubers in the ground. Such truffle dogs are very valuable for their owners, and the best truffle locations are carefully guarded secrets.

Truffes et olives

Le Sud de la vallée de l'Adige est connu pour ses produits agricoles de grande qualité. On y presse, par exemple, une huile d'olive excellente, ce qui est loin d'être exceptionnel en Italie. Plus rares sont les truffes noires, très appréciées des gourmets et très coûteuses, mais sans commune mesure toutefois avec les truffes blanches du Piémont. Elles sont récoltées grâce à des chiens spécialement entraînés, dont l'odorat très fin permet de les flairer dans la terre. Ces chiens truffiers sont une grande richesse pour leur propriétaire et les coins à truffes sont des secrets bien gardés !

Trüffel und Oliven

Das südliche Etschtal ist bekannt für hochwertige landwirtschaftliche Produkte. Beispielsweise werden hier vorzügliche Olivenöle hergestellt. Aber das ist in Italien nichts Ungewöhnliches. Besonders sind allerdings die schwarzen Trüffel, die von Feinschmeckern geschätzt werden und sehr teuer sind – aber längst nicht so teuer wie die weißen Trüffel im Piemont. Gefunden werden sie von speziell ausgebildeten Hunden, deren extrem feine Nasen die Knollen in der Erde erschnüffeln. Solche Trüffelhunde sind für ihre Besitzer sehr wertvoll. Um die besten Trüffelfundorte wird stets ein großes Geheimnis gemacht.

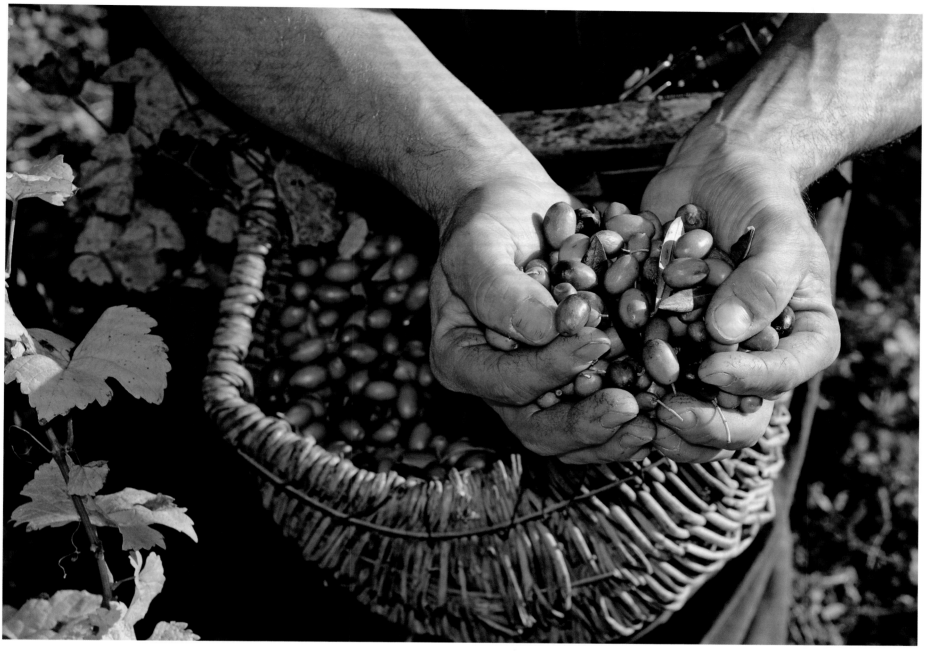

Olivos, Arco
Olives, Arco

Trufas y aceitunas

El sur del valle del Adigio es conocido por sus productos agrícolas de alta calidad. Por ejemplo, aquí se producen excelentes aceites de oliva. Pero esto no es nada inusual en Italia. Las trufas negras, sin embargo, son particularmente populares entre los gourmets y son muy caras (aunque de ningún modo tan caras como las trufas blancas en Piamonte). Las encuentran perros especialmente entrenados, cuyas narices extremadamente finas olfatean los tubérculos en la tierra. Estos perros truferos son muy valiosos para sus dueños. Las mejores localizaciones de trufas son siempre un gran secreto.

Trufas e azeitonas

O Vale do Adige meridional é conhecido pelos seus produtos agrícolas de alta qualidade. Por exemplo, são aqui produzidos excelentes azeites. Mas isso não é nada de invulgar em Itália. As trufas pretas, no entanto, são particularmente populares entre os gourmets e são muito caras – mas não tão caras como as trufas brancas no Piemonte. São encontrados por cães especialmente treinados, cujos narizes extremamente finos farejam os tubérculos da terra. Tais cães de trufa são muito valiosos para os seus donos. Um grande segredo é sempre feito sobre as melhores localizações de trufas.

Truffels en olijven

Het zuidelijk deel van de Adige-vallei staat bekend om hoogwaardige landbouwproducten. Hier wordt onder meer uitstekende olijfolie geproduceerd, wat in Italië op zich niets bijzonders is. Wel bijzonder zijn de zwarte truffels, die erg populair zijn bij fijnproevers. Ze zijn zeer duur, maar minder duur dan de witte truffels uit Piëmont. Het opspeuren van de truffels gebeurt door speciaal daarvoor opgeleide honden. Honden hebben een uitmuntende reukzin en ruiken zelfs de ondergrondse knollen. Dergelijke truffelhonden zijn zeer waardevol voor hun eigenaren. Over de beste truffellocaties wordt altijd heel geheimzinnig gedaan.

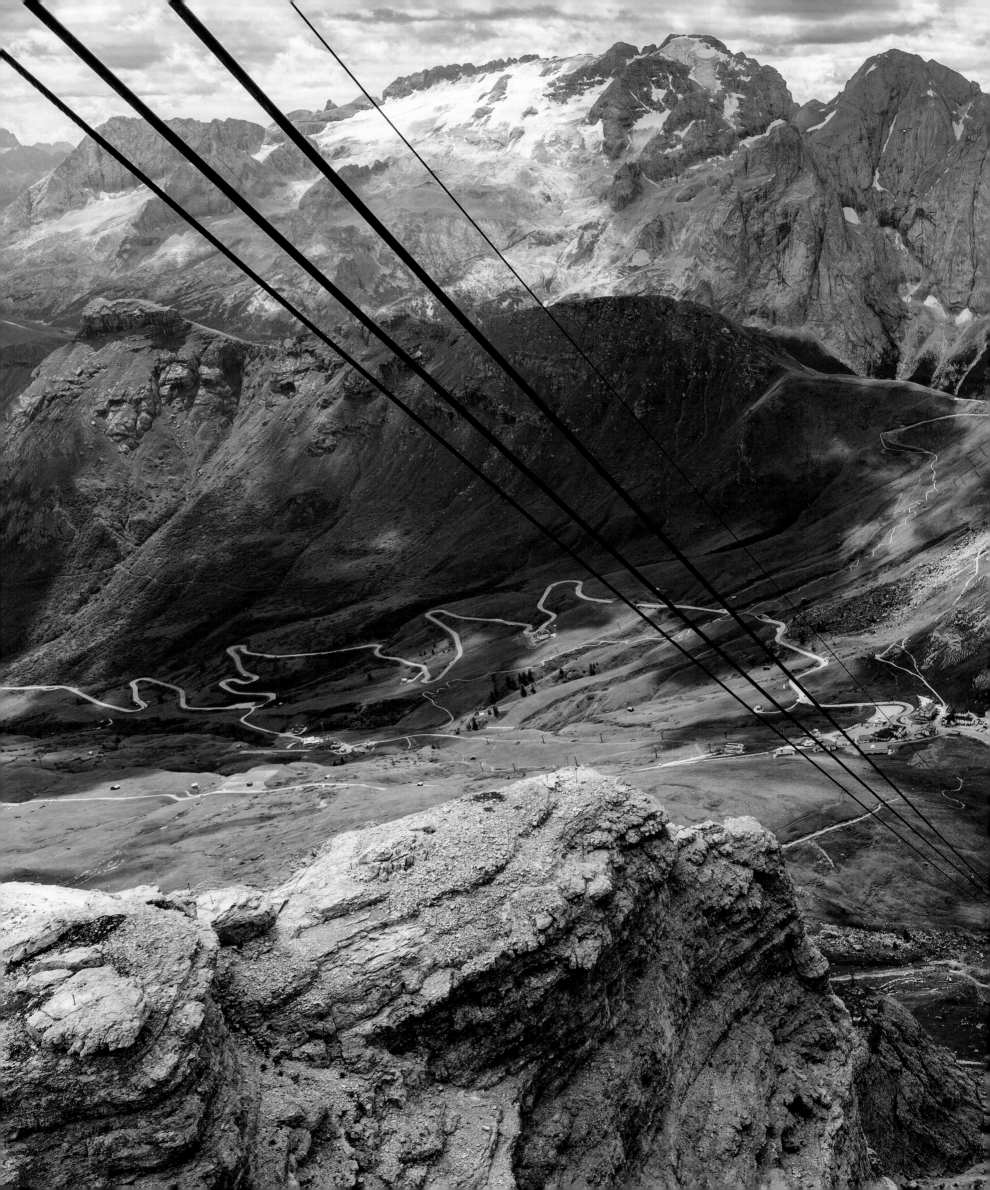

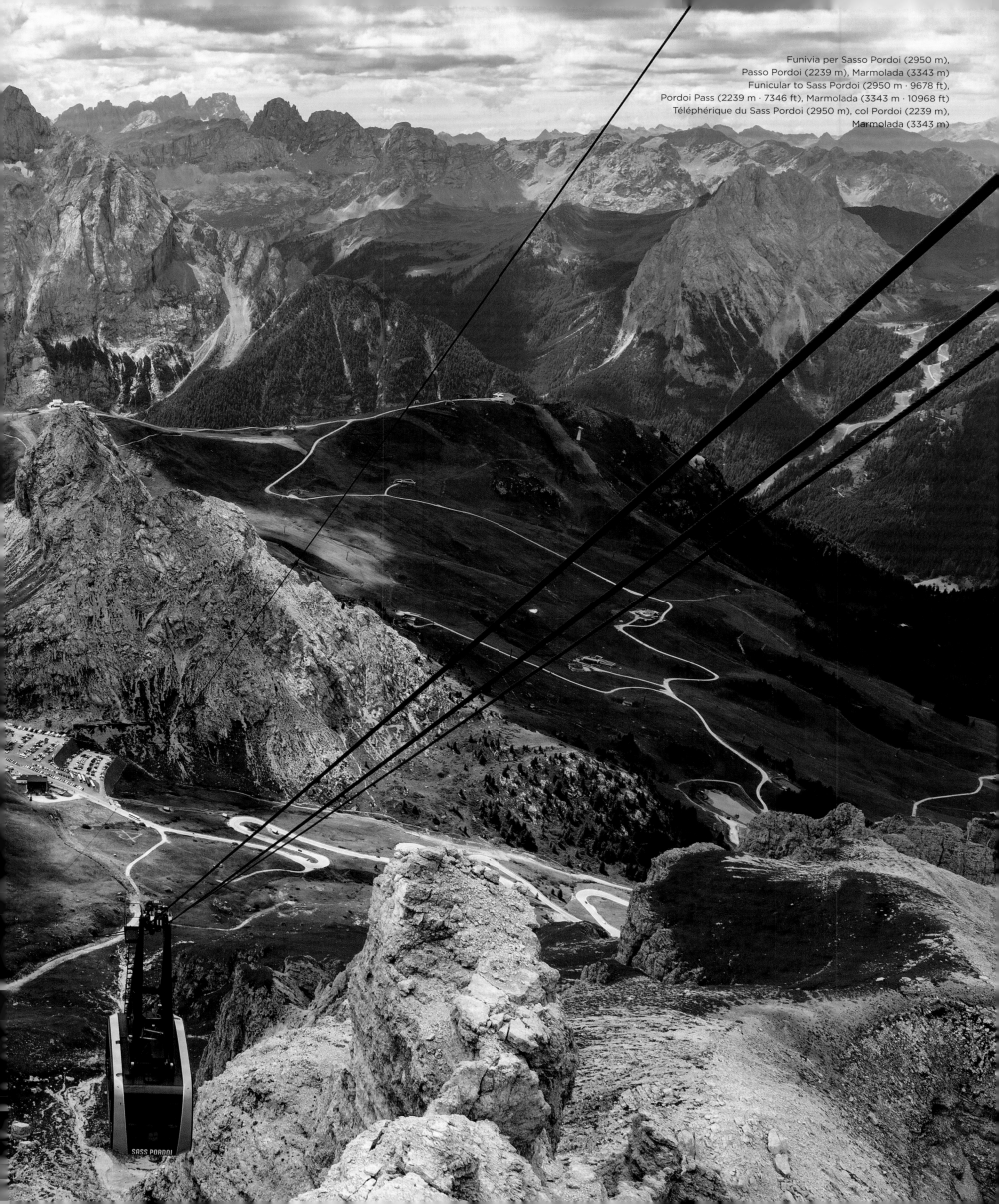

Funivia per Sasso Pordoi (2950 m),
Passo Pordoi (2239 m), Marmolada (3343 m)
Funicular to Sass Pordoi (2950 m · 9678 ft),
Pordoi Pass (2239 m · 7346 ft), Marmolada (3343 m · 10968 ft)
Téléphérique du Sass Pordoi (2950 m), col Pordoi (2239 m),
Marmolada (3343 m)

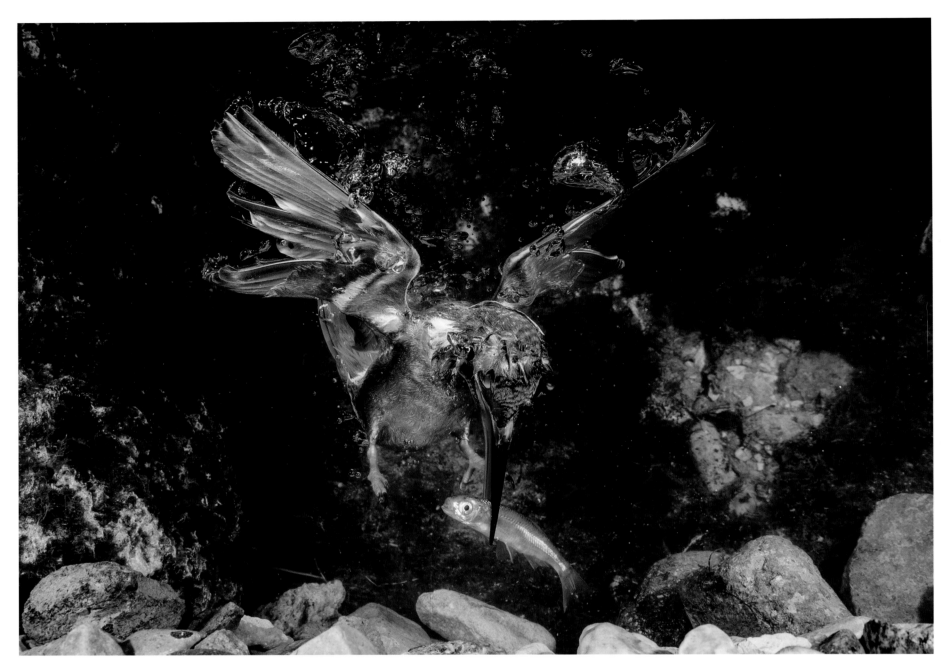

Martin pescatore
Kingfisher
Martin-pêcheur

Kingfisher

The kingfisher is a bird with blue upper and orange lower plumage, which feeds on small fish and water insects, and can be found near many waters in Trentino. The kingfisher has always played a large role in people's thinking. It was regarded as a harbringer of good luck for fishermen and travellers, and human qualities such as loyalty were attributed to it. Its feathers were also used as a talisman against lightning strikes.

Le martin-pêcheur

Le martin-pêcheur, aussi appelé martin-chasseur ou vire-vent, ou encore *kingfisher* en anglais, soit littéralement « pêcheur roi », est un oiseau au plumage roux et bleu qui se nourrit de petits poissons et d'insectes aquatiques. On le trouve beaucoup dans les eaux du Trentin. Il a toujours éveillé l'imagination des hommes. On voyait en lui un porte-bonheur pour les pêcheurs et les navigateurs, et on lui attribuait des qualités humaines comme la fidélité. Ses plumes étaient également considérées comme un talisman protégeant de la foudre.

Eisvogel

Der Eisvogel hat viele Namen: Im Deutschen gibt es zum Beispiel die (seltenen) Bezeichnungen Blauspecht, Wasserspecht, Sankt-Martins-Vogel und Königsfischer. Kingfisher wird er im Englischen genannt. Der Vogel mit dem blauroten Gefieder, der sich von kleinen Fischen und Wasserinsekten ernährt, ist an vielen Gewässern im Trentino anzutreffen. Er hat immer schon die Fantasie der Menschen beschäftigt. Als Glücksbringer für Fischer und Seereisende wurde er angesehen, menschliche Eigenschaften wie Treue wurden ihm angedichtet. Seine Federn wurden aber auch als Talisman gegen Blitzschlag eingesetzt.

Gufo marrone
Tawny owl
Chouette hulotte

Martín pescador

El martín pescador, también conocido como alción, recibe el nombre de "kingfisher" en inglés. El ave de plumaje púrpura, que se alimenta de pequeños peces e insectos acuáticos, se encuentra en muchas aguas de Trentino. Este ave siempre ha alimentado la fantasía de las personas. Era considerado como un amuleto de la suerte para pescadores y viajeros, y se le atribuían cualidades humanas como la lealtad. Sus plumas también se utilizaban como talismán contra los rayos.

Martim-Pescador

O guarda-rios tem muitos nomes: Em alemão, por exemplo, há os termos (raros) Blauspecht, Wasserspecht, Sankt-Martins-Vogel e Königsfischer. Kingfisher é chamado em inglês. A ave com plumagem roxa, que se alimenta de pequenos peixes e insetos aquáticos, pode ser encontrada em muitas águas do Trentino. Ele sempre se preocupou com as fantasias das pessoas. Era considerado um amuleto da sorte para pescadores e viajantes, e qualidades humanas como a lealdade eram atribuídas a ele. Suas penas também foram usadas como talismã contra relâmpagos.

IJsvogel

Anders dan in het Nederlands heeft de ijsvogel in sommige andere talen allerlei synoniemen. In het Duits werd hij ook wel 'Blauspecht', 'Wasserspecht', 'Sankt-Martins-Vogel' of 'Königsfischer' genoemd, de Engelsen noemen hem ook wel 'Kingfisher'. De vogel met het blauwrode verenkleed, die zich voedt met kleine vissen en waterinsecten, is aan veel wateren in Trentino te vinden. Vroeger had de ijsvogel ook mythische betekenis. Men geloofde dat hij vissers en zeevarenden geluk bracht en men dichtte hem zelfs menselijke kwaliteiten zoals trouw toe. Soms gebruikte men de veren van de ijsvogel als talisman tegen blikseminslag.

Passo Rolle (1984 m · 6509 ft), Pale di San Martino

Lago Nero (2200 m · 7218 ft), Dolomiti di Brenta

Punta Penia

The area around the Marmolata, on the border between Trentino and Veneto, is one of the most demanding and beautiful mountaineering areas in the Italian Alps. The summit cross of the Punta Penia can only be reached on difficult via ferratas. The steep vie ferrate, iron paths, are difficult mountain tracks which bear this name because they are equipped with iron safety devices. Originally they were built for military purposes. Their history goes back to the First World War, when the Dolomites were fiercely contested and the supply routes for the mountain troops were secured in this way.

La Punta Penia

La région qui entoure la Marmolada, à la limite entre le Trentin et la Vénétie, fait partie des zones des Alpes les plus belles mais aussi les plus exigeantes pour les alpinistes. La croix sommitale de la Punta Penia ne peut être atteinte qu'au prix d'une ascension périlleuse. Les chemins qui y mènent sont surnommés « via ferrata » (voie ferrée), car ils sont munis d'éléments métalliques visant à faciliter et sécuriser la progression. Ils ont été installés dans un contexte très particulier : leur histoire remonte à la Première Guerre mondiale, où de rudes combats firent rage dans les Dolomites et où il convenait d'assurer le ravitaillement des troupes combattant dans les montagnes.

Punta Penia

Die Gegend um die Marmolata an der Grenze zwischen dem Trentino und Venetien gehört zu den anspruchsvollsten, aber auch schönsten Klettergebieten in den italienischen Alpen. Das Gipfelkreuz der Punta Penia zu erreichen ist nur über schwierige Klettersteige möglich. Via Ferrate, Eisenwege, werden die Steige genannt, weil sie mit Eisensicherungen versehen sind. Ursprünglich wurden sie für Kriegszwecke angelegt. Ihre Geschichte reicht zurück bis zum Ersten Weltkrieg, als in den Dolomiten erbittert gekämpft wurde und die Versorgungswege für die Gebirgstruppen auf diese Weise gesichert wurden.

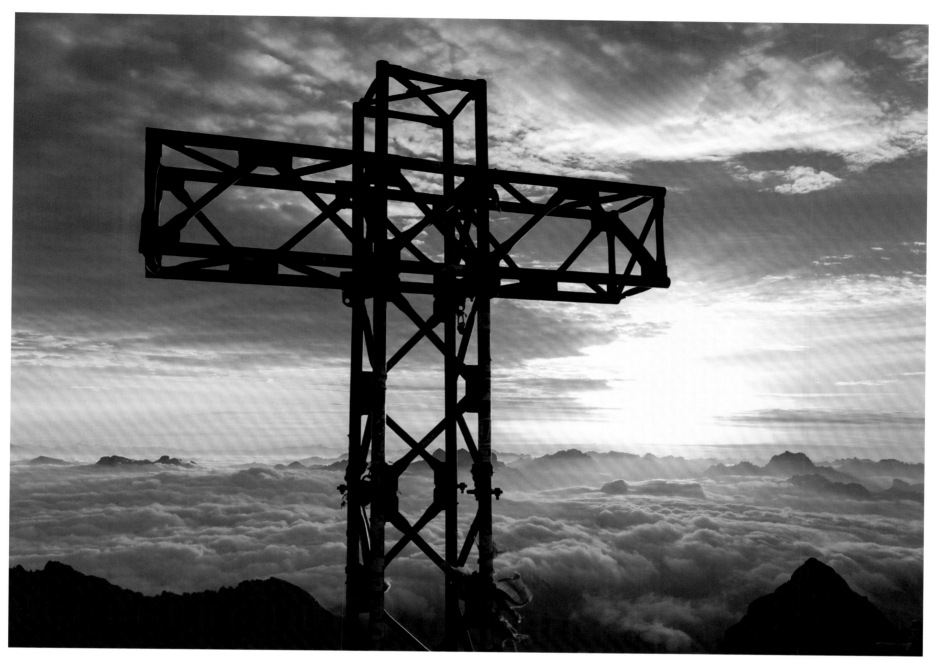

Punta Penia (3343 m · 10968 ft)

Punta Penia

La zona de la Marmolada, en la frontera entre
Trentino y Veneto, es una de las zonas de escalada
más exigentes y bellas de los Alpes italianos.
Solo se puede llegar a la cruz de la cumbre de
Punta Penia a través de la complicada vía ferrata.
Via Ferrate (caminos de hierro) se denominan
caminos empinados porque están equipados con
dispositivos de seguridad de hierro. Originalmente
fueron construidos con fines de guerra. Su historia
se remonta a la Primera Guerra Mundial, cuando los
Dolomitas fueron combatidos ferozmente y las rutas
de abastecimiento de las tropas de montaña fueron
aseguradas de esta manera.

Punta Penia

A área em torno da Marmolata, na fronteira entre
Trentino e Veneto, é uma das mais exigentes e belas
áreas de escalada nos Alpes italianos. Para chegar ao
cume da cruz Punta Penia só é possível via difícil via
ferratas. Via Ferrate, caminhos de ferro, são chamados
de trilhos íngremes porque estão equipados com
dispositivos de segurança em ferro. Originalmente
foram construídos para fins de guerra. A sua história
remonta à Primeira Guerra Mundial, quando as
Dolomitas foram ferozmente combatidas e as rotas
de abastecimento das tropas de montanha foram
asseguradas desta forma.

Punta Penia

Het Marmolada-gebergte op de grens tussen Trentino
en Veneto behoort tot de zwaarste, maat ook mooiste
klimgebieden van de Italiaanse Alpen. De top van de
Punta Penia bijvoorbeeld is alleen te bereiken via niet
ongevaarlijk via ferrata's. Deze 'ijzeren paden' bestaan
meestal uit in rotsen gemonteerde stalen ladders en
trappen. De oorsprong van deze via ferrata's gaat
terug tot de Eerste Wereldoorlog, toen men deze
'paden' aanlegde als aanvoerroutes voor de troepen
die in de Dolomieten vochten.

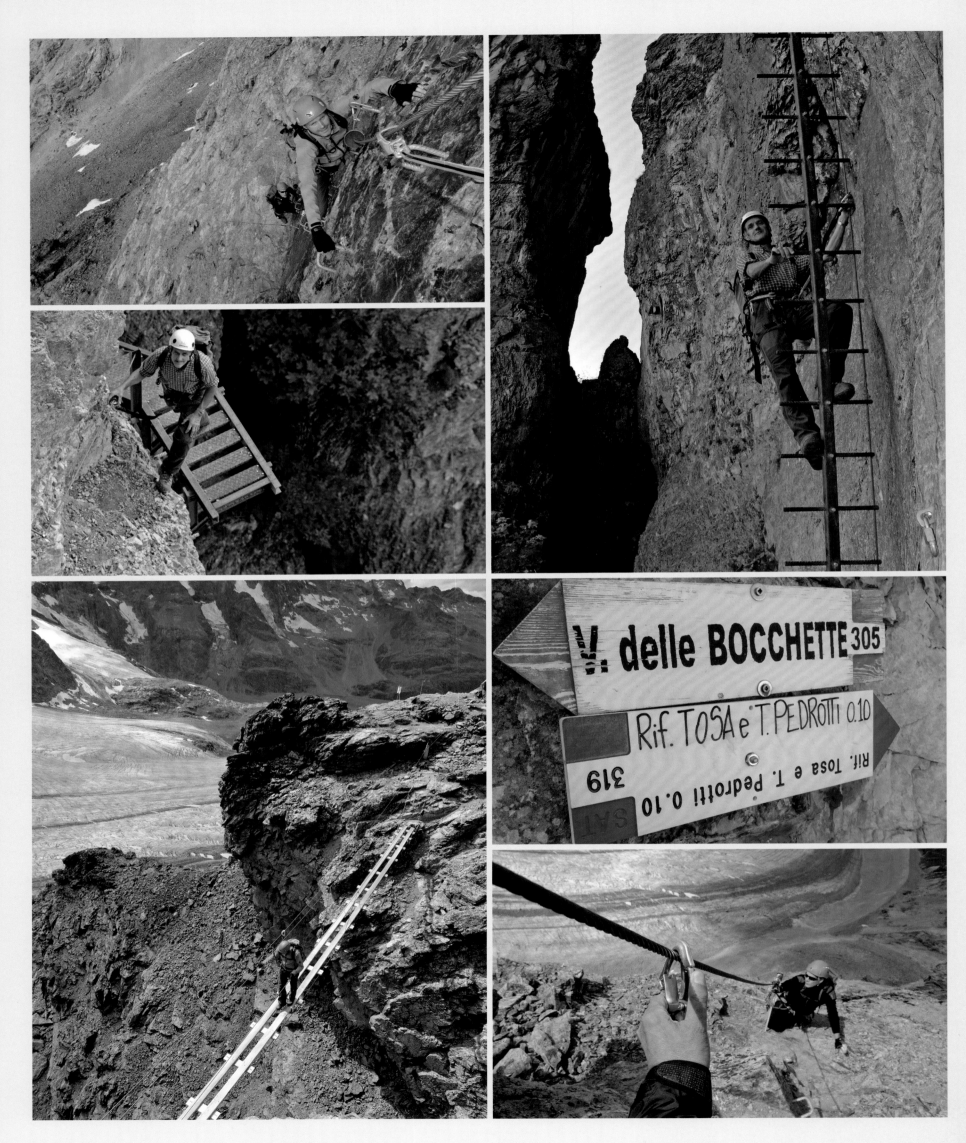

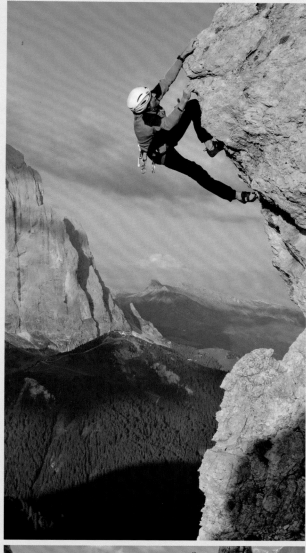

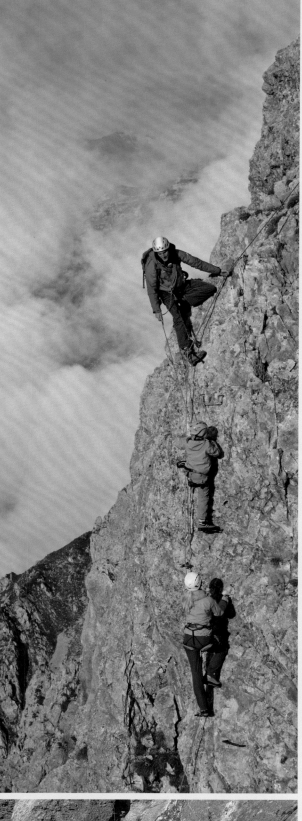

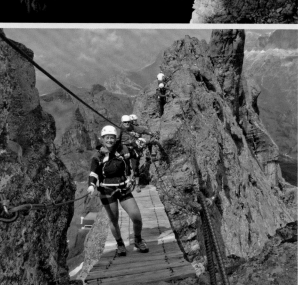

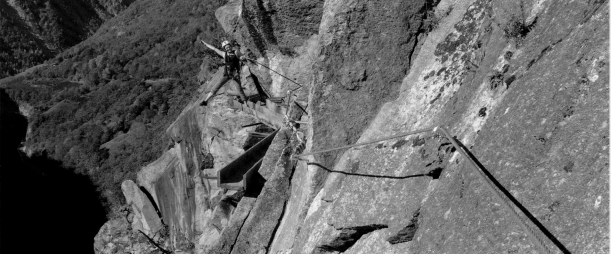

Via ferrata

The number of 'iron paths' in the Alps is constantly increasing. The routes secured by iron ropes are a more demanding alternative to mountain hiking. Steel cables, brackets and pins driven into the rock, even ladders and bridges give access to spectacular paths. Travellers are rewarded by fantastic views and intensive experiences. The climbs can be extremely challenging and require good equipment, surefootedness and a head for heights.

Via ferrata

Les chemins aménagés sur les parois rocheuses dit « via ferrata » sont une alternative sportive à la randonnée pédestre. Des câbles d'acier, des marches et des échelons enfoncés dans la roche, des échelles et des ponts ouvrent des voies spectaculaires. La récompense pour cette expérience intensive en montagne est une vue fantastique. Les montées parfois très difficiles, dont le nombre ne cesse d'augmenter, requièrent un bon équipement, un pied sûr et une tête froide.

Klettersteige

Klettersteige sind eine sportliche Alternative zum Wandern. Stahlseile, in den Fels getriebene Klammern und Stifte, Leitern und Brücken erschließen spektakuläre Routen. Lohn des intensiven Bergerlebnisses sind traumhafte Ausblicke. Die teils extrem herausfordernden Steige, deren Zahl stetig zunimmt, erfordern eine gute Ausrüstung, Trittsicherheit und Schwindelfreiheit.

Via ferrata

Vaste touwroutes zijn een sportief alternatief voor wandelen. Stalen kabels, beugels en pennen in de rotsen, ladders en bruggen openen spectaculaire routes. De beloning voor de intensieve bergervaring zijn fantastische uitzichten. De soms zeer uitdagende beklimmingen, waarvan het aantal voortdurend toeneemt, vereisen een goede uitrusting, zekerheid en vooral geen hoogtevrees.

Via ferrata

Os percursos de corda fixa são uma alternativa desportiva às caminhadas. Cordas de aço, suportes e pinos levados pela rocha, escadas e pontes abrem rotas espetaculares. A recompensa pela experiência intensiva da montanha são as vistas fantásticas. As subidas, por vezes extremamente desafiantes, cujo número aumenta constantemente, requerem um bom equipamento, segurança nos pés e uma cabeça para as alturas.

Vía ferrata

La vía ferrata es una alternativa deportiva al senderismo. Una serie de cuerdas de acero, grapas y clavos fijados en la roca, así como escaleras y puentes nos abren rutas espectaculares. La recompensa de la intensa experiencia en la montaña son unas vistas de ensueño. Las subidas, que a veces son extremadamente difíciles y van aumentando constantemente, requieren un buen equipo, seguridad y no tener vértigo

Südtirol · Alto Adige · Tyrol du Sud

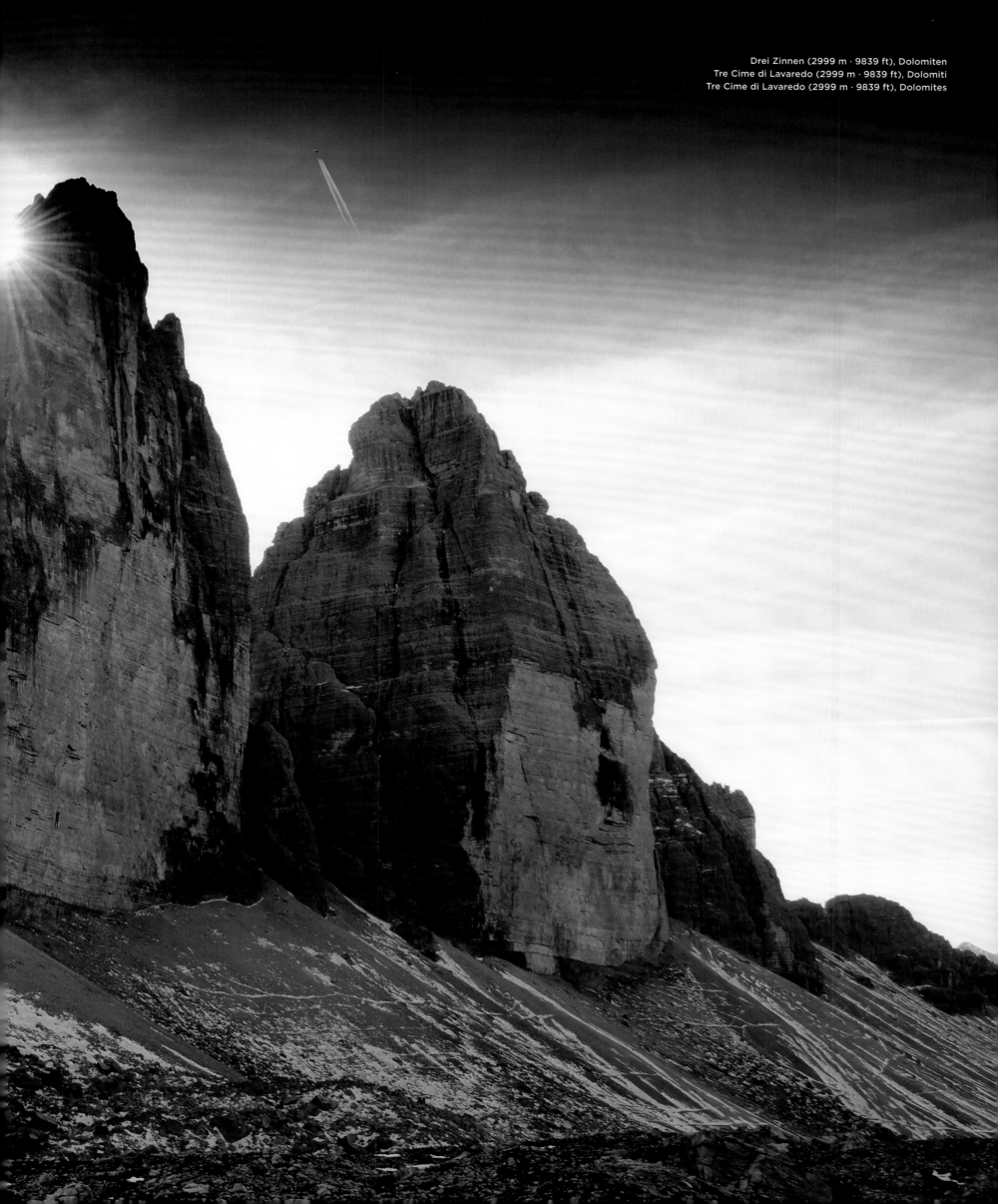

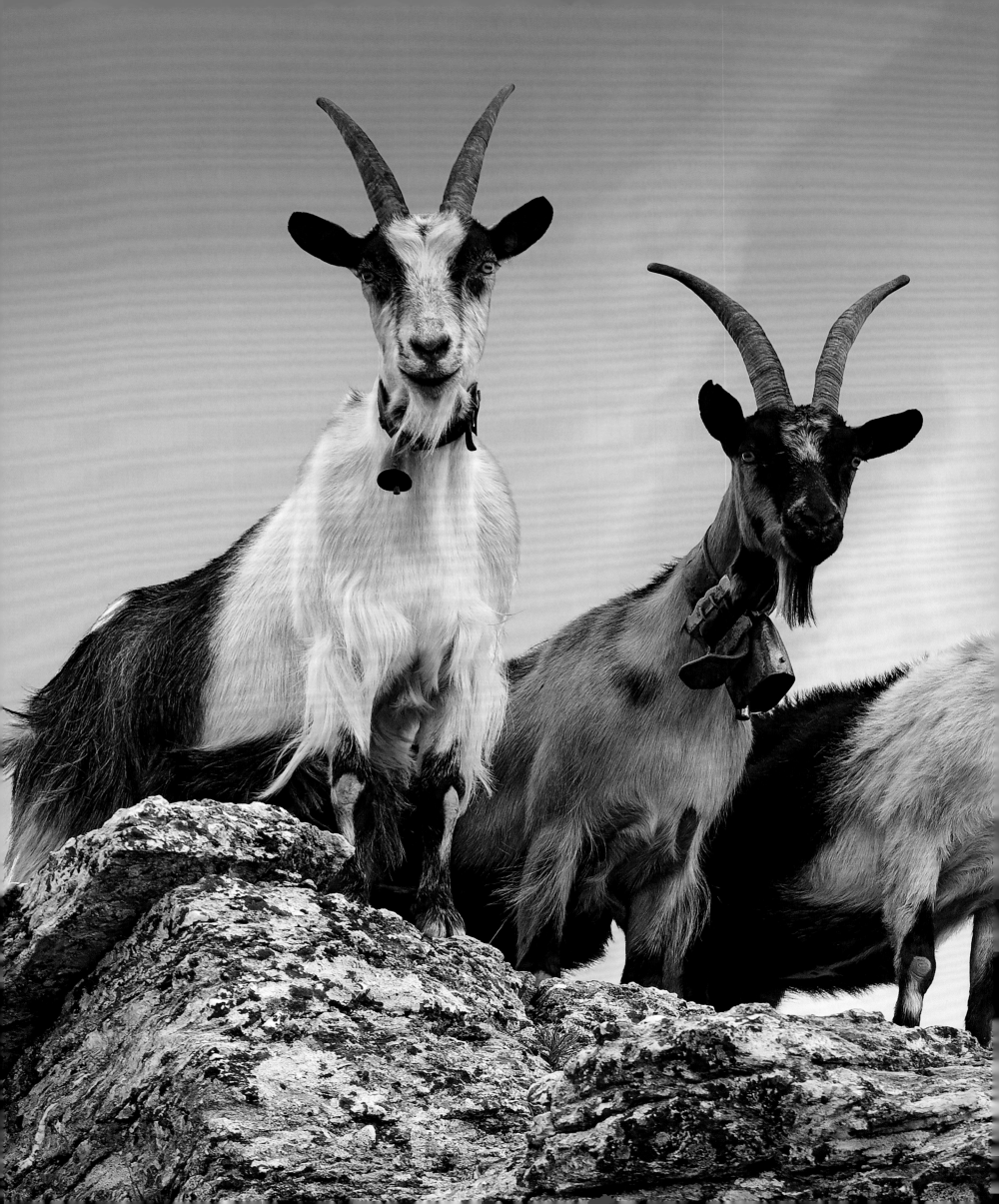

Große Zinne (2999 m · 9839 ft), Dolomiten
Cima Grande (2999 m · 9839 ft), Dolomiti
Cima Grande ou « grande cime » (2999 m · 9839 ft), Dolomites

Tre Cime di Lavaredo, Dolomites

The highest peak of the Tre Cime di Lavaredo, the Cima Grande (2999 m · 9839 ft), was climbed for the first time in 1869. Since then, countless climbers have tried their hand at the imposing mountains, which are accessible on several routes. On the way there one passes the picturesque rock needle which the Italians call "Salsiccia" or "Frankfurter Würstel". The region was fiercely contested in the First World War; traces can still be seen today. If one does nott want to climb but just enjoy beautiful views, one can follow a hiking trail around the Three Peaks, which is so popular that one is never alone.

Les Tre Cime di Lavaredo, dans les Dolomites

Le plus haut sommet de ces « trois cimes », la Cima Grande (2999 m), a été atteint pour la première fois en 1869. Depuis, d'innombrables alpinistes ont tenté leur chance sur ces montagnes emblématiques, accessibles par plusieurs voies. Sur le chemin qui y mène, on passe devant une aiguille rocheuse pittoresque que les Italiens surnomme la « Salsiccia », la « saucisse ». Cette région a été le théâtre de rudes combats pendant la Première Guerre mondiale, ce qui a laissé des traces jusqu'à aujourd'hui. Pour ceux qui n'aiment pas l'alpinisme mais sont friands de beaux panoramas, un chemin de randonnée fait le tour des trois cimes, mais son succès est tel que l'on y est rarement seul.

Drei Zinnen, Dolomiten

Erstmals bestiegen wurde der höchste Gipfel der Drei Zinnen, die Große Zinne (2999 m), im Jahr 1869. Seither versuchen sich zahllose Kletterer an den markanten Bergen, die durch mehrere Routen erschlossen sind. Auf dem Weg dorthin passiert man die pittoreske Felsnadel, die die Italiener „Salsiccia" oder „Frankfurter Würstel" nennen. Die Region war im Ersten Weltkrieg hart umkämpft, Spuren sind heute noch zu sehen. Wer nicht klettern, sondern nur schöne Ausblicke genießen will, kann einem Wanderweg rund um die Drei Zinnen folgen, der allerdings so beliebt ist, dass man dort niemals allein unterwegs ist.

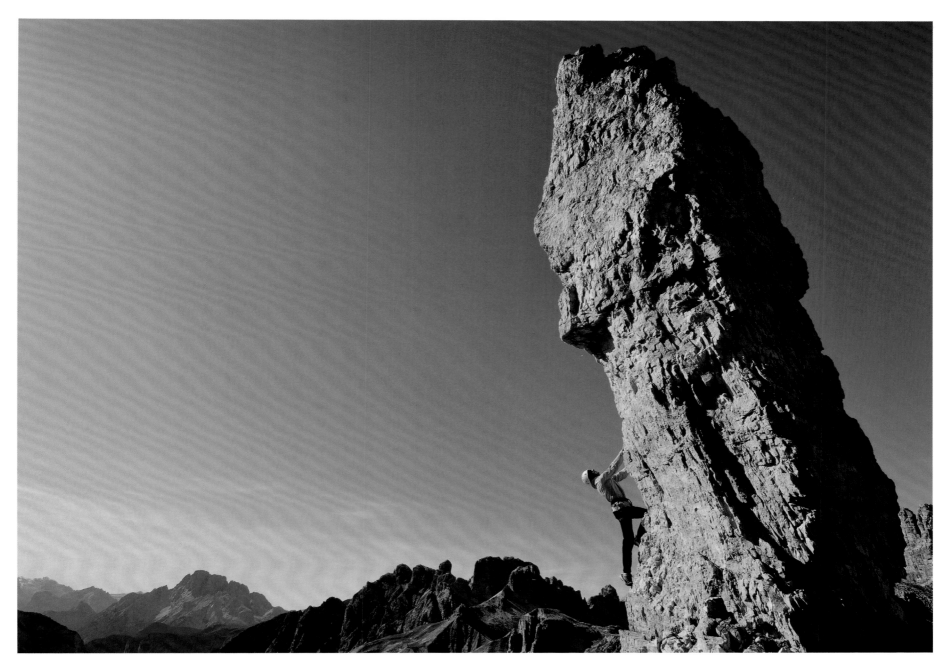

"Frankfurter Würstel", Drei Zinnen
"Frankfurter Würstel", Tre Cime di Lavaredo
« La saucisse de Francfort », Tre Cime di Lavaredo

Tres Cimas de Lavaredo, Dolomitas

El pico más alto de las Tres Cimas, la Cima Grande/ Große Zinne (2999 m), fue escalado por primera vez en 1869 y desde entonces, innumerables escaladores han probado su destreza en las impresionantes montañas, a las que se puede acceder a través de varias rutas. En el camino se pasa por la pintoresca aguja de roca que los italianos llaman "Salsiccia" y los alemanes "Frankfurter Würstel". La región fue ferozmente disputada en la Primera Guerra Mundial; aún hoy se pueden ver rastros. Aquellos que no quieran escalar, sino solo disfrutar de las hermosas vistas, pueden seguir una ruta de senderismo alrededor de las Tres Cimas, que es tan popular que nunca se verán solos.

Três Picos, Dolomitas

O pico mais alto dos Três Picos, o Große Zinne (2999 m), foi escalado pela primeira vez em 1869. Desde então, inúmeros alpinistas têm tentado chegar às impressionantes montanhas, que são acessíveis através de várias rotas. No caminho para lá passa-se a pitoresca agulha de pedra que os italianos chamam "Salsiccia" ou "Frankfurter Würstel". A região foi ferozmente disputada na Primeira Guerra Mundial, ainda hoje se podem ver vestígios. Se você não quer subir, mas apenas desfrutar de belas vistas, você pode seguir uma trilha de caminhada ao redor dos Três Picos, que é tão popular que você nunca está sozinho.

Drei Zinnen, Dolomieten

De hoogste top van de Drei Zinnen (Tre Cime di Lavaredo), de Große Zinne (Cima Grande, 2999 m), werd in 1869 voor het eerst beklommen. Sindsdien is deze opvallende bergformatie populair bij klimmers, die via verschillende routes de toppen kunnen bereiken. Onderweg ligt een schilderachtige spitse rots die de Italianen 'Salsiccia' noemen. Tijdens de Eerste Wereldoorlog was dit gebied heftig betwist, wat ook tegenwoordig nog blijkt uit tal van sporen. Voor mensen die niet van klimmen houden, maar gewoon willen genieten van de prachtige vergezichten, is de populaire wandelroute rondom de Drei Zinnen een aanrader.

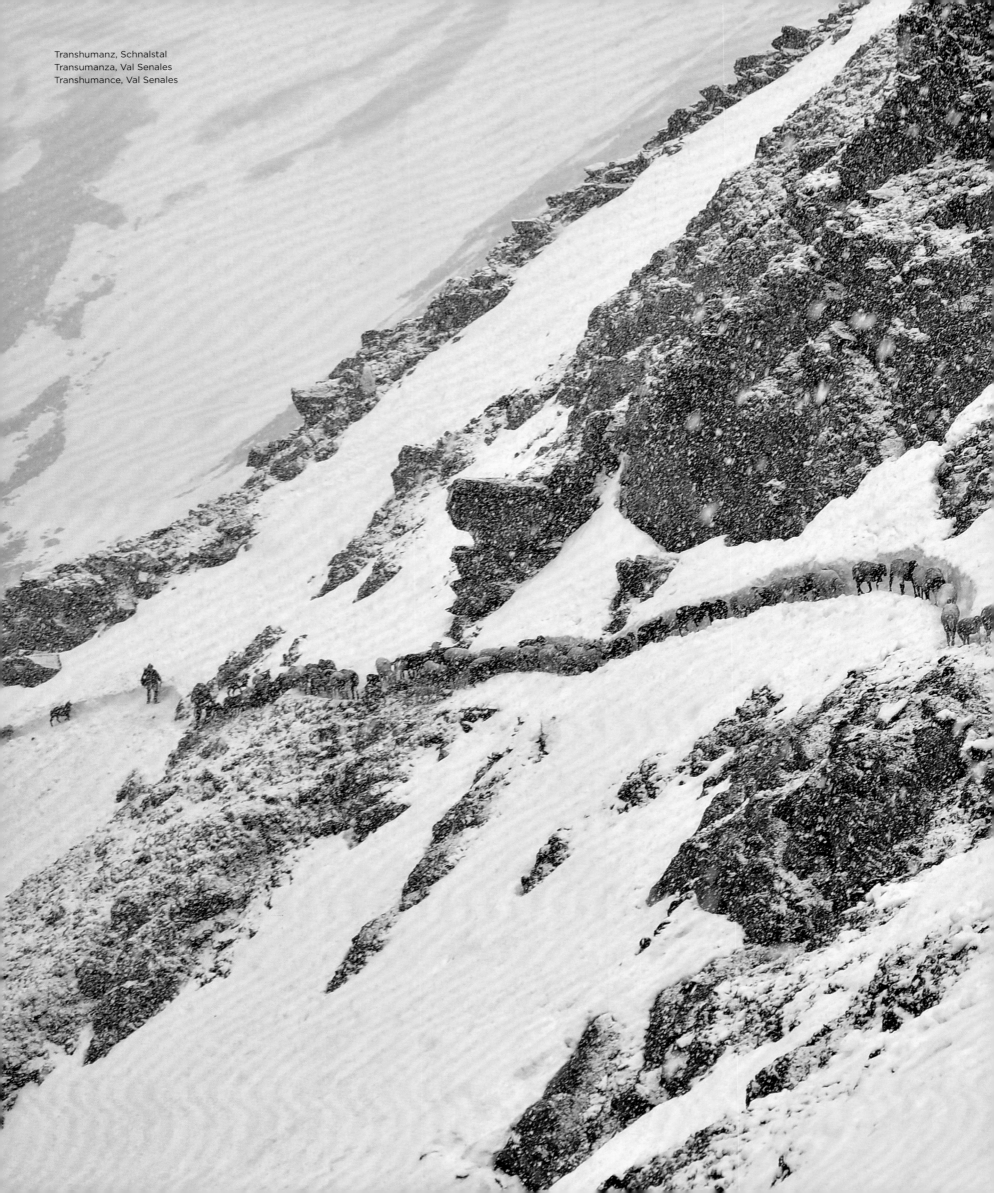

Transhumanz, Schnalstal
Transumanza, Val Senales
Transhumance, Val Senales

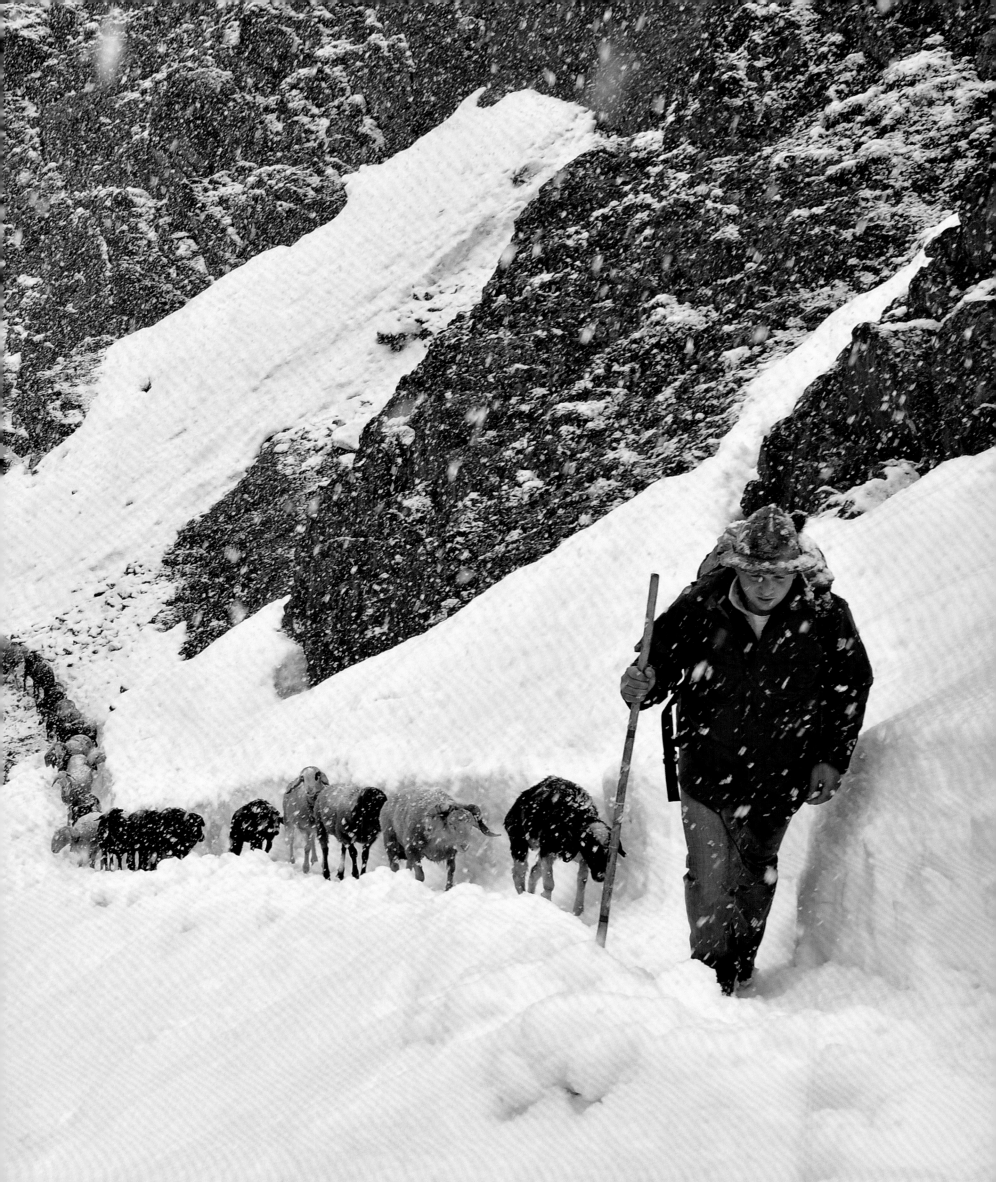

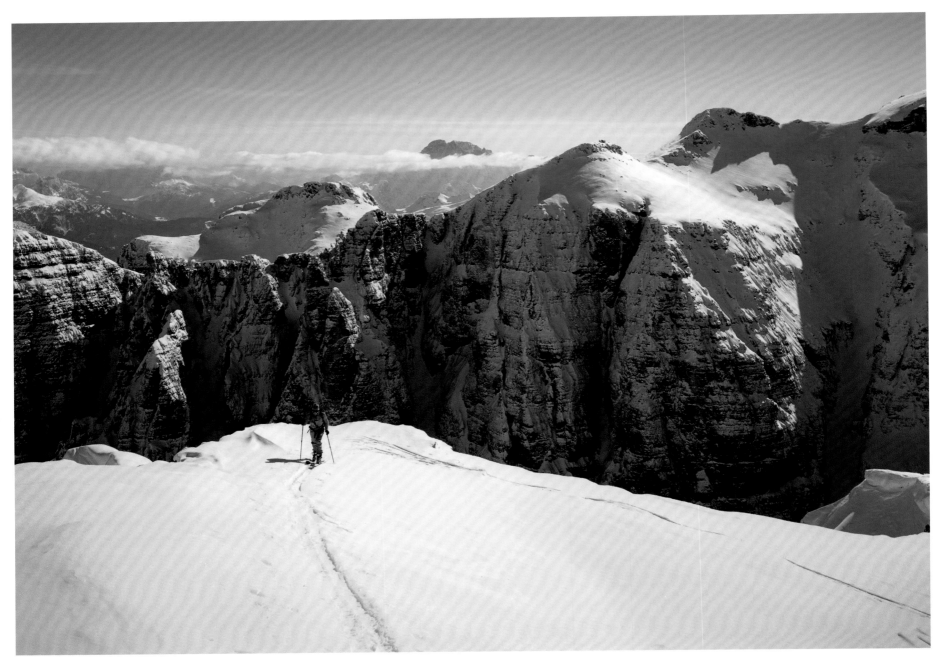

Rissa del Daint, Sella

Sella Ronda

The 55 km (34 mi) long circuit around the Sella massif, with four passes, can be travelled by bike or motorbike in summer. In winter, there is a popular ski circuit with a length of 26 km (16 mi) long utilising the Sellaronda ski lift carousel. In the past, the area was considered snow-sure, but now snow cannons have to be used occasionally to make the circuit passable. A highlight every year is the Sellaronda Ski Marathon, which takes place at night: The athletes start at sunset and overcome an altitude difference of around 2700 m (8858 ft) over 42 (26 mi) km.

Sellaronda

En fait, Sellaronda est comme un manège, mais qui fonctionnerait dans les deux sens. En été, on peut parcourir à vélo ou à moto cette boucle de 55 km autour du massif du Sella, tandis qu'en hiver c'est une piste de ski très appréciée, de 26 km de long. Autrefois, cette région avait un bon enneigement, mais aujourd'hui il faut parfois faire appel aux canons à neige pour que la piste soit intégralement praticable. Chaque année, le marathon de ski de Sellaronda, qui se déroule la nuit, est une véritable attraction : les athlètes partent au coucher du soleil et parcourent 42 km et un dénivelé de 2700 m.

Sella Ronda

Eigentlich ist die Sella Ronda ein Karussell, das aber in beiden Laufrichtungen funktioniert. Die 55 km lange Runde um das Sellamassiv mit vier Pässen kann im Sommer mit dem Fahrrad oder dem Motorrad befahren werden, im Winter ist es mit 26 km Länge eine beliebte Skirunde. Früher galt die Gegend als schneesicher, inzwischen müssen gelegentlich Schneekanonen eingesetzt werden, um die Runde durchgängig befahrbar zu machen. Jedes Jahr ein Highlight ist der nachts stattfindende Sellaronda-Skimarathon: Die Athleten starten bei Sonnenuntergang und überwinden auf 42 km rund 2700 m Höhenunterschied.

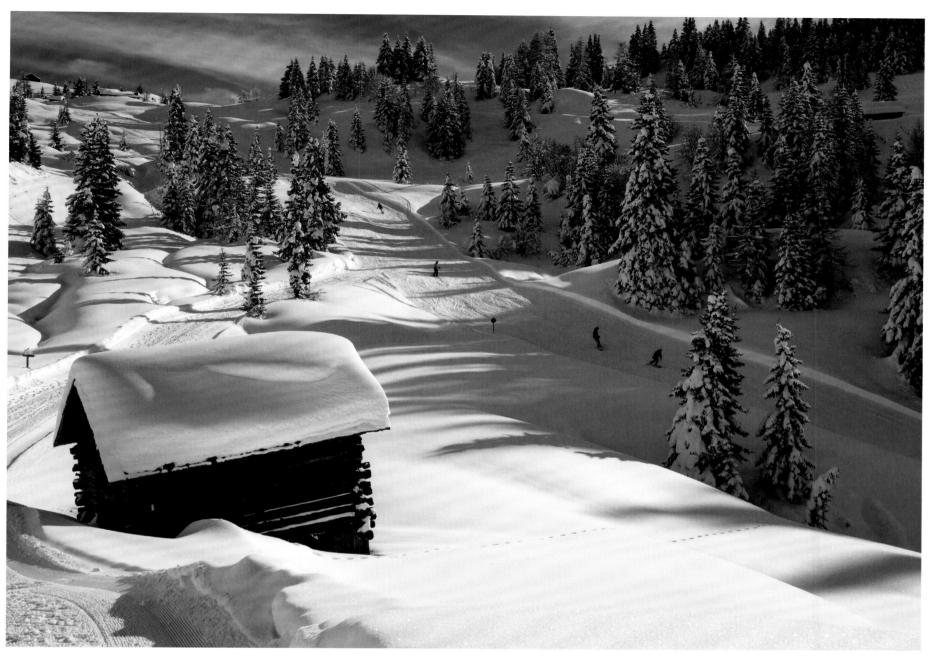

Sella Ronda, Planac

Sella Ronda

En realidad, la Sella Ronda es un carrusel, pero funciona en ambas direcciones. El circuito de 55 km de largo alrededor del macizo del Sella, con cuatro pasos, se puede recorrer en bicicleta o motocicleta en verano, y en invierno es un circuito de esquí muy popular de 26 km. En el pasado, la zona estaba siempre nevada, pero ahora hay que usar a veces cañones de nieve para que el circuito sea transitable por los esquiadores. Un punto culminante cada año es el Sellaronda Ski Marathon, que tiene lugar por la noche: los atletas comienzan al atardecer y superan una diferencia de altitud de alrededor de 2700 m a lo largo de 42 km.

Sella Ronda

Na verdade, a Sella Ronda é um carrossel, mas funciona nos dois sentidos. O circuito de 55 km ao redor do maciço de Sella, com quatro passes, pode ser percorrido de bicicleta ou motocicleta no verão, e 26 km no inverno, é um circuito de esqui popular. No passado, a área era considerada segura para a neve, mas agora os canhões de neve têm de ser usados ocasionalmente para tornar o circuito passível. Um destaque a cada ano é a Maratona de Esqui Sellaronda, que acontece à noite: os atletas começam ao pôr-do-sol e superam uma diferença de altitude de cerca de 2700 m ao longo de 42 km.

Sella Ronda

De Sella Ronda is een rondlopende toeristische route. In de zomer is de 55 km lange route rondom het Sellamassief met vier passen geschikt voor fietsers en motorrijders. In de winter is de route 'slechts' 26 km lang en een populaire skipiste. Vroeger was het gebied sneeuwzeker, maar nu moeten er af en toe sneeuwkanonnen worden gebruikt om de piste volledig begaanbaar te maken. Een van de jaarlijkse hoogtepunten is de Sellaronda Ski Marathon, die 's nachts plaatsvindt: de start is bij zonsondergang, de totale lengte bedraagt 42 km en het hoogteverschil is ongeveer 2700 m.

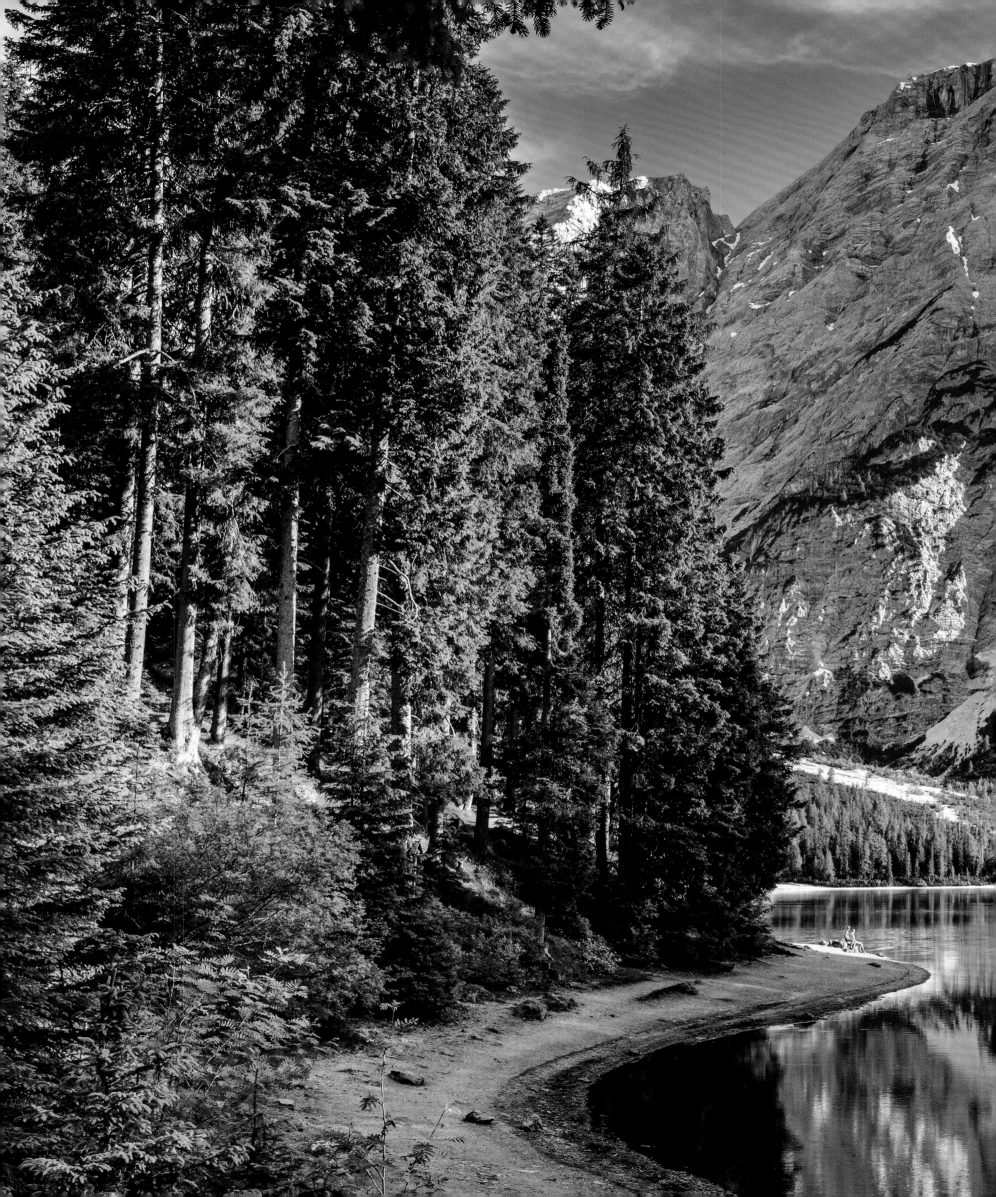

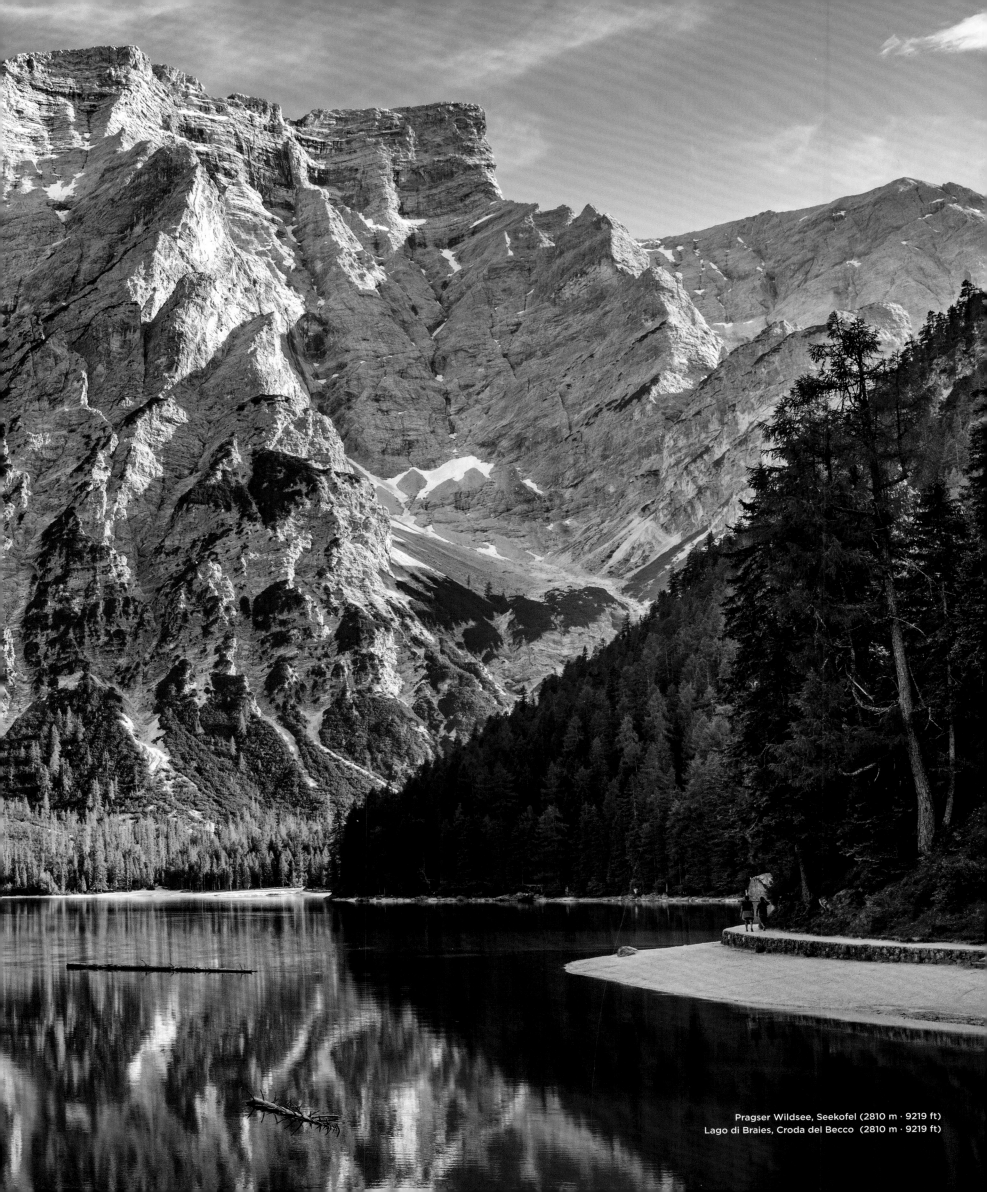

Pragser Wildsee, Seekofel (2810 m · 9219 ft)
Lago di Braies, Croda del Becco (2810 m · 9219 ft)

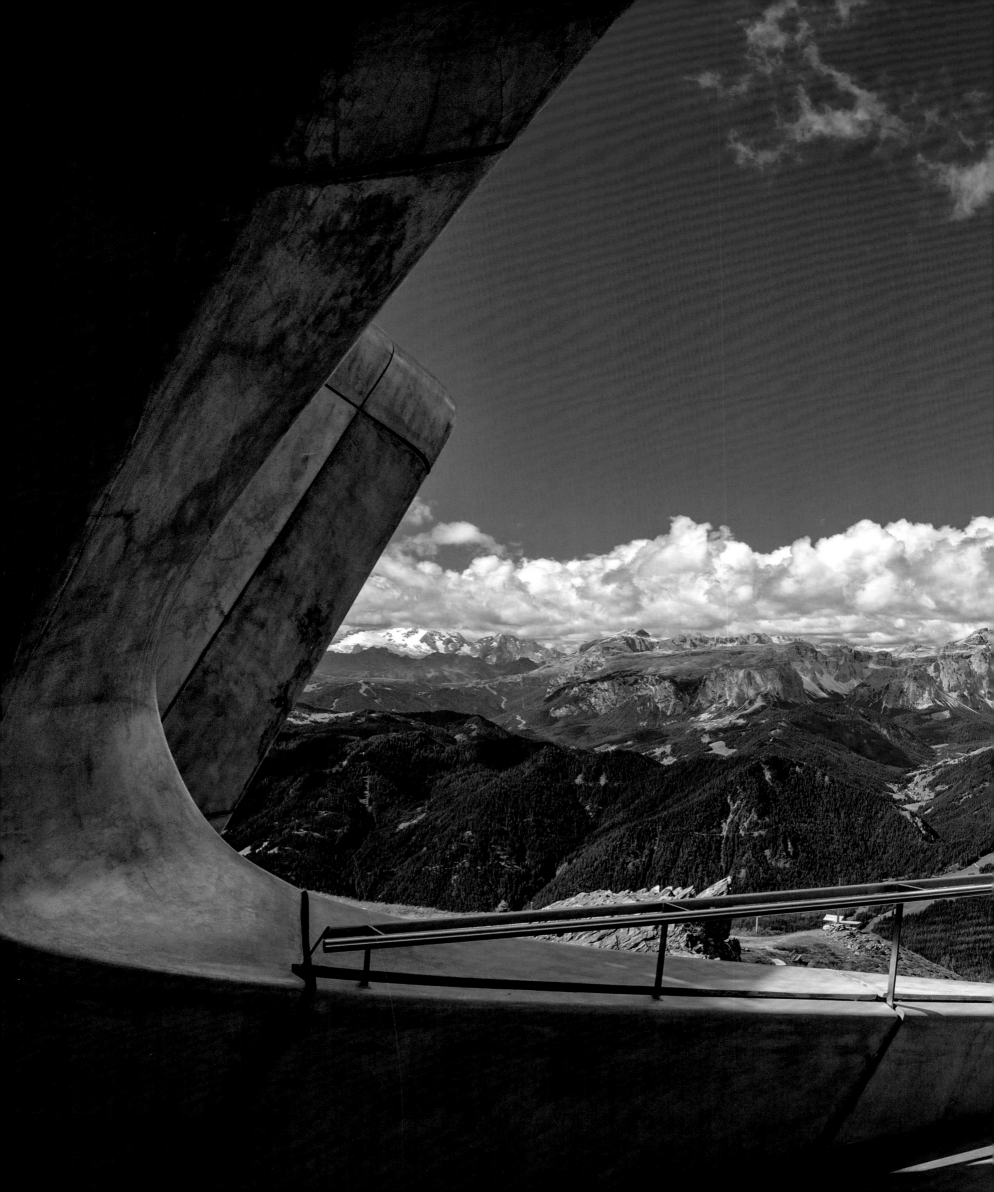

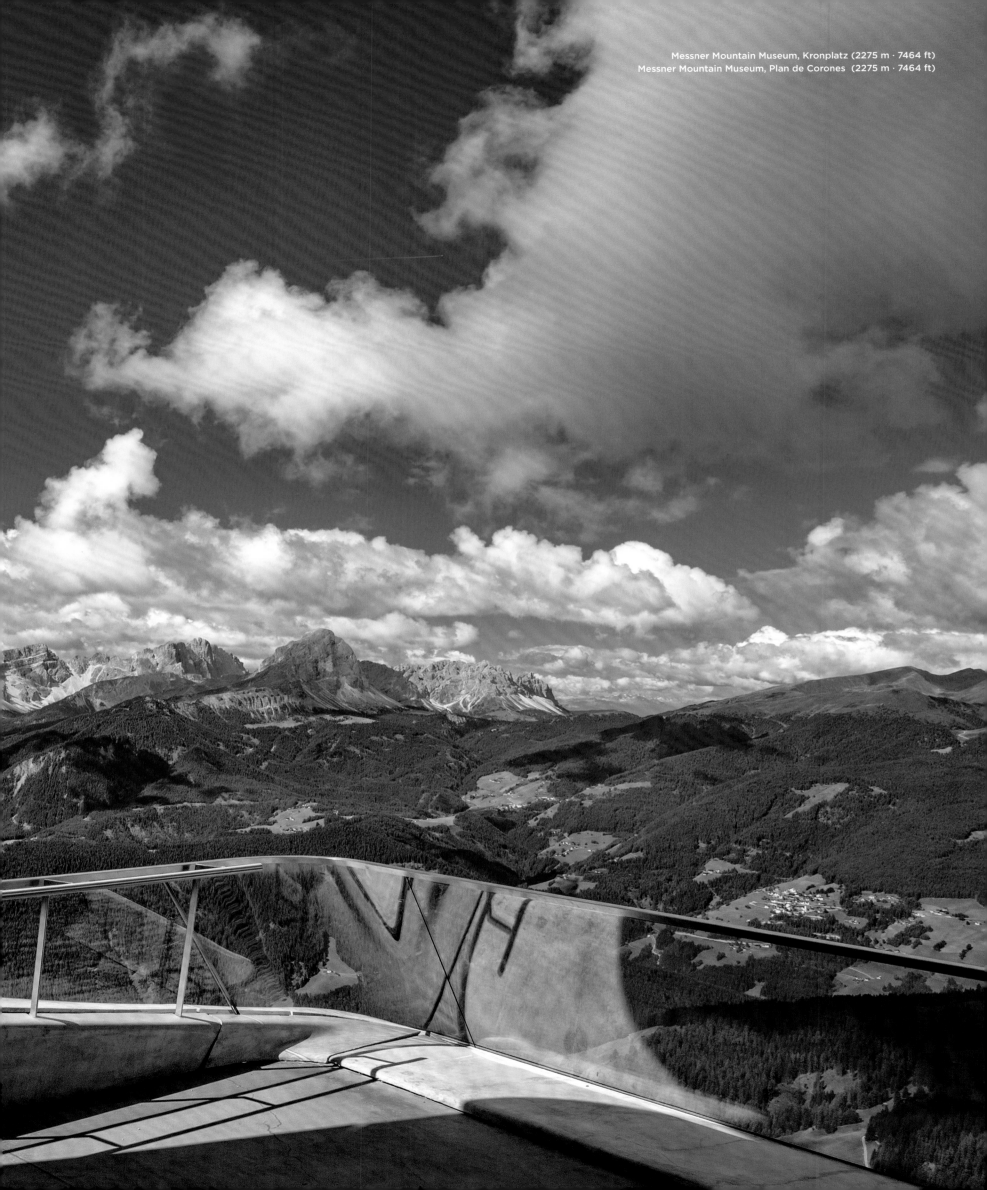

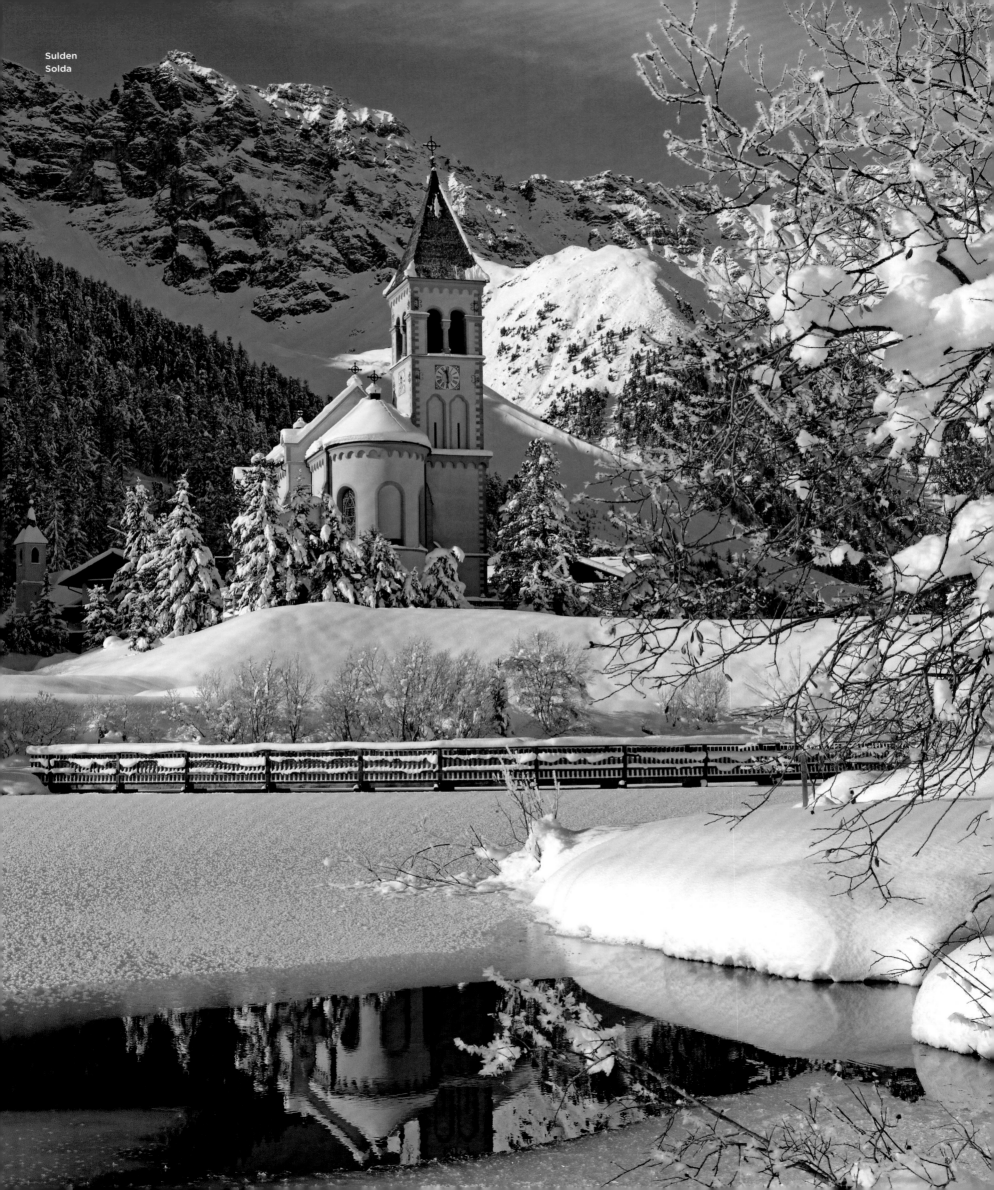

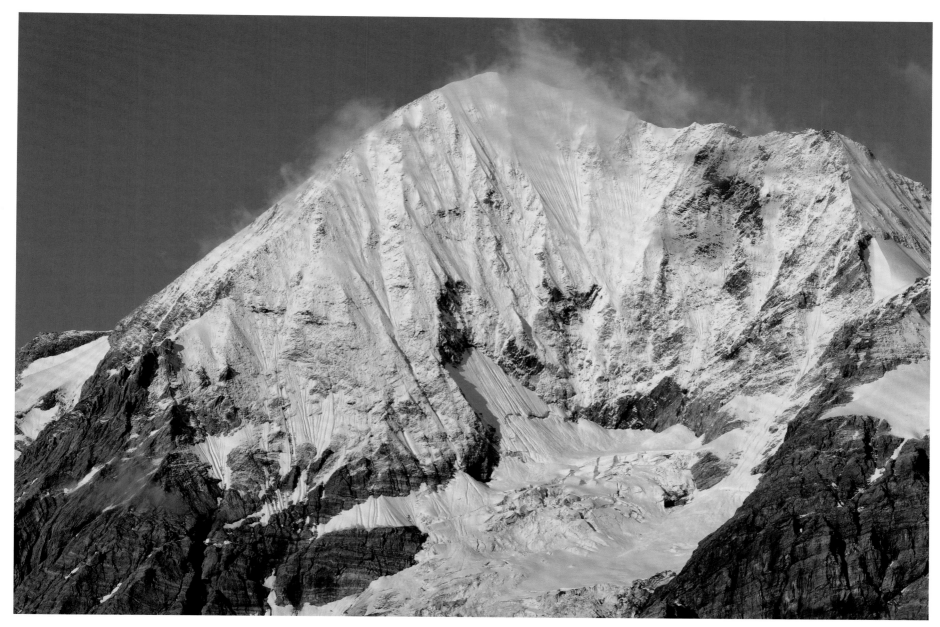

Königspitze (3851 m · 12635 ft)
Gran Zebrù (3851 m · 12635 ft)

Sulden

Winter sports and hiking: The community of Sulden am Ortler is tourism-orientated. What one wouldn't expect: a herd of yaks, which the famous mountaineer Reinhold Messner keeps here. Sulden is also one of the six sites of the Messner Mountain Museum. An underground installation south of the village is devoted to the theme of eternal ice.

Sulden

Sports d'hiver et randonnée : le village de Sulden, au pied de l'Ortles, vit du tourisme. Il réserve une surprise : un troupeau de yacks appartenant au célèbre alpiniste Reinhold Messner. Sulden abrite aussi l'un des six Messner Mountain Museums : au sud du village, ce musée souterrain est consacré aux neiges éternelles.

Sulden

Wintersport und Wandern: Die Gemeinde Sulden am Ortler lebt vom Tourismus. Was man nicht erwarten würde: eine Herde von Yaks anzutreffen, die der bekannte Bergsteiger Reinhold Messner hier hält. Sulden ist auch einer der sechs Standorte des Messner Mountain Museum. In einer unterirdischen Anlage südlich des Ortes wird das Thema Ewiges Eis dargestellt.

Solda

Deportes de invierno y senderismo: la comunidad de Solda (Sulden am Ortler) vive del turismo. Lo que no se puede esperar: encontrar una manada de yaks que el famoso montañero Reinhold Messner mantiene aquí. Solda es también uno de los seis lugares del Museo de la Montaña Messner. En una instalación subterránea al sur del pueblo, se representa el tema de los hielos eternos.

Dívidendos

Desportos de Inverno e caminhadas: A comunidade de Sulden am Ortler vive do turismo. O que você não esperava: encontrar uma manada de iaques que o famoso alpinista Reinhold Messner mantém aqui. Sulden é também um dos seis locais do Museu da Montanha Messner. Em uma instalação subterrânea ao sul da aldeia, o tema do gelo eterno é retratado.

Sulden

Het plaatsje Sulden aan de voet van de Ortler is razend populair bij wintersporters en wandelaars en leeft van het toerisme. Wat je hier wellicht niet zou verwachten zijn een jakken. Ze zijn eigendom van de beroemde bergbeklimmer Reinhold Messner. Sulden is ook een van de zes locaties van het Messner Mountain Museum. Hier is in een ondergronds complex ten zuiden van het dorp 'eeuwig ijs' te zien.

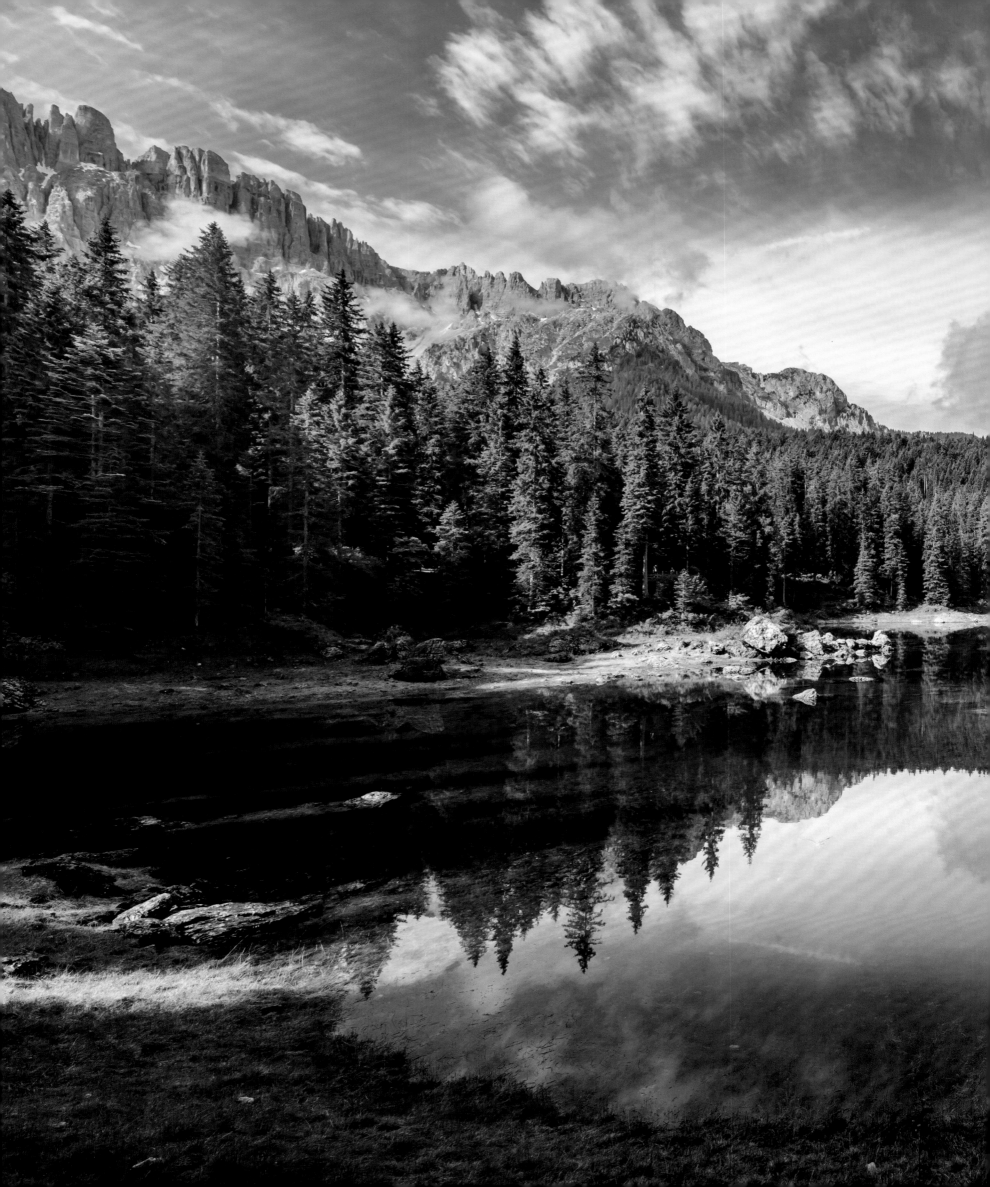

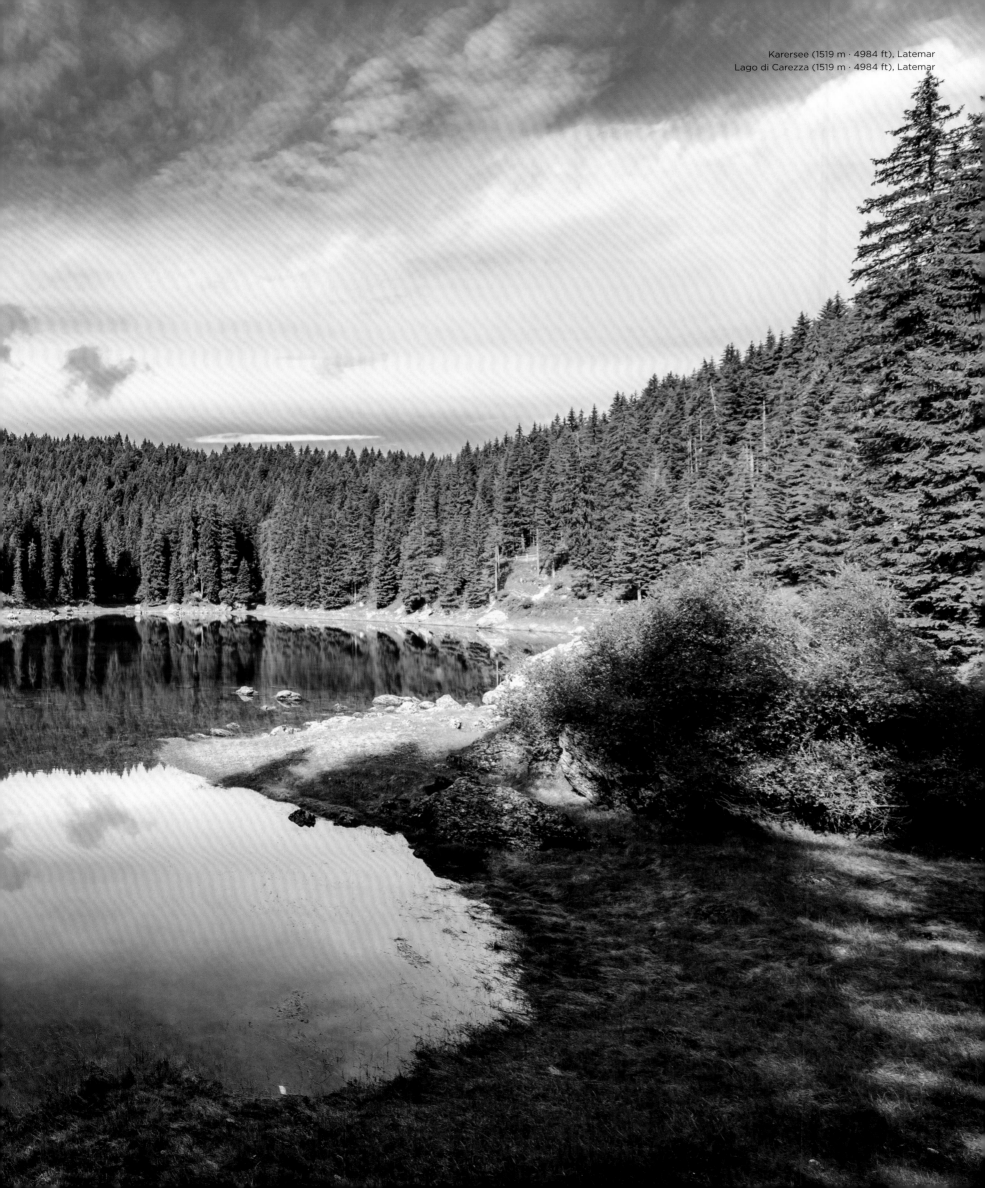

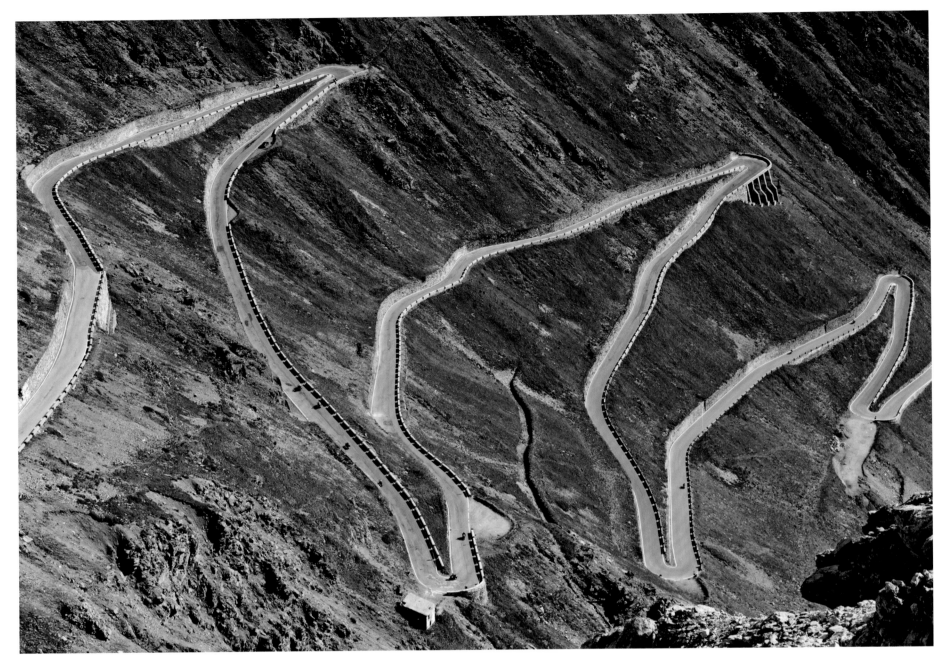

Stilfser Joch (2757 m · 9045 ft)
Passo dello Stelvio (2757 m · 9045 ft)
Col du Stelvio (2757 m · 9045 ft)

Stelvio Pass

Pass roads such as those over the Stilfser Joch (Stelvio Pass) used to be of military importance as well as of economic importance for transportation. This often involved connecting separate parts of the country with each other. With the capricious history of the European states, the importance of passes also changed. The Stilfser Joch last played a military role in the First World War. Today, the road with the second highest mountain pass in the Alps (2757 m · 9045 ft) is of particular interest for cyclists looking for a challenge. The Giro d'Italia also regularly leads across the pass.

Le col du Stelvio

Autrefois, les cols comme celui du Stelvio jouaient non seulement un rôle économique, mais aussi un rôle militaire, car ils reliaient entre elles des régions séparées. Au fil de l'histoire mouvementée des pays européens, l'importance respective des différents cols a évolué. C'est au cours de la Première Guerre mondiale que le col du Stelvio a joué pour la dernière fois un rôle notable. Aujourd'hui, cette route – qui est la deuxième des Alpes par son altitude (2 757 m) – intéresse surtout les cyclistes à la recherche de défis. Le Tour d'Italie passe d'ailleurs régulièrement par ce col.

Stilfser Joch

Passstraßen wie die über das Stilfser Joch hatten früher neben der wirtschaftlichen Bedeutung für den Verkehr meist auch militärische Bedeutung. Dabei ging es oft darum, getrennte Landesteile miteinander zu verbinden. Mit der wechselhaften Geschichte der europäischen Staaten änderte sich auch der Stellenwert der Pässe. Eine militärische Rolle spielte das Stilfser Joch zuletzt im Ersten Weltkrieg. Heute ist die Straße mit dem zweithöchsten Gebirgspass der Alpen (2757 m) vor allem für Radfahrer interessant, die hier eine Herausforderung suchen. Auch der Giro d'Italia führt regelmäßig über den Pass.

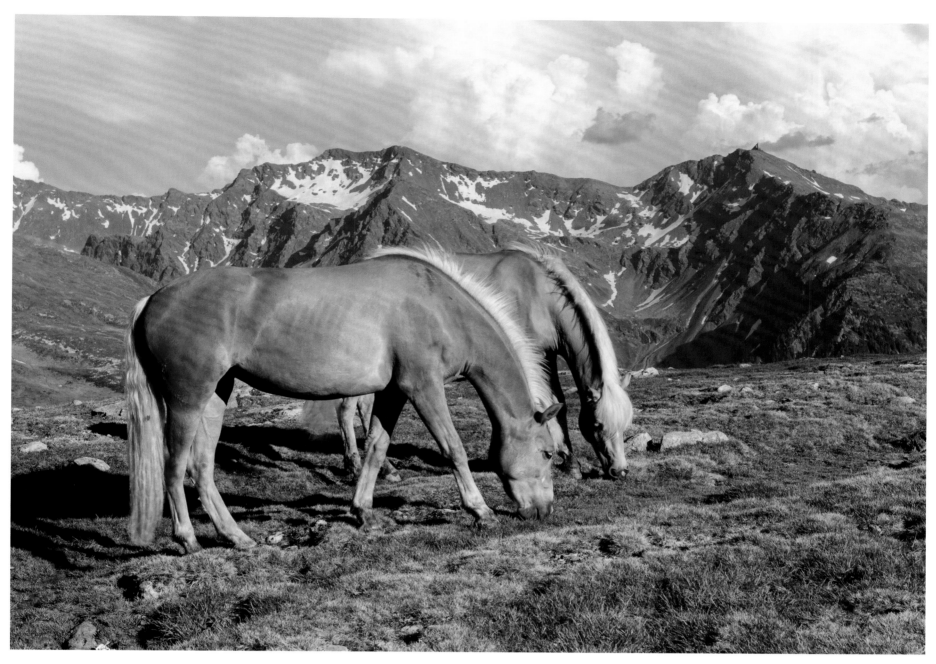

Haflinger, Penser Joch (2211 m · 7254 ft)
Avelignes, Passo di Pennes (2211 m · 7254 ft)
Chevaux Haflinger, col du Penserjoch (2211 m · 7254 ft)

Paso Stelvio

Las carreteras de paso como las del Paso Stelvio eran de importancia militar, además de su importancia económica para el tráfico. Esto a menudo consistía en conectar distintas partes del país entre sí. Con la historia cambiante de los estados europeos, la importancia de los pasaportes también cambió. El Paso Stelvio desempeñó por última vez un papel militar en la Primera Guerra Mundial. Hoy en día, la carretera con el segundo puerto de montaña más alto de los Alpes (2757 m) es especialmente interesante para los ciclistas que buscan un reto aquí. El Giro de Italia también atraviesa regularmente el puerto.

Stelvio Yoke

As estradas de passagem como aquelas sobre o Stilfser Joch costumavam ser de importância militar, além de sua importância econômica para o tráfego. Isto implicava muitas vezes ligar partes separadas do país entre si. Com a história mutável dos Estados europeus, a importância dos passaportes também mudou. O Stilfser Joch desempenhou pela última vez um papel militar na Primeira Guerra Mundial. Hoje, a estrada com a segunda maior passagem de montanha dos Alpes (2757 m) é particularmente interessante para os ciclistas que procuram um desafio aqui. A Giro d'Italia também atravessa regularmente o passe.

Stilfser Joch

Een bergpas zoals die over de Stilfser Joch was vroeger niet alleen van economisch maar ook van militair belang. Zo'n bergpas werd aangelegd om bepaalde delen van het land met elkaar te verbinden. Het belang van de meeste bergpassen wisselde en was mede afhankelijk van de onderlinge betrekkingen tussen de Midden-Europese landen. Van militair belang was de Stilfser Joch voor het laatst in de Eerste Wereldoorlog. Tegenwoordig is de één na hoogste bergpas van de Alpen (2757 m) een eldorado voor fietsers die hier een uitdaging zoeken. Ook de Giro d'Italia komt hier regelmatig langs.

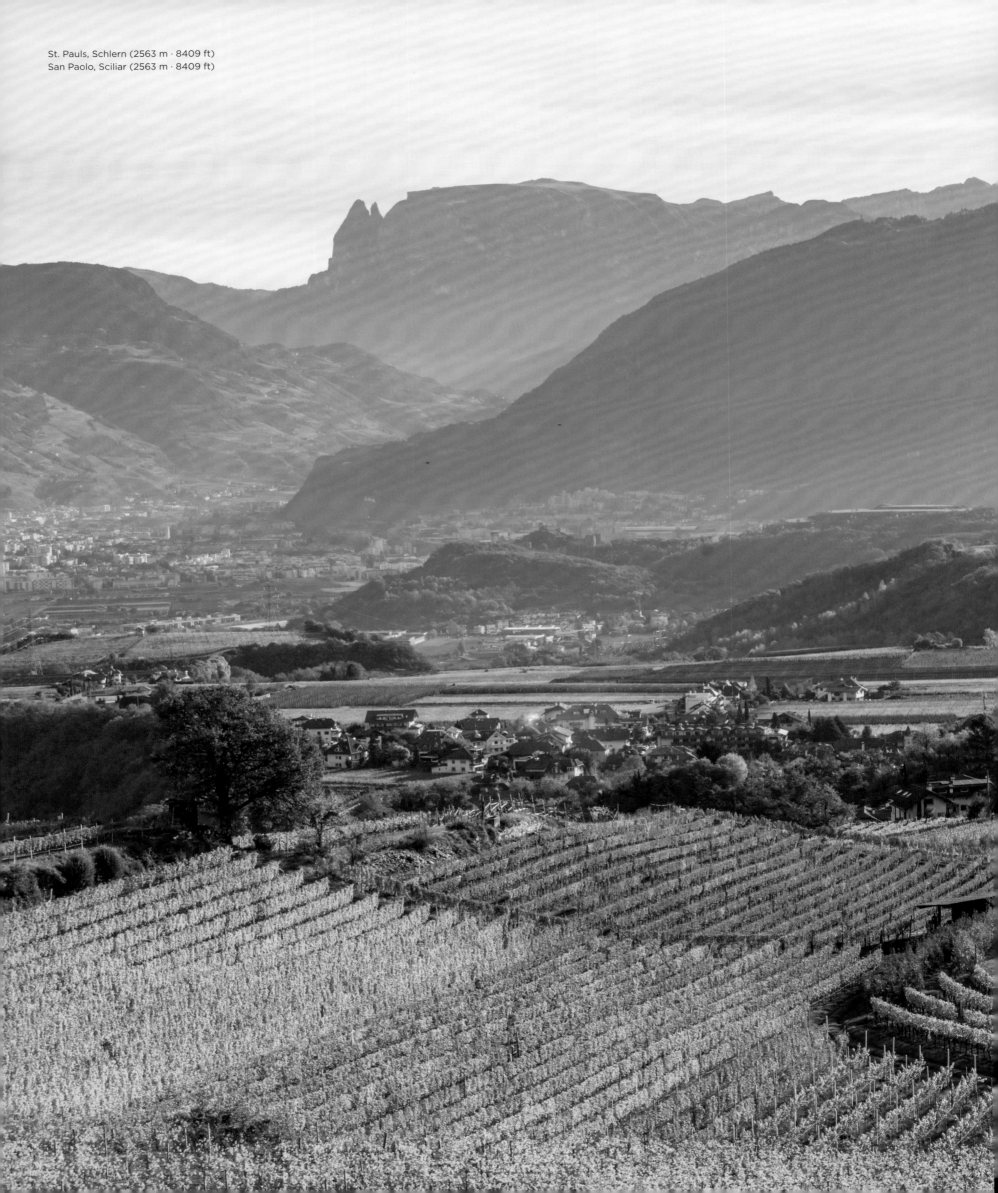

St. Pauls, Schlern (2563 m · 8409 ft)
San Paolo, Sciliar (2563 m · 8409 ft)

Apple Harvest, Vinschgau

Almost Mediterranean climate with 300 sunny days a year: The conditions for apple growing are ideal in Vinschgau. Approximately 300,000 tons of apples are harvested here annually, in the whole of South Tyrol it is almost 1 million tons, about half of which are exported.

La récolte des pommes, dans le val Venosta

Un climat presque méditerranéen avec 300 jours d'ensoleillement par an : les conditions sont idéales dans le val Venosta pour la culture des pommes. On y récolte chaque année environ 300 000 tonnes de pommes, et près d'un million de tonnes dans tout le Tyrol du Sud, la moitié étant réservée à l'exportation.

Apfelernte, Vinschgau

Fast schon mediterranes Klima mit 300 Sonnentagen im Jahr: Die Bedingungen für den Apfelanbau im Vinschgau sind ideal. Rund 300 000 Tonnen Äpfel werden jährlich geerntet, in ganz Südtirol sind es fast 1 Mio. Tonnen, von denen etwa die Hälfte exportiert wird.

Cosecha de manzanas, Val Venosta

Clima casi mediterráneo con 300 días de sol al año: las condiciones para el cultivo de la manzana en Val Venosta son ideales. Al año se se cosechan aproximadamente 300 000 toneladas de manzanas; en todo el Tirol del Sur se cosechan casi 1 millón de toneladas, de las cuales aproximadamente la mitad se exportan.

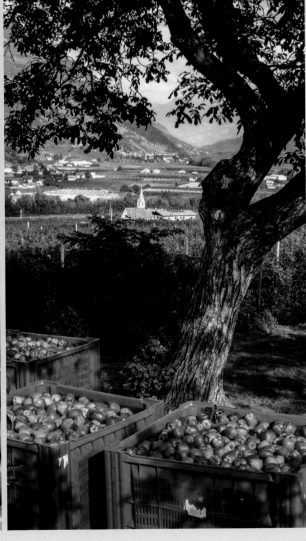

Colheita da Maçã, Vinschgau

Clima quase mediterrânico com 300 dias de sol por ano: as condições ideais para o cultivo da maçã em Vinschgau são ideais. Aproximadamente 300 000 toneladas de maçãs são colhidas anualmente, em todo o Tirol do Sul quase 1 milhão de toneladas são colhidas, das quais cerca de metade são exportadas.

Appeloogst, Vintzgouw

Het welhaast mediterraan klimaat in Vintzgouw met 300 dagen zon per jaar is ideaal voor de appelteelt. In deze streek worden jaarlijks ongeveer 300 000 t appels geoogst, in heel Zuid-Tirol bijna 1 miljoen t, waarvan ongeveer de helft wordt geëxporteerd.

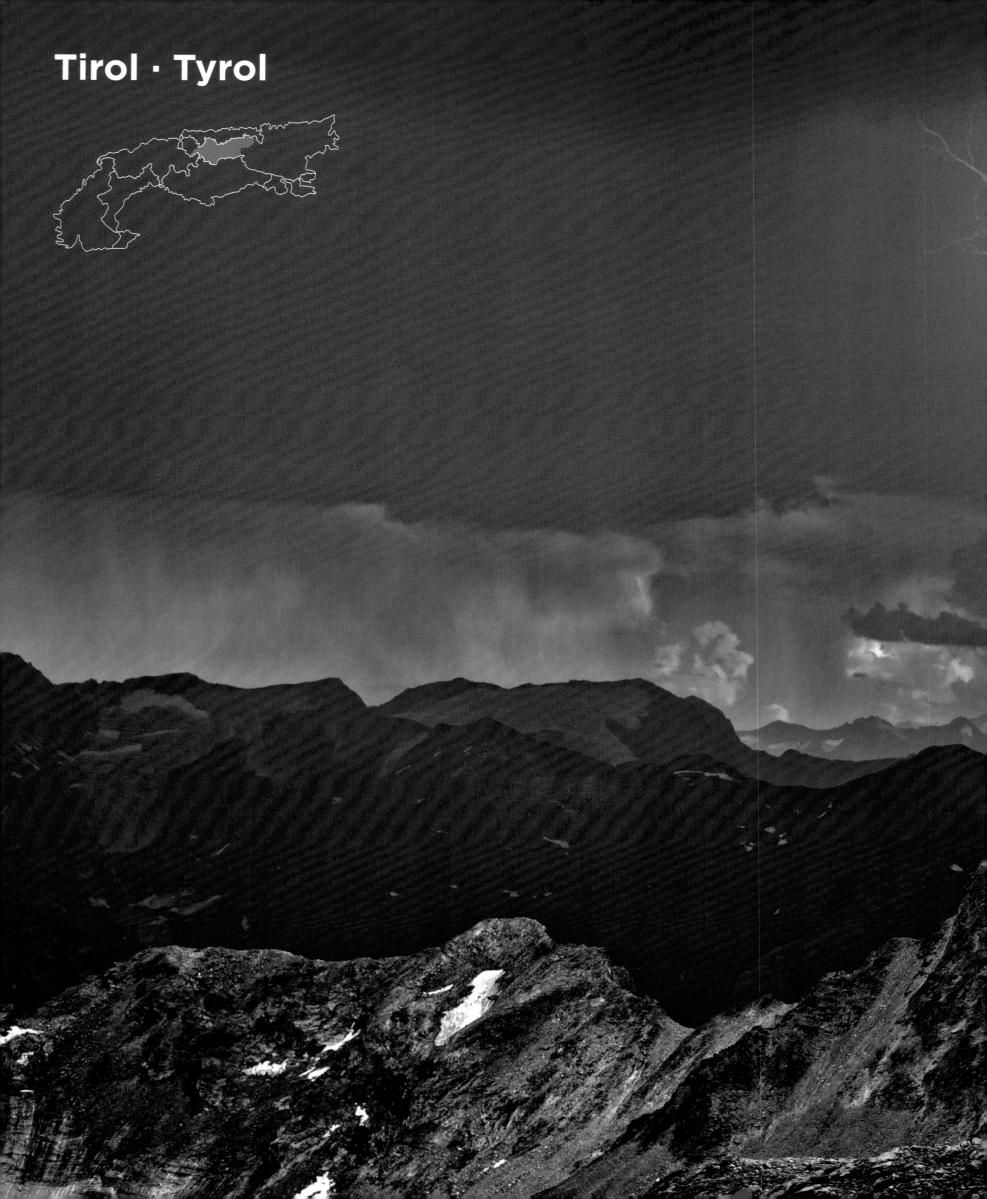

Tirol · Tyrol

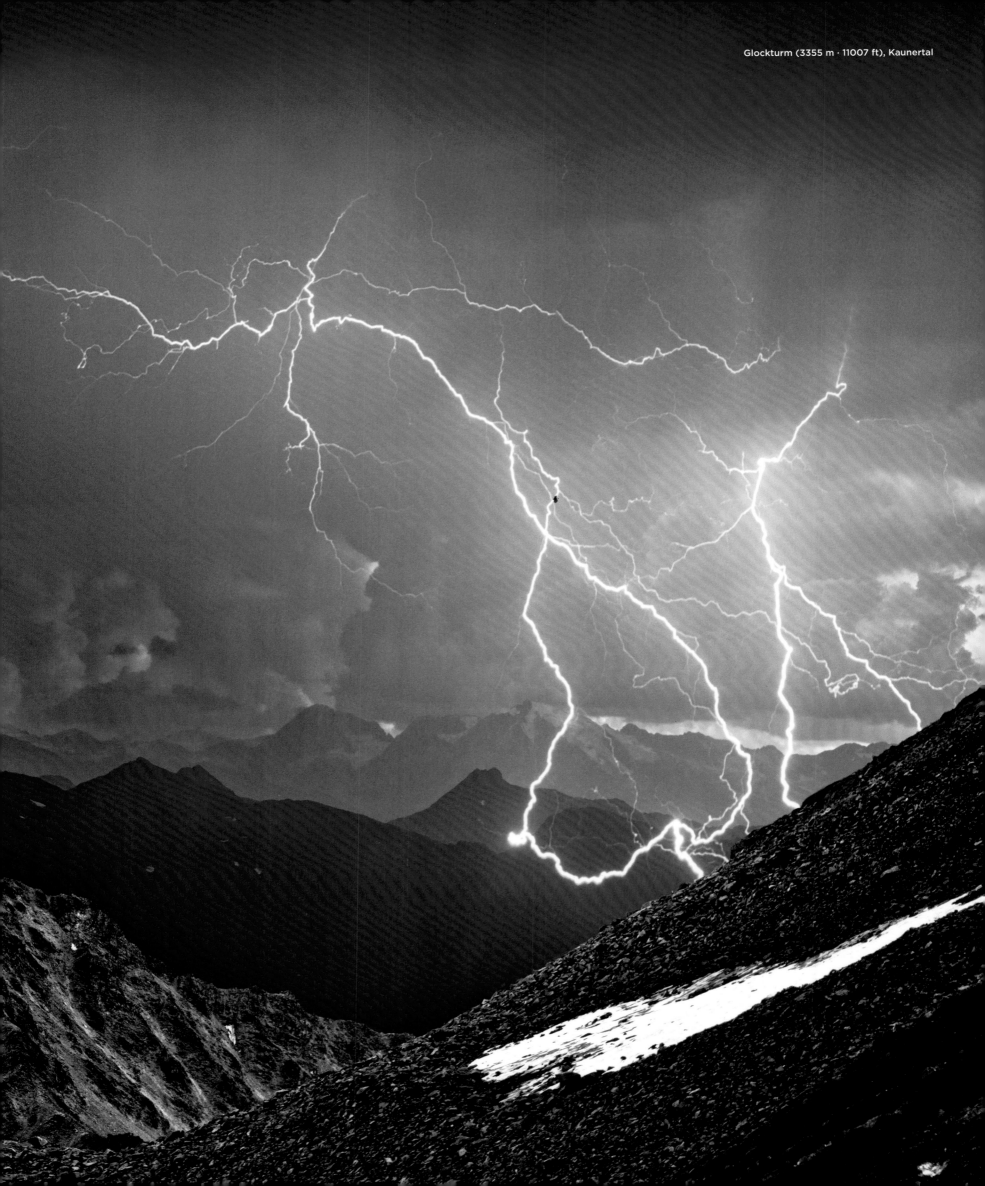

Kal

Regalm, Going, Wilder Kaiser

Tyrol

The federal state with the capital Innsbruck was often at the centre of European history. At the beginning of the 19th century, the Tyroleans rose up against Bavarian rule. The name of the freedom hero Andreas Hofer, who still has a great sound today, is associated with this popular uprising. Together with South Tyrol and Trentino, Tyrol forms a European region.

Le Tyrol

La région autrichienne du Tyrol, dont Innsbruck est la capitale, se situe au cœur de l'histoire européenne. Au début du XIXᵉ siècle, les habitants du Tyrol se soulevèrent contre la domination bavaroise. Cette révolte populaire est étroitement liée au nom de son chef, Andreas Hofer, encore célébré aujourd'hui. Le Tyrol, le Tyrol du Sud et le Trentin forment ensemble une eurorégion (Tyrol-Haut-Adige-Trentin).

Tirol

Das Bundesland mit der Hauptstadt Innsbruck stand oft im Zentrum europäischer Geschichte. Anfang des 19. Jahrhunderts erhoben sich die Tiroler gegen die bayrische Herrschaft. Mit diesem Volksaufstand verbunden ist der Name des Freiheitshelden Andreas Hofer, der auch heute noch einen großen Klang hat. Zusammen mit Südtirol und Trentino bildet Tirol eine Europaregion.

Tirol

El estado federal con capital en Innsbruck fue a menudo el centro de la historia europea. A principios del siglo XIX, los tiroleses se rebelaron contra el dominio bávaro. El nombre del héroe de la libertad Andreas Hofer, que todavía hoy tiene una gran sonoridad, está asociado con este levantamiento popular. Junto con el Tirol del Sur y Trentino, Tirol forma una región europea.

Tirol

O Estado federal com a capital Innsbruck estava frequentemente no centro da história europeia. No início do século XIX, os tiroleses revoltaram-se contra o domínio bávaro. O nome do herói da liberdade Andreas Hofer, que ainda hoje tem um grande som, está associado a esta revolta popular. Juntamente com o Tirol do Sul e o Trentino, o Tirol forma uma região europeia.

Tirol

De deelstaat Tirol met de hoofdstad Innsbruck speelde in de Europese geschiedenis niet zelden een belangrijke rol. Begin 19e eeuw kwamen de Tirolers onder aanvoering van Andreas Hofer in opstand tegen de Beierse overheersing. De naam van deze vrijheidsstrijder spreekt ook tegenwoordig nog tot de verbeelding. Samen met Zuid-Tirol en Trentino vormt Tirol een Euregio.

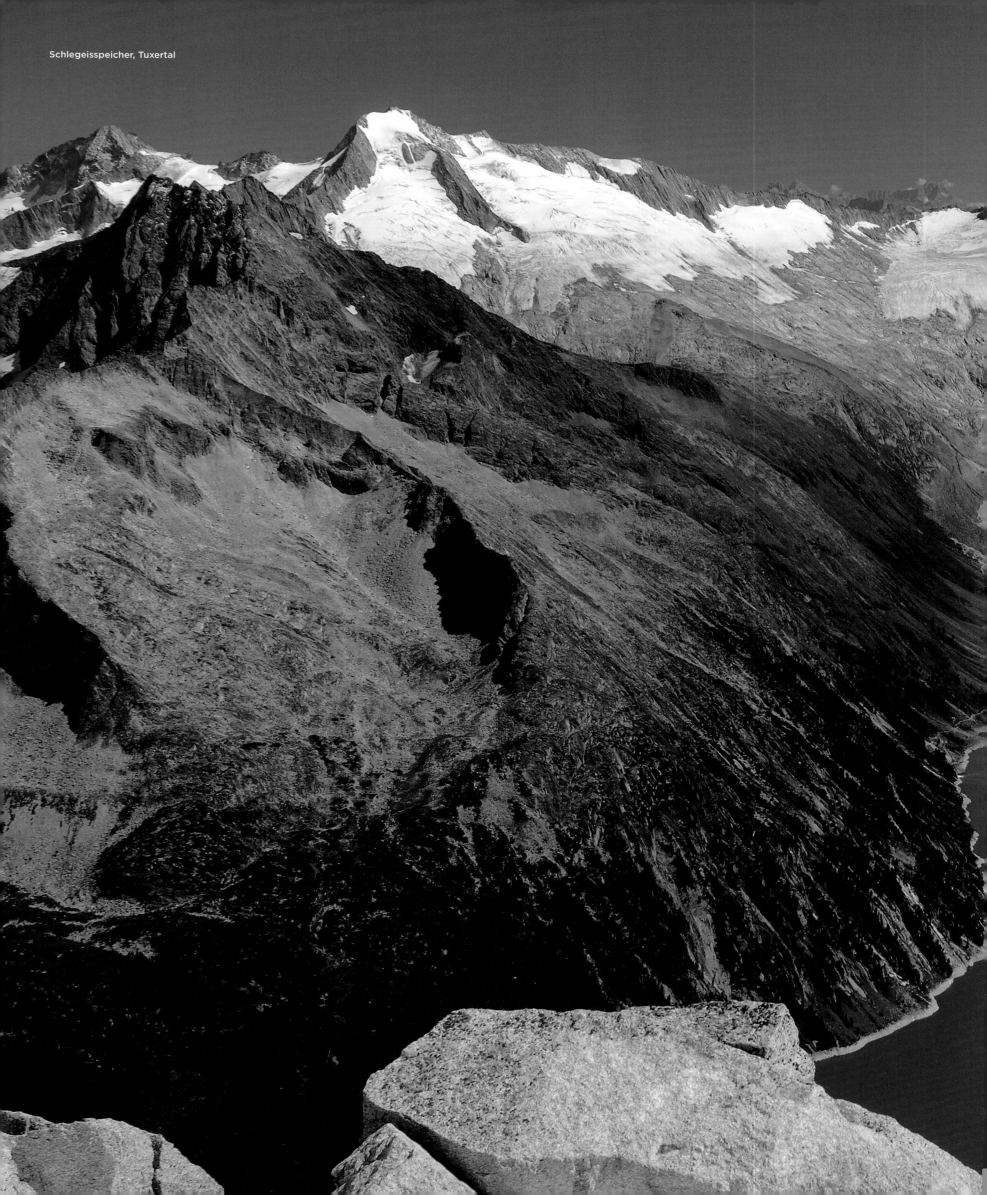

Schlegeisspeicher, Tuxertal

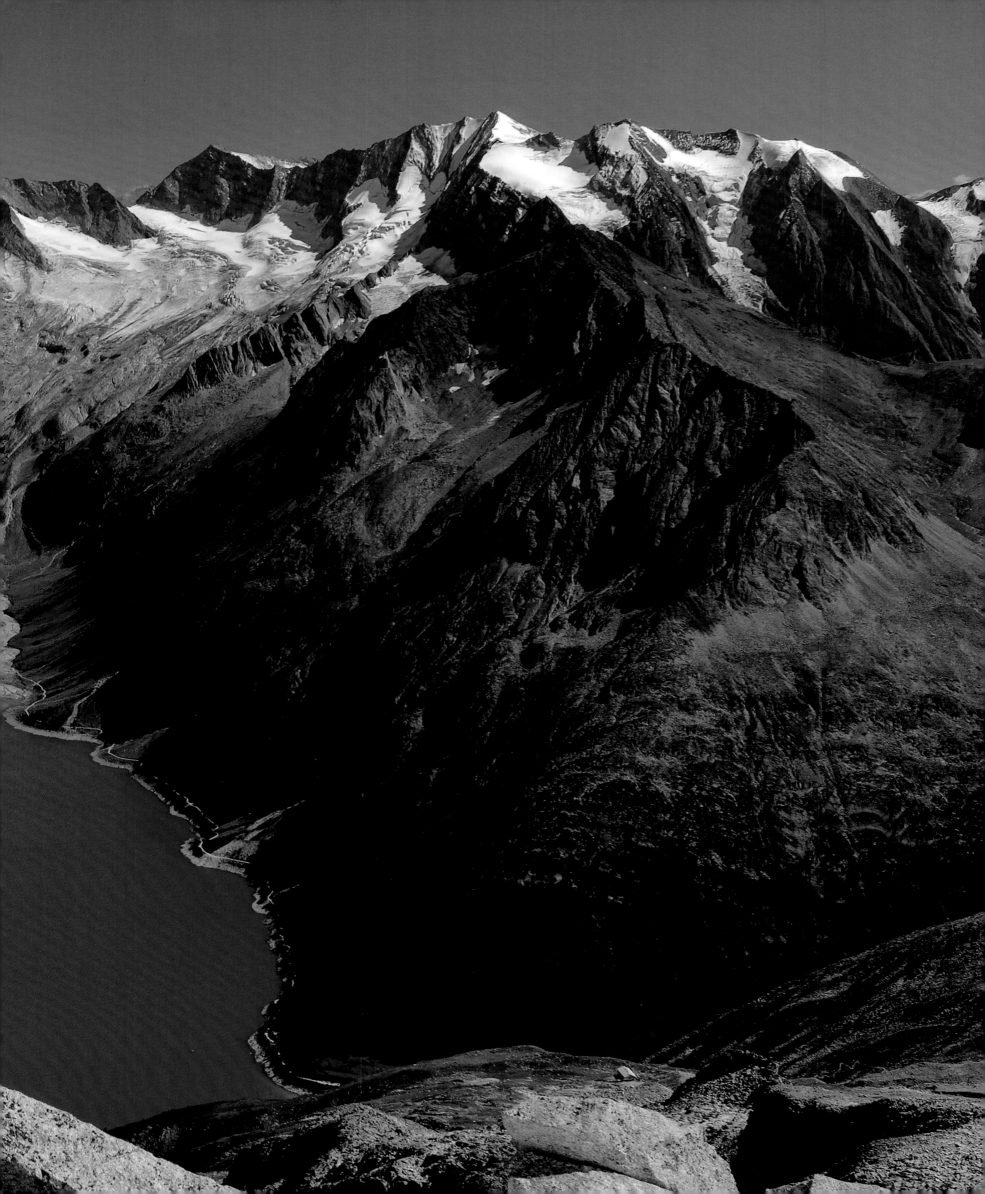

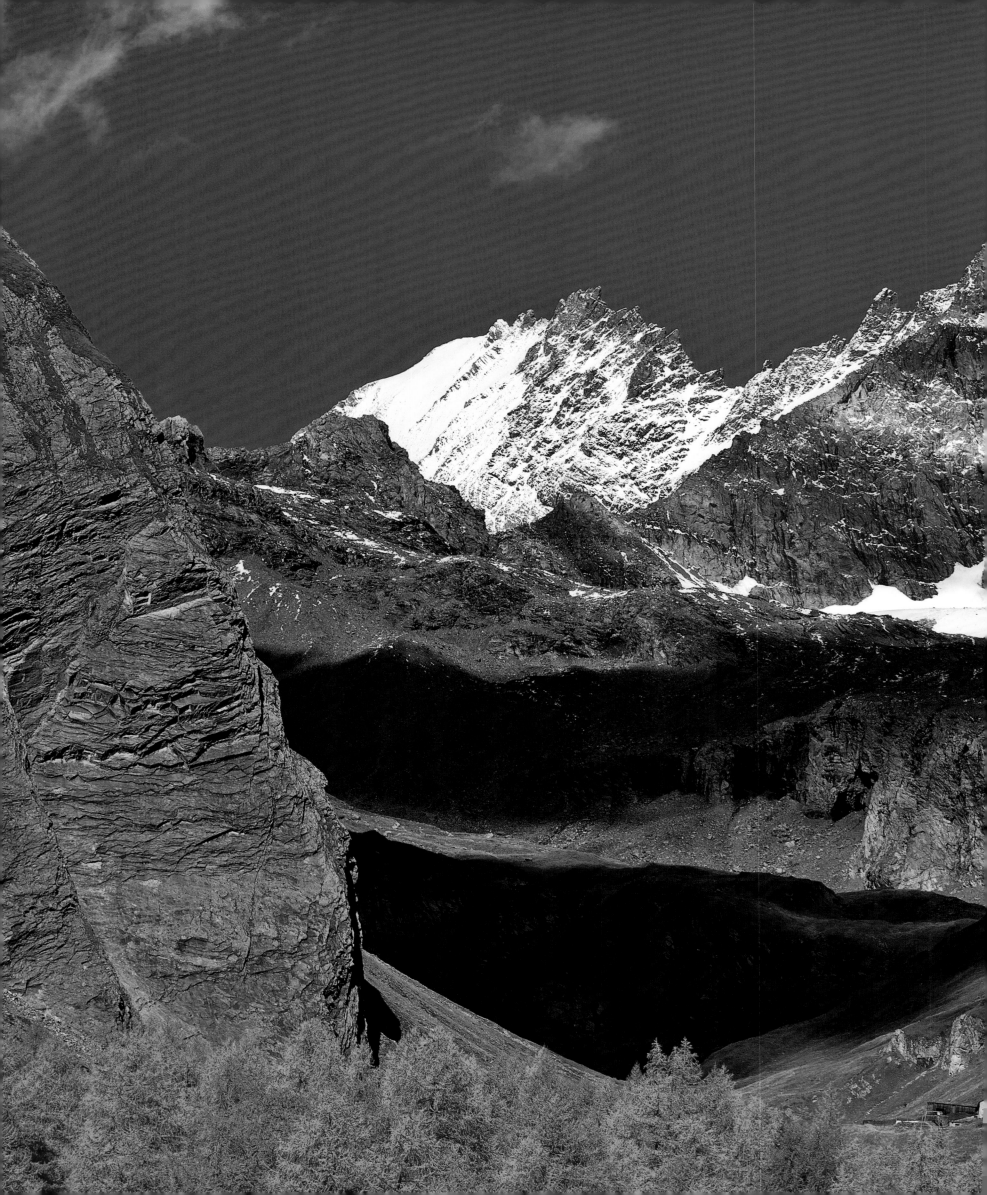

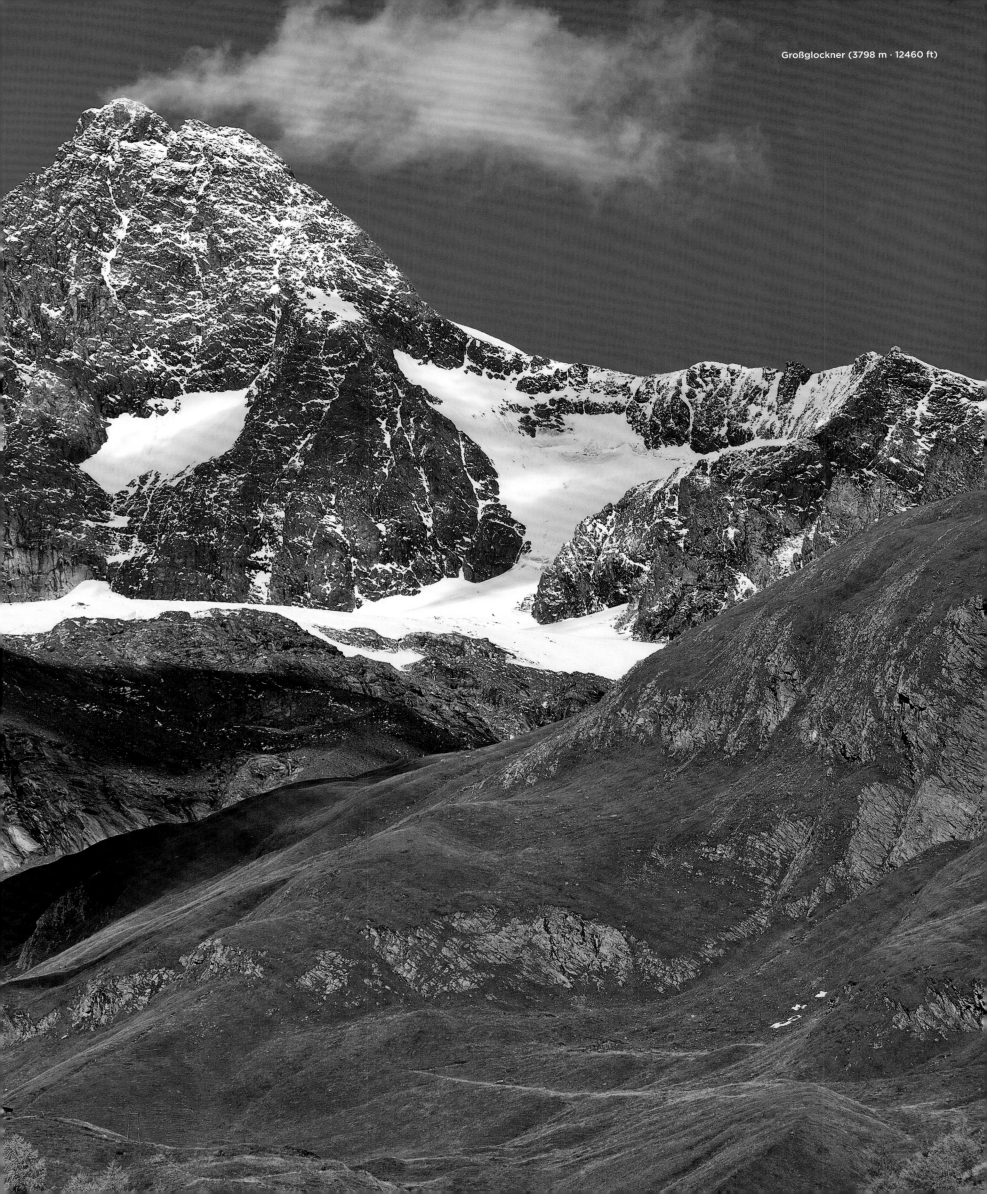

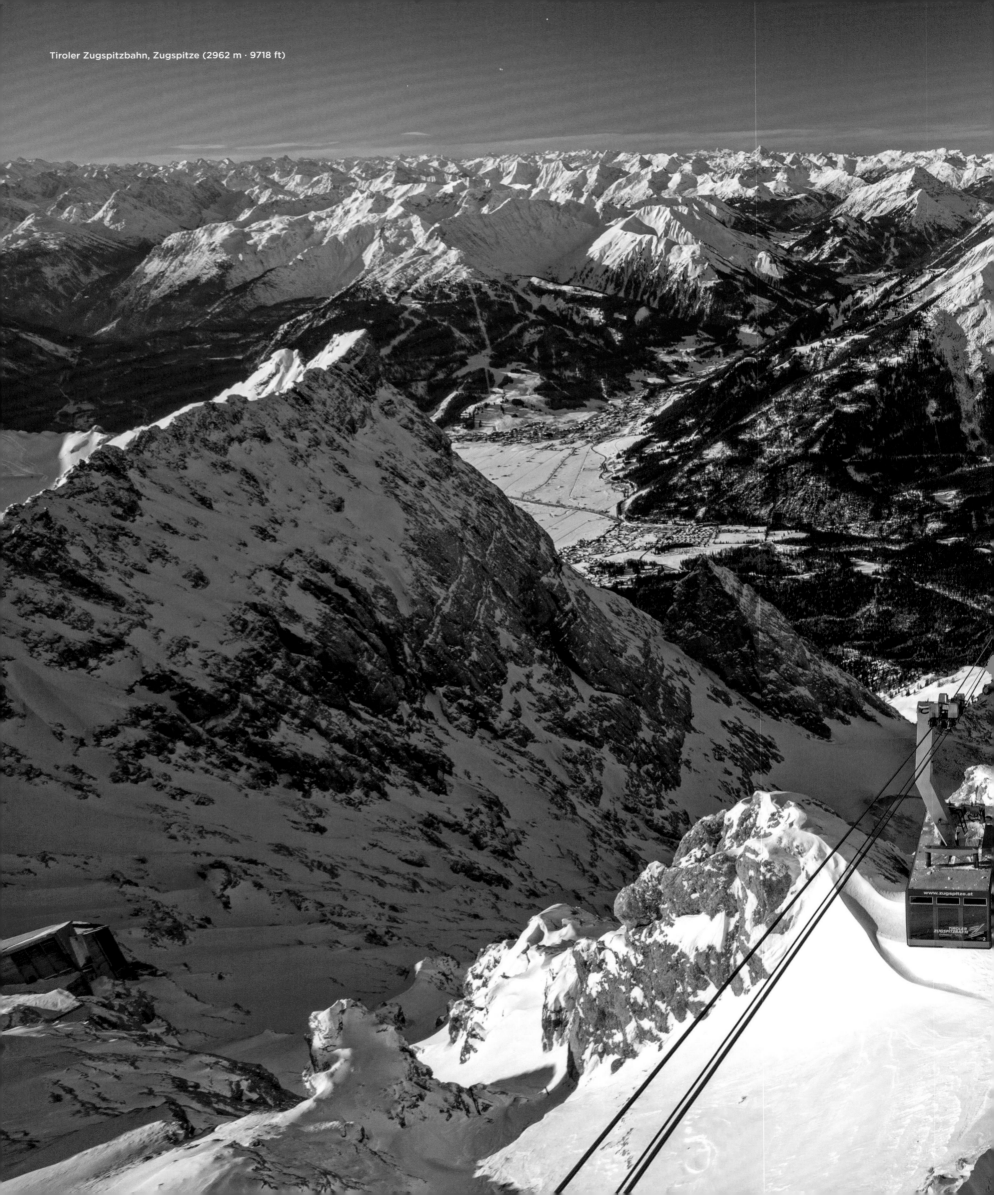

Tiroler Zugspitzbahn, Zugspitze (2962 m · 9718 ft)

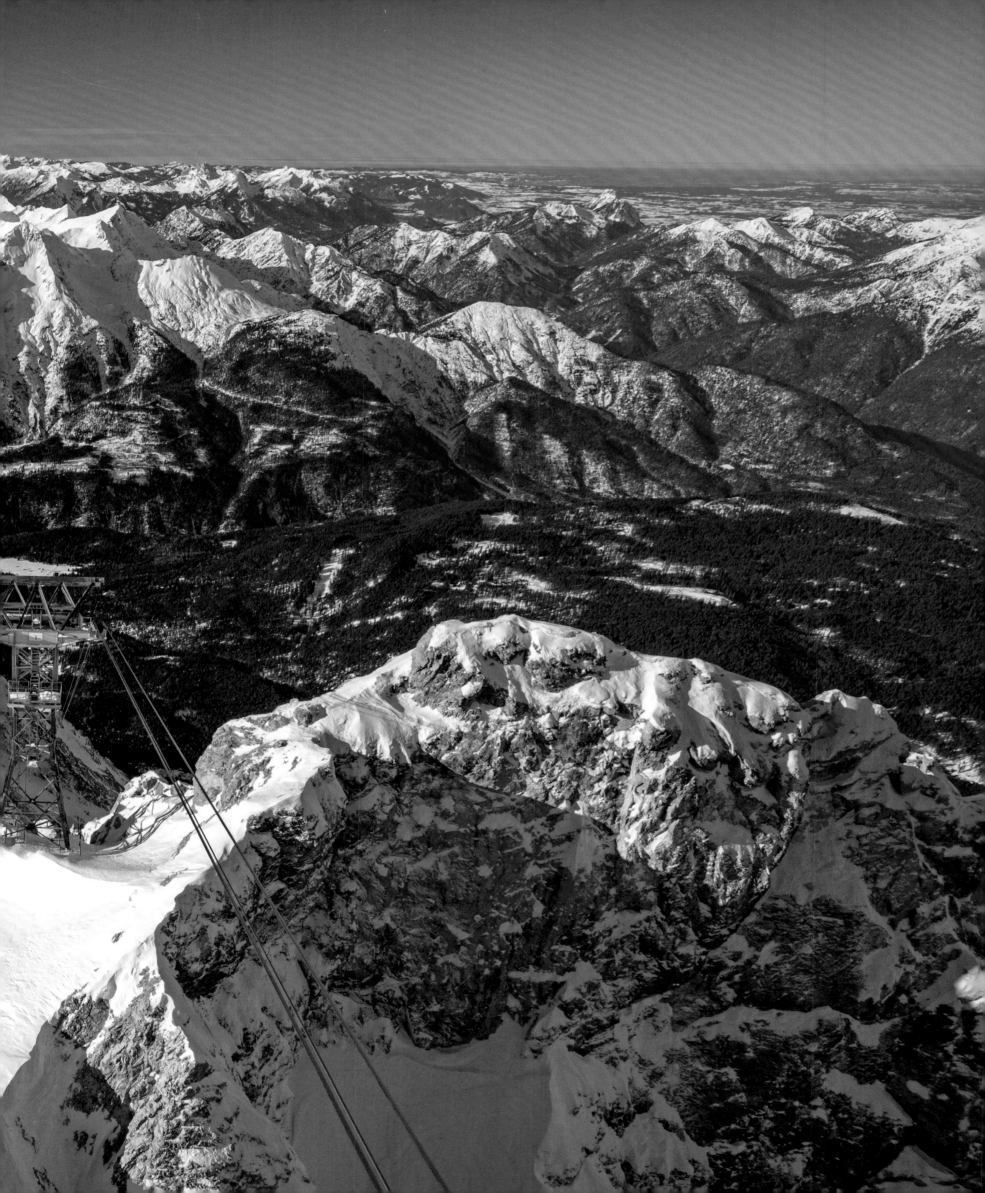

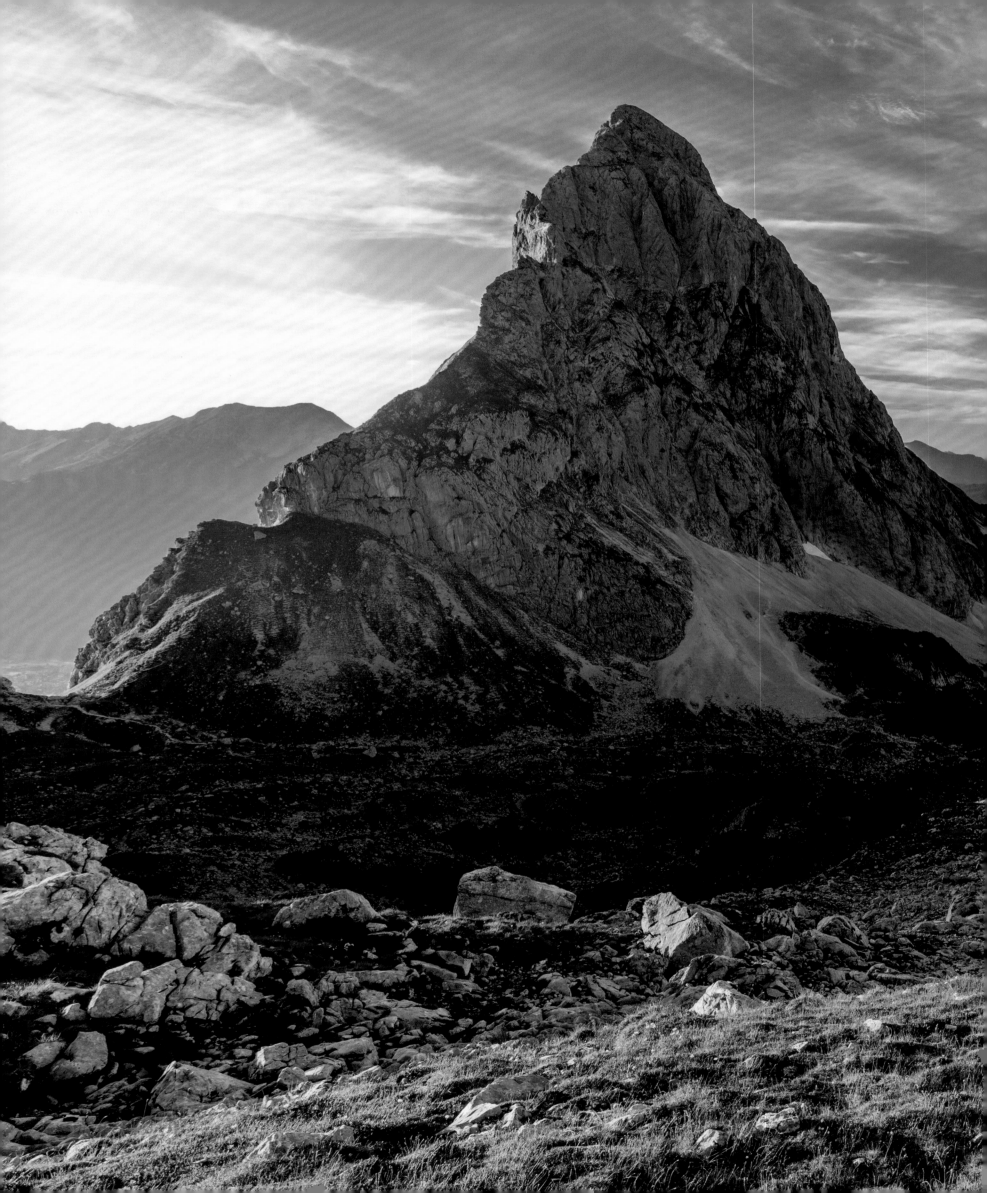

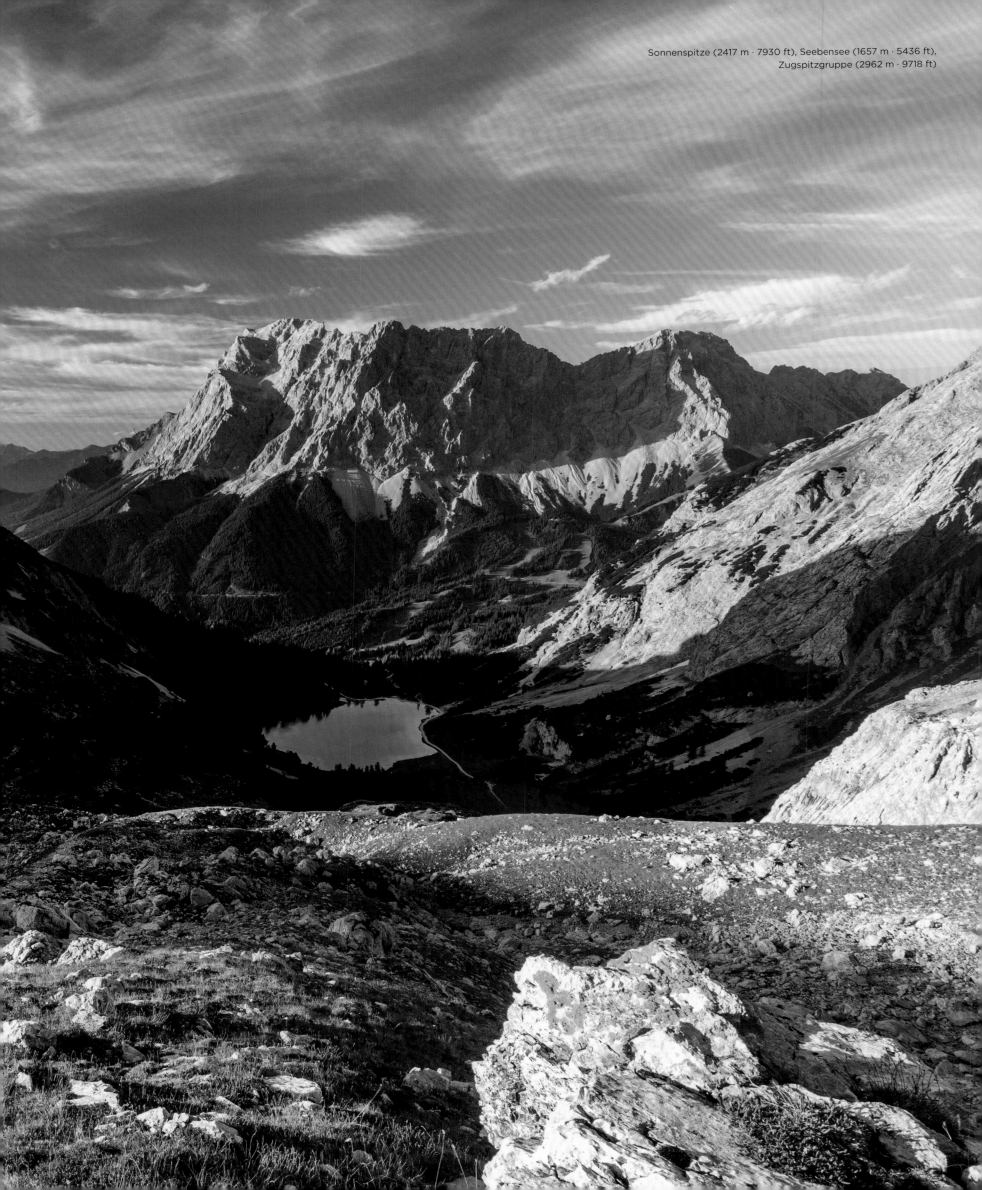

Sonnenspitze (2417 m · 7930 ft), Seebensee (1657 m · 5436 ft),
Zugspitzgruppe (2962 m · 9718 ft)

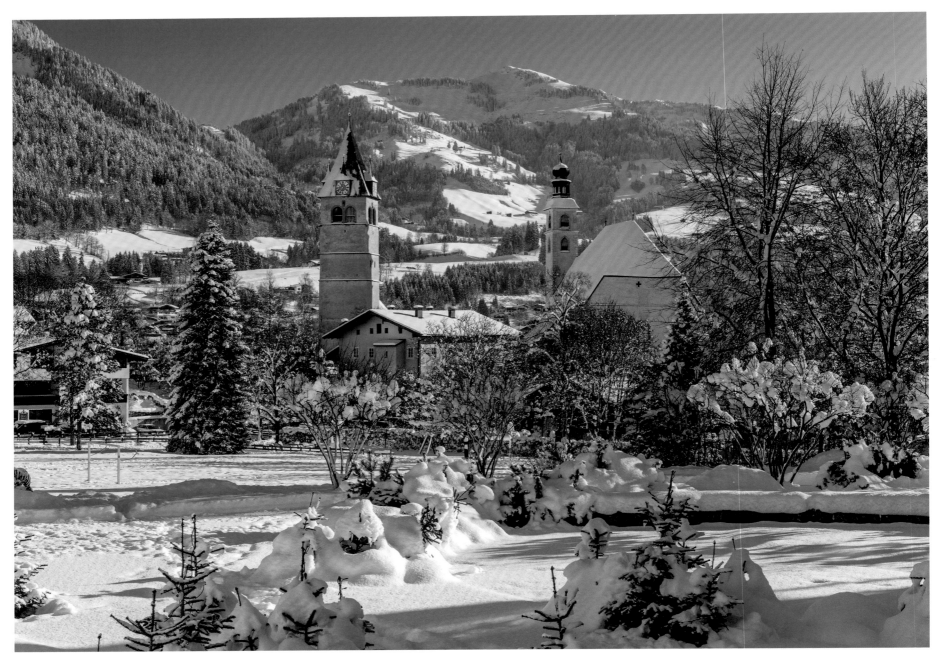

Kitzbühel

Kitzbühel

As peaceful as the Tyrolean winter sports resort of Kitzbühel with its church towers looks, every year in January all hell breaks loose here, when the world's best ski professionals plunge down the notorious "Streif" of the Hahnenkamm Race: a sporting venture for some, a long party for many of the spectators. At other times it is indeed quieter in this sophisticated ski resort, which is one of the preferred destinations for the international jet set. Many celebrities, such as German footballer Franz Beckenbauer, have even bought houses here. The controversial film director Leni Riefenstahl, popular with Hitler and other Nazi greats, also resided here.

Kitzbühel

Bien que la station de sports d'hiver tyrolienne de Kitzbühel paraisse bien paisible avec ses clochers, l'animation est à son comble chaque année en janvier, lorsque les meilleurs skieurs du monde s'élancent sur la « Streif », une piste aussi admirée que redoutée du Hahnenkamm : un exploit périlleux pour certains, une véritable fête pour les spectateurs. Le reste du temps, ce domaine skiable mondain apprécié de la jet-set du monde entier est beaucoup plus calme. Beaucoup de personnalités se sont même acheté une maison ici, à l'instar du footballeur Franz Beckenbauer. C'est aussi ici que résidait Leni Riefenstahl, une réalisatrice controversée très appréciée d'Hitler et d'autres dignitaires nazis.

Kitzbühel

So friedlich der Tiroler Wintersportort Kitzbühel mit seinen Kirchtürmen wirkt – alljährlich im Januar ist die Hölle los, wenn bei der Abfahrt des Hahnenkammrennens die weltbesten Skiprofis sich die berühmt-berüchtigte „Streif" hinunterstürzen: sportliches Wagnis für die einen, Dauer-Party für viele Zuschauer. Ansonsten geht es ruhiger zu in dem mondänen Skiort, der zu den bevorzugten Zielen des internationalen Jetset zählt. Viele Prominente kauften sich hier sogar ein Haus, etwa Franz Beckenbauer. Auch die umstrittene, bei Hitler und anderen Nazigrößen beliebte Regisseurin Leni Riefenstahl residierte hier.

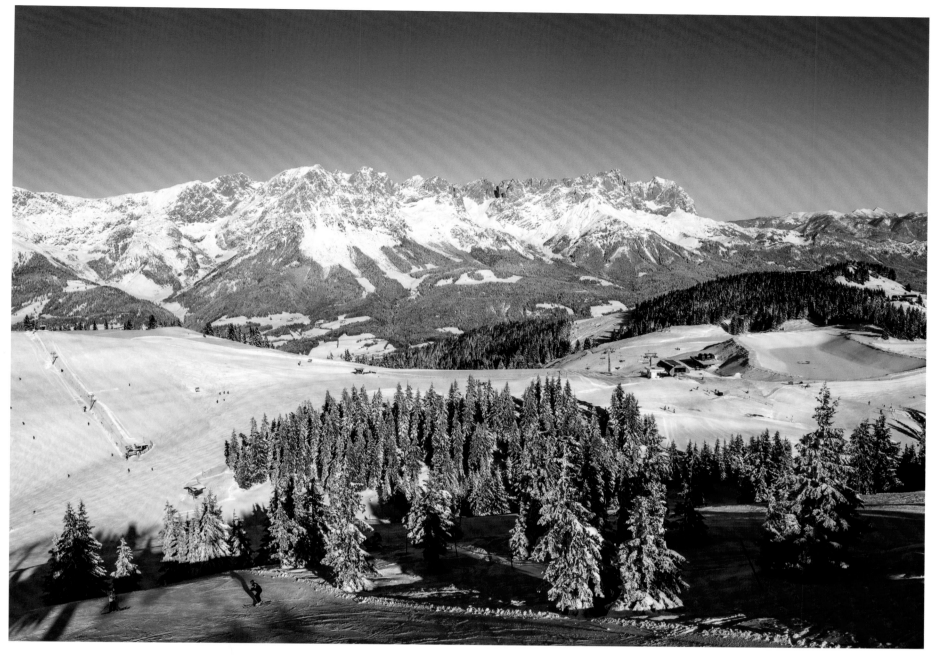

Skigebiet Wilder Kaiser-Brixental

Kitzbühel

Tan tranquila como parece la estación de deportes de invierno tirolesa de Kitzbühel con sus torres de iglesia, cada año en enero se desata un infierno cuando los mejores profesionales del esquí del mundo se sumergen en el famoso "Streif" en el descenso de la Hahnenkamm Race: una aventura deportiva para algunos, una larga fiesta para muchos espectadores. Aparte de esto, esta sofisticada estación de esquí es bastante tranquila; es uno de los destinos preferidos de la jet set internacional. Muchas celebridades incluso se compraron una casa aquí, como Franz Beckenbauer. El controvertido director Leni Riefenstahl, popular entre Hitler y otros grandes nazis, también residió aquí.

Kitzbühel

Tão tranquila como a estância de desportos de Inverno do Tirol, em Kitzbühel, com as suas torres de igreja, parece - todos os anos, em Janeiro, o inferno desaparece quando os melhores profissionais de esqui do mundo mergulham na famosa "Streif" na descida da Hahnenkamm Race: uma aventura desportiva para alguns, uma longa festa para muitos espectadores. Caso contrário, é mais tranquilo nesta sofisticada estação de esqui, que é um dos destinos preferidos para o jet set internacional. Muitas celebridades até compraram uma casa aqui, como Franz Beckenbauer. O controverso diretor Leni Riefenstahl, popular entre Hitler e outros grandes nazistas, também residia aqui.

Kitzbühel

De Tiroolse wintersportplaats Kitzbühel met zijn kerktorens oogt zo vredig, maar schijn bedriegt. In januari breekt hier elk jaar weer de hel los. Dan razen de beste skiërs ter wereld op de beruchte skipiste de 'Streif' op de Hahnenkamm-berg met grote snelheid naar beneden. Voor de skiërs zelf is het een wedstrijd, voor de vele toeschouwers een feest. Buiten dit weekend om is het duidelijk rustiger in dit mondaine skioord dat erg in trek is bij de internationale jetset. Veel beroemdheden zoals Franz Beckenbauer hebben hier een huis. Ook de omstreden filmregisseur Leni Riefenstahl, die enkele films voor de nazi's maakte, vertoefde hier een tijdje.

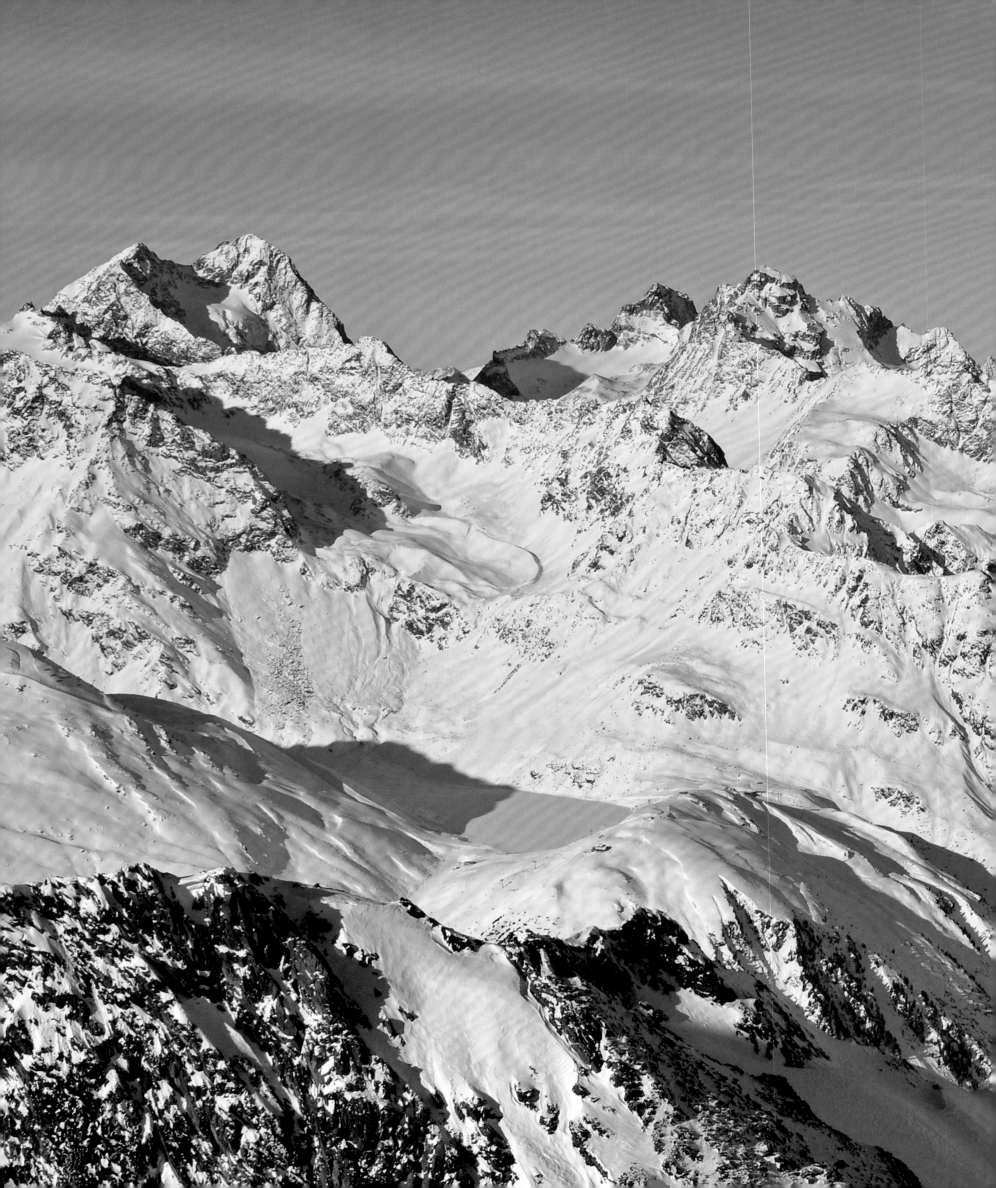

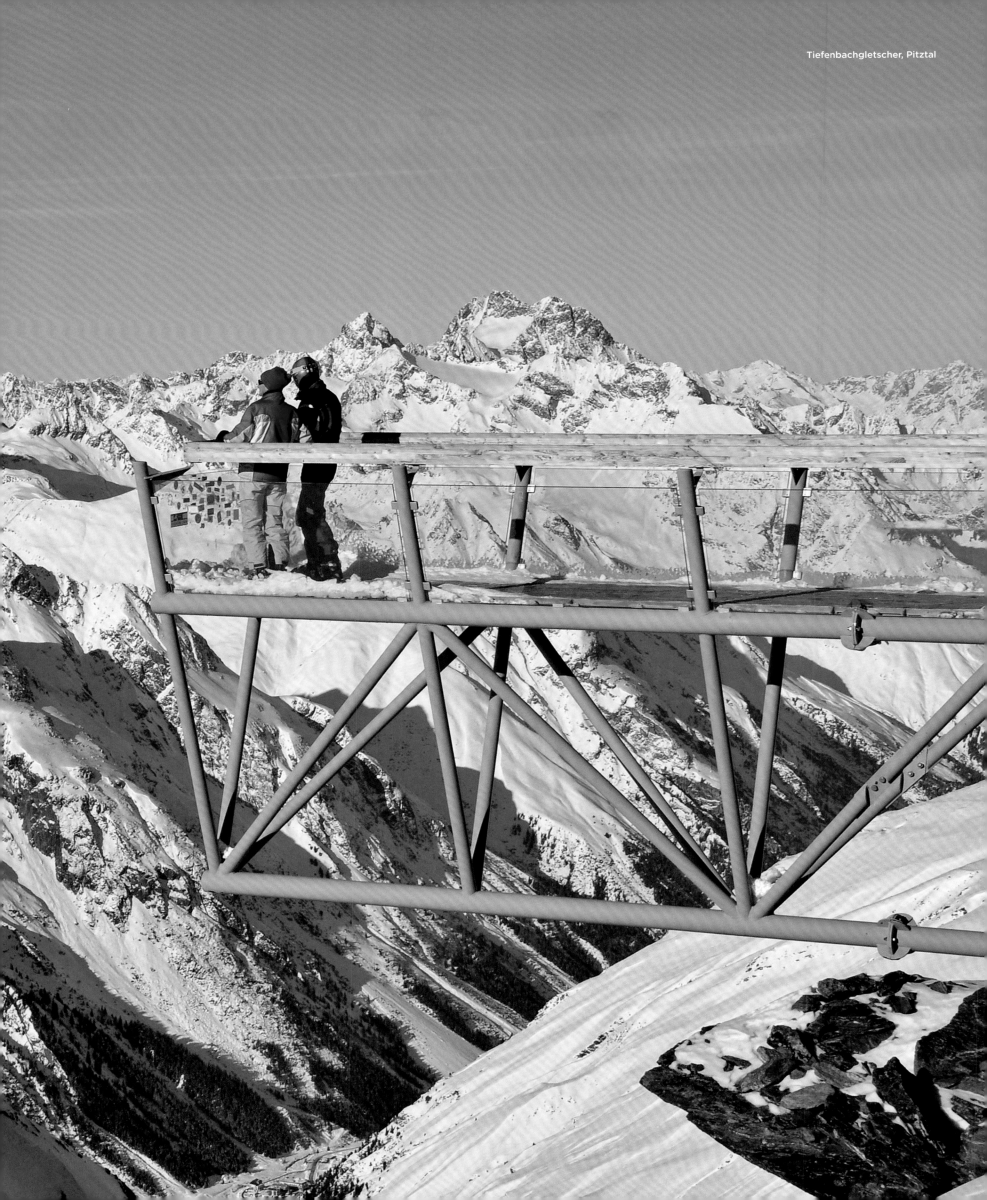

RENOVATVM
ANO 17

TERTIO
82

RESTAVROR POST HORRENDOS CONTINVO ANO

Helblinghaus, Innsbruck

Innsbruck

If one reaches the Tyrolean capital Innsbruck by plane, one has the frightening feeling of almost touching the mountain walls before landing on the valley floor. Innsbruck's landmark is the "Golden Roof", a magnificent bay window on the residence of the 15th century prince. The shingles are made of copper, but are fire-gilded.

Innsbruck

Quand on arrive en avion à Innsbruck, capitale du Tyrol, on a l'impression angoissante que l'on va érafler les montagnes lors de l'atterrissage. Le symbole d'Innsbruck est le « petit toit d'or », un encorbellement somptueux appartenant à la demeure d'un seigneur du XVe siècle. Ses bardeaux ne sont certes qu'en cuivre, mais ils sont plaqués d'or.

Innsbruck

Wer die Tiroler Landeshauptstadt Innsbruck mit dem Flugzeug erreicht, hat das beklemmende Gefühl, bei der Landung auf dem Talboden fast die Bergwände zu streifen. Wahrzeichen Innsbrucks ist das „Goldene Dachl", ein prächtiger Erker an der Residenz des Landesfürsten aus dem 15. Jahrhundert. Die Dachschindeln sind zwar nur aus Kupfer, aber immerhin vergoldet.

Innsbruck

Quien llega en avión a la capital del Tirol, Innsbruck, tiene la opresiva sensación de casi rozar las paredes de la montaña al aterrizar en el fondo del valle. El punto de referencia de Innsbruck es el "Tejado Dorado", un magnífico ventanal en la residencia del príncipe del siglo XV.

Innsbruck

Quem chega à capital Tirolesa Innsbruck de avião tem a sensação opressiva de quase tocar nas paredes da montanha ao aterrar no fundo do vale. O marco de Innsbruck é o "Golden Roof", uma magnífica janela de baía na residência do príncipe do século XV. As telhas são feitas apenas de cobre, mas douradas.

Innsbruck

Veel mensen die naar de Tiroolse hoofdstad vliegen, hebben bij de landing het beklemmende gevoel dat het vliegtuig de bergwanden zal raken. De bekendste bezienswaardigheid van Innsbruck is het 'gouden dak', een prachtige voorgevel in de 15e-eeuwse residentie van de toenmalige prins – met dakspanen van verguld koper.

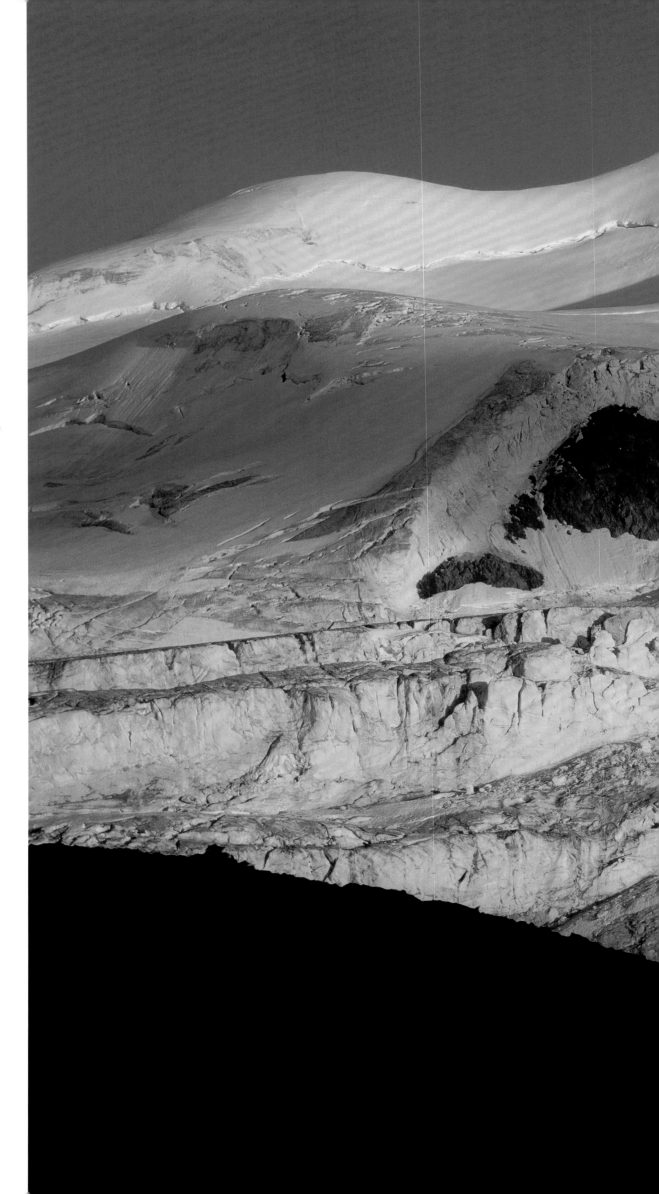

Alpensteinbock, Wildspitze (3768 m)
Alpine ibex, Wildspitze (3768 m · 12362 ft)
Bouquetin des Alpes, Wildspitze (3768 m)

Alpine Ibex

The Alpine ibex is one of the most iconic animal species of the high mountain regions in the Alps. The impressive wild goat with its horns of up to 1 m (3 ft) length was almost extinct because it was hunted intensively. Only about 100 individuals survived. After these were finally placed under strict protection, the population recovered.

Le bouquetin des Alpes

Le bouquetin des Alpes est presque l'animal le plus emblématique de cette région de haute montagne. Pourtant, cette espèce majestueuse de chèvre, avec ses cornes pouvant atteindre un mètre, a été menacée d'extinction à cause de la chasse. Seule une centaine d'individus a survécu. Grâce à des mesures de protection strictes, les populations se sont reformées.

Alpensteinbock

Wie kaum ein anderes Tier gehört der Alpensteinbock zu den ikonischen Bewohnern der Hochgebirgsregionen der Alpen. Dabei war die imposante Ziegenart mit den bis zu 1 m langen Hörnern fast ausgestorben, weil sie intensiv bejagt wurde. Nur etwa 100 Exemplare überlebten. Nachdem diese schließlich unter strengen Schutz gestellt wurden, erholten sich die Bestände.

Cabra salvaje de los Alpes

Como casi ningún otro animal, la cabra salvaje de los Alpes es uno de los habitantes icónicos de las regiones alpinas de alta montaña. Este impresionante tipo de cabra, cuyos cuernos pueden llegar a medir hasta 1 m de largo, estaba casi extinto debido a su intensa caza. Solo sobrevivieron unos 100 ejemplares. Al final, tras ser puestos bajo estricta protección, las poblaciones se recuperaron.

Ibex alpino

Como quase nenhum outro animal, o ibex alpino é um dos habitantes icônicos das regiões de alta montanha dos Alpes. O impressionante tipo de cabra com chifres de até 1 m de comprimento estava quase extinto porque era caçado intensamente. Apenas cerca de 100 cópias sobreviveram. Depois de estes terem sido finalmente colocados sob protecção rigorosa, as populações recuperaram.

Alpensteenbok

De alpensteenbok is dé iconische bewoner van het hooggebergte van de Alpen. Dit indrukwekkende dier uit het geslacht van de geiten met hoorns die wel 1 m lang kunnen worden, was ooit bijna uitgestorven omdat het te sterk werd bejaagd. Nadat men de laatste 100 exemplaren onder bescherming had geplaatst, nam de populatie weer langzaam toe.

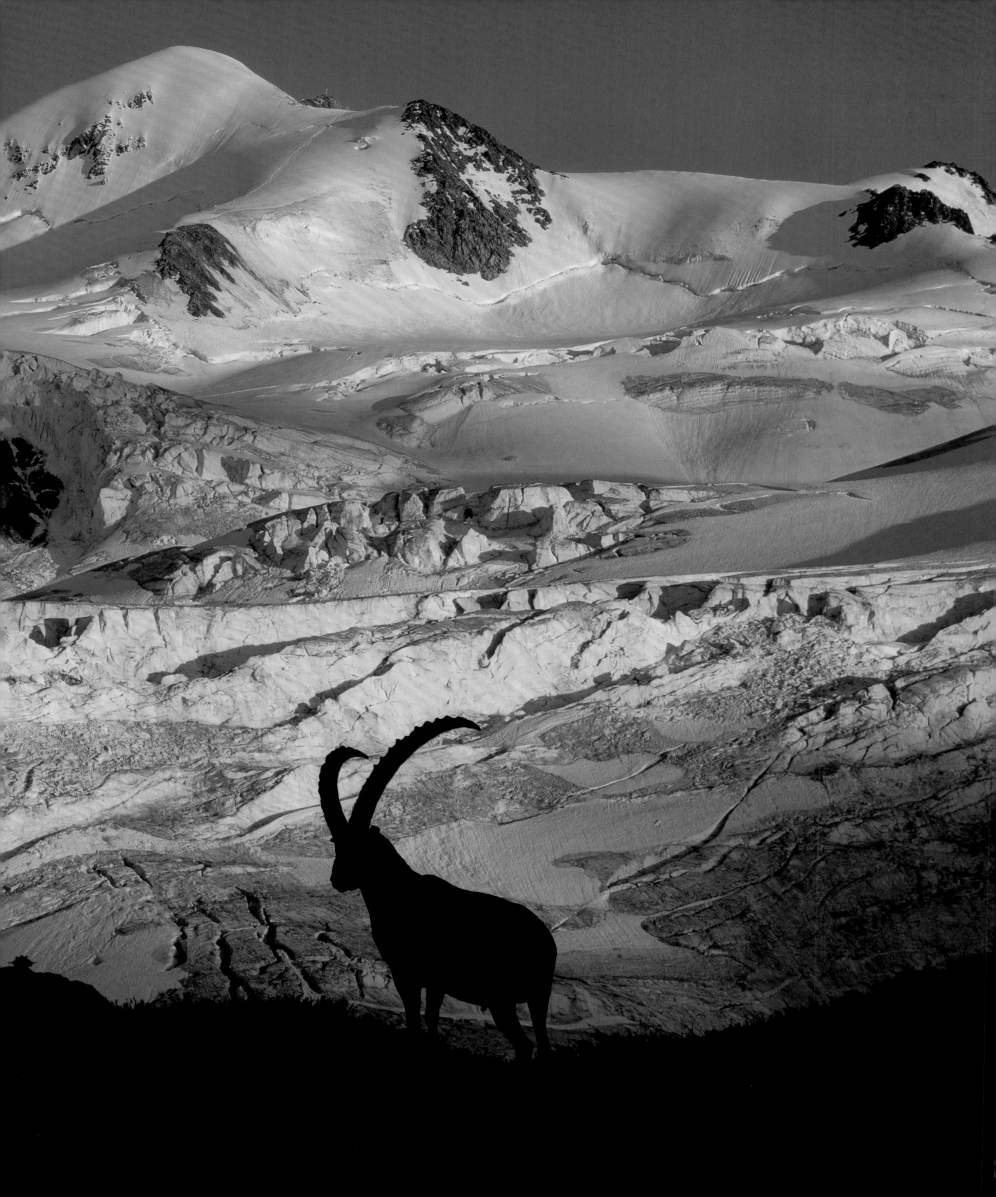

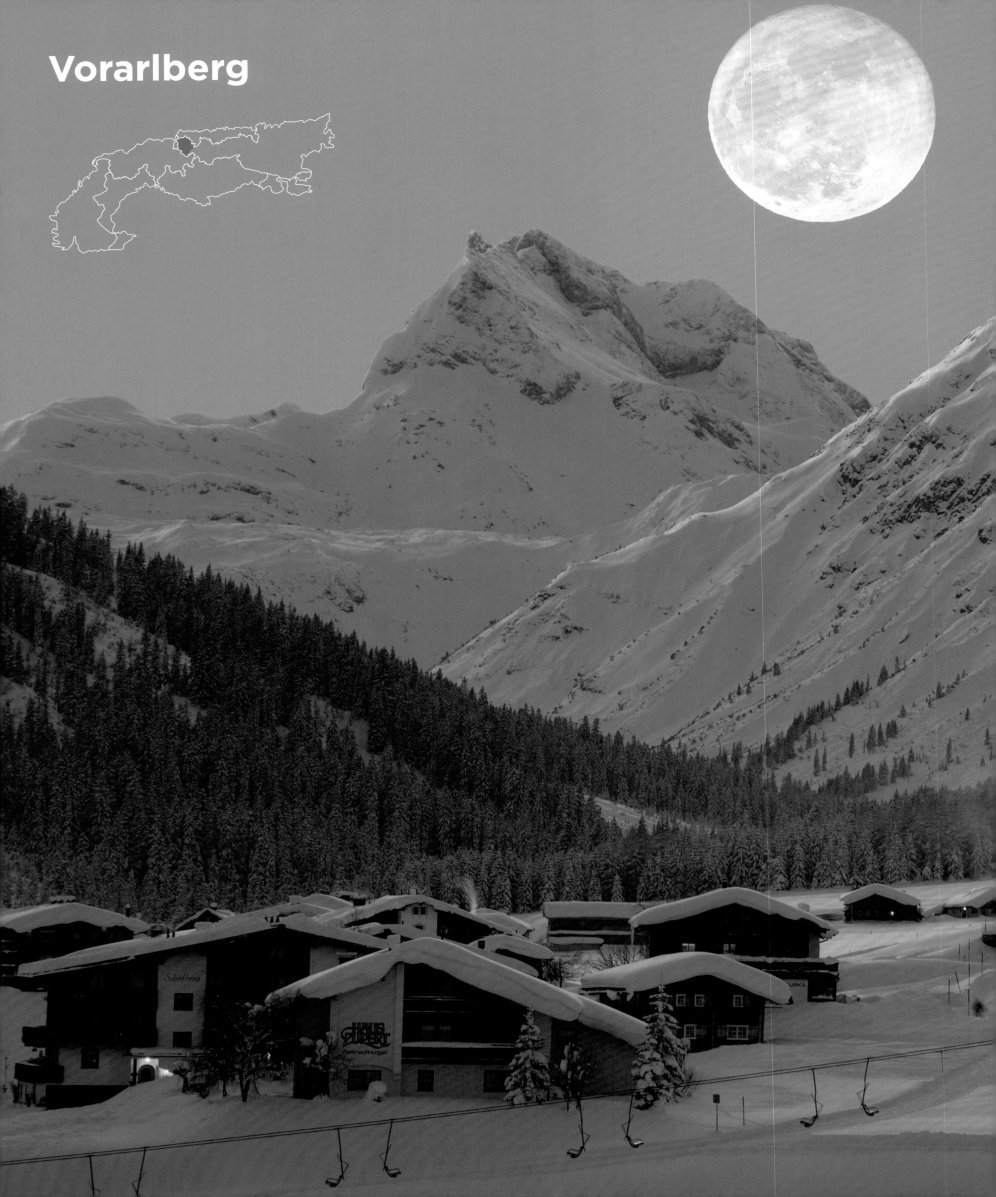

Vorarlberg

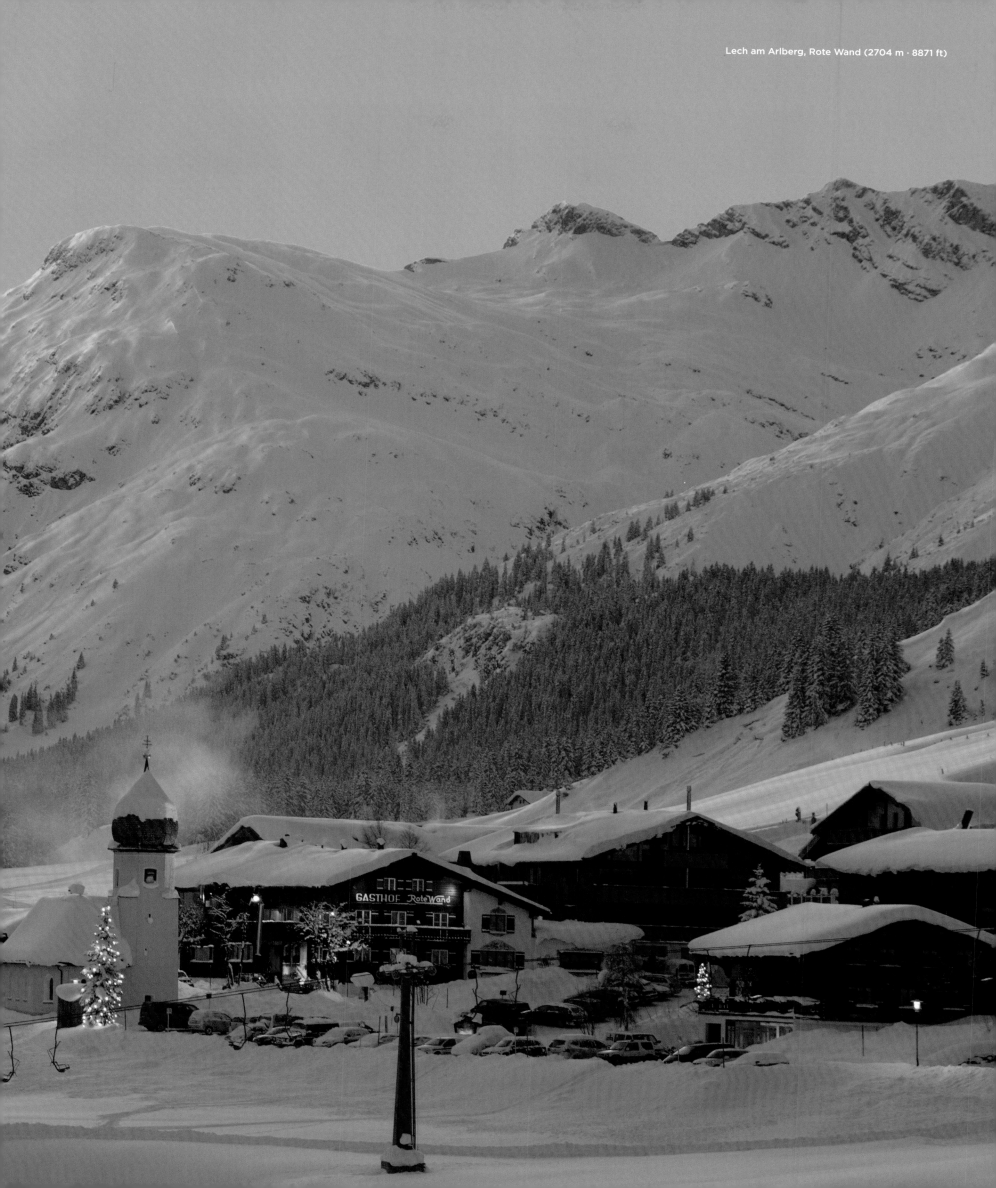

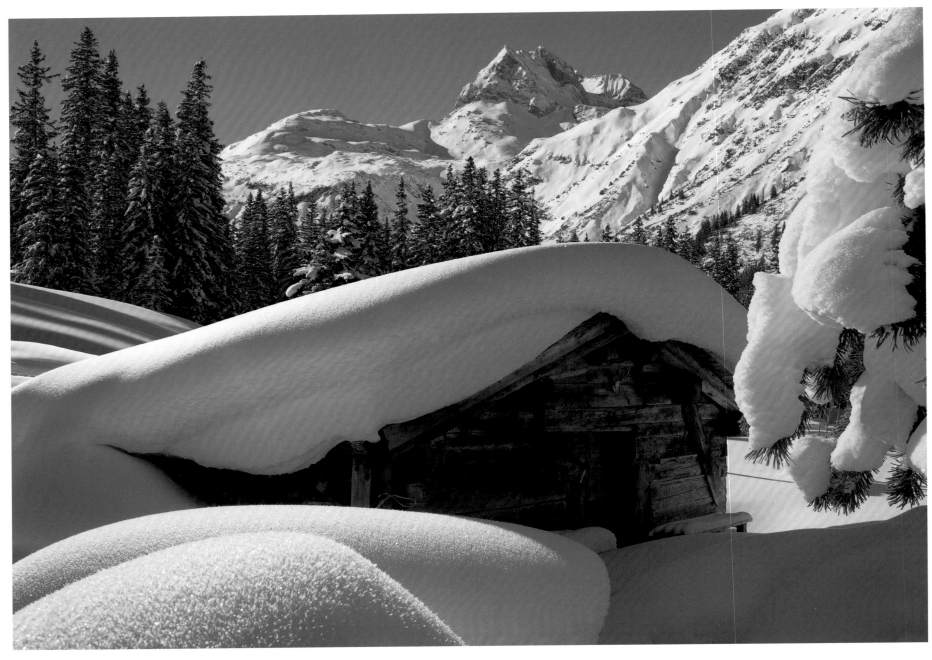

Rote Wand (2704 m · 8871 ft), Lech am Arlberg

Vorarlberg

Where the Rhine cuts through the Alps, the small province of Vorarlberg stretches to the east and is only connected to the rest of Austria by a few mountain passes. The Rhine plain from Feldkirch on the border with Liechtenstein to Bregenz on Lake Constance is one of the most densely populated regions in the Alps. But the province also reaches alpine heights with the Piz Buin (3312 m · 10866 ft); therefore, in addition to industry, tourism with winter sports also has great economic importance. The state capital of Bregenz is internationally known for the Bregenz Festival.

Le Vorarlberg

La petite région du Vorarlberg se situe à la croisée du Rhin et des Alpes et n'est reliée au reste de l'Autriche que par quelques cols. La partie de la vallée du Rhin qui s'étend de Feldkirch, à la frontière avec le Liechtenstein, à Brégence (Bregenz), près du lac de Constance, est l'une des plus densément peuplées des Alpes. Mais cette région comprend aussi des sommets alpins, comme le Piz Buin (3 312 m) ; c'est pourquoi le tourisme et les sports d'hiver sont économiquement très importants, au même titre que l'industrie. Brégence, la capitale de cette région, est surtout connue pour ses festivals de musique et de danse.

Vorarlberg

Wo der Rhein die Alpen durchschneidet, erstreckt sich östlich das kleine Bundesland Vorarlberg, das verkehrsmäßig nur über einige Pässe ans übrige Österreich angebunden ist. Zu den am dichtesten besiedelten Regionen im Alpenraum gehört die Rheinebene von Feldkirch an der Landesgrenze zu Liechtenstein bis nach Bregenz am Bodensee. Doch das Land erreicht auch alpine Höhen mit dem Piz Buin (3312 m); daher hat neben der Industrie auch der Tourismus mit dem Wintersport große wirtschaftliche Bedeutung. Die Landeshauptstadt Bregenz ist vor allem durch die Bregenzer Festspiele international bekannt.

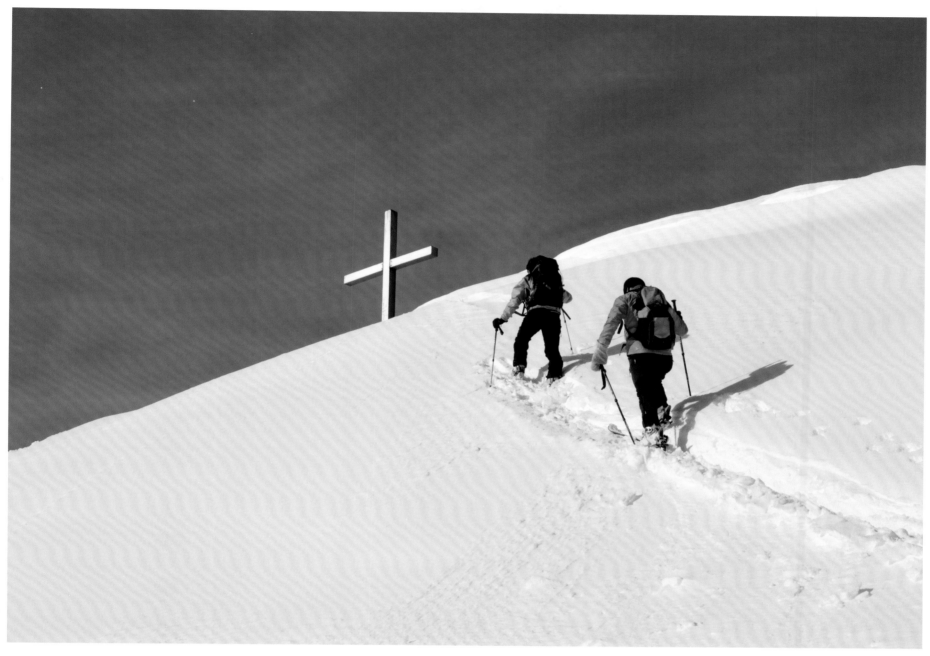

Diedamskopf (2090 m · 6857 ft), Bregenzerwald

Vorarlberg

Donde el Rin atraviesa los Alpes, la pequeña provincia de Vorarlberg se extiende hacia el este y solo está conectada con el resto de Austria a través de unos pocos pasos. Una de las regiones más densamente pobladas de la región alpina es la llanura del Rin, desde Feldkirch (en la frontera con Liechtenstein) hasta Bregenz (en el lago de Constanza). Pero el país también alcanza alturas alpinas con el Piz Buin (3312 m); por lo tanto, además de la industria, el turismo con deportes de invierno también tiene una gran importancia económica. La capital del estado de Bregenz es conocida internacionalmente por su Festival de Bregenz.

Vorarlberg

Quando o Reno atravessa os Alpes, a pequena província de Vorarlberg estende-se para leste e só está ligada ao resto da Áustria através de algumas passagens. Uma das regiões mais densamente povoadas da região alpina é a planície do Reno, desde Feldkirch, na fronteira com o Liechtenstein, até Bregenz, no Lago Constança. Mas o país também alcança alturas alpinas com o Piz Buin (3312 m); portanto, além da indústria, o turismo com esportes de inverno também tem grande importância econômica. A capital do estado de Bregenz é conhecida internacionalmente por seu Festival de Bregenz.

Vorarlberg

Waar de Rijn de Alpen doorsnijdt, strekt de kleine provincie Vorarlberg zich naar het oosten uit. Dit deel van het Oostenrijk is vanuit andere delen van het land slechts via een paar passen te bereiken. Hier ligt ook een van de dichtstbevolkte gebieden van het alpengebied, de Boven-Rijnse Laagvlakte vanaf Feldkirch nabij de Liechtensteinse grens tot aan Bregenz aan de Bodensee. De streek telt enkele hoge bergtoppen zoals de bekende Piz Buin (3312 m) en is een populair wintersportgebied. Het toerisme is de op een na belangrijkste inkomstenbron, na de industrie. De hoofdstad Bregenz staat internationaal bekend om de 'Festspiele'.

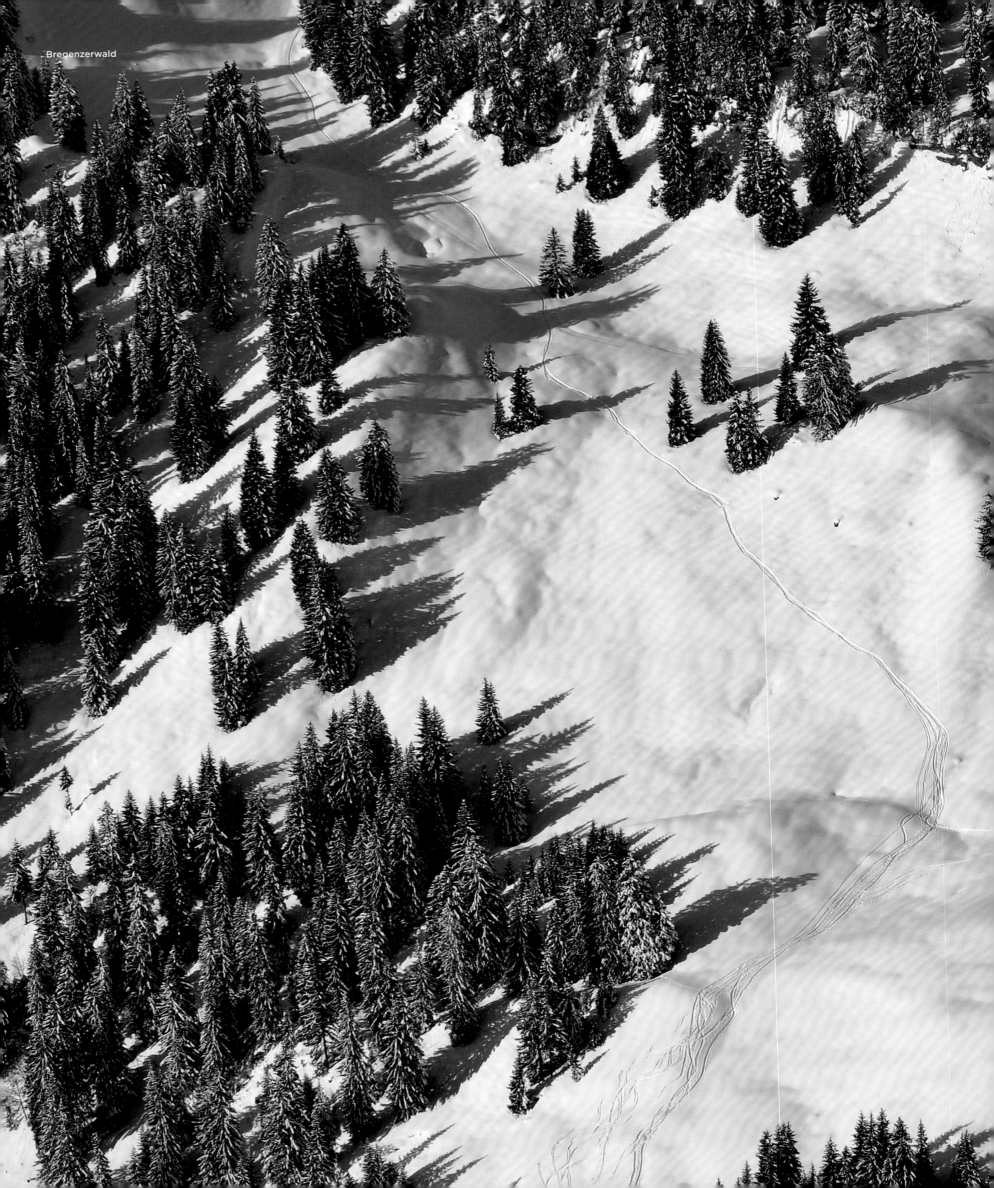

Bregenzerwald

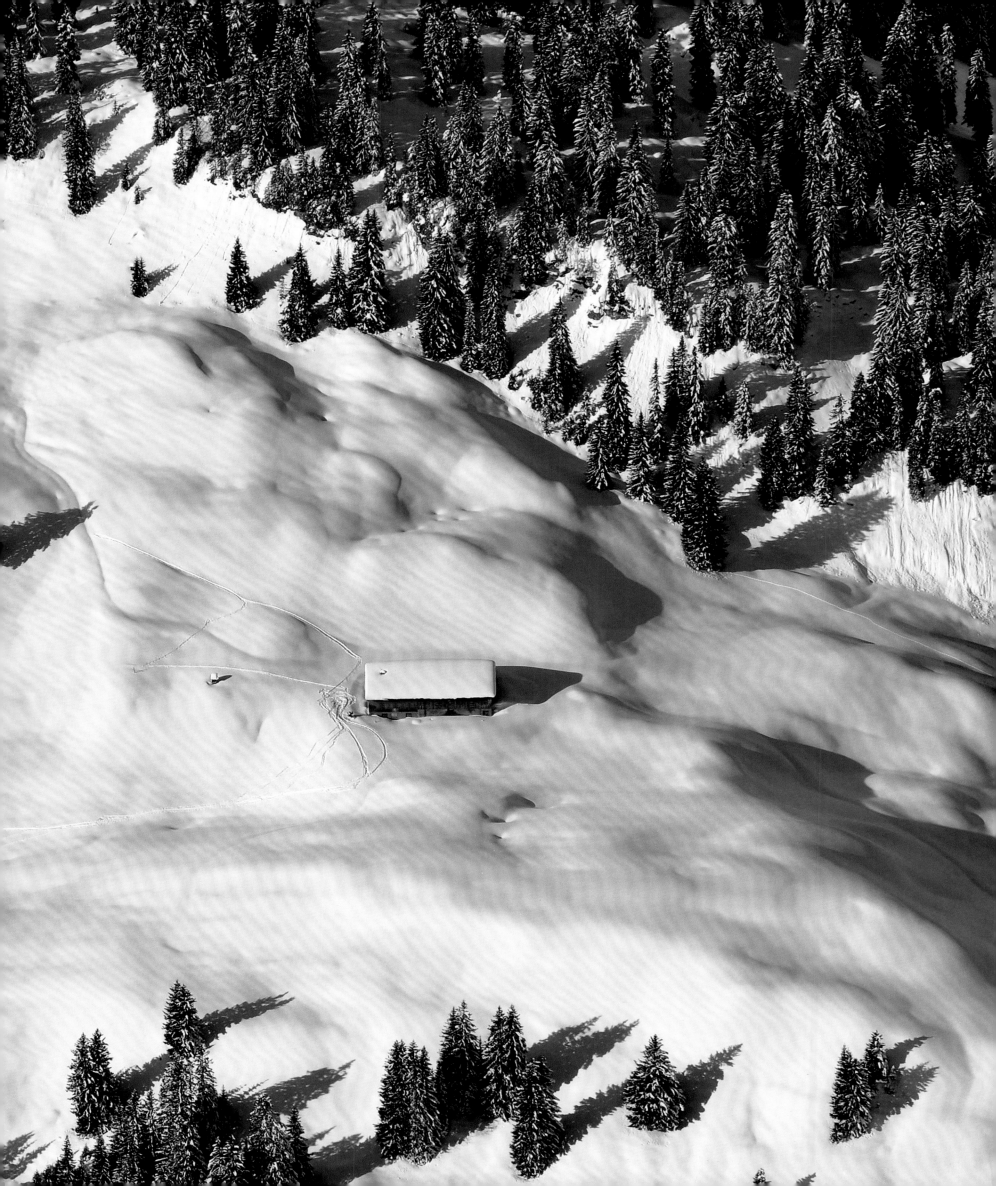

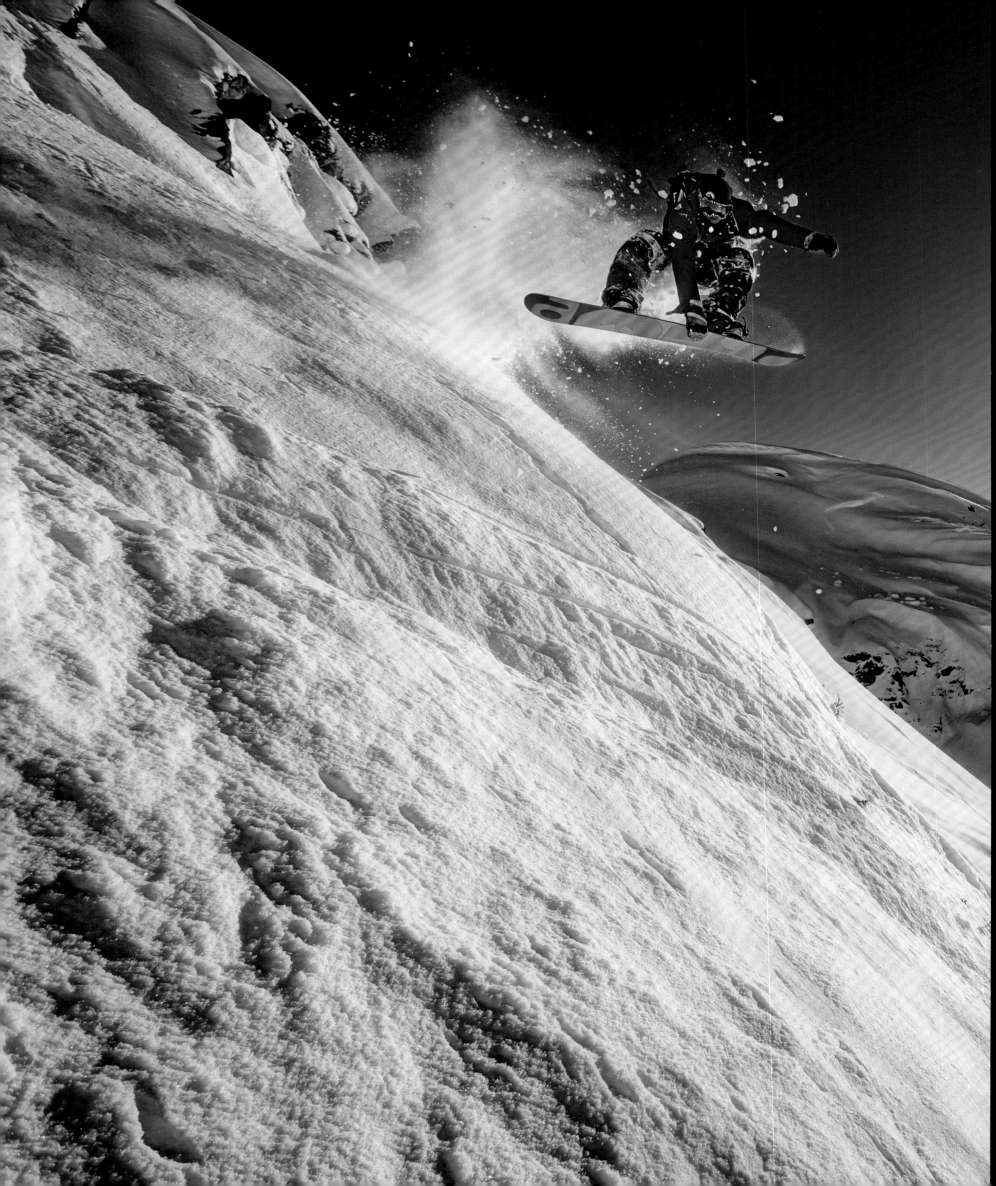

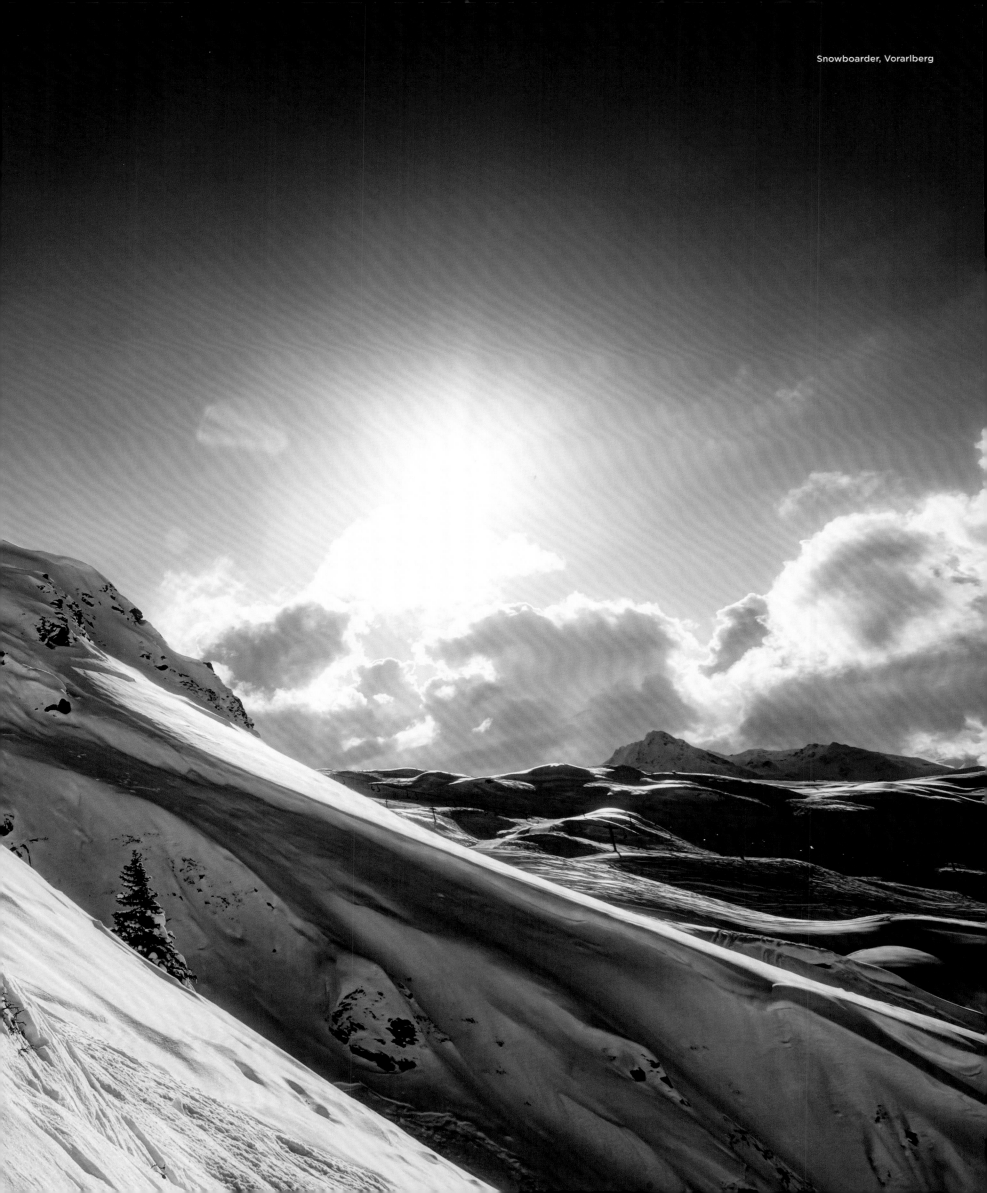

Snowboarder, Vorarlberg

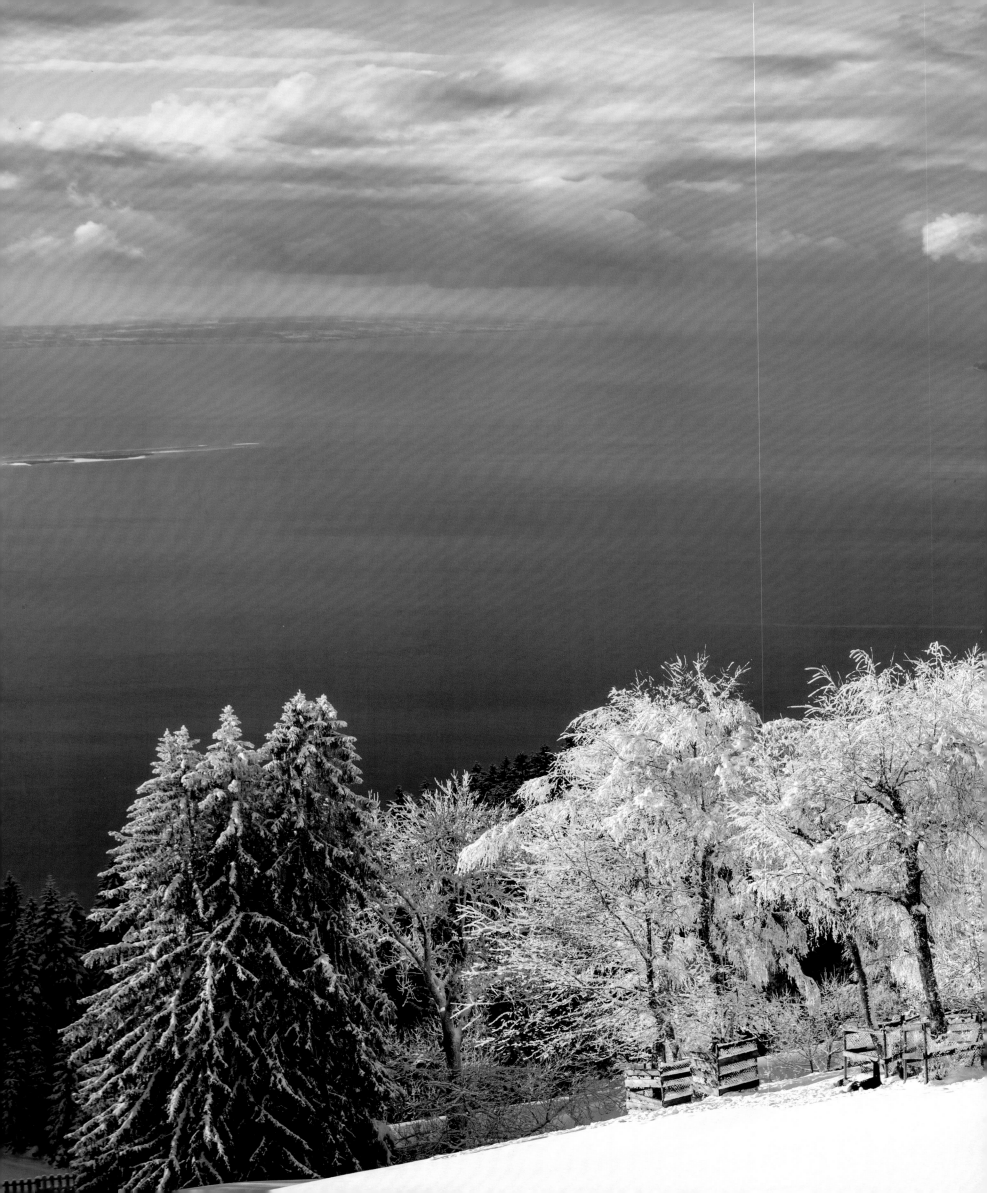

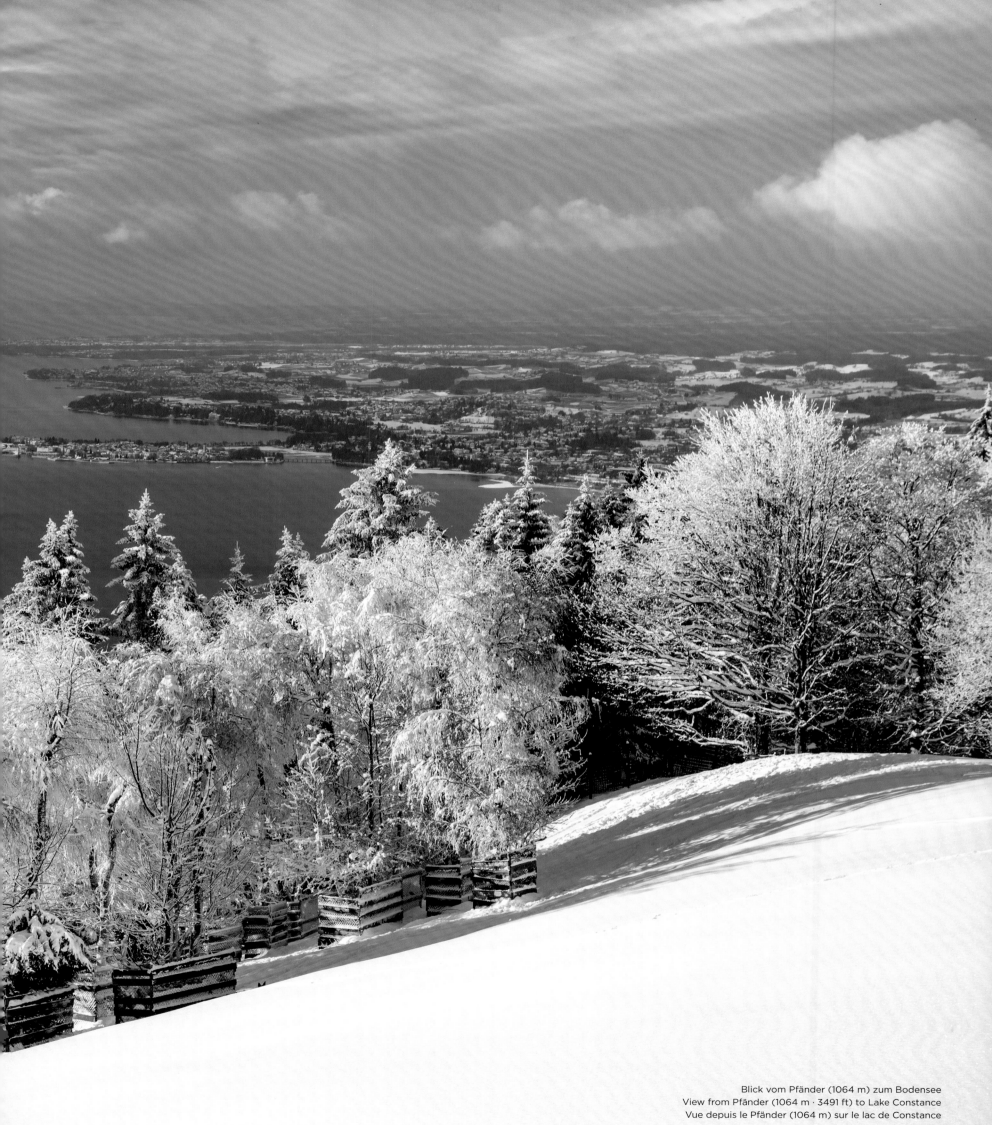

Blick vom Pfänder (1064 m) zum Bodensee
View from Pfänder (1064 m · 3491 ft) to Lake Constance
Vue depuis le Pfänder (1064 m) sur le lac de Constance

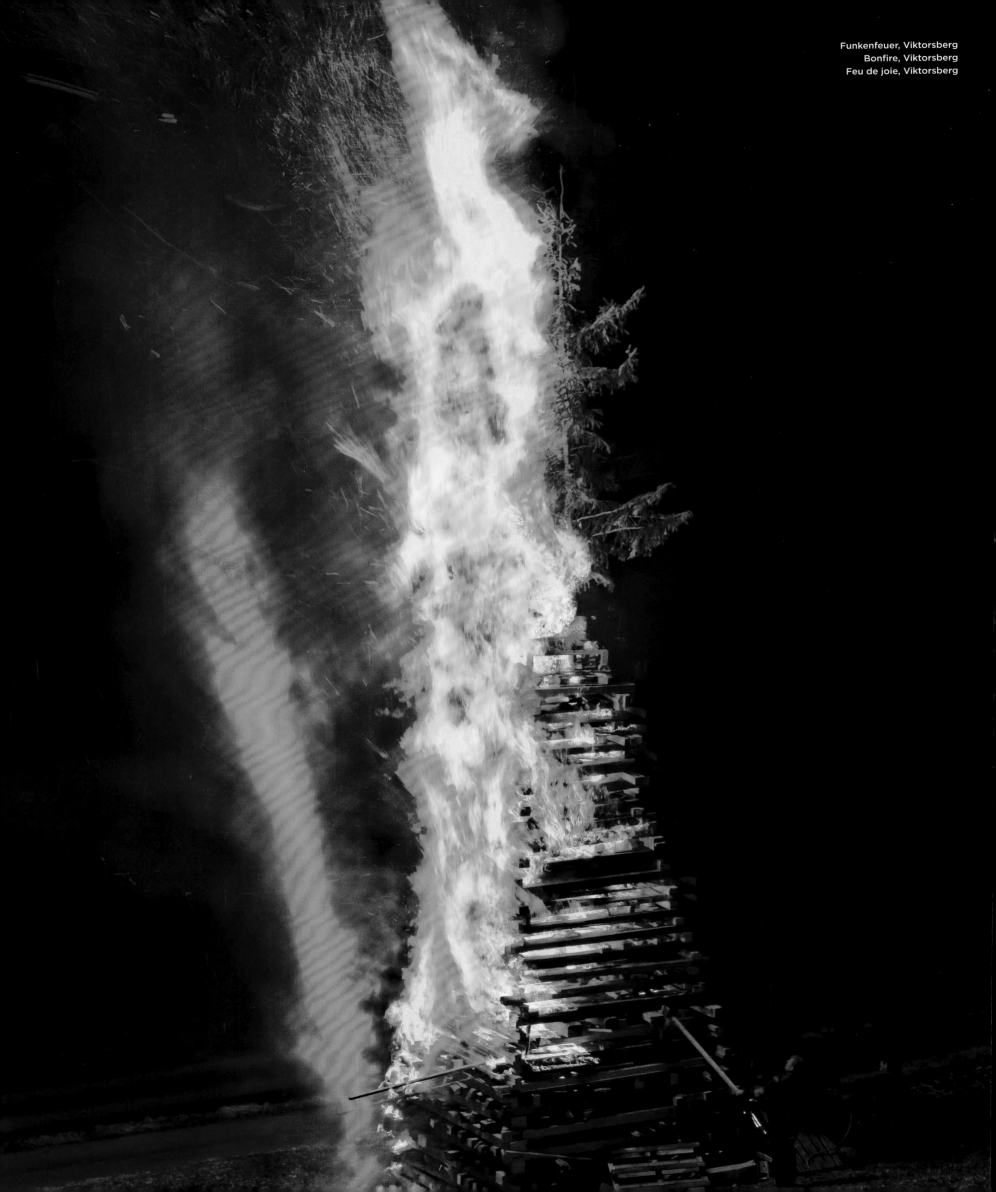

Funkenfeuer, Viktorsberg
Bonfire, Viktorsberg
Feu de joie, Viktorsberg

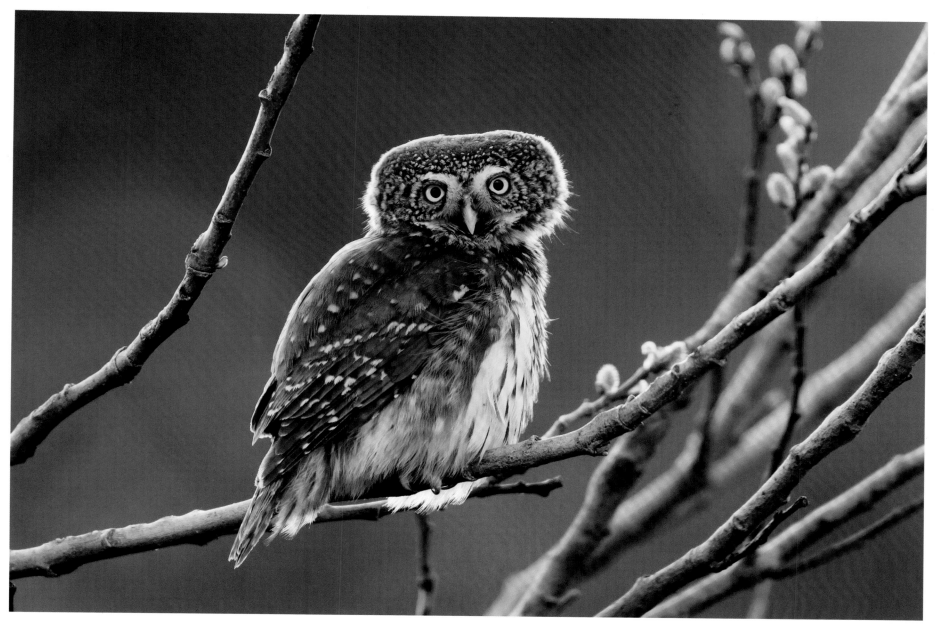

Sperlingskauz
Eurasian pygmy owl
Chevêchette d'Europe

Funkenfeuer, Viktorsberg

Every year on the first Sunday of Lent, bonfires ('Funkenfeuer') are lit to drive out winter—the pagan version—or to mark the beginning of Lent—according to the Christian calendar. Everywhere in Vorarlberg the villages and towns compete for the highest 'Funken'. The custom is listed as a UNESCO Intangible Cultural Heritage.

Les feux de joie

Peut-être est-ce un rite païen destiné à chasser l'hiver, peut-être le début du Carême dans le calendrier catholique joue-t-il un rôle ? Dans tous les cas, le premier dimanche du Carême, d'immenses feux de joie flambent dans tout le Vorarlberg. Les différentes localités rivalisent pour savoir qui aura le plus haut feu. Cette coutume a été inscrite au patrimoine culturel immatériel de l'UNESCO.

Funkenfeuer, Viktorsberg

Vielleicht sollte nach heidnischer Sitte der Winter vertrieben werden, vielleicht spielt der Beginn der Fastenzeit nach dem christlichen Kalender eine Rolle: Auf jeden Fall lodern alljährlich am ersten Fastensonntag in ganz Vorarlberg die Funkenfeuer. Dabei wetteifern die Orte um den höchsten „Funken". Der Brauch gehört zum Immateriellen Unesco Weltkulturerbe.

Hoguera, Viktorsberg

Tal vez, según la costumbre pagana, el invierno debería ser expulsado, tal vez el comienzo de la Cuaresma juega un papel según el calendario cristiano: en cualquier caso, las hogueras se encienden anualmente el primer domingo de Cuaresma en Vorarlberg. Los lugares compiten por la mayor hoguera. La costumbre es Patrimonio Cultural Inmaterial de la UNESCO.

Farol Spark, Viktorsberg

Talvez de acordo com o costume pagão o inverno deve ser afastado, talvez o início da Quaresma desempenha um papel de acordo com o calendário cristão: Em qualquer caso, a faísca fogueiras ardem anualmente no primeiro domingo da Quaresma em Vorarlberg completamente. Os lugares competem pela maior "faísca". O costume pertence ao Patrimônio Cultural Intangível da Unesco.

Vreugdevuren, Viktorsberg

Waarom elk jaar op de eerste vastenzondag grote vreugdevuren ('Funkenfeuer') worden ontstoken in Vorarlberg is niet geheel duidelijk. Volgens sommigen is het een heidens gebruik om de winter te verjagen, anderen beschouwen het als begin van de christelijke vastentijd. Bij dit gebruik, dat op de Werelderfgoedlijst van de Unesco staat, wedijveren de plaatsen om de hoogste "vonken".

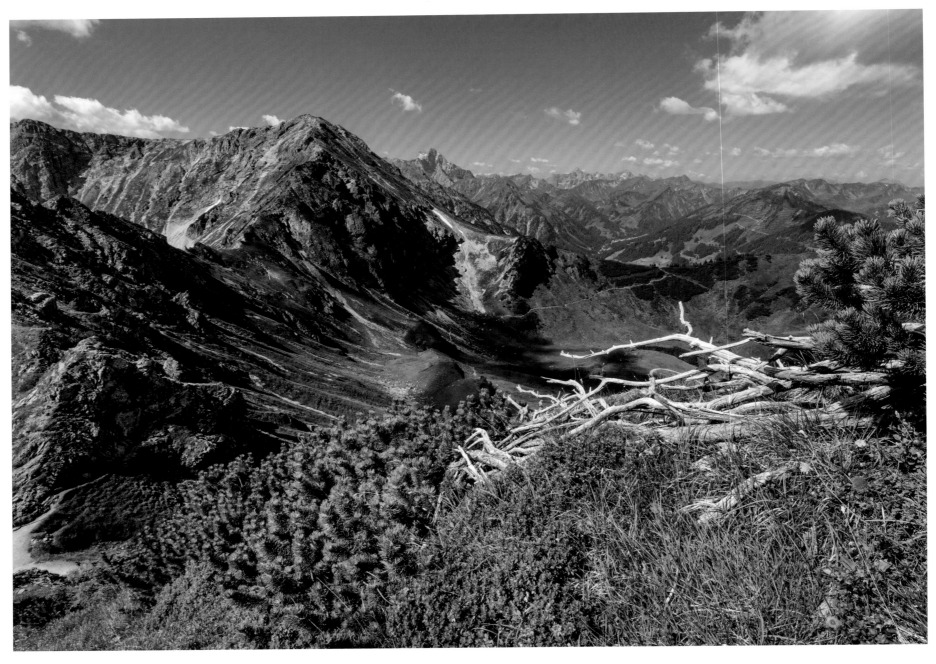

Kanzelwand (2058 m · 6752 ft), Kleinwalsertal

Kleinwalsertal

The Kleinwalsertal has been settled since ancient times; humans already lived here in valley during the Stone Age. In medieval times, emigrants from the Valais settled in this remote area. The Walser kept their traditions for centuries, and even today their dialect is clearly different from that of the neighbouring communities. The main town is Mittelberg. In the past agriculture shaped the valley, today tourism is the most important means of income, both in summer and winter. And the valley is no longer so remote today: The transport connections are good and there is even a casino.

Le Kleinwalsertal

Le Kleinwalsertal est une vallée habitée depuis très longtemps : on y a trouvé des traces de peuplement humain datant de l'âge de pierre. Au Moyen Âge, des habitants du Valais vinrent s'installer dans cette vallée isolée. Les Walser conservèrent leurs traditions au fil des siècles, et leur dialecte se différencie aujourd'hui encore nettement de ceux des communautés voisines. Sa principale commune est Mittelberg. Autrefois, l'agriculture occupait ici une place importante, mais elle a été remplacée par le tourisme, dynamique en été comme en hiver. D'ailleurs, la vallée n'est plus aussi isolée qu'autrefois : elle est bien desservie par la route et abrite même un casino.

Kleinwalsertal

Ein uraltes Siedlungsgebiet ist das Kleinwalsertal; schon in der Steinzeit lebten hier Menschen. Im Mittelalter siedelten sich Auswanderer aus dem Wallis in dem abgelegenen Tal an. Die Walser bewahrten über Jahrhunderte ihre Traditionen, und bis heute unterscheidet sich ihr Dialekt deutlich von dem der Nachbargemeinden. Der Hauptort ist Mittelberg. Früher prägte die Landwirtschaft das Tal, heute ist der Tourismus der wichtigste Industriezweig, im Sommer wie im Winter. Und so abgelegen ist das Tal heute auch nicht mehr: Die Verkehrsverbindungen sind gut, und inzwischen gibt es sogar ein Kasino.

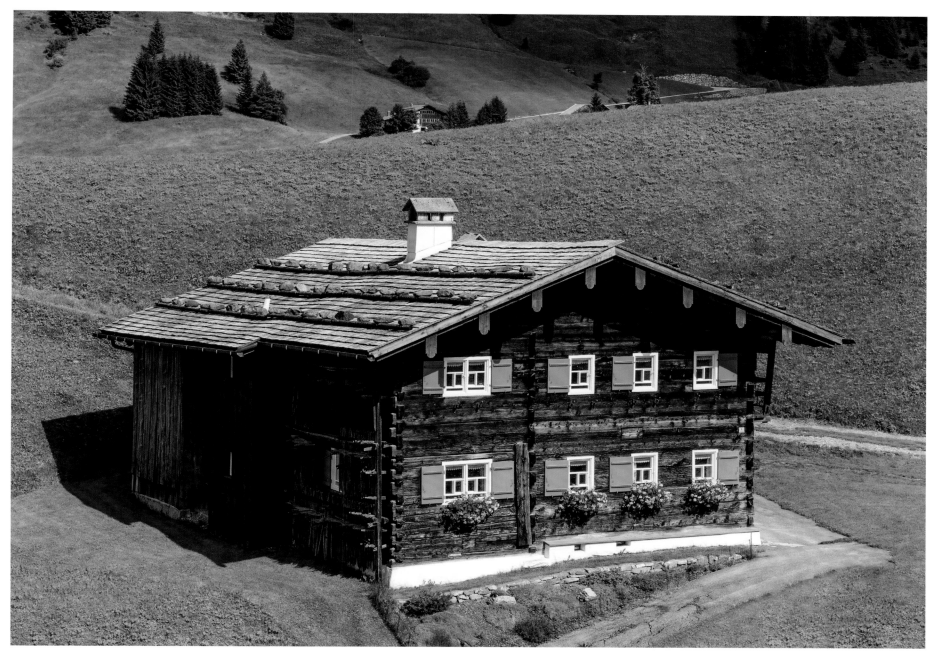

Mittelberg, Kleinwalsertal

Valle Kleinwalsertal

El Kleinwalsertal es una antigua zona de asentamiento; la gente ya vivía aquí en la Edad de Piedra. En la Edad Media, los emigrantes del Valais se asentaron en este remoto valle. Los walser mantuvieron sus tradiciones durante siglos, y aún hoy su dialecto es muy diferente al de las comunidades vecinas. La ciudad principal es Mittelberg. En el pasado la agricultura modelaba el valle; hoy en día el turismo es la rama más importante de la industria, tanto en verano como en invierno. Y el valle ya no es tan remoto en la actualidad: las conexiones de transporte son buenas e incluso hay un casino.

Kleinwalsertal

O Kleinwalsertal é uma antiga área de colonização; as pessoas já viviam aqui na Idade da Pedra. Na Idade Média, os emigrantes dos Valais se instalaram neste vale remoto. Os Walser mantiveram as suas tradições durante séculos, e ainda hoje o seu dialecto é claramente diferente do das comunidades vizinhas. A cidade principal é Mittelberg. No passado a agricultura moldou o vale, hoje o turismo é o ramo mais importante da indústria, tanto no verão como no inverno. E o vale já não é tão remoto hoje em dia: as ligações de transporte são boas e existe mesmo um casino.

Kleinwalsertal

Al in de steentijd bouwden mensen nederzettingen in het Kleinwalsertal. In de Middeleeuwen vestigden zich hier in de afgelegen vallei emigranten uit het Zwitserse Wallis. Deze Walser wisten hun oude tradities eeuwenlang te bewaren; hun dialect is ook nog steeds geheel anders dan dat van mensen in de naburige dorpen. De belangrijkste plaats in deze streek is Mittelberg. Vroeger leefden de mensen hoofdzakelijk van de landbouw, tegenwoordig van het toerisme, zowel 's zomers als 's winters. Intussen is de vallei niet meer zo afgelegen als vroeger en heeft het goede verkeersverbindingen – en zelfs een casino.

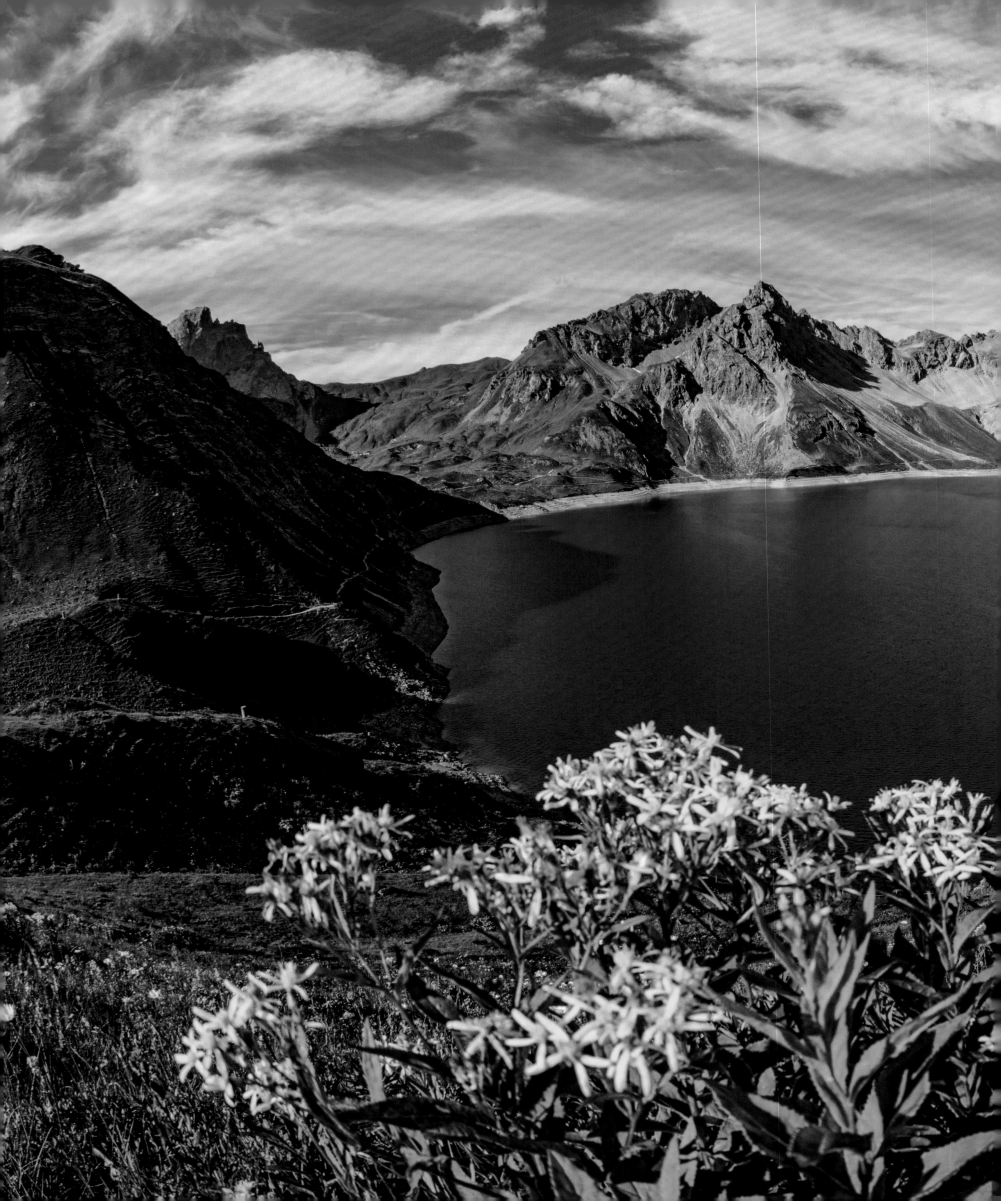

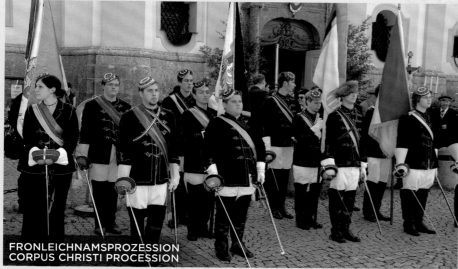

FRONLEICHNAMSPROZESSION
CORPUS CHRISTI PROCESSION

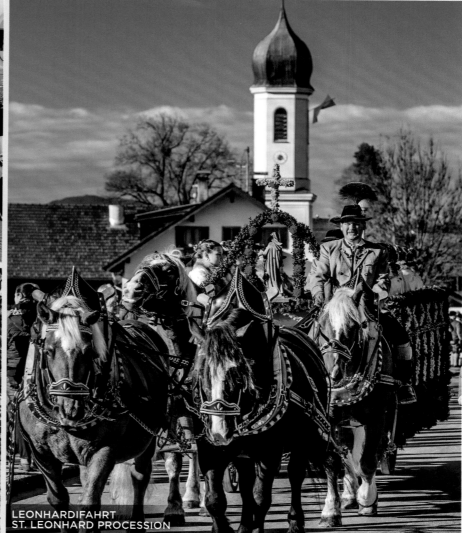

LEONHARDIFAHRT
ST. LEONHARD PROCESSION

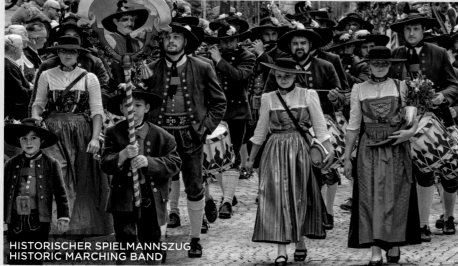

HISTORISCHER SPIELMANNSZUG
HISTORIC MARCHING BAND

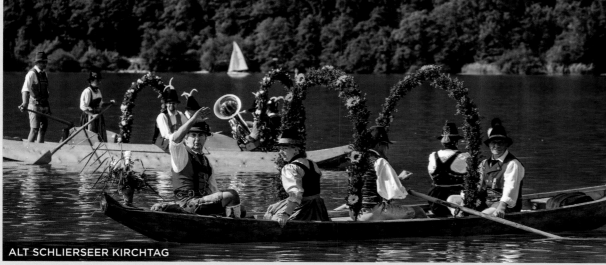

ALT SCHLIERSEER KIRCHTAG

NIKOLOSPIEL

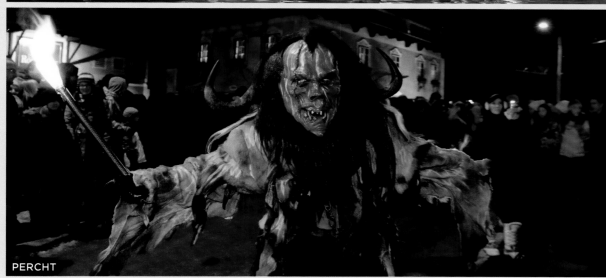

PERCHT

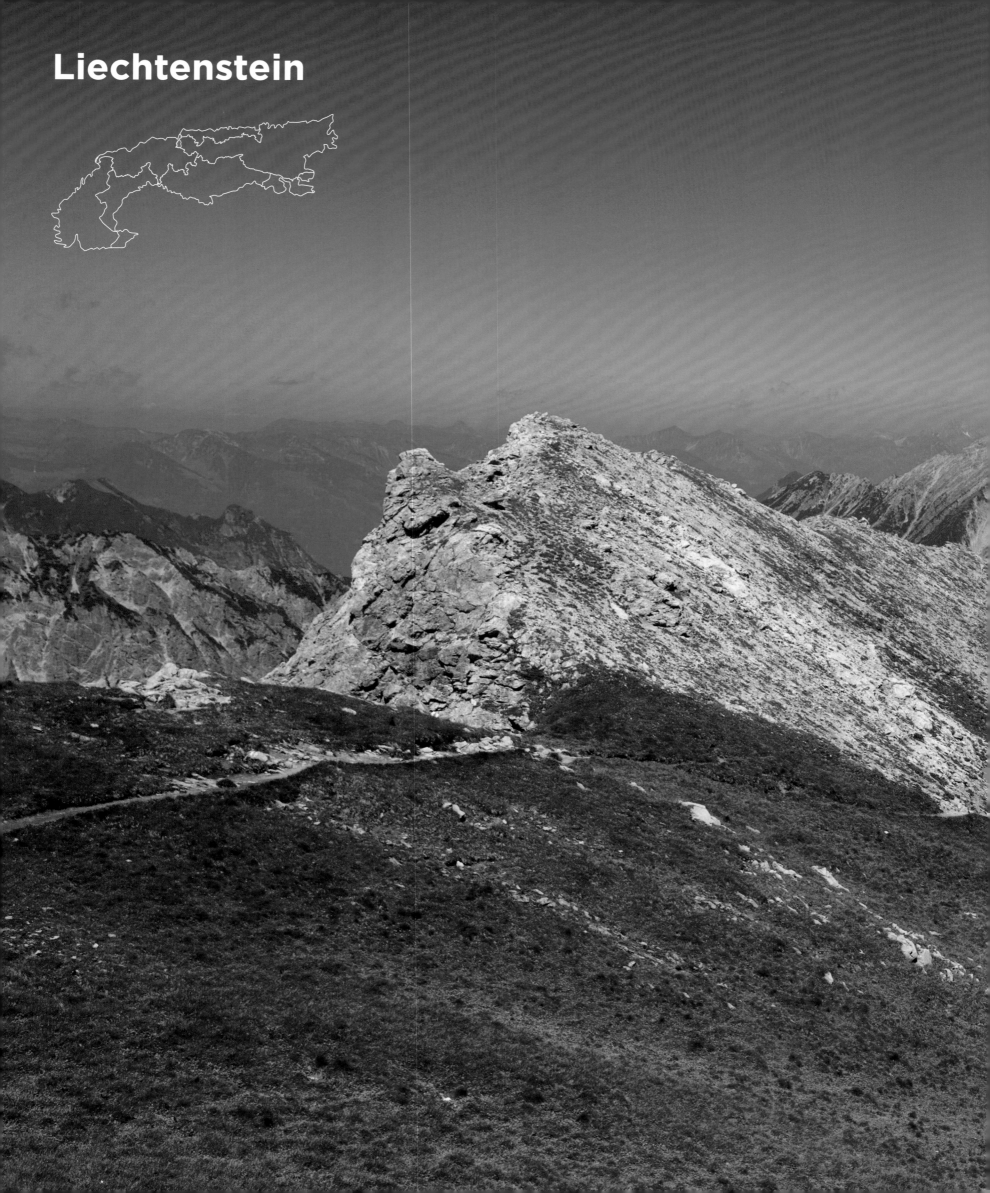

Liechtenstein

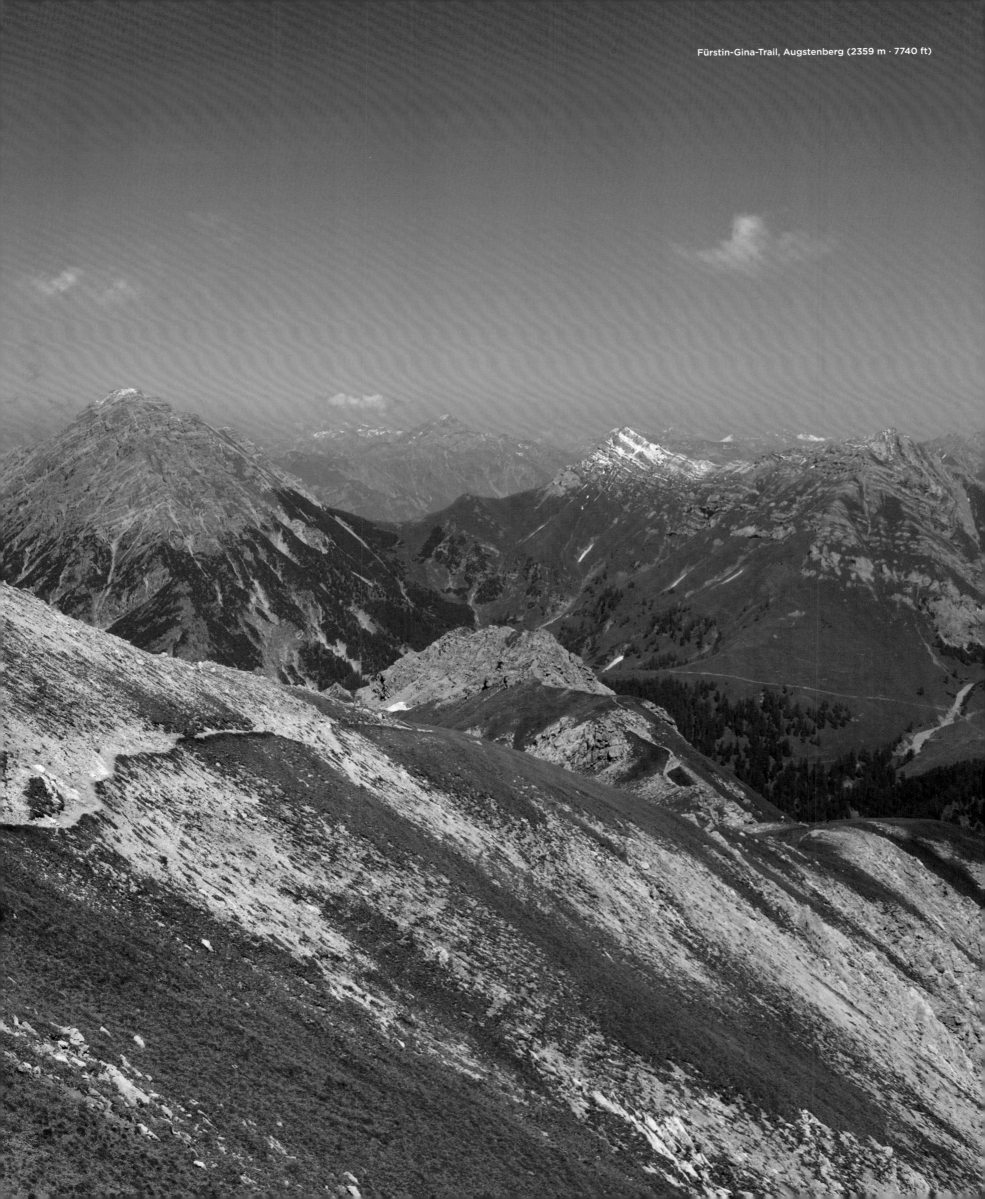

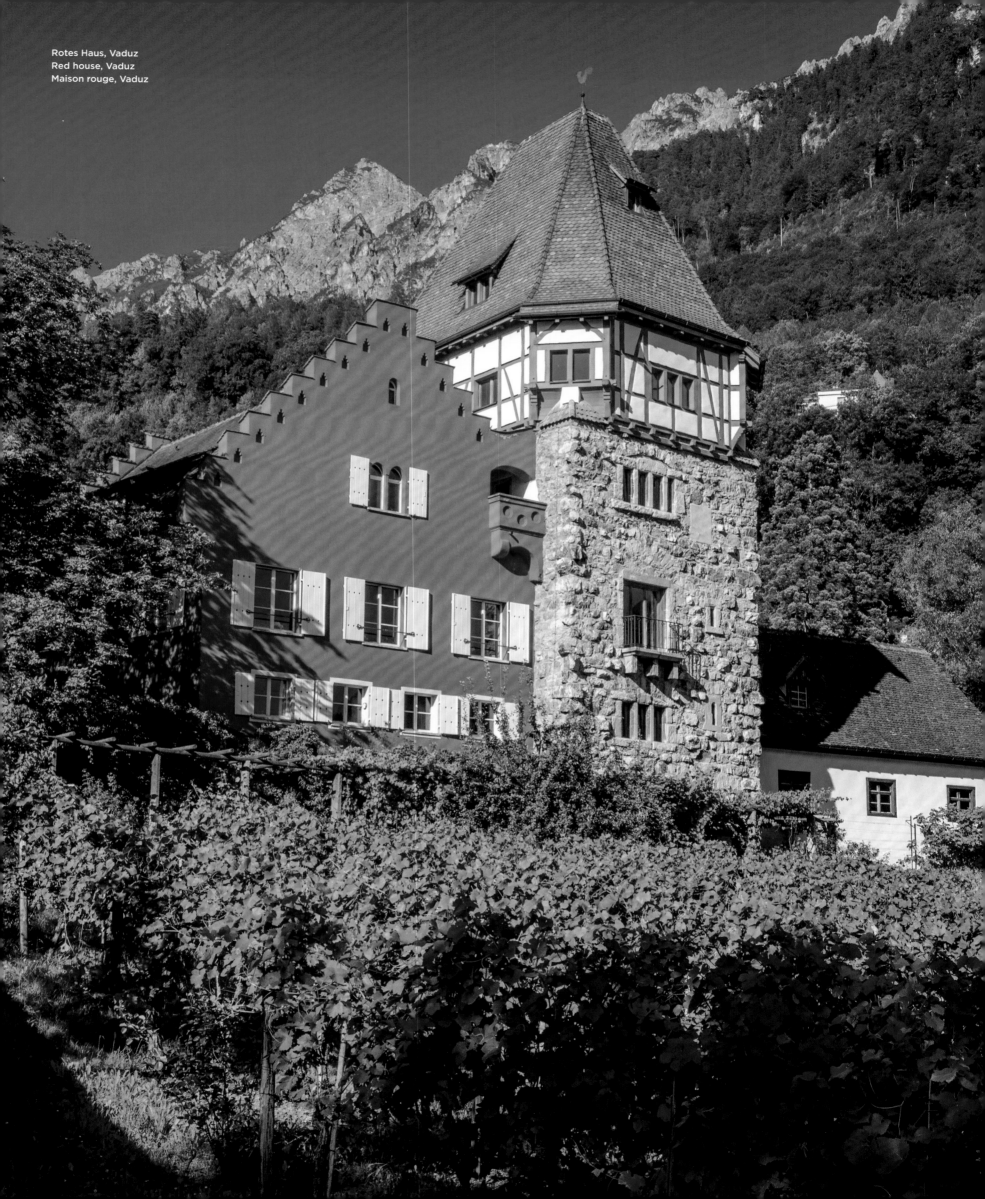

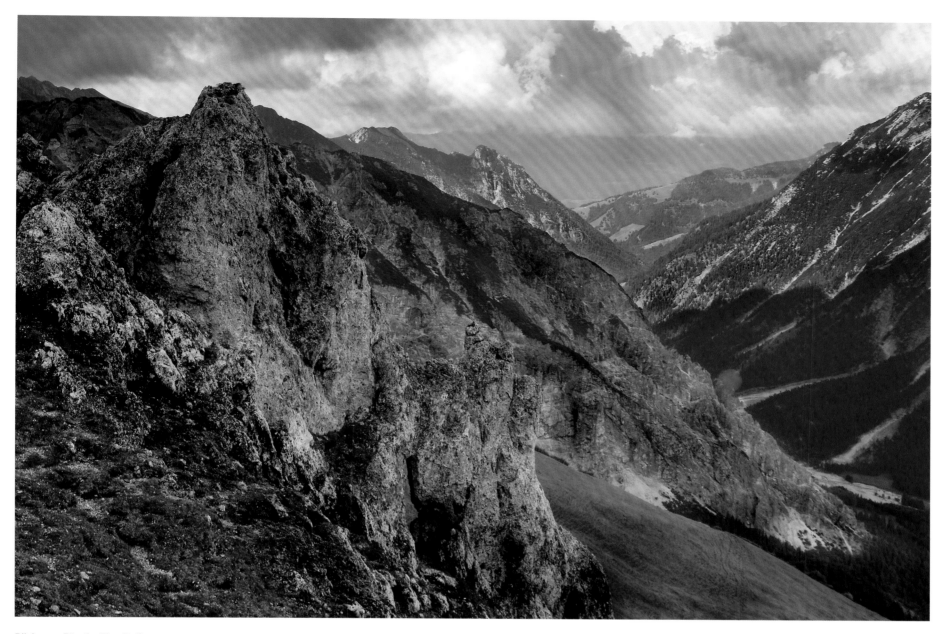

Blick vom Fürstin-Gina-Trail
View from Fürstin-Gina-Trail
Vue du chemin de la princesse Gina

Liechtenstein

The Principality of Liechtenstein extends along the eastern bank of the Rhine for just 25 km (16 mi). The 160 km² (99 sq mi) large, affluent state is an important financial centre and closely linked to Switzerland. In the capital Vaduz, striking buildings such as the medieval Red House and the castle above, seat of the reigning family, are worth seeing.

Le Liechtenstein

La principauté de Liechtenstein s'étend sur 25 km, sur la rive est du Rhin. Ce micro-État particulièrement aisé, avec sa superficie de 160 km², est une place financière importante étroitement liée avec la Suisse. Sa capitale, Vaduz, présente des bâtiments remarquables, comme la Maison rouge, remontant au Moyen Âge, ou encore un château perché sur une hauteur, résidence de la famille princière.

Liechtenstein

Am Ostufer des Rheins erstreckt sich über gerade einmal 25 km Länge das Fürstentum Liechtenstein. Der 160 km² große, wohlhabende Kleinstaat, ein bedeutender Finanzplatz, ist eng mit der Schweiz verbunden. Sehenswert sind in der Hauptstadt Vaduz markante Gebäude wie das mittelalterliche Rote Haus und das oberhalb gelegene Schloss, Sitz der Fürstenfamilie.

Liechtenstein

El Principado de Liechtenstein se extiende a lo largo de la orilla oriental del Rin por apenas 25 km. El pequeño y próspero estado de 160 km² es un importante centro financiero que está estrechamente vinculado a Suiza. En la capital, Vaduz, destacan edificios como la Casa Roja medieval y el castillo de arriba, sede de la familia principesca.

Liechtenstein

O Principado do Liechtenstein estende-se ao longo da margem oriental do Reno por apenas 25 km. O pequeno estado afluente de 160 km², um importante centro financeiro, está intimamente ligado à Suíça. Na capital Vaduz, edifícios marcantes como a Casa Vermelha medieval e o castelo acima, sede da família principesca, merecem ser vistos.

Liechtenstein

Het vorstendom Liechtenstein strekt zich over 25 km uit langs de oostelijke Rijnoever. Dit slechts 160 km² grote, welvarende ministaatje is een belangrijk financieel centrum en onderhoudt nauwe banden met Zwitserland. De hoofdstad Vaduz beschikt over enkele fraaie bezienswaardigheden zoals het middeleeuwse Rode Huis en het kasteel erboven, waar de vorstelijke familie woont.

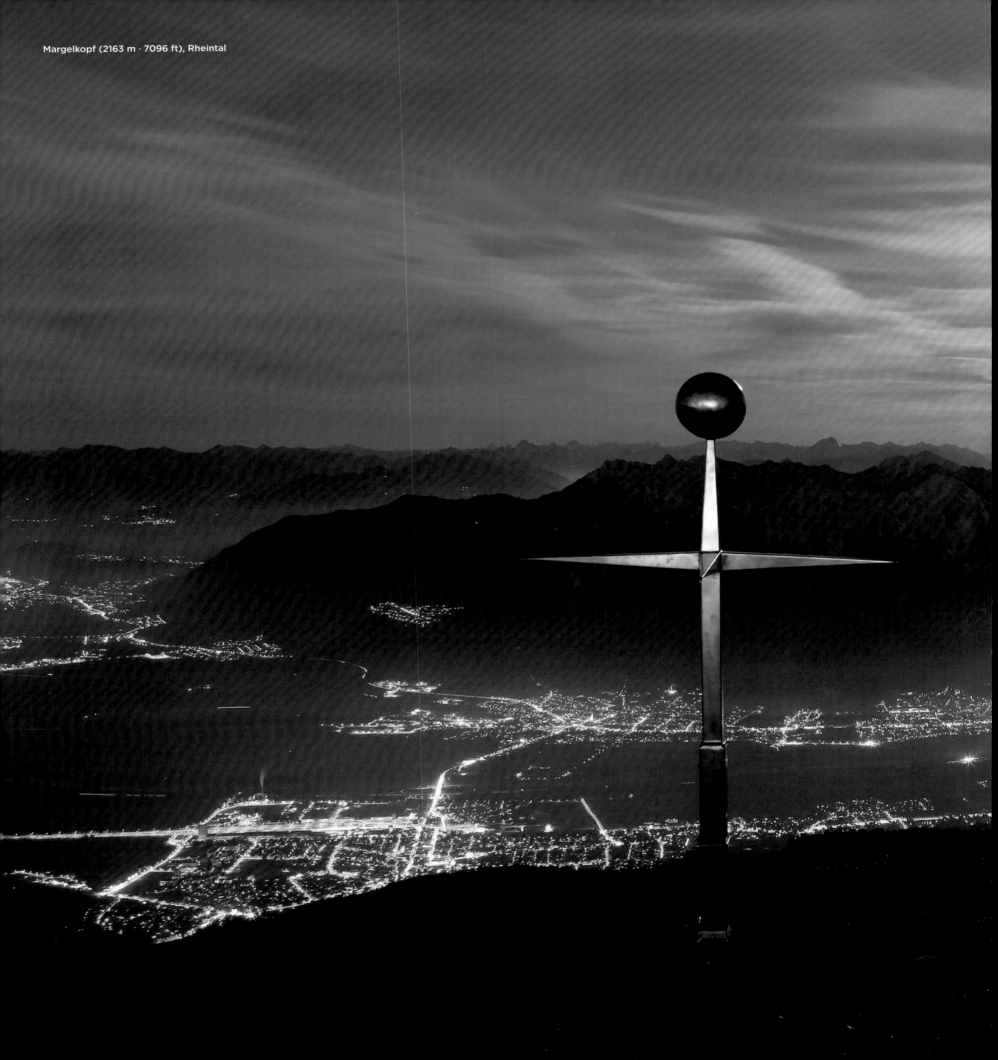

Margelkopf (2163 m · 7096 ft), Rheintal

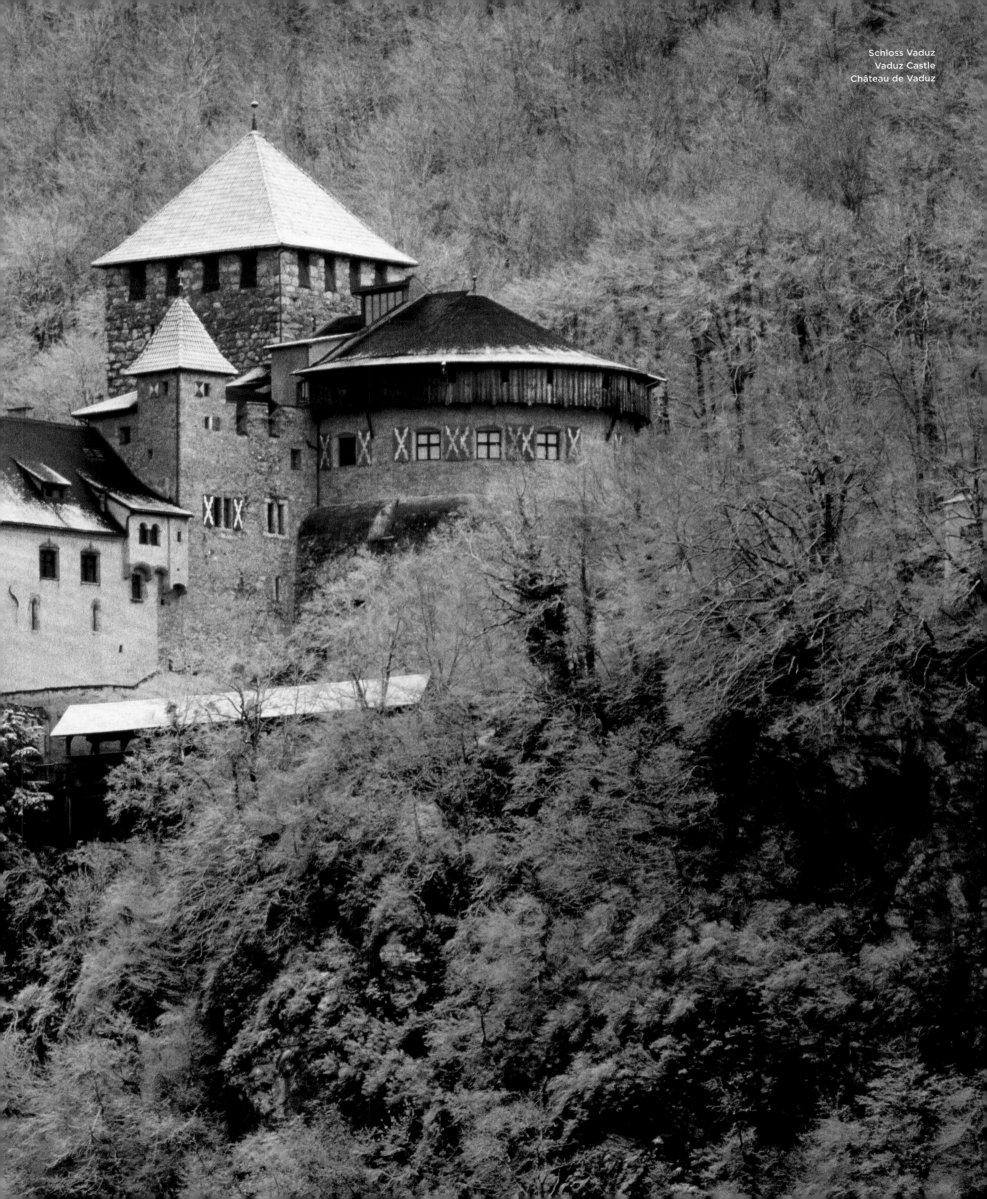

Allgäu & Bayerische Alpen · Allgäu & Bavarian Alps · Allgäu & Alpes bavaroises

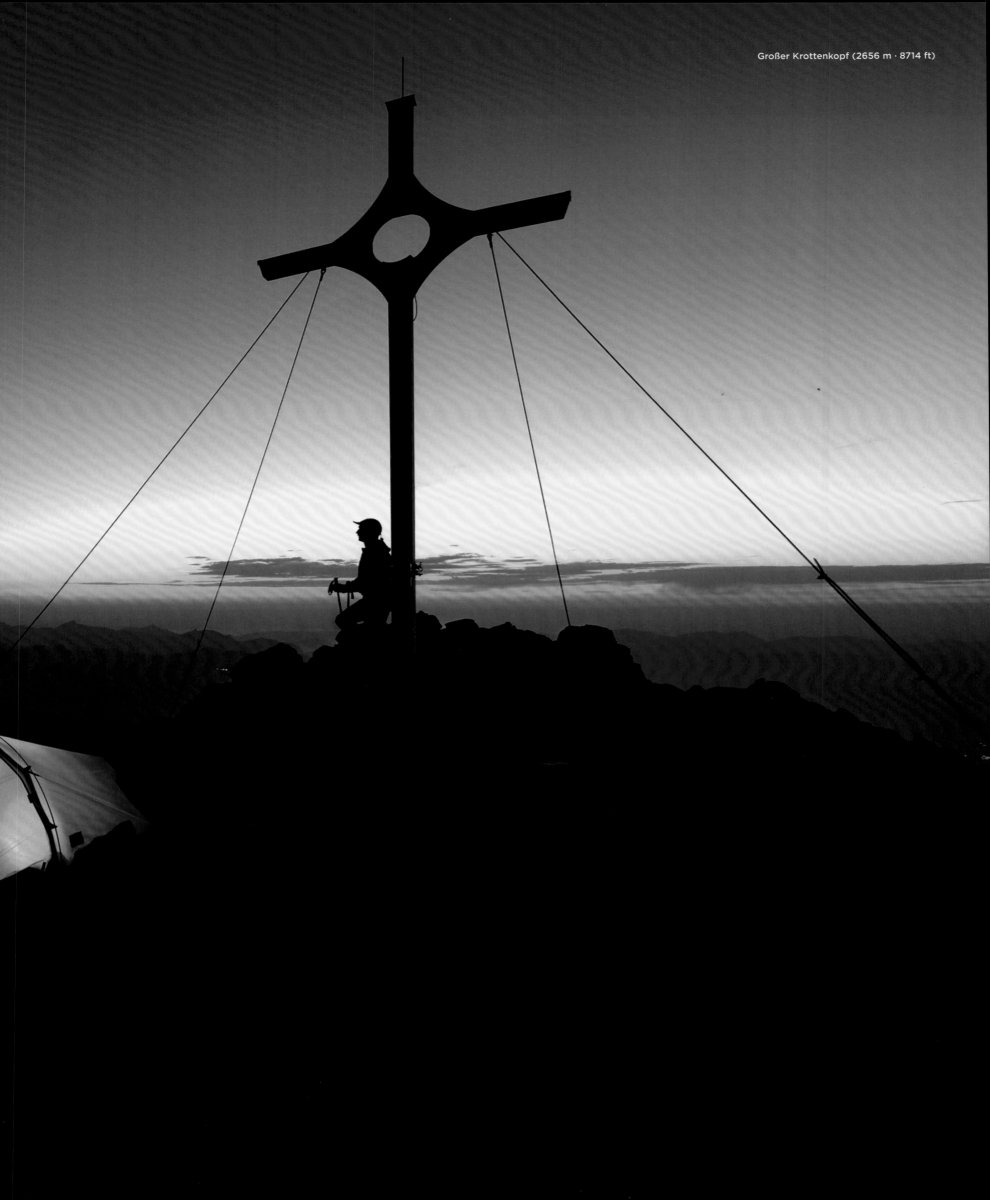

Großer Krottenkopf (2656 m · 8714 ft)

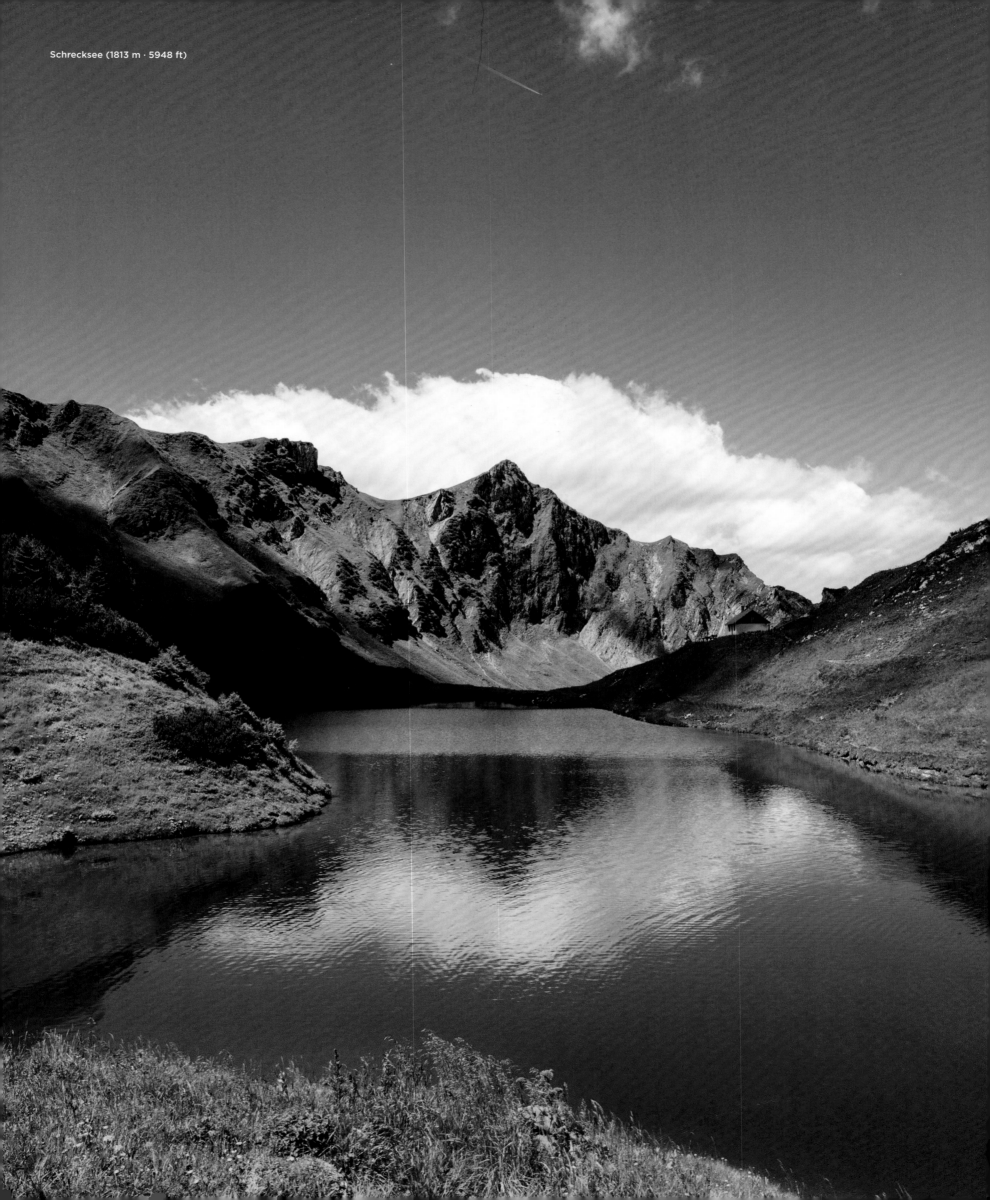

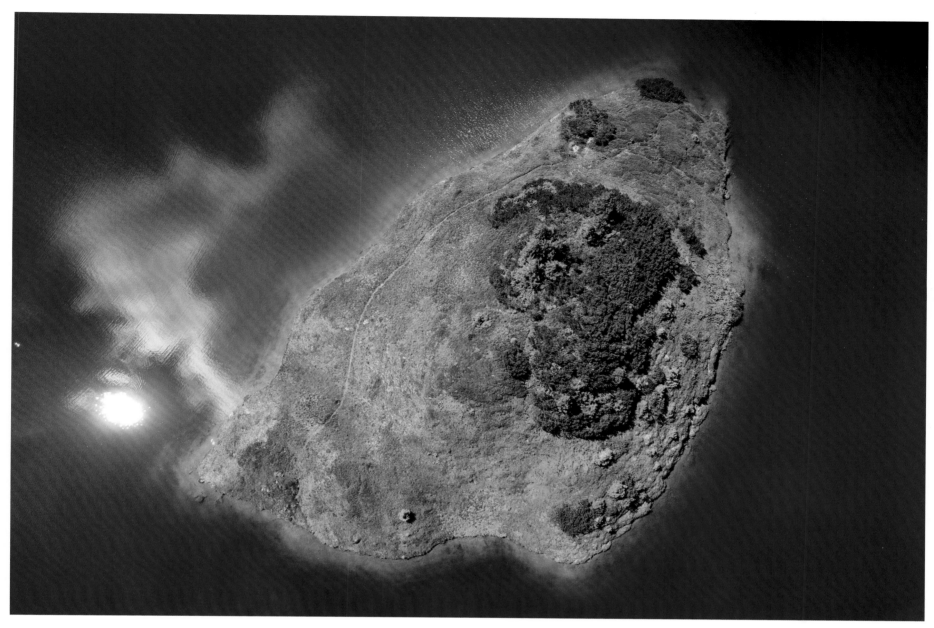

Schrecksee (1813 m · 5948 ft)

Allgäu and Bavarian Alps

The Allgäu is a cultural landscape that has been inhabited for thousands of years and is used intensively for agriculture. To the south it climbs to altitudes of 2650 m (8694 ft), 30 peaks reaching over 2000 m (6562 ft). This is also the southernmost region of Germany. Tourism is playing an increasingly important role in the Allgäu. All needs of holidaymakers are well catered to, and there are many long-distance hiking trails.

L'Allgäu et les Alpes bavaroises

L'Allgäu est une région habitée depuis des millénaires et où l'agriculture est particulièrement active. Au sud, elle s'élève à pas moins de 2650 m d'altitude, avec une trentaine de sommets de plus de 2000 m. On y trouve aussi le point le plus méridional d'Allemagne. Dans cette région, le tourisme joue un rôle de plus en plus important. Les touristes y trouvent toutes les infrastructures dont ils ont besoin, et notamment de nombreux chemins de grande randonnée.

Allgäu und Bayerische Alpen

Das Allgäu ist eine seit Jahrtausenden besiedelte Kulturlandschaft, die intensiv landwirtschaftlich genutzt wird. Nach Süden steigt sie bis in Höhen von 2650 m an, 30 Gipfel erreichen über 2000 m. Hier liegt auch der südlichste Punkt Deutschlands. In der Region spielt der Tourismus eine immer wichtigere Rolle. Urlauber finden eine perfekte Infrastruktur mit vielen Fernwanderwegen.

Algovia y los Alpes Bávaros

Algovia es un paisaje cultural que ha sido habitado durante miles de años y se utiliza intensivamente para la agricultura. Al sur se eleva a altitudes de 2650 m, 30 picos alcanzan más de 2000 m. Este es también el punto más meridional de Alemania. El turismo desempeña un papel cada vez más importante en la región. Los turistas encontrarán una infraestructura perfecta con muchas rutas de senderismo de larga distancia.

Allgäu e os Alpes da Baviera

O Allgäu é uma paisagem cultural habitada há milhares de anos e utilizada intensivamente na agricultura. Ao sul sobe para altitudes de 2650 m, 30 picos atingem mais de 2000 m. Este é também o ponto mais meridional da Alemanha. O turismo desempenha um papel cada vez mais importante na região. Os turistas encontrarão uma infra-estrutura perfeita com muitas trilhas para caminhadas de longa distância.

Allgäuer en Beierse Alpen

De Allgäu is een duizenden jaren oud cultuurlandschap waar op grote schaal intensieve landbouw wordt bedreven. In het zuiden verrijzen 30 toppen van ruim 2000 m hoogte, waarvan de Große Krottenkopf met 2656 m de hoogste is. Hier ligt ook het zuidelijkste puntje van Duitsland. In deze streek speelt het toerisme een steeds grotere rol. Vakantiegangers vinden hier een uitstekende infrastructuur met vele langeafstandswandelroutes.

Gerstrube, Oberstdorf

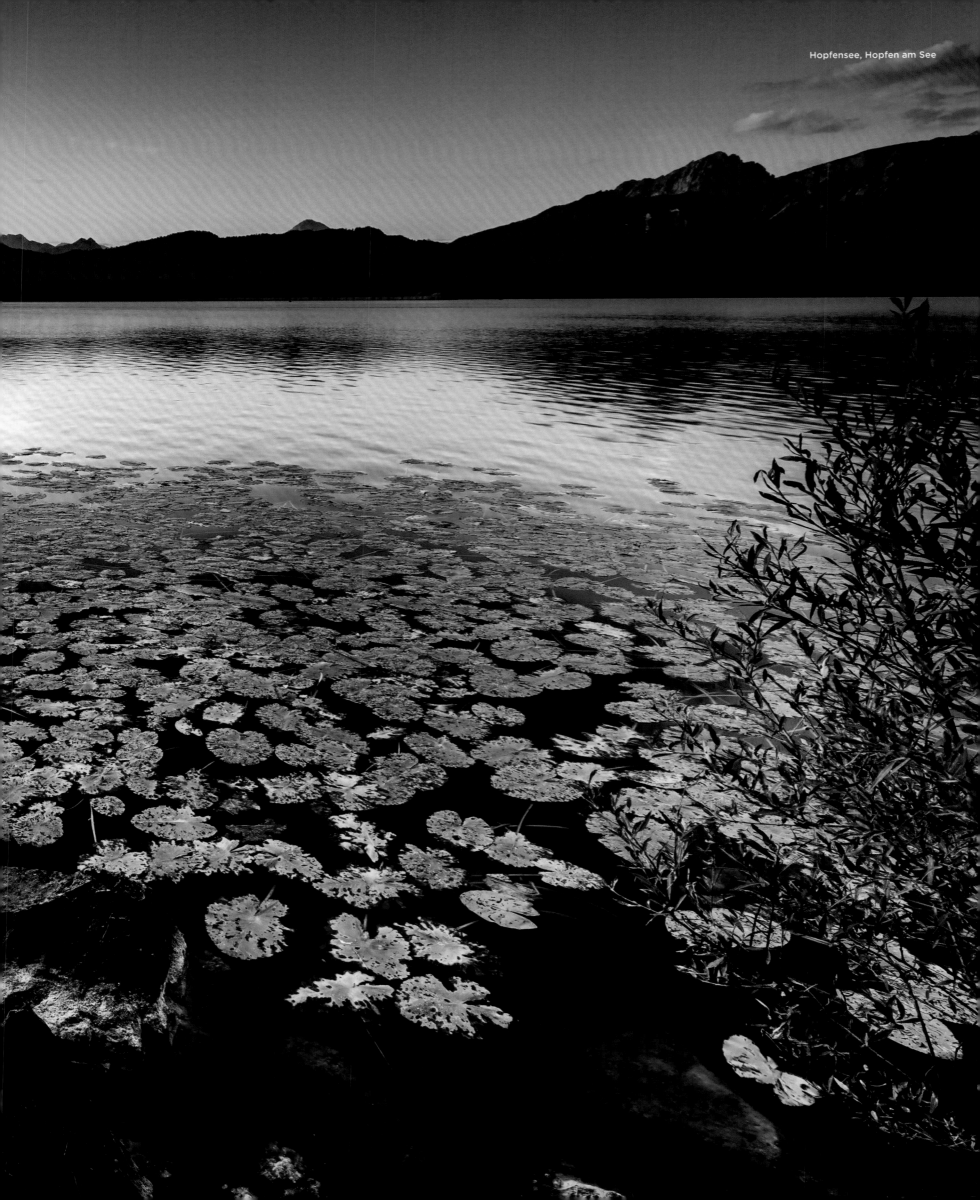

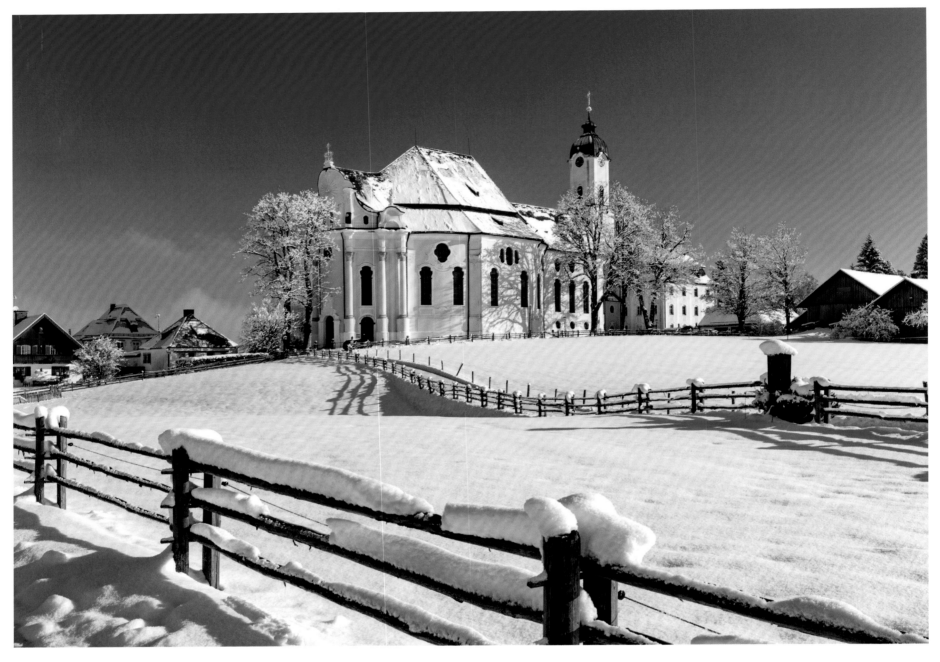

Wieskirche, Steingaden

Wies Church

The Bavarian "Pfaffenwinkel" has one of the big attractions in the German Alps with the Wieskirche near Steingaden. The Rococo pilgrimage church, built in the middle of the 18th century, boasts a lot of gold and magnificent frescoes; the ceiling frescoes were created by Johann Baptist Zimmermann. Its organ is also famous, and church concerts are held regularly, with visitors coming from far and wide. In 1983, the "Wies" was included in the UNESCO list of World Heritage Sites, a remarkable career for the church, which was almost never built due to the high costs.

L'église de Wies

Le *Pfaffenwinkel,* littéralement « coin des calotins », regorge d'édifices religieux, comme l'église de Wies, près de Steingaden, une attraction incontournable des Alpes. Cette église de pèlerinage construite au milieu du XVIIIᵉ siècle est un véritable étalage de dorures et de fresques fastueuses ; sa coupole est l'œuvre de Johann Baptist Zimmermann (1680–1758). Elle est aussi renommée pour son orgue et les concerts qui y sont organisés attirent des visiteurs venus de loin. En 1983, elle a été inscrite au patrimoine mondial de l'UNESCO ; une carrière haute en couleur pour une église qui a bien failli ne jamais voir le jour tellement les coûts de construction étaient élevés.

Wieskirche

Der bayrische „Pfaffenwinkel" besitzt mit der Wieskirche bei Steingaden eine der großen Attraktionen im Alpenland. Die Rokoko-Wallfahrtskirche, Mitte des 18. Jahrhunderts erbaut, prunkt mit viel Gold und prachtvollen Fresken; die Kuppelfresken schuf Johann Baptist Zimmermann. Berühmt ist auch ihre Orgel, regelmäßig finden Kirchenkonzerte statt, zu denen die Besucher von weither kommen. 1983 wurde die „Wies" in die Unesco-Liste des Weltkulturerbes aufgenommen – eine bemerkenswerte Karriere für die Kirche, die wegen zu hoher Kosten beinahe nicht gebaut worden wäre.

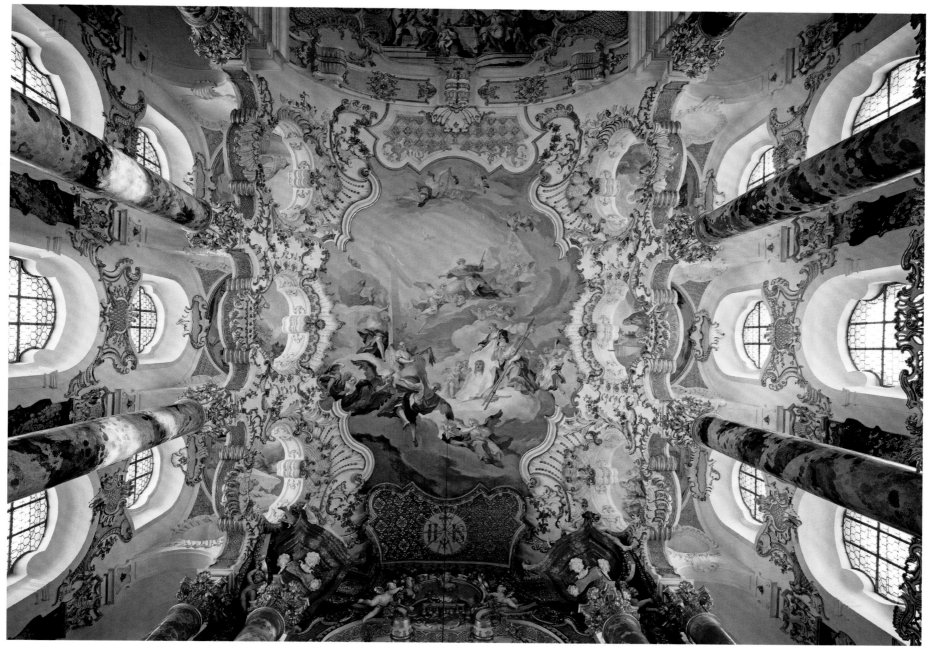

Wieskirche, Steingaden

Iglesia de Wies

El Pfaffenwinkel bávaro tiene con la Iglesia de Wies cerca de Steingaden una de las grandes atracciones del país alpino. La iglesia de peregrinación rococó, construida a mediados del siglo XVIII, posee una gran cantidad de oro y magníficos frescos; los frescos de la cúpula fueron creados por Johann Baptist Zimmermann. Su órgano es también famoso, y regularmente se celebran conciertos de iglesia, con visitantes de todas partes. En 1983, la Iglesia Wies fue incluida en la Lista del Patrimonio de la Humanidad de la UNESCO, una carrera notable para la iglesia, que estuvo a punto de no llegar a construirse por ser demasiado cara.

Igreja de Wies

O "Pfaffenwinkel" bávaro tem com o Wieskirche perto de Steingaden uma das grandes atrações no país alpino. A igreja de peregrinação rococó, construída em meados do século XVIII, ostenta muito ouro e magníficos frescos; os frescos em cúpula foram criados por Johann Baptist Zimmermann. Seu órgão também é famoso, e concertos de igreja são realizados regularmente, com visitantes vindo de longe e de longe. Em 1983, o "Wies" foi incluído na lista da Unesco de Patrimônios da Humanidade – uma carreira notável para a igreja, que quase nunca foi construída porque era muito cara.

Wieskirche

De Zuid-Beierse streek Pfaffenwinkel kan bogen op een van de grootste attracties van het alpengebied: de Wieskirche, het bedevaartkerkje in Wies bij Steingaden. Deze in rococostijl gebouwde kerk dateert van halverwege de 18e eeuw en heeft binnenin niet alleen veel goud, maar ook prachtige fresco's; voor de koepelfresco's tekende Johann Baptist Zimmermann. Het orgel is ook beroemd en in de kerk vinden regelmatig kerkconcerten plaats, die bezoekers van heinde en verre trekt. De kerk staat sinds 1983 op de Werelderfgoedlijst – een opmerkelijke carrière voor een kerk die, naar zeggen, maar ternauwernood aan de sloophamer is ontkomen.

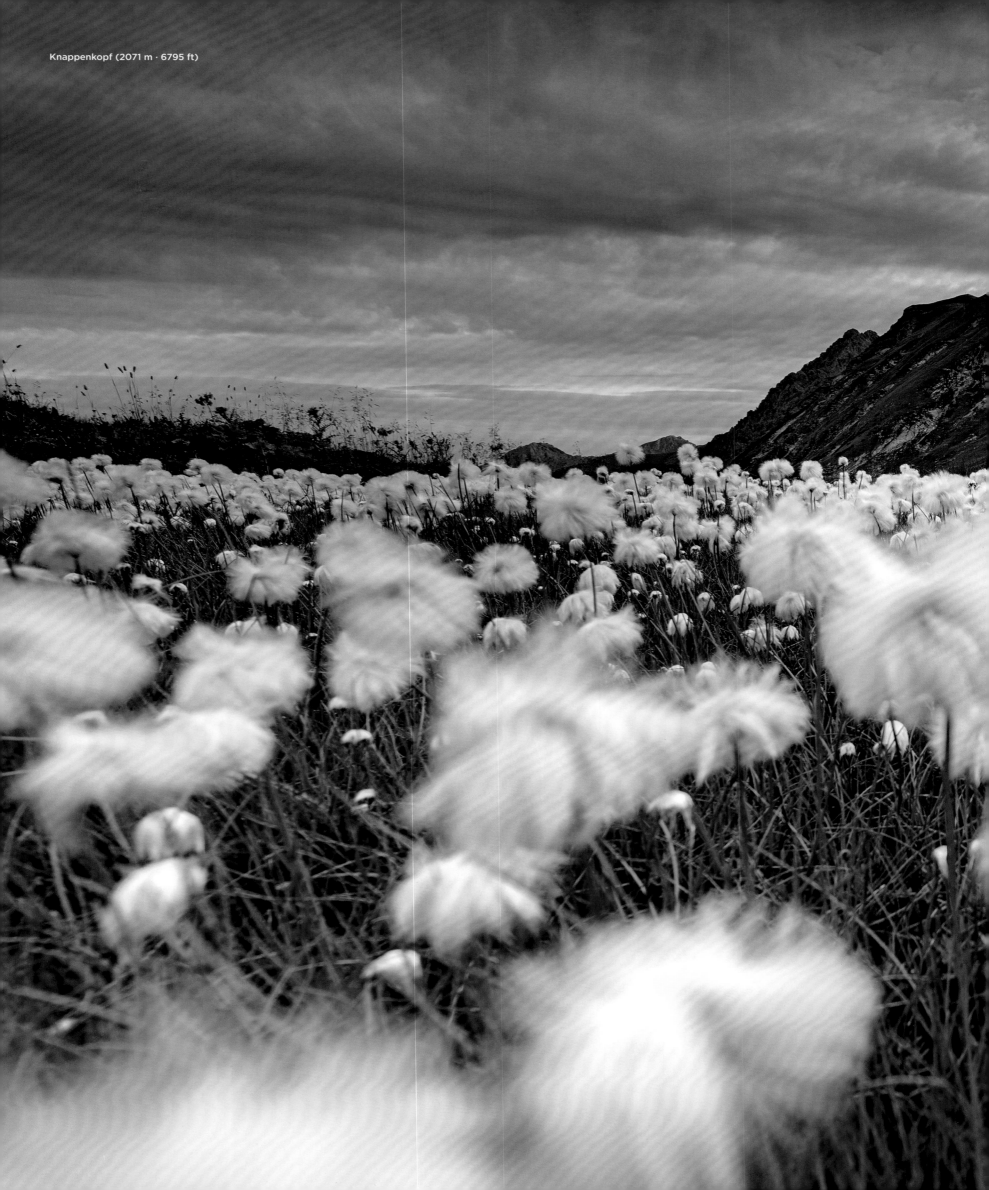

Knappenkopf (2071 m · 6795 ft)

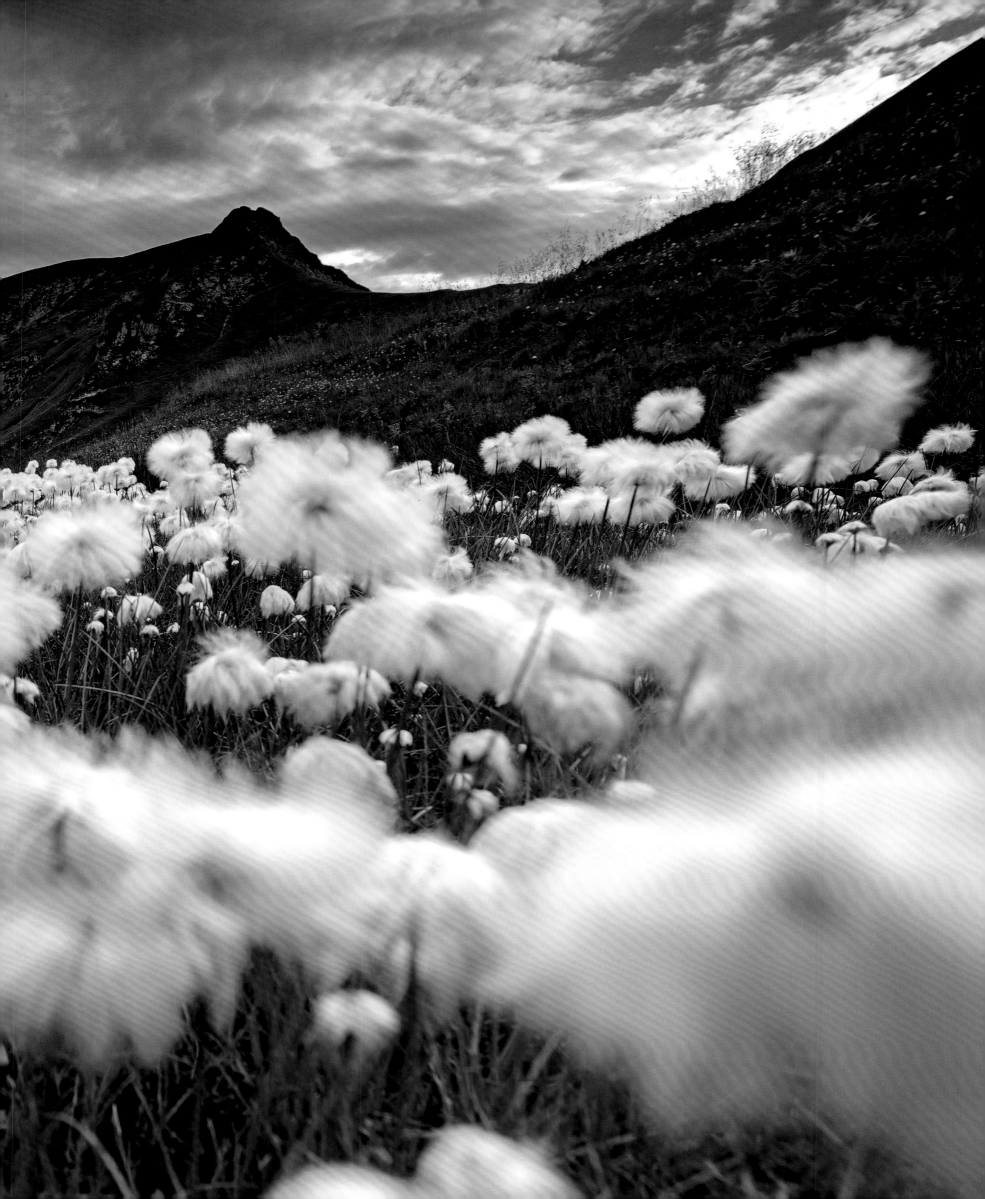

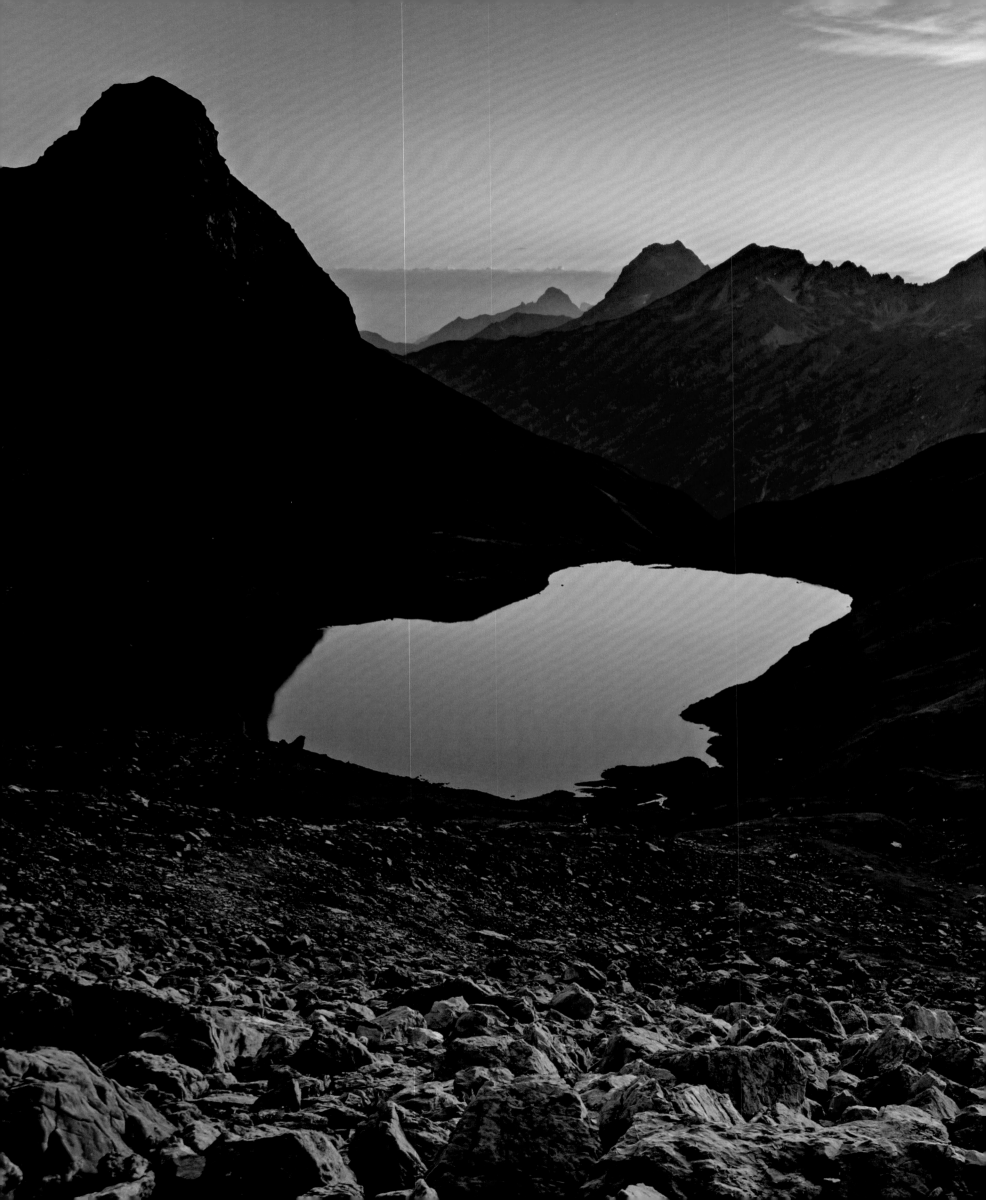

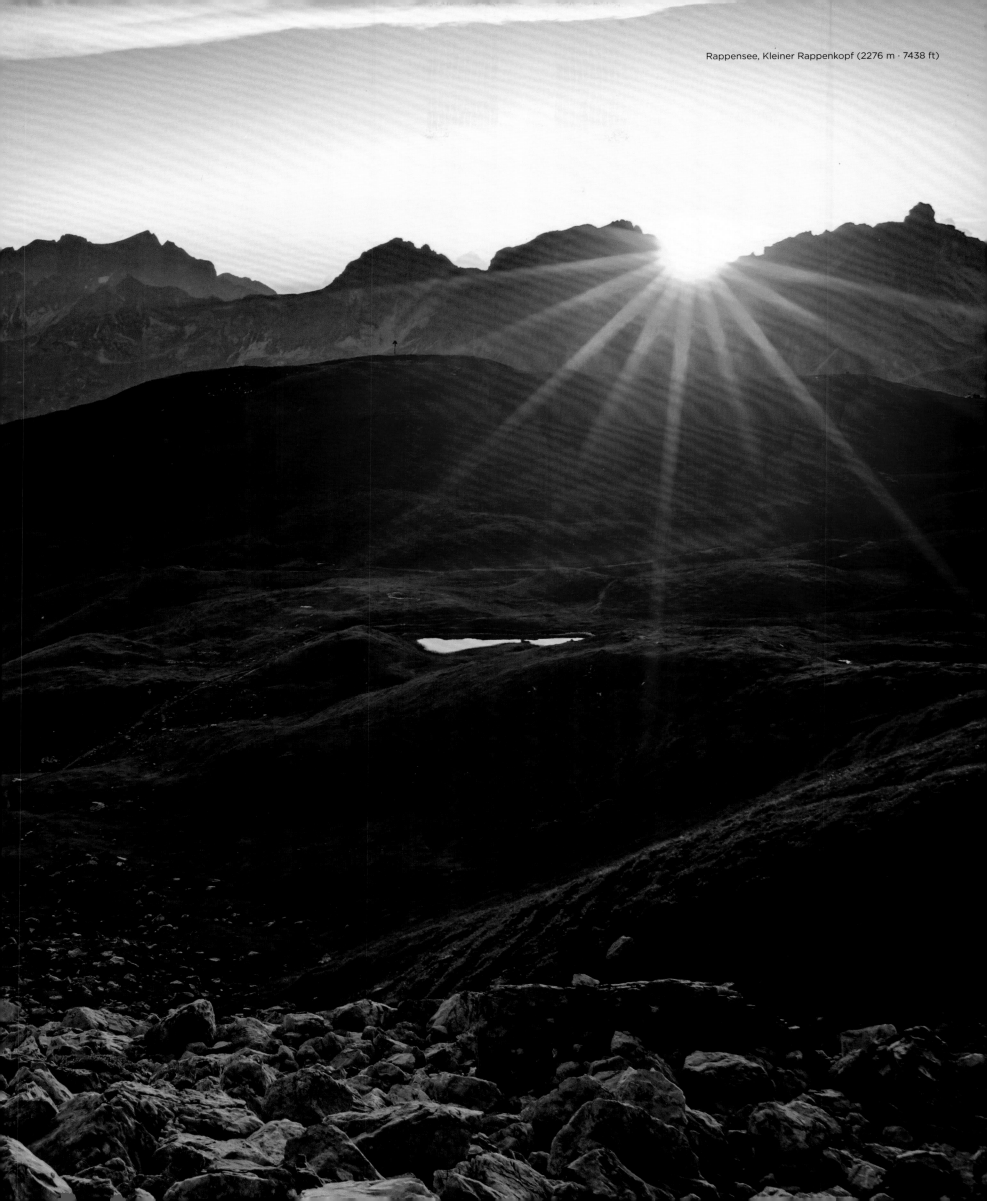

Rappensee, Kleiner Rappenkopf (2276 m · 7438 ft)

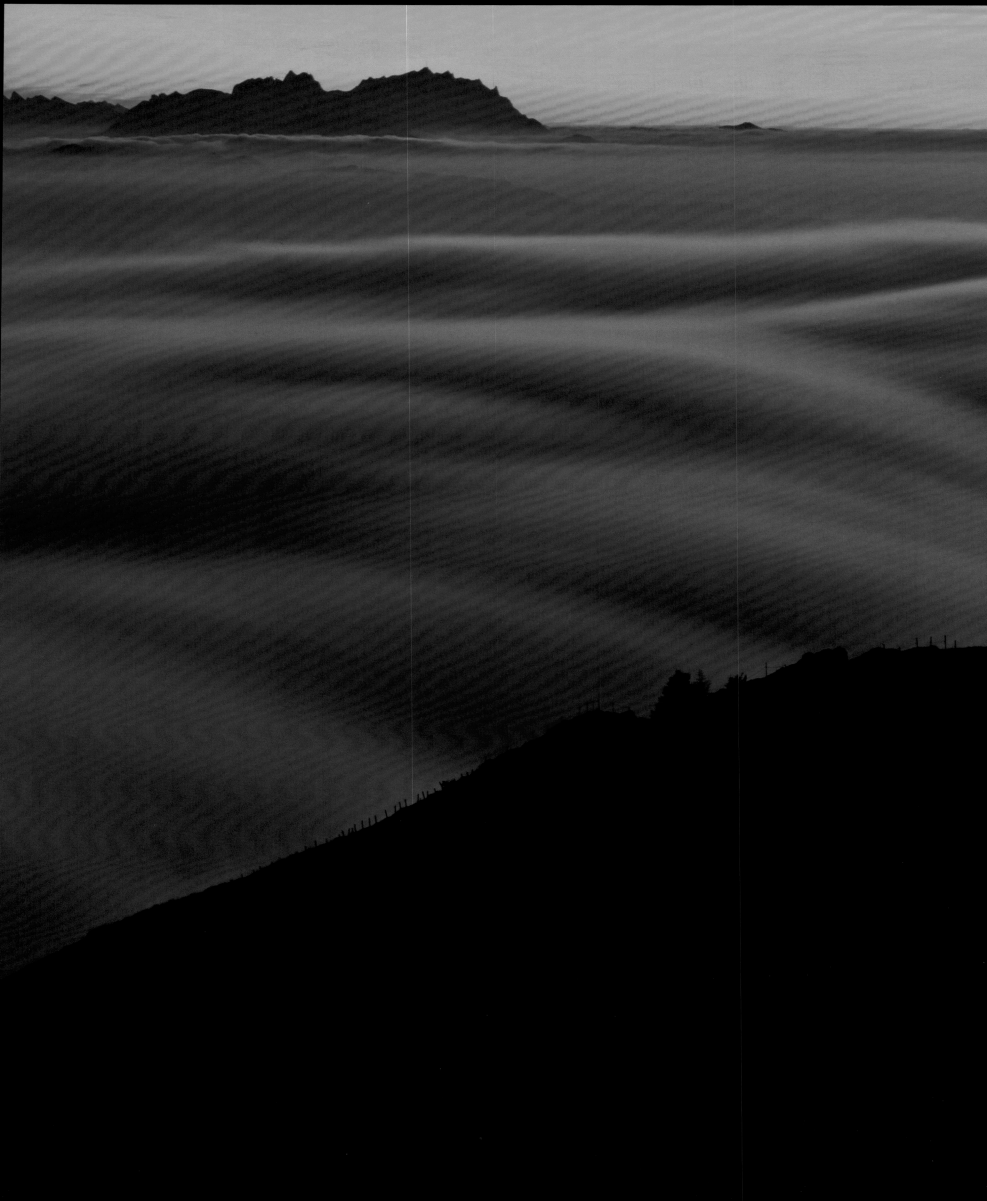

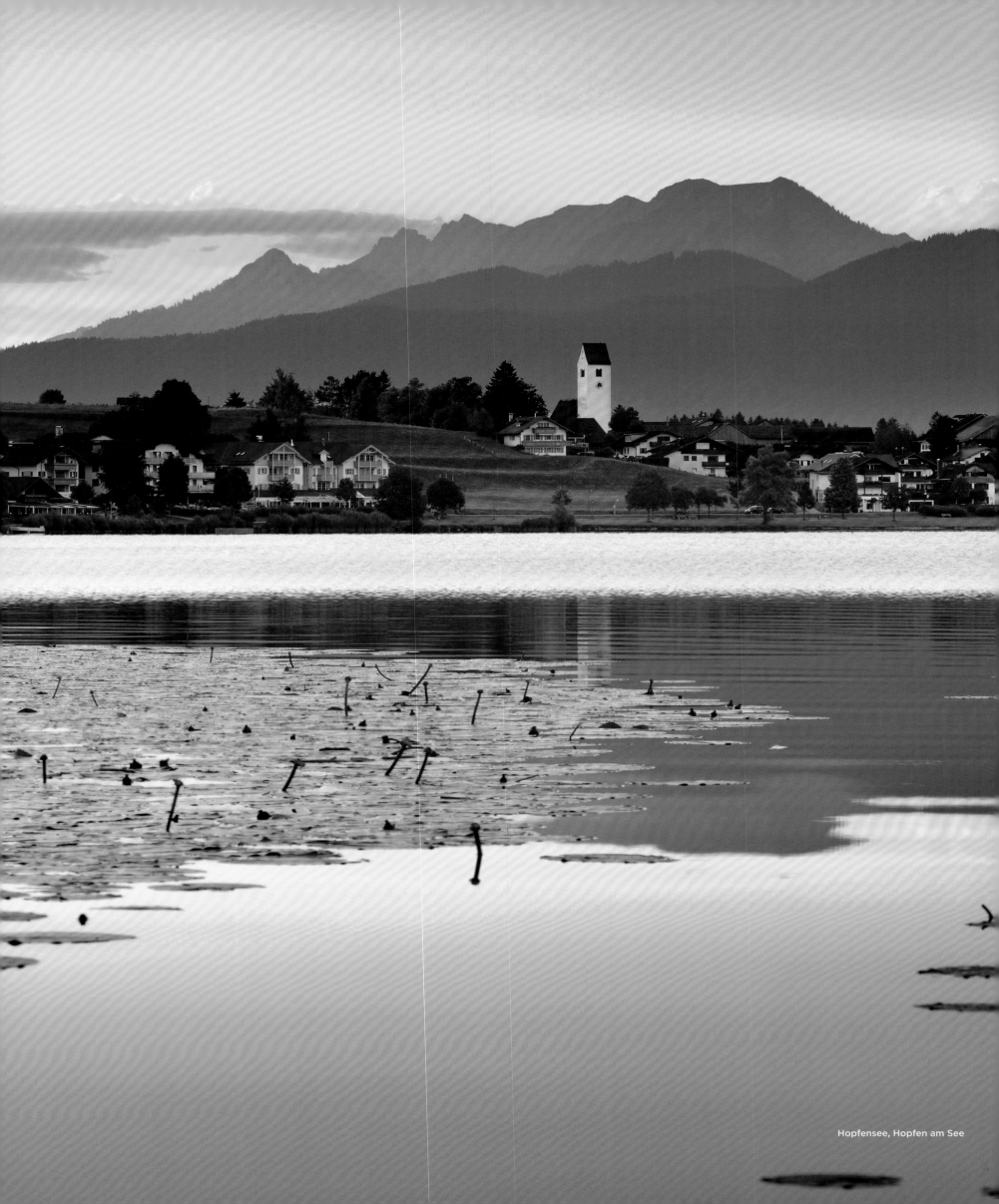

Hopfensee, Hopfen am See

Kleiner Wilder (2306 m · 7567 ft), Älpelesattel

Lake Hopfen

Hopfen am See, which belongs to the town of Füssen, is a well-known climatic health resort. Hikers will find a paradise here, because the paths around the lake and to the sights in the surrounding area, such as the ruins of the castle above the village or to Füssen, are not too demanding. The numerous spa guests also enjoy the mountain panorama of the Allgäu Alps.

Le lac Hopfen

Hopfen am See, qui appartient à la ville de Füssen, est une station climatique renommée. C'est un paradis pour les randonneurs, car les chemins qui tournent autour du lac ou mènent à Füssen ou aux différentes curiosités des environs, comme les ruines du château, ne sont pas trop difficiles. La vue magnifique sur les Alpes d'Allgäu fait aussi la joie des curistes.

Hopfensee

Hopfen am See, das zur Stadt Füssen gehört, ist ein bekannter Luftkurort. Wanderer finden hier ein Paradies, denn die Wege rund um den See und zu den Sehenswürdigkeiten der Umgebung, etwa den Ruinen der über dem Ort gelegenen Burg oder nach Füssen, sind nicht zu anspruchsvoll. Das Bergpanorama der Allgäuer Alpen genießen auch die zahlreichen Kurgäste.

Lago Hopfen

Hopfen am See, que pertenece a la ciudad de Füssen, es un conocido "Luftkurort" (que en alemán significa algo así como "balneario de aire limpio"). Los excursionistas encontrarán un paraíso aquí, porque los senderos que rodean el lago y las vistas de los alrededores, como las ruinas del castillo sobre el pueblo o hacia Füssen, no son demasiado exigentes. Los numerosos huéspedes del balneario también disfrutan del panorama montañoso de los Alpes de Algovia.

Lago Hopfen

Hopfen am See, que pertence à cidade de Füssen, é um conhecido resort de saúde climática. Os caminhantes encontrarão um paraíso aqui, porque os caminhos em torno do lago e as vistas da área circundante, como as ruínas do castelo acima da aldeia ou para Füssen, não são muito exigentes. Os numerosos hóspedes do spa também desfrutam do panorama montanhoso dos Alpes Allgäu.

Hopfensee

Het kuuroord Hopfen am See is een stadsdeel van Füssen. Voor wandelaars is de omgeving een paradijs, want de paden naar Füssen, rondom het meer en naar de bezienswaardigheden in de omgeving, zoals de kasteelruïnes boven Füssen, zijn niet al te zwaar. Veel kuurgasten komen hier om van het fraaie alpenpanorama te genieten.

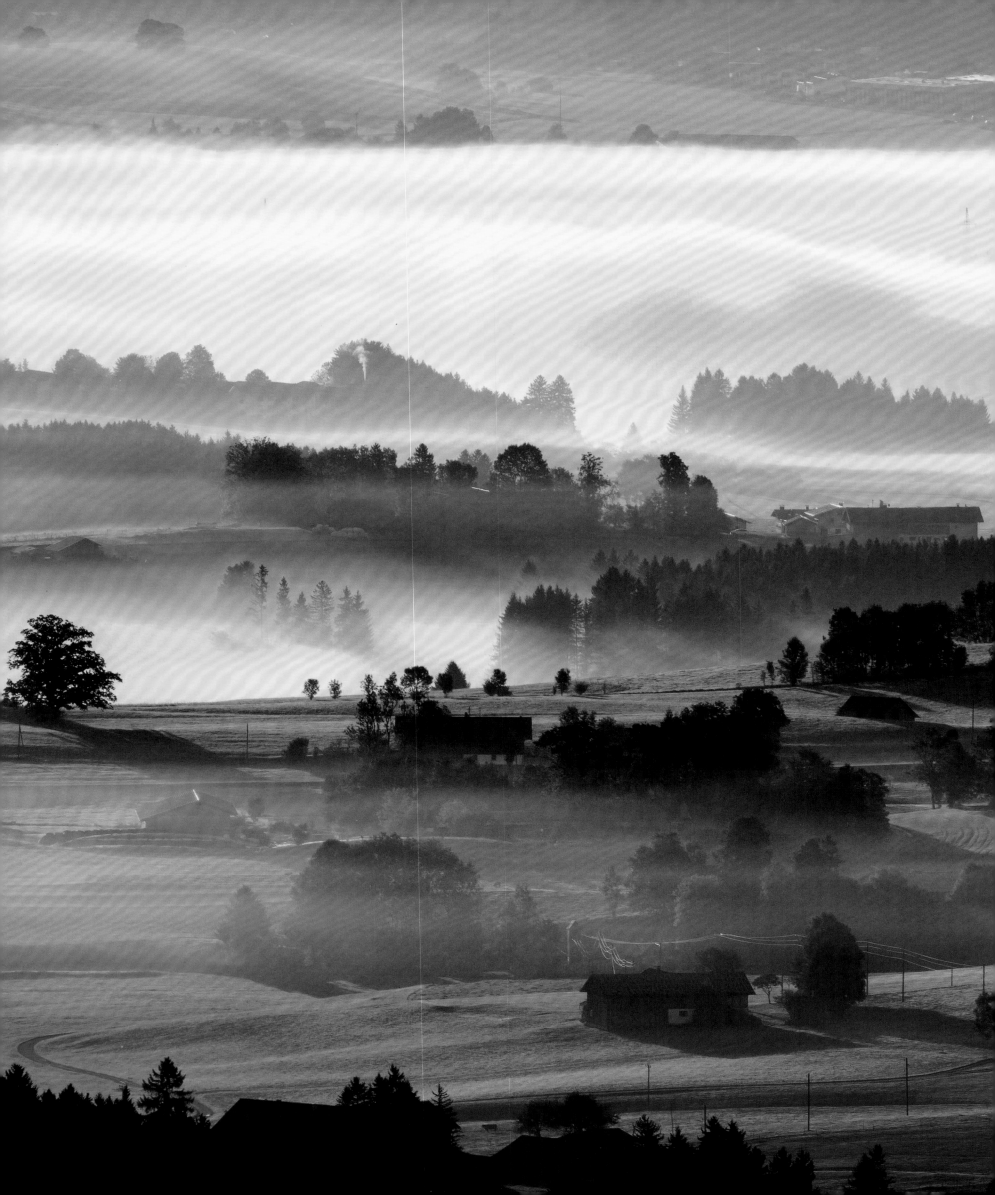

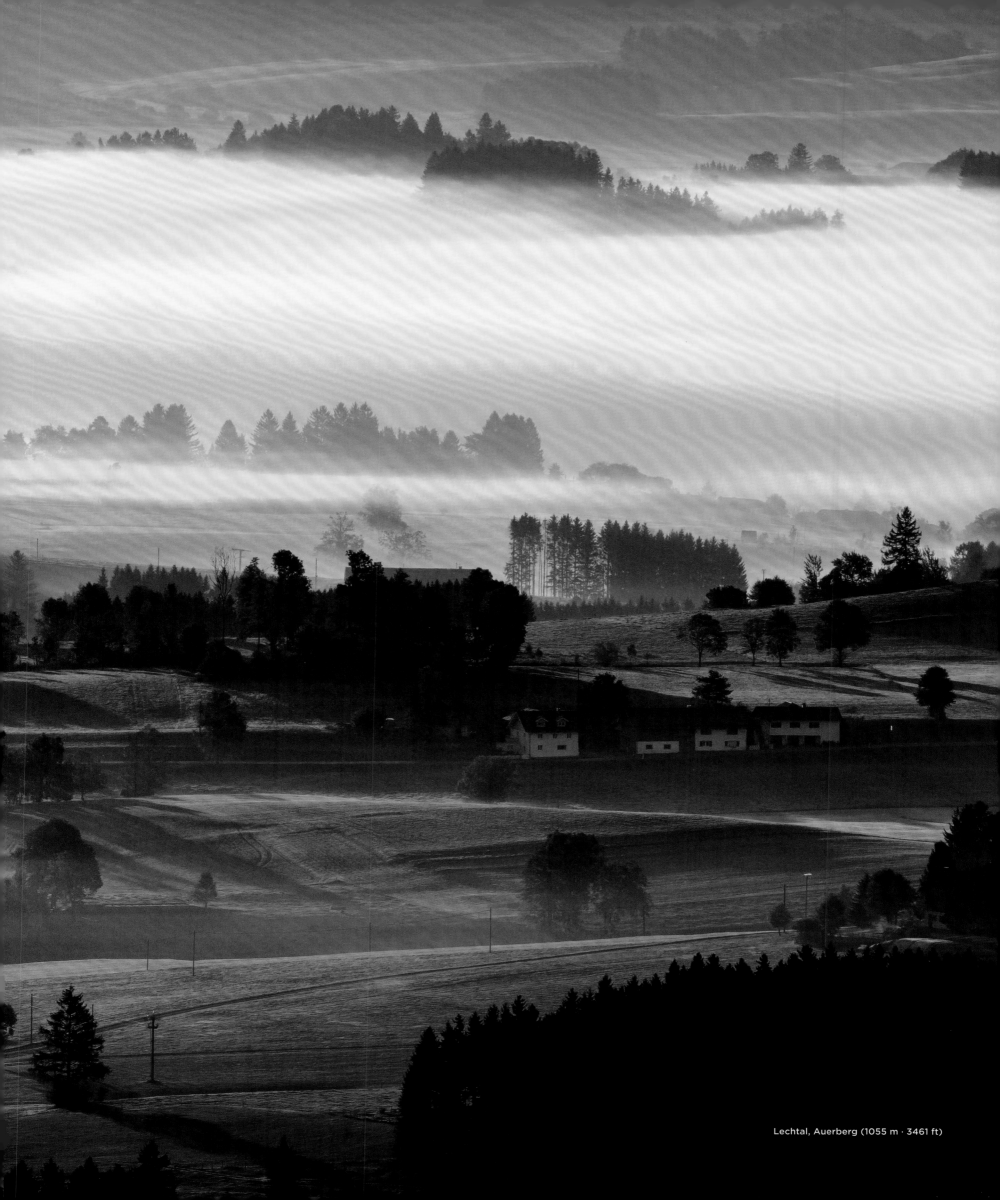

Lechtal, Auerberg (1055 m · 3461 ft)

Pilatushaus, Oberammergau

Oberammergau

Oberammergau is a small town with a big name: It became famous worldwide for the Passion Plays which take place every ten years. In 1633, the citizens vowed a performance of the Passion of Christ on stage if they were spared from the plague, and they kept this promise. In modern times the passion plays, staged at great expense, have developed into a huge attraction with half a million visitors. But the town is also worth a visit in other respects: Many of the houses are decorated with artistic paintings, the "Lüftlmalerei", which depict biblical scenes as well as fairy tales.

Oberammergau

Oberammergau est une petite commune, mais sa réputation va bien au-delà des frontières, grâce au « Jeu de la Passion » qu'elle met en scène tous les dix ans. Pour être délivrés de la peste, les habitants de la ville promirent solennellement en 1633 de jouer sur scène la Passion du Christ, et tinrent leur promesse. Aujourd'hui, le *Jeu de la Passion* est devenu une manifestation à gros budget qui attire un large public, pouvant atteindre un demi-million de visiteurs. Mais le lieu lui-même vaut également la visite : beaucoup de façades de maisons sont ornées de « Lüftlmalerei », des peintures représentant des scènes issues de la Bible ou de contes.

Oberammergau

Ein kleiner Ort mit großem Namen ist Oberammergau: Weltweit bekannt wurde er durch die alle zehn Jahre stattfindenden Passionsspiele. Für die Befreiung von der Pest gelobten 1633 die Bürger eine Aufführung der Passion Christi auf der Bühne, und sie hielten dieses Versprechen. Inzwischen haben sich die mit großem Aufwand inszenierten Passionspiele zu einem Publikumsmagneten mit einer halben Million Besuchern entwickelt. Doch auch sonst ist der Ort einen Besuch wert: Viele der Häuser sind mit kunstvollen Gemälden verziert, der „Lüftlmalerei", die biblische Szenen, aber auch Märchen darstellen.

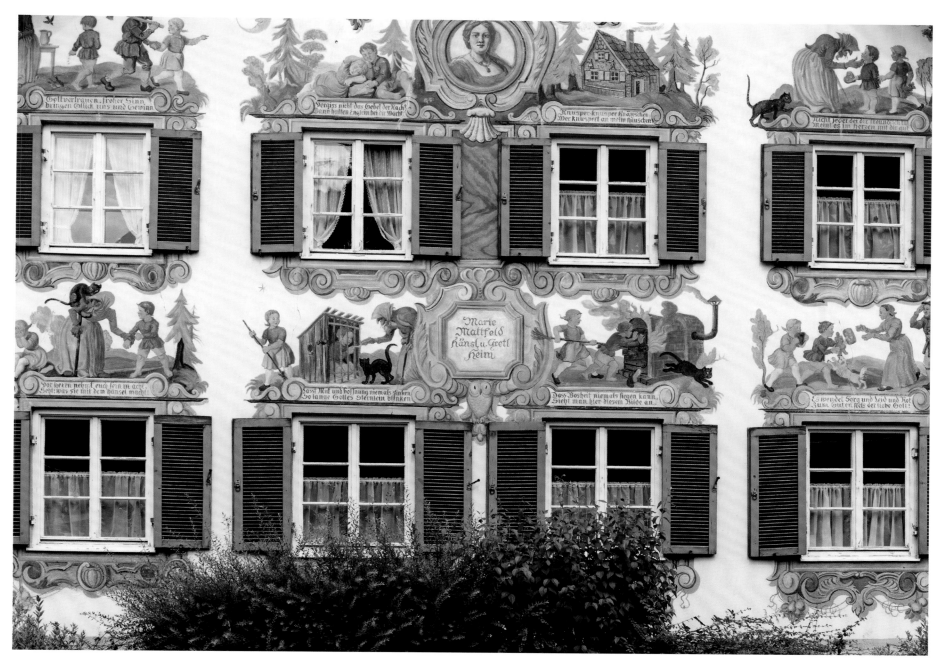

Hänsel und Gretel Haus, Oberammergau

Oberammergau

Oberammergau es una pequeña ciudad con un gran nombre: se hizo famosa en todo el mundo por la obra Pasión de Cristo, que se celebran cada diez años. En 1633, para ser liberados de la peste, los ciudadanos prometieron una representación de la Pasión de Cristo en el escenario, y cumplieron esta promesa. Las obras de teatro de la pasión, cuya puesta en escena conlleva un gran esfuerzo, se han convertido en una atracción para el público con medio millón de visitantes. Pero la ciudad también vale la pena visitarla por otros aspectos: muchas de las casas están decoradas con pinturas artísticas, las "Lüftlmalerei", que representan escenas bíblicas, pero también cuentos infantiles.

Oberammergau

Oberammergau é uma pequena cidade com um grande nome: tornou-se famosa mundialmente através das Peças da Paixão que acontecem a cada dez anos. Para a libertação da praga, em 1633, os cidadãos prometeram uma atuação da Paixão de Cristo em cena, e mantiveram esta promessa. Enquanto isso, as jogadas de paixão, encenadas com grandes custos, se transformaram em um puxador de multidões com meio milhão de visitantes. Mas a cidade também merece uma visita em outros aspectos: muitas das casas são decoradas com pinturas artísticas, os "Lüftlmalerei", que retratam cenas bíblicas, mas também contos de fadas.

Oberammergau

Oberammergau is klein, maar beroemd: de plaats verwierf wereldwijde faam door de passiespelen die hier om de tien jaar plaatsvinden. Ze ontstonden naar aanleiding van de bevrijding van de pest in 1633. Destijds beloofden de burgers het leven en lijden van Christus als toneelstuk uit te beelden, waaraan zij zich ook hielden. Intussen zijn deze passiespelen, waarvoor kosten noch moeite worden gespaard, uitgegroeid tot een attractie van jewelste met een half miljoen bezoekers. Het stadje zelf is ook een bezoek waard: veel huizen zijn versierd met muurschilderingen ('Lüftlmalereien'), die Bijbelse taferelen of sprookjes uitbeelden.

Music

Alpine music is folk music. On many occasions, secular as well as religious festivals, brass bands pass through the villages. Vocal as well as instrumental music show simple harmonies. Yodeling is a well-known vocal form, typical instruments are zither and harmonica. Of special note is the alphorn which is widespread in the German-speaking Alpine region.

Musique

La musique des Alpes est une musique folklorique. Pour de nombreuses occasions, religieuses ou profanes, on entend résonner les fanfares. Les chants comme les accompagnements présentent des harmonies simples, la cithare et l'harmonica sont des instruments typiques ; le yodel est l'une des formes les plus connues. Le cor des Alpes est un instrument très particulier que l'on trouve dans les Alpes germanophones.

Musik

Alpenländische Musik ist Volksmusik. Bei vielen Gelegenheiten, weltlichen wie religiösen Festen, ziehen Blaskapellen durch die Orte. Gesang wie Begleitung arbeiten mit einfachen Harmonien, bekannt ist das Jodeln, typische Instrumente sind Zither und Harmonika. Eine Besonderheit ist das im deutschsprachigen Alpenraum verbreitete Alphorn.

Música

La música alpina es música folclórica. En muchas ocasiones, tanto en las fiestas laicas como en las religiosas, las bandas de música van pasando por los pueblos. Tanto el canto como el acompañamiento trabajan con armonías simples; se conoce el canto a la tirolesa, y los instrumentos típicos son la cítara y la armónica. Una característica especial es la trompa alpina, que está muy extendida en la región alpina de habla alemana.

Música

A música alpina é música folclórica. Em muitas ocasiões, festivais seculares e religiosos, bandas de música passam pelas aldeias. Canto, bem como o trabalho de acompanhamento com harmonias simples, yodeling é conhecido, instrumentos típicos são cítara e harmônica. Uma característica especial é o alfabeto, muito difundido na região alpina de língua alemã.

Muziek

Alpenmuziek is volksmuziek. Bij veel gelegenheden, zowel wereldse als religieuze feesten, trekken fanfares door de dorpen. Zowel het gezang als de begeleiding baseert op eenvoudige harmonieën. Ook erg bekend is het jodelen, evenals typische instrumenten als citer en accordeon. Minder typisch is de alpenhoorn, die alleen in het Duitstalige alpengebied voorkomt.

DRUM CORPS

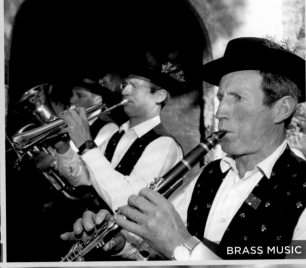

BRASS MUSIC

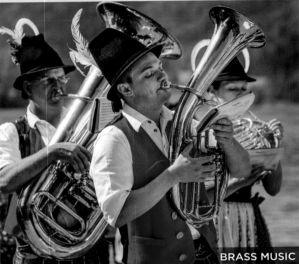

BRASS MUSIC

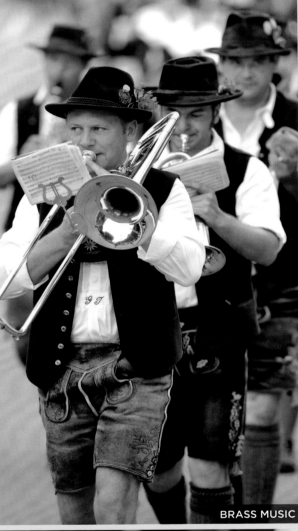

BRASS MUSIC

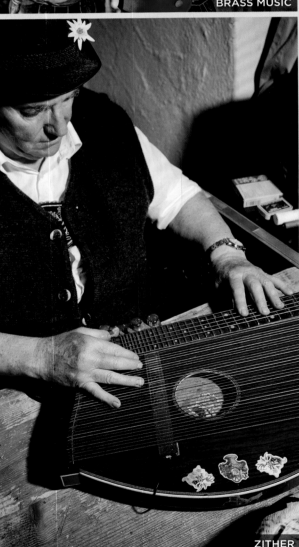

ZITHER

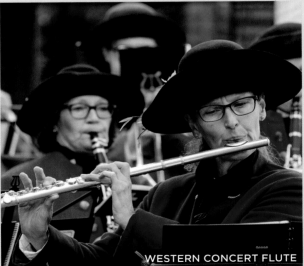

WESTERN CONCERT FLUTE

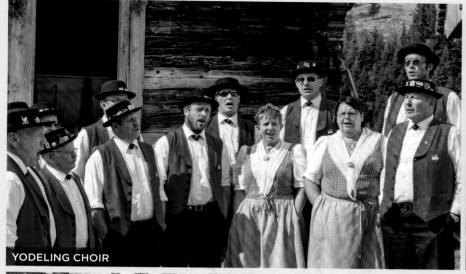
YODELING CHOIR

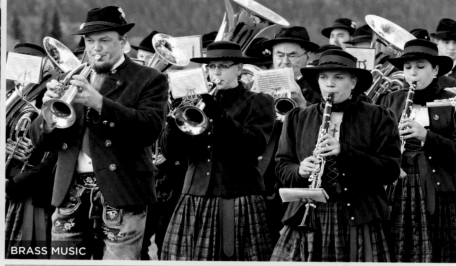
BRASS MUSIC

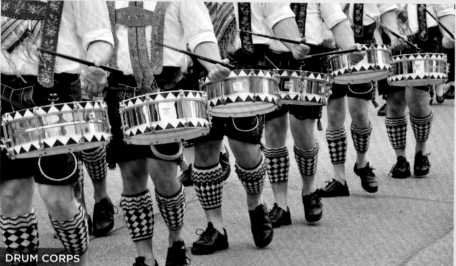
DRUM CORPS

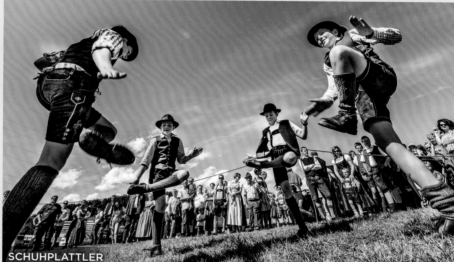
SCHUHPLATTLER

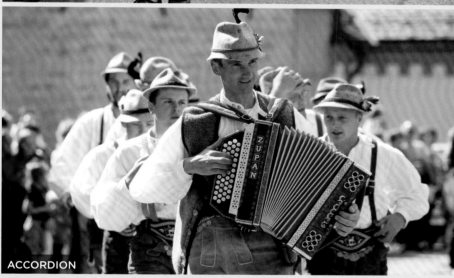
ACCORDION

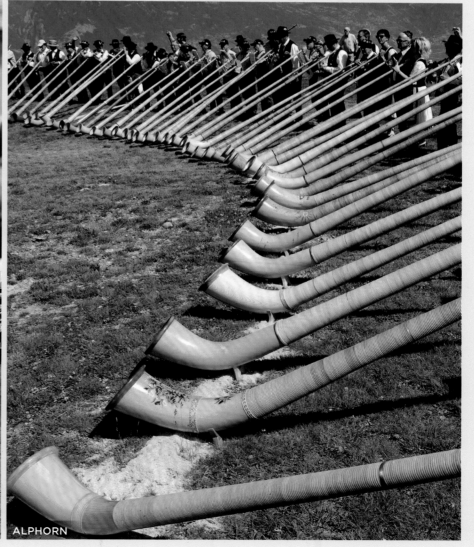
ALPHORN

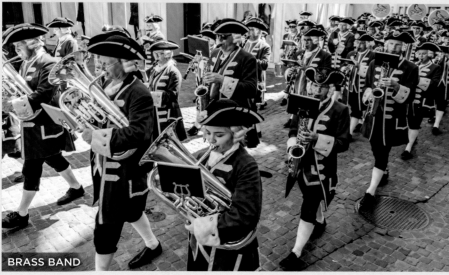
BRASS BAND

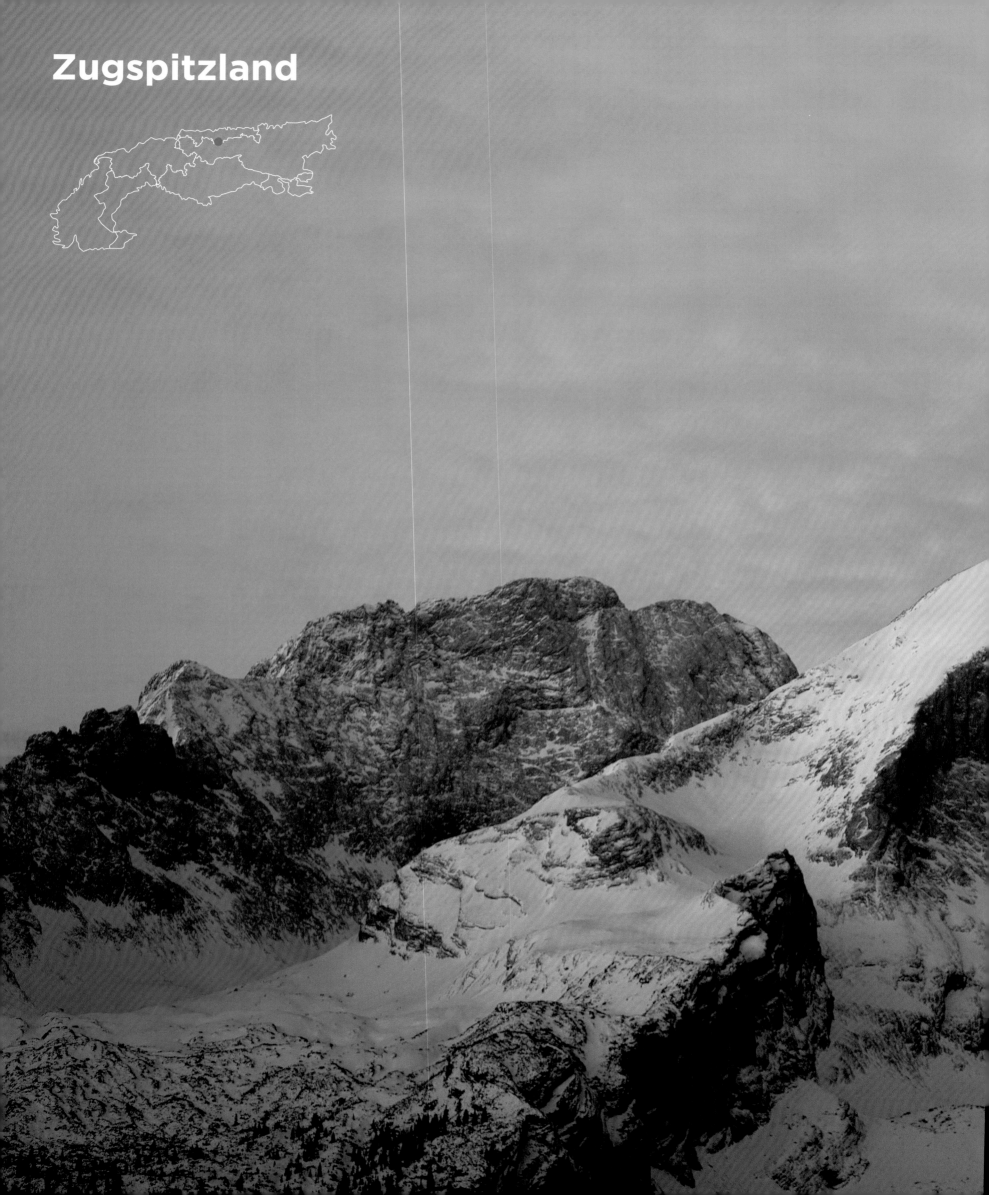

Zugspitzland

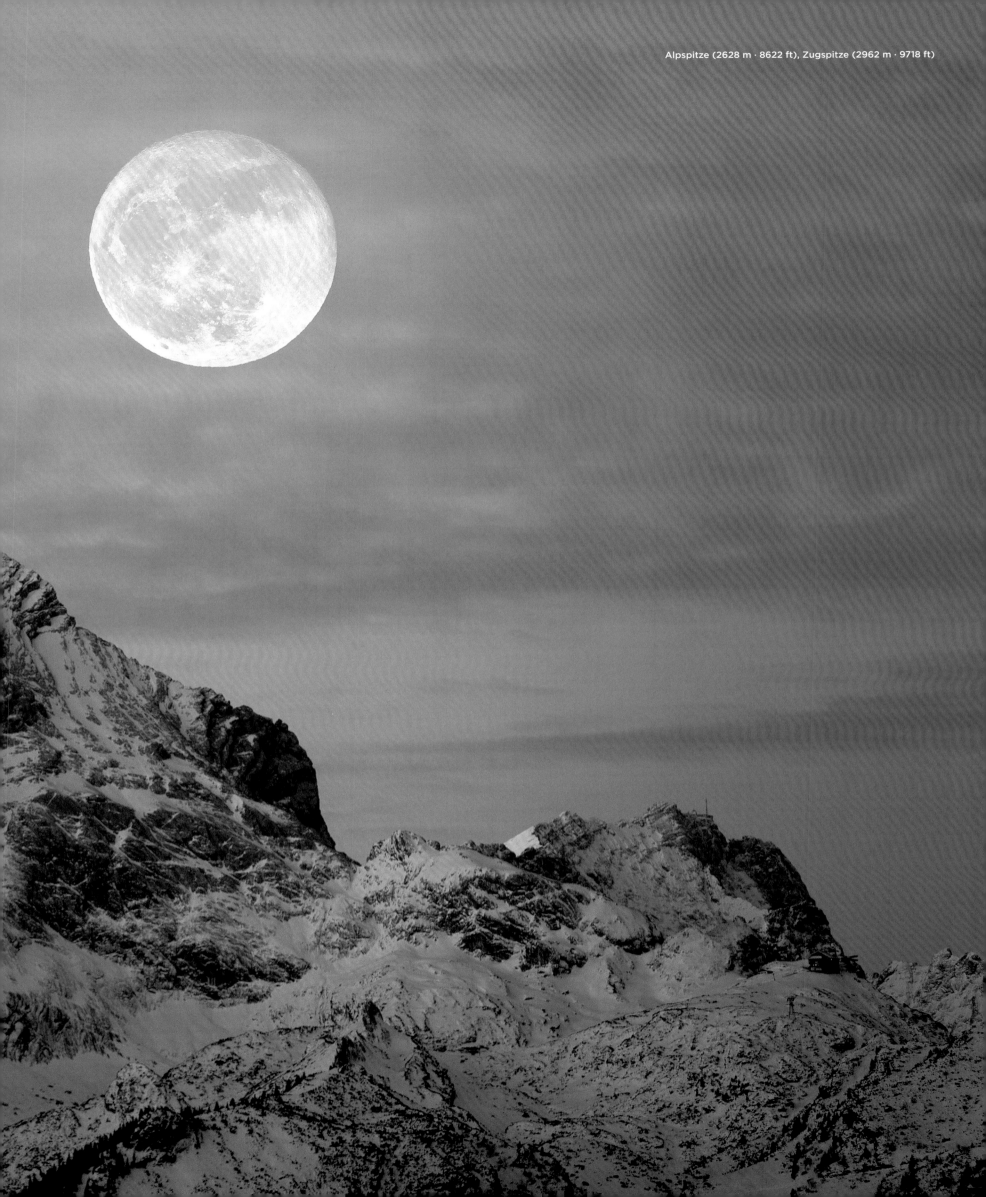

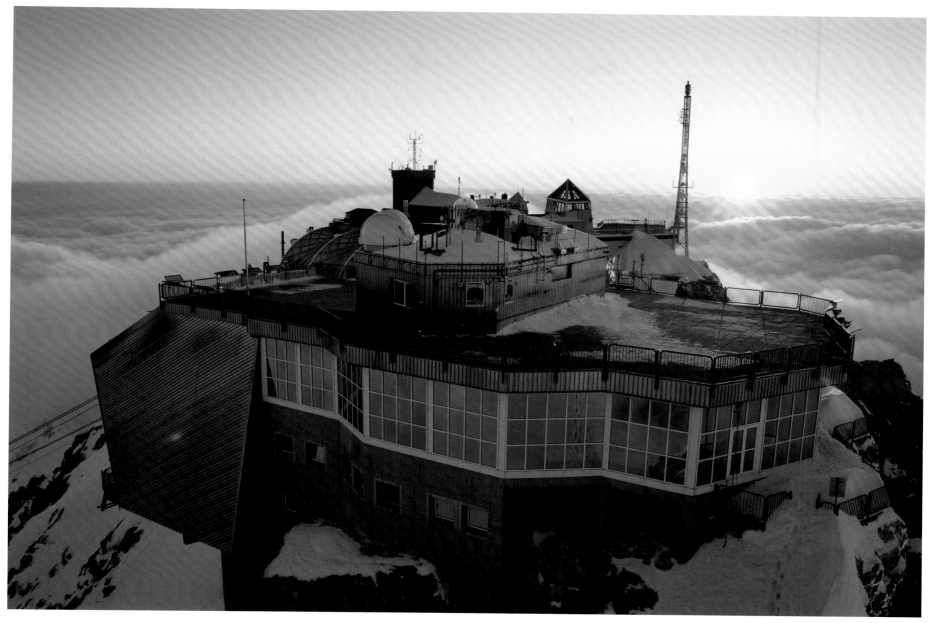

Bergstation, Zugspitze (2962 m · 9718 ft)

Zugspitzland

At 2962 m (9718 ft), the Zugspitze is Germany's highest mountain. First climbed in 1820, the summit is now an attraction easily accessed with rack railway and cable car by half a million visitors a year. Immediately below the summit, the Schneefernerhaus houses the Zugspitzbahn station, which has been used as a research facility since 1999.

Le Zugspitzland

La Zugspitze, qui culmine à 2962 m, est le plus haut sommet d'Allemagne. Sa première ascension attestée remonte à 1820. Aujourd'hui, ce sommet est aisément accessible grâce à un chemin de fer à crémaillère et à un téléphérique, et il attire chaque année un demi-million de visiteurs. Juste en dessous du sommet, l'ancien hôtel *Schneefernerhaus* servait autrefois de gare au chemin de fer de la Zugspitze et est utilisé depuis 1999 comme station de recherche.

Zugspitzland

Mit 2962 m ist die Zugspitze Deutschlands höchster Berg. Erstmals bestiegen wurde er 1820. Heute ist der Gipfel eine mit Zahnradbahn und Seilbahn leicht erreichbare Attraktion für jährlich eine halbe Million Besucher. Unmittelbar unterhalb des Gipfels beherbergt das Schneefernerhaus den Bahnhof der Zugspitzbahn, seit 1999 wird es als Forschungsstation genutzt.

Zugspitzland

Con 2962 m, el Zugspitze es la montaña más alta de Alemania. La cima, a la que se subió por primera vez en 1820, es ahora una atracción de fácil acceso para medio millón de visitantes al año en ferrocarril de cremallera y teleférico. Justo debajo de la cima, el Schneefernerhaus alberga la estación del ferrocarril Zugspitze, que ha sido utilizada como estación de investigación desde 1999.

Zugspitzland

A 2962 m, o Zugspitze é a montanha mais alta da Alemanha. Primeiro escalado em 1820, o cume é agora uma atração de fácil acesso para meio milhão de visitantes por ano por meio de um trem e teleférico. Imediatamente abaixo do cume, o Schneefernerhaus abriga a estação de Zugspitzbahn, que é utilizada como estação de pesquisa desde 1999.

Zugspitzland

Met 2962 m is de Zugspitze de hoogste top van Duitsland. De berg werd in 1820 voor het eerst beklommen en is tegenwoordig dankzij de tandradbaan en kabelbaan een gemakkelijk te bereiken attractie voor een half miljoen bezoekers per jaar. Direct onder de top staat het Schneefernerhaus, dat vroeger het station van de Zugspitzbahn herbergde, maar sinds 1999 als onderzoeksstation in gebruik is.

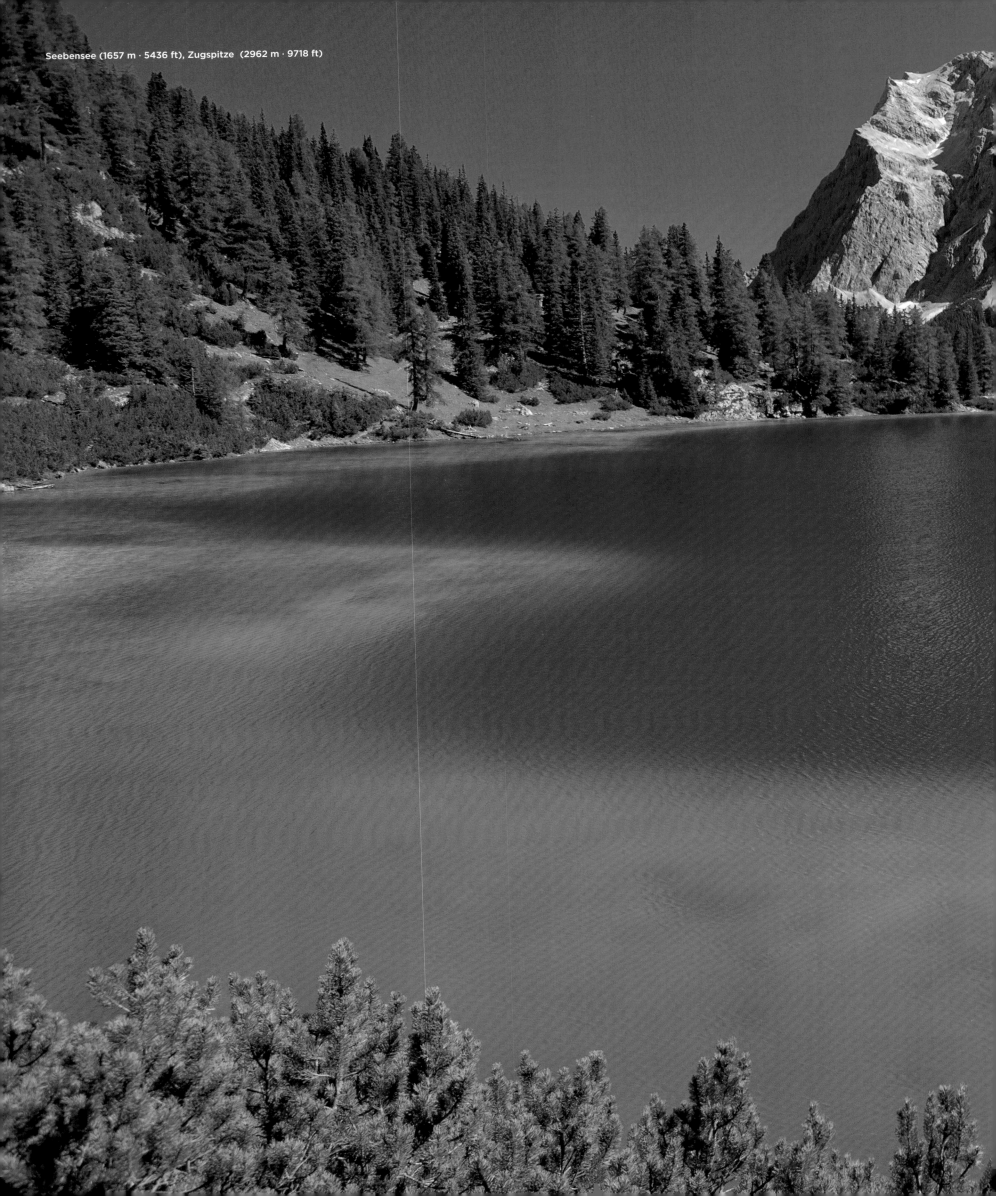

Seebensee (1657 m · 5436 ft), Zugspitze (2962 m · 9718 ft)

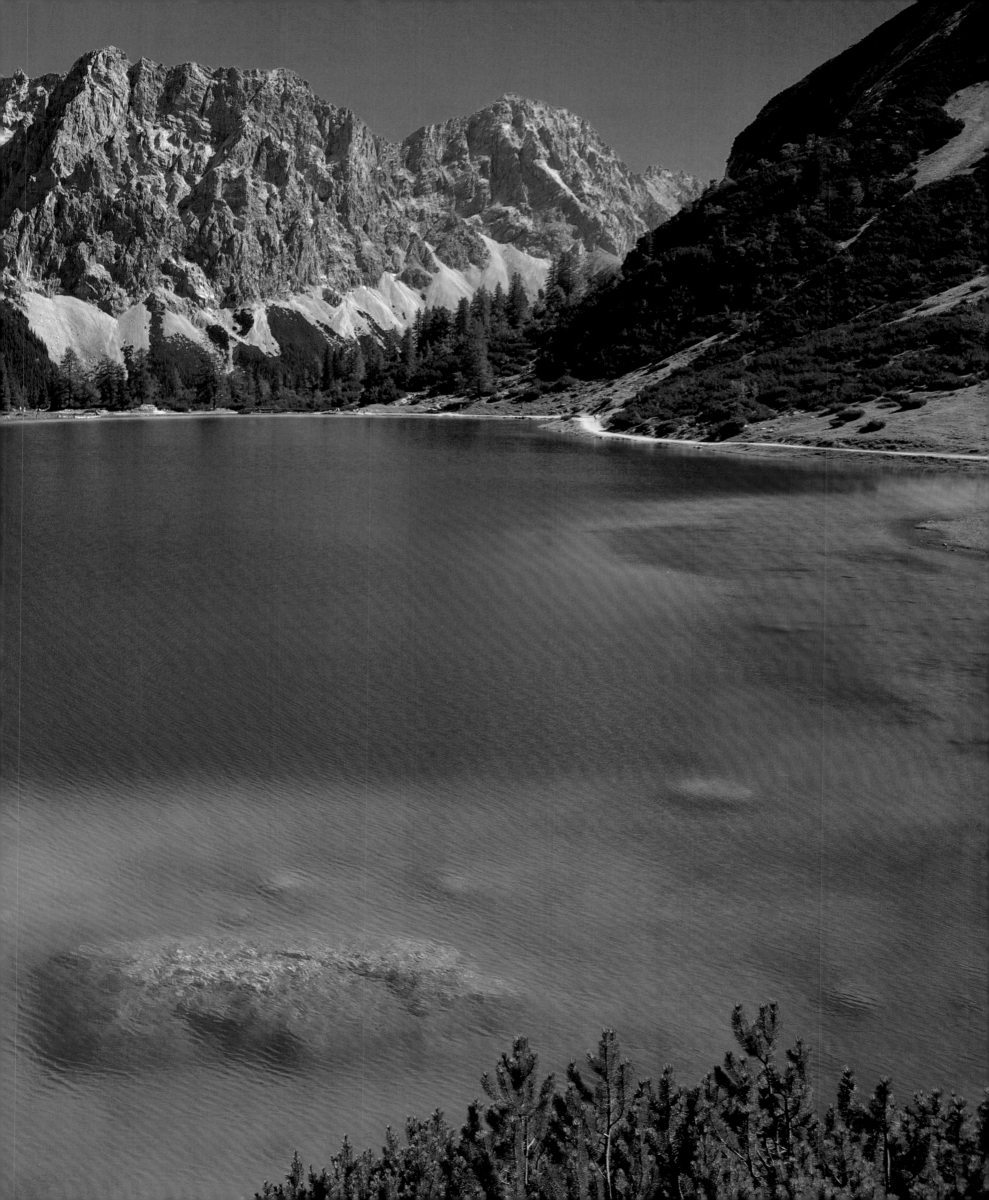

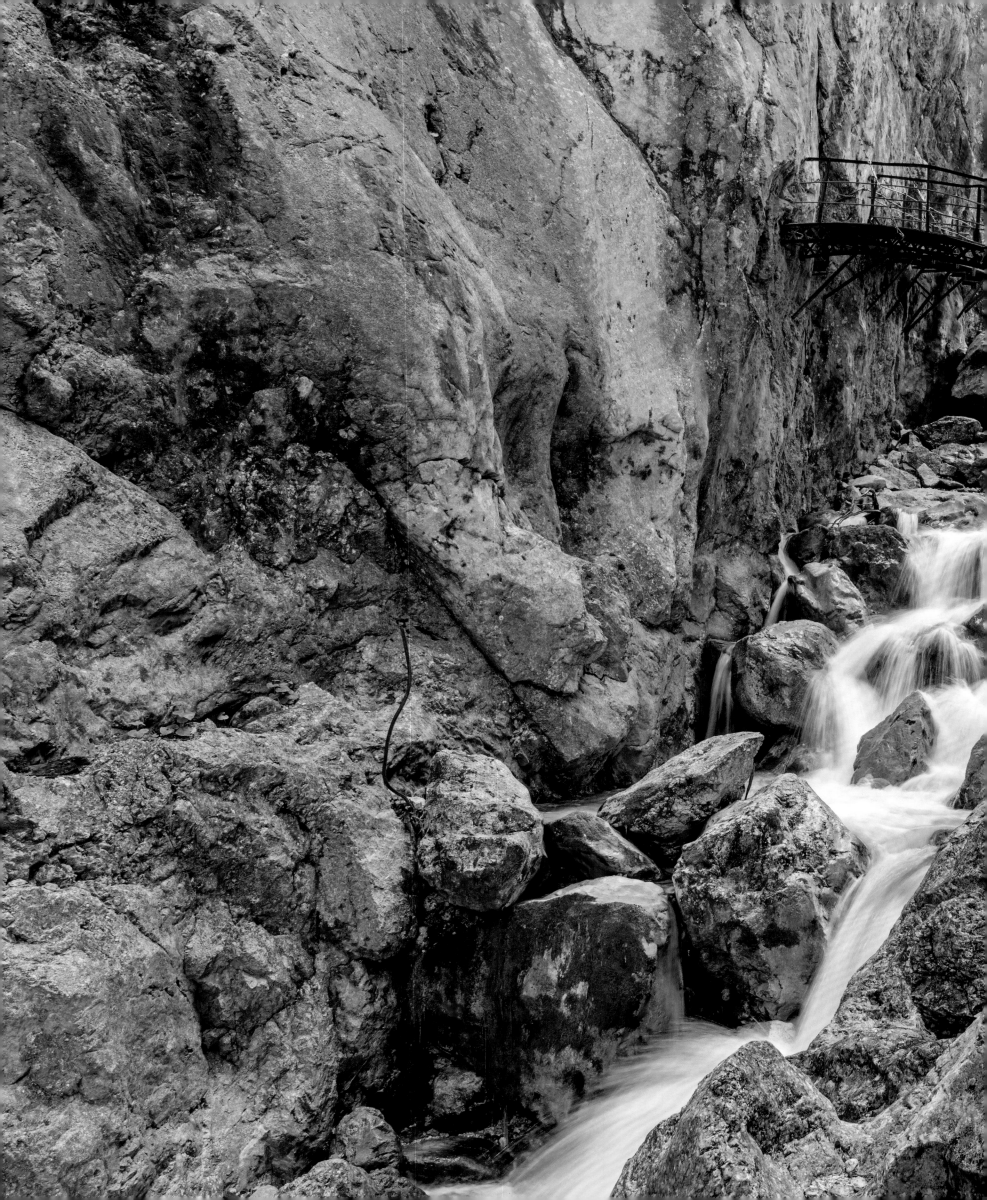

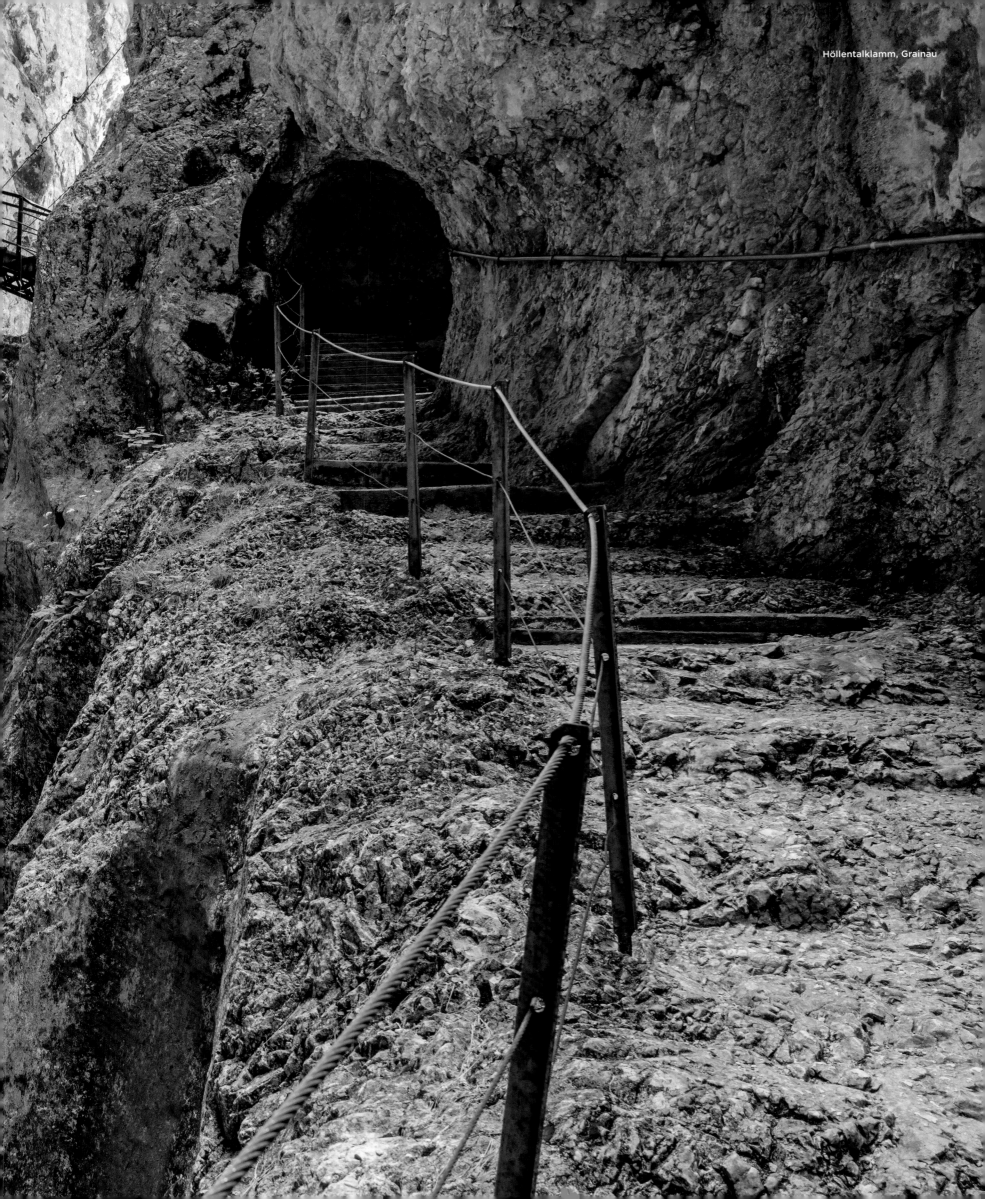

Höllentalklamm, Grainau

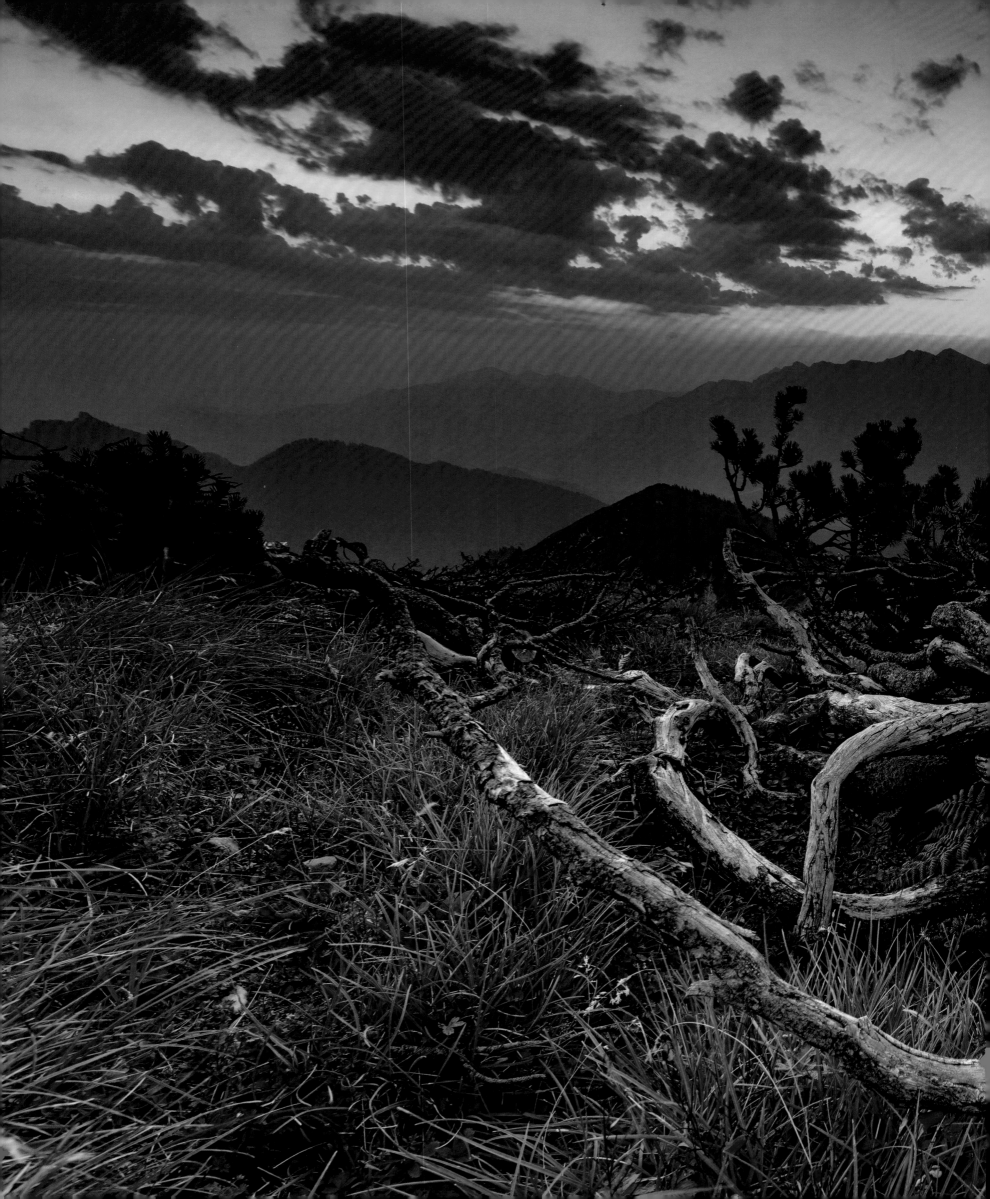

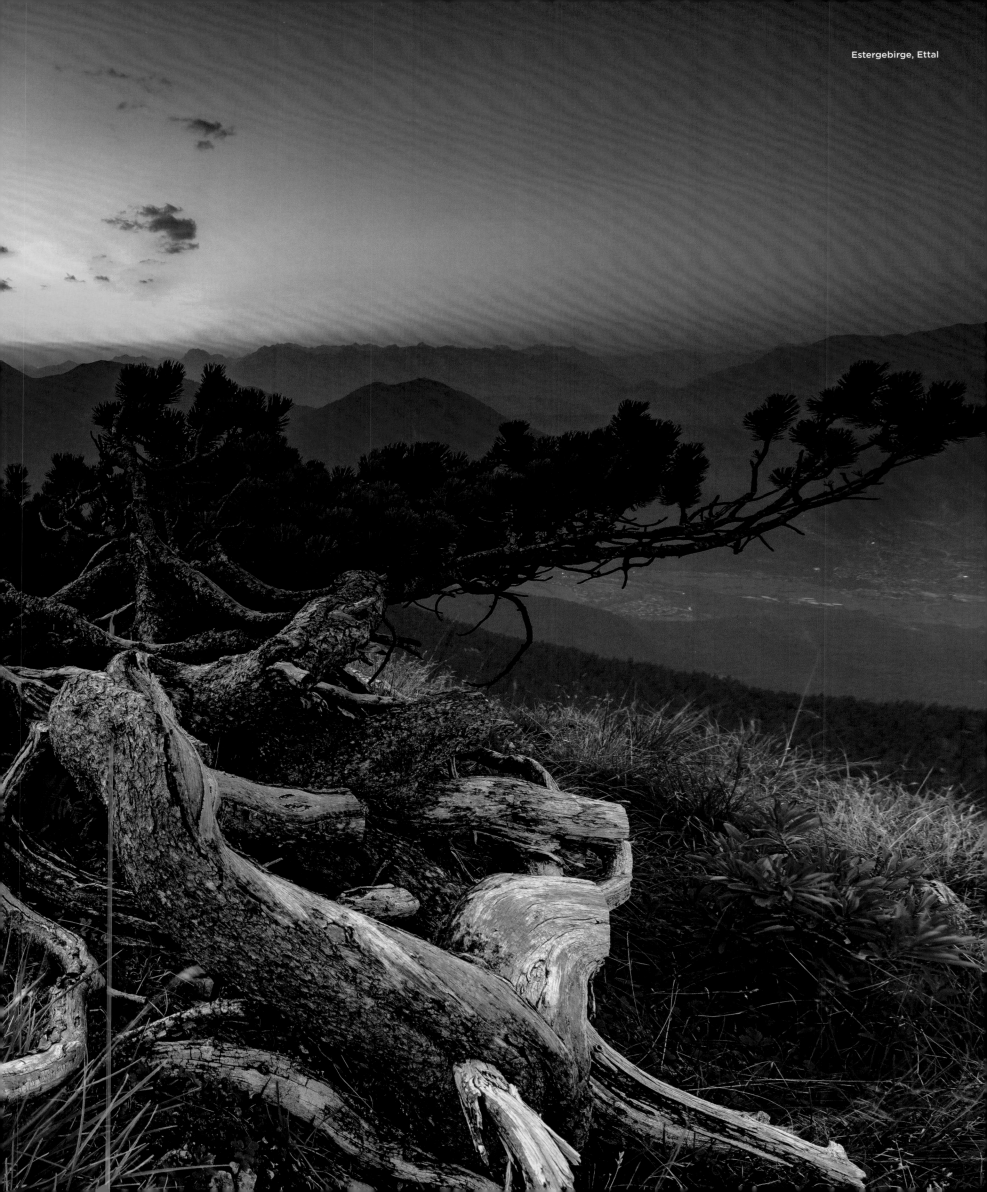

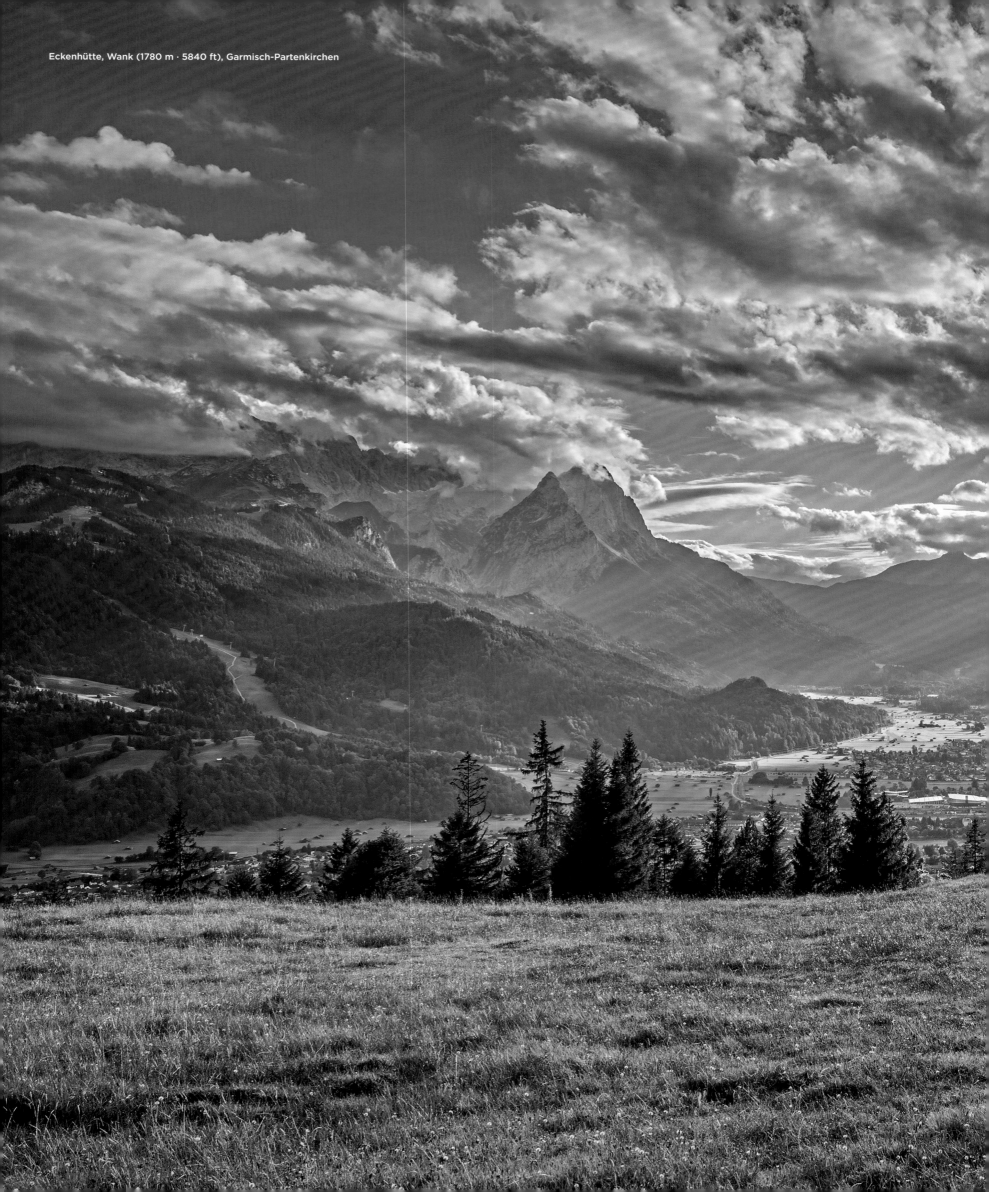

Eckenhütte, Wank (1780 m · 5840 ft), Garmisch-Partenkirchen

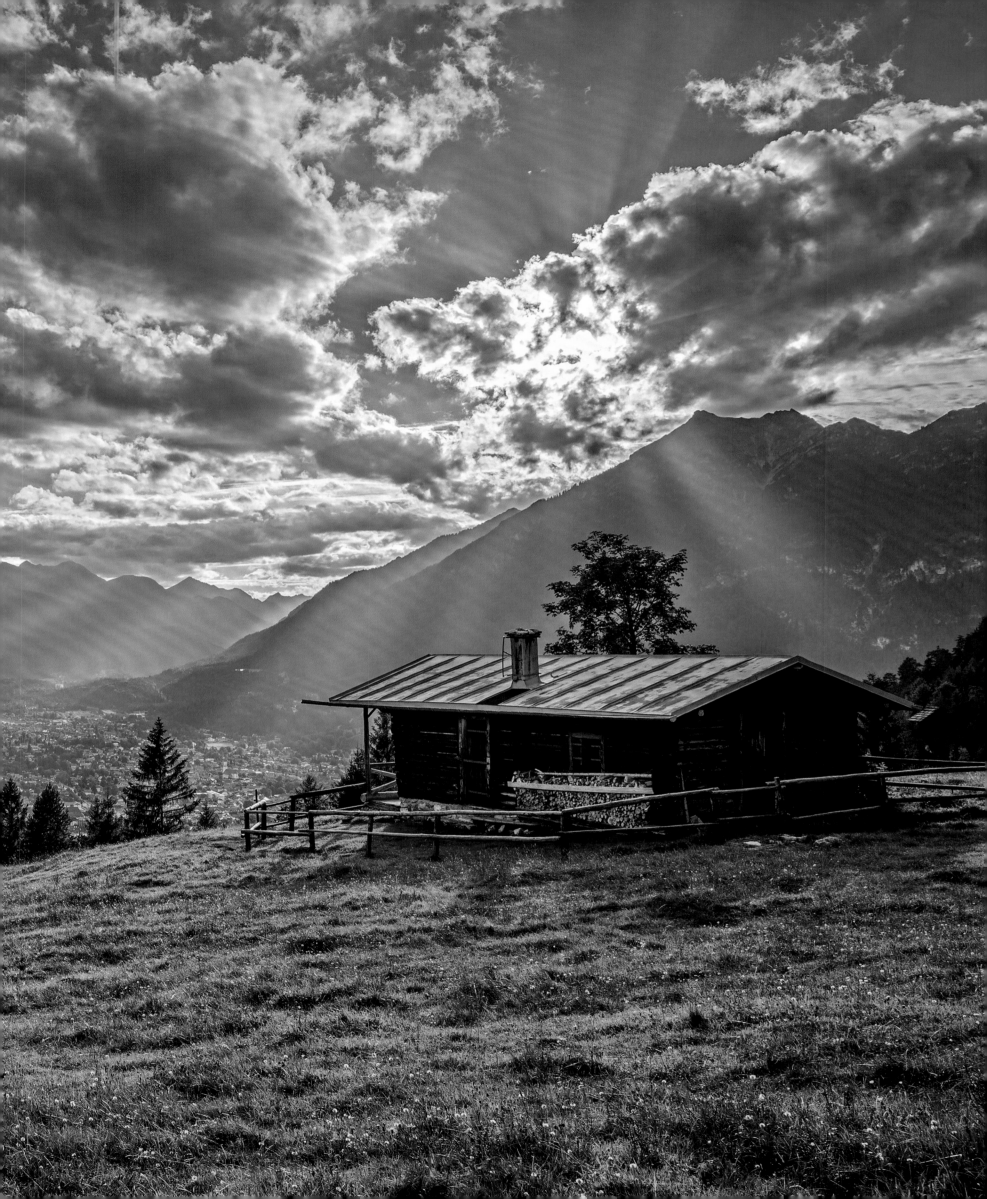

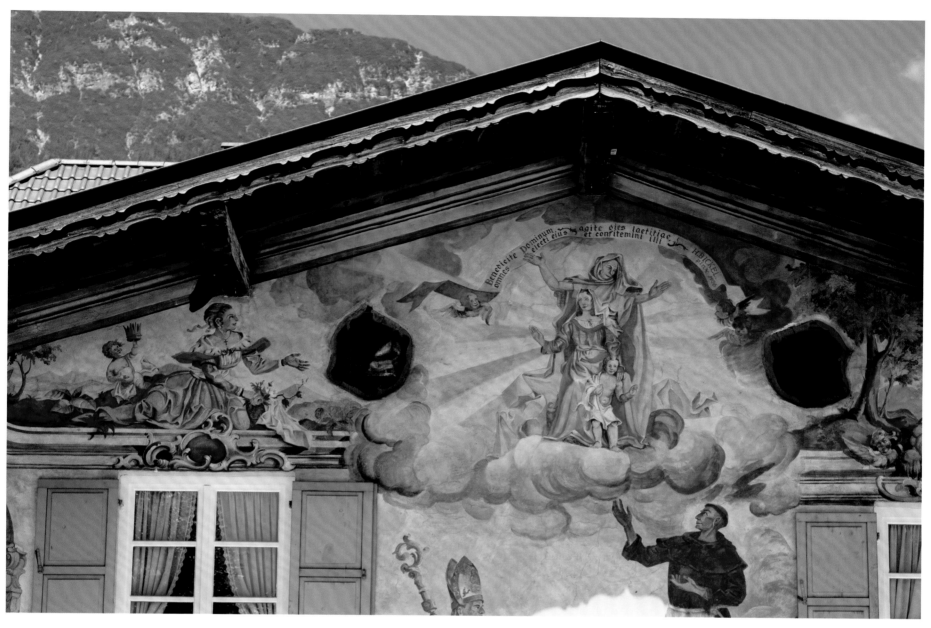

Sorge-Haus, Garmisch-Partenkirchen

Garmisch-Partenkirchen

The Alpine panorama of Garmisch-Partenkirchen is apparently extremely inspiring: Numerous artists and intellectuals settled here or regularly visited the town with its beautifully decorated houses. Richard Strauss composed the great *Alpine Symphony* in Garmisch-Partenkirchen, Erich Kästner and Kurt Tucholsky wrote verse and prose and Ernst Bloch philosophical texts here.

Garmisch-Partenkirchen

Il semblerait que la vue sur les Alpes que l'on a de Garmisch-Partenkirchen apporte de l'inspiration : nombre d'artistes et d'intellectuels choisirent de s'installer ici ou de venir régulièrement se ressourcer dans ce bourg aux si jolies maisons. C'est ici que naquirent la magnifique *Symphonie alpestre* de Richard Strauss, plusieurs poèmes d'Erich Kästner et Kurt Tucholsky et différents travaux de philosophie d'Ernst Bloch.

Garmisch-Partenkirchen

Das Alpenpanorama von Garmisch-Partenkirchen wirkt offenbar inspirierend: Zahlreiche Künstler und Intellektuelle ließen sich hier nieder oder besuchten den Ort mit den schön verzierten Häusern regelmäßig. Richard Strauss komponierte hier die großartige *Alpensinfonie,* Erich Kästner und Kurt Tucholsky dichteten und Ernst Bloch philosophierte.

Garmisch-Partenkirchen

El panorama alpino de Garmisch-Partenkirchen es aparentemente inspirador: numerosos artistas e intelectuales se establecieron aquí o visitaron regularmente la ciudad con sus casas bellamente decoradas. Richard Strauss compuso aquí la gran *Sinfonía Alpina,* Erich Kästner y Kurt Tucholsky escribieron poesía y Ernst Bloch filosofó.

Garmisch-Partenkirchen

O panorama alpino de Garmisch-Partenkirchen é aparentemente inspirador: numerosos artistas e intelectuais se estabeleceram aqui ou visitaram regularmente a cidade com as suas casas decoradas com beleza. Richard Strauss compôs a grande *Sinfonia Alpina* aqui, Erich Kästner e Kurt Tucholsky escreveram poesia e Ernst Bloch filosofou.

Garmisch-Partenkirchen

Het alpenpanorama vanuit Garmisch-Partenkirchen heeft altijd kunstenaars en intellectuelen geïnspireerd. Sommigen vestigden zich hier of bezochten de stad met zijn prachtig versierde huizen regelmatig. Richard Strauss componeerde hier bijvoorbeeld zijn *Eine Alpensinfonie,* Erich Kästner en Kurt Tucholsky schreven er gedichten en Ernst Bloch kwam ernaartoe om te filosoferen.

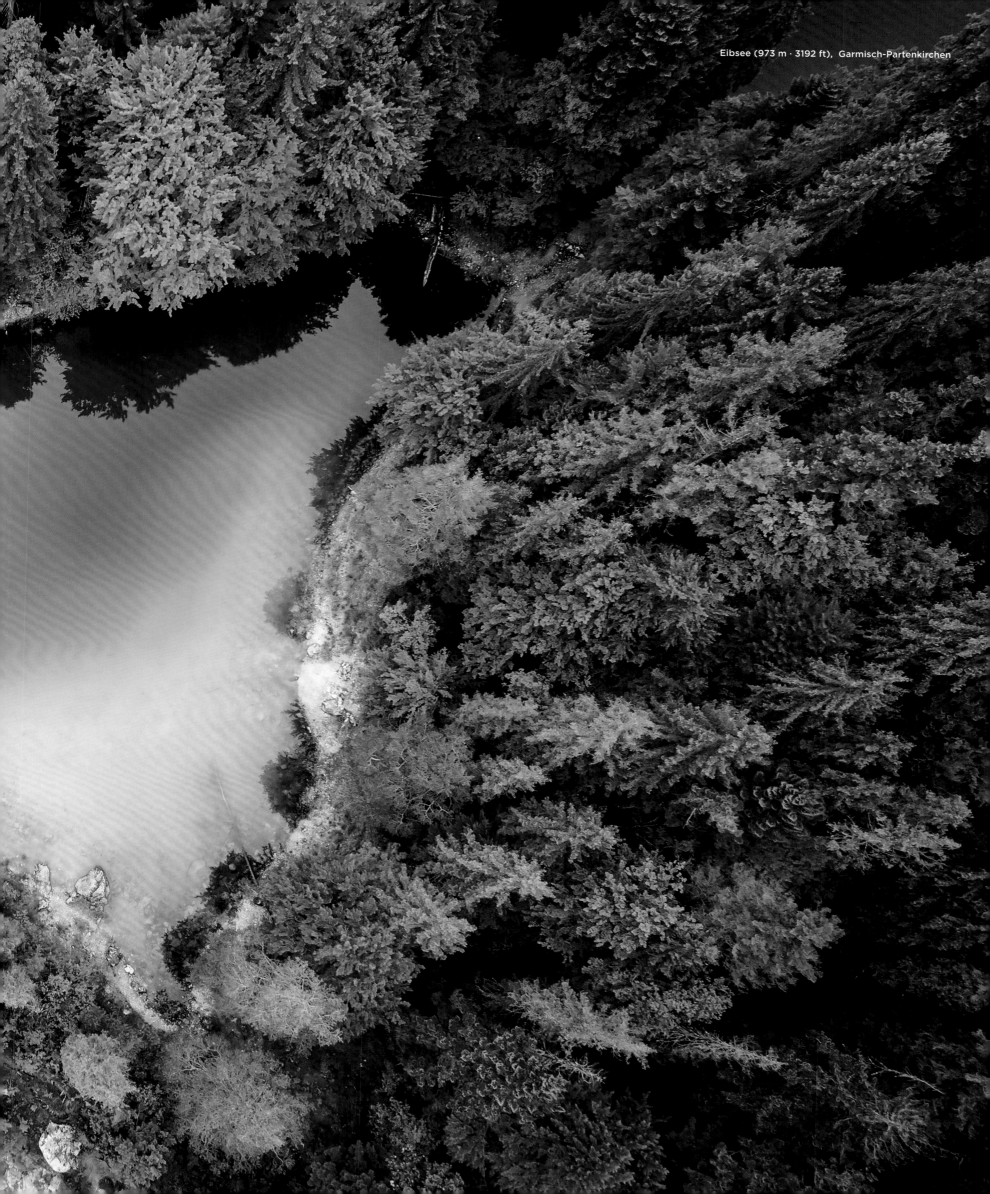

Eibsee (973 m · 3192 ft), Garmisch-Partenkirchen

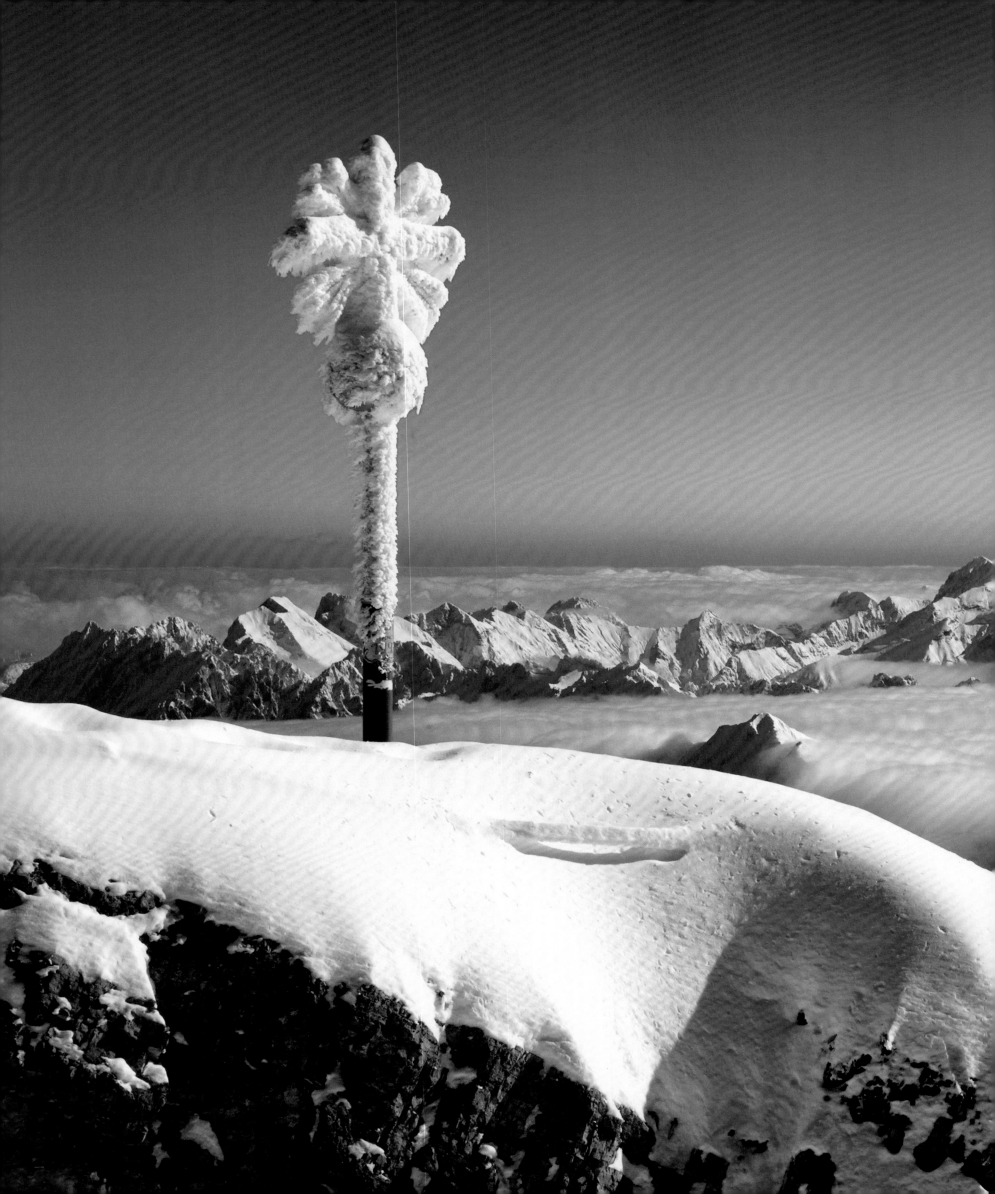

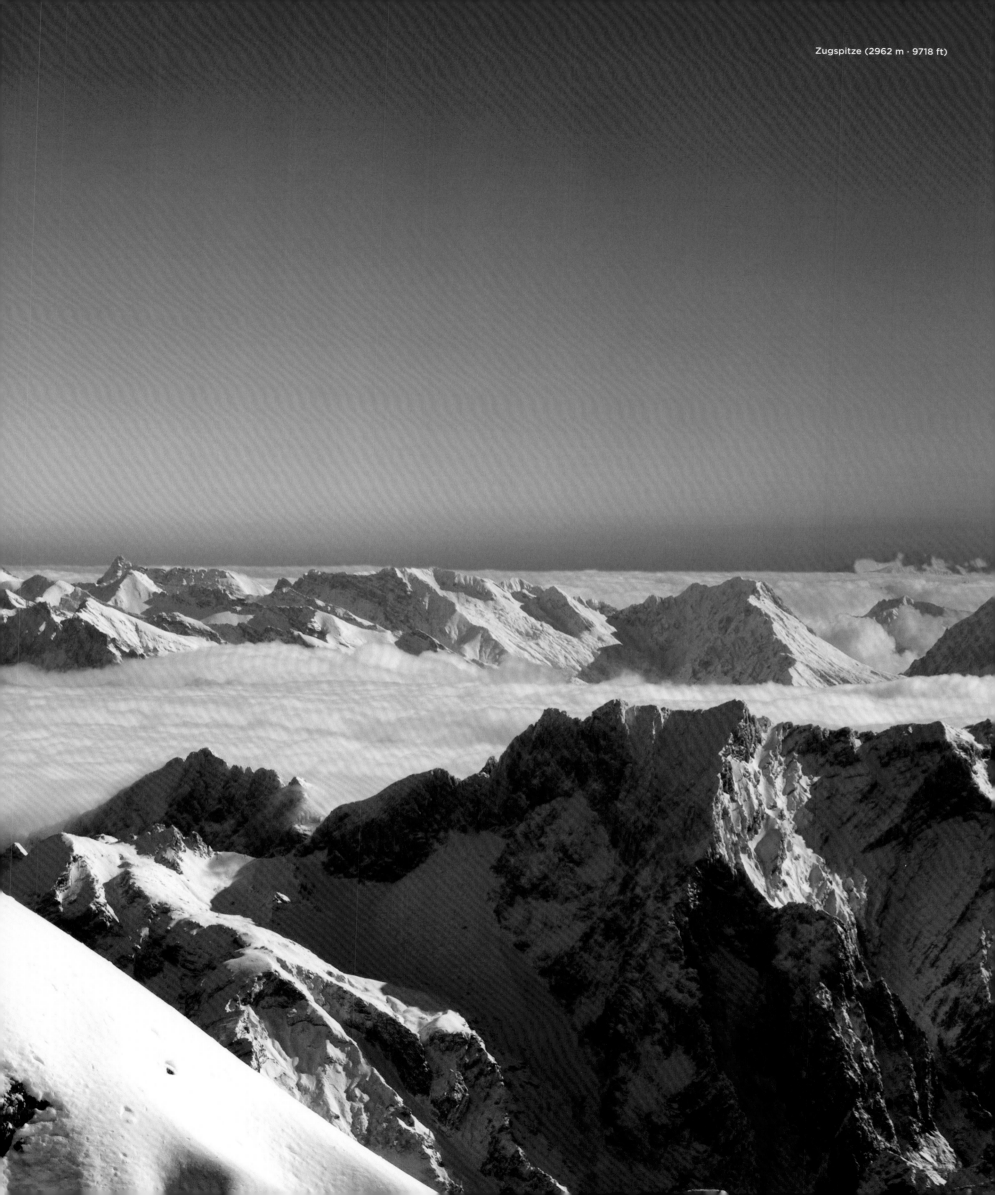

Zugspitze (2962 m · 9718 ft)

Chiemgau & Berchtesgadener Land

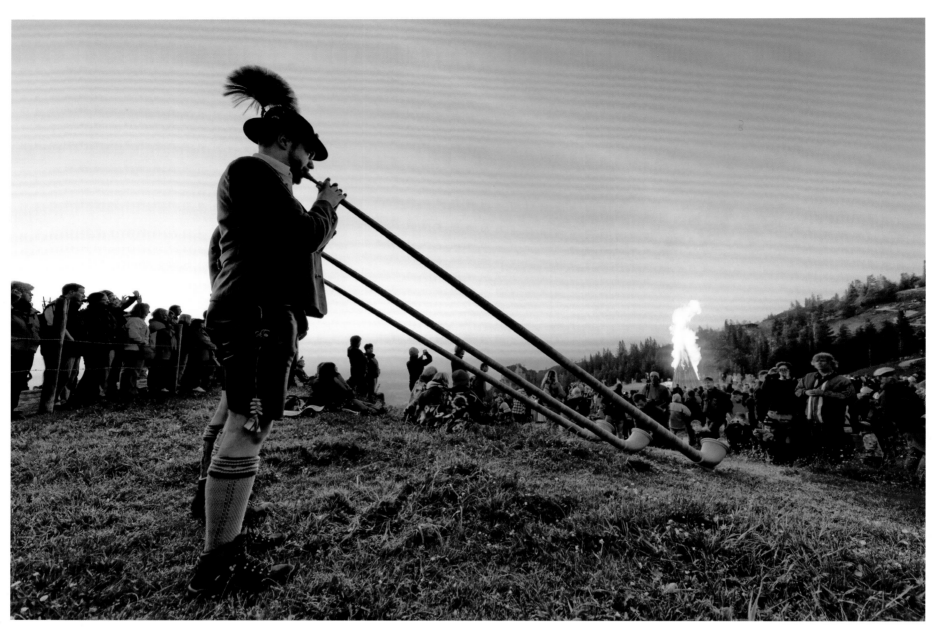

Sonnwendfeier, Kampenwand
Solstice, Kampenwand
Feu de joie, Kampenwand

Midsummer Bonfires, Kampenwand

Igniting solstice fires is an ancient, originally pagan custom. On the night of the summer solstice, the shortest night of the year, sometimes also on June 24th, St. John's Day, there are celebrations. Countless fires light up on the hills and mountaintops on the horizon. The musical framework is provided by alphorn players with their quaint instruments.

Les feux de joie de la Saint-Jean sur le Kampenwand

Les feux de joie sont une coutume païenne ancestrale. Dans la nuit du solstice d'été, la plus courte de l'année, ou bien le 24 juin, jour de la Saint-Jean, la fête bat son plein. Sur toutes les montagnes alentour, on voit briller d'innombrables feux. Les joueurs de cor des Alpes accompagnent les festivités avec leur instrument traditionnel.

Sonnwendfeuer, Kampenwand

Sonnwendfeuer zu entzünden, ist ein uralter, ursprünglich heidnischer Brauch. In der Nacht der Sommersonnenwende, der kürzesten Nacht des Jahres, manchmal auch am 24. Juni, dem Johannistag, wird gefeiert. Auf den Bergkuppen am Horizont leuchten dann zahllose Feuer. Die musikalische Umrahmung liefern Alphornbläser mit ihren urtümlichen Instrumenten.

Hogueras en el solsticio, Kampenwand

Encender la hoguera del solsticio es una costumbre antigua, originalmente pagana. La noche del solsticio de verano, la noche más corta del año, a veces también el 24 de junio, el día de San Juan, hay una celebración. En las cimas de las colinas en el horizonte se encienden innumerables hogueras. El marco musical lo proporcionan los músicos de la trompa alpina con sus instrumentos originales.

Luzes de Verão, Kampenwand

Ignorar o fogo do solstício é um costume antigo, originalmente pagão. Na noite do solstício de Verão, a noite mais curta do ano, por vezes também a 24 de Junho, Dia de São João, há uma celebração. No topo das colinas, no horizonte, acendem-se inúmeros incêndios. O quadro musical é fornecido por jogadores alfabéticos com os seus instrumentos originais.

Zonnewendevuur, Kampenwand

Zonnewendevuren zijn een oeroud, oorspronkelijk heidens gebruik. Het zonnewendevuur op de Kampenwand wordt ontstoken in de nacht van de zomerzonnewende, de kortste nacht van het jaar, soms ook op 24 juni, Sint-Jansdag. Ook op heuveltoppen in de omgeving zijn dergelijke vuren te bewonderen. Voor de muzikale omlijsting zorgen alpenhoornspelers met hun traditionele instrumenten.

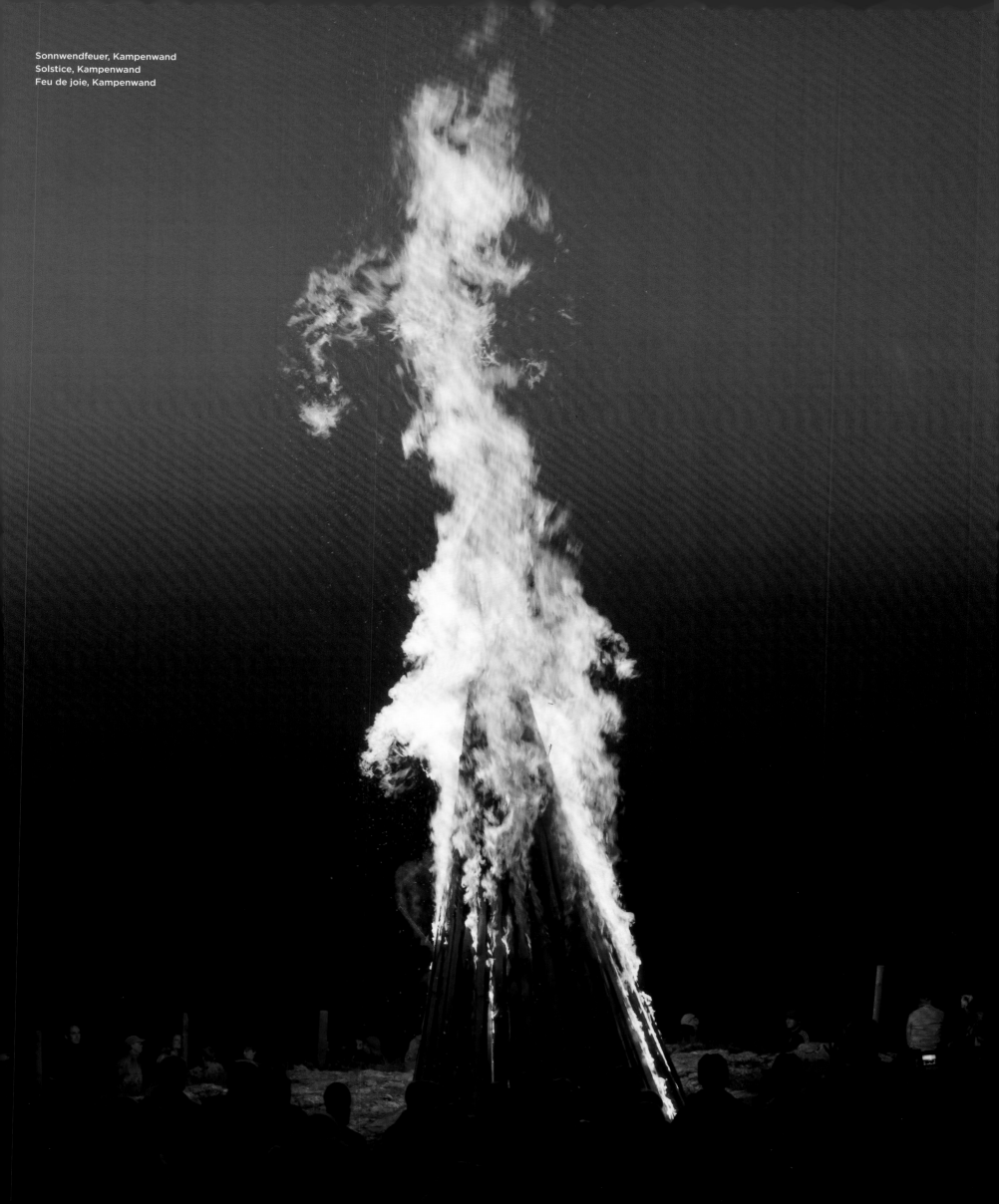

Sonnwendfeuer, Kampenwand
Solstice, Kampenwand
Feu de joie, Kampenwand

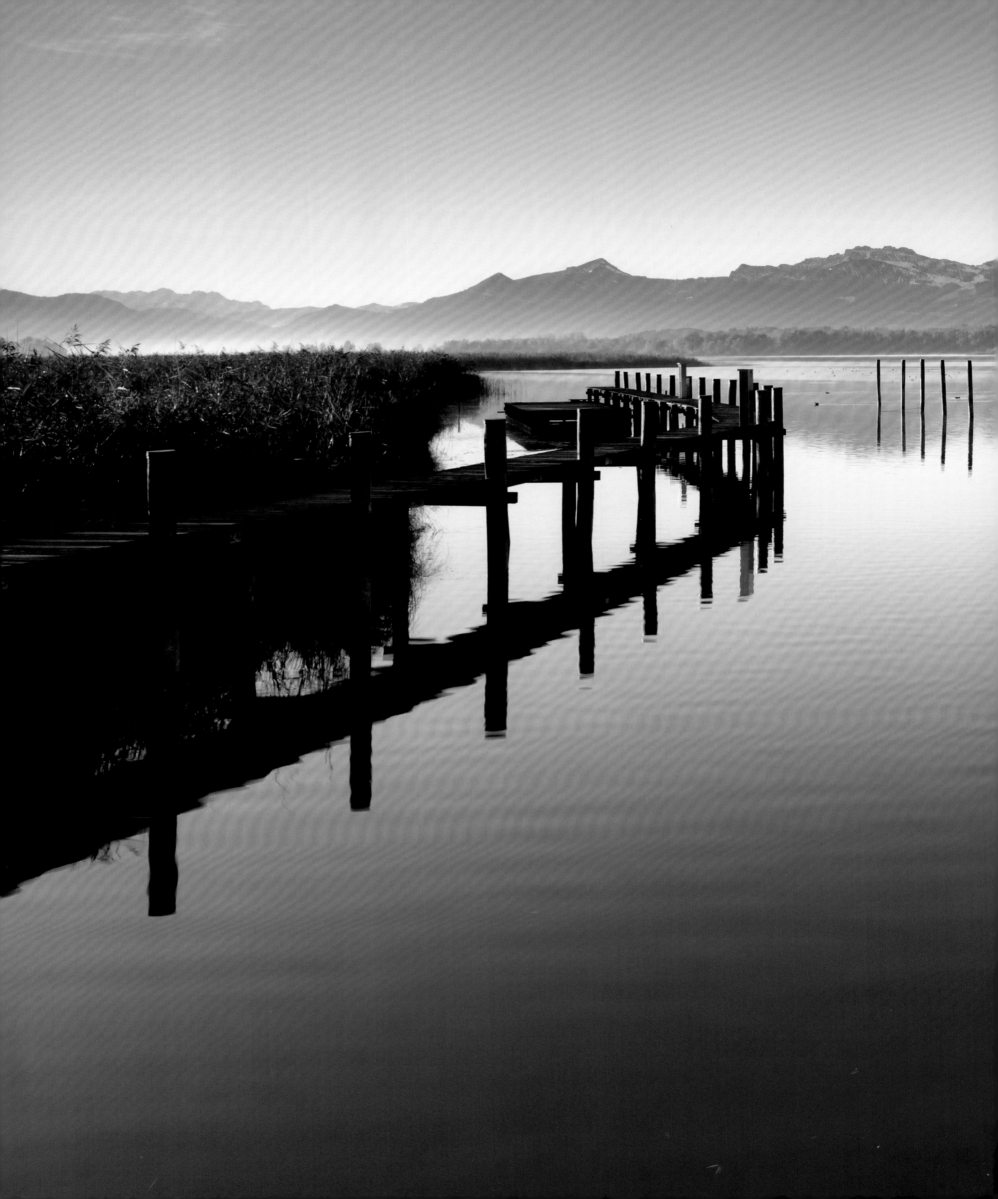

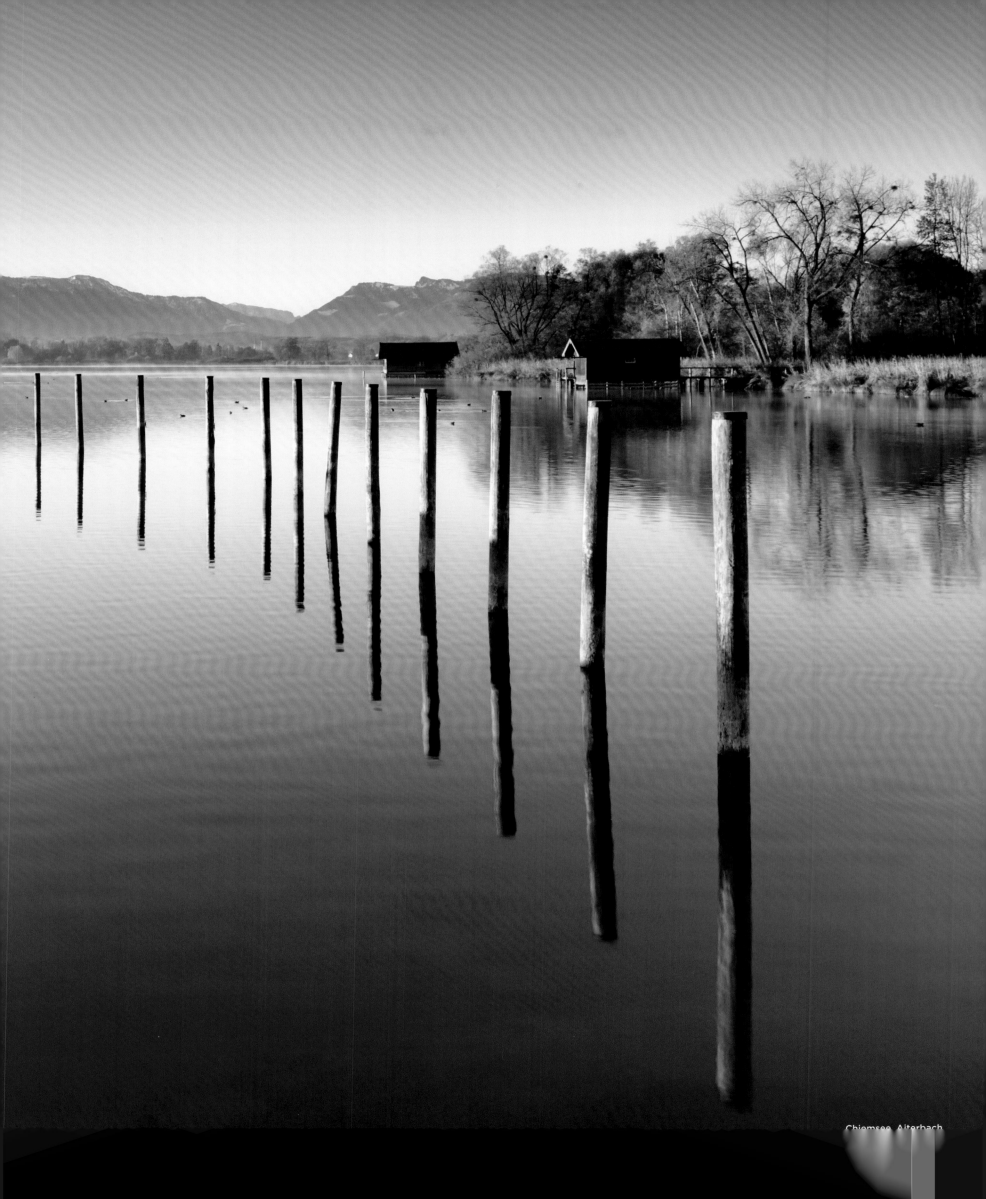

Chiemsee, Aiterbach

Winklmoosalm, Winklmoos

Reit im Winkl

Things are very traditional in the Upper Bavarian climatic health resort Reit im Winkl. It is not one of the destinations of the international jet set, it is not overcrowded, not even in winter, when there is a lot of snow and skiers and cross-country skiers get their money's worth. Nevertheless, summer and winter tourism are of great importance for the town. In winter, families in particular will find ideal conditions in the Winklmoosalm ski area, the pistes are easy and therefore also suitable for children and beginners. Reit achieved prominence as home of the ski racer and double Olympic champion Rosi Mittermaier.

Reit im Winkl

Dans la station climatique de Reit im Winkl, tout est traditionnel. Elle ne fait pas partie des rendez-vous de la jet-set et n'est jamais bondée, pas même en hiver où l'on peut pourtant être assuré de toujours trouver de la neige, pour le plus grand bonheur des adeptes de ski alpin ou de ski de fond. Le tourisme est pourtant essentiel pour cet endroit, aussi bien en été qu'en hiver. Le domaine skiable de Winklmoosalm est idéal pour les familles, car les pistes sont faciles et donc adaptées pour les enfants et les débutants. Reit im Winkl a gagné en notoriété grâce à Rosi Mittermaier, skieuse et double championne olympique, qui y est née.

Reit im Winkl

Traditionell geht es zu im oberbayrischen Luftkurort Reit im Winkl. Er gehört nicht zu den Zielen des internationalen Jetset, ist nicht überlaufen, nicht einmal im Winter, in dem zuverlässig viel Schnee liegt und die Skifahrer und Loipengänger auf ihre Kosten kommen. Dennoch ist der Sommer- wie Wintertourismus von großer Bedeutung für den Ort. Vor allem Familien finden im Winter im Skigebiet der Winklmoosalm ideale Bedingungen, die Pisten sind leicht, also auch für Kinder und Anfänger gut geeignet. Prominenz erlangte Reit durch die Skirennläuferin und Doppelolympiasiegerin Rosi Mittermaier.

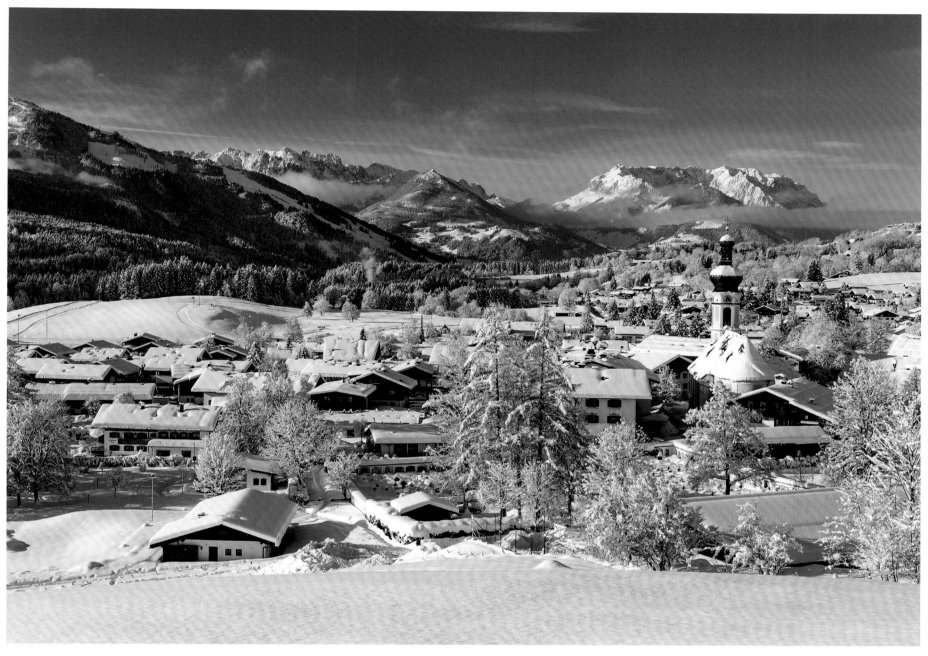

Reit im Winkl, Kaisergebirge

Reit im Winkl

Tradicionalmente se trata de un "Luftkurort" (balneario de aire limpio) de la Alta Baviera Reit im Winkl. No es un destino de la jet set internacional, no está superpoblada, ni siquiera en invierno, cuando hay mucha nieve y los esquiadores y esquiadoras de fondo se benefician de su dinero. Sin embargo, el turismo de verano y el de invierno son de gran importancia para la ciudad. En invierno, las familias en particular encontrarán condiciones ideales en la zona de esquí de Winklmoosalm (las pistas son fáciles y, por lo tanto, también adecuadas para niños y principiantes). Reit alcanzó prominencia a través de la esquiadora y doble campeona olímpica Rosi Mittermaier.

Equitação no Winkl

Tradicionalmente vai para o resort de saúde climática da Alta Baviera Reit im Winkl. Não pertence aos destinos do jet set internacional, não está superlotado, nem mesmo no inverno, quando há muita neve e os esquiadores e esquiadores de fundo fazem valer o seu dinheiro. No entanto, o turismo de verão e inverno são de grande importância para a cidade. No inverno, as famílias, em particular, encontrarão condições ideais na área de esqui de Winklmoosalm, as pistas são fáceis e, portanto, também adequadas para crianças e iniciantes. Reit alcançou destaque através do esquiador e duplo campeão olímpico Rosi Mittermaier.

Reit im Winkl

In het Opper-Beierse kuuroord Reit im Winkl is al van oudsher altijd veel te doen. De internationale jetset treft men hier niet aan en overvol is de plaats evenmin. Zelfs niet in de winter, wanneer er veel sneeuw ligt en de omstandigheden voor skiërs en langlaufers er ideaal zijn. Voor Reit im Winkl is het toerisme van groot belang, zowel 's zomers als 's winters. In de winter is het skigebied Winklmoosalm een echte aanrader voor gezinnen; de pistes zijn veelal gemakkelijk en ook geschikt voor kinderen en beginners. Reit im Winkl verwierf ooit internationale bekendheid door de tweevoudig Olympische skikampioene Rosi Mittermaier.

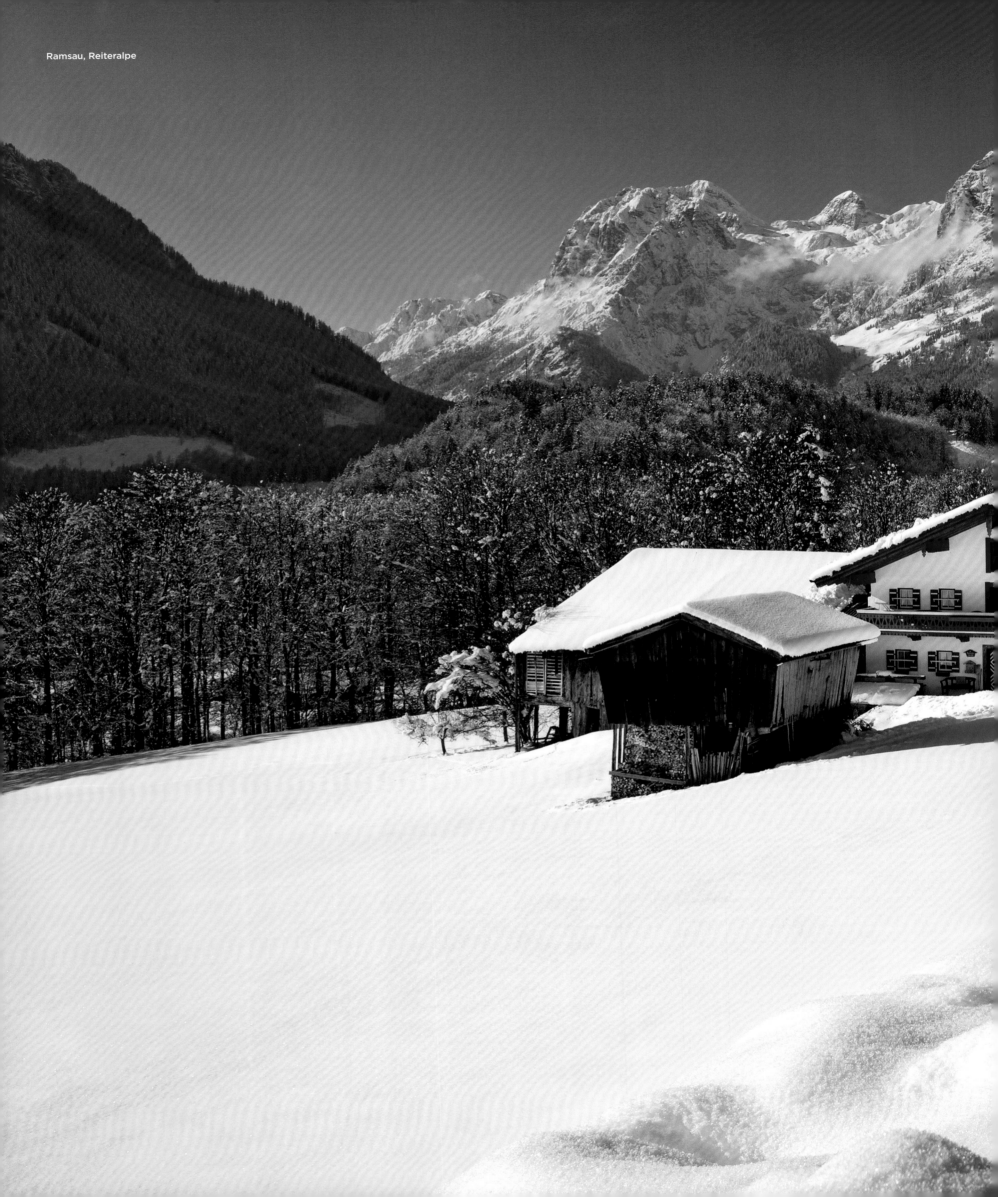

Ramsau, Reiteralpe

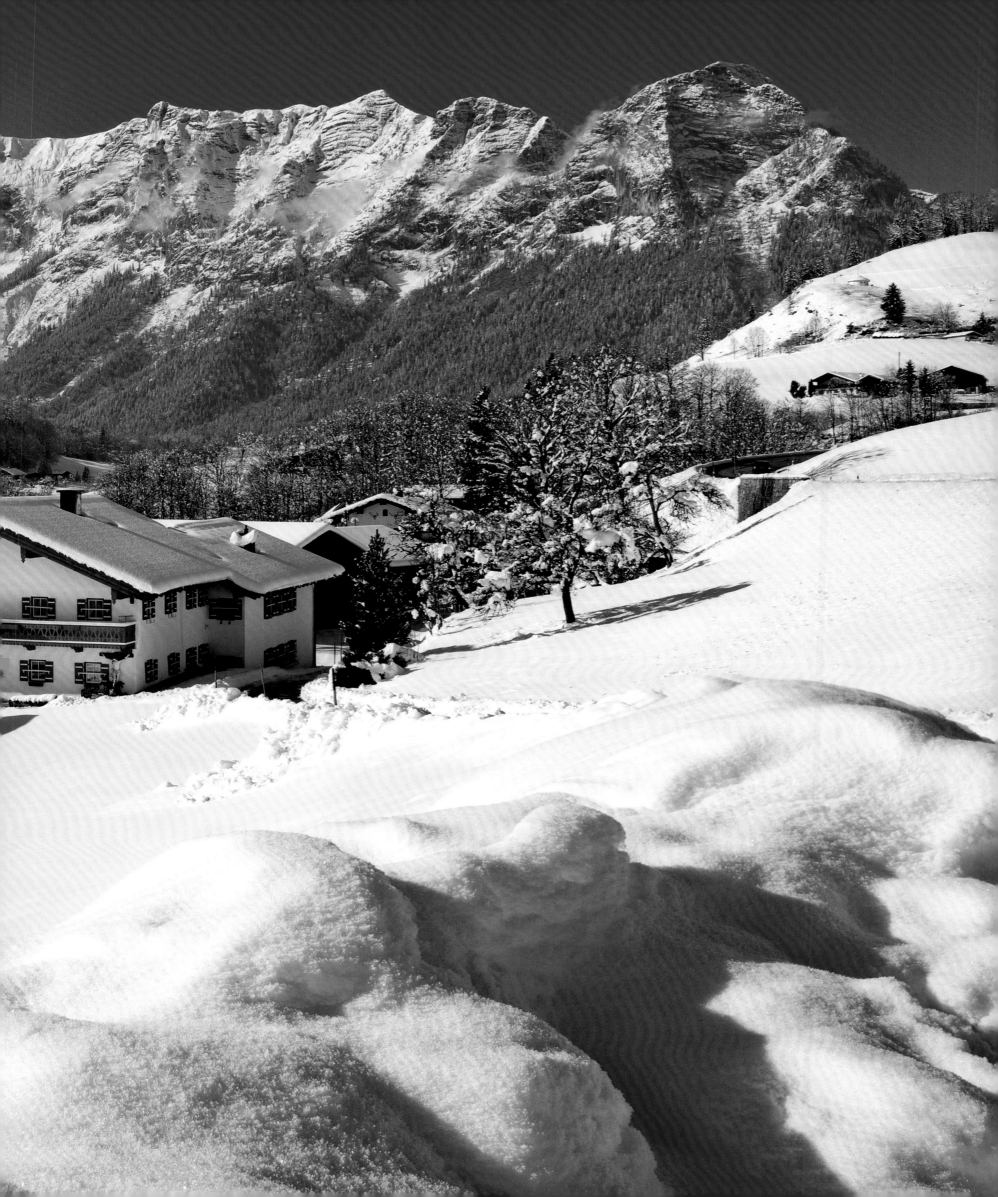

Blick von Archenkanzel (1346 m) zum Königssee,
Nationalpark Berchtesgaden
View from Archenkanzel (1346 m · 4416 ft) to Königssee,
Berchtesgaden National Park
Vue depuis l'Archenkanzel (1346 m) sur le Königssee

Königssee

The Königssee is one of the most beautiful—and
cleanest—lakes in the Alps. The pilgrimage chapel
St. Bartholomä stands picturesquely on a piece of
alluvial land in front of the impressive backdrop of the
Watzmann's east face. The Königssee is famous for
the echo which resounds from the steep shores and
can be heard during a trip on an excursion boat.

Le Königssee

Le Königssee fait partie des plus beaux lacs des Alpes,
et des plus propres. Il est entouré de montagnes,
qui à certains endroits descendent directement
dans l'eau. Située sur un terrain alluvial, la jolie
chapelle de pèlerinage de Saint Barthélemy se dresse
avec panache face au versant est du chaînon du
Watzmann. Le Königssee est aussi célèbre pour son
écho, que l'on entend résonner entre les montagnes
lorsque l'on fait une promenade en bateau.

Königssee

Der Königssee zählt zu den schönsten – und
saubersten – Alpenseen. Auf einem Stück
Schwemmland steht malerisch die Wallfahrtskapelle
St. Bartholomä vor der eindrucksvollen Kulisse der
Watzmann-Ostwand. Berühmt ist das Echo vom
Königssee, das bei einer Fahrt mit dem Ausflugsboot
von den steilen Ufern widerhallt.

Lago del Rey

El lago del Rey es uno de los lagos alpinos más
bonitos y limpios. La capilla de peregrinación
St. Bartholomä se encuentra pintorescamente
situada sobre una zona de tierra aluvial frente al
impresionante paisaje de la cara este de Watzmann. El
eco del lago del Rey es famoso, ya que resuena desde
las escarpadas orillas durante una excursión en barco.

Königssee

O Königssee é um dos mais belos e limpos lagos
alpinos. A capela de peregrinação St. Bartholomä fica
pitorescamente em um pedaço de terra aluvial em
frente ao impressionante pano de fundo da face leste
de Watzmann. Famoso é o eco do Königssee, que
ecoa das costas íngremes durante uma viagem com o
barco de excursão.

Königssee

De Königssee is een van de mooiste – en schoonste –
meren van de Alpen. Aan de westoever ligt de
bedevaartkapel Sint-Bartholomeüs op een stuk
aangeslibd land, schilderachtig gelegen voor het
imposante decor van de Watzmann. De Königssee
staat ook bekend om zijn echo, die tijdens een
tocht met een rondvaartboot weerkaatst tegen de
steile oevers.

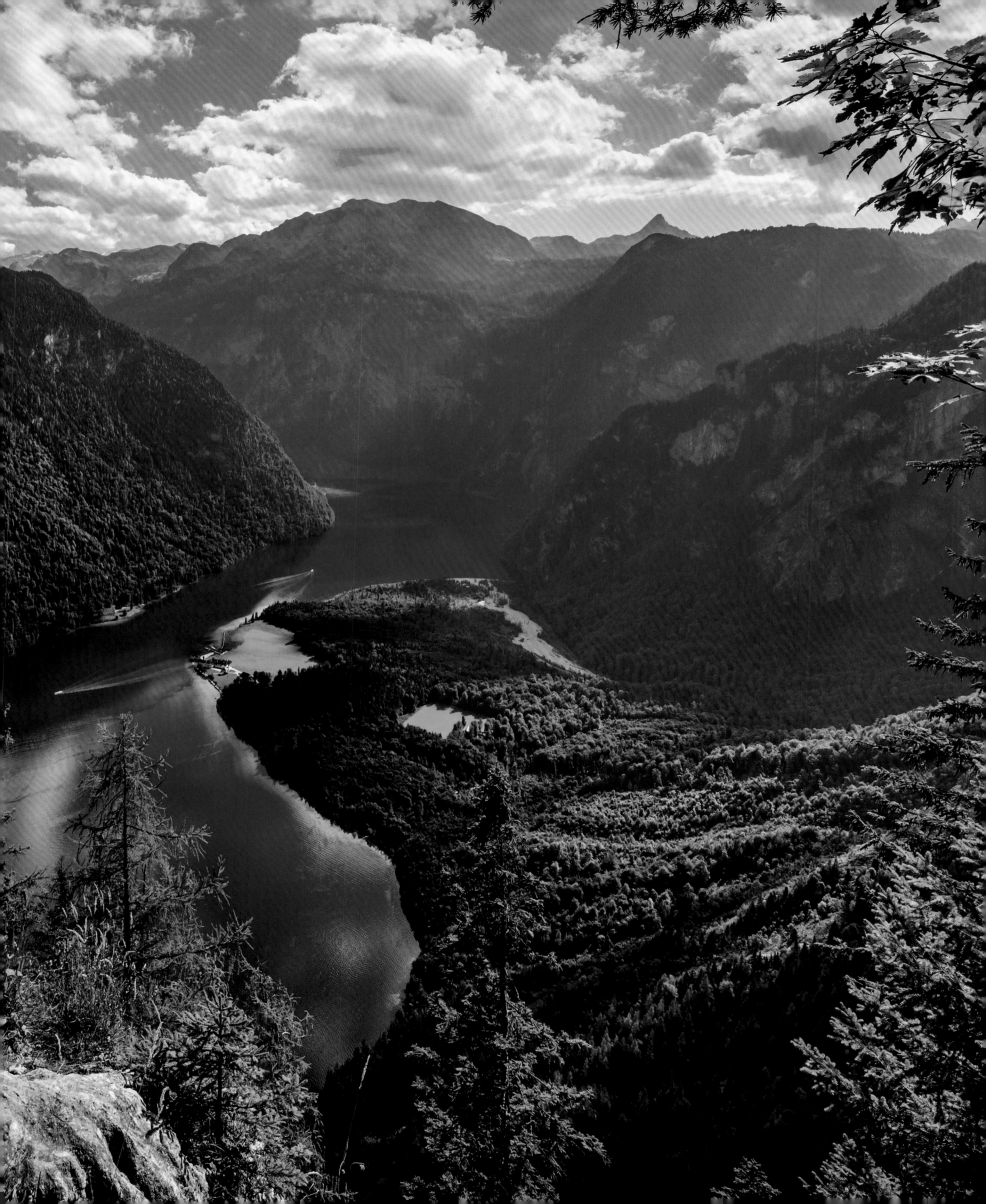

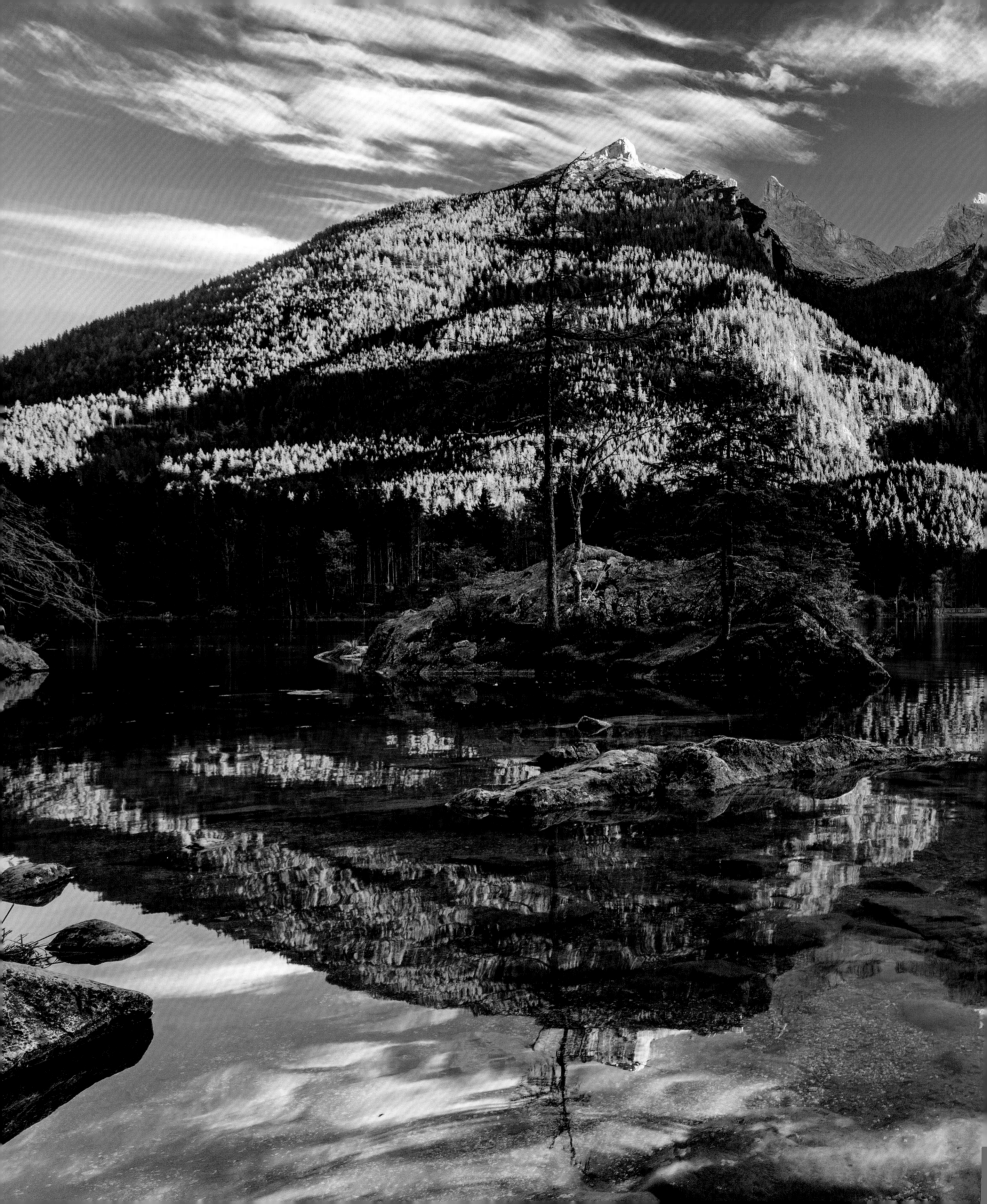

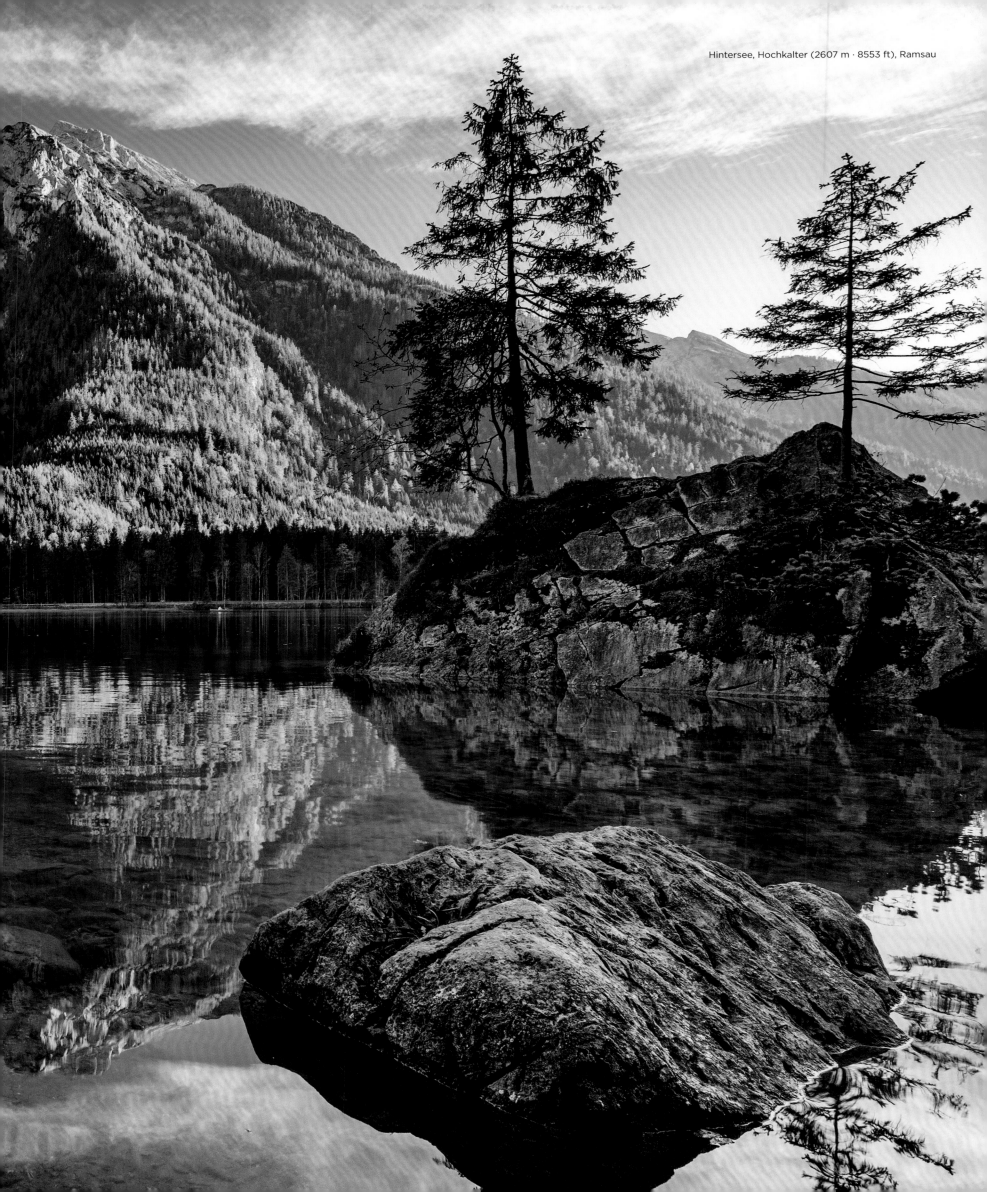

Hintersee, Hochkalter (2607 m · 8553 ft), Ramsau

Almabtrieb

In autumn, the cattle are driven from the mountain pastures, where they spent the summer, to the stables in the valleys where they stay in winter. The cows are festively decorated for the procession into the valley which is accompanied by the tolling of bells; music and festive events signal the end of the pasturing season.

La descente de l'alpage

À l'automne, les animaux qui ont passé l'été dans les alpages rentrent à l'étable pour l'hiver. Pour leur retour dans la vallée, dans un concert de clochettes, les vaches sont richement décorées, alors que musique et festivités clôturent dignement la saison.

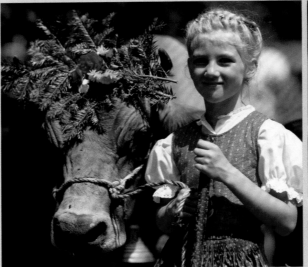

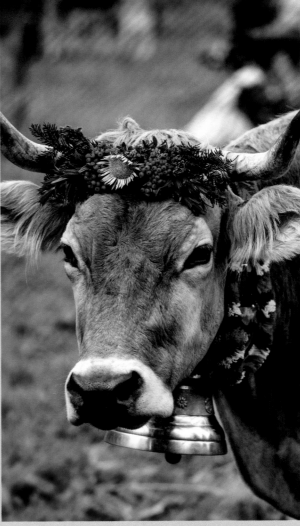

Almabtrieb

Im Herbst wird das Vieh von den Almen, wo es den Sommer verbracht hat, zur Überwinterung in die Ställe getrieben. Die Kühe werden für den von Glockengeläut begleiteten Zug ins Tal festlich geschmückt, Musik und Festveranstaltungen beschließen die Almsaison.

Ganado que baja de la montaña

En otoño, el ganado es trasladado de los pastos de montaña, donde pasa el verano, a los establos para pasar el invierno. Las vacas se decoran de manera festiva para la procesión hacia el valle, acompañadas por el sonido de las campanas; la música y los eventos festivos concluyen la temporada de alpinismo.

Gado a descer das pastagens das montanhas

No outono, o gado é conduzido das pastagens de montanha, onde passava o verão, para os estábulos para passar o inverno. As vacas são festivamente decoradas para a procissão no vale, acompanhadas pelo toque dos sinos; a música e os eventos festivos concluem a estação alpina.

'Almabtrieb'

In de herfst worden de koeien die in de zomer op de bergweiden leefden weer naar het dal gedreven om de winter in de stal door te brengen. Vaak zijn de koeien feestelijk uitgedost en wordt de stoet begeleid door luidende koeienbellen; het weideseizoen wordt afgesloten met muziek en festiviteiten.

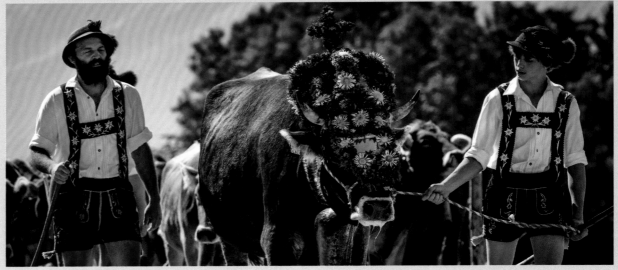

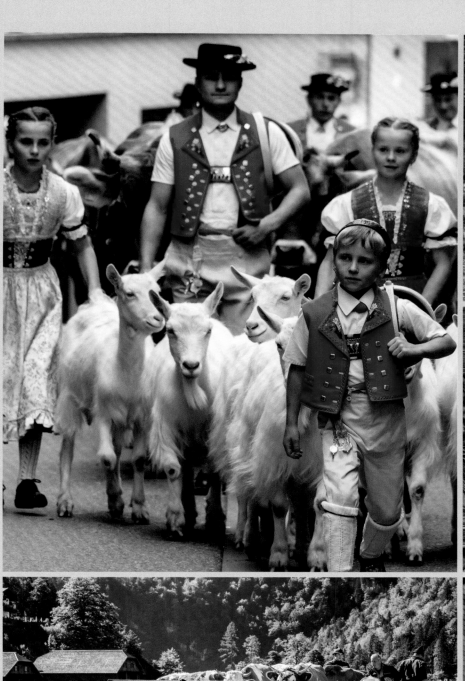
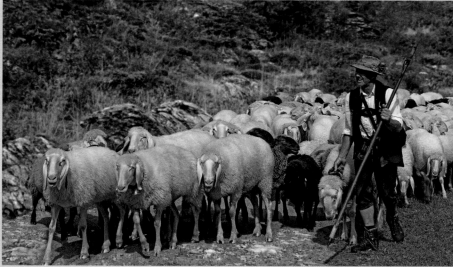

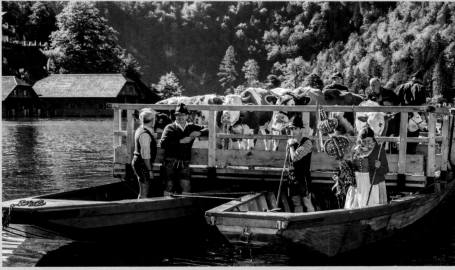
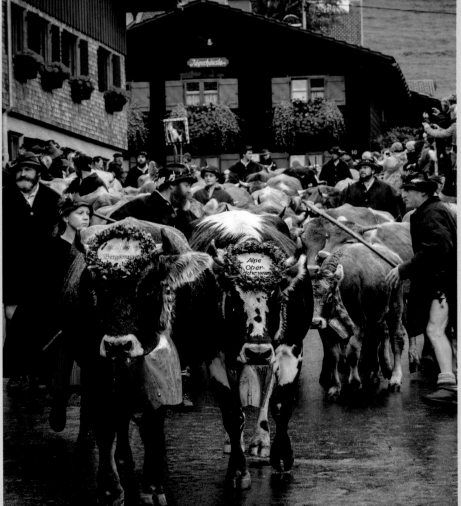
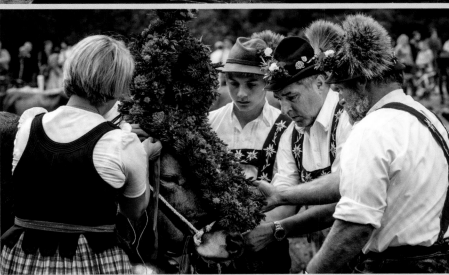

Karwendel

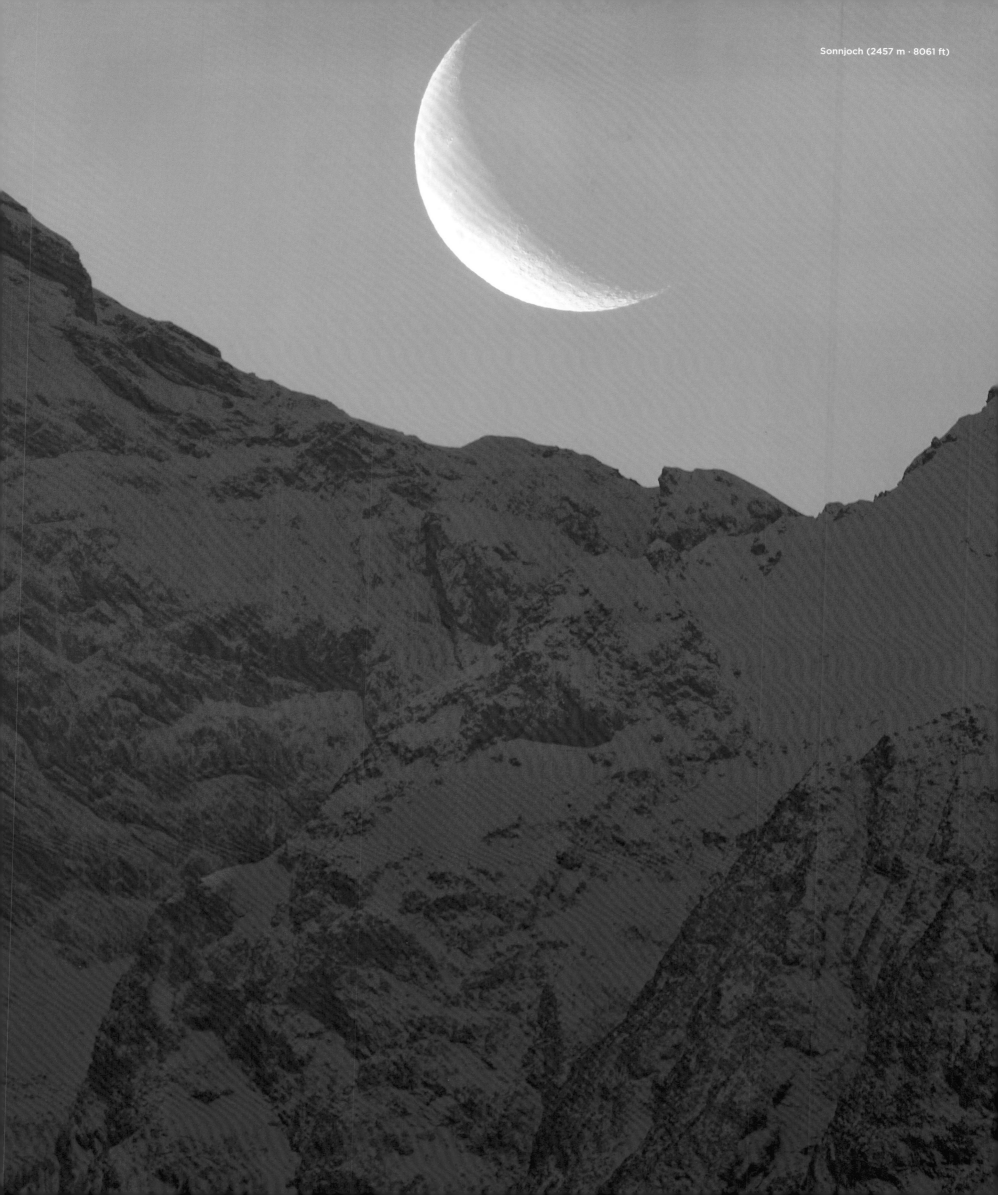

Sonnjoch (2457 m · 8061 ft)

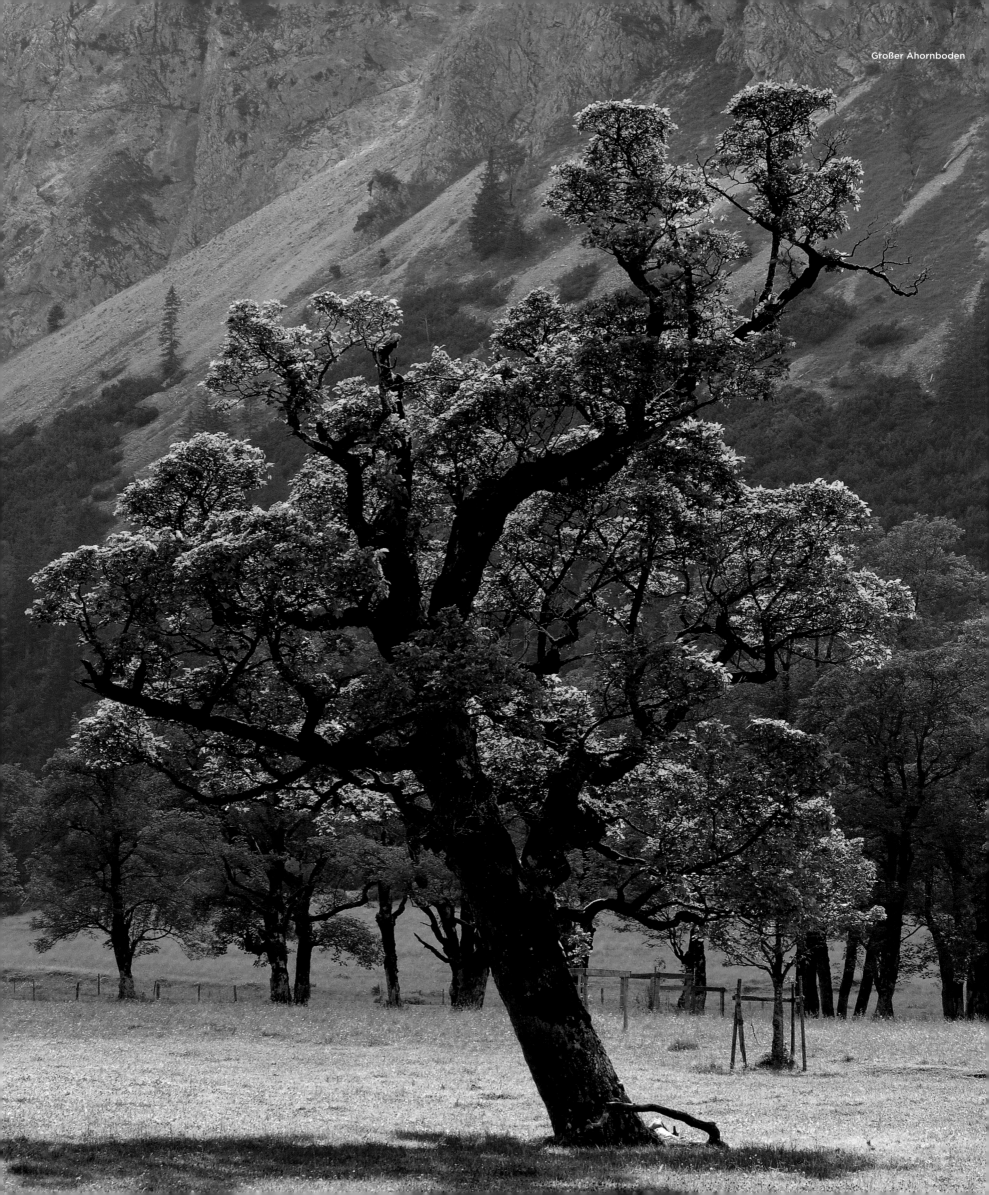

Großer Ahornboden

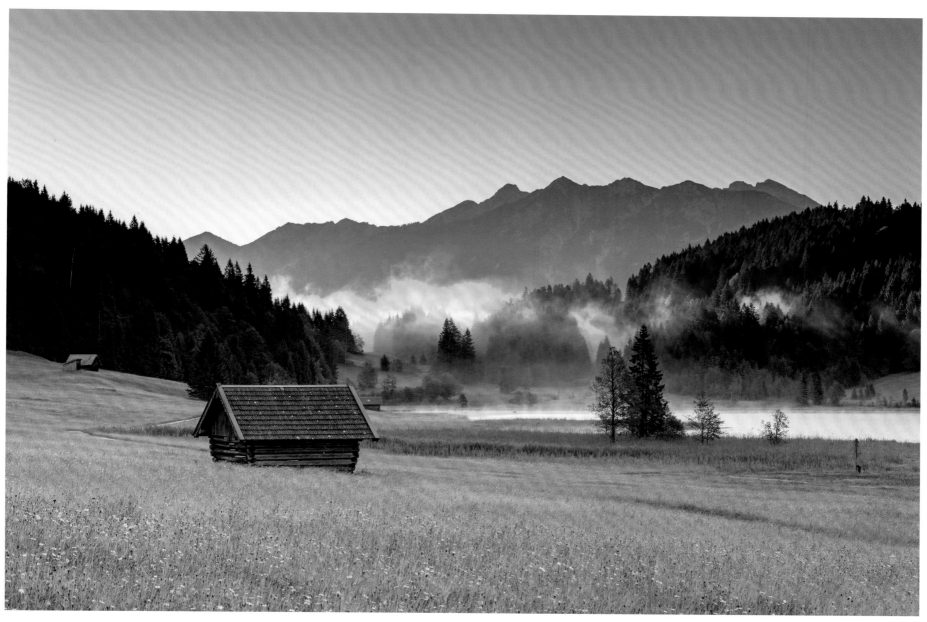

Geroldsee, Klais

Karwendel Mountains
The Karwendelgebirge extends from Innsbruck to the north into Bavaria. Its highest peak, the Birkkarspitze, reaches 2749 m (9019 ft). Well developed for hikers, the area has retained an appealing originality. Large parts are protected; with luck one can observe chamois and the numerous golden eagles.

Le massif des Karwendel
Le massif des Karwendel commence au nord d'Innsbruck et s'étend jusqu'en Bavière ; son plus haut sommet, le Birkkarspitze, culmine à 2 749 m. Aisément accessible aux randonneurs, cette région a su conserver son authenticité. Elle compte de nombreuses zones protégées et on peut avoir la chance d'y observer des chamois ou des aigles royaux, nombreux dans la région.

Karwendelgebirge
Nördlich von Innsbruck bis nach Bayern hinein erstreckt sich das Karwendelgebirge, dessen höchster Gipfel, die Birkkarspitze, 2749 m erreicht. Für Wanderer gut erschlossen, hat sich das Gebiet eine besondere Ursprünglichkeit bewahrt. Große Teile stehen unter Naturschutz; mit Glück kann man Gämsen beobachten und die hier zahlreichen Steinadler.

Montes del Karwendel
Al norte de Innsbruck hacia Baviera se extienden los Montes del Karwendel, cuyo pico más alto, el Birkkarspitze, alcanza los 2749 m. Bien desarrollada para los excursionistas, el área ha conservado una originalidad especial. Grandes extensiones están protegidas; con suerte se pueden observar gamuzas y las numerosas águilas reales.

Montanhas Karwendel
A norte, de Innsbruck à Baviera, estende-se o Karwendelgebirge, cujo pico mais alto, o Birkkkarspitze, atinge 2749 m. Bem desenvolvida para caminhantes, a área manteve uma originalidade especial. Grandes partes são protegidas; com sorte você pode observar a camurça e as numerosas águias douradas.

Karwendelgebergte
In het tussen Innsbruck en Beieren gelegen Karwendelgebergte is de 2749 m hoge Birkkarspitze de hoogste top. Het gebied is ideaal voor wandelaars en heeft zijn oorspronkelijke karakter in belangrijke mate weten te behouden. Het gebergte is goeddeels beschermd; met een beetje geluk kunt u er gemzen of steenarenden spotten.

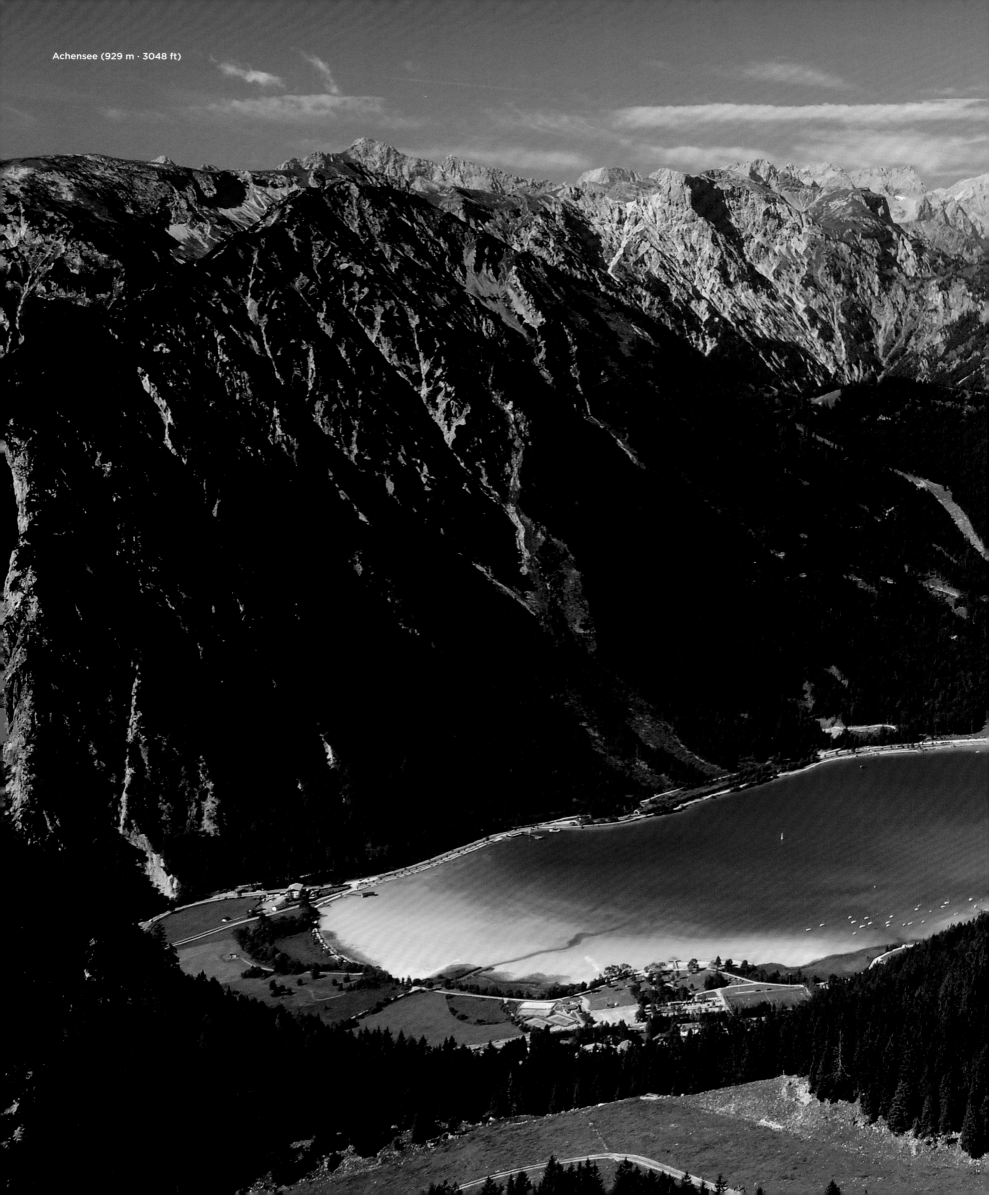

Achensee (929 m · 3048 ft)

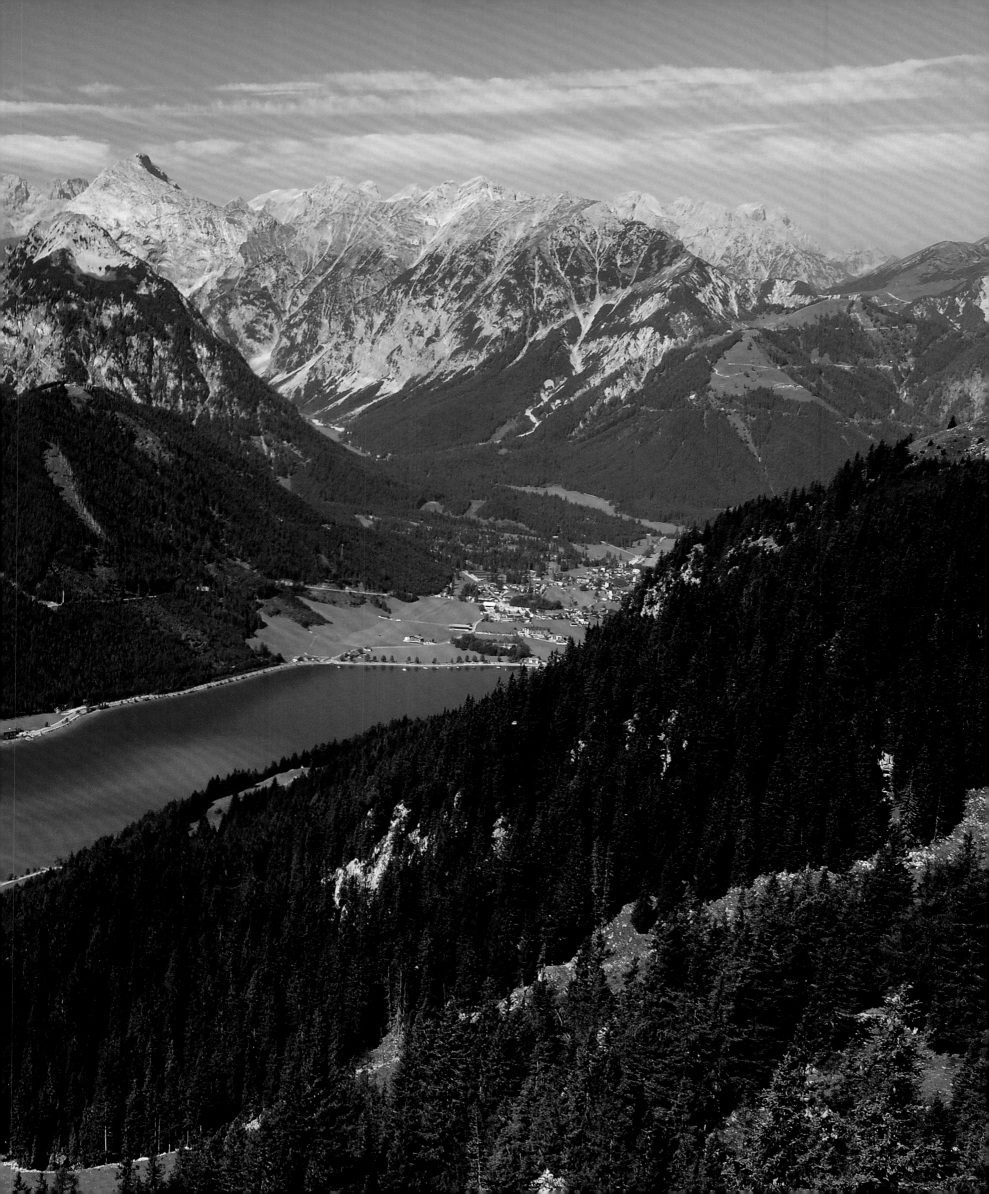

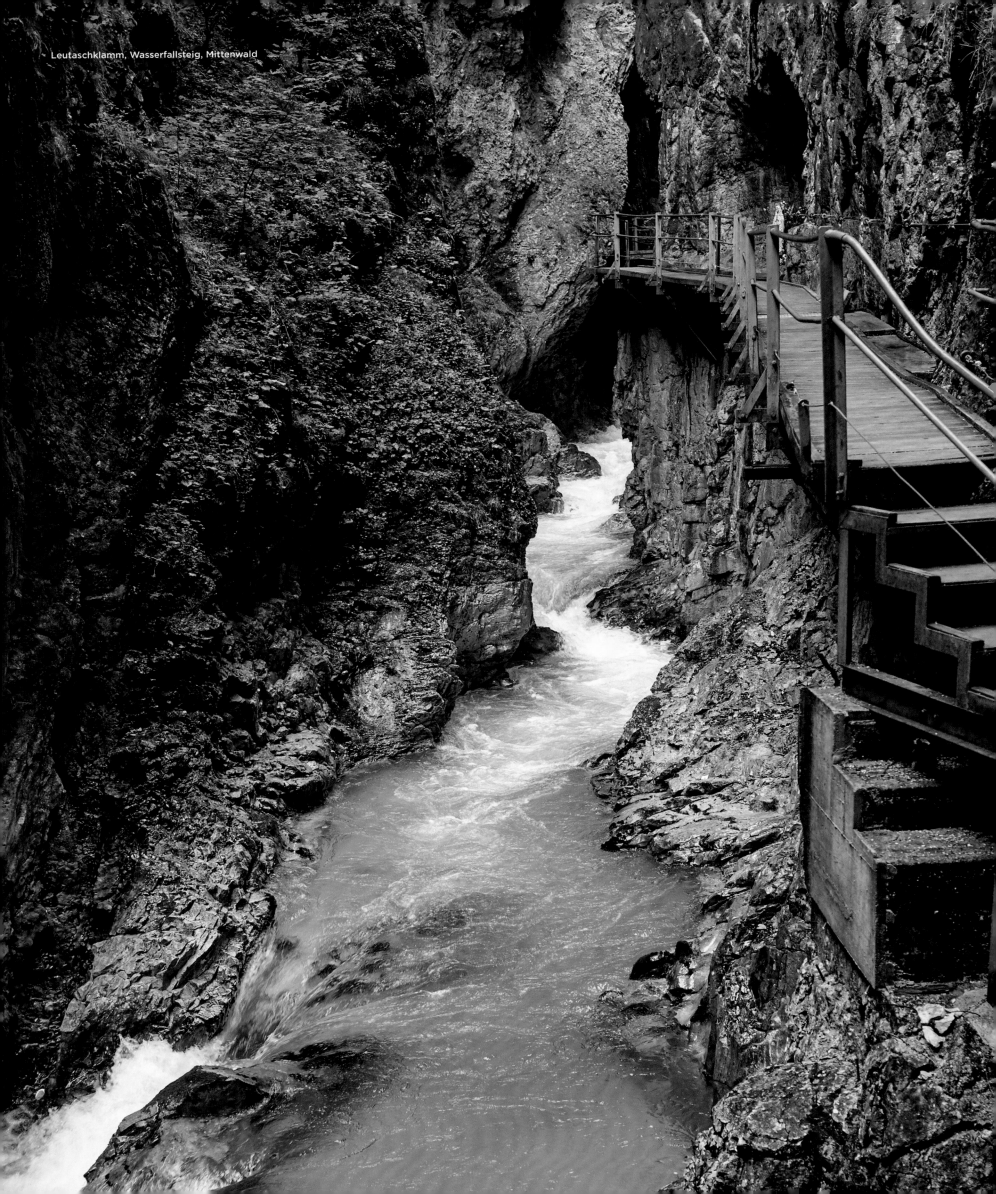
Leutaschklamm, Wasserfallsteig, Mittenwald

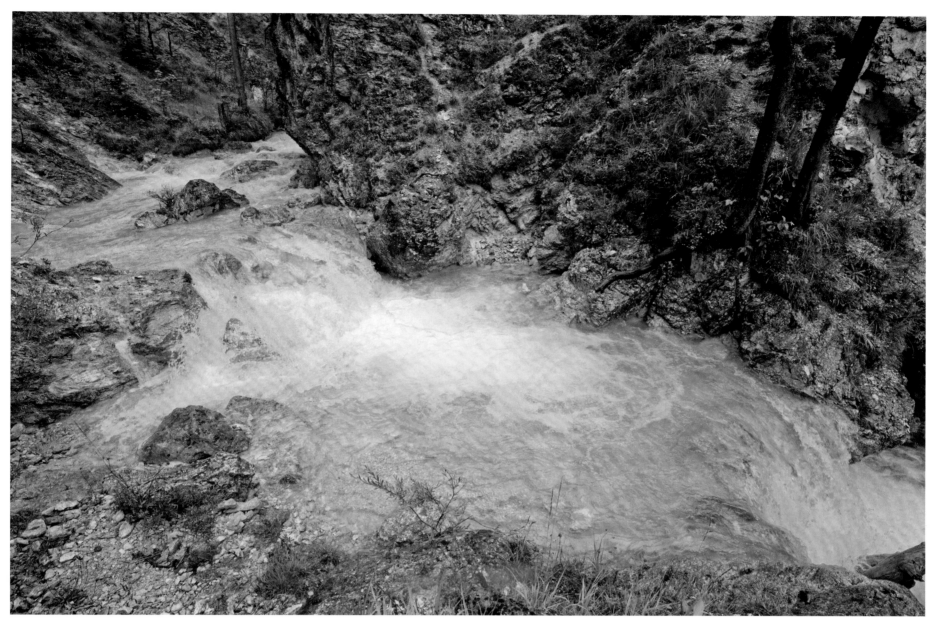

Gassellahnbach, Mittenwald

Leutasch Gorge

A hike through the gorge Leutaschklamm near Mittenwald is impressive. People were already of this opinion more than 100 years ago, when the first wooden paths were laid through the gorge, which is only 2 m (7 ft) wide in places. Just above the water the path leads into the gorge for a length of 200 m (656 ft) to end at a waterfall. A newer path is the Klammgeistweg.

La gorge de Leutasch

Il est très impressionnant de se promener dans la gorge de Leutasch, près de Mittenwald. Tel était aussi l'avis des gens de la région il y a plus d'un siècle, lors de l'installation des premiers chemins de rondins dans cette gorge dont la largeur à certains endroits n'excède pas 2 m. Ce chemin descend dans la gorge jusqu'à 200 m de profondeur, juste au-dessus du niveau de l'eau, et conduit à une cascade. Aujourd'hui, il en existe un autre : le Klammgeistweg.

Leutaschklamm

Eindrucksvoll ist eine Wanderung durch die Leutaschklamm bei Mittenwald. Das fanden die Menschen schon vor über 100 Jahren, als die ersten Holzbohlenwege durch die stellenweise nur 2 m breite Klamm angelegt wurden. Knapp über dem Wasser führt der Weg 200 m tief in die Klamm hinein bis zu einem Wasserfall. Ein neuerer Pfad ist der Klammgeistweg.

Leutaschklamm

Una caminata a través de la garganta de Leutaschklamm cerca de Mittenwald es impresionante. La gente lo encontró hace más de 100 años, cuando se construyeron los primeros senderos de madera a través de la garganta, que en algunos lugares solo tenía 2 m de ancho. Justo por encima del agua, el sendero conduce a 200 m de profundidad hacia el barranco y a una cascada. Un camino más nuevo es el Klammgeistweg.

Leutaschklamm

Uma caminhada pela garganta Leutaschklamm perto de Mittenwald é impressionante. As pessoas encontraram isso há mais de 100 anos, quando os primeiros caminhos de madeira foram colocados através do desfiladeiro, que tinha apenas 2 m de largura em alguns lugares. Logo acima da água, o caminho leva a uma cachoeira a 200 metros de profundidade até o desfiladeiro. Um caminho mais recente é o Klammgeistweg.

Leutaschklamm

Een wandeling door de Leutaschklamm bij Mittenwald is een indrukwekkende belevenis. Dat vonden de mensen ook al ruim een eeuw geleden, toen men met houten planken de paden door de deels slechts 2 m brede kloof aanlegde. Een van de oudste paden loopt een paar meter boven het water en leidt naar een waterval 200 m diep in de kloof. Een ander pad, de Klammgeistweg, is van latere datum.

Ahornbaum, Engtal
Maple tree, Engtal
Érable, Engtal

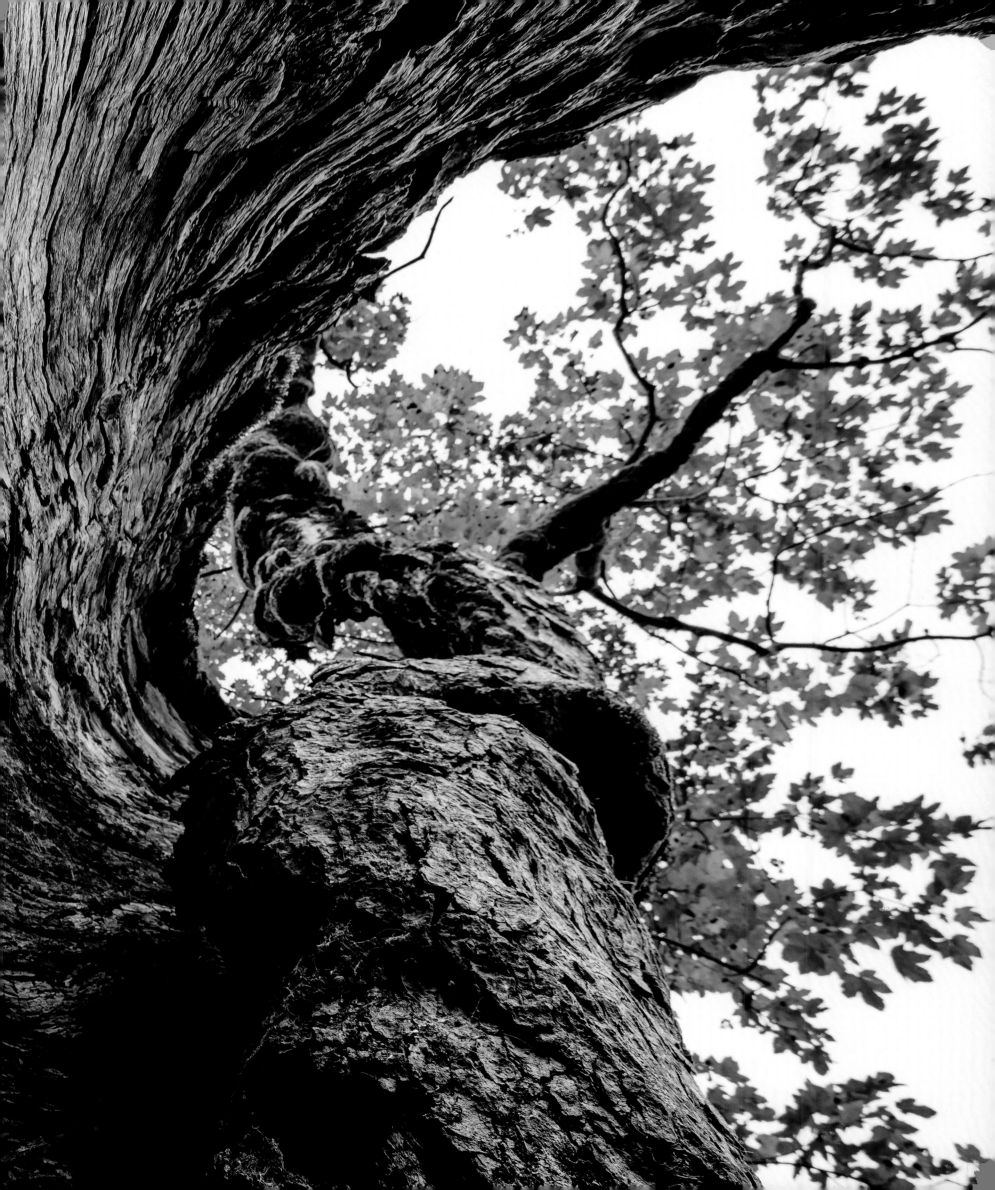

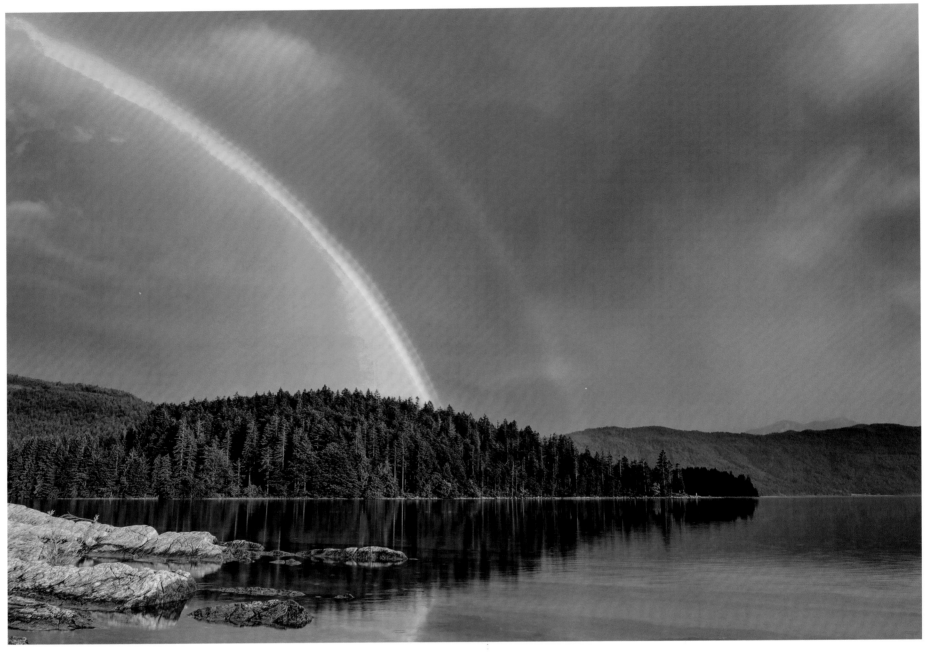

Walchensee

Walchensee

One of the most beautiful lakes in the Bavarian Alps is the Walchensee. Its clear, turquoise-green water and the surrounding mountain panorama make it a popular excursion destination and film location. Due to the strong wind often blowing over the lake it is an ideal spot for sailors and windsurfers. Divers also appreciate the lake: The visibility under water is good, and numerous wrecks, including two aircraft from the Second World War, which did not survive an emergency watering, make it interesting. A hydroelectric power station makes use of the drop to the Kochelsee, 200 m (656 ft) below.

Le lac Walchen

Le lac Walchen est l'un des plus beaux lacs des Alpes bavaroises. Son eau limpide et turquoise et les montagnes qui l'entourent en font un endroit rêvé pour les excursions et les tournages de films. Il est souvent balayé par un vent puissant, idéal pour les adeptes de voile et de windsurf. Les plongeurs aussi trouvent ici leur bonheur : sous l'eau, la visibilité est bonne, et le lac abrite plusieurs épaves intéressantes, notamment deux avions de la Seconde Guerre mondiale qui n'ont pas survécu à un amerrissage forcé. Une centrale hydroélectrique utilise la chute d'eau de 200 m de haut menant au lac de Kochel.

Walchensee

Einer der schönsten Seen in den bayerischen Alpen ist der Walchensee. Sein klares, türkisgrünes Wasser und das umgebende Bergpanorama machen ihn zu einem beliebten Ausflugsziel und Drehort für Filme. Durch den kräftigen Wind, der häufig über den See bläst, ist er ein ideales Revier für Segler und Windsurfer. Auch Taucher schätzen den See: Die Sicht unter Wasser ist gut, und zahlreiche Wracks, unter anderem zwei Flugzeuge aus dem Zweiten Weltkrieg, die eine Notwasserung nicht überstanden, machen ihn interessant. Ein Wasserkraftwerk macht sich das Gefälle zu dem 200 m tiefer liegenden Kochelsee zunutze.

Vomperloch

Lago Walchen

Uno de los lagos más hermosos de los Alpes bávaros es el Walchen. Sus aguas transparentes de color verde-turquesa y el panorama montañoso que la rodea la convierten en un destino popular para excursiones y cine. Debido al fuerte viento que a menudo sopla sobre el lago, es un lugar ideal para marineros y windsurfistas. Los buceadores también aprecian el lago: la visibilidad bajo el agua es buena, y numerosos restos de naufragios, incluyendo dos aviones de la Segunda Guerra Mundial que no sobrevivieron a un aterrizaje de emergencia sobre el agua, lo hacen interesante. Una central hidroeléctrica aprovecha la gradiente hasta el lago Kochel, 200 m más abajo.

Walchensee

Um dos lagos mais bonitos dos Alpes da Baviera é o Walchensee. Sua água clara, verde-turquesa e o panorama montanhoso circundante fazem dele um destino de excursão e local de cinema popular. Devido ao vento forte, que muitas vezes sopra sobre o lago, é um local ideal para marinheiros e windsurfistas. Os mergulhadores também apreciam o lago: a visibilidade debaixo de água é boa, e numerosos naufrágios, incluindo dois aviões da Segunda Guerra Mundial, que não sobreviveram a uma rega de emergência, tornam-no interessante. Uma usina hidrelétrica faz uso do gradiente para o Kochelsee, 200 m abaixo.

Walchensee

De Walchensee is een van de mooiste meren van de Beierse Alpen. Het meer is een bekende filmlocatie en populair bij dagjesmensen vanwege het heldere, turkooizen water en het bergpanorama. Door de stevige wind die hier vaak waait is het ook een eldorado voor zeilers en windsurfers. Duikers waarderen het meer vanwege het goede zicht onder water en de talrijke wrakken op de bodem, waaronder twee vliegtuigen uit de Tweede Wereldoorlog, die hier een noodlanding op het water wilden maken. Een pompcentrale wekt stroom op door handig gebruik te maken van het hoogteverschil met de Kochelsee, 200 m lager.

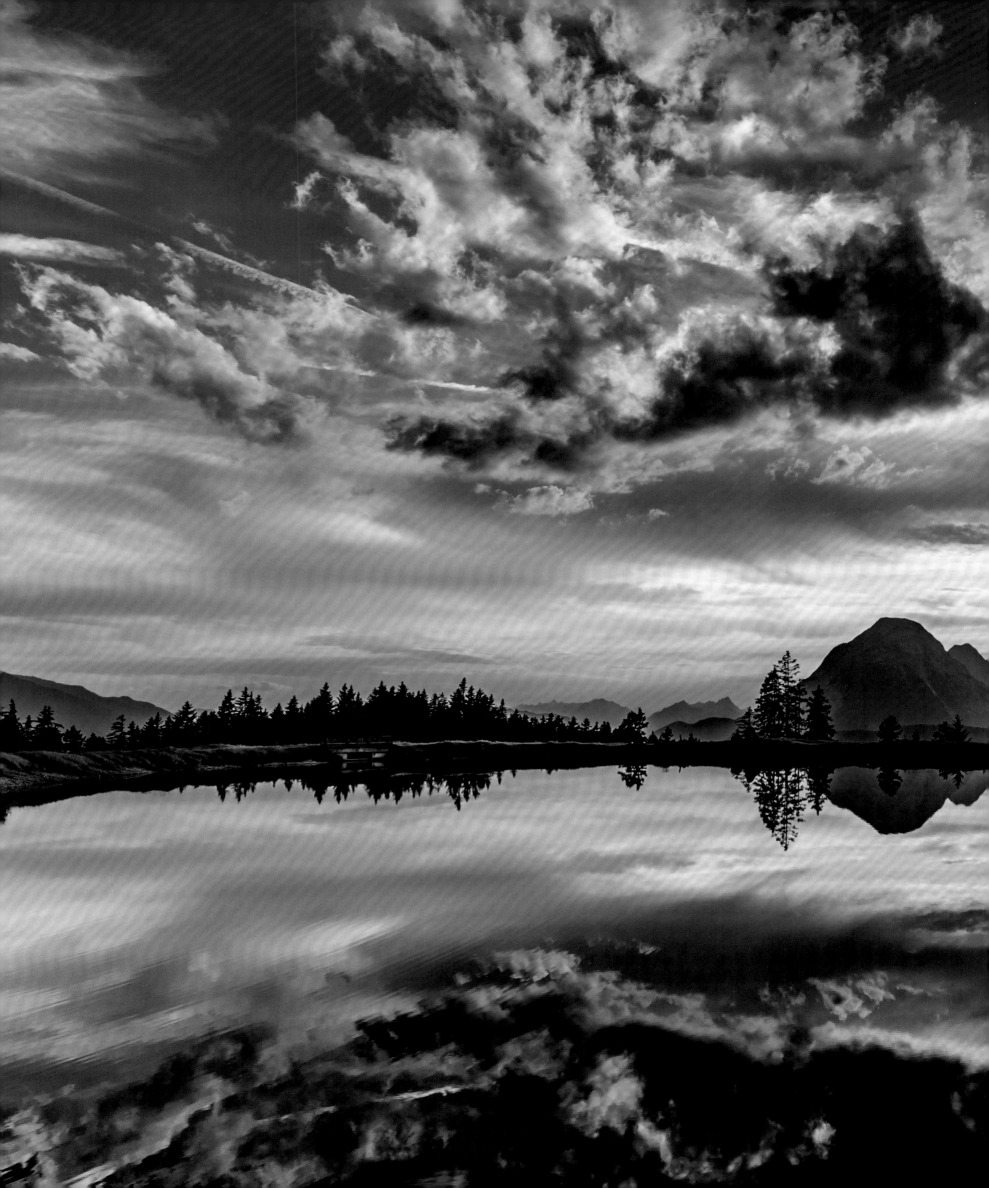

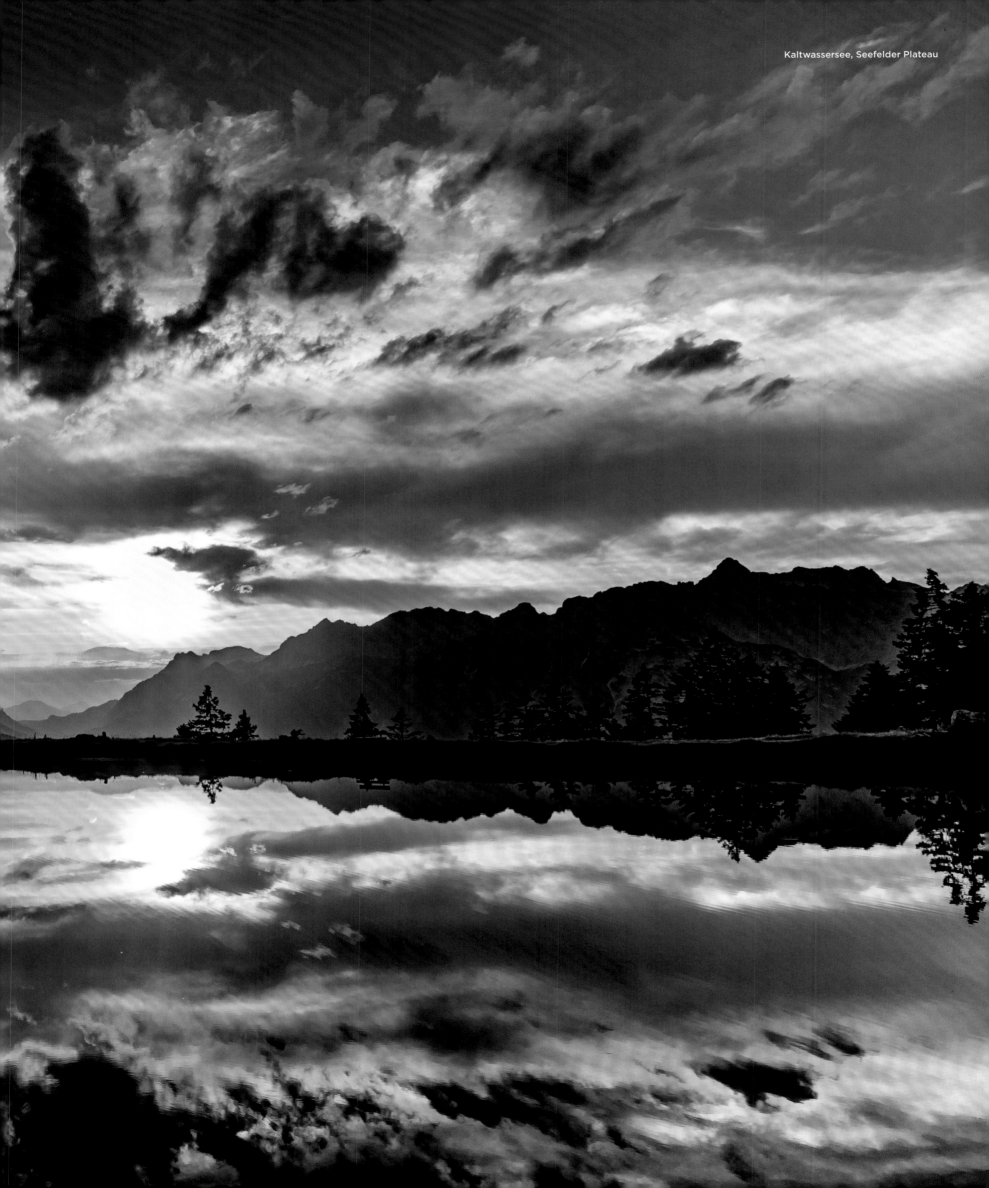

Oberösterreich · Upper Austria · Haute-Autriche

Hallstätter See, Hallstatt

Ebensee, Höllengebirge

Teichfrosch
Edible frog
Grenouille verte

Upper Austria

The Salzkammergut is lined with a a chain of large lakes, the most famous being the Hallstätter See, Mondsee and Wolfgangsee, all popular holiday destinations. While the mountains primarily offer charming landscapes, cultural highlights are to be found in the foothills of the Alps or north of them, for example in the provincial capital Linz.

La Haute-Autriche

Dans le Salzkammergut, toute une série de lacs attire les visiteurs ; les plus connus sont le Hallstättersee, le Mondsee et le Wolfgangsee. C'est dans les Alpes que les paysages sont les plus somptueux, mais les attractions culturelles en revanche sont plutôt concentrées dans les Préalpes ou plus au nord, et notamment à Linz, la capitale de cette région.

Oberösterreich

Wie an einer Kette aufgereiht, liegen im Salzkammergut große Seen, die bekanntesten sind Hallstätter See, Mondsee und Wolfgangsee, allesamt beliebte Urlaubsziele. Während die Alpenregion vor allem reizvolle Landschaften bietet, sind die kulturellen Highlights eher im Voralpengebiet oder nördlich davon zu finden, etwa in der Landeshauptstadt Linz.

Alta Austria

El Salzkammergut está alineado como una cadena con grandes lagos, siendo los más famosos lago de Hallstatt, el lago Mondsee y el lago Wolfgang, todos destinos turísticos populares. Mientras que la región alpina ofrece sobre todo paisajes encantadores, los aspectos culturales más destacados se encuentran en los Prealpes o al norte de ellos, por ejemplo, en la capital de la provincia, Linz.

Alta Áustria

O Salzkammergut está alinhado como uma cadeia com grandes lagos, sendo o mais famoso Hallstätter See, Mondsee e Wolfgangsee, todos destinos turísticos populares. Enquanto a região alpina oferece principalmente paisagens encantadoras, os destaques culturais estão mais no sopé dos Alpes ou ao norte deles, por exemplo, na capital da província, Linz.

Opper-Oostenrijk

Het Salzkammergut is een streek met tal van grote meren. De bekendste zijn de Hallstätter See, Mondsee en Wolfgangsee, stuk voor stuk populaire vakantiebestemmingen. Voor liefhebbers van fraaie landschappen is deze streek ideaal. En wie cultuur zoekt, komt bijvoorbeeld in plaatsen in de Vooralpen of in Linz, de hoofdstad van de deelstaat Opper-Oostenrijk, aan zijn trekken.

St. Wolfgang, Wolfgangsee

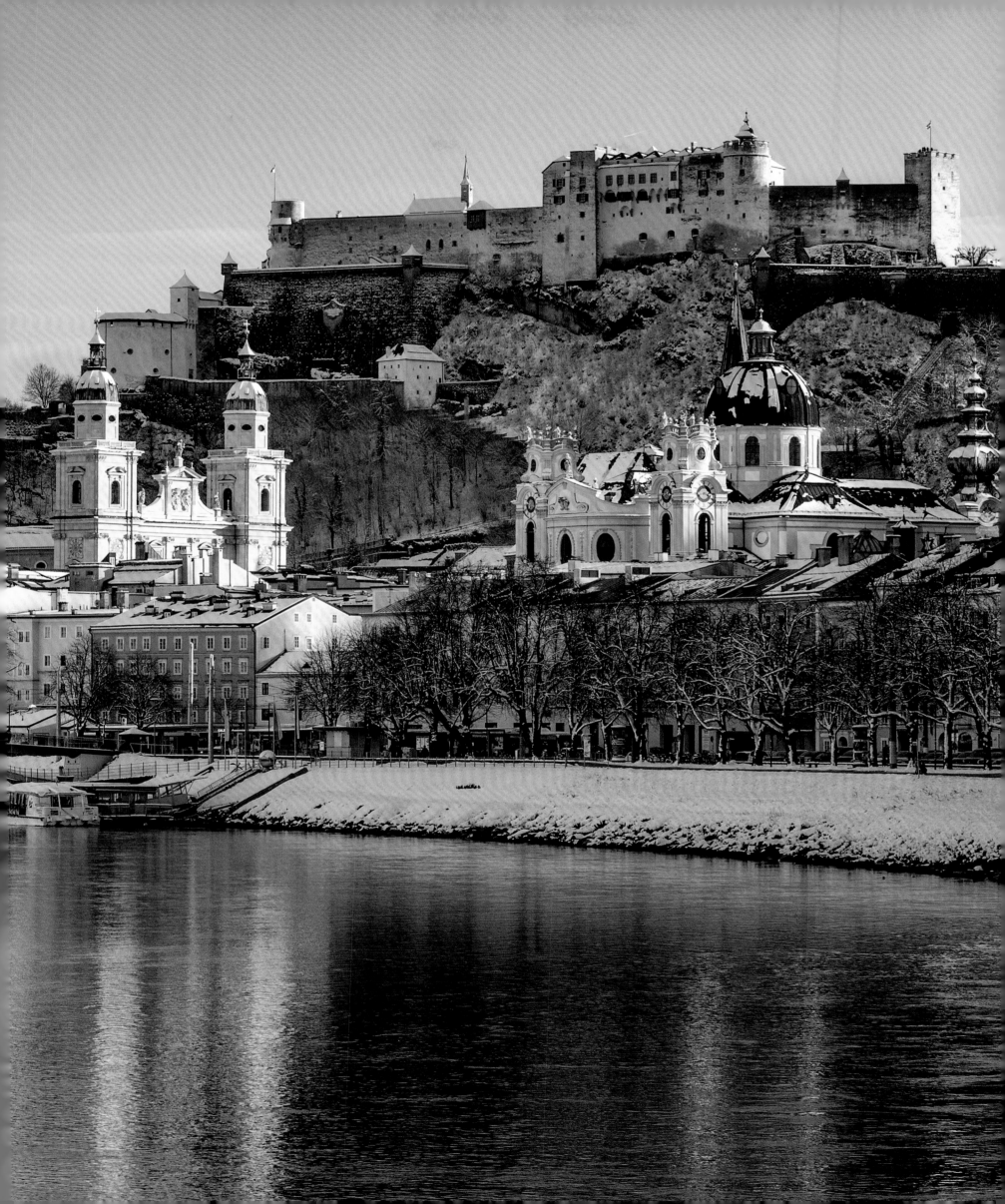

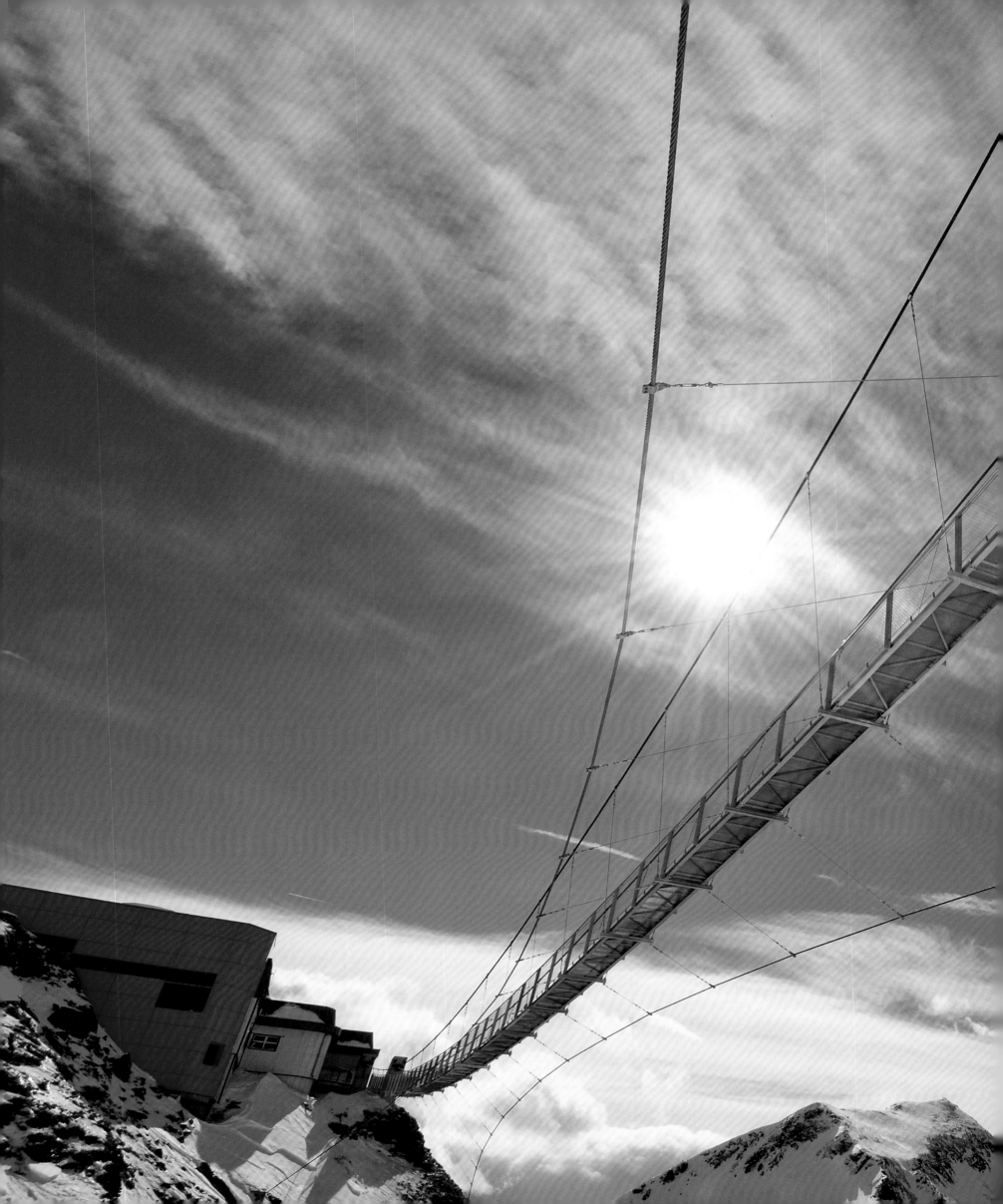

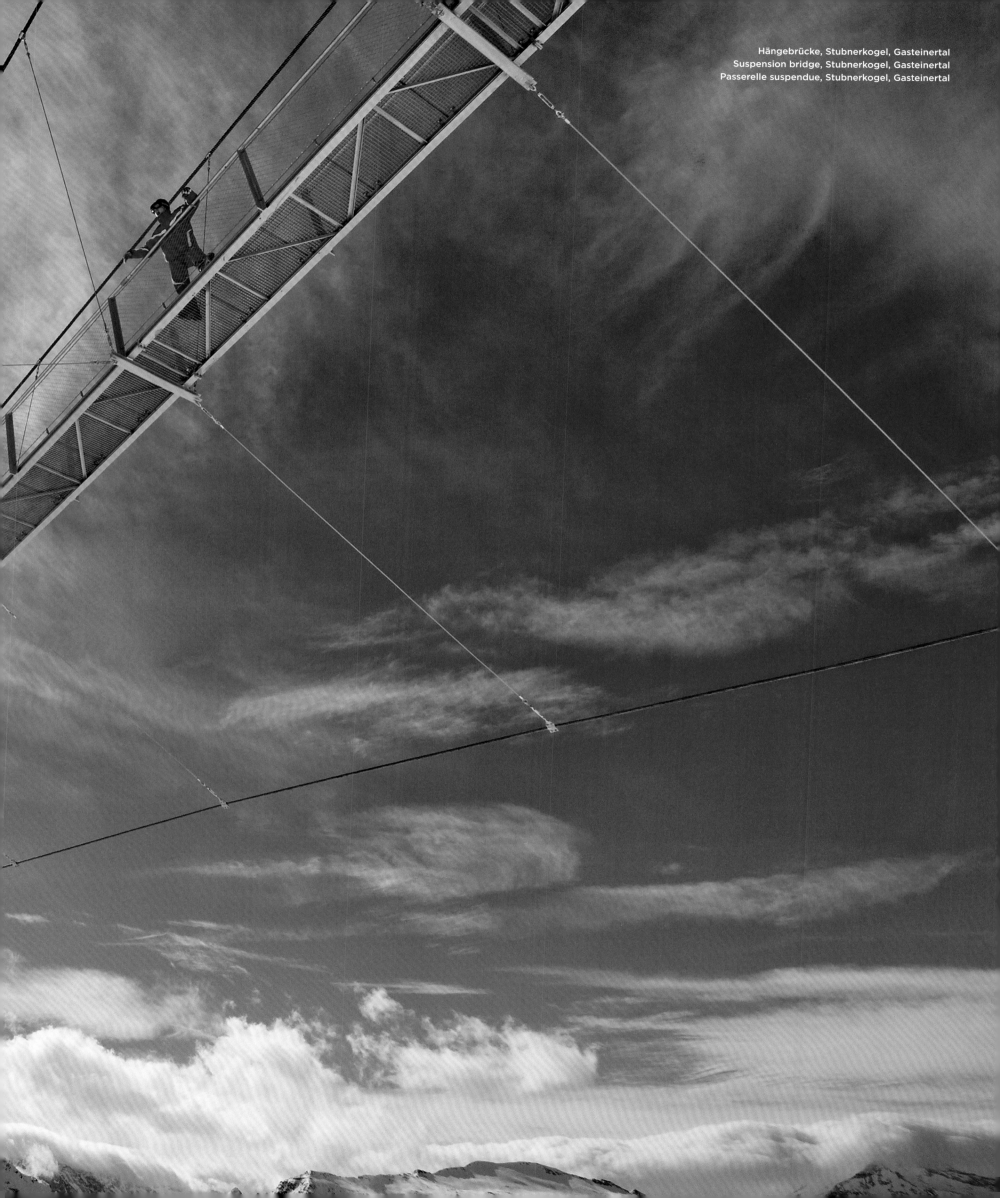

Hängebrücke, Stubnerkogel, Gasteinertal
Suspension bridge, Stubnerkogel, Gasteinertal
Passerelle suspendue, Stubnerkogel, Gasteinertal

"Villa Dachsteinblick", Tennengebirge

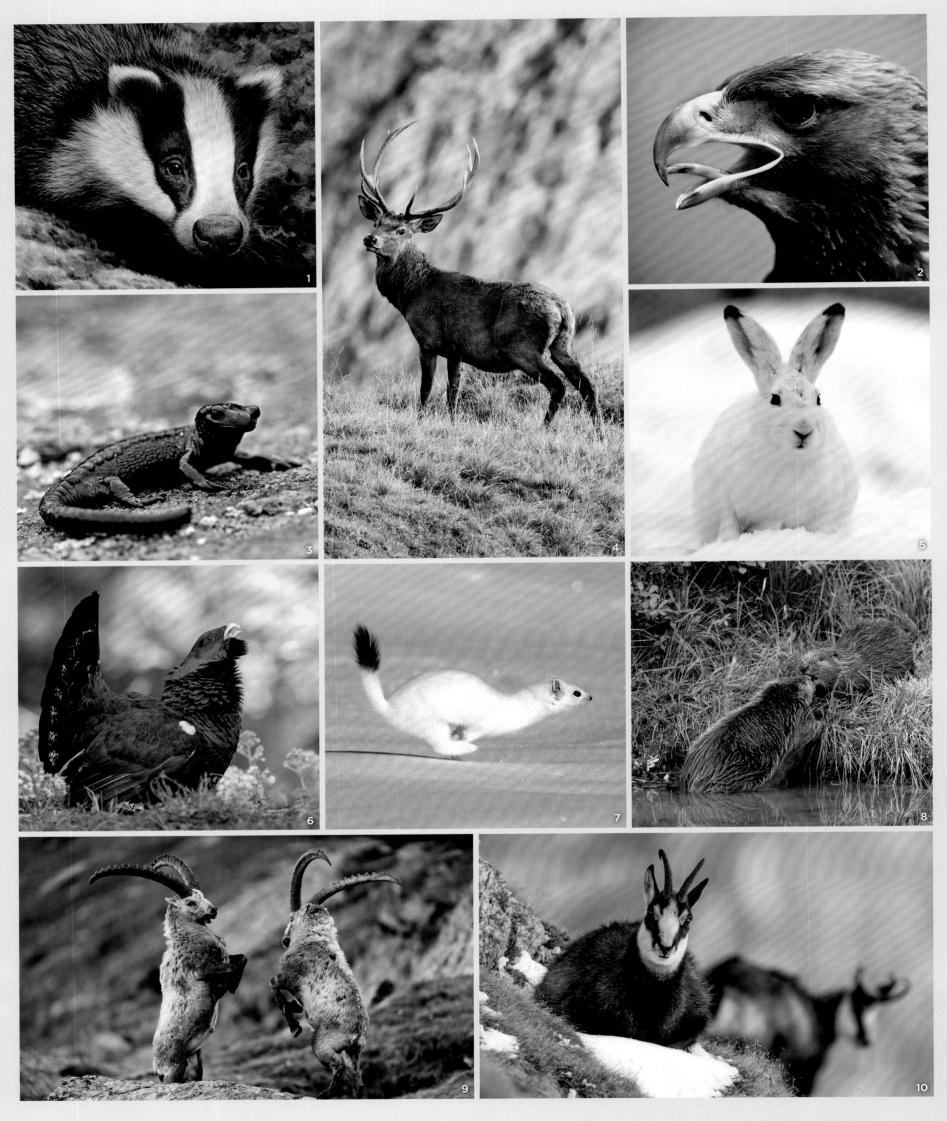

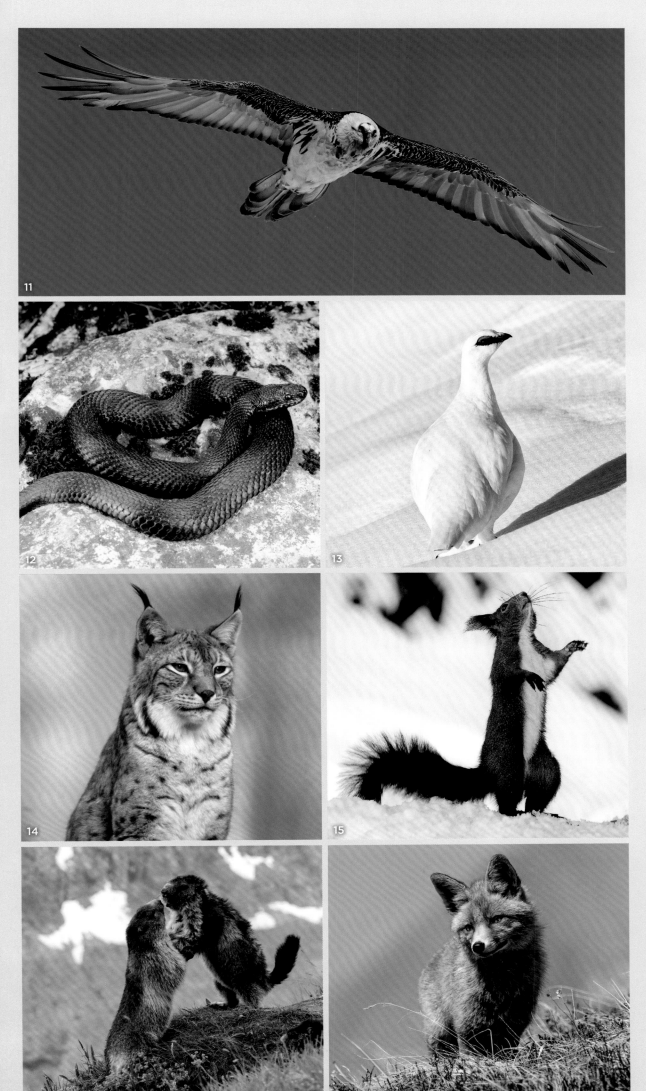

1 Badger, Blaireau, Dachs, Tejón, Texugo, Das
2 Golden eagle, Aigle royal, Steinadler, Águila real, Aguias douradas, Steenarend
3 Alpine salamander, Salamandre noire, Alpensalamander, Salamandra alpina, Salamandras alpinas, Alpenlandsalamander
4 Red deer, Cerf élaphe, Rothirsch, Ciervo rojo, Veado vermelho, Edelhert
5 Mountain hare, Lièvre variable, Schneehase, Liebre de montaña, Lebre das neves, Sneeuwhaas
6 Capercaillie, Grand coq de bruyère, Auerhahn, Urogallo, Capercaillie, Auerhaan
7 Ermine, Hermine, Hermelin, Armiño, Hermelijn
8 Beaver, Castor, Biber, Castores, Bever
9 Alpine ibex, Bouquetin des Alpes, Alpensteinbock, Íbice, Ibex alpino, Steenbok
10 Chamois, Gämse, Gamuza, Camurças, Gems
11 Bearded vulture, Gypaète barbu, Bartgeier, Quebrantahuesos, Abutre Barbado, Lammergier
12 Common European adder, Vipère péliade, Kreuzotter, Víbora, Víbora, Adder
13 Rock Ptarmigan, Lagopède alpin, Alpenschneehuhn, Perdiz nival, Rock Ptarmigan, Apensneeuwhoen
14 Lynx, Luchs, Lince, Lynxen
15 Eurasian squirrel, Écureuil roux, Eurasisches Eichhörnchen, Ardilla roja, Esquilo Euro-Asiático, Eekhoorn
16 Marmot, Marmotte des Alpes, Murmeltier, Marmota, Alpenmarmot
17 Red fox, Renard roux, Rotfuchs, Zorro rojo, Raposa vermelha, Vos

491

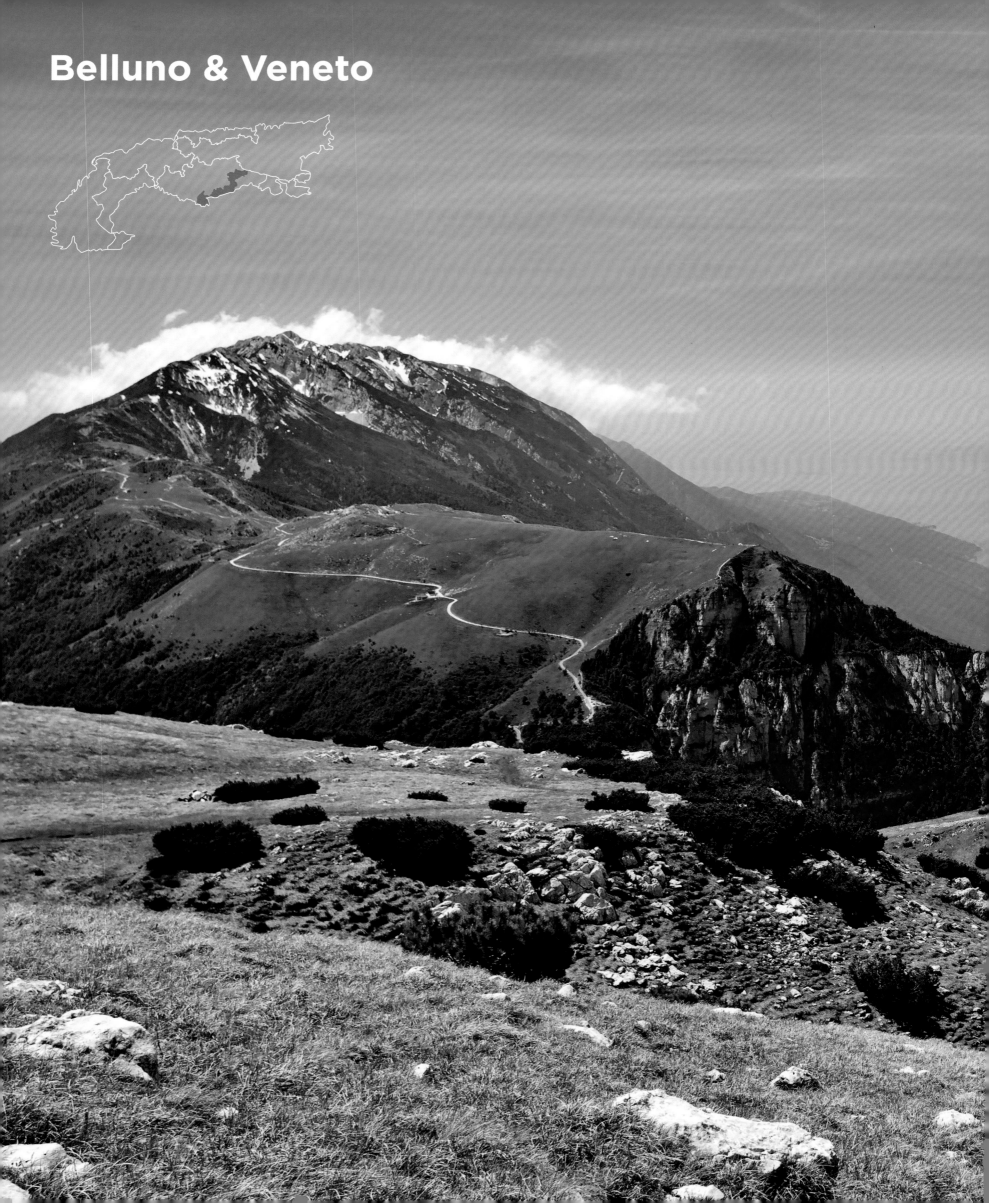

Belluno & Veneto

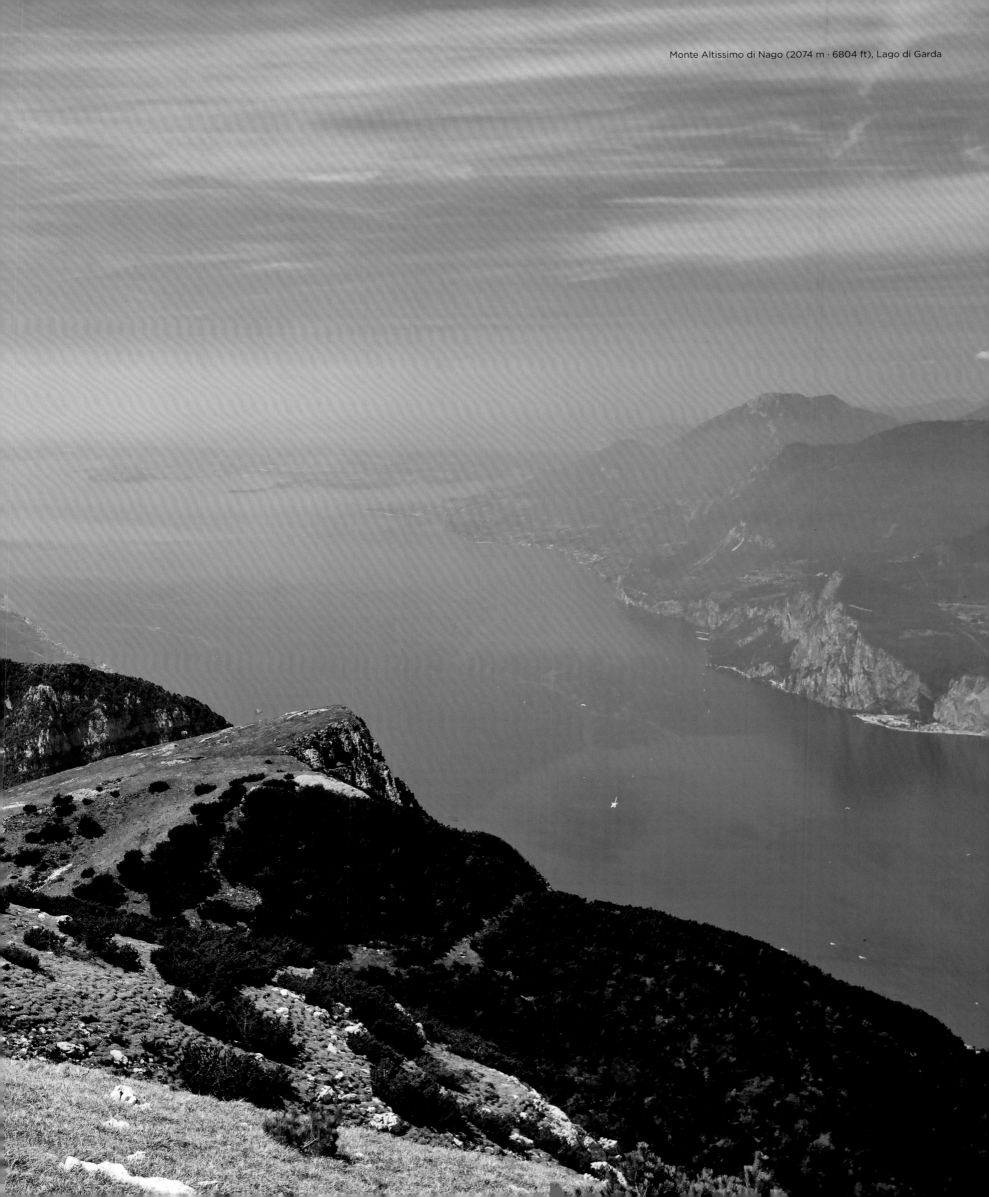

Monte Altissimo di Nago (2074 m · 6804 ft), Lago di Garda

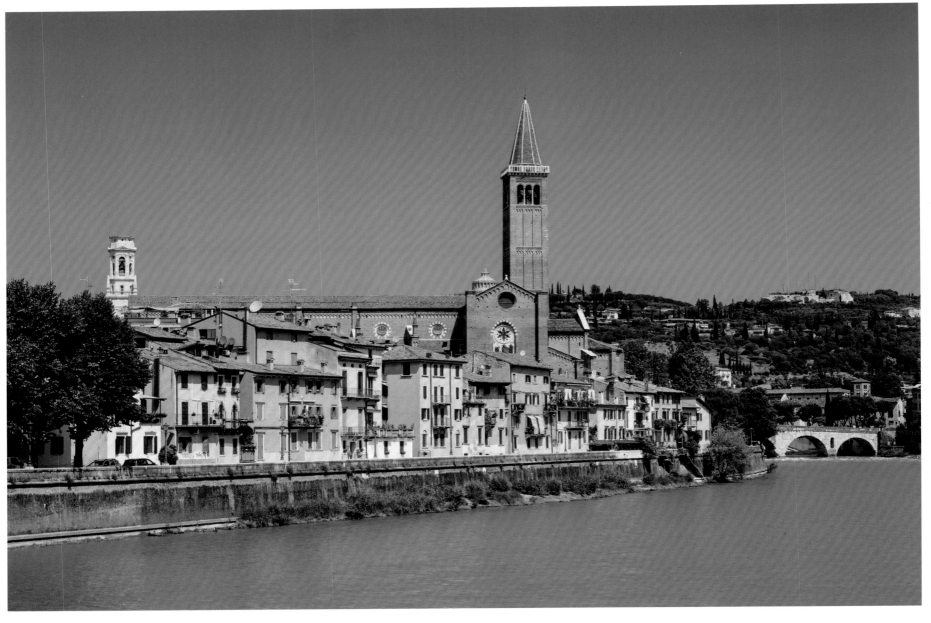

Adige, Verona

Belluno and Veneto

Charming contrasts make the Alpine region of Veneto and the province of Belluno one of the most visited holiday destinations in Italy. The Dolomites with the Marmolata as the highest peak (3343 m · 10,968 ft) and the Adriatic Sea are within a short distance of each other. In the mornings visitors can ski in the mountains and in the evenings they can enjoy a grand opera in Verona or Venice.

Belluno et la Vénétie

C'est grâce à leurs contrastes fascinants que la région alpine de Vénétie et la province de Belluno font partie des destinations les plus prisées d'Italie. Les Dolomites, dont la Marmolada représente le point culminant (3343 m), côtoient l'Adriatique et ses vastes lagunes, permettant de faire du ski le matin et d'écouter un bel opéra le soir à Vérone ou à Venise.

Belluno und Veneto

Reizvolle Gegensätze machen die Alpenregion von Veneto und der Provinz Belluno zu einem der meistbesuchten Urlaubsziele in Italien. Die Dolomiten mit der Marmolata als höchstem Gipfel (3343 m) und die Adria mit weiten Lagunen liegen nahe beieinander, vormittags kann man in den Bergen skifahren und abends in Verona oder Venedig große Oper genießen.

Belluno y Véneto

Los encantadores contrastes hacen de la región alpina del Véneto y de la provincia de Belluno uno de los destinos turísticos más visitados de Italia. Los Dolomitas con el Marmolada como pico más alto (3343 m) y el Mar Adriático con amplias lagunas están muy cerca; por las mañanas se puede esquiar en las montañas y por las tardes se puede disfrutar de una gran ópera en Verona o Venecia.

Belluno e Veneto

Os contrastes encantadores fazem da região alpina do Vêneto e da província de Belluno um dos destinos turísticos mais visitados da Itália. Os Dolomitas com a Marmolata como o pico mais alto (3343 m) e o Mar Adriático com lagoas largas estão próximos. Nas manhãs você pode esquiar nas montanhas e nas noites você pode desfrutar de uma grande ópera em Verona ou Veneza.

Belluno en Veneto

De alpenregio Veneto en de provincie Belluno behoren tot de meest bezochte vakantiebestemmingen van Italië, mede dankzij de enorme contrasten in deze streek. Enerzijds vinden we er de Dolomieten met de Marmolada als hoogste bergtop (3343 m) en anderzijds de Adriatische Zee met brede lagunes. Wie 's ochtends wil gaan skiën en 's avonds van een opera in Verona of Venetië wil genieten, is hier aan het juiste adres.

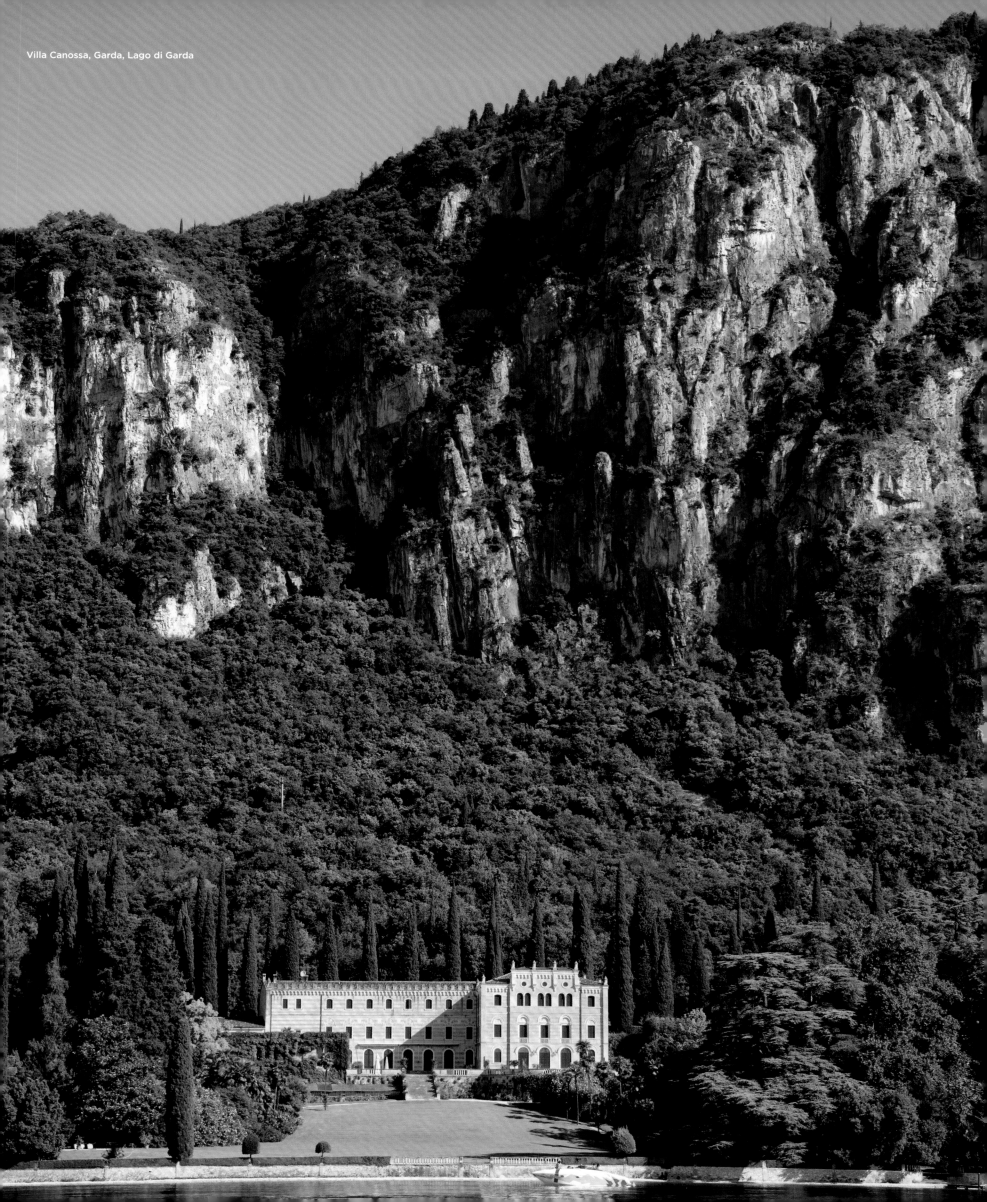

Villa Canossa, Garda, Lago di Garda

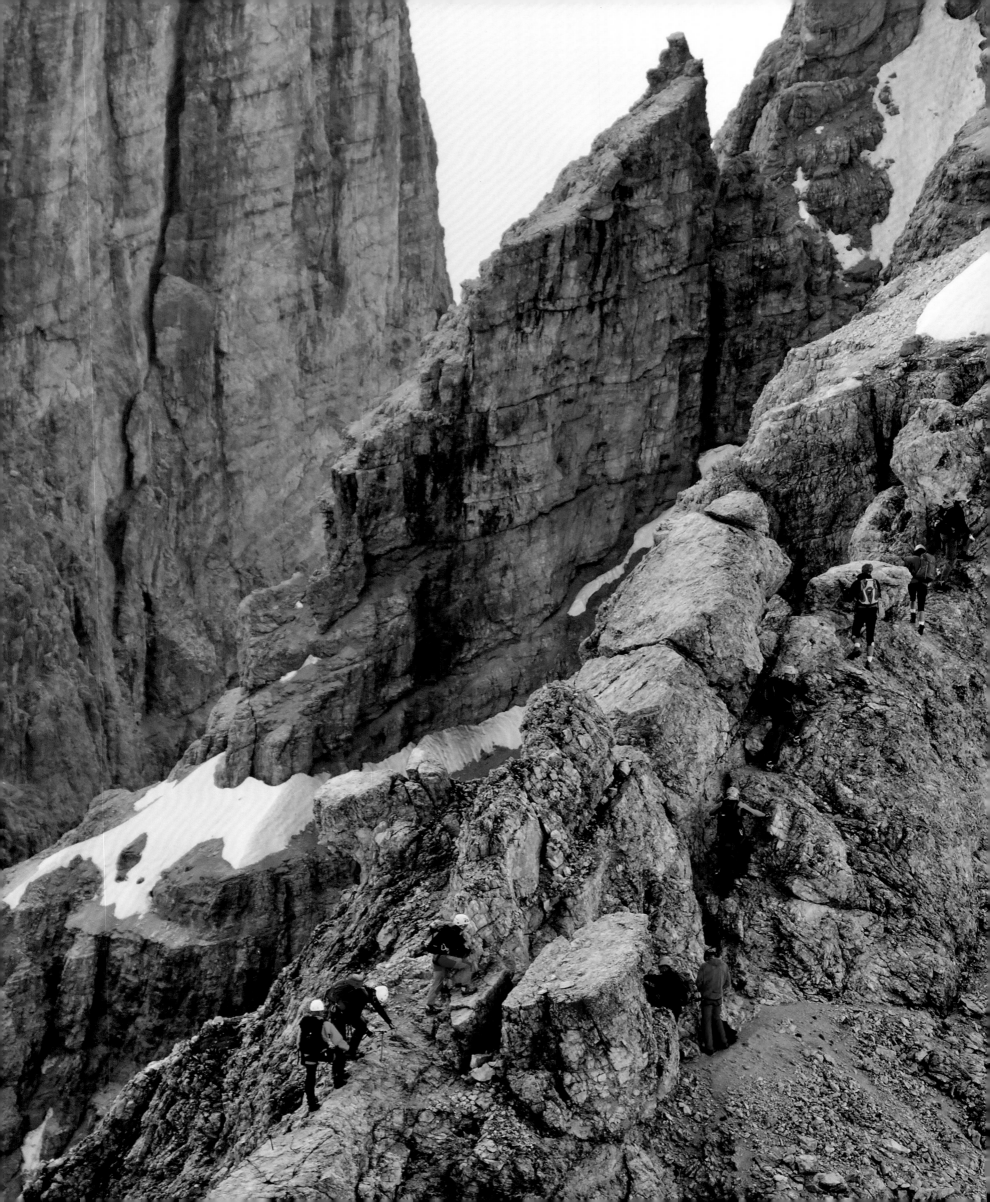

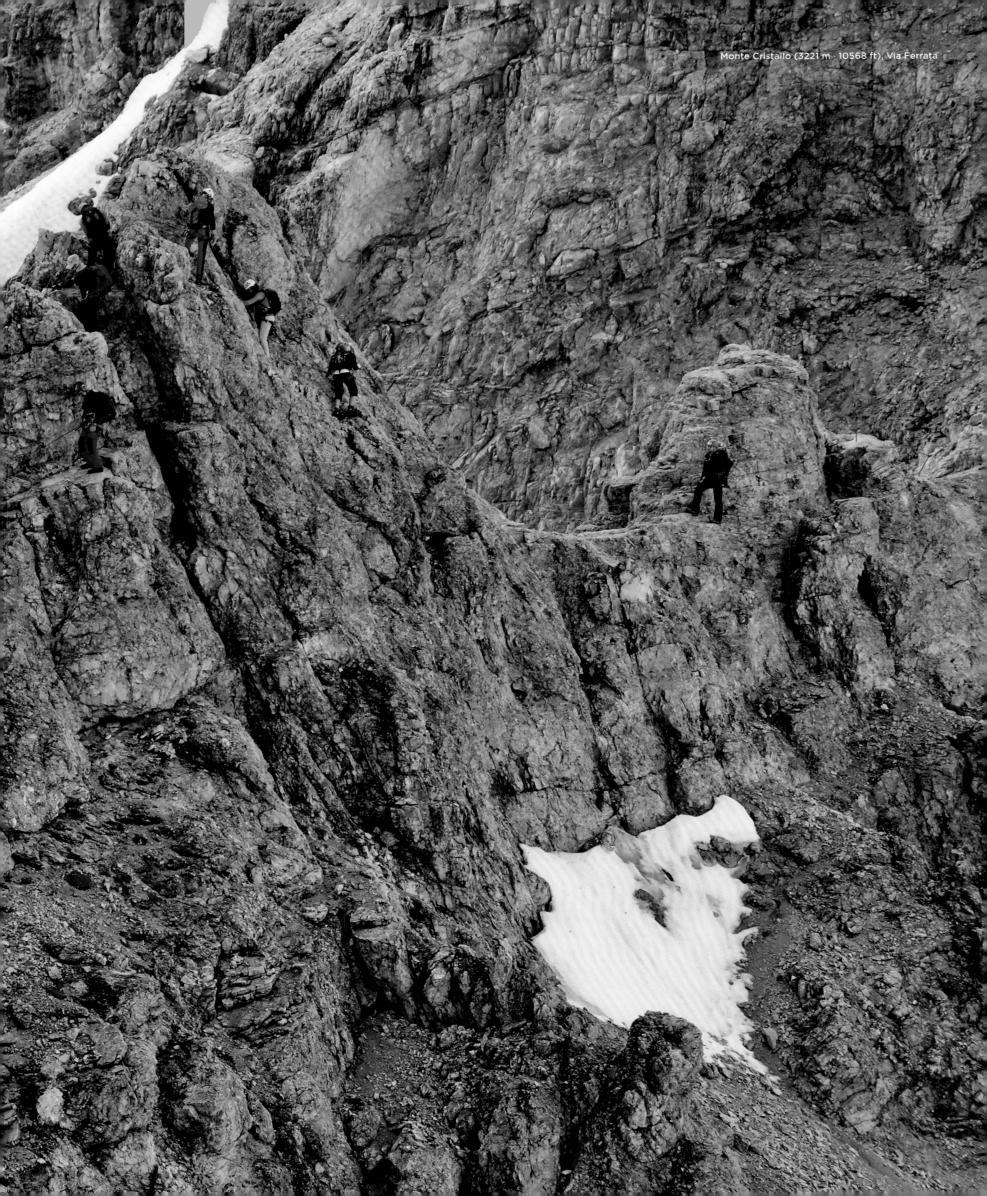

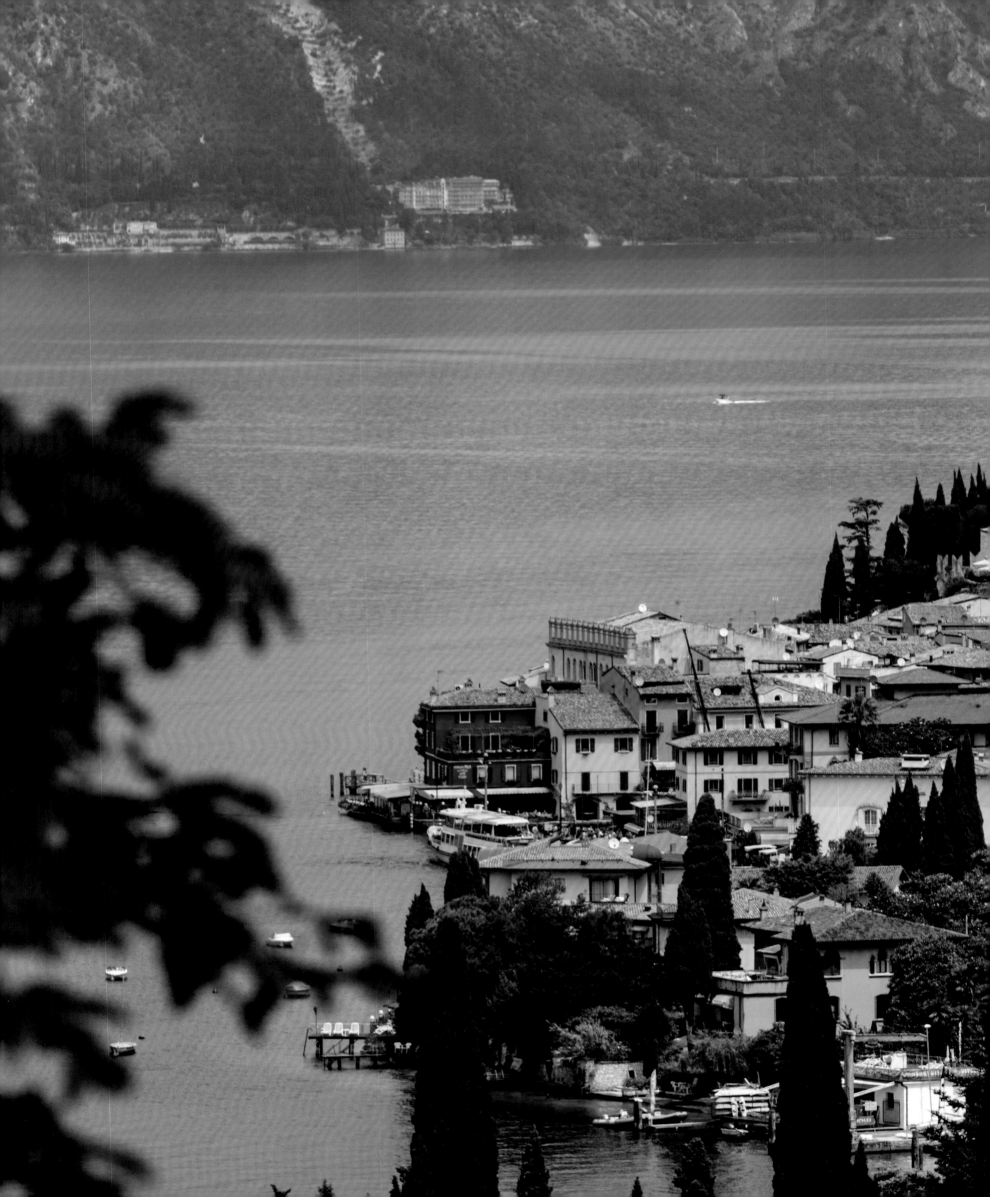

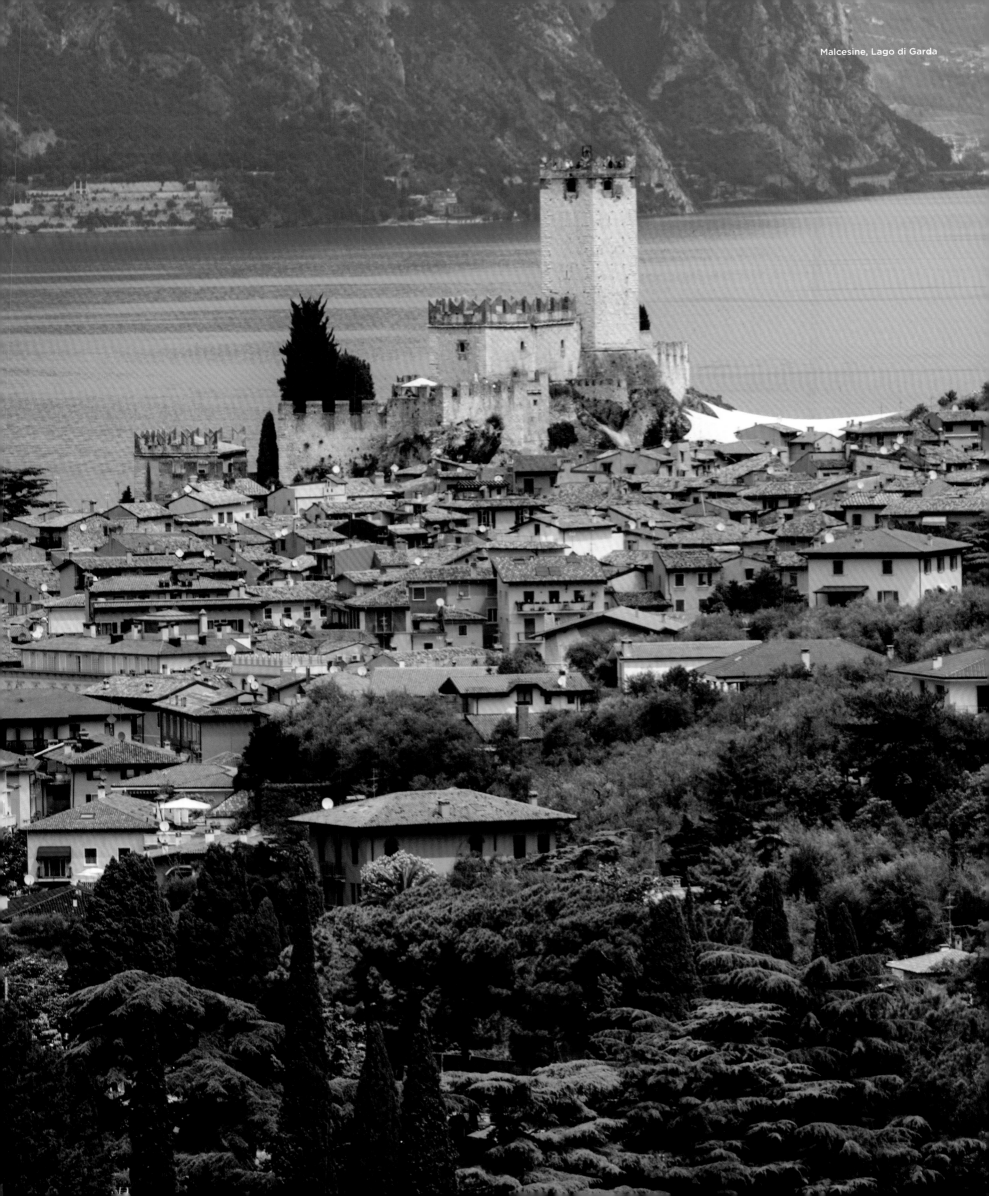
Malcesine, Lago di Garda

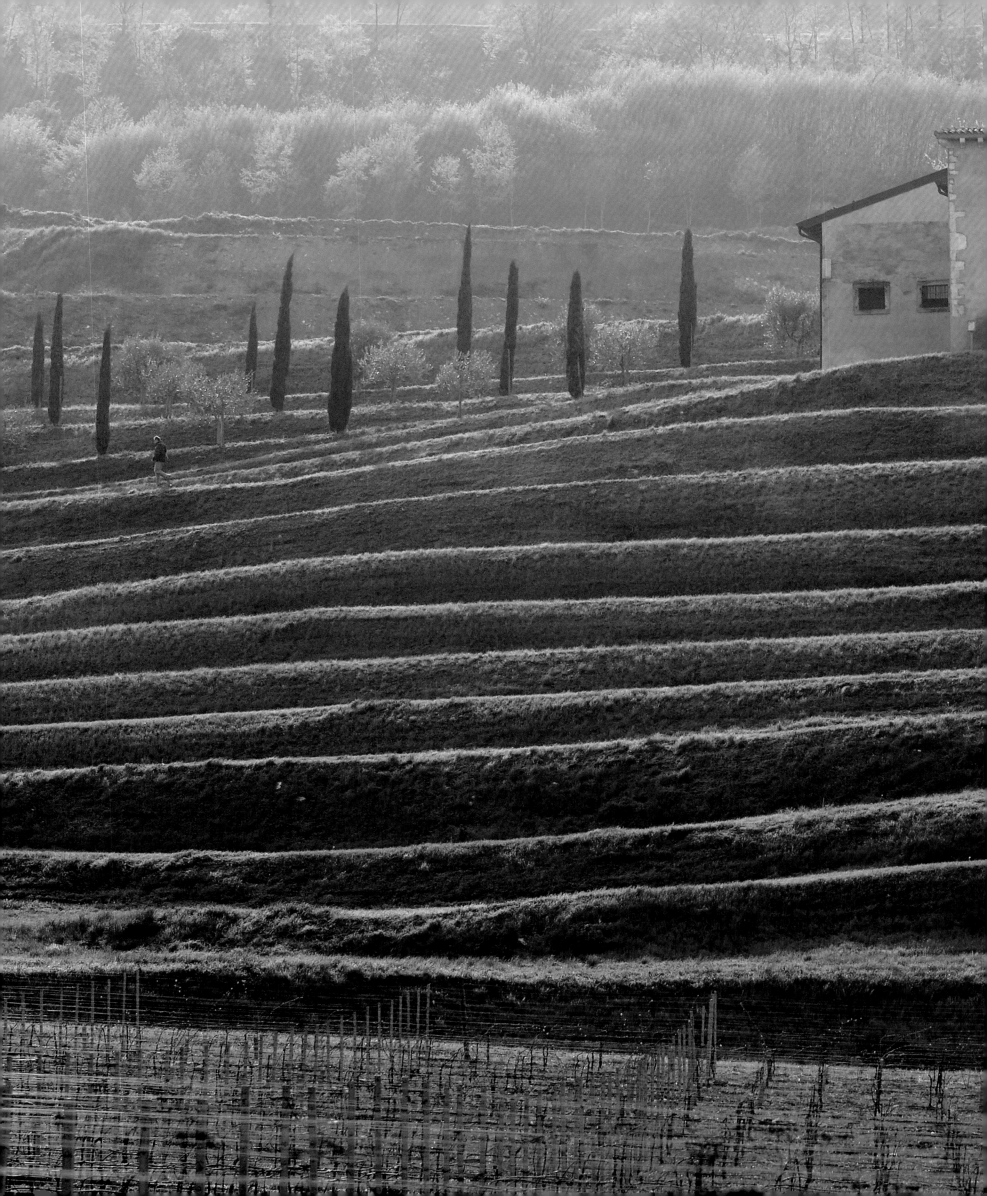

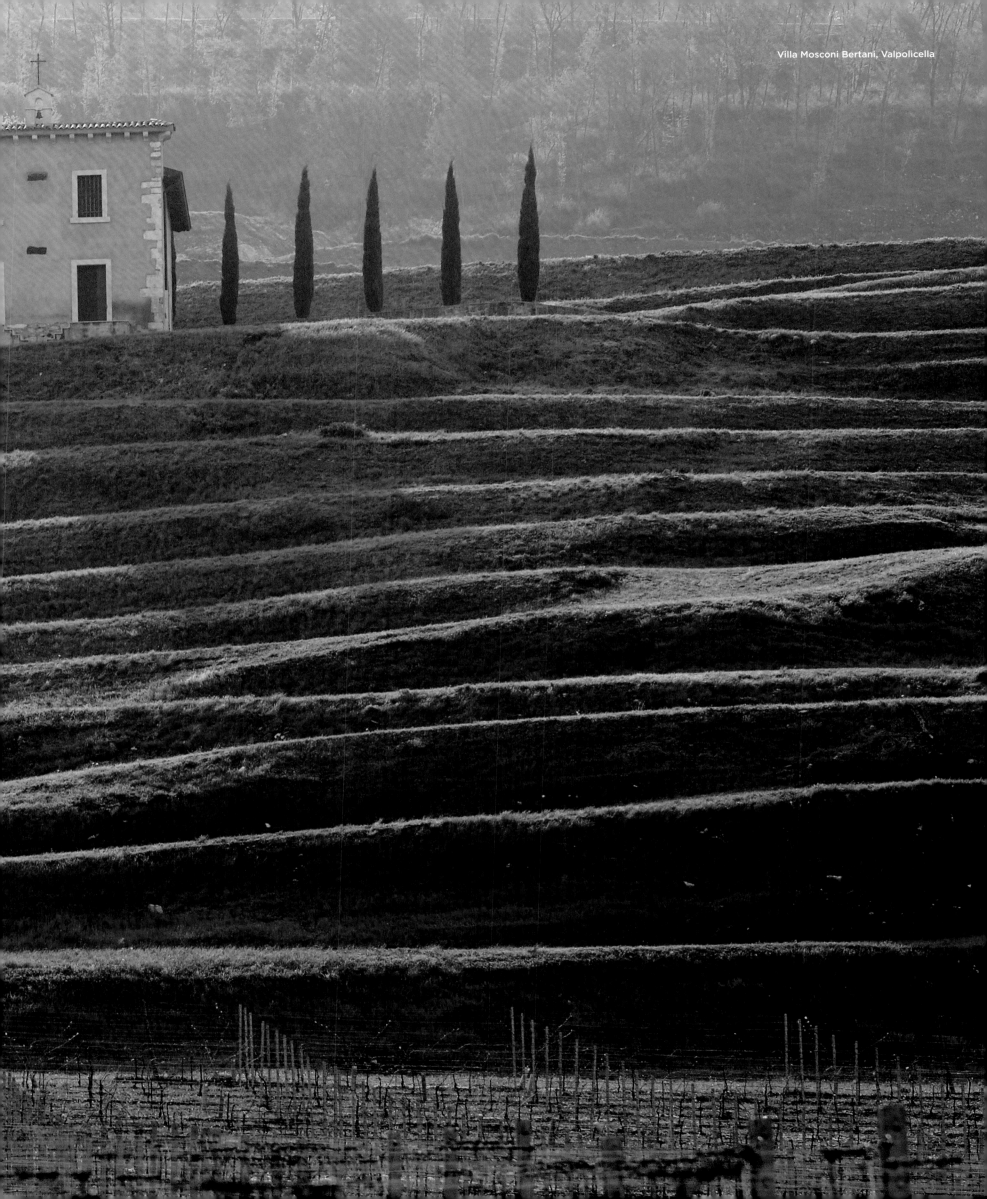

Villa Mosconi Bertani, Valpolicella

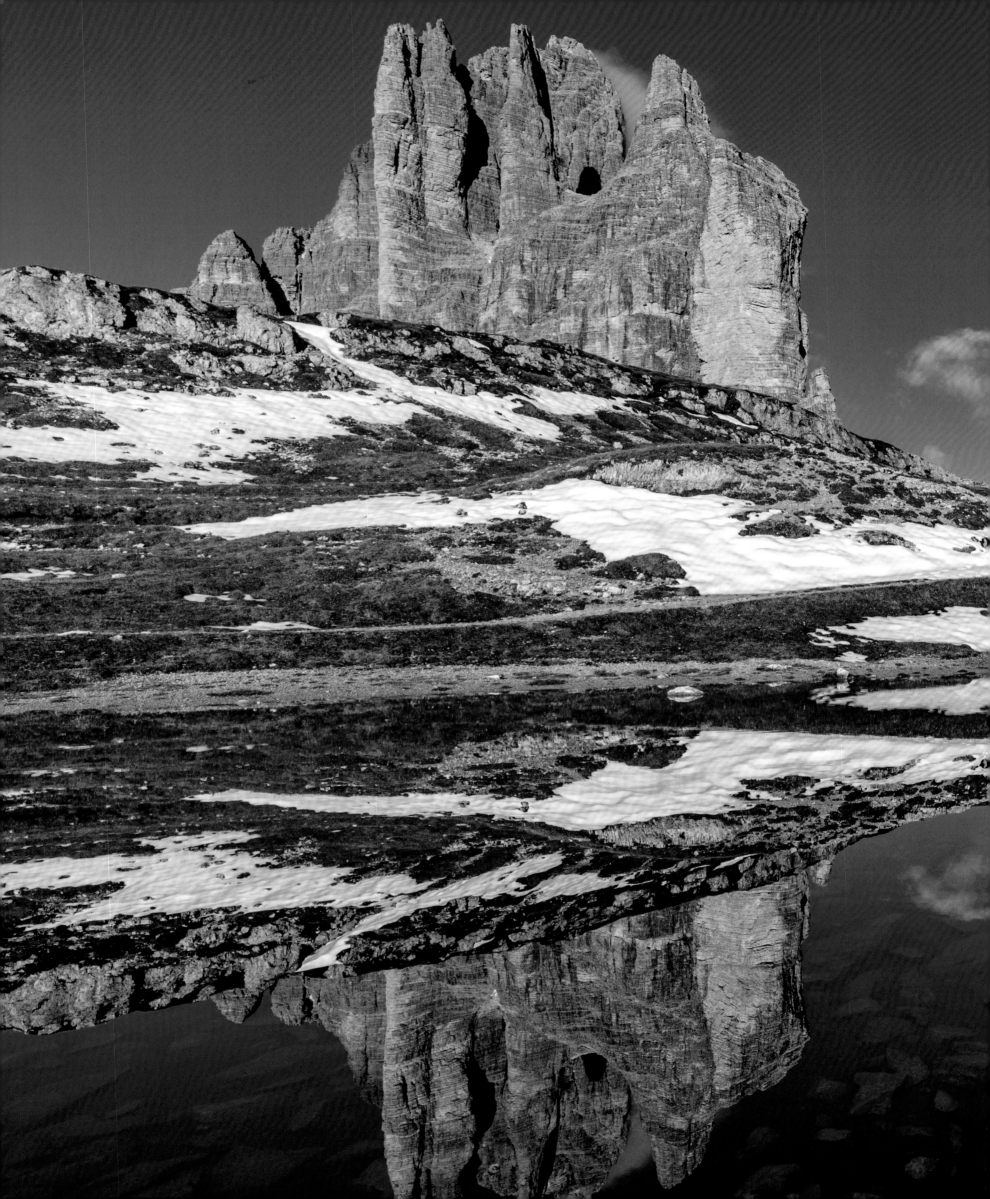

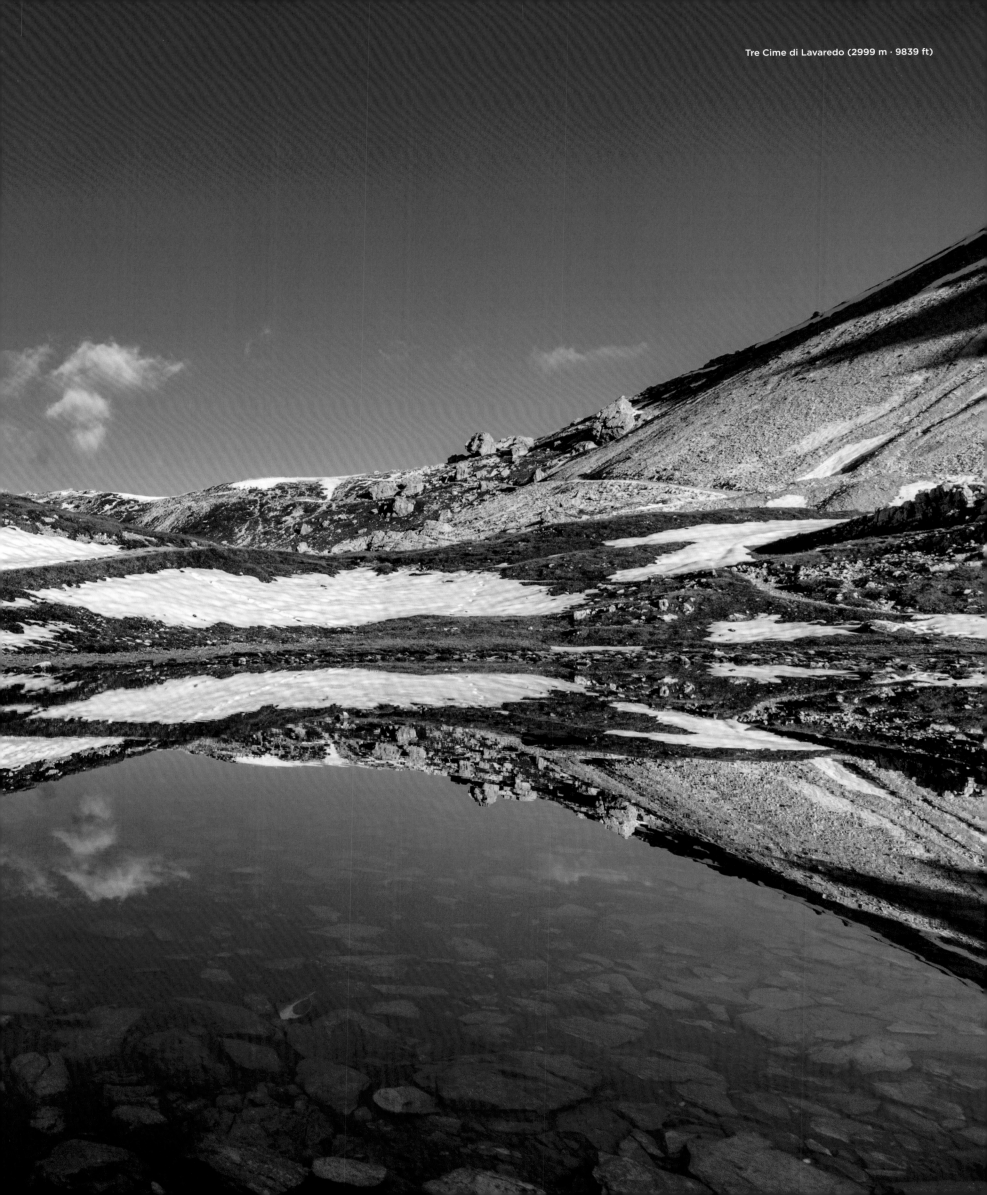

Tre Cime di Lavaredo (2999 m · 9839 ft)

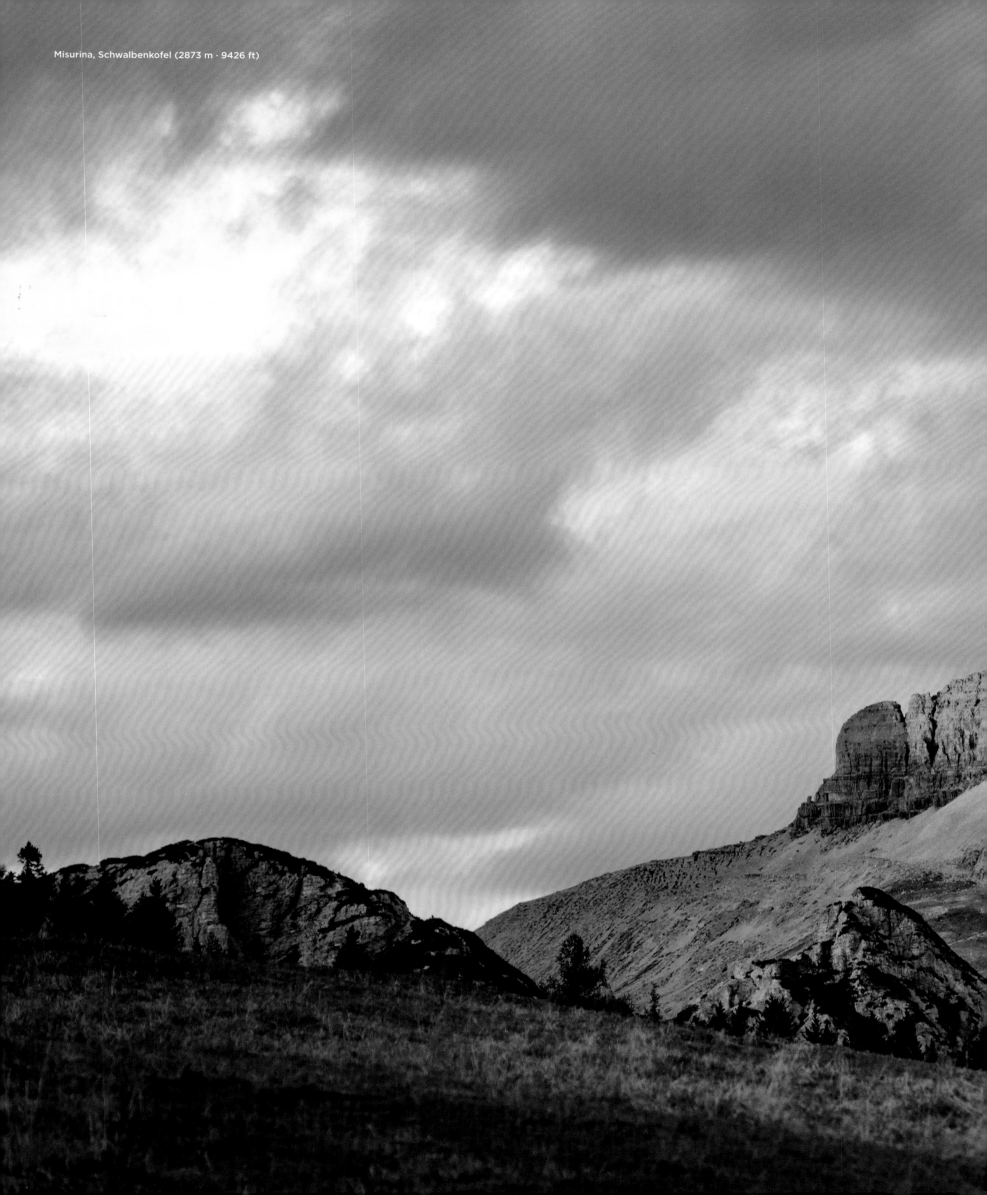

Misurina, Schwalbenkofel (2873 m · 9426 ft)

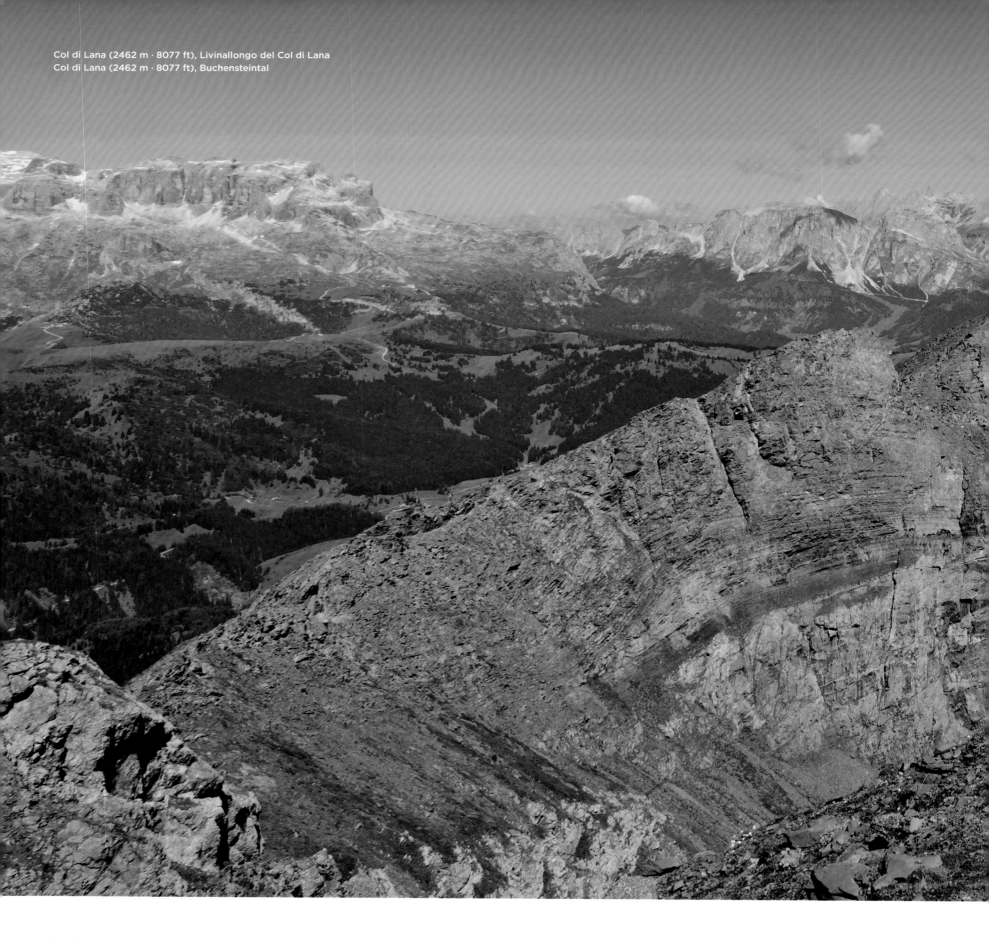

Col di Lana (2462 m · 8077 ft), Livinallongo del Col di Lana
Col di Lana (2462 m · 8077 ft), Buchensteintal

Col di Lana

Those who explore the beautiful mountain world of
the Dolomites by hiking in the summer Will soon
notice that they are in an area still showing traces
of past wars, for example in the Buchenstein valley.
During the First World War, the Col di Lana was the
front between Austria-Hungary and Italy for a time.
Ineffectual heavy artillery encounters tore deep holes
into the landscape and mine craters can still be seen
everywhere. Several monuments have been raised in
the memory of those bloodthirsty times.

Le Col di Lana

L'été, si l'on entreprend de se promener dans les
magnifiques montagnes des Dolomites, dans la
vallée de Buchenstein par exemple, on remarque bien
vite que les traces de la guerre perdurent encore.
Pendant la Première Guerre mondiale, le front entre
l'Autriche-Hongrie et l'Italie passa par le Col di Lana.
Les combats d'artillerie vains et sanglants creusèrent
d'énormes trous et on peut encore voir des cratères
un peu partout. Des monuments ont été érigés en
souvenir de ces temps meurtriers.

Col di Lana

Wer im Sommer in der schönen Bergwelt der
Dolomiten etwa im Buchensteintal Bergtouren
unternimmt, merkt bald, dass er sich in einem vom
Krieg immer noch gezeichneten Gebiet befindet. Im
Ersten Weltkrieg verlief auch am Col di Lana zeitweise
die Front zwischen Österreich-Ungarn und Italien.
Sinnlose, schwere Artilleriekämpfe rissen Löcher
auf, Minenkrater sieht man noch überall. Denkmäler
erinnern an die blutigen Zeiten.

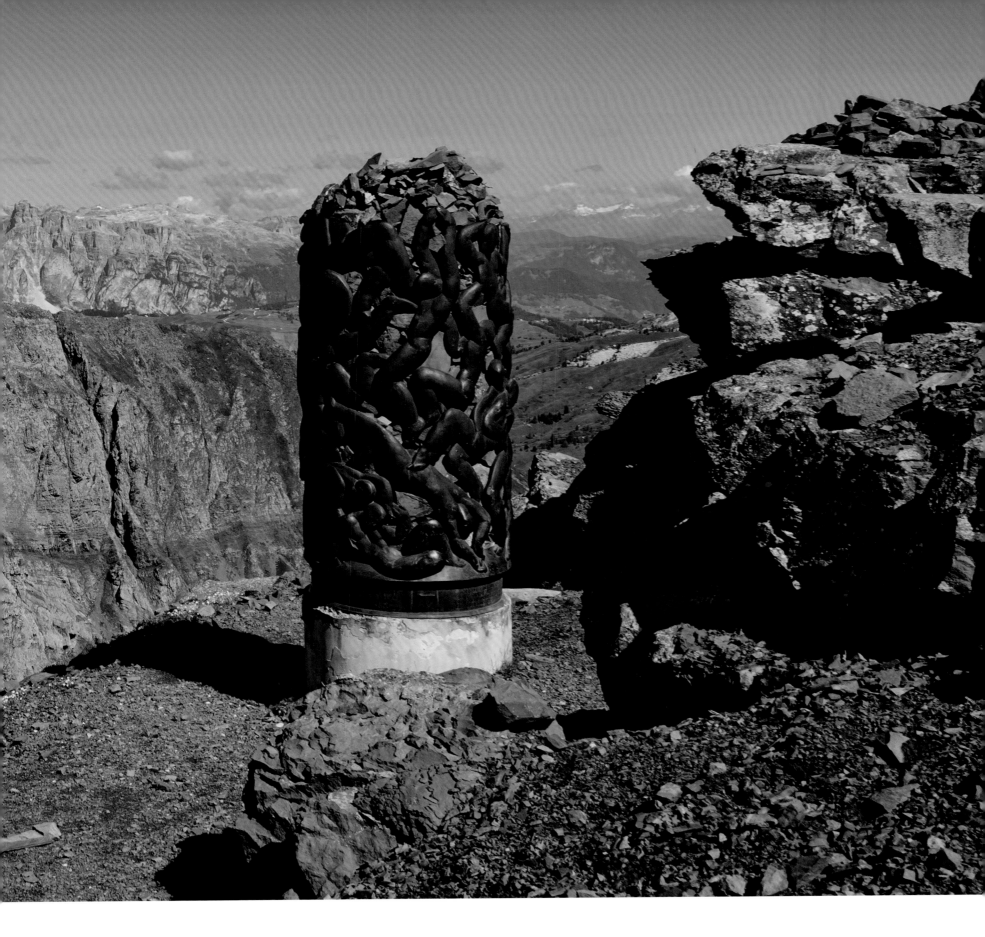

Col di Lana

Quienes realizan excursiones de montaña en verano en el hermoso mundo montañoso de los Dolomitas, por ejemplo en el valle Livinallongo del Col di Lana, pronto se darán cuenta de que se encuentran en una zona todavía marcada por la guerra. Durante la Primera Guerra Mundial, en Col di Lana también transcurrió el frente ocasional entre Austria-Hungría e Italia. Las peleas de artillería pesada y sin sentido abrieron agujeros; los cráteres de las minas todavía se pueden ver en todas partes. Los monumentos nos recuerdan a los tiempos sangrientos.

Col di Lana

Aqueles que empreendem excursões de montanha no verão no belo mundo montanhoso das Dolomitas, por exemplo no vale do Buchenstein, logo perceberão que estão em uma área ainda marcada pela guerra. Durante a Primeira Guerra Mundial, o Col di Lana também viu a frente ocasional entre a Áustria-Hungria e a Itália. As lutas de artilharia pesada e sem sentido abriram buracos, as crateras das minas ainda podem ser vistas em todo o lado. Os monumentos lembram-nos os tempos sangrentos.

Col di Lana

Wie in de zomer een wandeling in de prachtige bergen van de Dolomieten maakt, bijvoorbeeld in de Buchenstein-vallei, zal niet ontgaan dat hier ooit een oorlog heeft gewoed. Tijdens de Eerste Wereldoorlog lag de frontlinie tussen Oostenrijk-Hongarije en Italië precies op de Col di Lana. Zinloze, zware artilleriegevechten en mijnen hebben diepe kraters achtergelaten. Monumenten houden de herinnering aan deze bloedige tijden levendig.

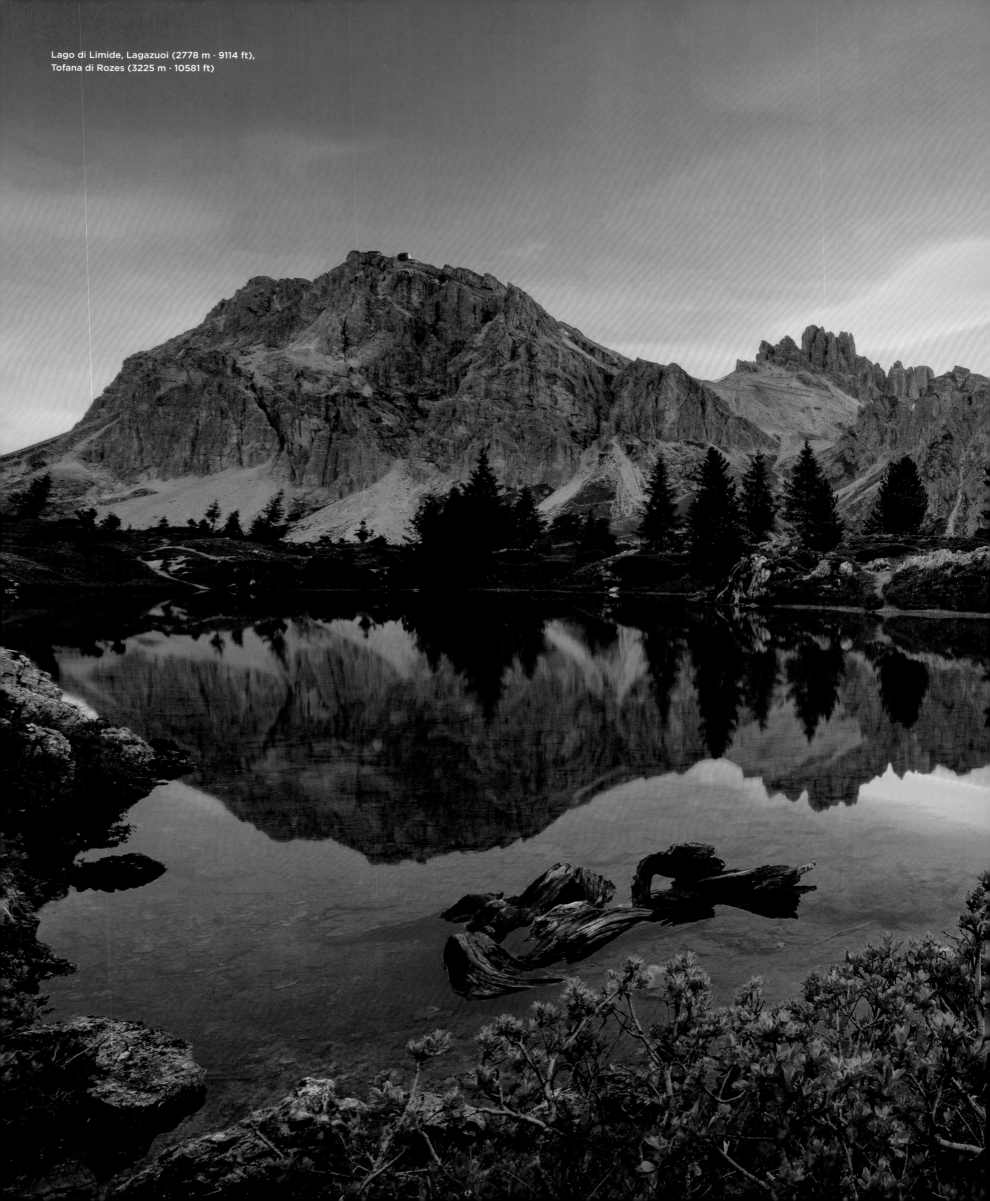

Lago di Limide, Lagazuoi (2778 m · 9114 ft),
Tofana di Rozes (3225 m · 10581 ft)

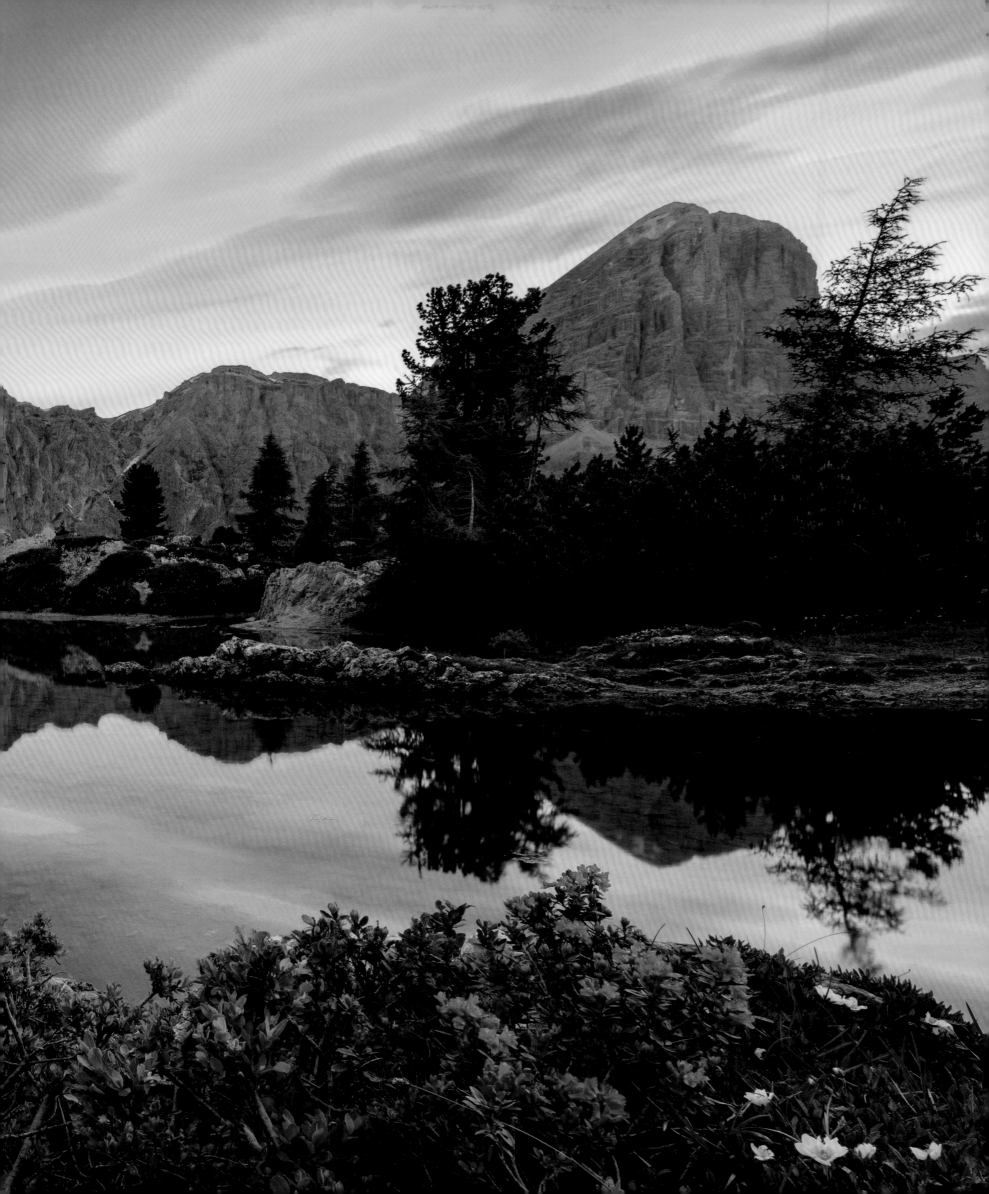

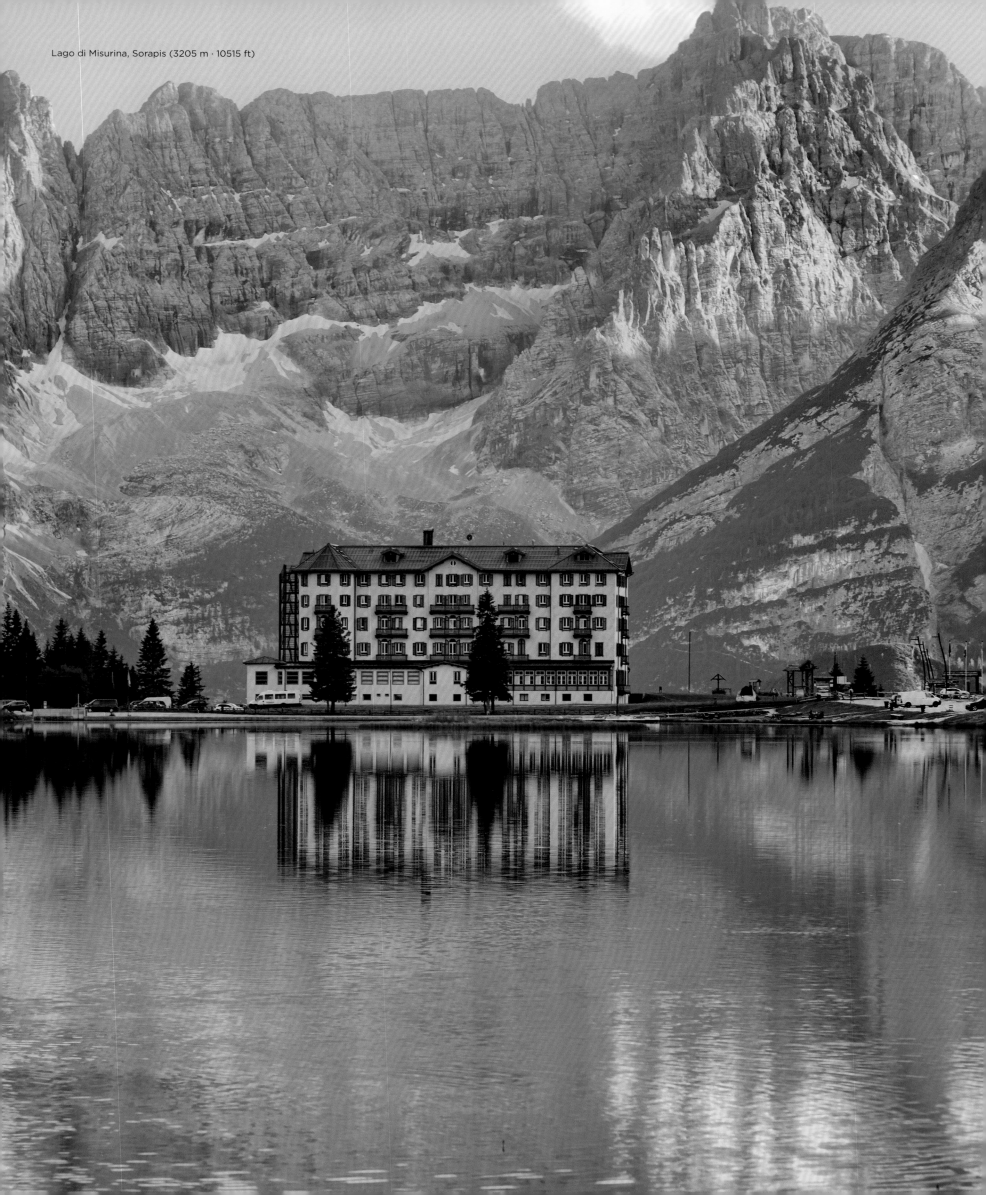

Lago di Misurina, Sorapis (3205 m · 10515 ft)

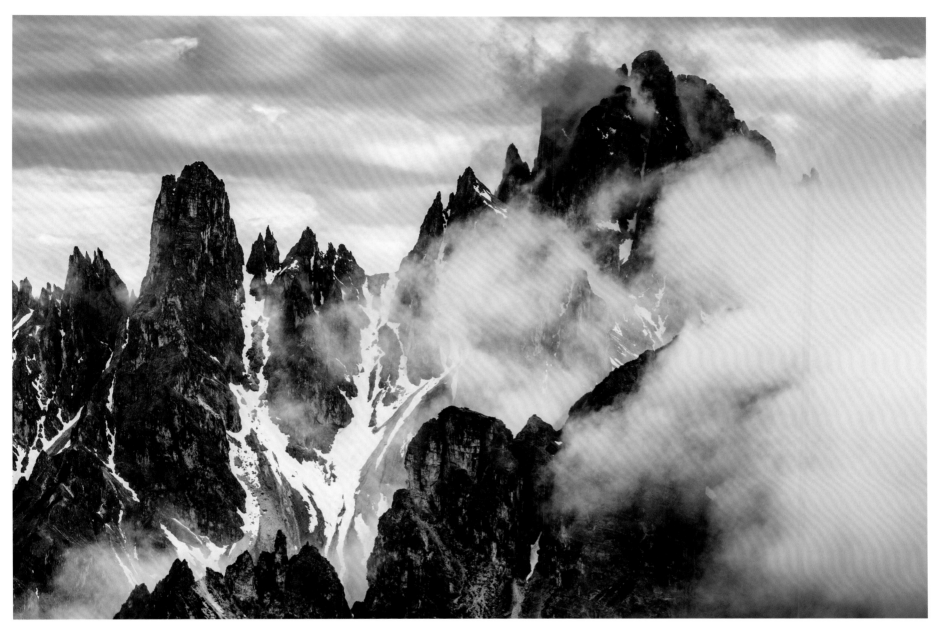

Cadini di Misurina (2404 m · 7887 ft)

Lago di Misurina

The surrounding Dolomite peaks form an enormous backdrop for the Lago di Misurina at an altitude of over 1700 m (5577 ft). The ideal climatic conditions, especially the low humidity, make it a popular health resort for people with respiratory diseases. In winter the lake is usually frozen over, then winter sports enthusiasts get their turn, for example with polo on the ice.

Le lac de Misurina

Les Dolomites constituent le décor grandiose qui entoure le lac de Misurina, perché à plus de 1700 m d'altitude. Ses conditions climatiques idéales, et notamment son air sec, en font un lieu de cure très apprécié des personnes souffrant de maladies des voies respiratoires. En hiver, le lac est souvent gelé, laissant place aux adeptes de sports d'hiver comme le polo sur glace.

Lago di Misurina

Die umgebenden Dolomitengipfel bilden eine gewaltige Kulisse für den über 1700 m hoch gelegenen Lago di Misurina. Beste klimatische Bedingungen wie die trockene Luft machen ihn zu einem gefragten Kurort für Menschen mit Atemwegserkrankungen. Im Winter ist der See meist zugefroren, dann sind die Wintersportler an der Reihe, etwa mit Polo auf dem Eis.

Lago di Misurina

Los picos de Dolomita que lo rodean forman un enorme telón de fondo para el Lago di Misurina a una altitud de más de 1700 metros. Las mejores condiciones climáticas, como el aire seco, lo convierten en un popular balneario para personas con enfermedades respiratorias. En invierno, el lago suele estar congelado, y luego es el turno de los entusiastas de los deportes de invierno, por ejemplo, con el polo sobre hielo.

Lago di Misurina

Os picos Dolomite circundantes formam um enorme pano de fundo para o Lago di Misurina a uma altitude de mais de 1700 metros. As melhores condições climáticas, como o ar seco, fazem dele uma estância de saúde popular para pessoas com doenças respiratórias. No inverno o lago é geralmente congelado, então é a vez dos entusiastas dos esportes de inverno, por exemplo, com pólo no gelo.

Meer van Misurina

De Dolomieten vormen een prachtig decor voor het op ruim 1700 m hoogte gelegen Meer van Misurina (Lago di Misurina). Dankzij het bijzondere microklimaat en de droge lucht is het een populair kuuroord voor mensen met aandoeningen aan de luchtwegen. In de winter is het meer meestal bevroren en is het de beurt aan de wintersporters, bijvoorbeeld aan spelers van winterpolo.

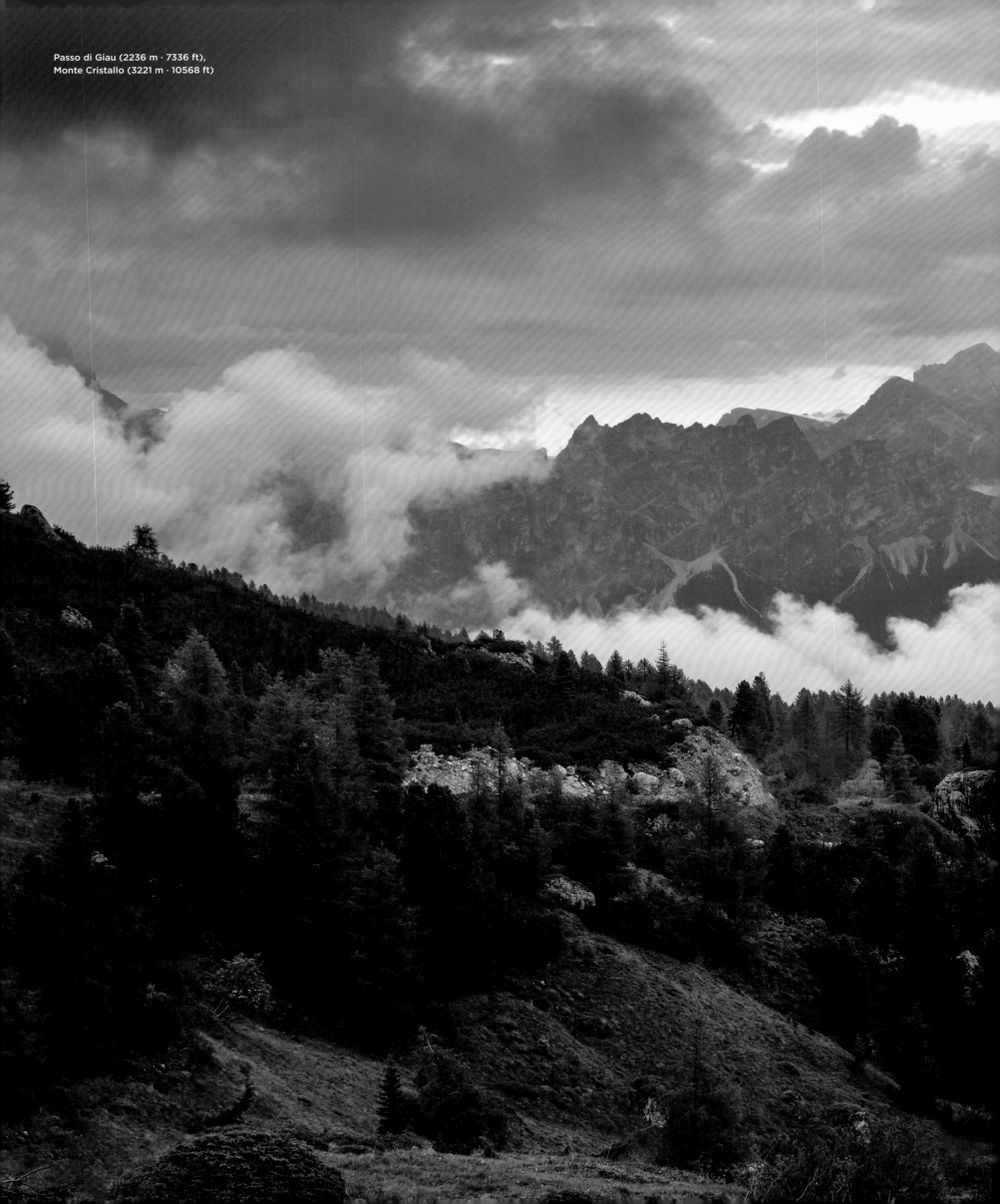

Passo di Giau (2236 m · 7336 ft),
Monte Cristallo (3221 m · 10568 ft)

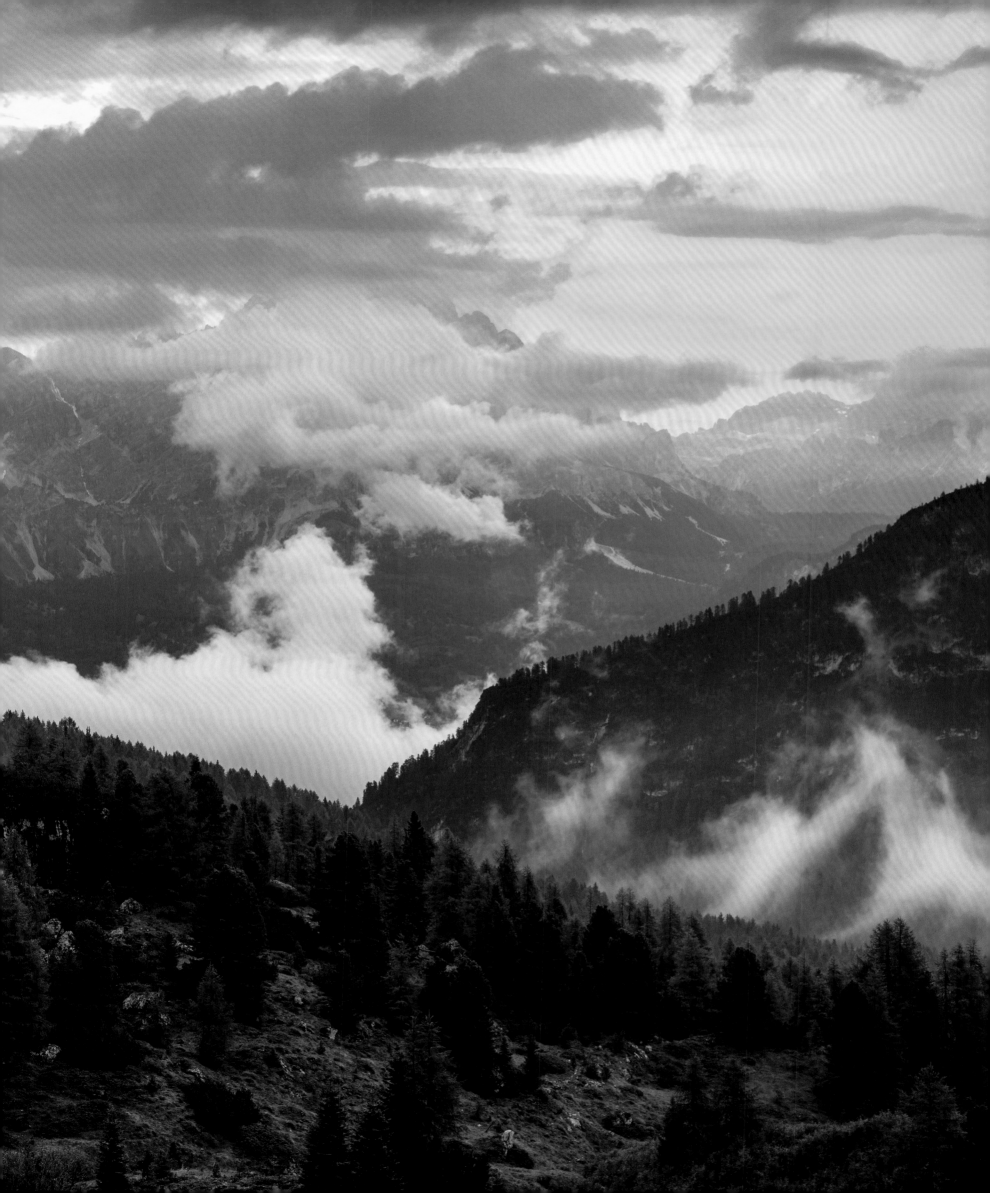

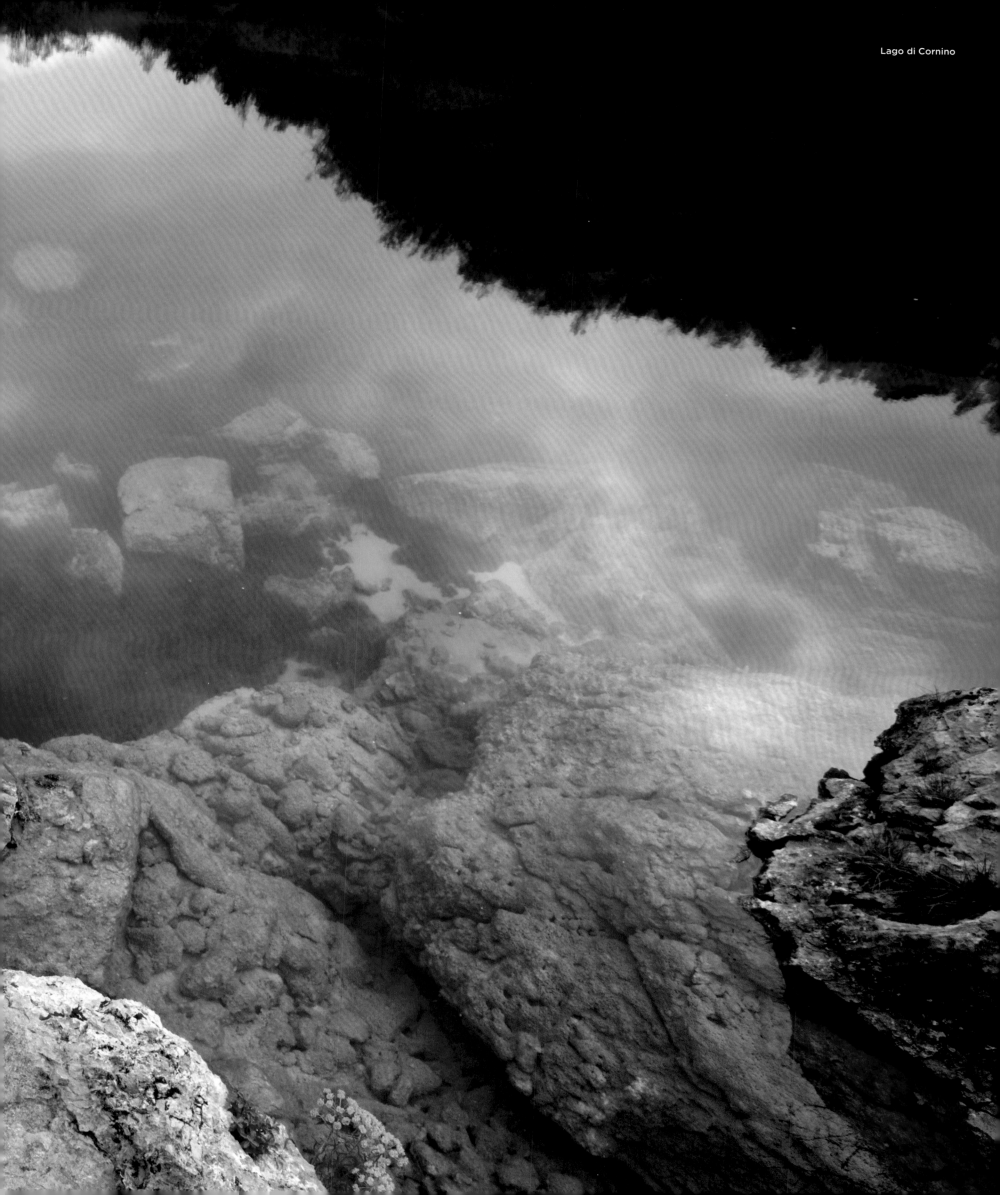

Lago di Cornino

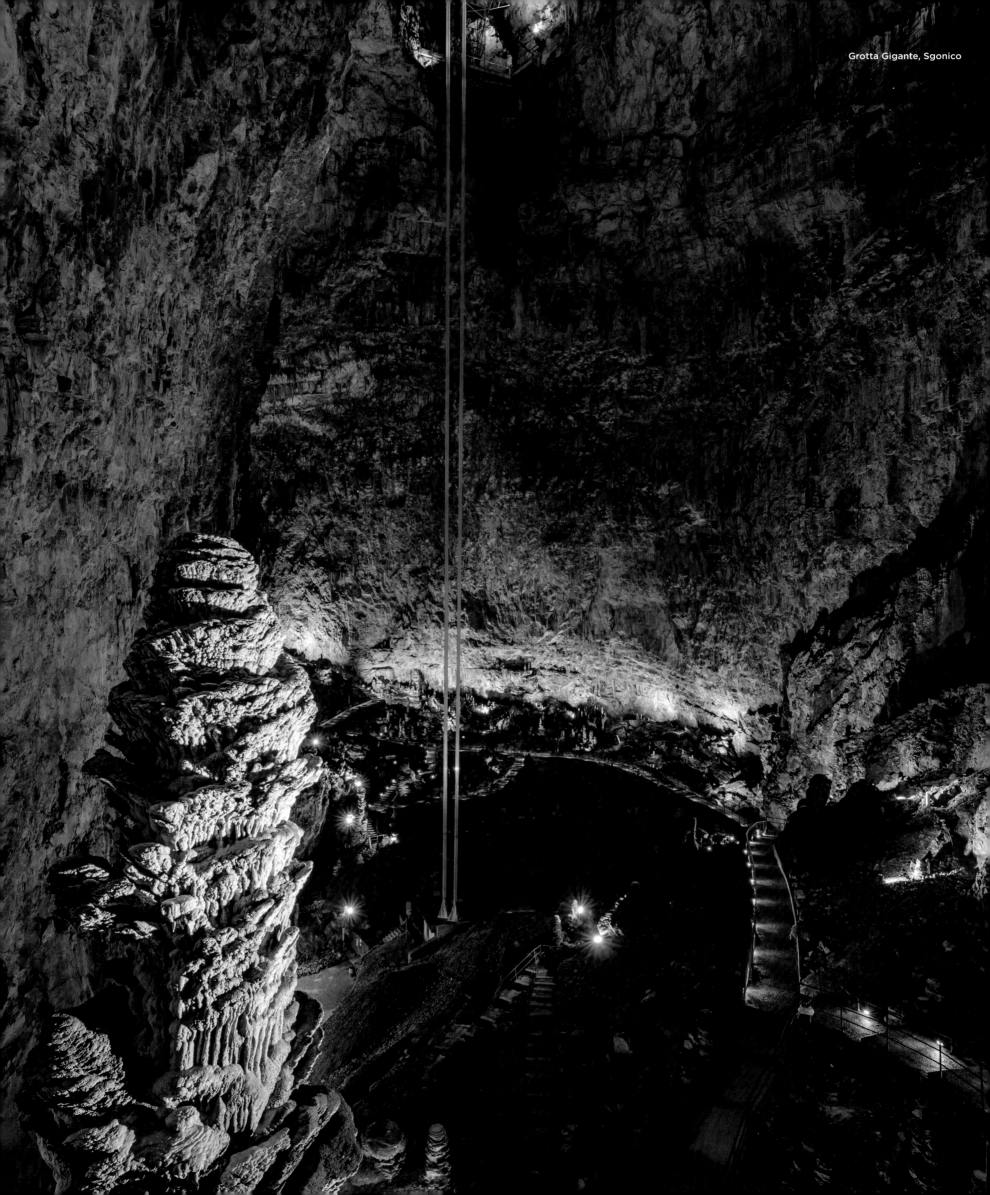

Grotta Gigante, Sgonico

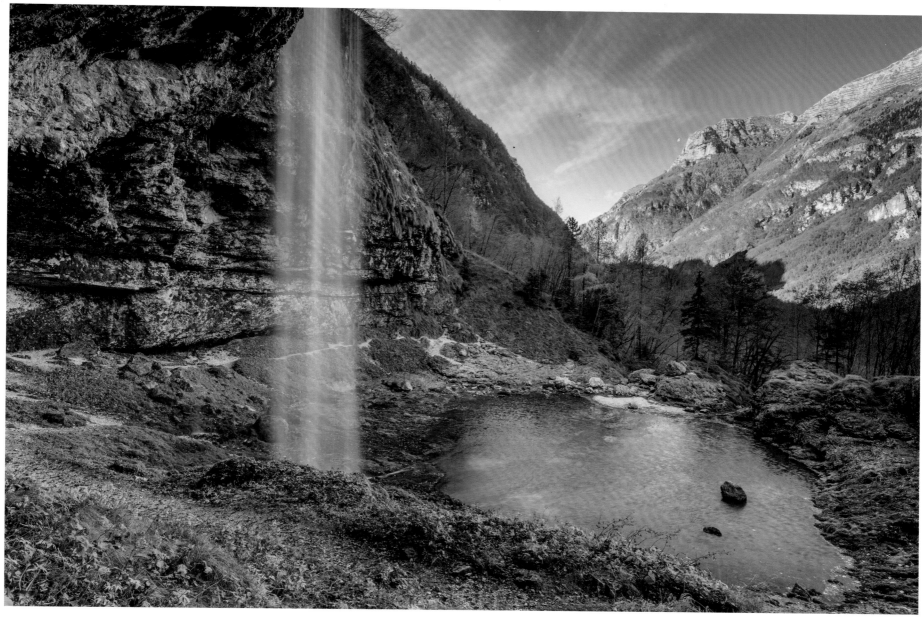

Fontanone di Goriuda, Val Raccolana

Friuli-Venezia Giulia

The autonomous Italian region lies in the extreme northeast of the country. It stretches from rugged mountain peaks in the Dolomites to a narrow coastal strip on the Adriatic with the regional capital Trieste. Friuli-Venezia Giulia has retained a strong cultural identity and the Furlan language, a branch of Romansh, is also kept alive.

Le Frioul-Vénétie julienne

Cette région italienne autonome est située au nord-est du pays. Elle s'étend des sommets escarpés des Dolomites jusqu'à une courte bande de terre au bord de l'Adriatique, et sa capitale est Trieste. Cette région a su conserver une forte identité culturelle et continue à utiliser le frioulan, une langue régionale romane.

Friaul-Julisch Venetien

Die autonome italienische Region liegt im äußersten Nordosten des Landes. Von schroffen Berggipfeln in den Dolomiten erstreckt sie sich bis zu einem schmalen Küstenstreifen an der Adria mit der Hauptstadt Triest. Die Region konnte sich eine starke kulturelle Eigenständigkeit bewahren und auch das Furlanische, eine romanische Regionalsprache, wird lebendig gehalten.

Friul-Venecia-Julia

La región autónoma italiana se encuentra en el extremo noreste del país. Se extiende desde los escarpados picos montañosos de los Dolomitas hasta una estrecha franja costera en el Mar Adriático con la capital Trieste. La región ha conservado una fuerte independencia cultural y la lengua friulana, una lengua regional romaní, también se mantiene viva.

Friuli Venezia Giulia

A região autónoma italiana situa-se no extremo nordeste do país. Ele se estende desde os picos montanhosos escarpados nas Dolomitas até uma estreita faixa costeira no Adriático com a capital Trieste. A região manteve uma forte independência cultural e a língua Furlan, uma língua regional romanche, também é mantida viva.

Friuli-Venezia Giulia

Deze autonome regio in het uiterste noordoosten van Italië heeft naast ruige bergtoppen in de Dolomieten ook een smalle kuststrook aan de Adriatische Zee te bieden. In cultureel opzicht heeft de streek met de hoofdstad Triëst zijn eigen identiteit weten te behouden. Daartoe behoort ook het Friulaans, één Reto-Romaanse taal, die alleen in Friuli wordt gesproken.

Vicino de Cividale
Near Cividale
Près de Cividale

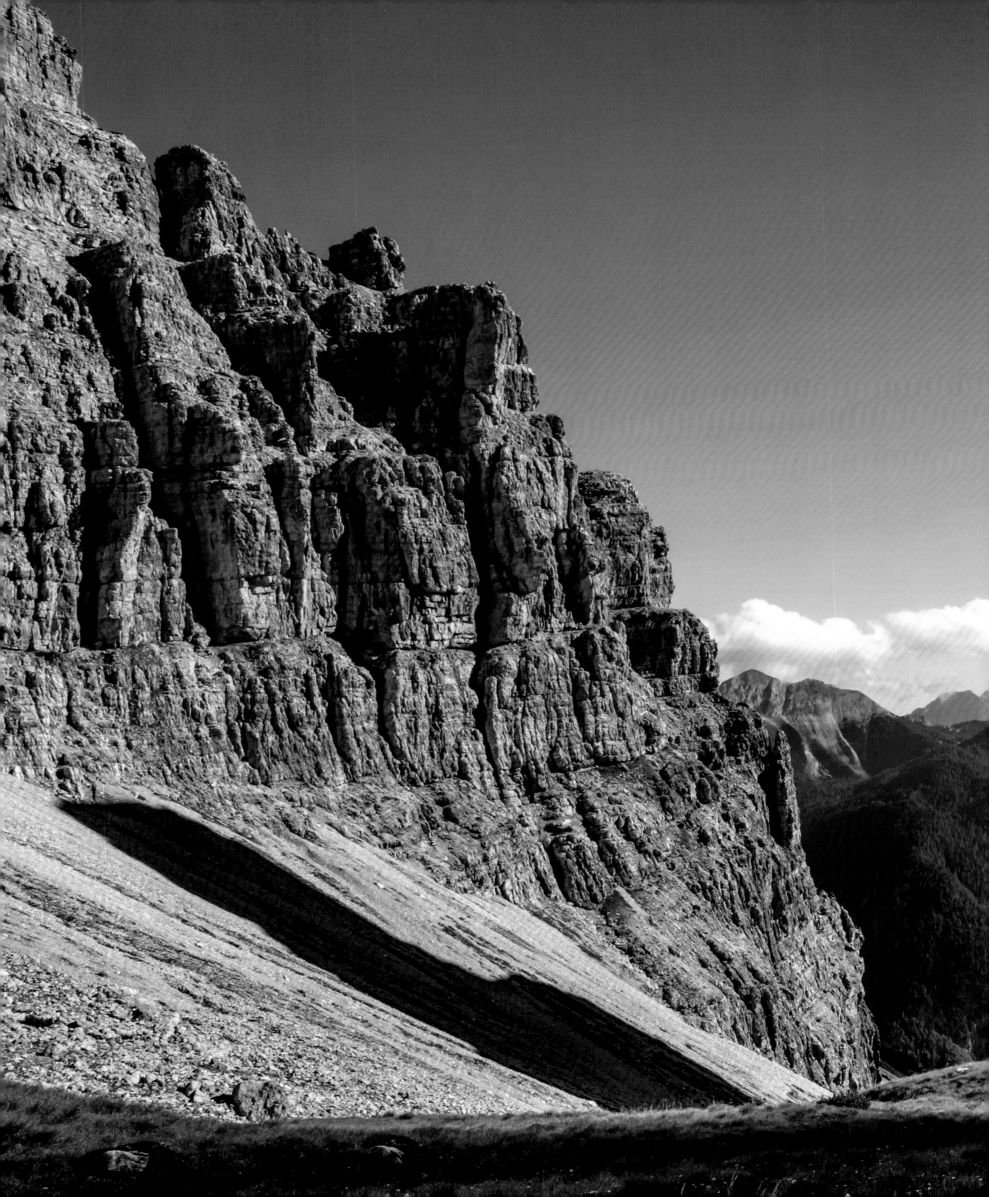

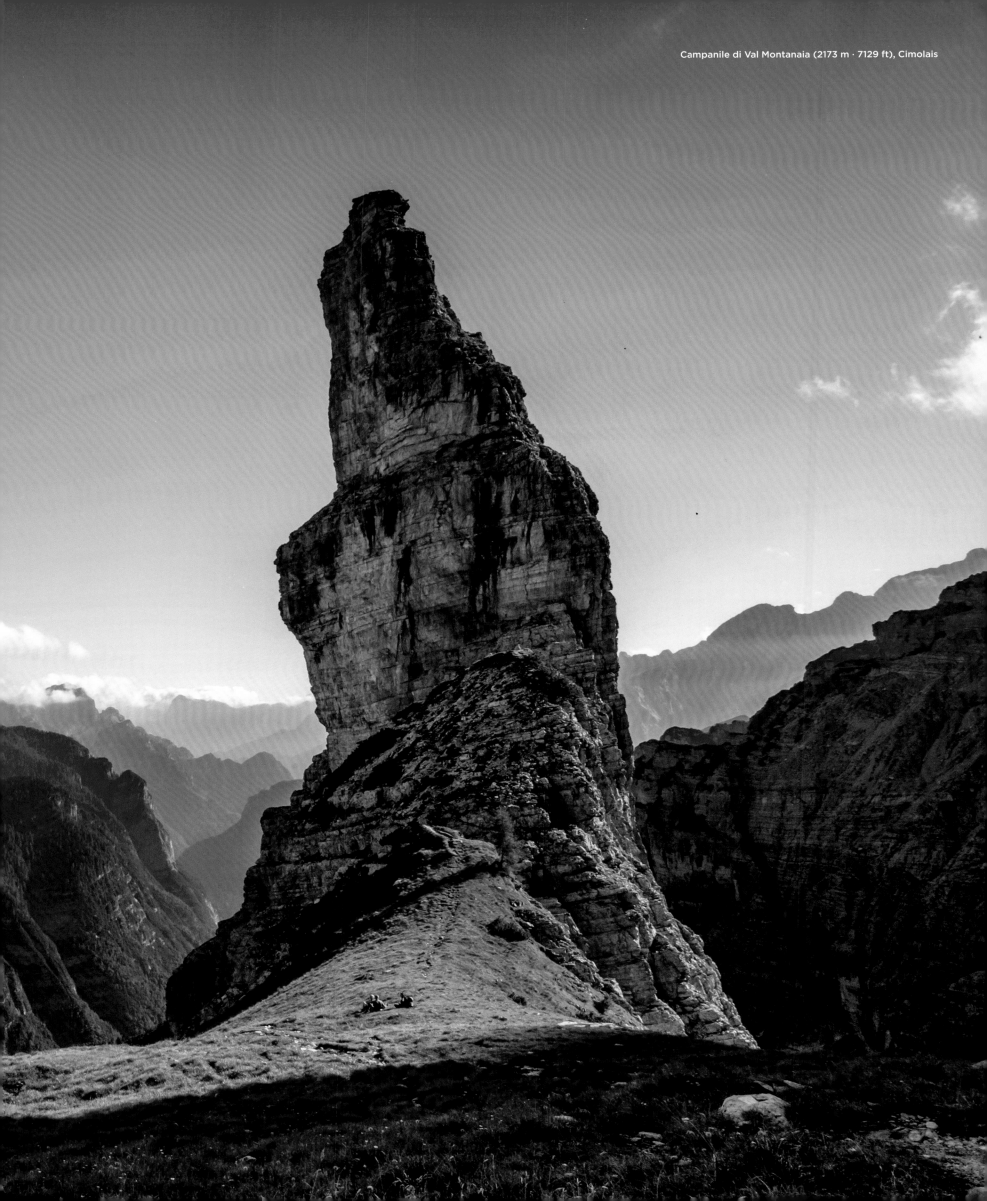

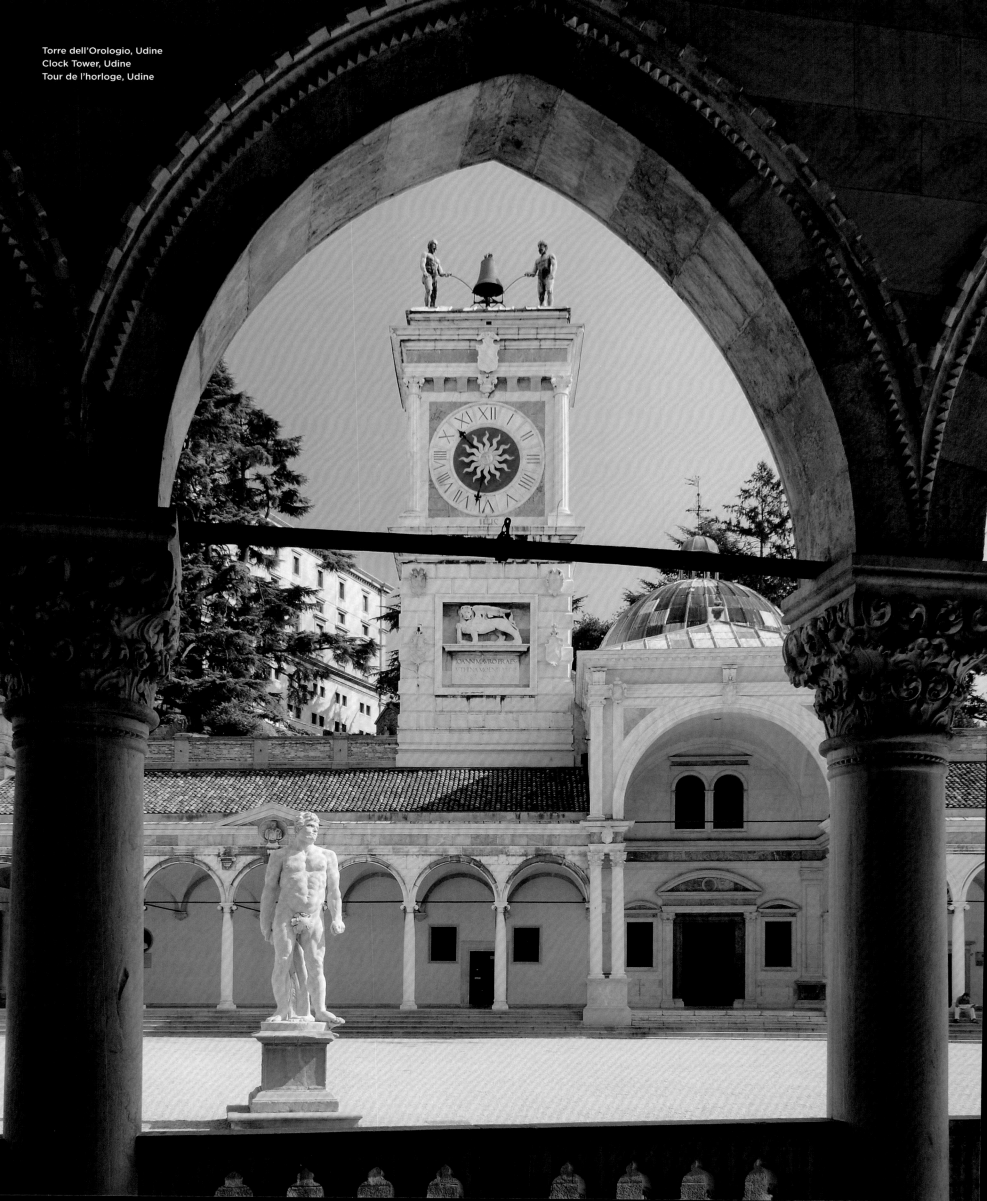

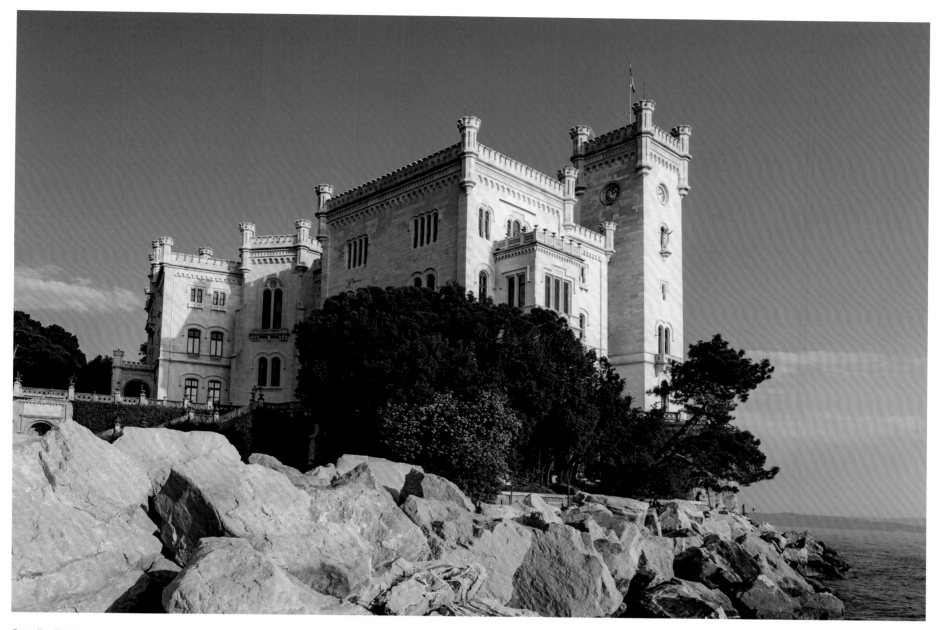

Castello di Miramare, Trieste
Miramare Castle, Trieste
Château de Miramare, Trieste

Miramare Castle

Not far from Trieste stands Miramare Castle, which Archduke Ferdinand Maximilian of Austria had built middle of the 19th century. The monumental building is an example of historicism, which transfigures epochs such as the Middle Ages and emulates them architecturally in a mix of styles. The castle, surrounded by an extensive park, is now a museum.

Le château de Miramare

Le château de Miramare se dresse non loin de Trieste et a été construit par l'archiduc d'Autriche Ferdinand Maximilien au milieu du XIXe siècle. Cet édifice monumental est un exemple d'historicisme, un style qui idéalisait des époques comme le Moyen Âge et s'inspirait d'un mélange de styles architecturaux. Ce château entouré d'un vaste parc est aujourd'hui devenu un musée.

Schloss Miramare

Unweit von Triest steht Schloss Miramare, das Erzherzog Ferdinand Maximilian von Österreich Mitte des 19. Jahrhunderts errichten ließ. Der monumentale Bau ist Beispiel für den Historismus, der Epochen wie das Mittelalter verklärt und in einem Stilmix architektonisch nachempfindet. Das von einem weitläufigen Park umgebene Schloss ist heute ein Museum.

Castillo de Miramar

No muy lejos de Trieste se encuentra el Castillo de Miramar, que el Archiduque Fernando Maximiliano de Austria mandó construir a mediados del siglo XIX. El edificio monumental es un ejemplo de historicismo, que transfigura épocas como la Edad Media y las emula arquitectónicamente en una mezcla de estilos. El castillo, rodeado de un extenso parque, es ahora un museo.

Castelo Miramare

Não muito longe de Trieste está o Castelo de Miramare, que o Arquiduque Ferdinand Maximiliano da Áustria tinha construído em meados do século XIX. O edifício monumental é um exemplo de historicismo, que transfigura épocas como a Idade Média e as emula arquitetonicamente em uma mistura de estilos. O castelo, rodeado por um extenso parque, é agora um museu.

Kasteel Miramare

Niet ver van Triëst staat het kasteel Miramare, dat aartshertog Ferdinand Maximiliaan van Oostenrijk halverwege de 19e eeuw liet bouwen. Het monumentale gebouw is een voorbeeld van historisme, dat tijdperken als de Middeleeuwen verheerlijkt en met een mix van architectonische stijlen nabootst. Het kasteel, dat omgeven is door een uitgestrekt park, is tegenwoordig een museum.

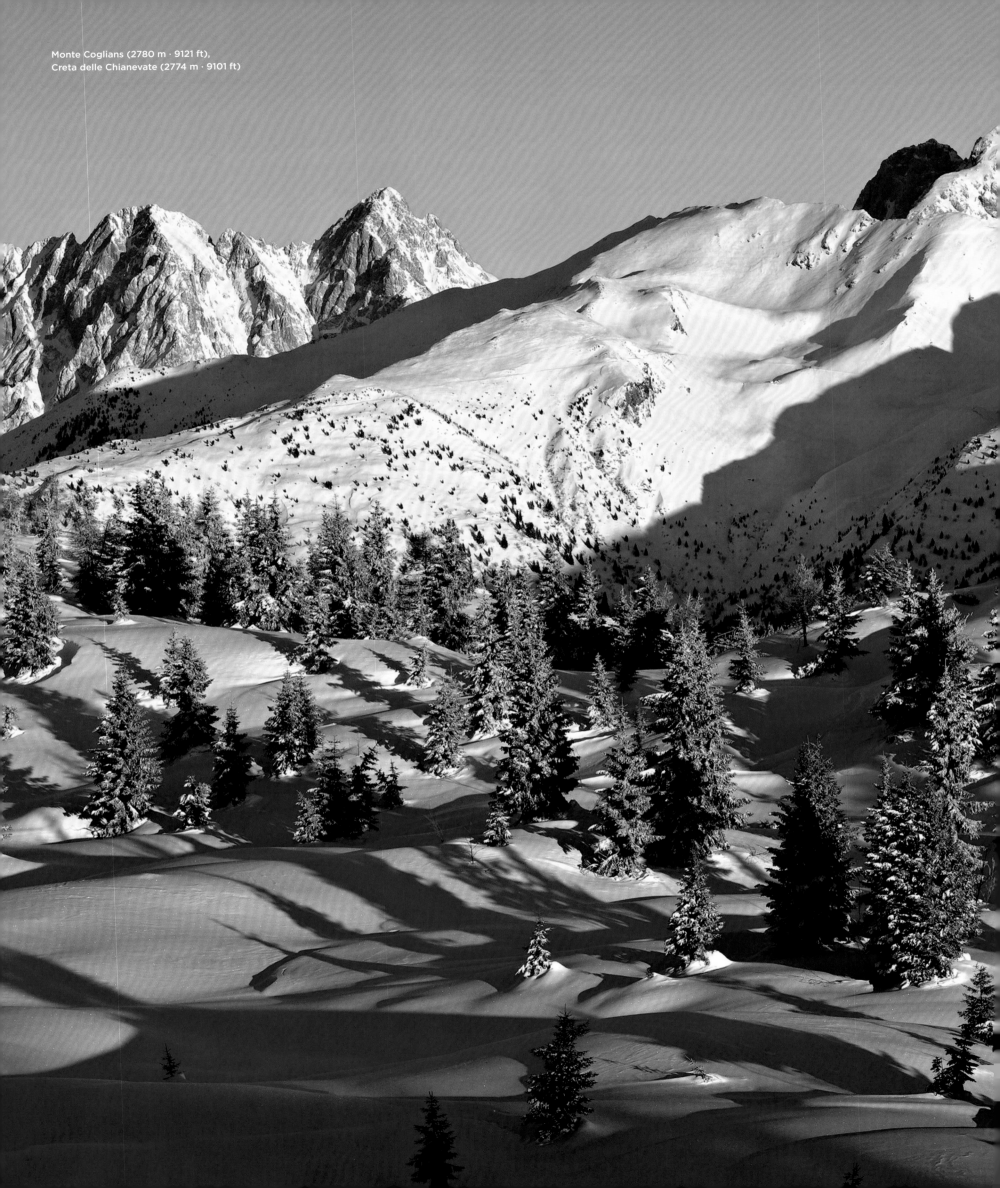

Monte Coglians (2780 m · 9121 ft),
Creta delle Chianevate (2774 m · 9101 ft)

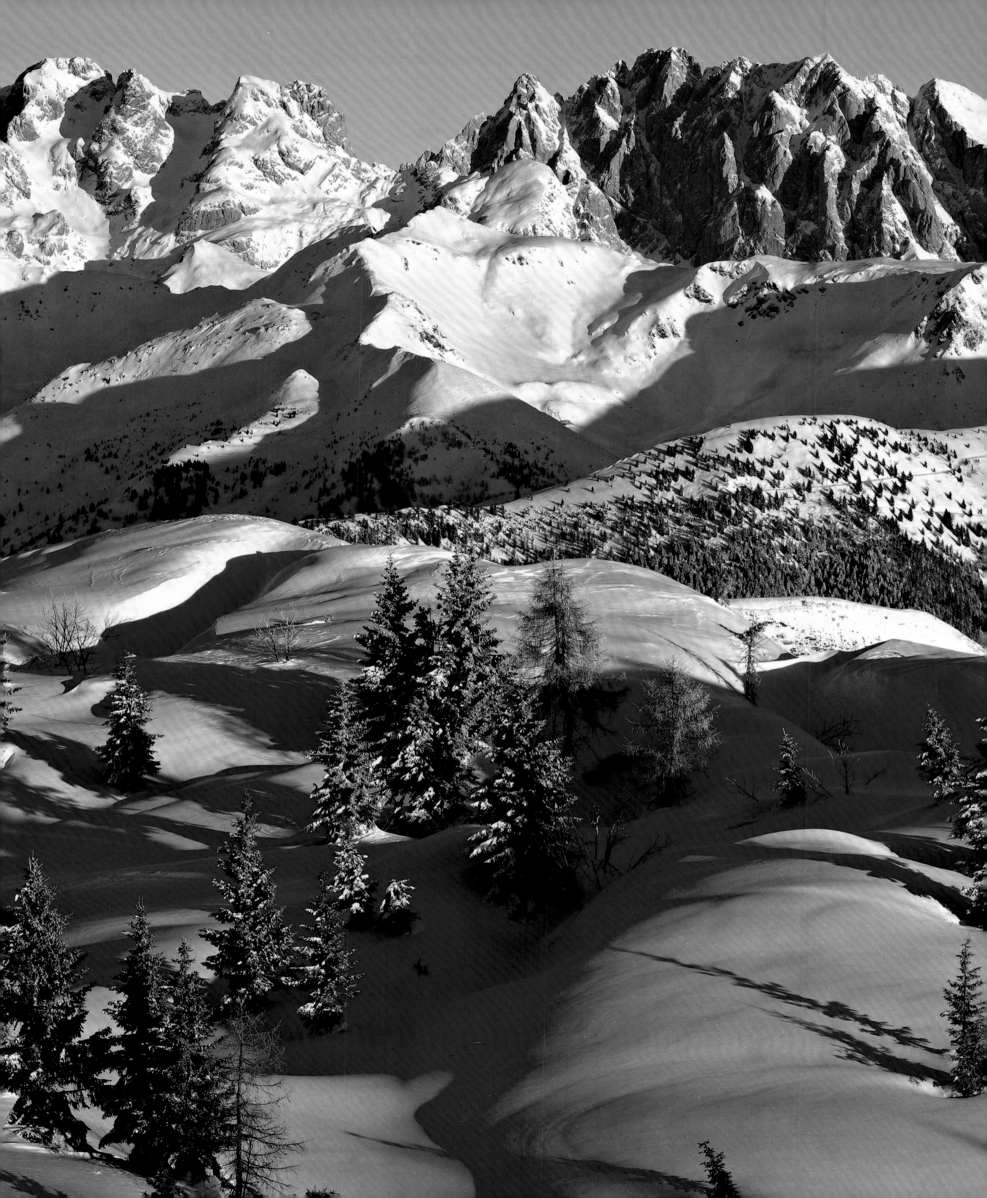

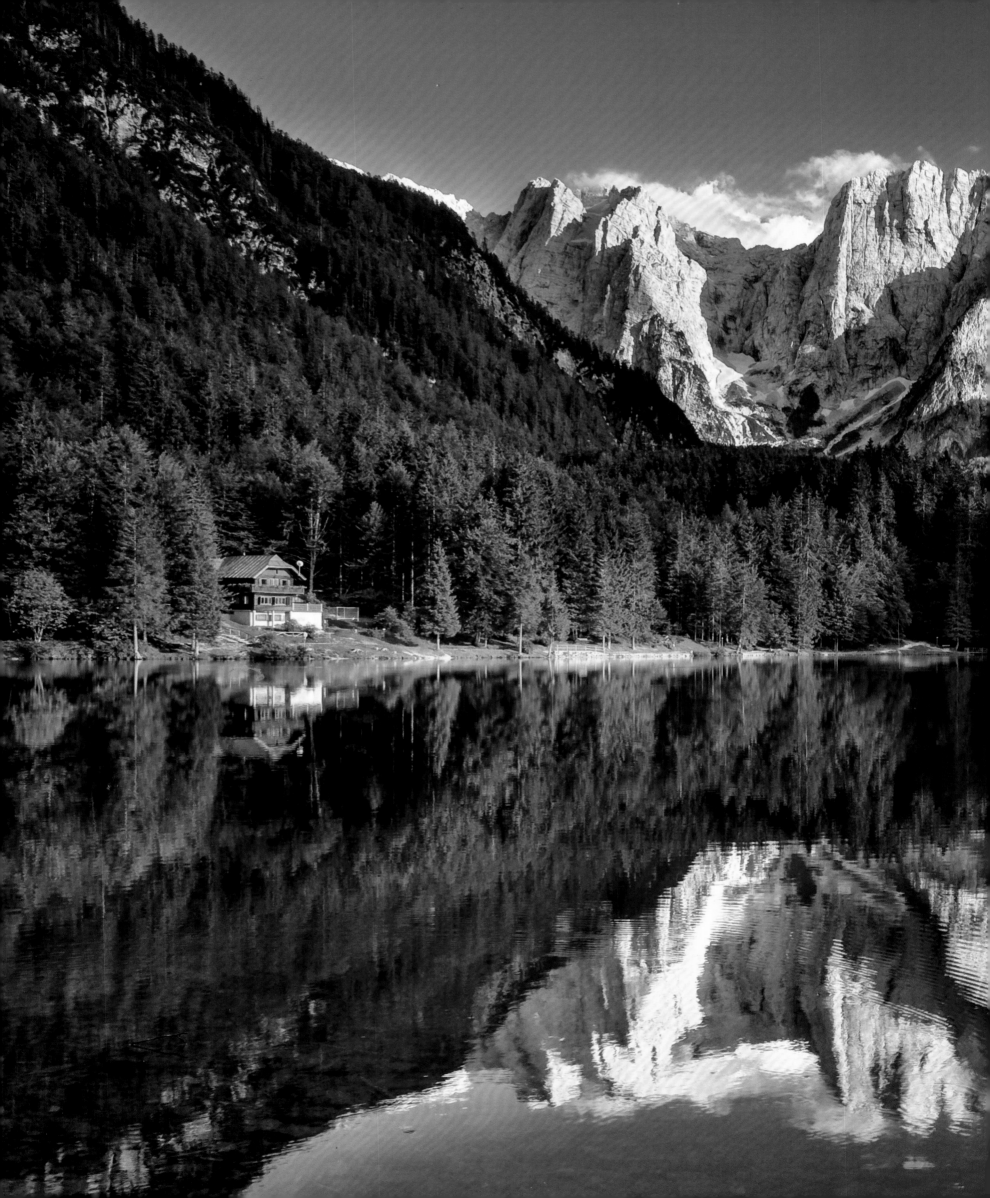

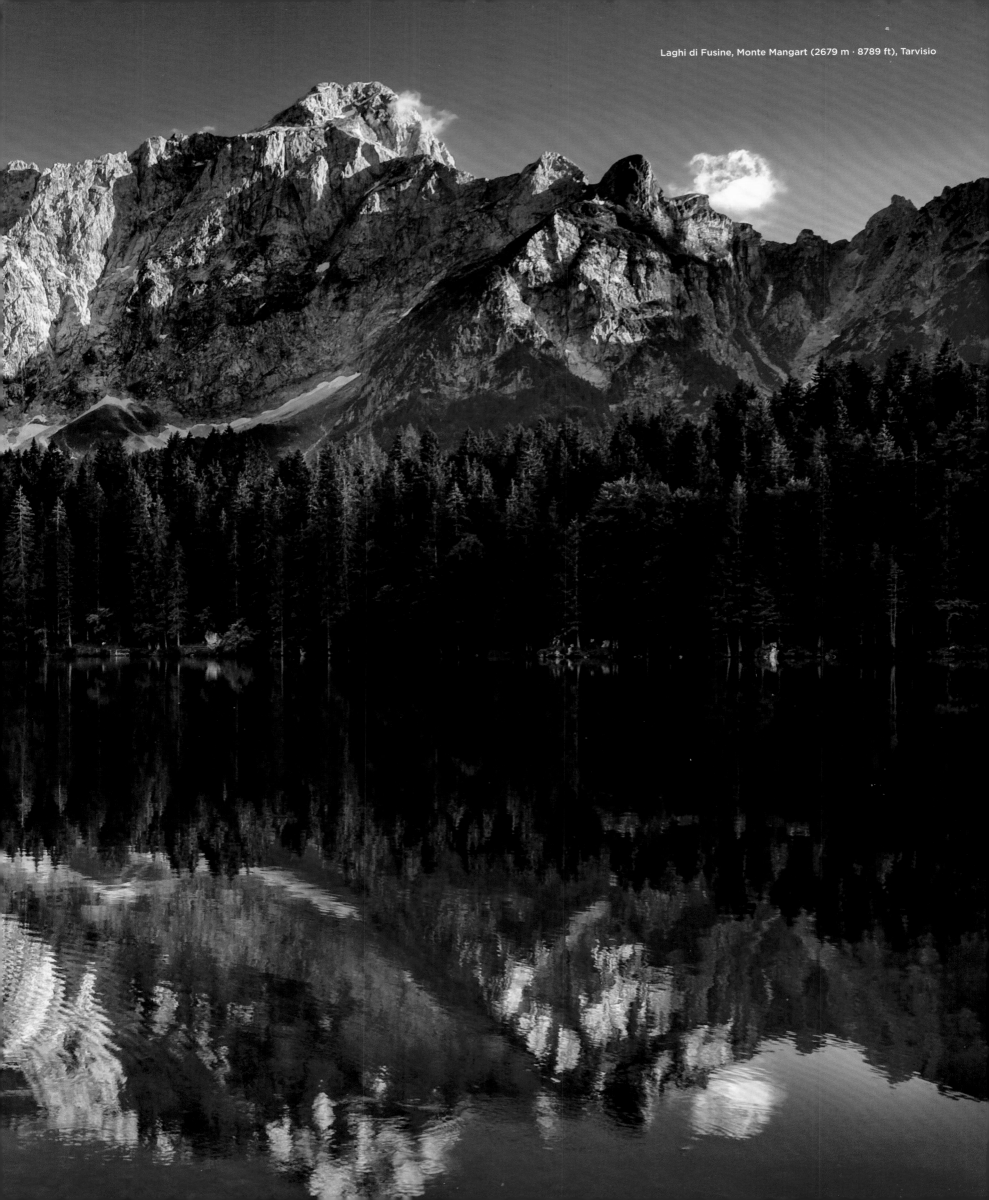

Laghi di Fusine, Monte Mangart (2679 m · 8789 ft), Tarvisio

Kärnten · Carinthia · Carinthie

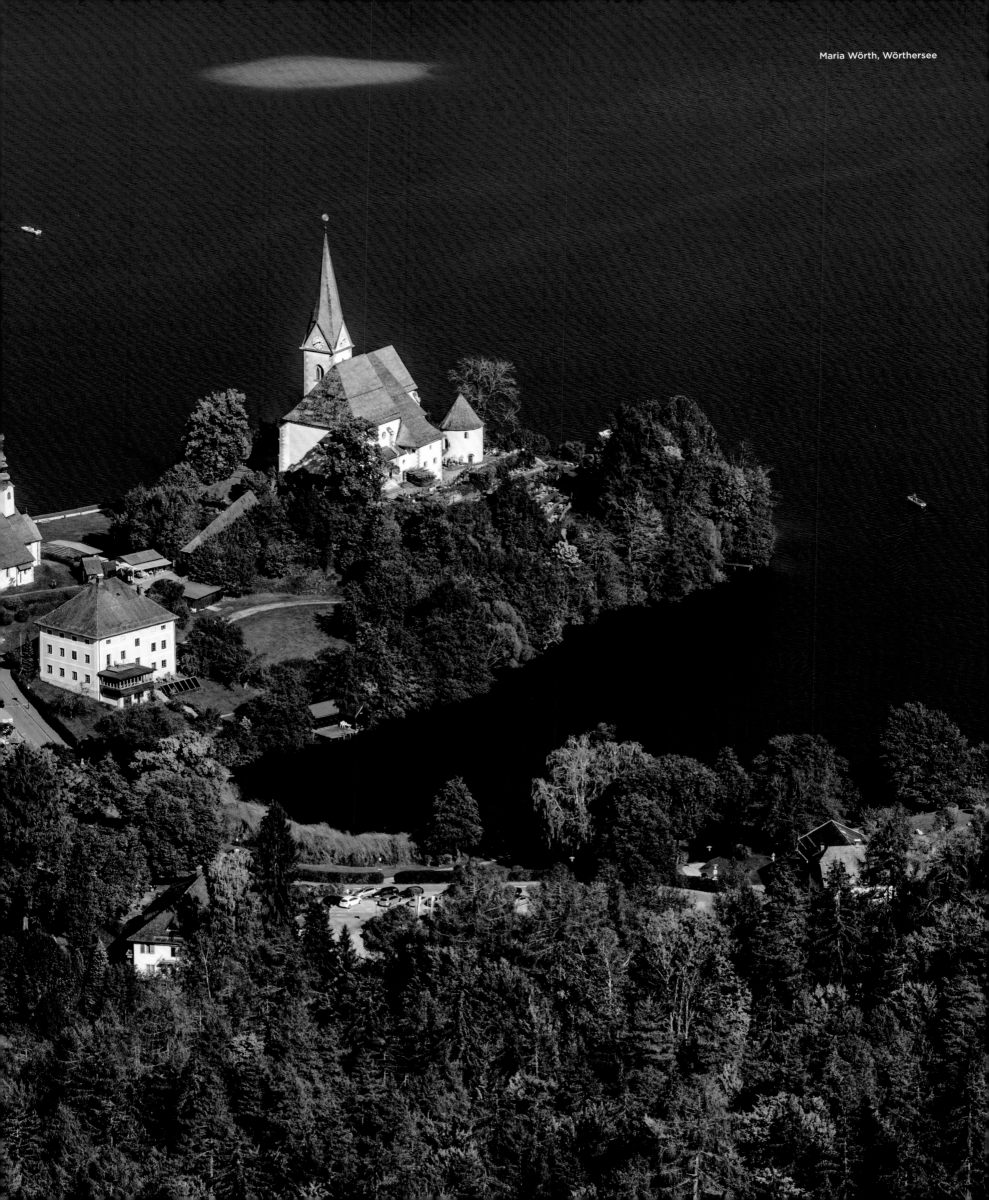

Maria Wörth, Wörthersee

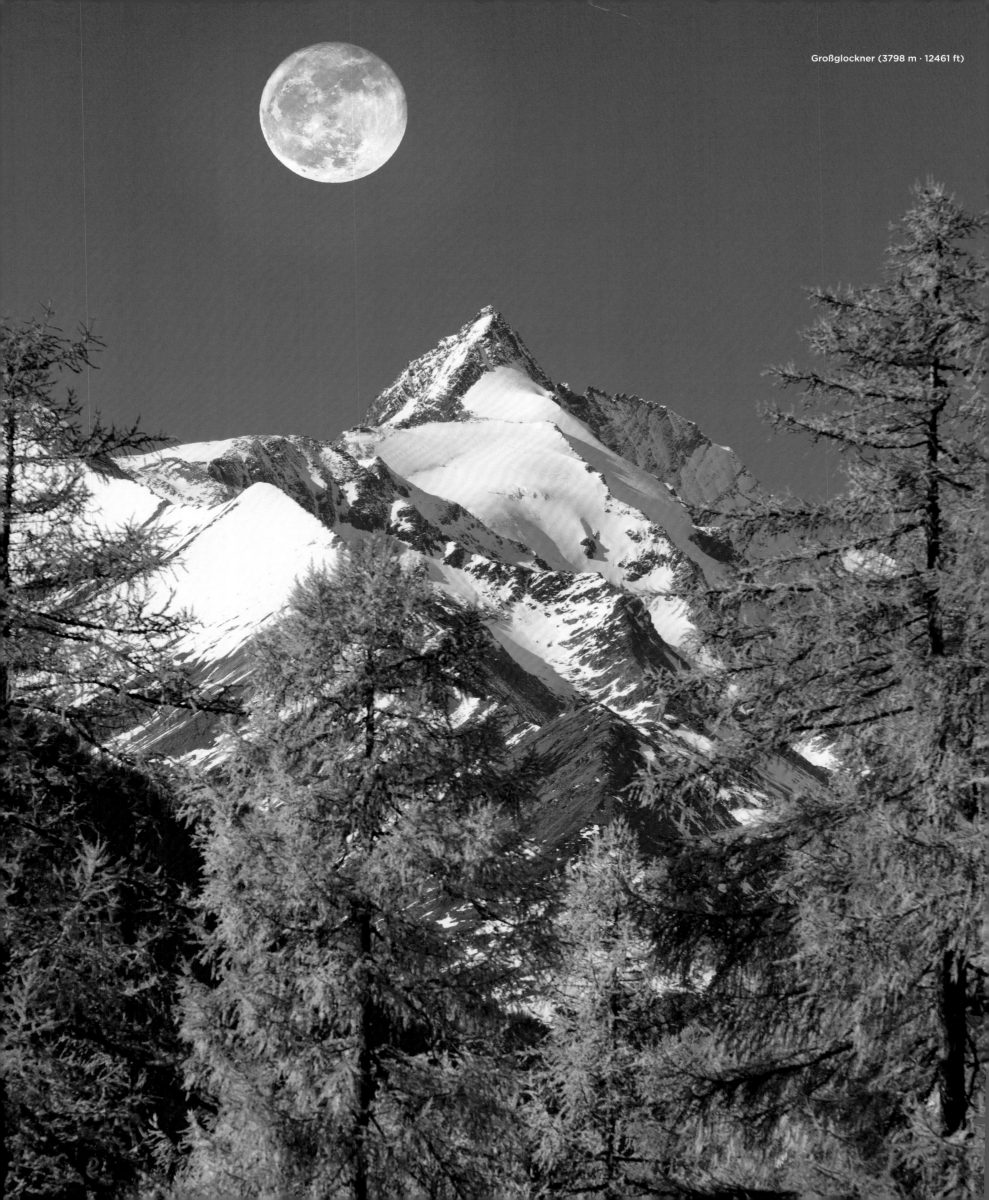

Großglockner (3798 m · 12461 ft)

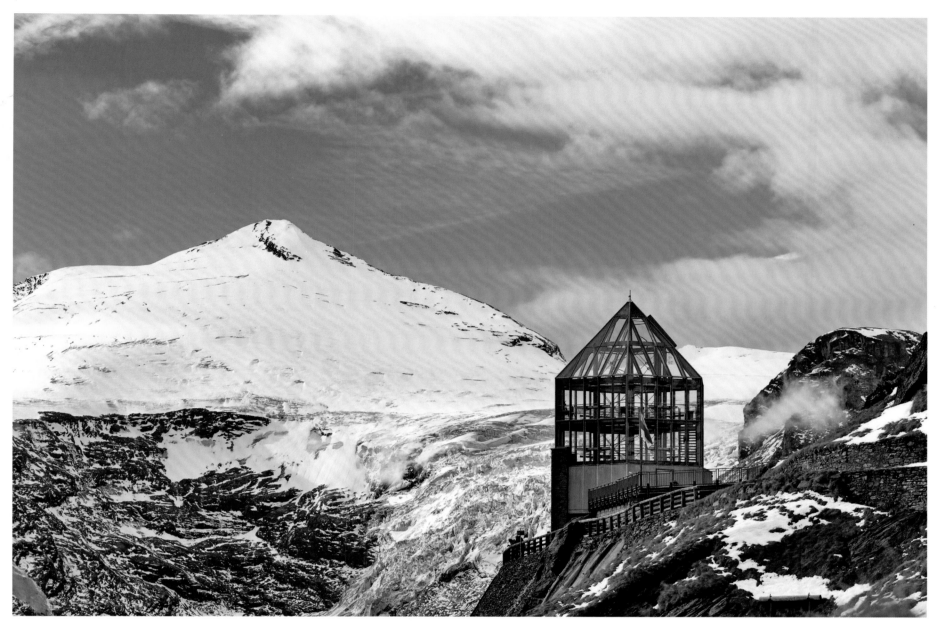

Wilhelm-Swarovski-Beobachtungswarte,
Kaiser-Franz-Josefs-Höhe (2369 m · 7772 ft), Johannisberg (3453 m · 11329 ft)

Carinthia

The southernmost province of Austria is blessed with scenic beauty. The big lakes such as the Wörthersee, the Ossiacher See or the Millstätter See, which has drinking water quality, are particularly characteristic. Carinthia is also known in the international world of literature for the Ingeborg Bachmann Prize, which is awarded in the state capital of Klagenfurt.

La Carinthie

La région la plus méridionale d'Autriche présente des paysages magnifiques. On la connaît surtout pour ses grands lacs, comme le Wörthersee, l'Ossiacher See ou encore le Millstätter See, dont l'eau est même potable. Elle a aussi acquis une renommée internationale grâce à ses « Journées de la littérature de langue allemande », organisées dans la capitale de Klagenfurt, et où est décerné le prix Ingeborg-Bachmann.

Kärnten

Das südlichste Bundesland Österreichs ist mit landschaftlicher Schönheit gesegnet. Prägend sind vor allem die großen Seen wie der Wörthersee, der Ossiacher See oder der Millstätter See, der Trinkwasserqualität hat. International bekannt ist Kärnten auch durch die Literaturveranstaltung um den Ingeborg-Bachmann-Preis in der Landeshauptstadt Klagenfurt.

Carintia

La provincia más meridional de Austria está bendecida con una belleza escénica. Los grandes lagos como el Wörthersee, el Ossiach o el lago de Millstatt, que tiene calidad de agua potable, son particularmente formativos. Carintia es también conocida internacionalmente por su evento literario sobre el Premio Ingeborg Bachmann en la capital del estado de Klagenfurt.

Caríntia

A província mais austral da Áustria é abençoada com beleza cênica. Os grandes lagos, como o Wörthersee, o Ossiacher See ou o Millstätter See, que tem qualidade de água potável, são particularmente formativos. A Caríntia é também conhecida internacionalmente pelo seu evento de literatura sobre o Prémio Ingeborg Bachmann na capital do estado de Klagenfurt.

Karinthië

De zuidelijkste deelstaat van Oostenrijk is gezegend met natuurschoon. Het landschap wordt bepaald door grote meren zoals de Wörthersee, de Ossiacher See en de Millstätter See met water van drinkwaterkwaliteit. Karinthië is ook internationaal bekend om de uitreiking van de Ingeborg Bachmann-literatuurprijs in de hoofdstad Klagenfurt.

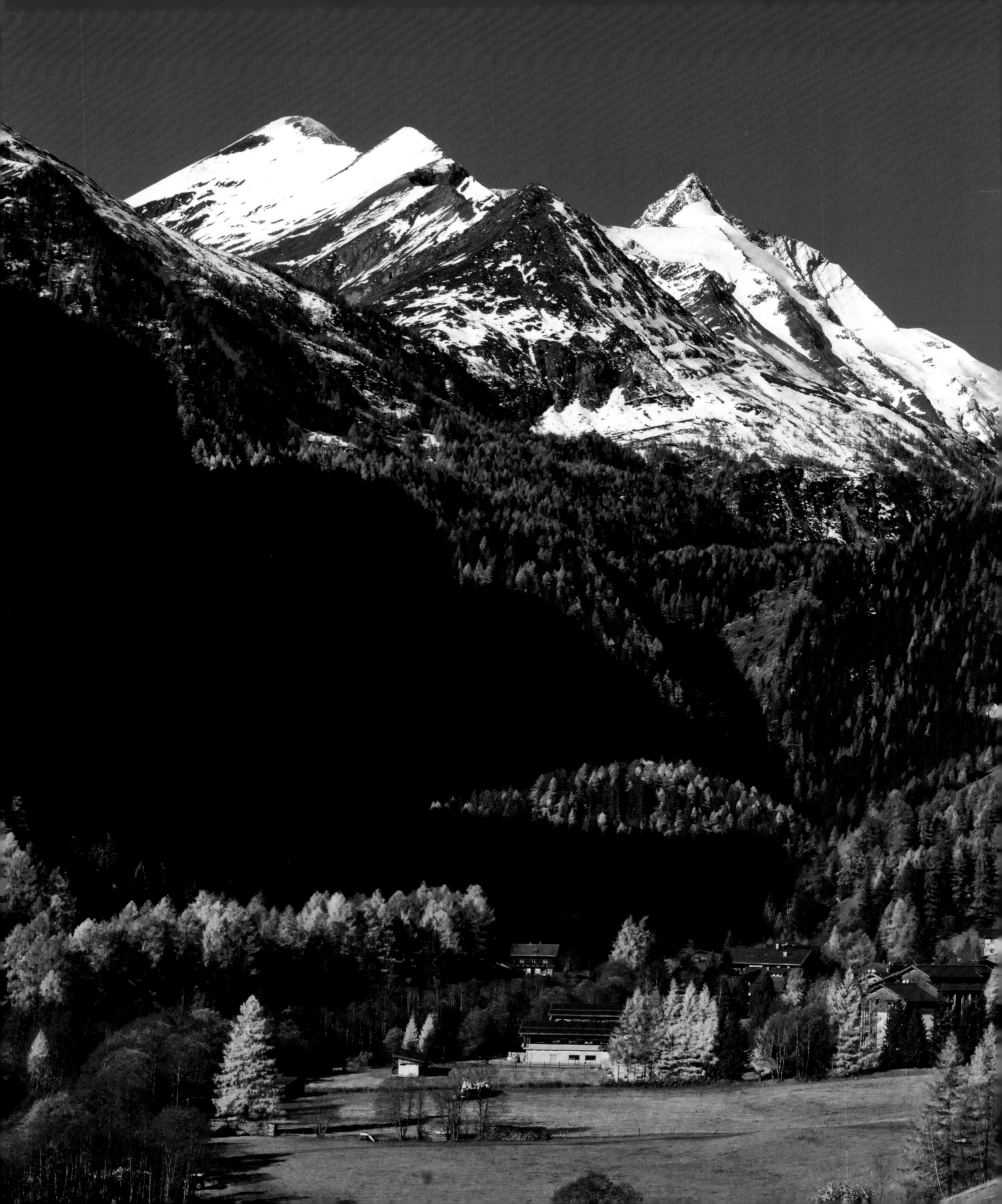

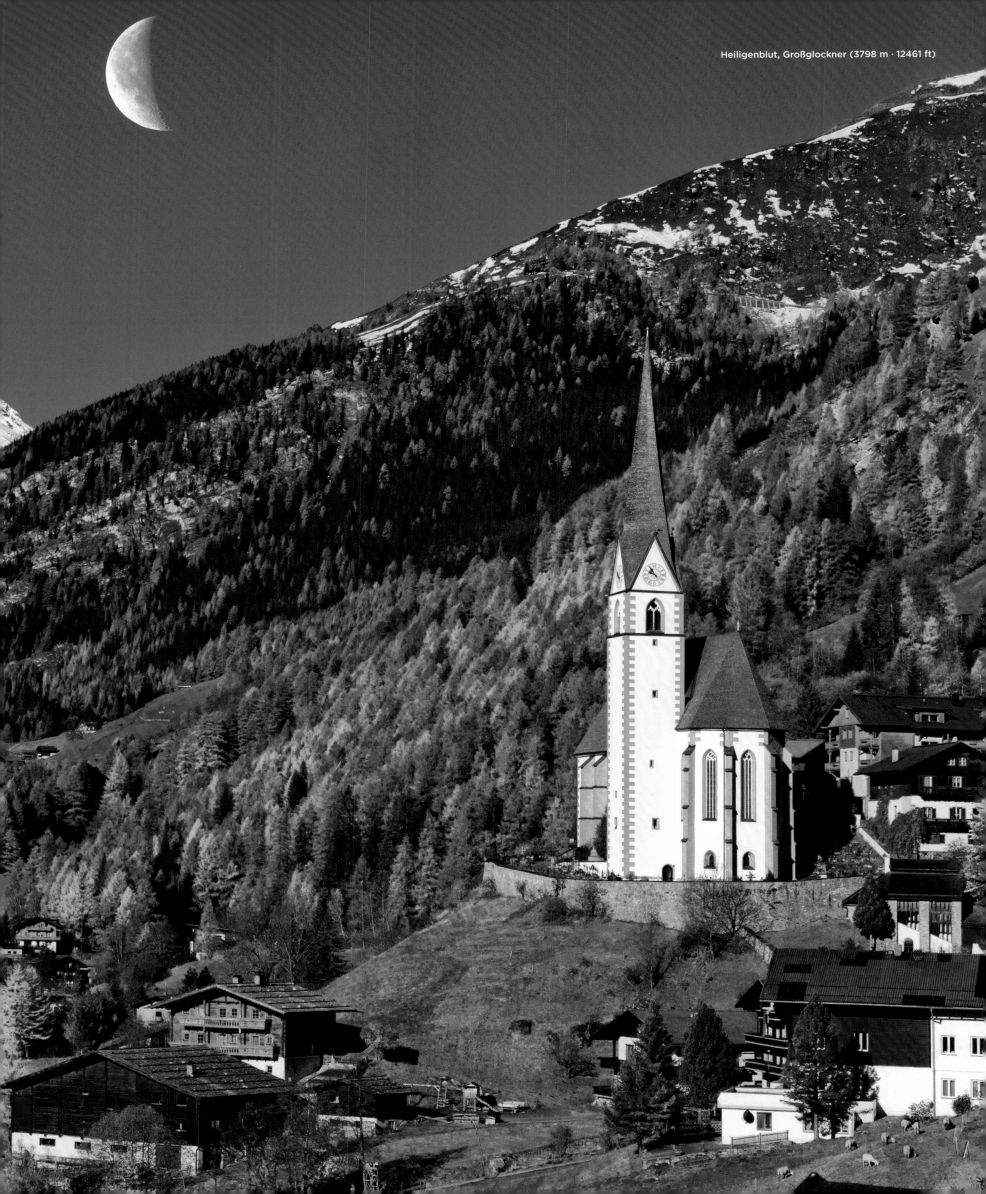

Heiligenblut, Großglockner (3798 m · 12461 ft)

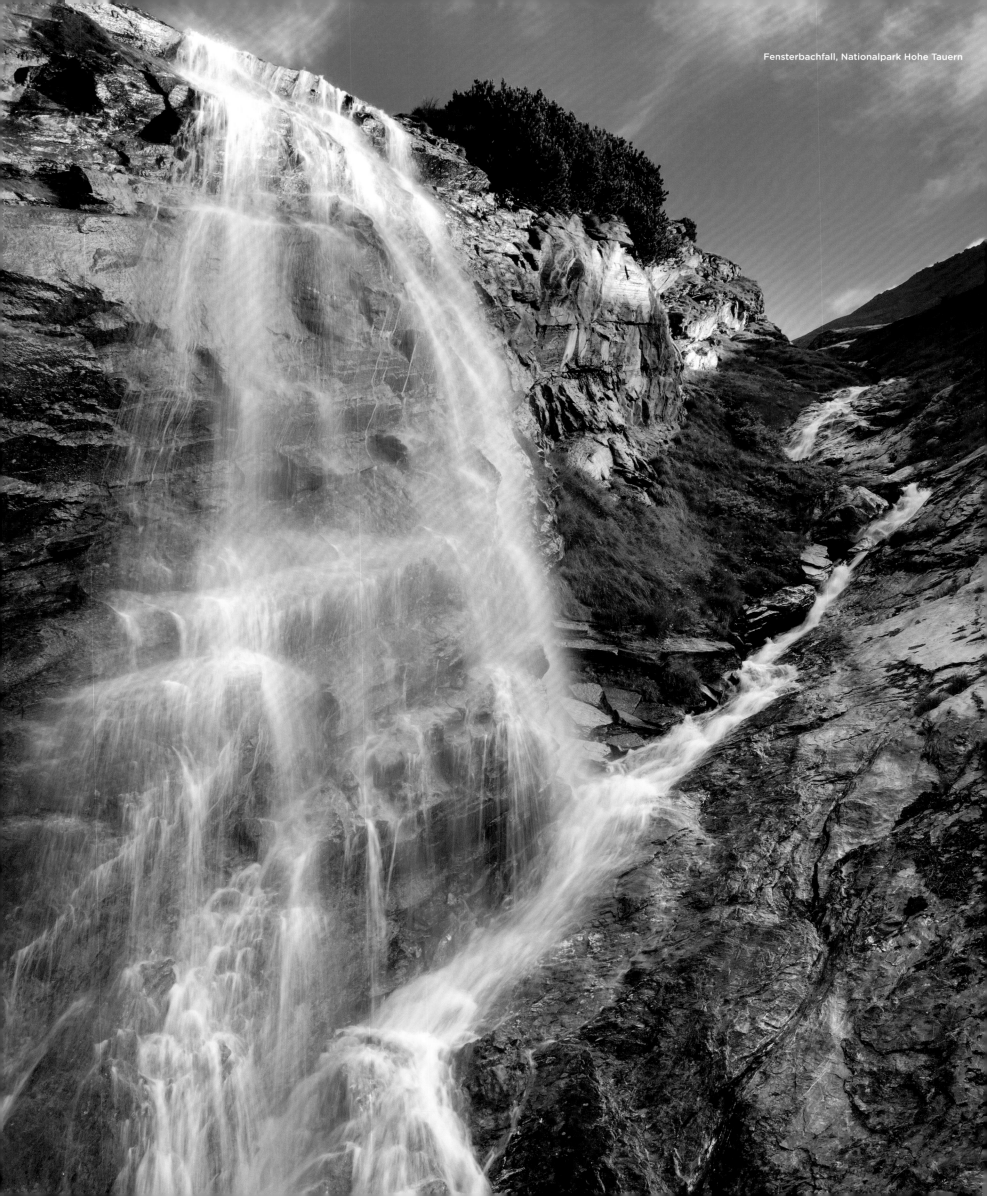

Fensterbachfall, Nationalpark Hohe Tauern

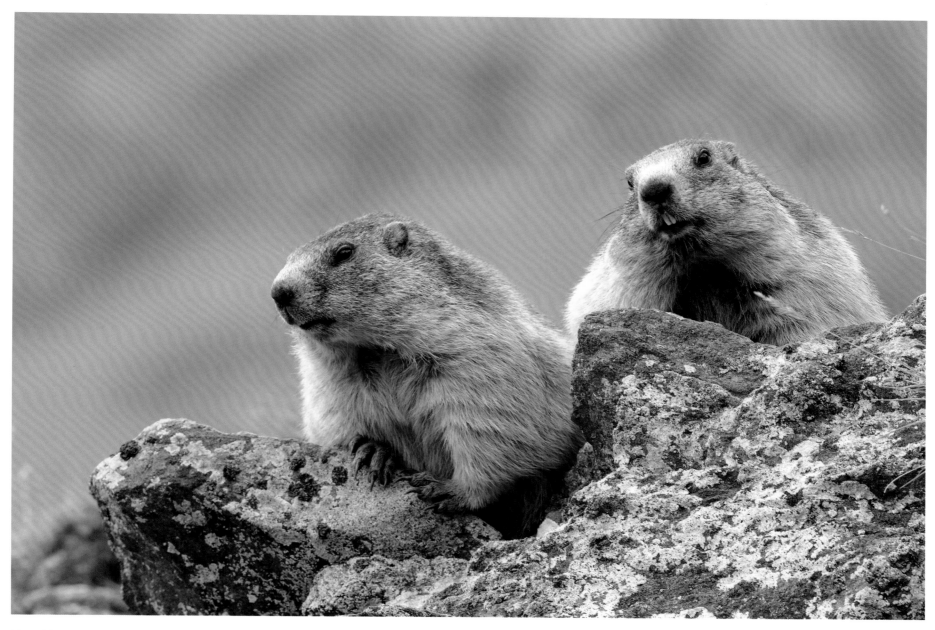

Murmeltiere, Nationalpark Hohe Tauern
Marmots, High Tauern National Park
Marmottes, parc national des Hohe Tauern

Fensterbach Falls, High Tauern

A number of spectacular waterfalls such as the Fensterbach Falls can be found in the High Tauern National Park not far from the Grossglockner High Alpine Road. The road crosses the Hohe Tauern National Park, which includes the Grossglockner, Austria's highest mountain (3798 m · 12461 ft). The alpine landscape is characterized by glaciers, snow and water.

La chute de Fensterbach, dans les Hohe Tauern

On trouve toute une série de chutes d'eau impressionnantes, comme la chute de Fensterbach, dans le parc national des Hohe Tauern, à proximité de la « Haute route alpine du Grossglockner ». Cette route alpine traverse le parc national et porte le nom du plus haut sommet d'Autriche, qui culmine à 3 798 m. Ses paysages sont composés d'eau, de neige et de glaciers.

Fensterbachfall

Eine Reihe spektakulärer Wasserfälle wie etwa der Fensterbachfall sind im Nationalpark Hohe Tauern unweit der Großglockner-Hochalpenstraße zu finden. Die Straße durchquert den Nationalpark Hohe Tauern, der mit dem Großglockner den höchsten Berg Österreichs aufzuweisen hat (3798 m). Die hochalpine Landschaft ist geprägt von Gletschern, Schnee und Wasser.

Cascadas de Fensterbach, Hohe Tauern

En el Parque Nacional Hohe Tauern, no muy lejos de la carretera de alta montaña del Grossglockner, se encuentran varias cascadas espectaculares, como la de Fensterbach. La carretera atraviesa el Parque Nacional Hohe Tauern, que cuenta con el Grossglockner, la montaña más alta de Austria (3798 m). El paisaje de alta montaña se caracteriza por sus glaciares, nieve y agua.

Fensterbachfall, Hohe Tauern

Uma série de cachoeiras espetaculares como a Fensterbachfall podem ser encontradas no Hohe Tauern National Park não muito longe da Grossglockner High Alpine Road. A estrada atravessa o Parque Nacional Hohe Tauern, que possui o Grossglockner, a montanha mais alta da Áustria (3798 m). A paisagem alpina alta é caracterizada por geleiras, neve e água.

Fensterbach-waterval, Hohe Tauern

Het nationaal park Hohe Tauern beschikt over een aantal spectaculaire watervallen niet ver van de Grossglockner Hochalpenstraße, zoals de Fensterbach-waterval. De weg doorkruist het nationaal park, waar zich ook de de Grossglockner (3798 m), de hoogste berg van Oostenrijk bevindt. Hier wordt het hooggebergtelandschap gekenmerkt door gletsjers, sneeuw en water.

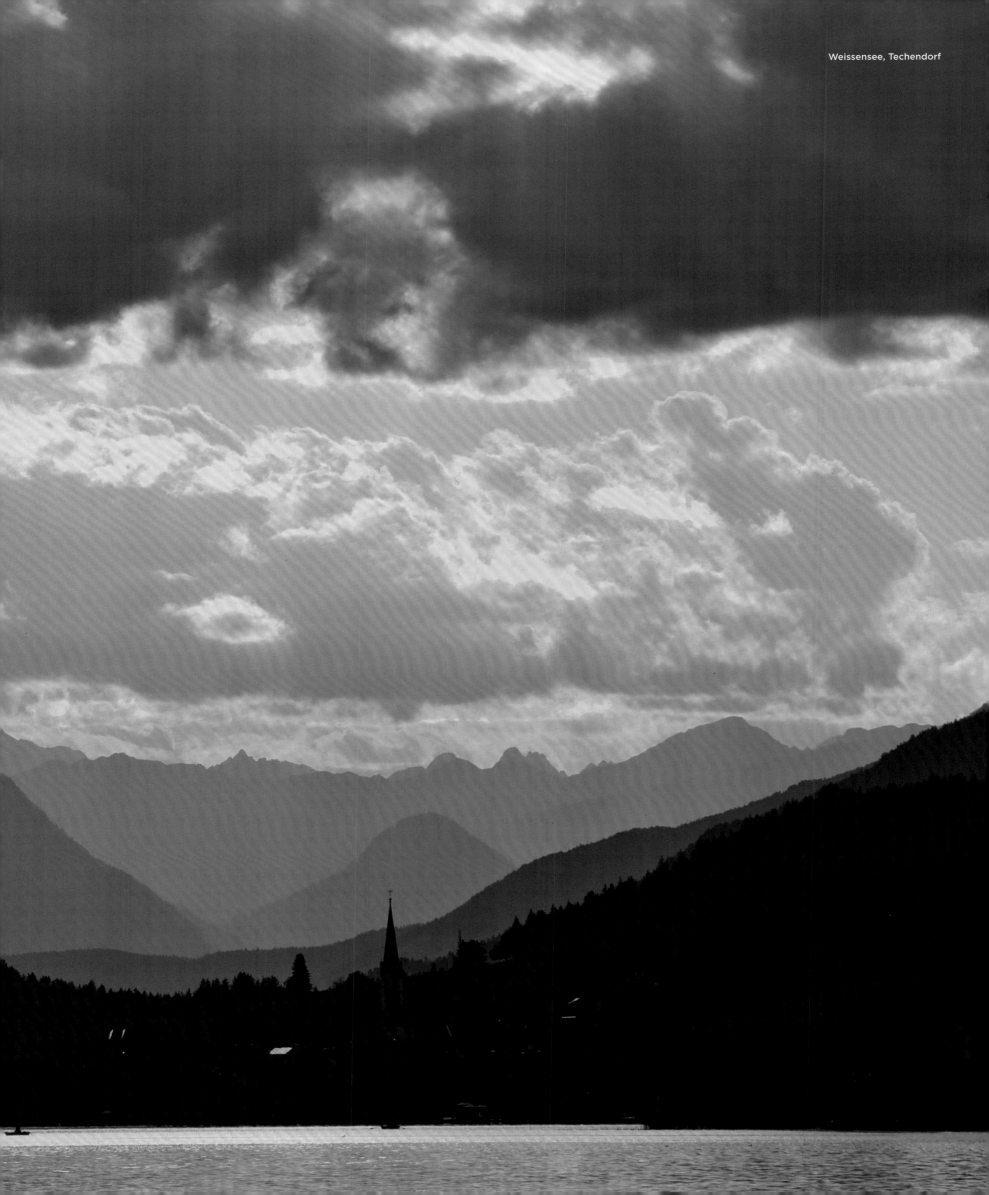

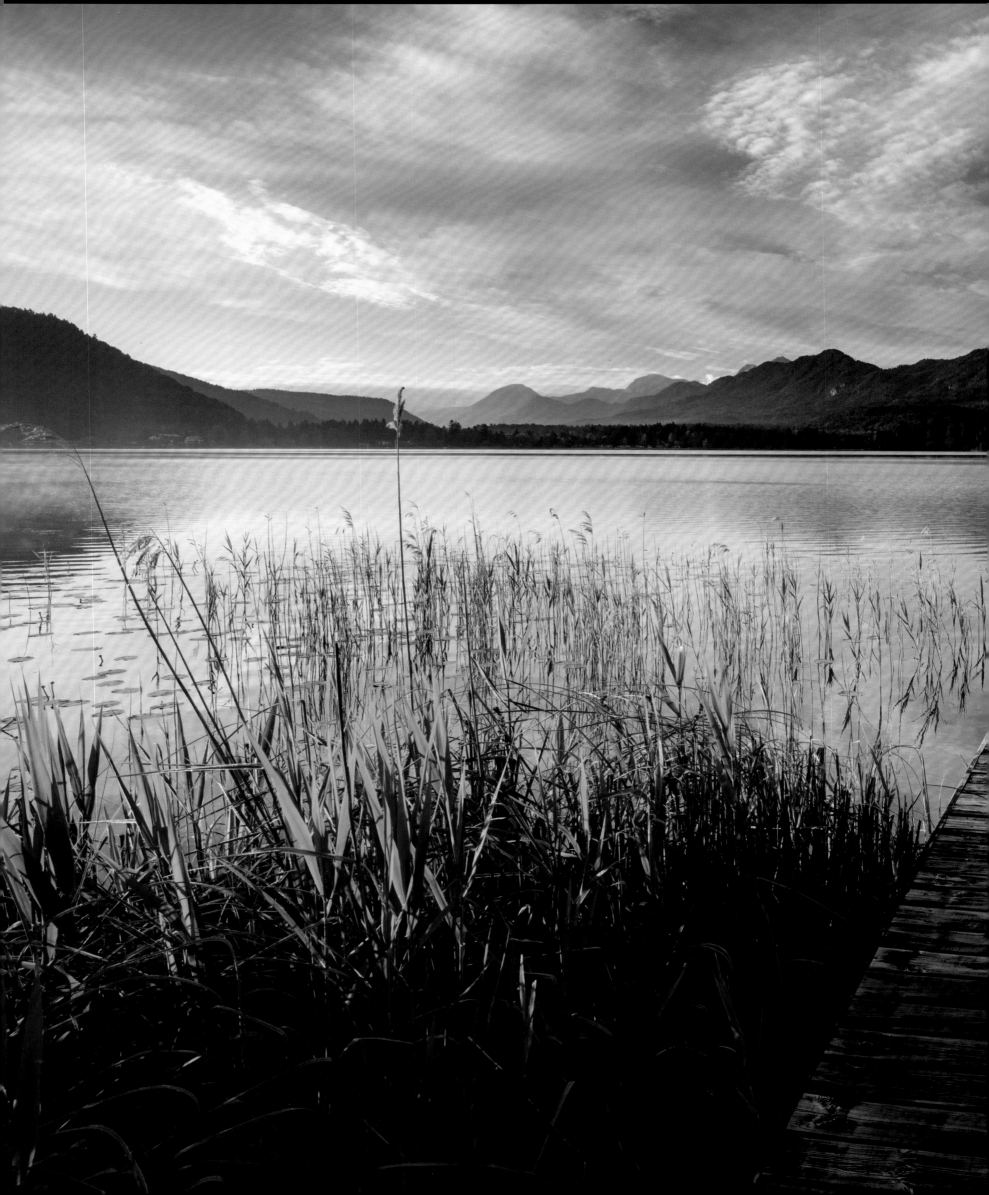

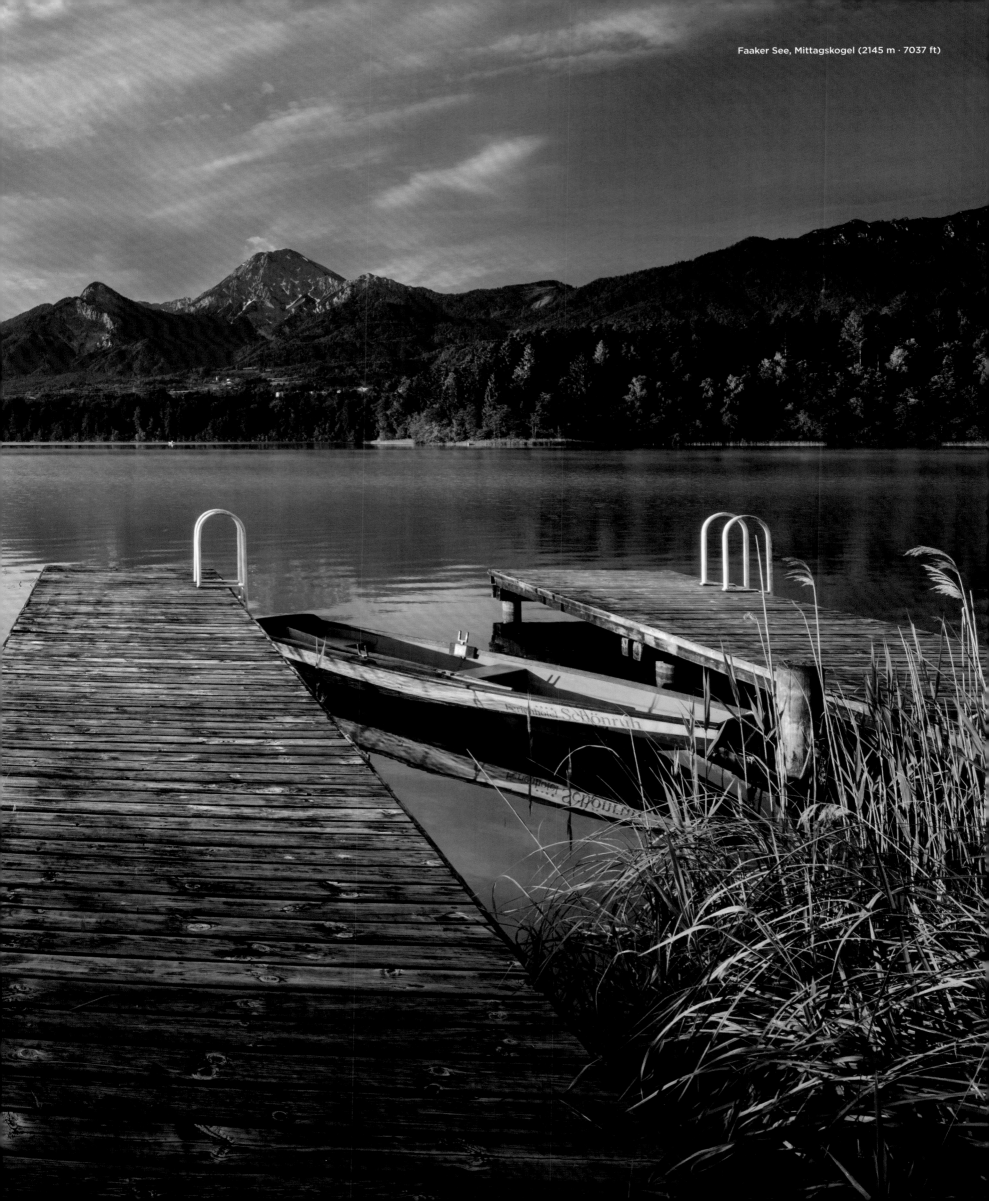

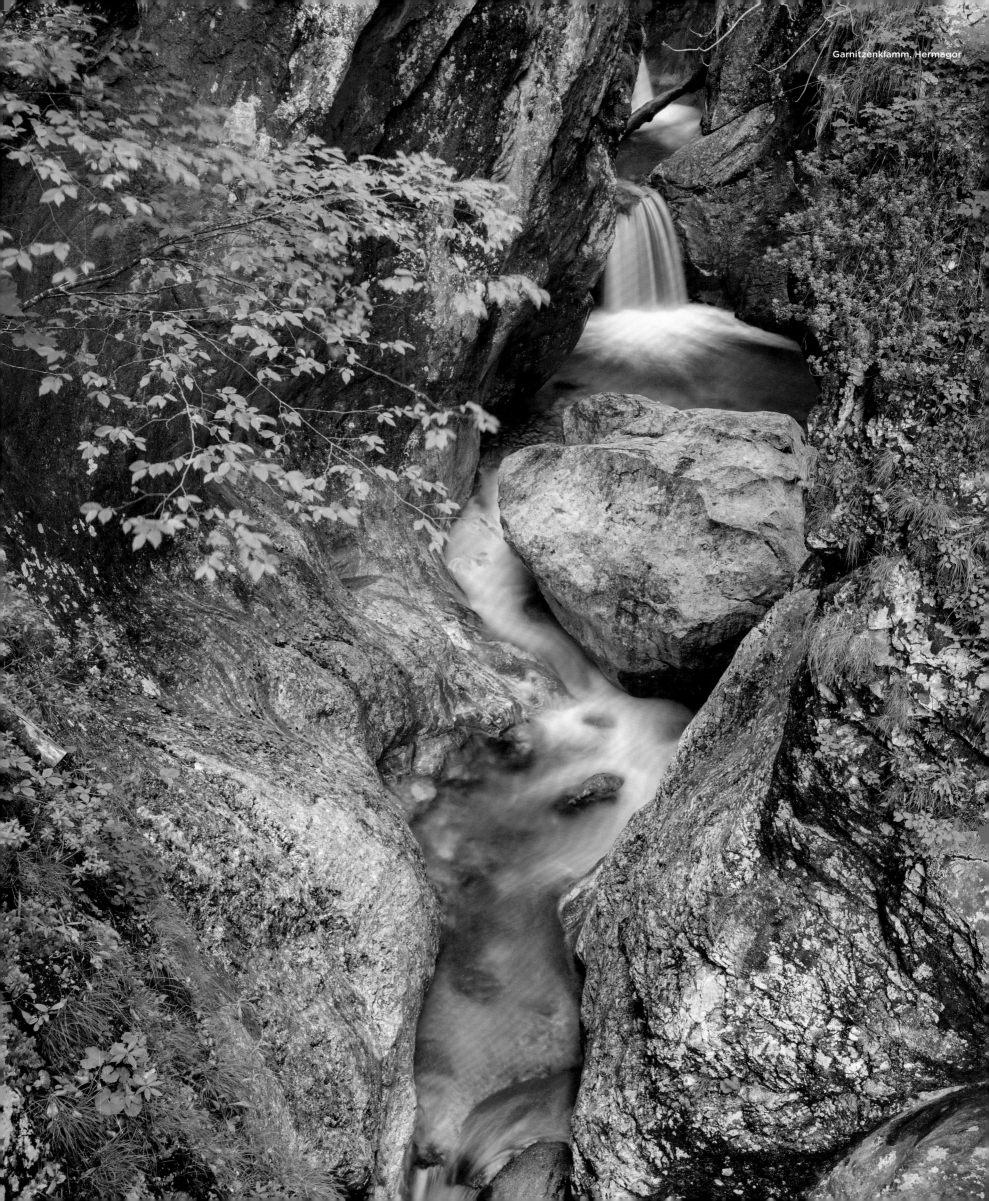

Pasterze, Nationalpark Hohe Tauern

Pasterze, HIgh Tauern

The Pasterze at the foot of the Großglockner is the largest glacier in Austria. Its meltwater and sediment deposits indicate that the approximately 8 km (5 mi) long glacier is in motion. As everywhere in the Alps, climate change is responsible for an increase in the melting rate of the glacier; every year it loses about 50 m (164 ft) in length.

Le Pasterze, dans les Hohe Tauern

Situé au pied du Grossglockner, le Pasterze est le plus grand glacier d'Autriche. Ses eaux de fonte et ses dépôts de sédiments montrent bien que ce glacier d'environ 8 km de long est toujours en mouvement. Comme dans tout le reste des Alpes, le changement climatique entraîne une fonte croissante du glacier, qui perd environ 50 m par an.

Pasterze

Die Pasterze am Fuß des Großglockners ist der größte Gletscher Österreichs. Sein Schmelzwasser und die Sedimentablagerungen zeigen an, dass der etwa 8 km lange Gletscher in Bewegung ist. Wie überall in den Alpen ist der Klimawandel verantwortlich für ein zunehmendes Abschmelzen des Gletschers; jedes Jahr verliert er rund 50 m an Länge.

Pasterze, Hohe Tauern

El Pasterze al pie del Großglockner es el glaciar más grande de Austria. Sus depósitos de agua de deshielo y sedimentos indican que el glaciar, de aproximadamente 8 km de largo, se encuentra en movimiento. Como en todas partes en los Alpes, el cambio climático es responsable de un creciente derretimiento del glaciar, que cada año pierde unos 50 m de longitud.

Pasterze, Hohe Tauern

O Pasterze ao pé do Großglockner é o maior glaciar da Áustria. Seus depósitos de água de fusão e sedimentos indicam que a geleira de aproximadamente 8 km de comprimento está em movimento. Como em todos os Alpes, as alterações climáticas são responsáveis pelo derretimento crescente do glaciar; todos os anos perde cerca de 50 m de comprimento.

Pasterze, Hohe Tauern

De Pasterze aan de voet van de Grossglockner is de grootste gletsjer van Oostenrijk. Aan het smeltwater en de sedimentafzettingen is te zien dat de ongeveer 8 km lange gletsjer in beweging is. Overal in de Alpen is de klimaatverandering verantwoordelijk voor een toenemend afsmelten van de gletsjer; de Pasterze trekt zich per jaar ongeveer 50 meter verder terug.

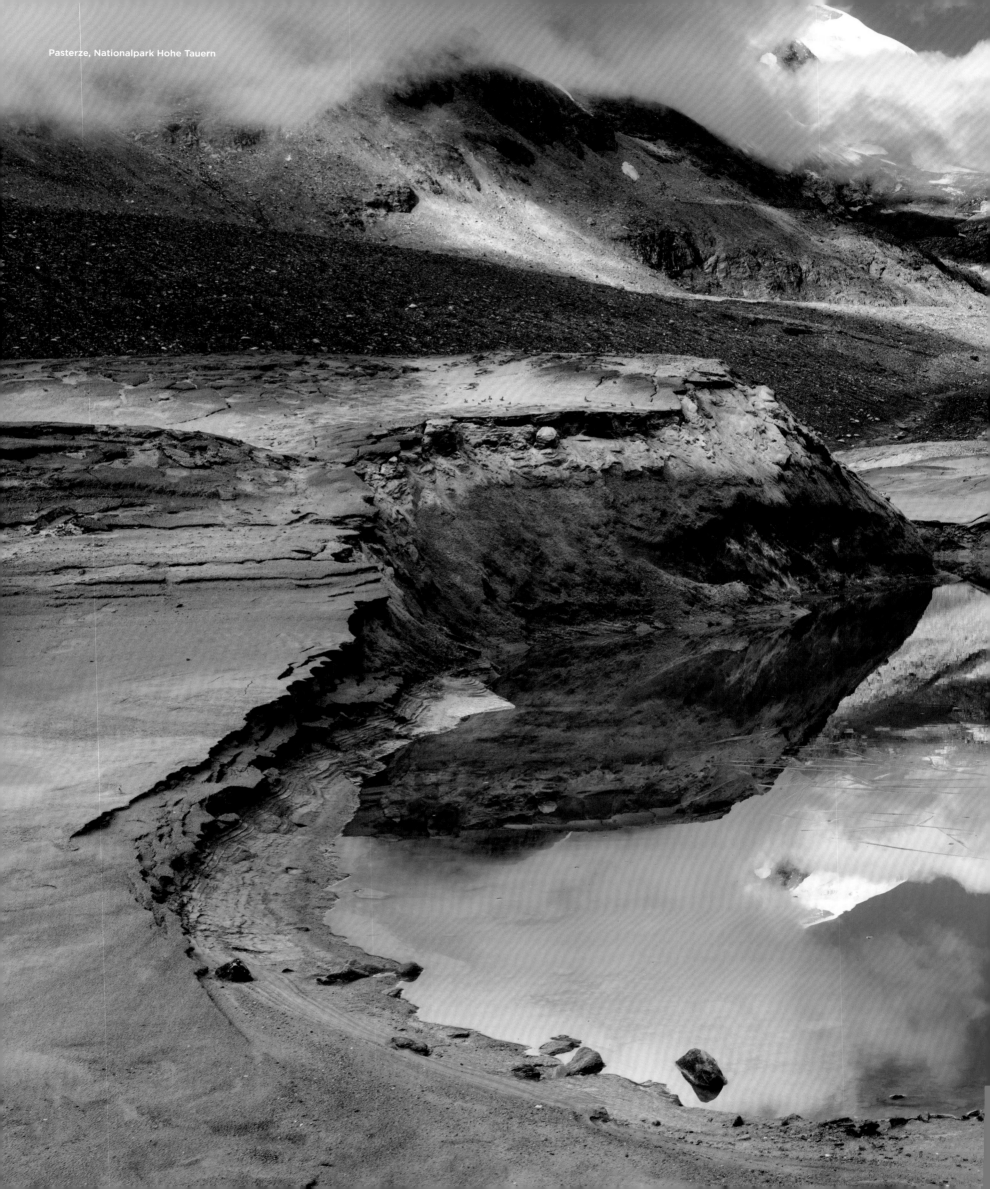

Pasterze, Nationalpark Hohe Tauern

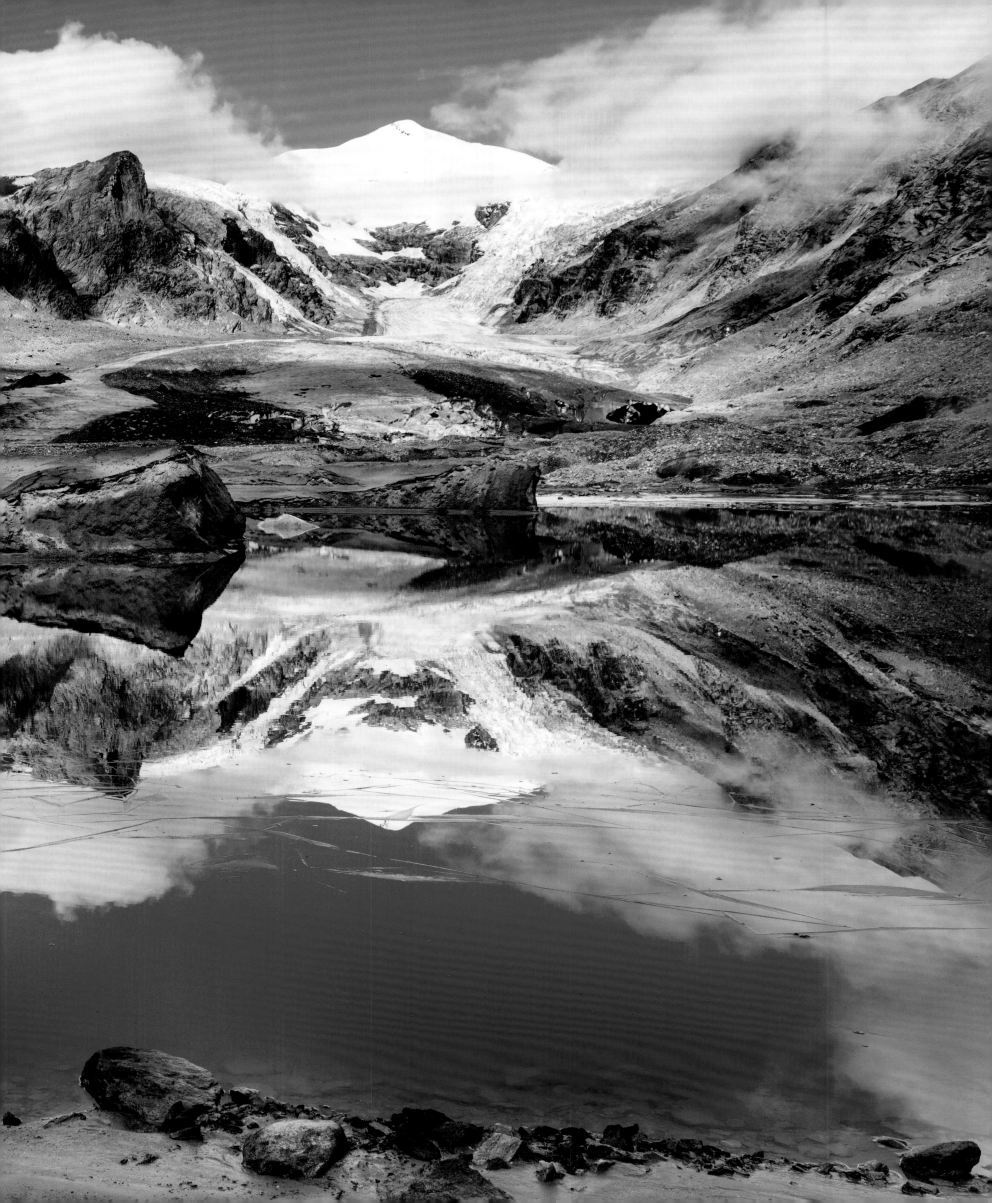

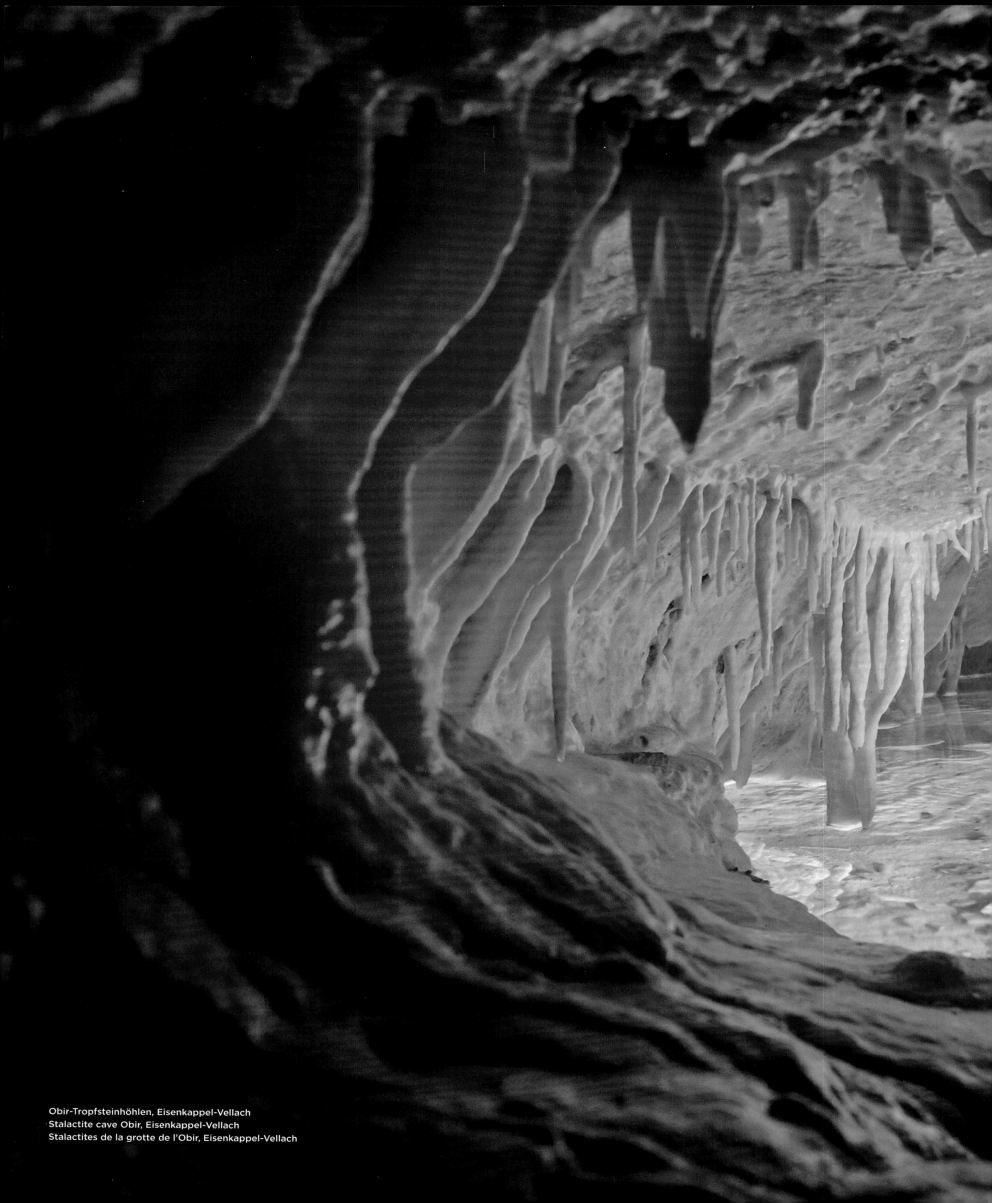

Obir-Tropfsteinhöhlen, Eisenkappel-Vellach
Stalactite cave Obir, Eisenkappel-Vellach
Stalactites de la grotte de l'Obir, Eisenkappel-Vellach

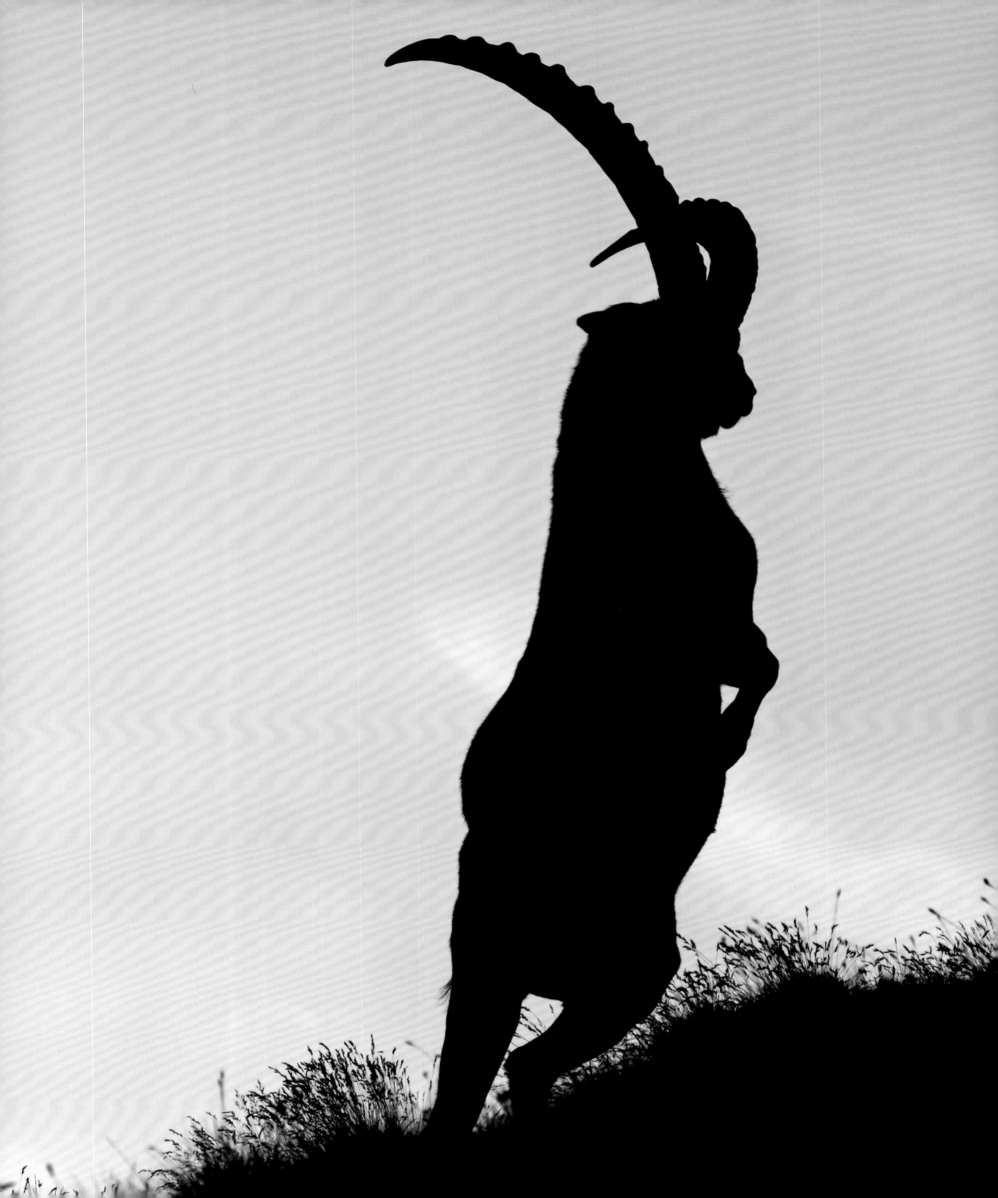

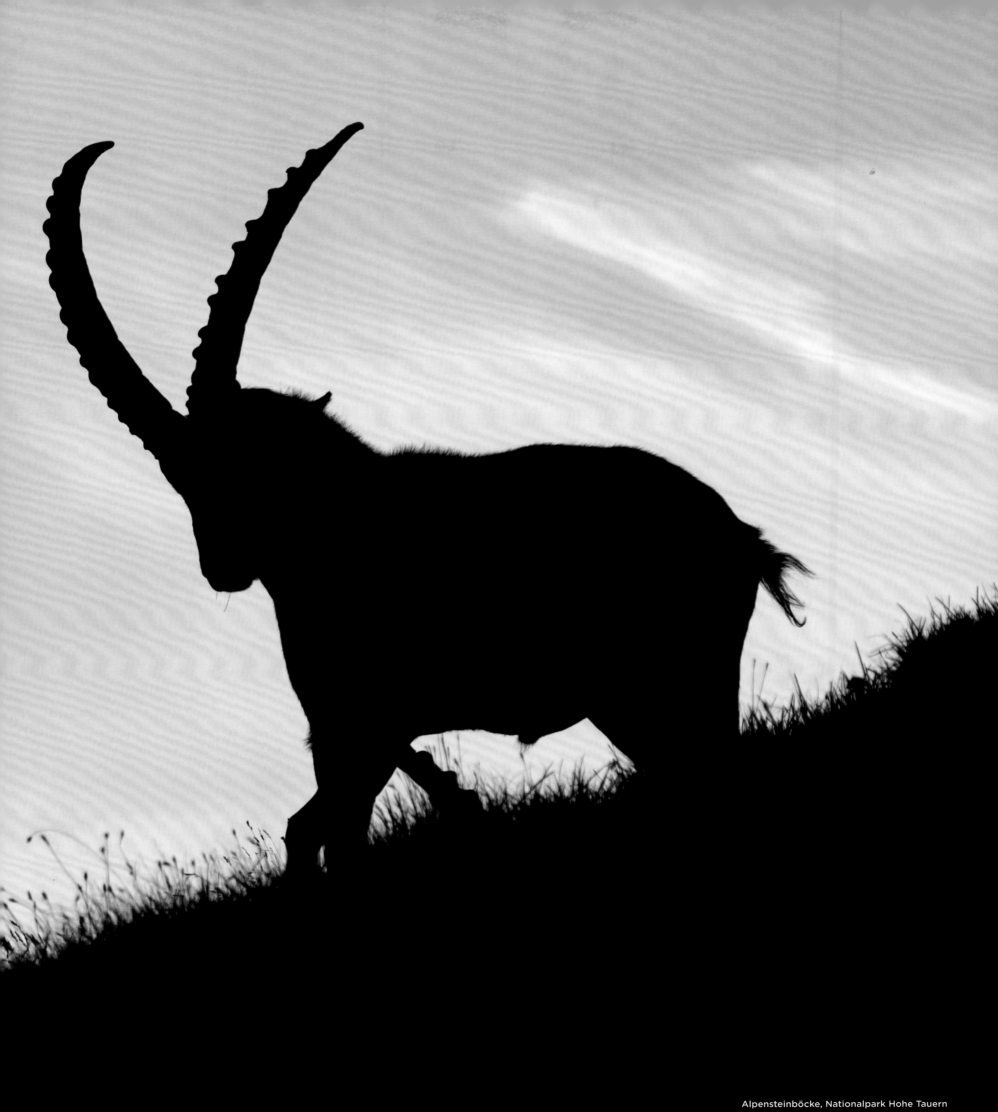

Alpensteinböcke, Nationalpark Hohe Tauern
Alpine ibex, High Tauern National Park
Bouquetins des Alpes, parc national des Hohe Tauern

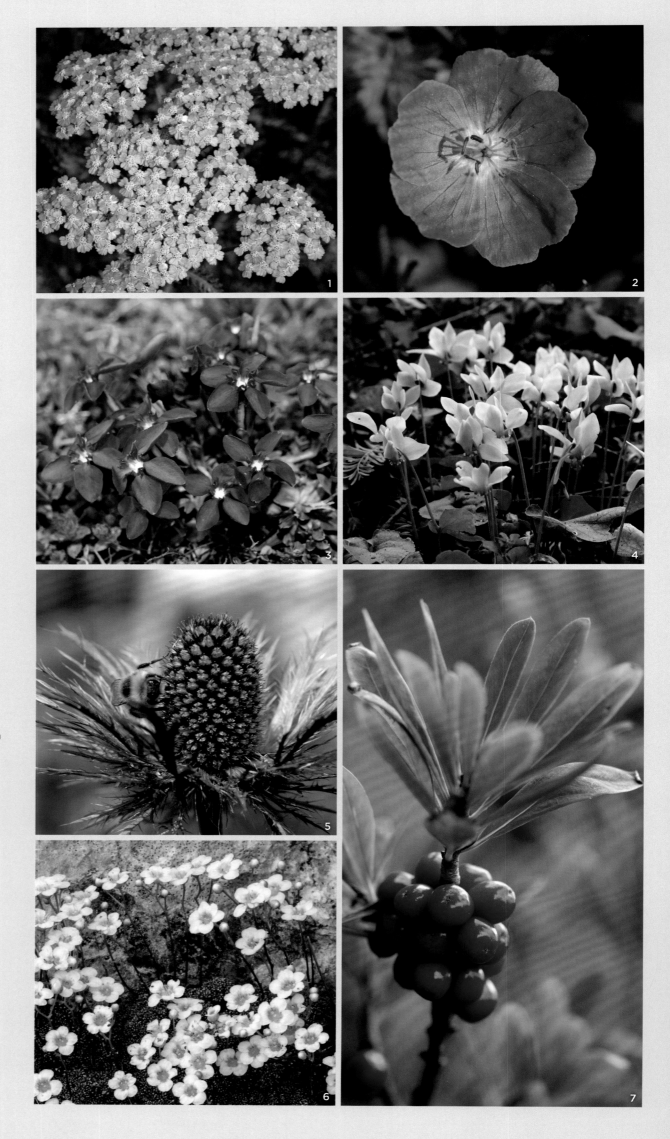

1 Common yarrow, Achillée millefeuille, Wiesenschafgarbe, Milenrama, Yarrow do Prado, Duizendblad

2 Bloody crane's-bill, Géranium sanguin, Blutroter Storchschnabel, Geranios de sangre, Geranium Vermelho Sangue, Bloedooievaarsbek

3 Spring gentian, Gentiane de printemps, Frühlings-Enzian, Gitanilla menuda, Mola Gentiana, Voorjaarsgentiaan

4 European cyclamen, Cyclamen d'Europe, Europäisches Alpenveilchen, Ciclamen de Europa, Ciclames Europeus, Alpenviooltje

5 Queen of the Alps, Panicaut bleu des Alpes, Alpenmannstreu, Eringio alpino, Ninhada de Alpenmann, Alpenkruisdistel

6 *Saxifraga squarrosa,* Saxifrage squarreuse, Sparriger Steinbrech, Saxifraga

7 Daphne, Daphné, Seidelbast, Peperboompje

8 Glacier buttercup, Renoncule des glaciers, Gletscher-Hahnenfuß, Ranúnculo glacial, Geleira Buttercup, Gletsjerboterbloem

9 Alpine clematis, Clématite des Alpes, Alpen-Waldrebe, *Clematis alpina,* Vinha de Floresta Alpina

10 Alpine columbine, Ancolie des Alpes, Alpen-Akelei, *Aquilegia alpina,* Alpenakelei

11 Rusty-leaved alpenrose, Rhododendron ferrugineux, Rostblättrige Alpenrose, Rododendro, Rosa Alpina com Folhas de Ferrugem, Gewone alpenroos

12 Edelweiss, Alpen-Edelweiß, Flor de las nieves, Alpine Edelweiss

13 Rock thyme, Sarriette des Alpes, Alpen-Steinquendel, Acino alpino, Quendel de Pedra Alpina, Steentijm

14 Many-leaved lupine, Lupin des jardins, Vielblättrige Lupine, Lupino, Lupino Multifolha, Vaste lupine

15 Alpine poppy, Pavot des Alpes, Alpen-Mohn, Amapola alpina, Sementes de Papoila Alpina, *Papaver alpinum* ('alpenklaproos')

16 Wolfsbane, Aconit napel, Blauer Eisenhut, Acónito común, Monges azuis, Blauwe monnikskap

17 Alpine anemone, Anémone des Alpes, Alpen-Kuhschelle, Pulsatilla alpina, Grampo de couro de vaca alpino, Alpenanemoon

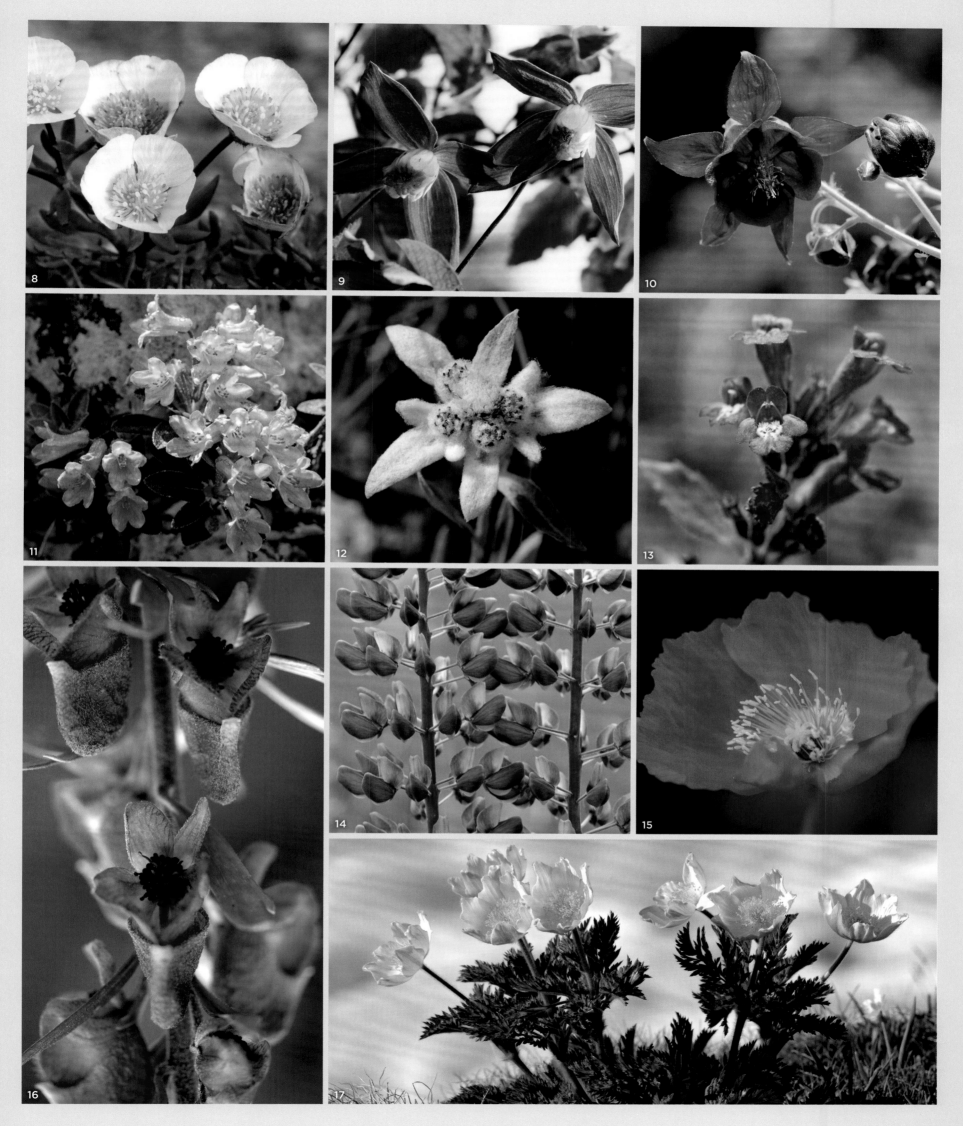

Steiermark · Styria · Styrie

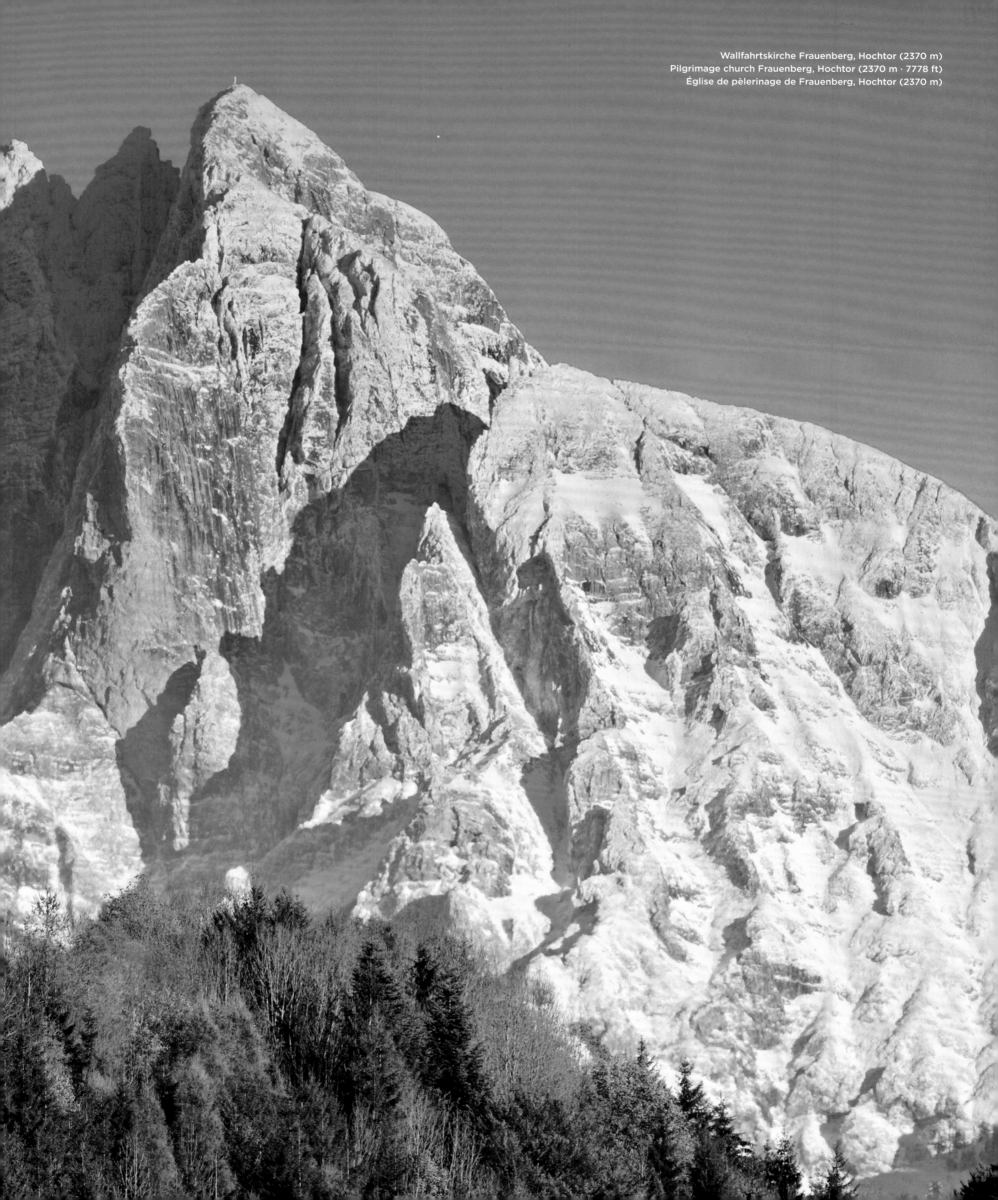

Wallfahrtskirche Frauenberg, Hochtor (2370 m)
Pilgrimage church Frauenberg, Hochtor (2370 m · 7778 ft)
Église de pèlerinage de Frauenberg, Hochtor (2370 m)

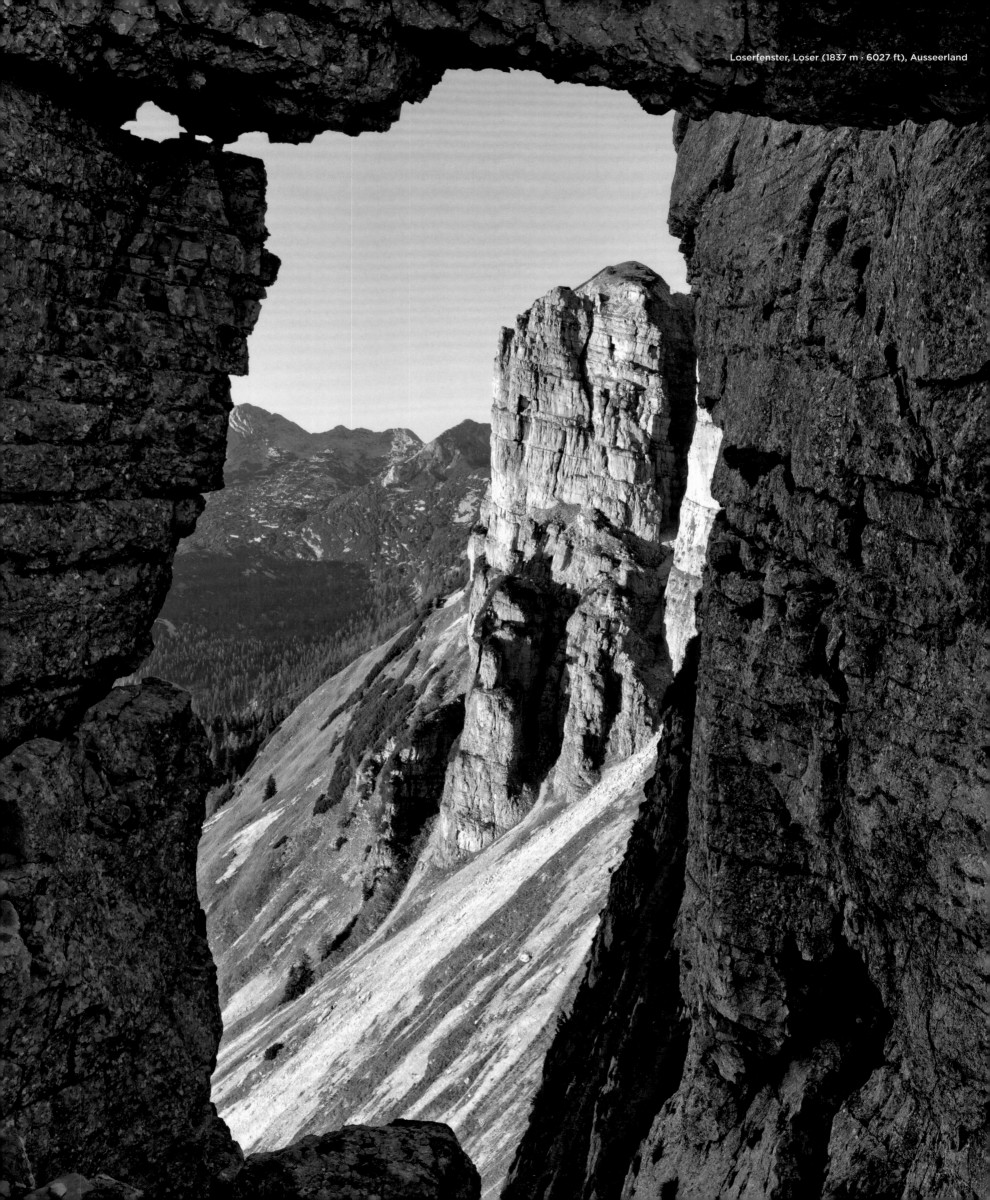

Loserfenster, Loser (1837 m · 6027 ft), Ausseerland

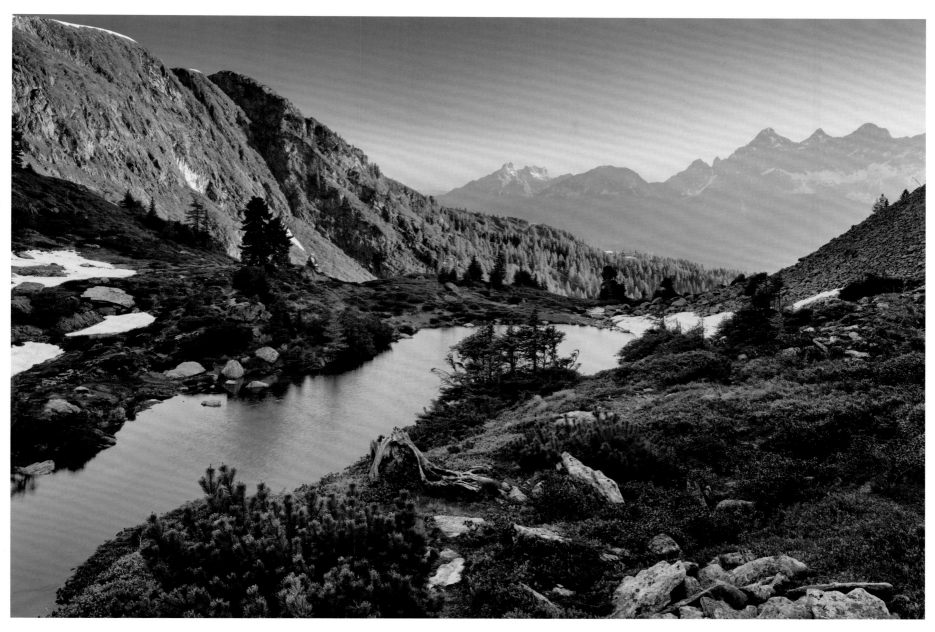

Spiegelsee, Reiteralm, Dachsteinmassiv

Styria

Almost two thirds of Styria are covered by forests, the areas suitable for agriculture are used to cultivate excellent wines and pumpkins.The famous Styrian pumpkin seed oil plays an outstanding role bot only in Styrian cuisine. The capital Graz, Austria's second largest city, owes its lively cultural scene to its many students.

La Styrie

La Styrie est composée aux deux tiers de forêts, mais sur les terres cultivables restantes, on produit d'excellents vins et un grand nombre de courges : l'huile de graines de courge joue un rôle essentiel dans la gastronomie locale. Sa capitale est Graz, deuxième ville d'Autriche par sa taille, une ville universitaire à la scène culturelle très dynamique.

Steiermark

Auf der landwirtschaftlich nutzbaren Fläche der zu fast zwei Dritteln bewaldeten Steiermark werden u. a. ausgezeichnete Weine angebaut – und Kürbisse; das berühmte Kürbiskernöl spielt in der Kulinarik des Landes eine herausragende Rolle. Die Hauptstadt Graz, zweitgrößte Stadt Österreichs, verdankt ihre lebendige Kulturszene auch den vielen Studenten.

Estiria

En la zona agrícola de Estiria, que tiene casi dos tercios de bosque, se cultivan, entre otros, excelentes vinos y calabazas; el famoso aceite de semilla de calabaza desempeña un papel destacado en la gastronomía del país. La capital, Graz, que es la segunda ciudad más grande de Austria, también debe su animada escena cultural a la gran cantidad de estudiantes a los que acoge.

Estíria

Na área agrícola utilizável da Estíria, que é quase dois terços arborizada, são cultivados excelentes vinhos e abóboras; o famoso óleo de semente de abóbora desempenha um papel de destaque na culinária do país. A capital Graz, a segunda maior cidade da Áustria, também deve sua animada cena cultural a seus muitos estudantes.

Stiermarken

Bijna twee derde van Stiermarken is met bossen bedekt, voor de landbouw blijft niet veel over. Van dat deel komen echter uitstekende wijnen – en pompoenen; de beroemde pompoenpitolie speelt een grote rol speelt in de keuken van de deelstaat. De hoofdstad Graz, de op één na grootste stad van Oostenrijk, heeft een levendige culturele scene, mede dankzij de talloze studenten.

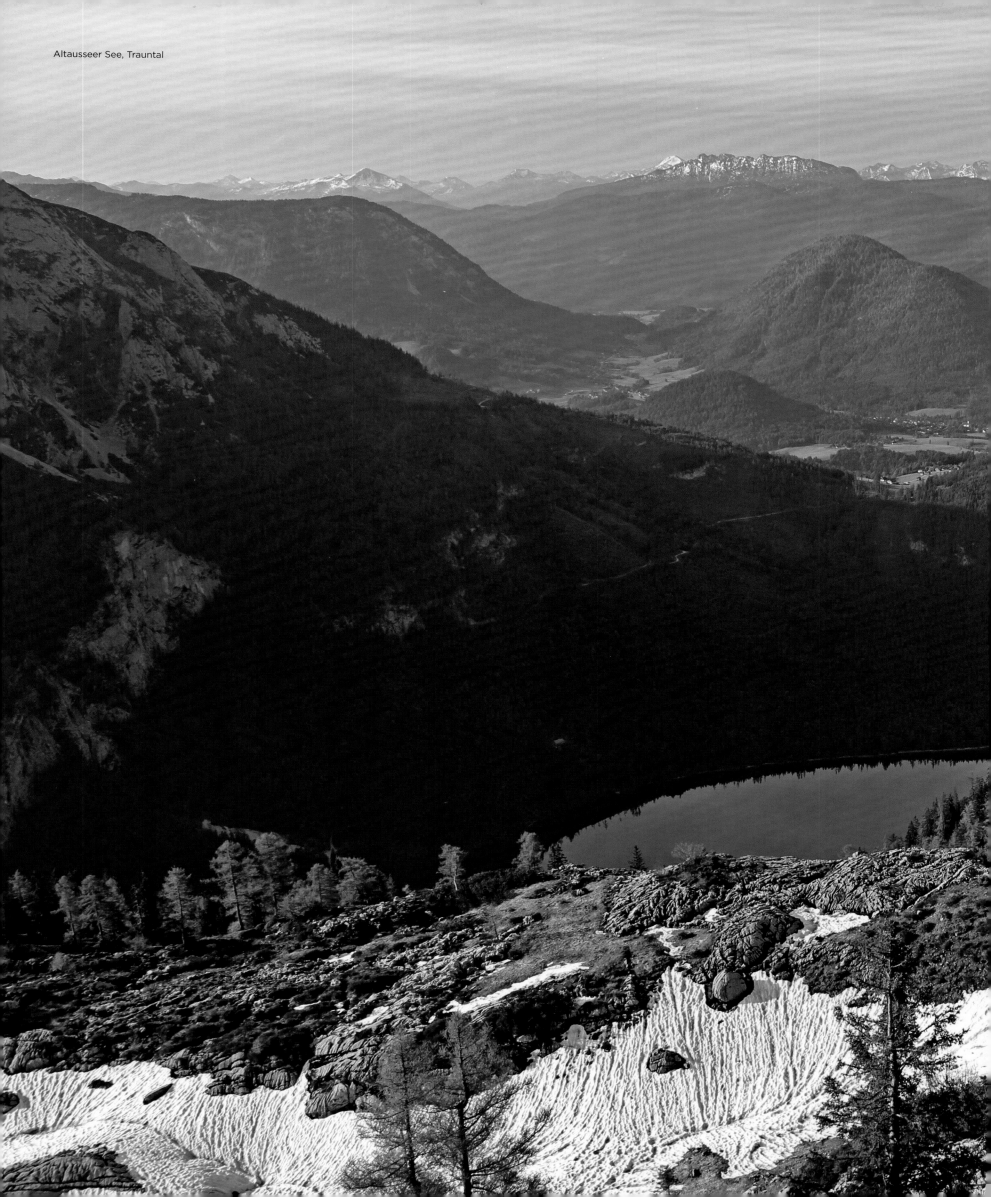

Altausseer See, Trauntal

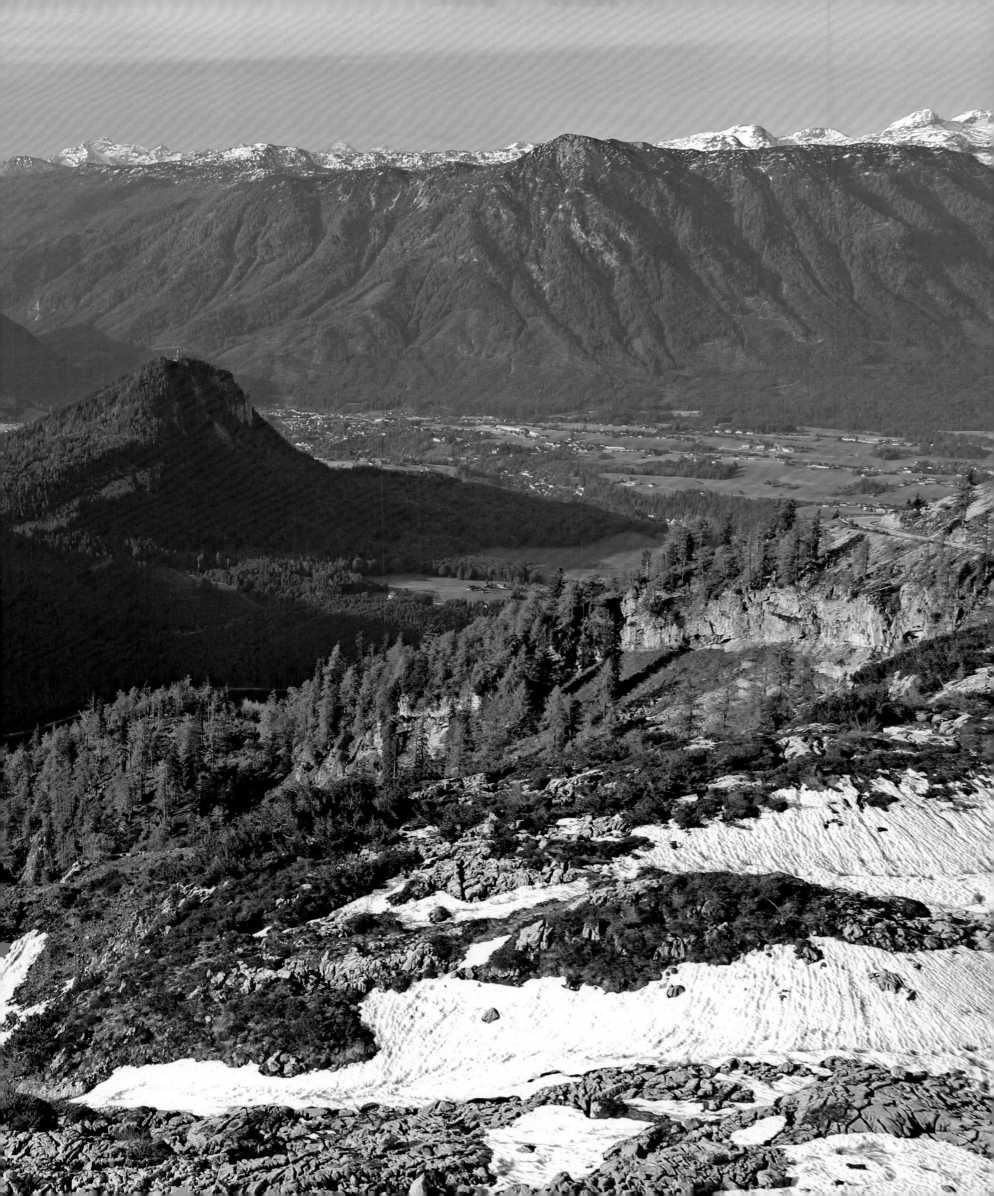

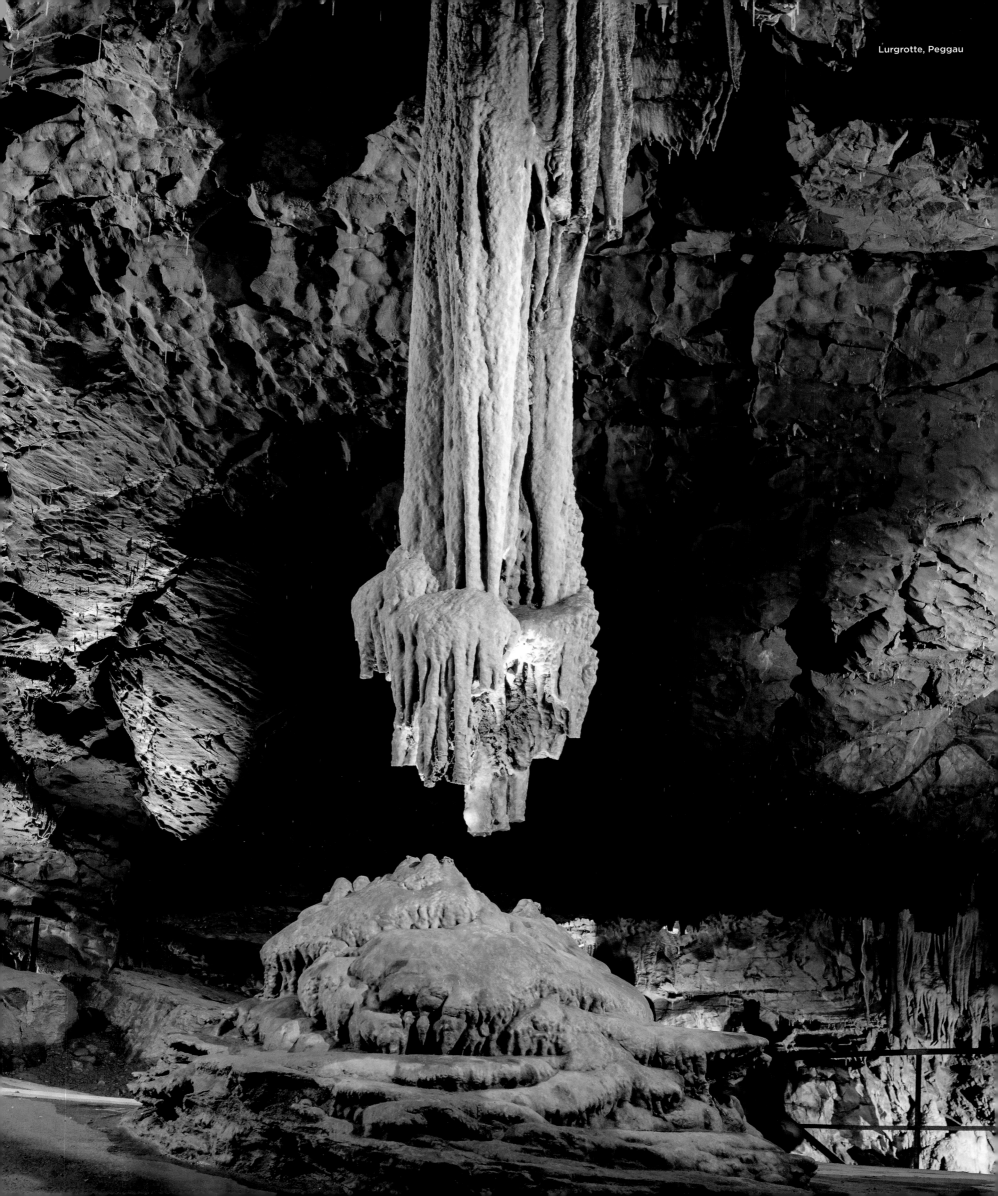

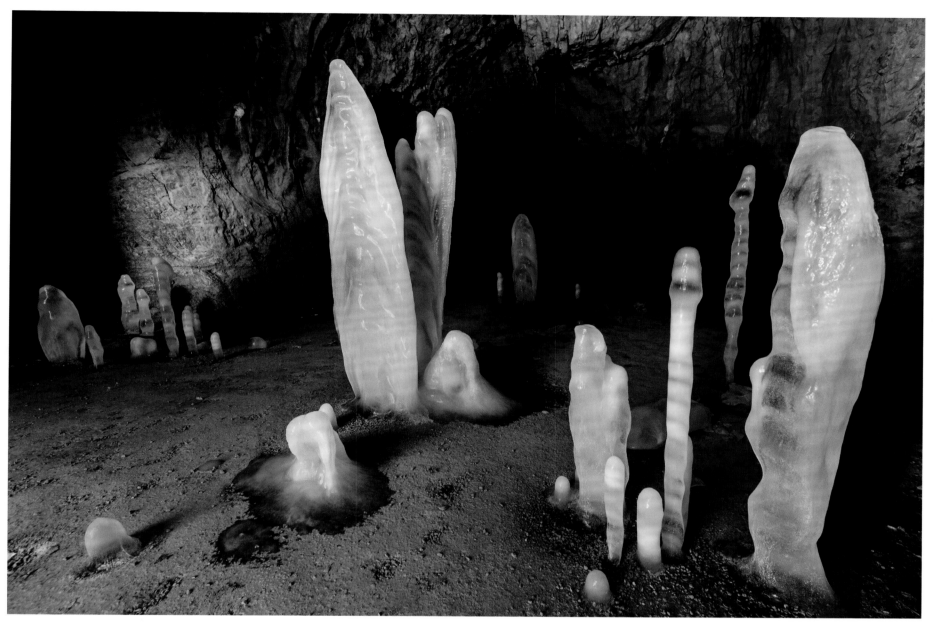

Lurgrotte, Peggau

Lurgrotte, Peggau

The Lurgrotte near Peggau north of Graz is about 5 km (3 mi) long; it is Austria's largest stalactite cave. The exploration and development of the cave began in 1894 and was not without difficulties. A speleologist died in 1926, and in 1975 subterranean constructions were washed away by a storm. A large part of the grotto is again open for visitors today.

La Lurgrotte, près de Peggau

Située près de Peggau, au nord de Graz, la Lurgrotte mesure environ 5 km de long et c'est la plus grande grotte à concrétions d'Autriche. L'exploration et l'exploitation de cette grotte ont commencé en 1894 et ne se sont pas déroulées sans difficulté. En 1926, une spéléologue y a perdu la vie et, en 1975, une partie des aménagements souterrains a été emportée par un violent orage. Aujourd'hui, une bonne part de la grotte est de nouveau accessible aux visiteurs.

Lurgrotte, Peggau

Rund 5 km lang ist die Lurgrotte bei Peggau nördlich von Graz; sie ist Österreichs größte Tropfsteinhöhle. Die Erforschung und Erschließung der Höhle begann 1894 und verlief nicht ohne Schwierigkeiten. Eine Forscherin kam 1926 ums Leben, und 1975 wurden unterirdische Bauten durch ein Unwetter weggespült. Ein großer Teil der Grotte kann heute wieder besichtigt werden.

Lurgrotte, Peggau

La gruta Lurgrotte, cerca de Peggau, al norte de Graz, tiene unos 5 km de longitud; es la cueva de estalactitas más grande de Austria. La exploración y el desarrollo de la cueva comenzaron en 1894 y no estuvieron exentos de dificultades. Un investigador murió en 1926, y en 1975 las construcciones subterráneas fueron arrastradas por una tormenta. Una gran parte de la gruta puede ser visitada de nuevo hoy en día.

Lurgrotte, Peggau

A Lurgrotte, perto de Peggau, a norte de Graz, tem cerca de 5 km de comprimento; é a maior caverna de estalactites da Áustria. A exploração e desenvolvimento da gruta começou em 1894 e não foi sem dificuldades. Um pesquisador morreu em 1926, e em 1975 os edifícios subterrâneos foram arrastados por uma tempestade. Uma grande parte da gruta pode ser visitada novamente hoje.

Lurgrotte, Peggau

De ongeveer 5 km lange Lurgrotte bij Peggau ten noorden van Graz is de grootste druipsteengrot van Oostenrijk. De exploratie en ontsluiting van de grot begon al in 1894, maar verliep niet zonder slag of stoot. In 1926 stierf hier een onderzoeker en in 1975 spoelde een zwaar onweer bouwwerken in de grot weg. Tegenwoordig is de grot weer grotendeels te bezichtigen.

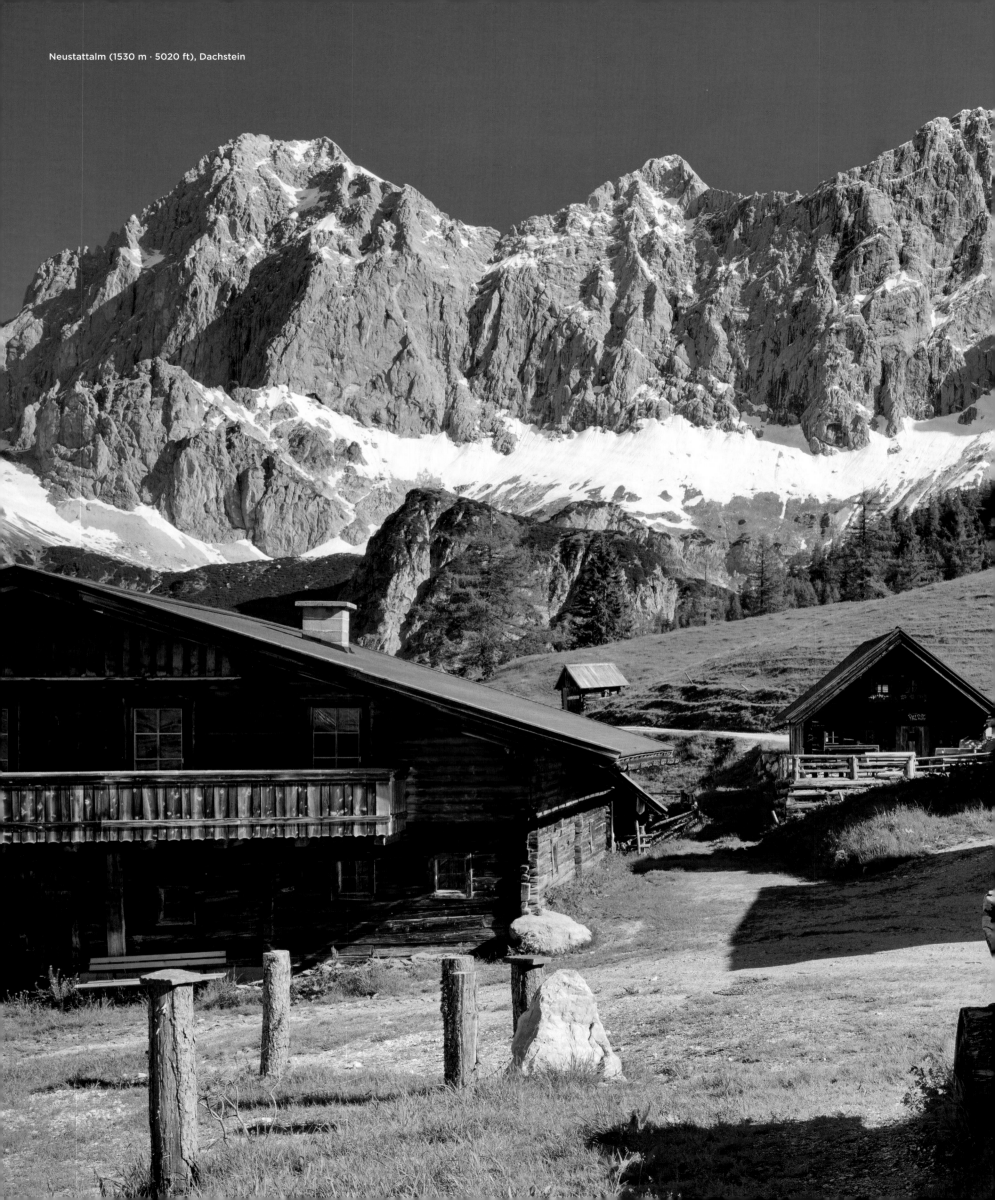

Neustattalm (1530 m · 5020 ft), Dachstein

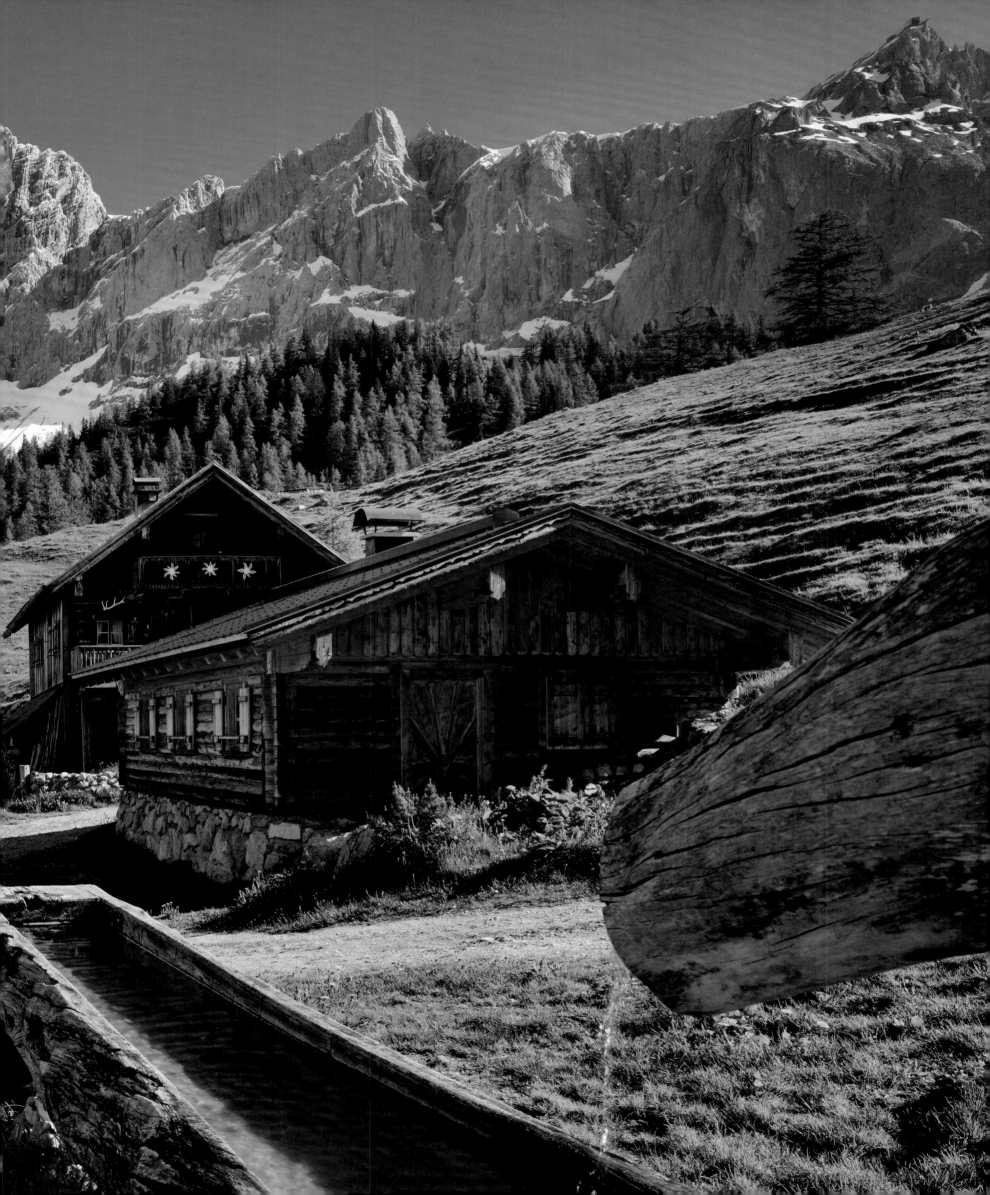

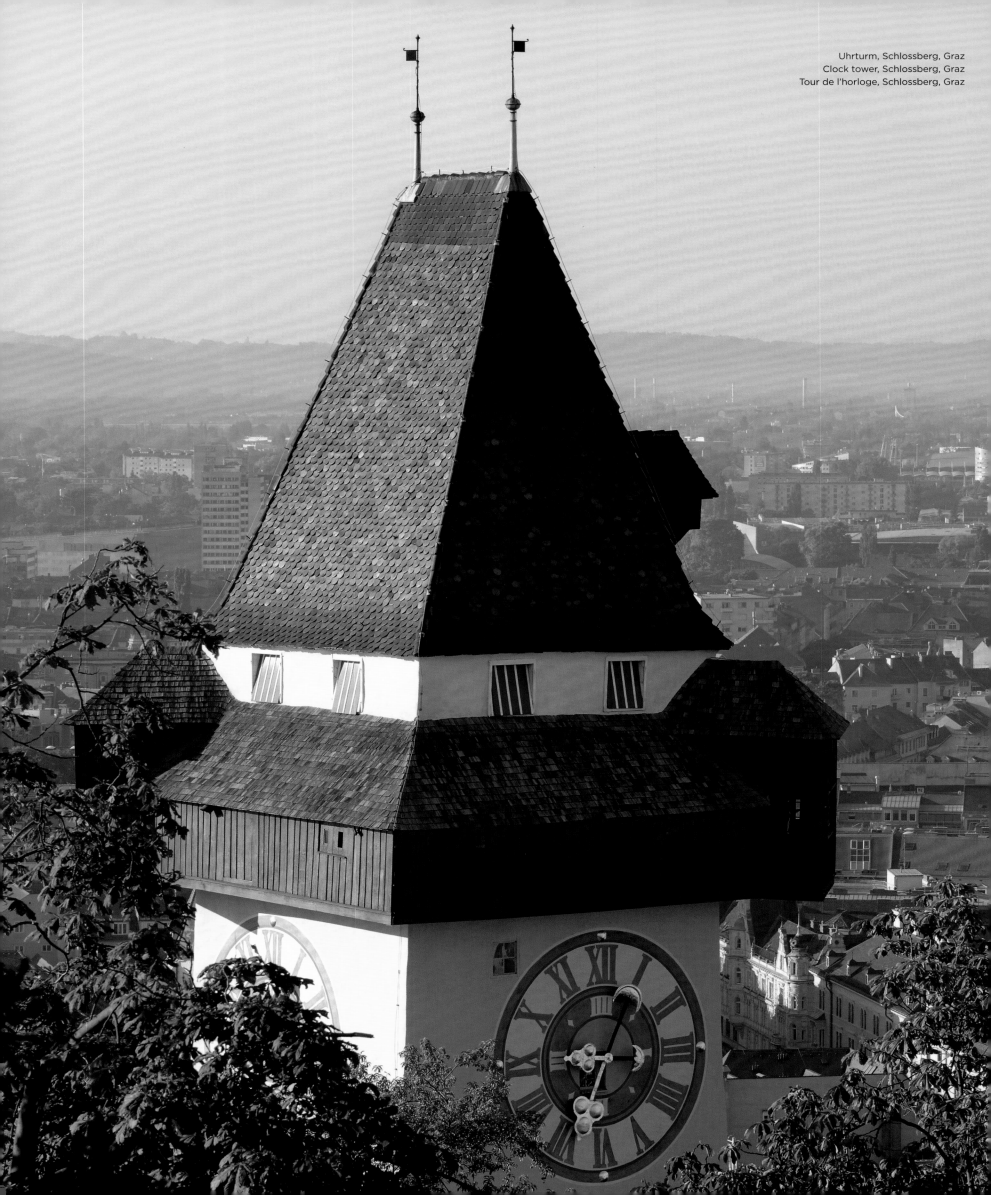

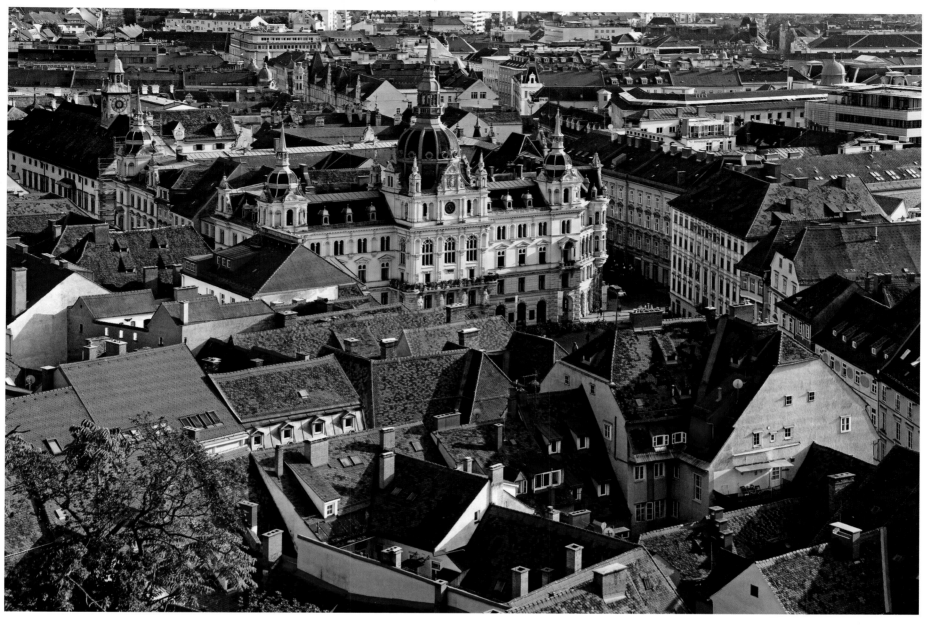

Graz

Clock Tower, Graz

One of the most striking buildings in the Styrian capital Graz is the landmark clock tower on the Schlossberg. Not only the four giant dials, each 5 m (16 ft) in diameter, but also the surrounding defensive walkway with its wooden cladding make the tower unique. In 2003, when Graz was European Capital of Culture, a steel twin tower stood right next to it.

La tour de l'horloge de Graz

La tour de l'horloge, sur le Schlossberg, est l'un des édifices les plus impressionnants de Graz, capitale de la Styrie, et également son emblème. Outre ses quatre énormes cadrans, de 5 m de diamètre chacun, la tour possède aussi un chemin de ronde en bois qui lui confère une apparence unique. En 2003, quand Graz était capitale européenne de la culture, une tour identique mais faite d'acier a été érigée juste à côté, mais démontée par la suite.

Graz

Eines der markantesten Gebäude in der steirischen Hauptstadt Graz und ihr Wahrzeichen ist der Uhrturm auf dem Schlossberg. Nicht nur die vier riesigen Zifferblätter mit je 5 m Durchmesser, auch der umlaufende hölzerne Wehrgang machen den Turm einzigartig. 2003, als Graz Europas Kulturhauptstadt war, stand direkt nebenan ein Zwillingsturm aus Stahl.

Torre del Reloj, Graz

Uno de los edificios más llamativos de la capital de Estiria, Graz, y su punto de referencia es la torre del reloj en el Schlossberg. La torre es única no solo por las cuatro esferas gigantes de 5 m de diámetro cada una, sino también por la presa de madera que la rodea. En 2003, cuando Graz era la Capital Europea de la Cultura, al lado había una torre gemela de acero.

Torre do Relógio, Graz

Um dos edifícios mais marcantes da capital da Estíria, Graz, e seu marco é a torre do relógio no Schlossberg. Não só os quatro mostradores gigantes, cada um com 5 m de diâmetro, mas também o açude de madeira circundante tornam a torre única. Em 2003, quando Graz era a Capital Europeia da Cultura, uma torre dupla de aço ficava mesmo ao lado.

Klokkentoren, Graz

De klokkentoren op de Schlossberg is het symbool van de Stiermarkse hoofdstad Graz en tevens een van de meest opvallende gebouwen. Niet alleen de vier reusachtige wijzerplaten, die elk een diameter hebben van 5 m, maar ook de houten weergang eromheen maken de toren uniek. In 2003, toen Graz de Culturele Hoofdstad van Europa was, stond naast de toren een stalen kopie.

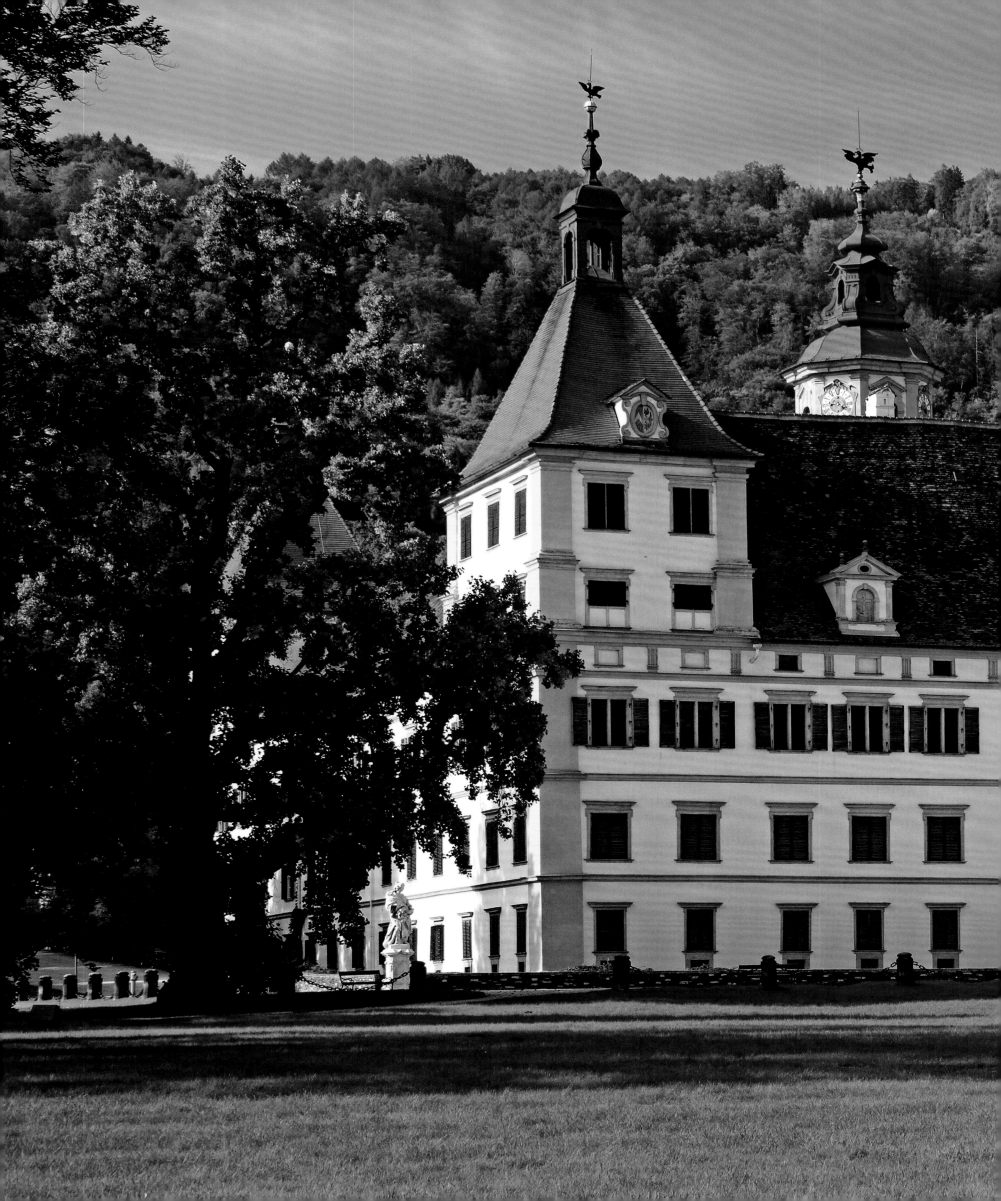

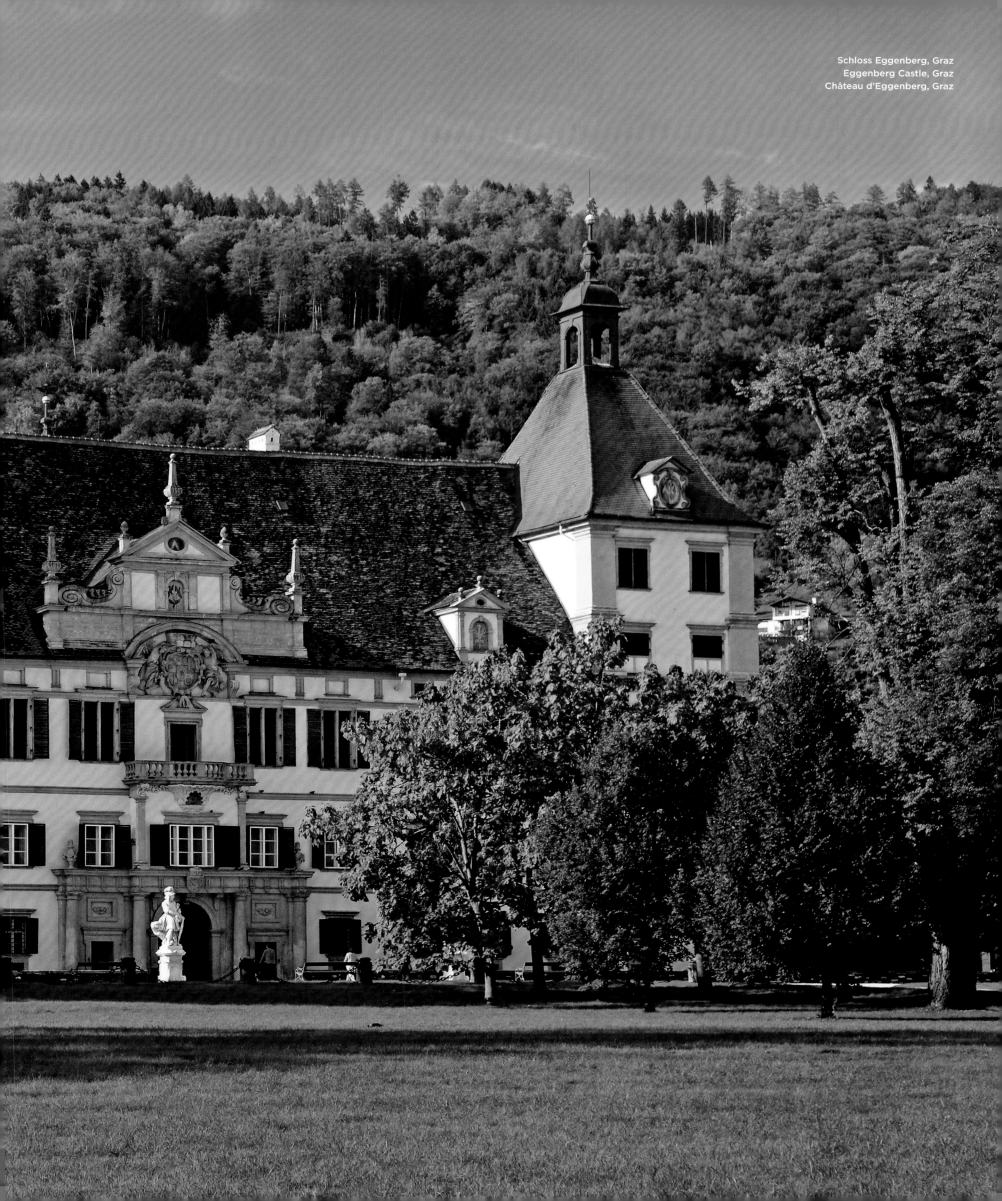

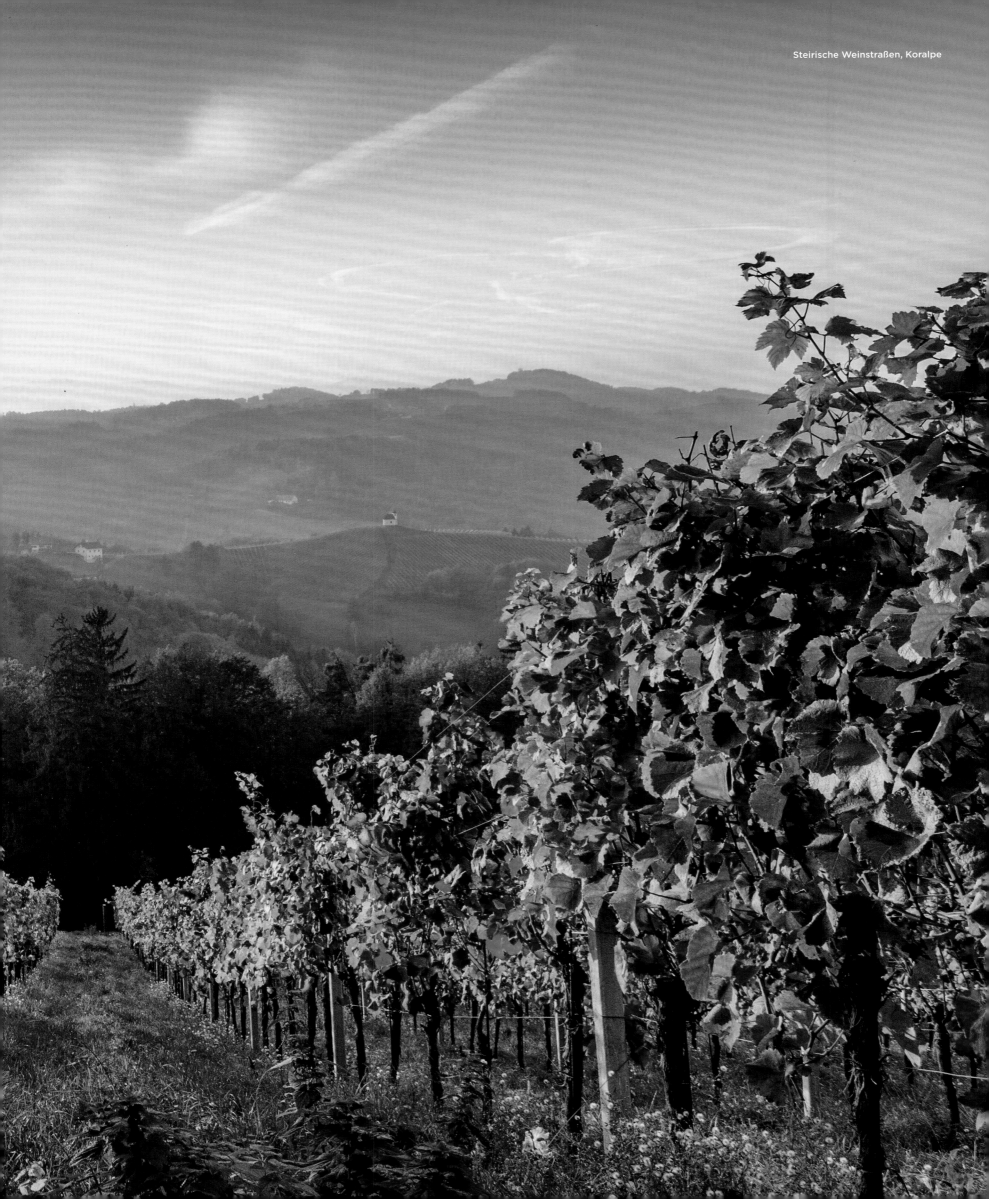

Steirische Weinstraßen, Koralpe

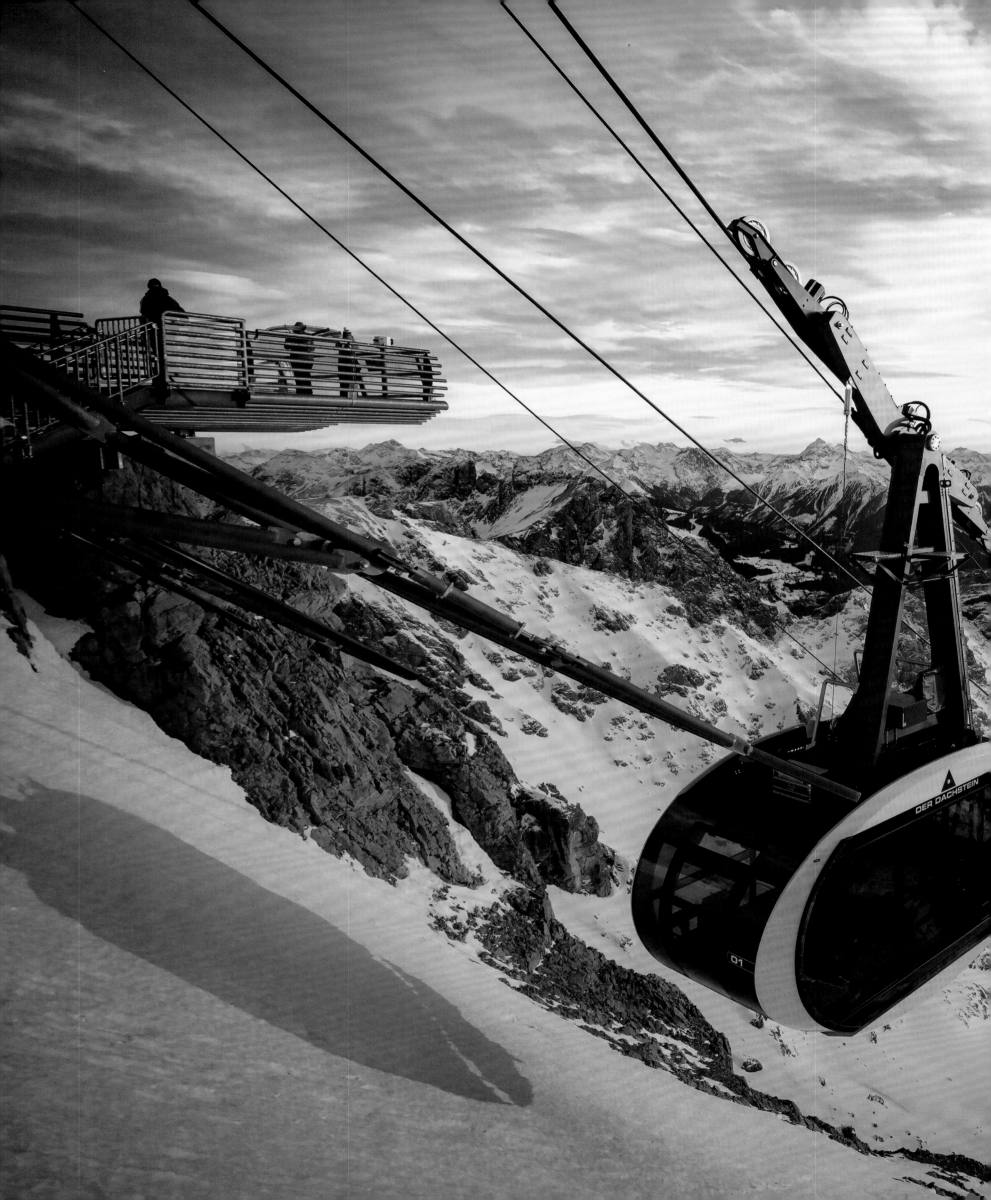

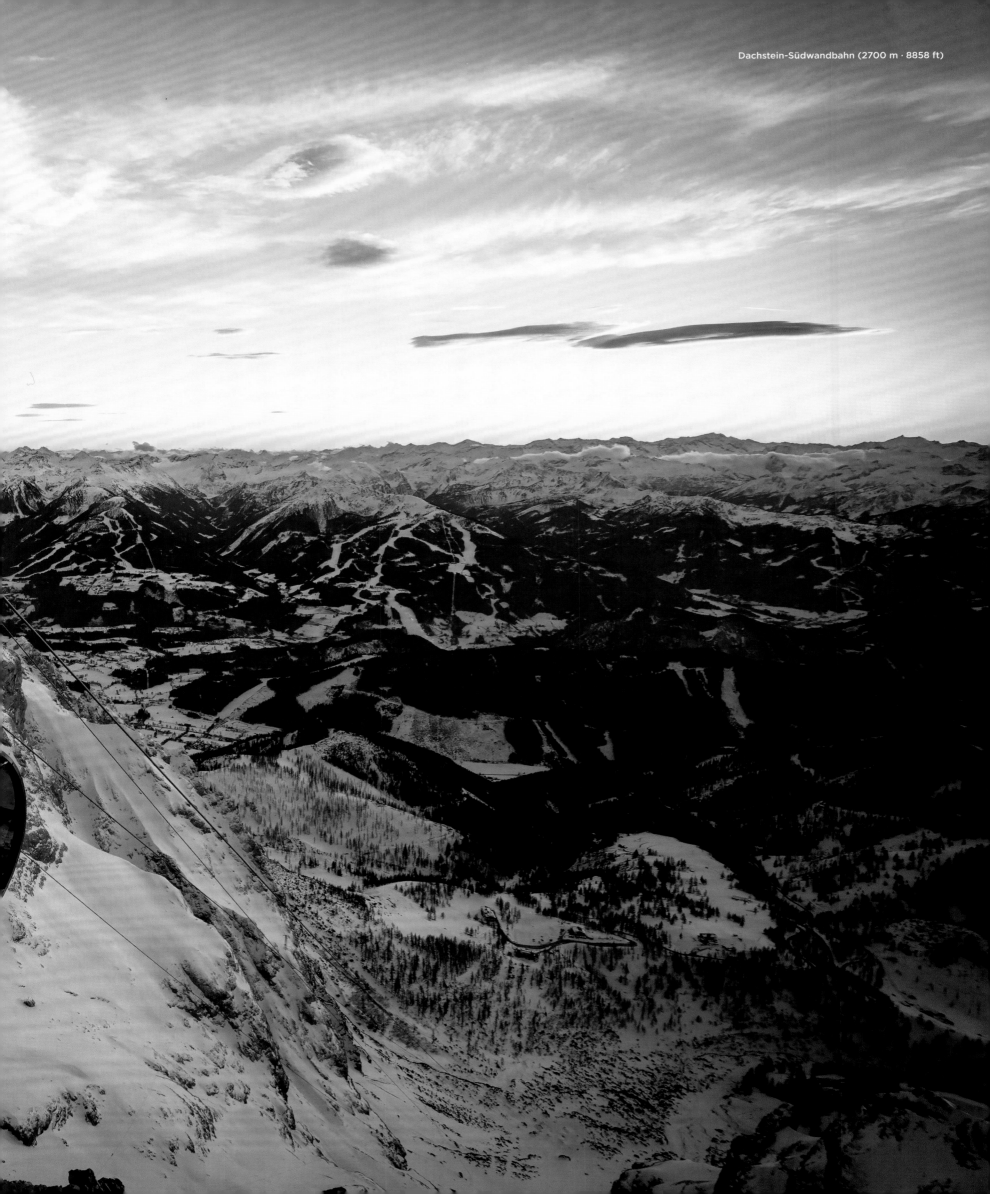

Dachstein-Südwandbahn (2700 m · 8858 ft)

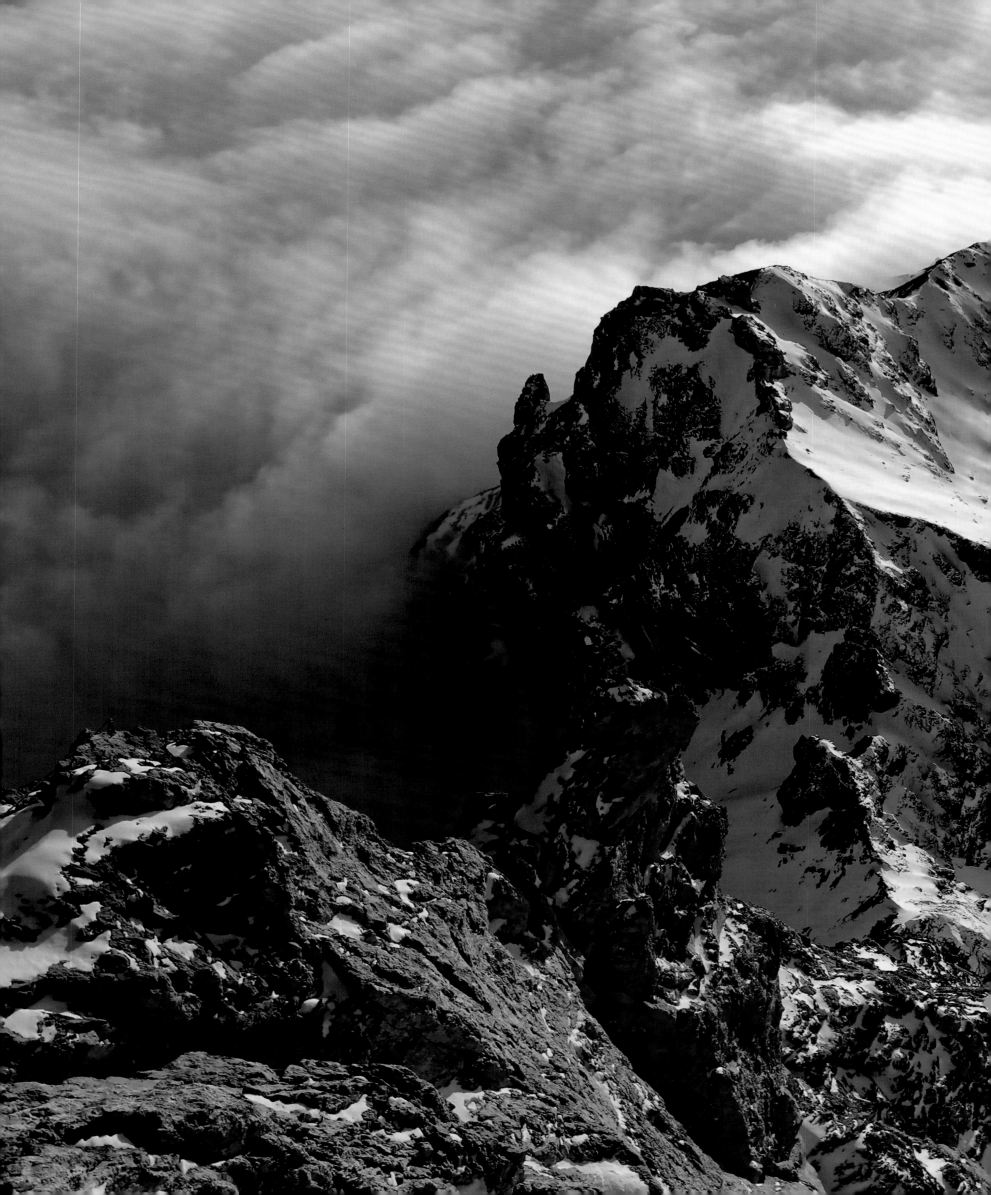

Dachstein (2995 m · 9826 ft)

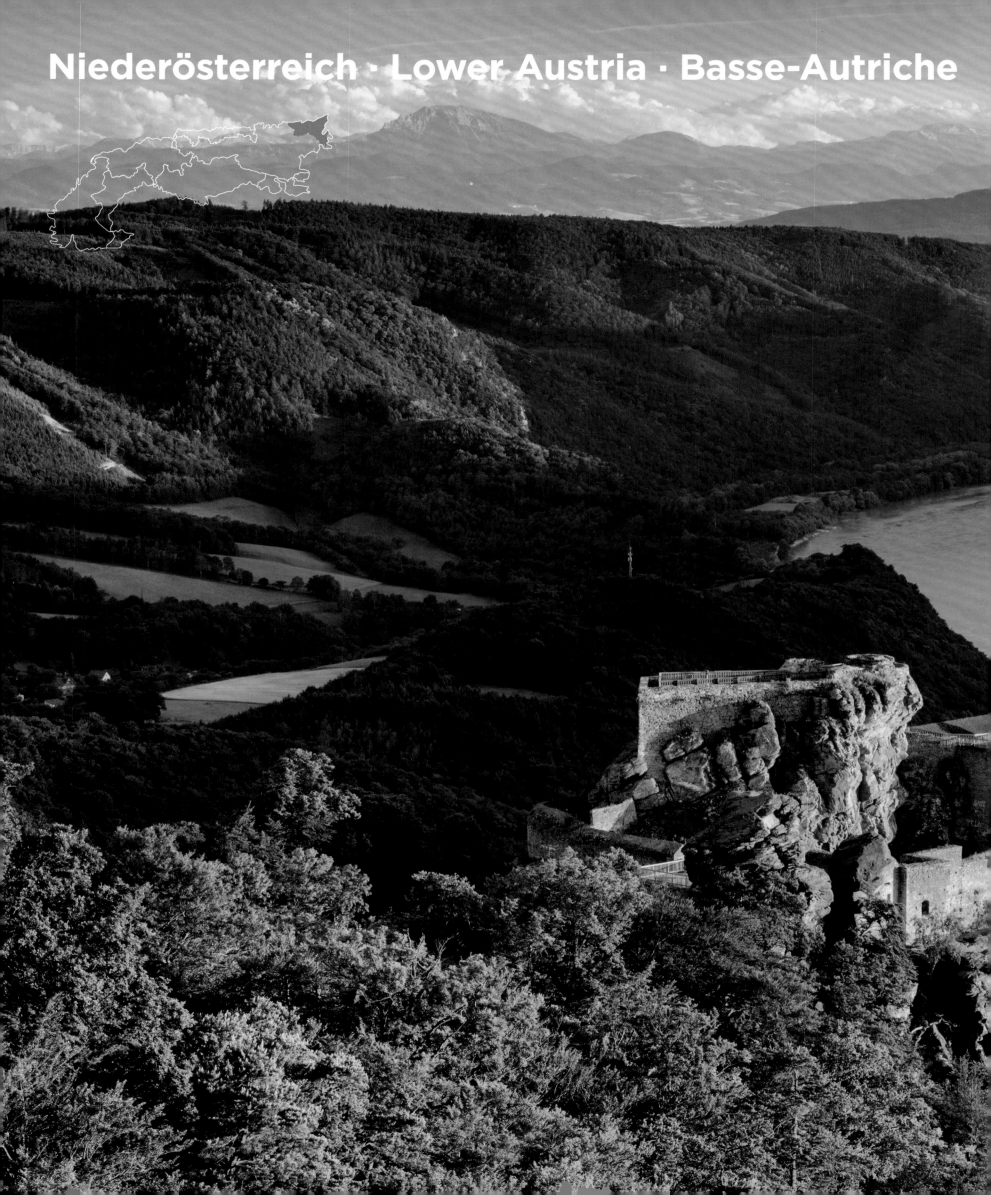

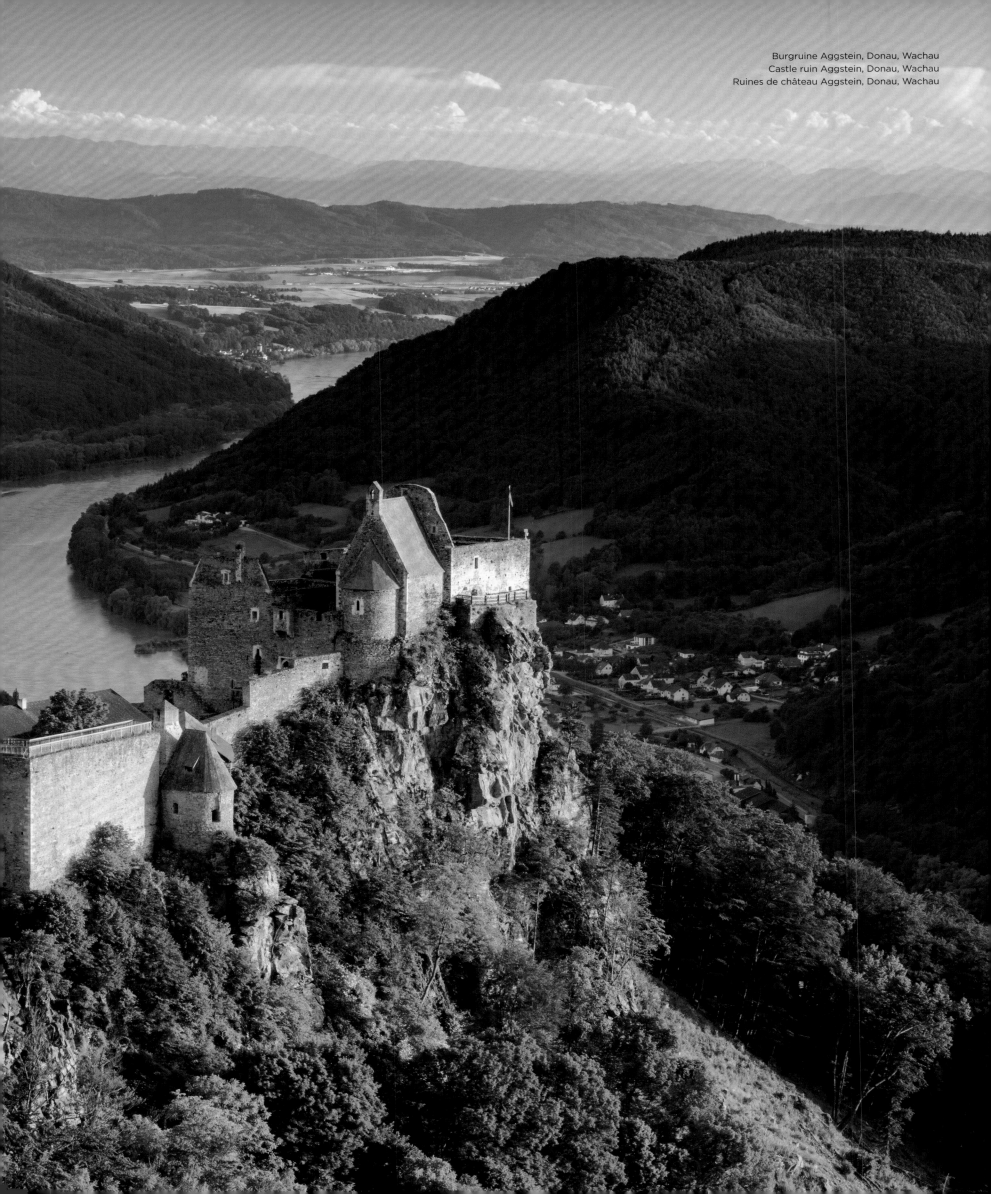

Burgruine Aggstein, Donau, Wachau
Castle ruin Aggstein, Donau, Wachau
Ruines de château Aggstein, Donau, Wachau

Peilstein, Triestingtal

Lower Austria

Austria's largest federal state stretches from the Danube plain over foothills of the Alps to mountain regions reaching an altitude of 2000 m (6562 ft). Even if the share of the Alps is not particularly high, many holidaymakers are attracted by the excellent hiking in the mountains. More important, however, is cultural tourism. Lower Austria has a lot to offer in this respect with its numerous museums, castles, churches and monasteries. Austria's capital Vienna—which is a federal state in its own right—is the main attraction of the region with its charm and the multitude of landmarks and points of interest.

La Basse-Autriche

La plus grande région d'Autriche s'étend de la plaine du Danube aux Préalpes vallonnées et jusque dans des montagnes atteignant 2 000 m d'altitude. Bien qu'elle ne représente qu'une toute petite partie des Alpes, elle attire les touristes avides de randonnées dans les montagnes. Mais la Basse-Autriche fait également la part belle au tourisme culturel, avec de nombreux musées, châteaux, églises et monastères. La capitale de l'Autriche, Vienne, possède un charme tout particulier et une multitude d'attractions touristiques. C'est la principale destination de la région.

Niederösterreich

Von der Donauebene über hügeliges Voralpenland bis in Gebirgsregionen, die 2000 m Höhe erreichen, erstreckt sich Österreichs größtes Bundesland. Auch wenn der Anteil an den Alpen nicht besonders groß ist, zieht es Urlauber vor allem zum Wandern in die Bergwelt. Bedeutender ist aber der Kulturtourismus. Hier hat Niederösterreich mit zahlreichen Museen, Schlössern, Kirchen und Klöstern viel zu bieten. Österreichs Hauptstadt Wien – mit dem Status eines eigenen Bundeslandes – mit ihrem Charme und der Vielzahl an Attraktionen ist Hauptanziehungspunkt der Region.

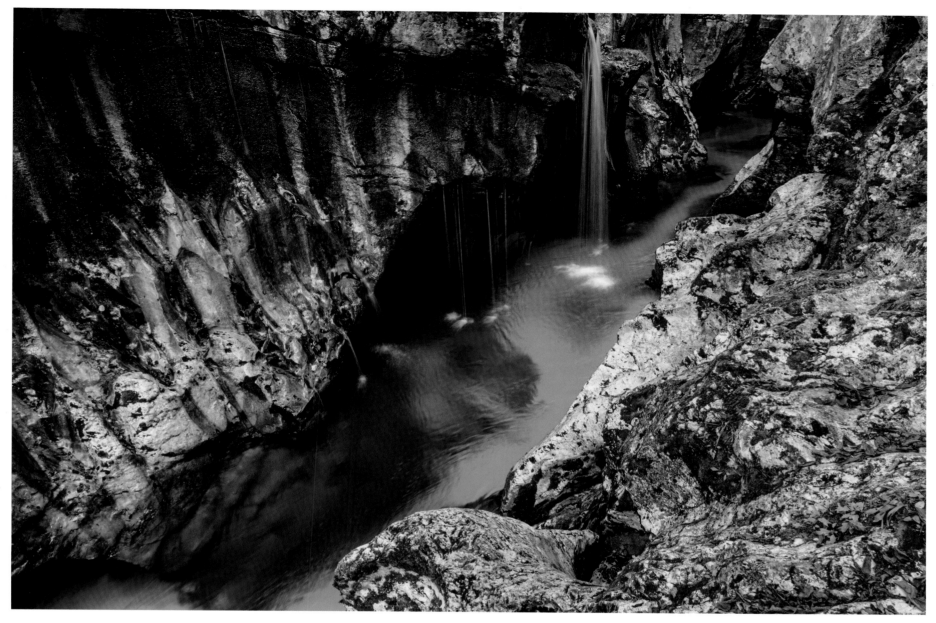

Soteska Soča, Triglavski narodni park
Soca gorge, Triglav National Park

Slovenia

The landscape in the northern part of Slovenia is dominated by the Alps. In the extreme northwest the Julian Alps reach heights of up to 2864 m (9396 ft). The further one ventures east, the lower the foothills become. In Slovenia one can still experience nature in the mountains without the hustle and bustle usual in other regions of the Alps.

La Slovénie

Dans le Nord de la Slovénie, les Alpes font partie intégrante du paysage. À l'extrême nord-ouest du pays, les Alpes juliennes culminent jusqu'à 2864 m. Plus on s'éloigne vers l'est et moins les contreforts sont hauts. Contrairement à la plupart des autres régions des Alpes, la Slovénie permet encore de profiter de la nature à l'état brut.

Slowenien

Das Landschaftsbild im nördlichen Teil Sloweniens wird von den Alpen bestimmt. Im äußersten Nordwesten erreichen die Julischen Alpen Höhen von bis zu 2864 m. Je weiter nach Osten, desto niedriger werden die Hochgebirgsausläufer. Anders als in den meisten Alpenregionen kann man in Slowenien noch Naturerfahrungen im Gebirge ohne den üblichen Rummel machen.

Eslovenia

El paisaje del norte de Eslovenia está definido por los Alpes. En el extremo noroeste los Alpes julianos alcanzan alturas de hasta 2864 m. Cuanto más al este, más bajas se vuelven las estribaciones de las altas montañas. A diferencia de la mayoría de las regiones alpinas, en Eslovenia todavía se puede experimentar la naturaleza en las montañas sin el habitual ajetreo y bullicio.

Eslovênia

A paisagem na parte norte da Eslovénia é dominada pelos Alpes. No extremo noroeste, os Alpes Julianos atingem alturas de até 2864 m. Quanto mais a leste, mais baixa se torna a base da alta montanha. Ao contrário da maioria das regiões alpinas, na Eslovénia ainda pode experimentar a natureza nas montanhas sem a habitual agitação e agitação.

Slovenië

Het landschapsbeeld van Noord-Slovenië wordt bepaald door de Alpen. In de Julische Alpen in het uiterste noordwesten bereikt de hoogste top 2864 m, maar hoe verder naar het oosten, hoe lager de uitlopers. Het bijzondere aan de Sloveense bergen is de stilte: anders dan in de meeste andere delen van de Alpen valt de natuur hier nog steeds te beleven zonder de gebruikelijke drukte.

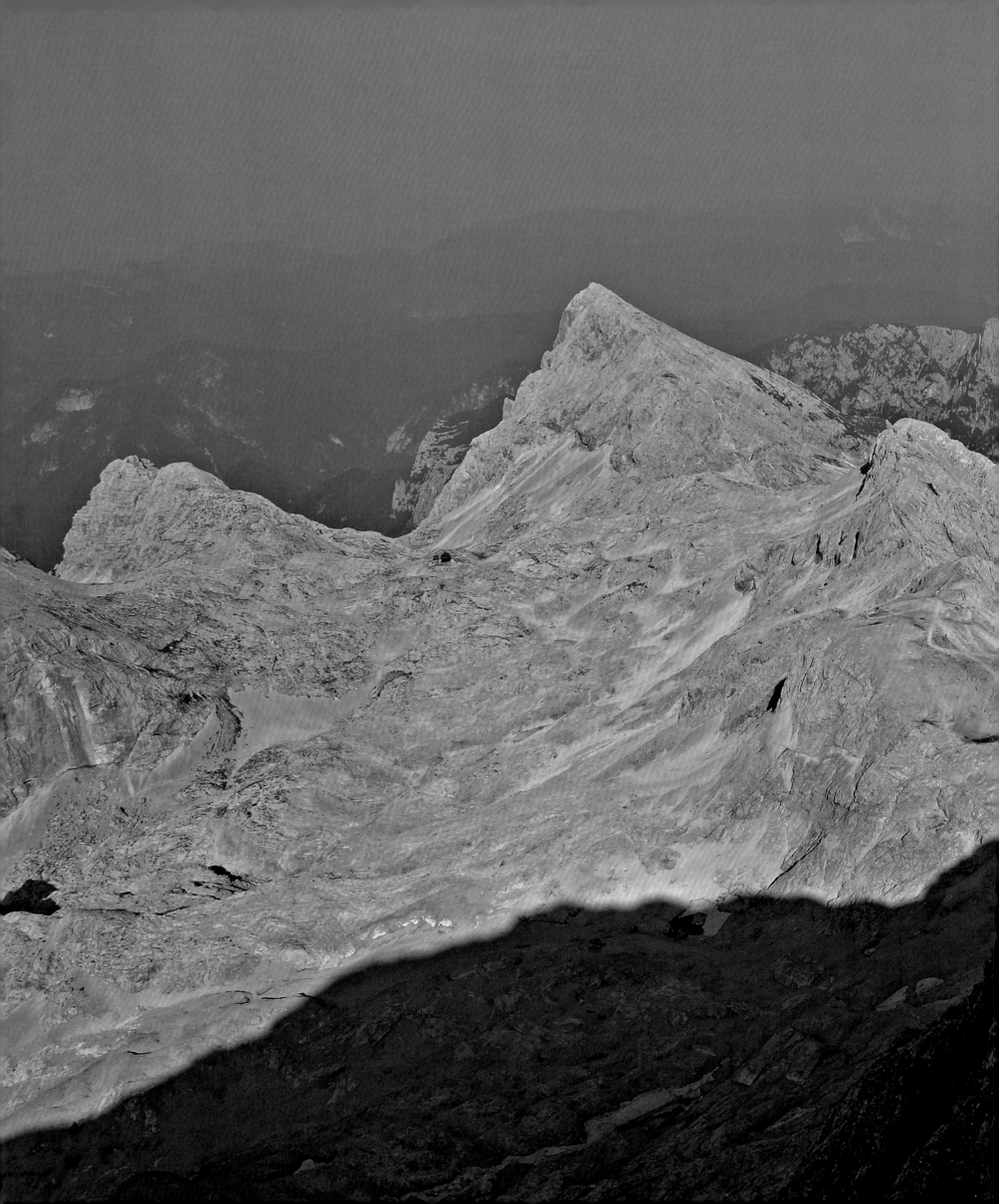

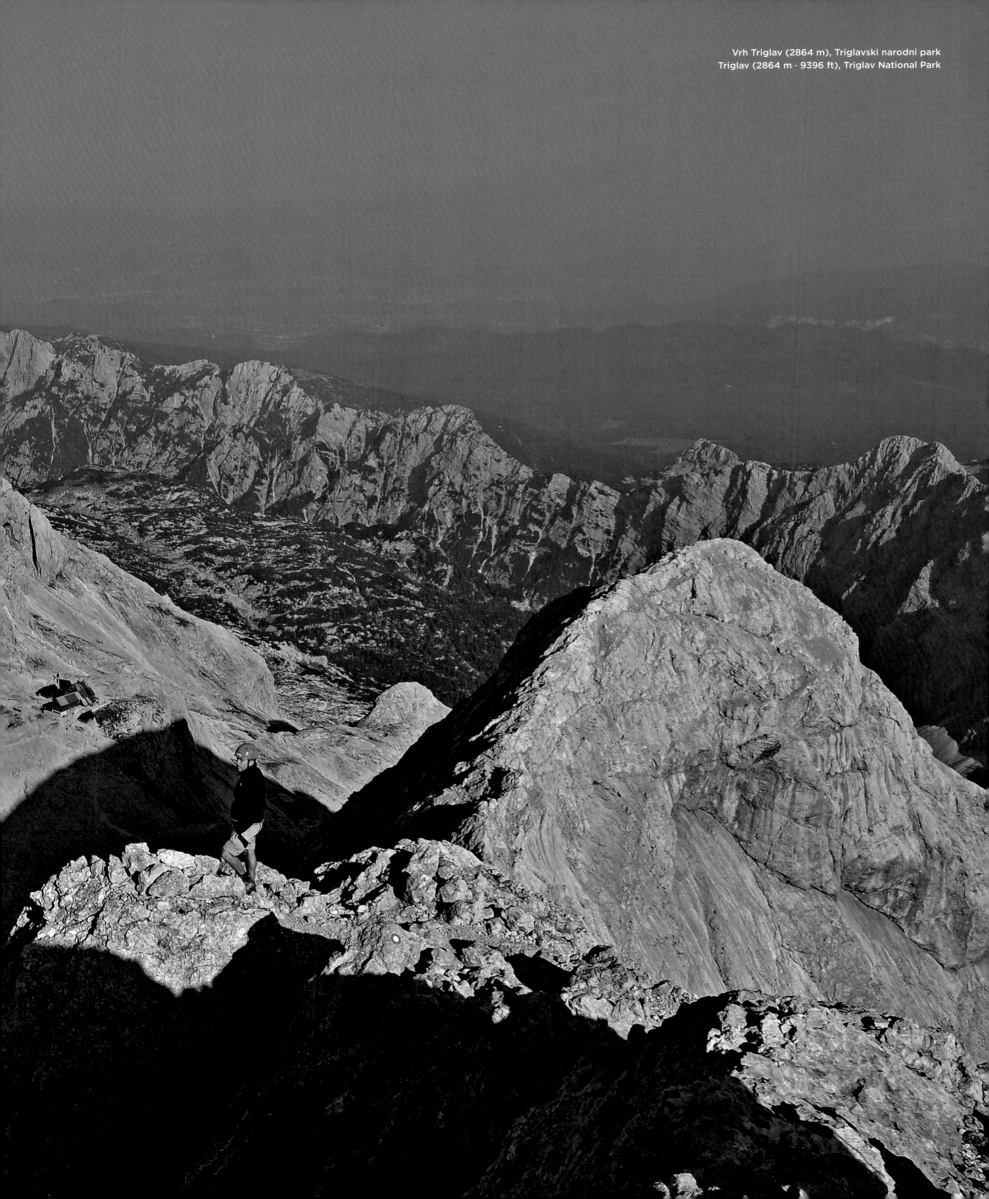

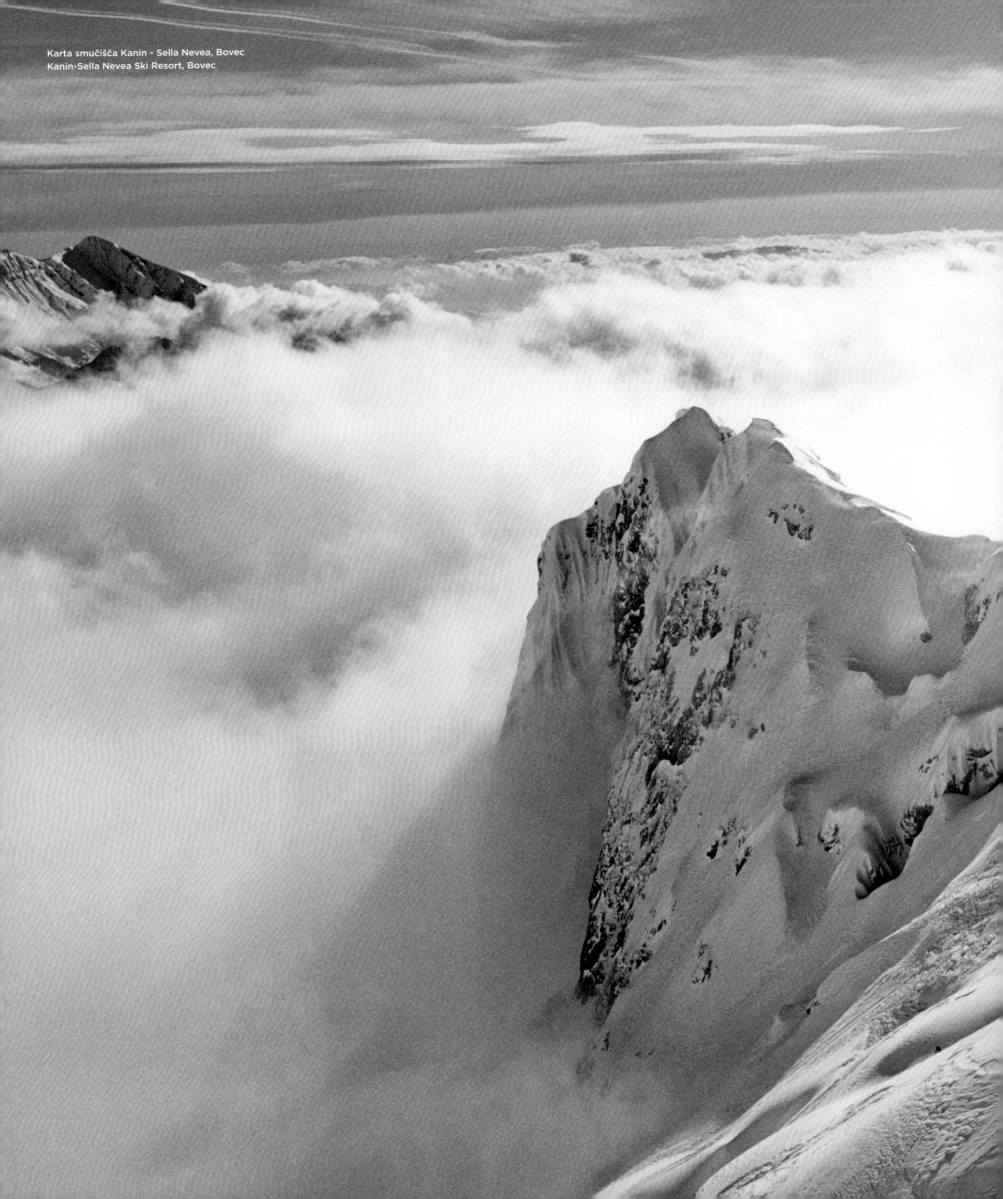

Karta smučišča Kanin - Sella Nevea, Bovec
Kanin-Sella Nevea Ski Resort, Bovec

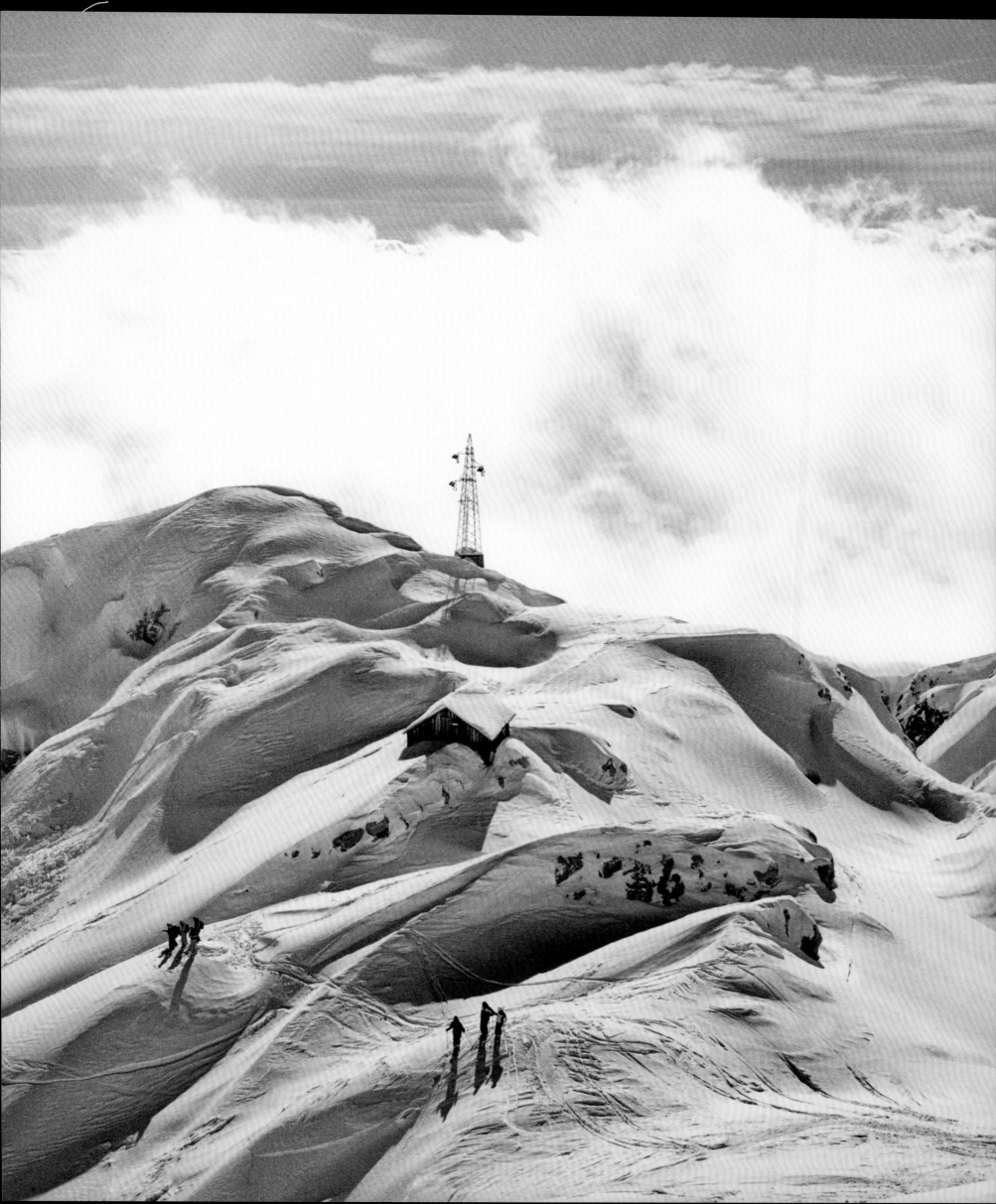

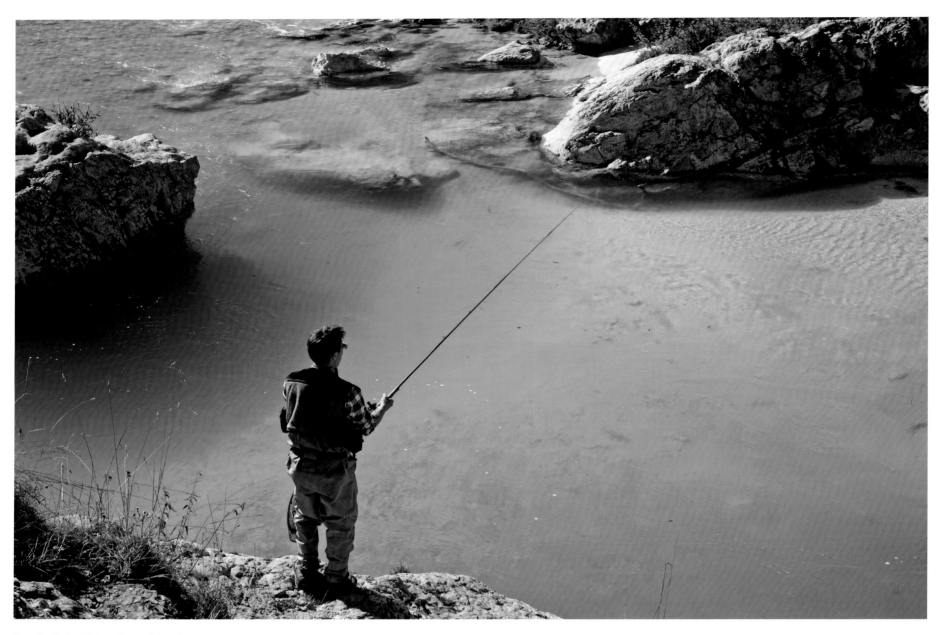

Soteska Soča, Triglavski narodni park
Soca gorge, Triglav National Park

Triglav National Park

The national park of the same name was established in 1981 around the Triglav, with 2864 m (9396 ft) the highest mountain of Slovenia. Fishermen and water sports enthusiasts can pursue their hobbies in the Soča Valley. The region is rightly famous for the high, snow-sure Pokljuka plain, which is one of the stops in the international Biathlon World Cup.

Le parc national du Triglav

En 1981, un parc national a été créé autour du plus haut sommet de Slovénie, le Triglav, qui culmine à 2864 m. Les amoureux de la pêche et des sports nautiques peuvent se livrer à leur passion dans la vallée de la Soča. Cette région doit surtout sa notoriété au domaine skiable de Pokljuka, qui fait partie des stations de la Coupe du monde de biathlon.

Triglav-Nationalpark

Rund um den höchsten Berg Sloweniens, den 2864 m hohen Triglav, wurde 1981 der gleichnamige Nationalpark eingerichtet. Angler und Wassersportler können im Soča-Tal ihren Hobbies nachgehen. Bekannt wurde die Region vor allem durch die hochgelegene, schneesichere Pokljuka-Ebene, die zu den Stationen im internationalen Biathlon-Weltcup gehört.

Parque Nacional de Triglav

Alrededor de la montaña más alta de Eslovenia, el Triglav de 2864 m de altura, se estableció el parque nacional del mismo nombre en 1981. Los pescadores y los entusiastas de los deportes acuáticos pueden perseguir sus aficiones en el Valle de Soča. La región se hizo famosa sobre todo por su llanura de Pokljuka, que es una de las paradas de la Copa Mundial de Biatlón internacional.

Parque Nacional Triglav

Em torno da montanha mais alta da Eslovênia, o Triglav de 2864 m de altura, o parque nacional com o mesmo nome foi criado em 1981. Pescadores e entusiastas de esportes aquáticos podem perseguir seus hobbies no Soča Valley. A região ficou famosa principalmente por sua alta planície de Pokljuka, que é uma das paradas da Copa do Mundo Internacional de Biatlo.

Nationaal park Triglav

Rond de hoogste bergtop van Slovenië, de 2864 m hoge Triglav, werd in 1981 het gelijknamige nationaal park opgericht. Een eldorado voor vissers en watersporters is de rivier de Soča, terwijl wintersporters terecht kunnen op de sneeuwzekere Pokljuka-hoogvlakte, waar 's winters de wereldbekerwedstrijd biatlon plaatsvindt.

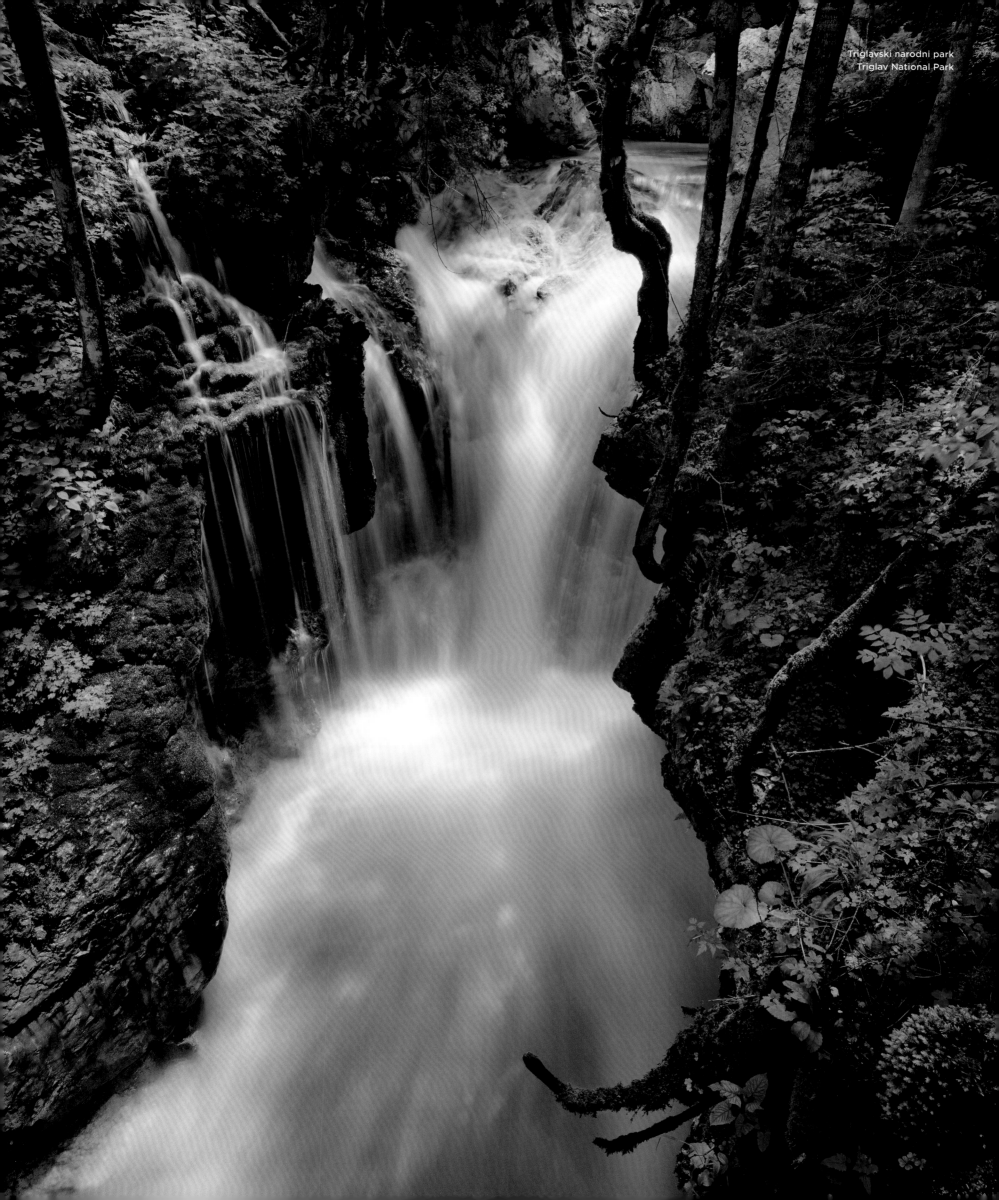

Triglavski narodni park
Triglav National Park

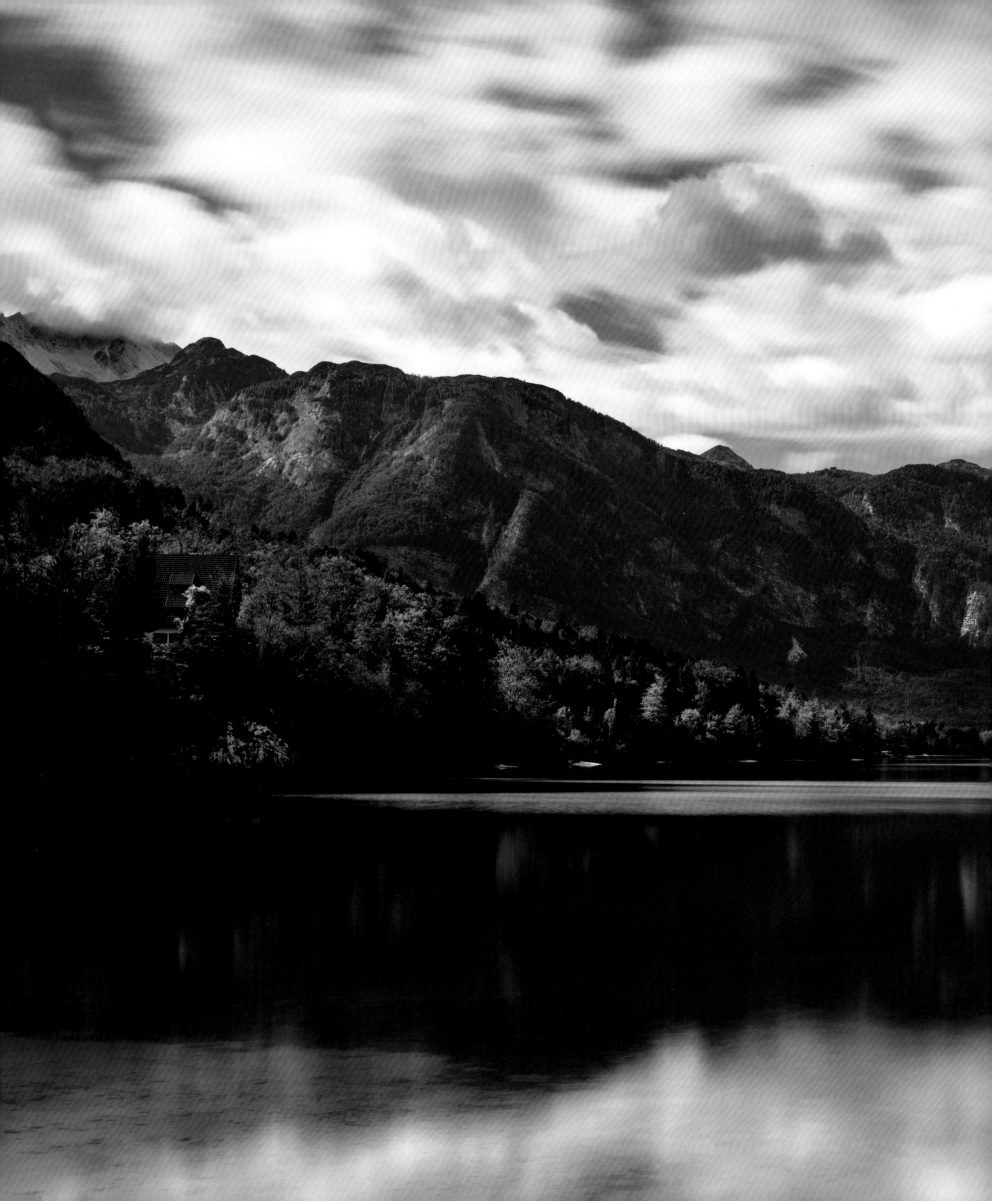

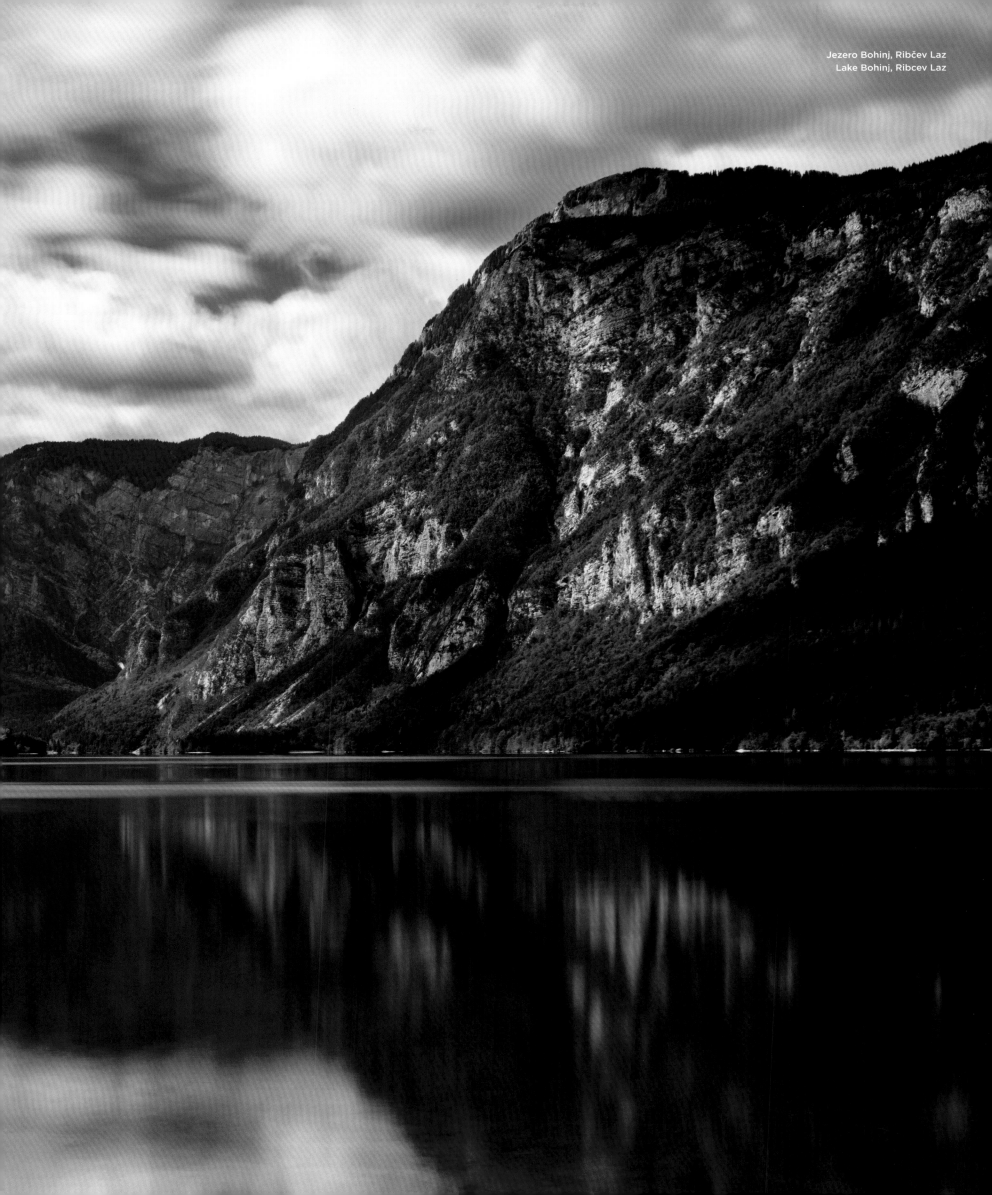

Jezero Bohinj, Ribčev Laz
Lake Bohinj, Ribcev Laz

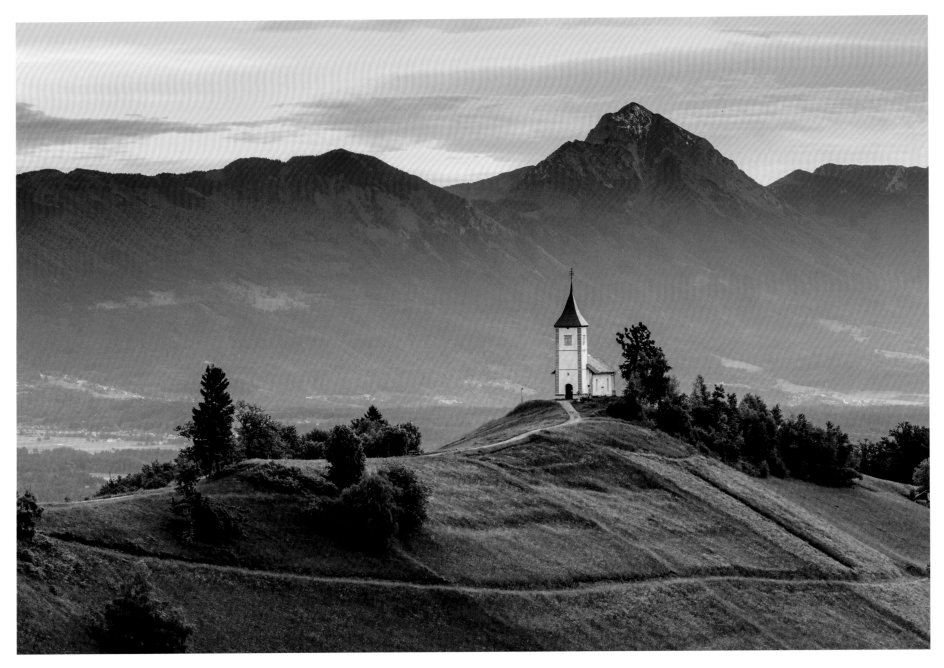

Cerkev svetega Primoža
St Primoz Church

St. Primus and Felician, Jamnik

It is undoubtedly the particularly beautiful location that makes the small church in Jamnik, dedicated to St. Primus and Felician, one of the most photographed churches in Slovenia. About 80 km (50 mi) from the capital Ljubljana, it is built on a long, gently rising ridge near the town of Jamnik, and offers a wonderful panoramic view. In the northwest the mountains of the Julian Alps with the Triglav rise high, to the east the view goes towards the Save valley and the chain of the Steiner Alps. The saints whose names the church bears lived in the 3rd century and died as martyrs.

Saints Prime et Félicien, à Jamnik

C'est sûrement grâce à son décor idyllique que la petite église Saints-Prime-et-Félicien, à Jamnik, est l'une des églises les plus photographiées du pays. Elle est située à environ 80 km de Ljubljana, la capitale, un peu à l'écart du village de Jamnik, perchée sur une arête d'où l'on a une vue panoramique incroyable. Au nord-ouest, on peut voir les Alpes juliennes et le Triglav, tandis qu'à l'est, le regard se perd dans la vallée de la Save et jusqu'aux Alpes kamniques. Les deux saints auxquels l'église doit son nom ont vécu au IIIe siècle et sont morts en martyrs.

St. Primus und Felician, Jamnik

Zweifellos ist es die besonders schöne Lage, die die kleine, St. Primus und Felician geweihte Kirche in Jamnik zu einer der meistfotografierten Kirchen im Land macht. Etwa 80 km von der Hauptstadt Ljubljana entfernt, ist sie abseits des Ortes Jamnik auf einem langen, sanft ansteigenden Berggrat erbaut, von wo sich ein wunderbarer Rundblick bietet. Im Nordwesten liegt das Hochgebirge der Julischen Alpen mit dem Triglav, nach Osten geht der Blick in Richtung Save-Tal und zur Kette der Steiner Alpen. Die Heiligen, deren Namen die Kirche trägt, lebten im 3. Jahrhundert und starben als Märtyrer.

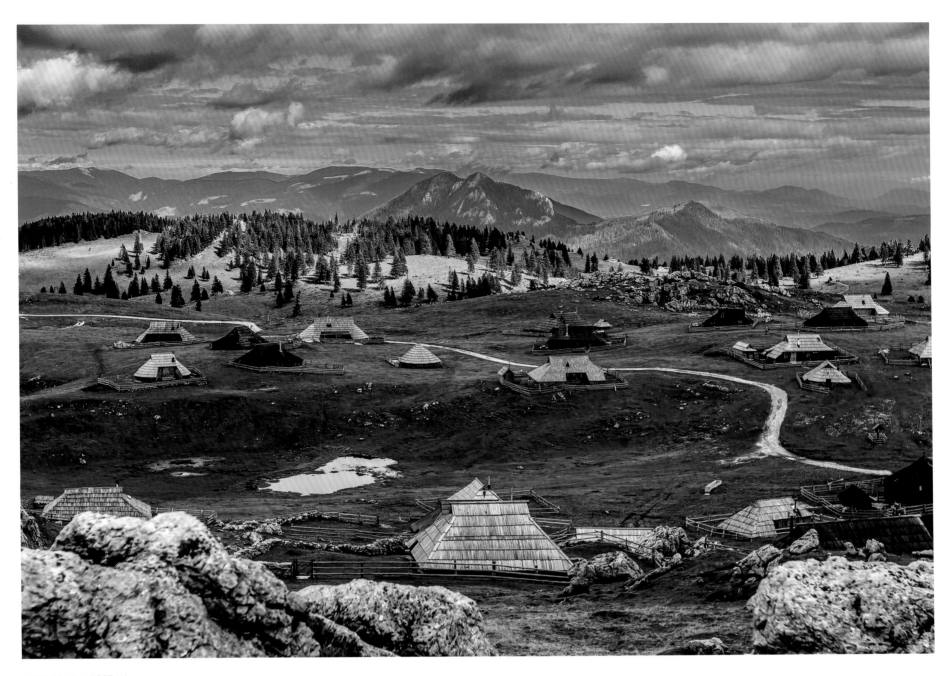

Velika Planina (1667 m)
Big Pasture Plateau (1667 m · 5469 ft)

St. Primus y Felician, Jamnik

Es, sin duda, el lugar especialmente bello lo que hace de la pequeña iglesia de Jamnik, dedicada a San Primo y a Feliciano, una de las iglesias más fotografiadas del país. A unos 80 km de la capital, Liubliana, está construida sobre una larga cresta que se eleva suavemente lejos del asentamiento de Jamnik, ofreciendo una maravillosa vista panorámica. En el noroeste, las altas montañas de los Alpes julianos se encuentran con el Triglav; al este, la vista se dirige hacia el valle de Save y la cadena de los Alpes de Kamnik y de la Savinja. Los santos cuyos nombres lleva la iglesia vivieron en el siglo III y murieron como mártires.

St. Primus e Feliciano, Jamnik

É sem dúvida a localização particularmente bonita que torna a pequena igreja em Jamnik, dedicada a São Primus e Feliciano, uma das igrejas mais fotografadas do país. A cerca de 80 km de Ljubljana, a capital, está construída sobre uma longa crista que se eleva suavemente a partir de Jamnik, oferecendo uma vista panorâmica maravilhosa. No noroeste estão as altas montanhas dos Alpes Julianos com o Triglav, ao leste a vista vai para o vale de Save e a cadeia dos Alpes Steiner. Os santos cujos nomes a igreja tem viveram no século III e morreram como mártires.

St. Primus en Felician, Jamnik

Dat het kleine, aan St. Primus en Felician gewijde kerkje in Jamnik een van de meest gefotografeerde kerken van Slovenië is, heeft het ongetwijfeld te danken aan de bijzonder fraaie ligging. Het ligt namelijk op een heuvelrug in een zacht glooiend landschap op ongeveer 80 km van de hoofdstad Ljubljana en biedt een geweldig panorama. In het noordwesten zijn de toppen van de Julische Alpen met de Triglav te zien, in het oosten de Save-vallei en de Kamnische Alpen. De heiligen naar wie het kerkje werd vernoemd, leefden in de 3e eeuw en stierven beide als martelaren.

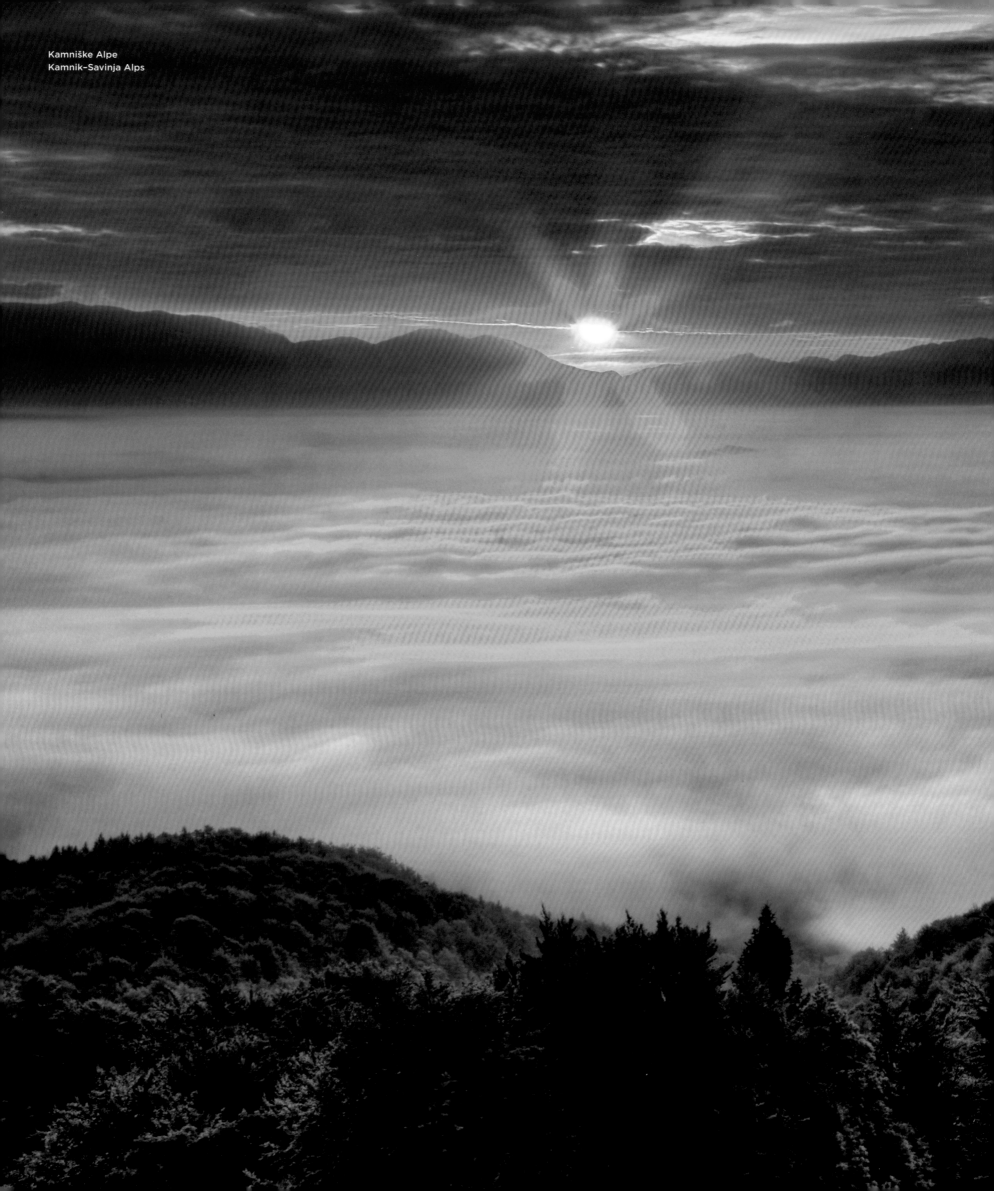

Kamniške Alpe
Kamnik–Savinja Alps

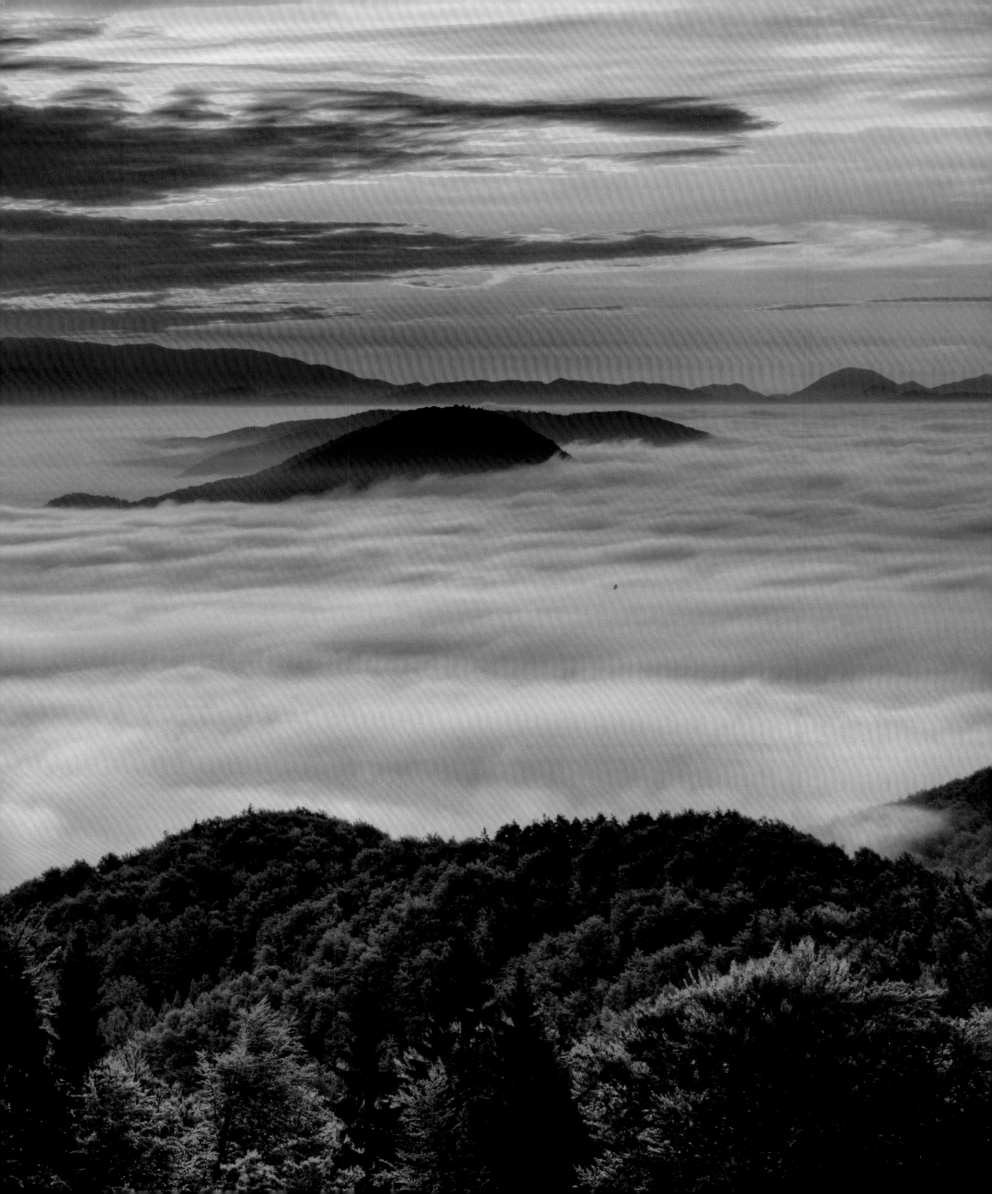

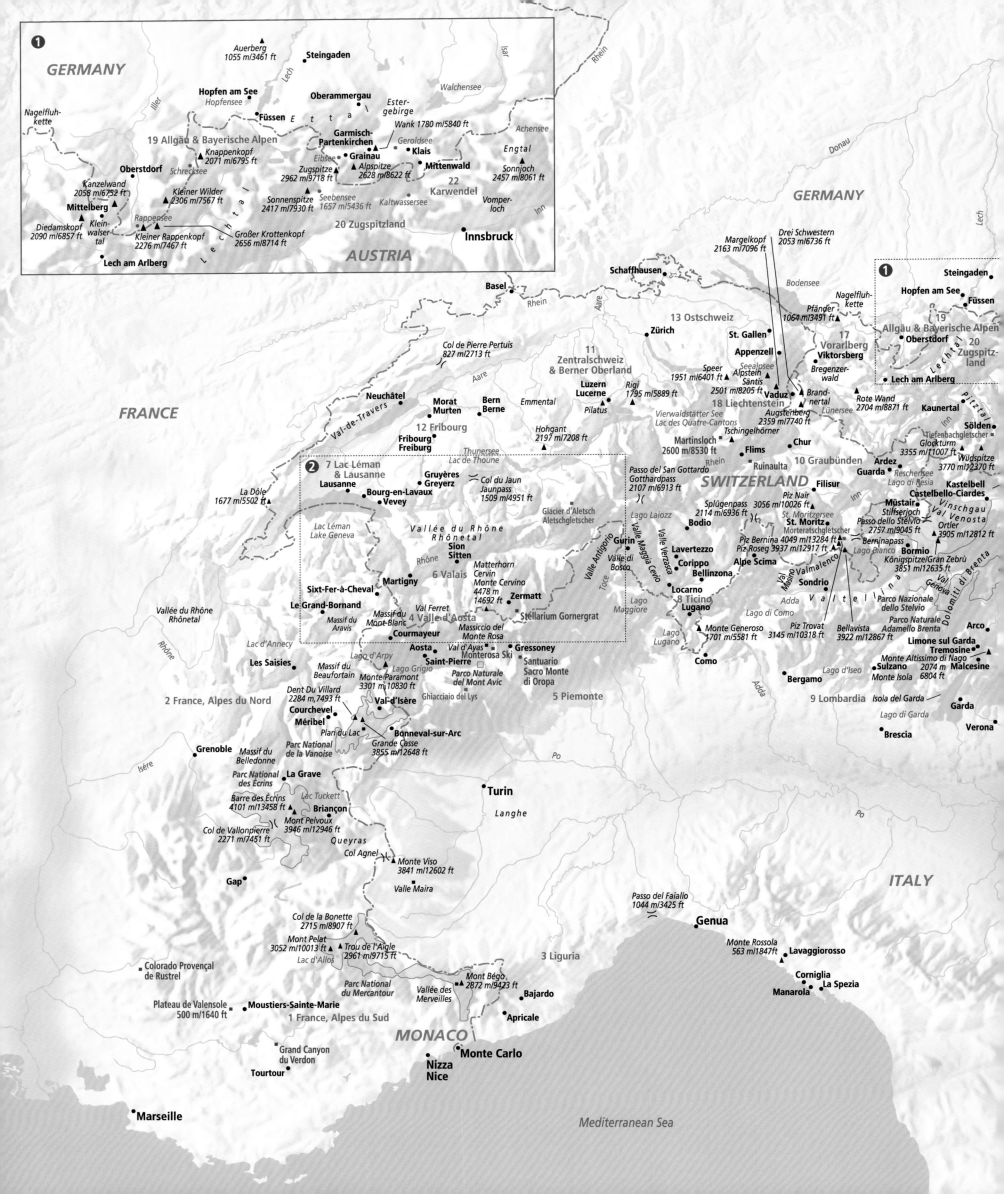

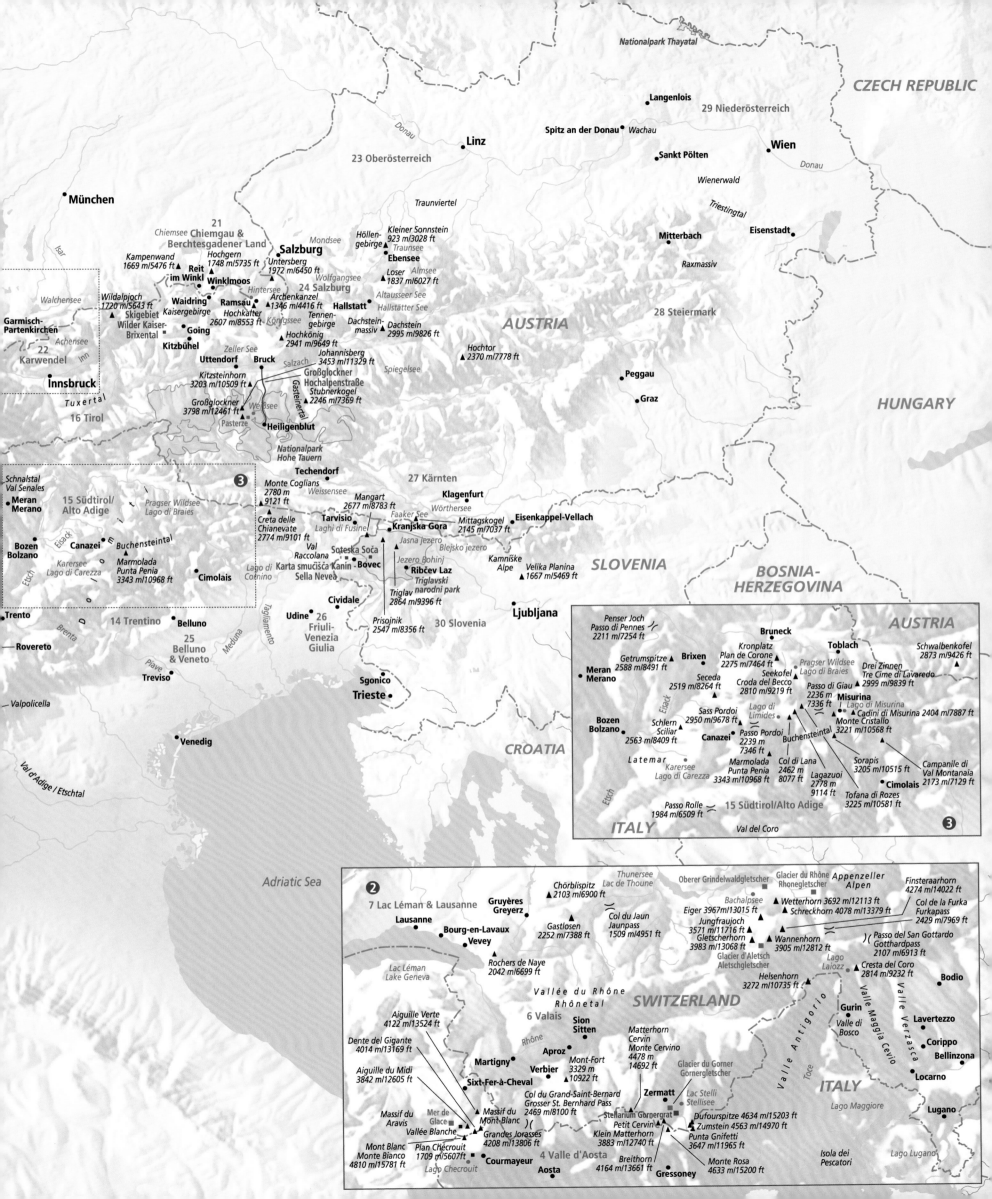

CZECH REPUBLIC

Langenlois
29 Niederösterreich
Spitz an der Donau • Wachau
Linz
Sankt Pölten
Wien
Donau
Wienerwald
München
Traunviertel
Triestingtal
Chiemsee 21 Chiemgau &
Berchtesgadener Land
Mondsee
Mitterbach
Eisenstadt
Kampenwand
1669 m/5476 ft ▲
Reit
im Winkl
Hochgern
1748 m/5735 ft ▲
Untersberg
1972 m/6450 ft
Salzburg
Höllen-
gebirge
Kleiner Sonnstein
923 m/3028 ft
Raxmassiv
Traunsee
Winklmoos
Hintersee
Wolfgangsee
24 Salzburg
Ebensee
Loser
1837 m/6027 ft ▲
AUSTRIA
28 Steiermark
Wildalpjoch
1720 m/5643 ft ▲
Waidring
Kaisergebirge
Ramsau
Archenkanzel
1346 m/4416 ft ▲
Hallstatt
Altausseer See
Hallstätter See
Garmisch-
Partenkirchen
Skigebiet
Wilder Kaiser-
Brixental
Hochkalter
2607 m/8553 ft
Going
Tennen-
gebirge
Dachstein-
massiv
Dachstein
2995 m/9826 ft
22
Karwendel
Achensee
Kitzbühel
Hochkönig
2941 m/9649 ft
Hochtor
▲ 2370 m/7778 ft
Peggau
Innsbruck
Uttendorf
Bruck
Johannisberg
3453 m/11329 ft
Großglockner
Hochalpenstraße
Graz
Inn
Kitzsteinhorn
3203 m/10509 ft ▲
Salzach
Stubnerkogel
▲ 2246 m/7369 ft
Tuxertal
16 Tirol
Großglockner
3798 m/12461 ft
Gasteinertal
Weißsee
Pasterze
Heiligenblut
HUNGARY
Zeller See
Spiegelsee
Nationalpark
Hohe Tauern
Techendorf
27 Kärnten
Schnalstal
Val Senales
15 Südtirol/
Alto Adige
Monte Coglians
2780 m
9121 ft
Weissensee
Pragser Wildsee
Lago di Braies
Mangart
2677 m/8783 ft
Klagenfurt
Wörthersee
Meran
Merano
Creta delle
Chianevate
2774 m/9101 ft
Tarvisio
Laghi di Fusine
Mittagskogel
2145 m/7037 ft
Eisenkappel-Vellach
Bozen
Bolzano
Eisack
Canazei
Buchensteintal
Val
Raccolana
Soteska Soča
Kranjska Gora
Jasna jezero
Blejsko jezero
Kamniške
Alpe
Velika Planina
1667 m/5469 ft ▲
SLOVENIA
BOSNIA-
HERZEGOVINA
Karersee
Lago di Carezza
Marmolada
Punta Penia
3343 m/10968 ft
Cimolais
Karta smučišča Kanin
Sella Nevea
Bovec
Ribčev Laz
Jezero Bohinj
Triglav
2864 m/9396 ft
Triglavski
narodni park
Trento
14 Trentino
Belluno
Lago di
Cornino
Tagliamento
Cividale
Prisojnik
2547 m/8356 ft
Triglavski
Ljubljana
30 Slovenia
Rovereto
25
Belluno
& Veneto
Brenta
Meduna
Udine 26 Friuli-
Venezia
Giulia
Treviso
Plave
Sgonico
Trieste
CROATIA
Venedig
Val d'Adige / Etschtal
Valpolicella
Adriatic Sea

Inset 3:

Penser Joch
Passo di Pennes
2211 m/7254 ft
Bruneck
Toblach
AUSTRIA
Getrumspitze
2588 m/8491 ft
Brixen
Kronplatz
Plan de Corone
2275 m/7464 ft
Pragser Wildsee
Lago di Braies
Schwalbenkofel
2873 m/9426 ft
Meran
Merano
Seceda
2519 m/8264 ft
Seekofel
Croda del Becco
2810 m/9219 ft
Passo di Giau
2236 m
7336 ft
Drei Zinnen
Tre Cime di Lavaredo
2999 m/9839 ft
Misurina
Lago di Misurina
Cadini di Misurina 2404 m/7887 ft
Bozen
Bolzano
Schlern
Sciliar
2563 m/8409 ft
Sass Pordoi
2950 m/9678 ft
Lago di
Limides
Canazei
Passo Pordoi
2239 m
7346 ft
Buchensteintal
Monte Cristallo
3221 m/10568 ft
Latemar
Karersee
Lago di Carezza
Marmolada
Punta Penia
3343 m/10968 ft
Col di Lana
2462 m
8077 ft
Lagazuoi
2778 m
9114 ft
Sorapis
3205 m/10515 ft
Tofana di Rozes
3225 m/10581 ft
Campanile di
Val Montanaia
2173 m/7129 ft
Cimolais
Passo Rolle
1984 m/6509 ft
15 Südtirol/Alto Adige
ITALY
Val del Coro
Etsch

Inset 2:

Thunersee
Lac de Thoune
Oberer Grindelwaldgletscher
Glacier du Rhône
Rhonegletscher
Appenzeller
Alpen
Finsteraarhorn
4274 m/14022 ft
Chörblispitz
2103 m/6900 ft
Bachalpsee
Wetterhorn 3692 m/12113 ft
Col de la Furka
Furkapass
2429 m/7969 ft
7 Lac Léman & Lausanne
Gruyères
Greyerz
Col du Jaun
Jaunpass
1509 m/4951 ft
Eiger 3967m/13015 ft
Schreckhorn 4078 m/13379 ft
Lausanne
Gastlosen
2252 m/7388 ft
Jungfraujoch
3571 m/11716 ft
Gletscherhorn
3983 m/13068 ft
Passo del San Gottardo
Gotthardpass
2107 m/6913 ft
Bourg-en-Lavaux
Vevey
Rochers de Naye
2042 m/6699 ft
Wannenhorn
3905 m/12812 ft
Glacier d'Aletsch
Aletschgletscher
Helsenhorn
3272 m/10735 ft
Lago
Laiozz
Cresta del Coro
2814 m/9232 ft
Bodio
Lac Léman
Lake Geneva
Vallée du Rhône
Rhônetal
SWITZERLAND
Gurin
Valle di
Bosco
Lavertezzo
Aiguille Verte
4122 m/13524 ft
6 Valais
Sion
Sitten
Matterhorn
Cervin
Monte Cervino
4478 m
14692 ft
Valle Antigorio
Valle Maggia
Cevio
Valle Verzasca
Corippo
Dente del Gigante
4014 m/13169 ft
Rhône
Aproz
Mont-Fort
3329 m
10922 ft
Glacier du Gorner
Gornergletscher
Bellinzona
ITALY
Aiguille du Midi
3842 m/12605 ft
Martigny
Verbier
Toce
Locarno
Massif du
Aravis
Massif du
Mont-Blanc
Col du Grand-Saint-Bernard
Grosser St. Bernhard Pass
2469 m/8100 ft
Stellarium Gornergrat
Zermatt
Lac Stelli
Stellisee
Dufourspitze 4634 m/15203 ft
Lugano
Mer de
Glace
Grandes Jorasses
4208 m/13806 ft
Petit Cervin
Klein Matterhorn
3883 m/12740 ft
Zumstein 4563 m/14970 ft
Punta Gnifetti
3647 m/11965 ft
Lago Maggiore
Vallée Blanche
Plan Chécrouit
1709 m/5607 ft
4 Valle d'Aosta
Breithorn
4164 m/13661 ft
Monte Rosa
4633 m/15200 ft
Isola dei
Pescatori
Mont Blanc
Monte Bianco
4810 m/15781 ft
Courmayeur
Lago Checrouit
Aosta
Gressoney
Lago Lugano